Vincent van Gogh

The Complete Paintings

Part I

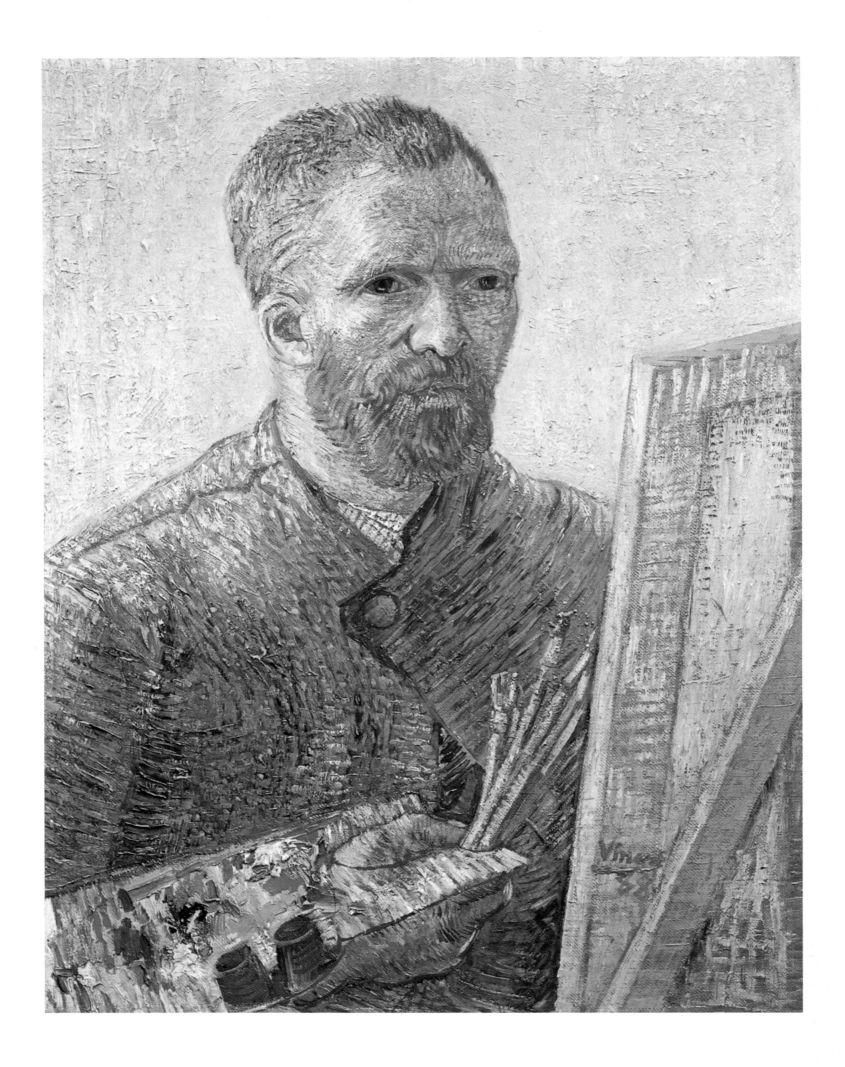

Ingo F. Walther · Rainer Metzger

Vincent van Gogh

The Complete Paintings

Part I

Etten, April 1881 – Paris, February 1888

TASCHEN

KÖLN LISBOA LONDON · NEW YORK PARIS TOKYO

Contents

© 1997 Benedikt Taschen Verlag GmbH
Hohenzollernring 53, D–50672 Köln
English translation: Michael Hulse

Printed in Germany
ISBN 3-8228-8265-8
GB

This work was originally published in two volumes.

Illustration page 2:
Self-Portrait in Front of the Easel
cf. p. 298

Illustration page 302:
Self-Portrait
cf. p. 537

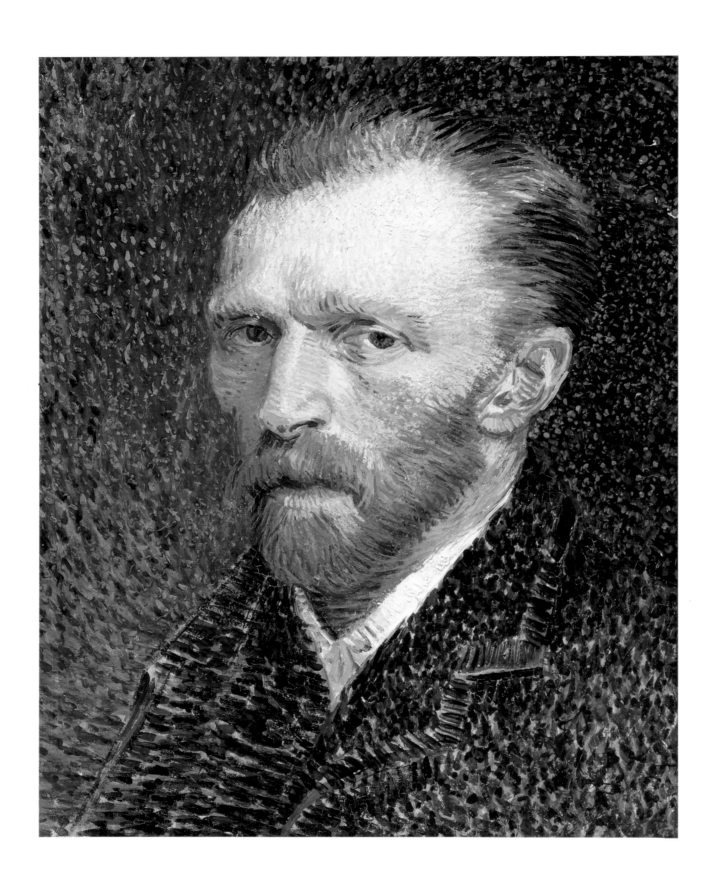

Deserted

Two chairs. Each of them dominating the painting it appears in. Positioned at an angle, touching the edges of the canvas, they have a monumental quality, and seem to be saying: "Go ahead, sit down." Both chairs are unoccupied. There are only one or two objects on them, waiting to be removed or picked up by the person they belong to. Both of these chairs dominate the pictures, filling the painted space, solid, palpable; yet they are intensely related to each other, too, like two panels of a diptych that achieve new unity in being brought together. Juxtaposed, the chairs will be looking at each other, as it were, offering an invitation to talk, to confide; or else, back to back, they will have turned away from each other, as if they had nothing more to say and existed in different worlds.

"Now, at any rate", wrote Vincent van Gogh to his brother Theo (Letter 563) in December 1888, when he painted the two chairs, "I can tell you that the latest two studies are most remarkable. One chair made of wood and extremely yellow wicker, up against the wall, on red tiles (by daylight). Then Gauguin's armchair, red and green, a nocturnal mood, the wall and floor similarly red and green, two novels and a candle on the seat. On canvas, the paint thickly applied." The curious subjects van Gogh was taking were furniture in his house at Arles and represented the daily meeting-place of van Gogh and his guest, Paul Gauguin. The two painters would sit talking about Art and the affairs of the world, debating, quarrelling, till things went up in their faces: Gauguin's sojourn was to be inseparably linked to the nervous break-down from which van Gogh was never fully to recover. "A few days before we parted", van Gogh subsequently wrote to A. E. Aurier (Letter 626a), describing the nocturnal painting of Gauguin's chair, "before illness forced me to enter a home, I tried to paint his empty chair."

The two paintings are his statement of the friendship of two artists. His own chair, simple and none too comfortable, with his dearly-loved pipe lying on it, stands for the artist himself. It is meant just as metaphorically as the more elegant, comfortable armchair where Gauguin liked to settle. Everyday things, purely functional objects, acquire symbolic power. The eye of love sees the mere thing as representing the

Self-Portrait
Paris, Spring 1887
Oil on cardboard, 42 x 33.7 cm
F 345, JH 1249
Chicago, The Art Institute of Chicago

man who uses it quite matter-of-factly. We may well be tempted to recall the pictorial tradition that provided van Gogh with his earliest artistic impressions. Dutch Calvinism sternly insisted on an iconographic ban that prohibited all images of the Holy Family except symbolic ones: the danger that the faithful might be distracted from their prayers by the beauty of the human form had to be avoided at all costs. Thus Christ could be represented by a 'vacant throne,' the symbol of judgement and power. It was enough to prompt responses of awe and devotion. Van Gogh's unoccupied chairs pay respect to a tendency to avoid representation of the human figure. Gauguin is there, seated in his armchair, even if we cannot see him – according to this formula.

The break in the two artists' friendship had become inevitable. When Gauguin decided to leave, he left the ruins of van Gogh's dreams of an artists' community in the South behind. "As you know, I have always considered it idiotic that painters live alone. It is always a loss if one is left to one's own devices", van Gogh had written to his brother (Letter 493), describing his longing for solidarity amongst painters. When he lost Gauguin, he also lost his overall perspective on Life. Thus we must see the two chairs as facing away from each other, expressing the irreconcilability of day and night – a polarity van Gogh establishes in the very colours used in the paintings.

Empty chairs had been a feature of van Gogh's thinking since childhood. The memories that crowd behind this single image are connected with deep mournfulness, with thoughts of the omnipresence of death. "After I had seen Pa off at the station, and had watched the train as long as it, or even only its smoke, was still in sight, and after I had returned to my room and Pa's chair was still drawn up to the table where the books and periodicals still lay from the day before, I felt as miserable as a child, even though I am well aware that we shall soon be seeing each other again." (Letter 118.) Irrational though the twenty-five-year-old's grief at the sight of the chair may seem, it was a constant tendency in van Gogh: to endow the most banal of objects with the properties of a memento mori. In 1885, when his father had died, van Gogh arranged his smoking tackle as a still life, simple yet laden with significance. It is no coincidence that a pipe and tobacco pouch are on his own wicker chair in the 1888 painting.

And we must not forget Charles Dickens, the English novelist, who (according to van Gogh) approved a pipe as a tried and tested prophylactic against suicide (Letter W11). Dickens's own vacant chair had been made famous by an illustration in *The Graphic*: "*Edwin Drood* was Dickens's last work", Vincent wrote to his brother (Letter 252), "and Luke Fields, who had got to know Dickens through doing the little illustrations, entered his room the day he died and saw his vacant chair. And that is how it came about that one of the old issues of *The Graphic* carried the moving drawing, 'The Empty Chair'. Empty chairs – there

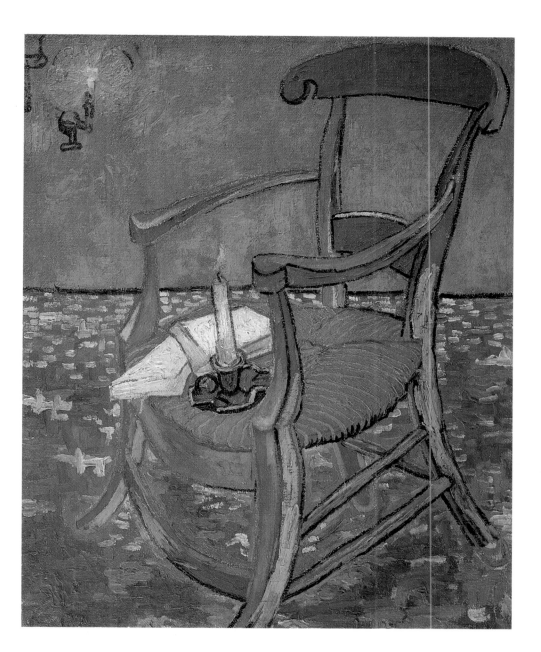

Paul Gauguin's Armchair
Arles, December 1888
Oil on canvas, 90.5 x 72.5 cm
F 499, JH 1636
Amsterdam, Rijksmuseum Vincent van
Gogh, Vincent van Gogh Foundation

are a great many of them, more will be added to their number, and sooner or later there will be nothing left ... but empty chairs."

Van Gogh's life's work as an artist remains ambivalent to a degree that has not yet been fully recognized. His paintings are notable for their immediacy, their sensuous impact. They draw their power from the painter's affectionate openness towards all things, towards Man and Nature. Still, the pleasure that he takes in a veritably naive identification with the world is continually overshadowed by profound eschatological intuitions, by apprehensions of transience and death. The hand that reaches out tenderly is retracted at the last moment because it has too often been hurt. There can be no doubt that van Gogh learnt from experience; indeed, his life precluded him taking a straight and simple course. Yet van Gogh naturally remained a child of his age. He grew up in a century when people for the first time saw their own existence as everything, with no transcendental support system – a century that produced many odd and even self-destructive characters.

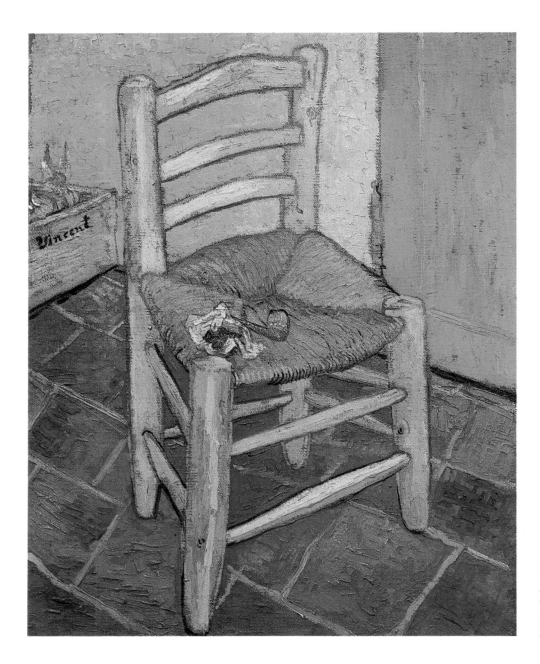

Vincent's Chair with His Pipe
Arles, December 1888
Oil on canvas, 93 x 73.5 cm
F 498, JH 1635
London, National Gallery

The Austrian art historian Hans Sedlmayr gives the title 'The vacant throne' to the final chapter of his essay in cultural criticism, *The Loss of the Centre [Verlust der Mitte]*. Sedlmayr writes: "It must be added that the artists have been among those who suffered the most in the 19th and 20th centuries, the very people whose task it has been to render the Fall of Man and of his world visible in their terrible visions. In the 19th century there was an altogether new type of suffering artist: the lonely, lost, despairing artist on the brink of insanity. It was a type that previously only occurred in isolated instances, if that. The 19th century artists, great and profound minds, often have the character of sacrificial victims, of victims who sacrifice themselves. From Hölderlin, Goya, Friedrich, Runge and Kleist through Daumier, Stifter, Nietzsche and Dostoyevsky to van Gogh, Strindberg and Trakl there was a line of solidarity in suffering at the hands of the times. All of them suffered from the fact that God was remote, and 'dead', and Man debased."

Van Gogh's chairs constitute a metaphor of the crisis of the entire century, a metaphor that corresponds to the somewhat forced pathos of Sedlmayr's account. We cannot grasp van Gogh's own *via dolorosa*, through to his fits of madness and final suicide, in isolation from the century he lived in. Van Gogh's ailment was the *maladie du siècle*, the self-fulfilling *Weltschmerz*, that Sedlmayr attempts to explain by the loss of belief in God. In his *History of Modern Culture [Kulturgeschichte der Neuzeit]*, Egon Friedell (albeit in rather more specific terms) moves in the same direction: "It has been claimed, frequently and emphatically, that our existence may have become more quotidian and grey but is the more rational, but this is a mistake. The 19th century was the inhuman century *par excellence*; the triumph of technology mechanized our lives totally, rendering us stupid; the worship of Mammon has irredeemably impoverished mankind, without exception; and a world without God is not only the least moral but also the least comfortable that can be conceived. As he enters the Present, modern man reaches the inmost circle of hell along his absurd and necessary path of suffering."

Thus it is only consistent if we write the history of van Gogh's art and life, less in a personal than in a historical sense. The causes for his failure in life, and for the subsequent rapid (all the more rapid) success of his cultural counterworld, need not be sought in the untouchable torments of a solitary visionary. Quite the contrary: the reason lies in van Gogh's tireless ambition for recognition, even if only in the image society had fashioned and could accept, the image of the outsider, the isolated genius. If ever there was a genius against his own will, it was Vincent van Gogh.

THIS EDITION. This two-volume edition of Vincent van Gogh's complete paintings is not intended to replace the two catalogues of his work that have long been available. Though its approach to chronological sequence is rather muddled, the indispensable catalogue for research purposes remains Jacob-Baart de la Faille's *The Works of Vincent van Gogh*, published in 1928, revised edition 1970. Jan Hulsker's *The Complete van Gogh* (1980) continued de la Faille's work and made vital corrections. Catalogue numbers in these two publications are keyed **F** or **JH** in the picture captions.

Unlike the available catalogues, this edition seeks to offer colour reproductions of as many as possible of the approximately 870 paintings by van Gogh (the exact number varies owing to a number of disputed attributions). The present authors believe there is little point in reproducing van Gogh in black and white. It is the first time the entirety of van Gogh's work as a painter has been accessible to the public on this scale, and the authors hope the book will also be of service to scholars. Information on the titles, dates, measurements and ownership of paintings is as up-to-date as possible.

It was impossible to reproduce every work in colour because some have been burnt or their whereabouts are unknown, others are in anonymous private hands, and in some cases permission to reproduce in colour was refused. This edition nevertheless reproduces over 83% of van Gogh's paintings in colour, many for the first time. The paintings are arranged in chronological order, with occasional departures for technical or aesthetic reasons. The chapters of the text are also chronologically conceived, though the text and illustrations may be far apart because of the sheer number of illustrations. To assist the reader, marginal titles include information on the place and date of painting. In Volume II, all the paintings are from three periods: Arles, Saint-Rémy and Auvers.

The text was a joint effort, though Rainer Metzger did by far the lion's share, for which I am grateful. We hope that by offering a catalogue and monograph within the same covers we are doing a service both to scholars and to the general public, and that the book will be a pleasure to read and look at. I.F.W.

Man Digging
The Hague, August 1882
Oil on paper on panel, 30 x 29 cm
F 12, JH 185
Private collection
(Christie's Auction, London, 5. 12. 1978)

THE MAKING OF AN ARTIST
1853-1883

The Family
1853-1875

Carpenter's Workshop, Seen from the Artist's Studio
The Hague, May 1882
Pencil, pen, brush, heightened with white,
28.5 x 47 cm
F 939, JH 150
Otterlo, Rijksmuseum Kröller-Müller

Vincent van Gogh was the son of a Dutch pastor, Theodorus van Gogh, and his wife, Anna Cornelia. Their first son was still-born; a year later to the day, on 30 March 1853, another boy saw the light of day. This healthy son was given the names of the still-born first, Vincent Willem, after his two grandfathers. So Vincent van Gogh's very first day of life was an ominous one. This curious fact need not have disturbed the parents too much, but ever since a veritable army of analysts have been responding to the lasting fascination of a child that was born on the anniversary of its death, as it were. And it may well be that Vincent's taste for the paradoxical grew out of this remarkable coincidence.

His family lived a quiet life in the modest vicarage at Zundert near Breda, in Dutch Brabant. Theodorus's father had been a pastor too; indeed, so had generations of the van Goghs. They were not strict Calvinists in belief, but adherents of the Groninger party, a liberal branch of the Dutch Reformed Church. Vincent was profoundly influenced by the hard-working and pious atmosphere of his parental home;

Boy Cutting Grass with a Sickle
Etten, October 1881
Black chalk, watercolour, 47 x 61 cm
F 851, JH 61
Otterlo, Rijksmuseum Kröller-Müller

15 PAINTINGS: ETTEN 1881

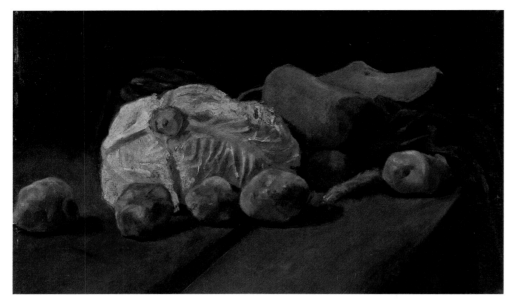

Still Life with Cabbage and Clogs
Etten, December 1881
Oil on paper on panel, 34.5 x 55 cm
F 1, JH 81
Amsterdam, Rijksmuseum Vincent van
Gogh, Vincent van Gogh Foundation

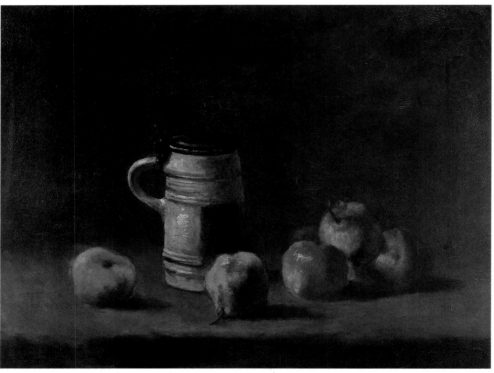

Still Life with Beer Mug and Fruit
Etten, December 1881
Oil on canvas, 44.5 x 57.5 cm
F 1a, JH 82
Wuppertal, Von der Heydt-Museum

and the eruptive violence with which he expressed himself strikes us as a necessary strategy for ridding himself of the cosy image of the world that was imposed on him in childhood.

Theodorus and Anna Cornelia van Gogh had six children. Vincent, the first-born, was followed by Anna Cornelia (born 1855), Theo (born 1857), Elisabetha Huberta (born 1859), Willemina Jacoba (born 1862) and finally Cornelis Vincent (born 1867). During his lifetime, Vincent was to keep up close relations with only two of his siblings: Willemina, to whom some twenty letters dating from late in his life were addressed, and Theo, his financial support, father confessor and viewer of his pictures. The childhood and youth of the siblings seem to have been much what we would expect in a *petit bourgeois* household, and later, after a fit of madness, Vincent was to long for the unruffled happiness of

Beach at Scheveningen in Calm Weather
The Hague, August 1882
Oil on paper on panel, 35.5 x 49.5 cm
F 2, JH 173
Private collection

Dunes
The Hague, August 1882
Oil on panel, 36 x 58.5 cm
F 2a, JH 176
Amsterdam, Private collection

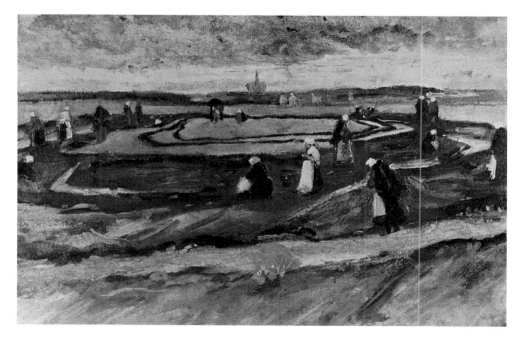

Women Mending Nets in the Dunes
The Hague, August 1882
Oil on paper on panel, 42 x 62.5 cm
F 7, JH 178
Private collection
(Mak van Waay Auction, Amsterdam,
15. 4. 1975)

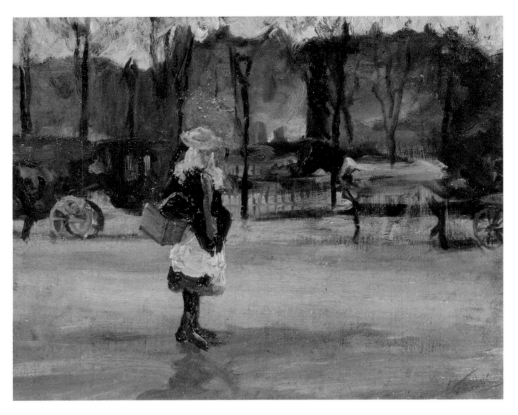

A Girl in the Street, Two Coaches in the Background
The Hague, August 1882
Oil on canvas on panel, 42 x 53 cm
F 13, JH 179
Winterthur, Collection L. Jäggli-Hahnloser

his Zundert home: "During my illness I saw every room in the Zundert house, every path, every plant in the garden, the surroundings, the fields, the neighbours, the graveyard, the church, our kitchen garden at the back – down to the magpie nest in a tall acacia in the graveyard." (Letter 573.) In the last year of his life, longing for his childhood home never relaxed its grip on Vincent van Gogh.

Vincent's father had no fewer than ten brothers and sisters. Vincent's uncles, who lived in various parts of the Netherlands, emphasized their authority over their nephew. Four of them played an especially influential role. Hendrick Vincent van Gogh, "Uncle Hein", was an art dealer in Brussels; it was under him that Theo first ventured into the wider

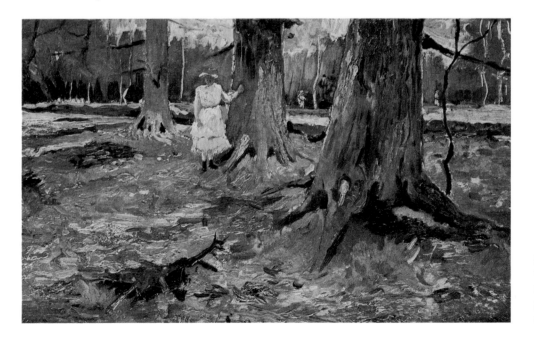

Girl in White in the Woods
The Hague, August 1882
Oil on canvas, 39 x 59 cm
F 8, JH 182
Otterlo, Rijksmuseum Kröller-Müller

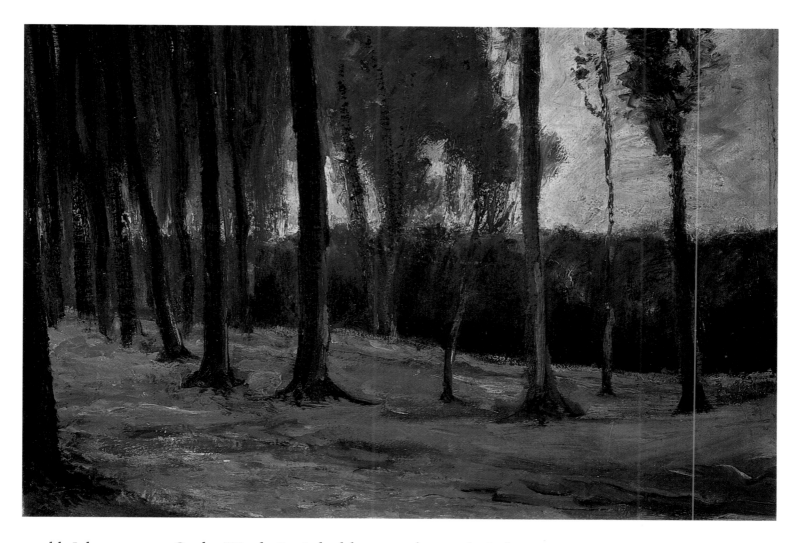

world. Johannes van Gogh, "Uncle Jan", had been made an admiral; Vincent was to live at his home in Amsterdam for the best part of a year. Cornelis Marinus van Gogh, "Uncle Cor", was also an art dealer, and thus active in the field that (along with the pulpit) was the other traditional profession of the van Goghs. Indeed, Vincent van Gogh, "Uncle Cent", was also an art dealer; he was the young Vincent's godfather. He had made the most impressive career for himself, working his way up in The Hague from the most modest of beginnings and ultimately incorporating his shop into the gallery chain of the Paris art publisher Goupil & Cie. There the young Vincent was to make his own first contacts with paintings and drawings.

The family had found a respectable station in society, and the constant pressure to conform which was brought to bear upon Vincent must have felt all the more burdensome when his own career as an art dealer soon proved to have been a false start. In due course, the resigned twenty-four-year-old was to write to his brother (Letter 98): "When I consider the past – when I consider the future, all the well-nigh insuperable difficulties, the vast and arduous toil which I feel no taste for and which I, wicked I, would like to avoid, when I think of the eyes of so many people, gazing at me – people who will know what the reason was if I am unsuccessful, people who will not level the customary re-

Edge of a Wood
The Hague, August 1882
Oil on canvas on panel, 34.5 x 49 cm
F 192, JH 184
Otterlo, Rijksmuseum Kröller-Müller

Two Women in the Woods
The Hague, August 1882
Oil on paper on panel, 35 x 24.5 cm
F 1665, JH 181. Paris, Private collection

Girl in the Woods
The Hague, August 1882
Oil on panel, 35 x 47 cm
F 8a, JH 180
Netherlands, Private collection

Dunes with Figures
The Hague, August 1882
Oil on canvas on panel, 24 x 32 cm
F 3, JH 186
Berne (Switzerland), Private collection

The Sower
The Hague, December 1882
Pencil, brush, Indian ink, 61 x 40 cm
F 852, JH 275
Amsterdam, P. and N. de Boer Foundation

proaches because, tried and tested in all things good and decent, in all that is refined gold, they will say by means of their expressions: We helped you, we were a light to you on your way – we did what we could for you; did you sincerely want it? What is our reward? Where is the fruit of our labour?"

When Vincent joined the branch of Goupil & Cie in The Hague as an apprentice in 1869, at the age of sixteen, there seemed no obstacle to the kind of career the family council would have wished him. Goupil was one of the leading firms in Europe and had recently begun its conquest of America. The house specialized in the reproduction of printed graphics, and leading engravers and painters worked for it. By 1869 the firm had seven branches. Uncle Cent was a partner in it. From 1873, the firm was also Theo van Gogh's employer. Vincent was subsequently remembered as a friendly, dependable employee; the reference written in 1873 by Mr. Tersteg (manager of the branch in The Hague) was a paean of praise. When he was transferred to London in summer 1873, the move was doubtless meant as a reward. It was that transfer that finally set the stone rolling.

Till then, statements such as "Theo, I must seriously advise you to smoke a pipe, it does you good when you're in a bad mood, as is often the case with me" (Letter 5) had been secret confidences. The inescapable loneliness Vincent was soon to experience in London was to accompany him his whole life long. He had fallen from the broad lap of his big family, and now nothing more kept him in the self-sufficiency of a predestined path in Life. The tone of his letters to Theo became noticeably more melancholy. His appeals to the common fraternal spirit were quintessentially expressed in the image of a walk taken together: "How I would like to have you here some time; what fine times we spent together in The Hague, I think so often of our walk along the Rijswijk road, where we drank milk after the rain near the mill... For me, the Rijswijk road is connected with memories that are perhaps the loveliest of all the memories I have." (Letter 10) The cosiness of an idyllic walk was to accompany Vincent van Gogh's life as an artist and became one of his recurrent themes.

Van Gogh's Other Art
The Letters

Beach at Scheveningen in Stormy Weather
The Hague, August 1882
Oil on canvas on cardboard, 34.5 x 51 cm
F 4, JH 187
Amsterdam, Stedelijk Museum (on loan)

"But we must write each other plenty of letters", Vincent van Gogh baldly proposed to his brother Theo on 13 December 1872 (Letter 2). From this acorn, within two brief decades, there grew a mighty oak of correspondence which many have praised as a work of art in its own right. Over 800 of the letters have been preserved, thanks above all to Theo van Gogh's industrious collector instincts. The letters to Theo were the more important; it was to Theo that Vincent's first letter was written, and his last, too; indeed, over three quarters of the letters were addressed to Theo. In 1914–1915, Theo's widow (i.e. Vincent's sister-in-

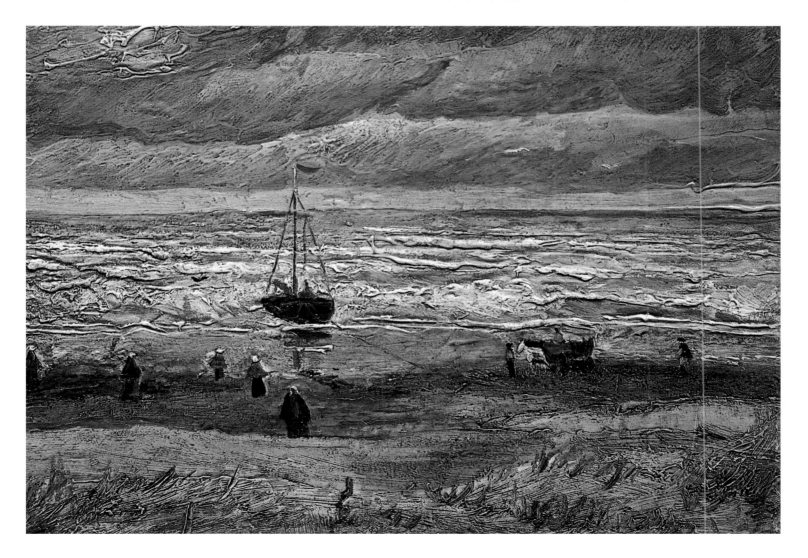

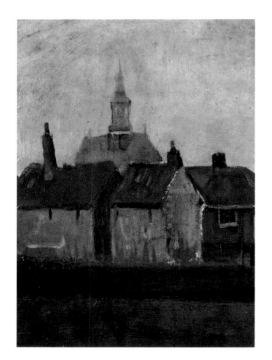

Cluster of Old Houses with the New Church in The Hague
The Hague, August 1882
Oil on canvas on cardboard, 34 x 25 cm
F 204, JH 190
Whereabouts unknown
(Sotheby's Auction, 20. 11. 1968)

law) Jo van Gogh-Bonger first published the material that was in her hands: 652 letters in all. The numbering that was given to the letters has been retained to this day, but in the meantime other written material has been added at the appropriate chronological point (marked with a small letter). Emile Bernard, one of van Gogh's closest painter friends, published the letters addressed to himself in 1911: these have their own numbering and carry a capital B. In 1937 the correspondence between van Gogh and Anton van Rappard was made available to the public in an expanded edition of the letters: the letters to Rappard have a capital R before the number. And then in 1954 Vincent's letters to his sister Willelmina appeared in print: these bear a capital W. To mark the centenary of van Gogh's birth, a first complete edition of the writings was published between 1952 and 1954; this edition added replies to Vincent written by Theo and his wife, all marked with a capital T.

"It is almost as if when writing I did not encounter the same difficulty as I do when painting. In order to do things to my own satisfaction, the work requires far less deliberation when I put something down on paper than it does if I aim at complete satisfaction in my painting. We spend our whole lives in unconscious exercise of the art of expressing our thoughts with the help of words... We ought to write letters that demand our whole attention and on which our fate may depend every day. It is for such reasons that men of significance invariably write well, especially when dealing with matters they have a thorough knowledge of." Thus Eugène Delacroix, Vincent van Gogh's great paragon, in a diary entry on the close ties between writing and painting, and the opportunities writing affords an artist for occasional ease or self-scrutiny. In art history, the link between writing and the visual arts has

Fisherman on the Beach
The Hague, August 1882
Oil on canvas on panel, 51 x 33.5 cm
F 5, JH 188
Otterlo, Rijksmuseum Kröller-Müller

Fisherman's Wife on the Beach
The Hague, August 1882
Oil on canvas on panel, 52 x 34 cm
F 6, JH 189
Otterlo, Rijksmuseum Kröller-Müller

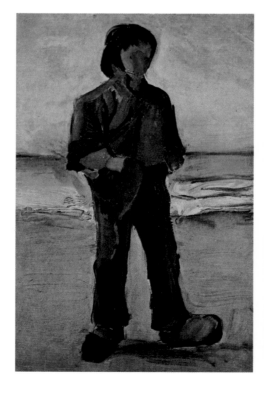
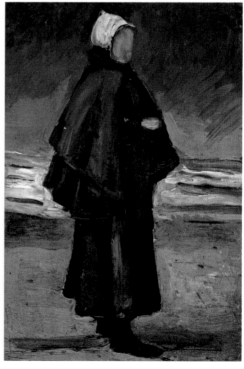

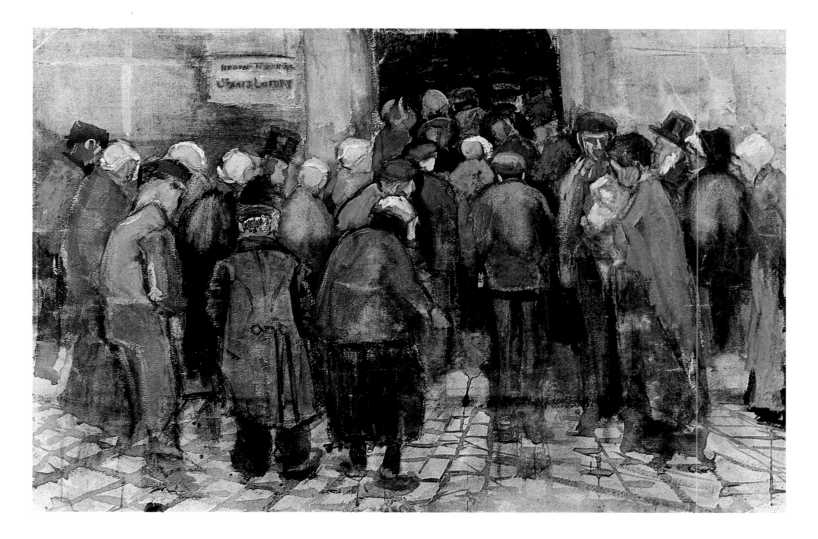

a sturdy tradition: the ancient idea of *ut pictura poesis* (as in painting, so in poetry) has kept a firm grip on art and the ways artists have thought down the centuries.

Van Gogh's own correspondence breathes the spirit of that idea, seeking to bridge the gap between Art and Reality through sheer vividness of description. "A female figure in a black woollen dress is lying before me; I am certain that if you had her for a day or so you would be reconciled to the technique." (Letter 195.) Does not this comment on a drawing read as if he were writing of a real person close to him? "A flock of doves goes sailing by across the red tiled roofs, between the black smoking chimneys. Beyond is an infinity of soft, delicate green, mile upon mile of flat pasture land and a grey sky – as tranquil and peaceful as in Corot or van Goyen." (Letter 219.) When van Gogh looks at a real landscape, is it not as if he were considering a painted one?

We are reminded of the literature of his contemporaries – of Emile Zola, for instance, who subjected his eye to the schooling of Art. "It was not until after seven", we read in his novel *La Bête Humaine* (1890), "that Jacques finally saw the panes growing brighter and taking on a milky white colour. Gradually, through the whole room, an indefinable light spread, in which the furniture seemed to swim, as it were. The stove rose out of the waters, as did the cupboard, the sideboard." Zola is

The State Lottery Office
The Hague, September 1882
Watercolour, 38 x 57 cm
F 970, JH 222
Amsterdam, Rijksmuseum Vincent van Gogh, Vincent van Gogh Foundation

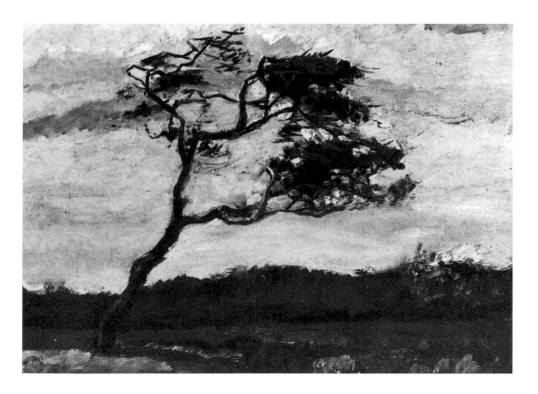

A Wind-Beaten Tree
The Hague, August 1883
Oil on canvas, 35 x 47 cm
F 10, JH 384
Whereabouts unknown

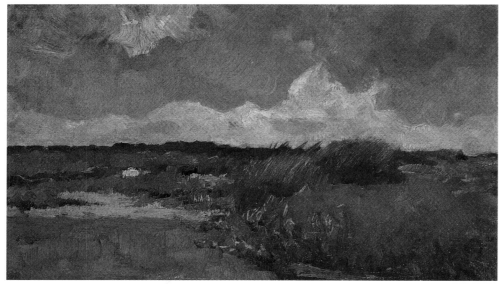

Marshy Landscape
The Hague, August 1883
Oil on canvas, 25 x 45.5 cm
No F Number, JH 394
Private collection
(Koller Auction, Zurich, 12. 11. 1976)

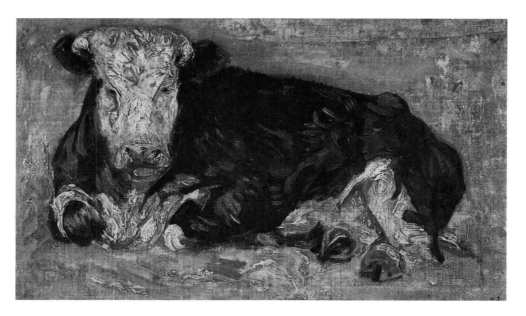

Lying Cow
The Hague, August 1883
Oil on canvas, 19 x 47.5 cm
F 1C, JH 389. Whereabouts unknown
(Sotheby's Auction, 11. 11. 1959)

Lying Cow
The Hague, August 1883
Oil on canvas, 30 x 50 cm
F 1b, JH 388. Whereabouts unknown

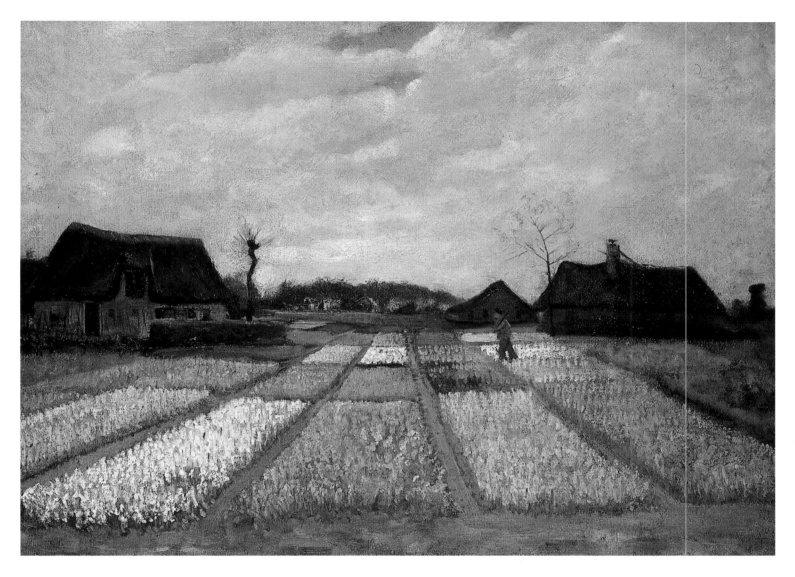

describing an interior that is as real as an interior in an Impressionist painting. In van Gogh's own playing with the nuances of natural and artificial description we can clearly detect his aim to give the language of his letters a flexibility and immediacy beyond statements of personal involvement, to take his bearings from the eloquence of writers such as Zola. It is that eloquence that gives van Gogh's letters the literary value widely ascribed to them.

And then, of course, van Gogh's letters provide a running commentary on his paintings. Almost every one of his works is referred to in some way, be it the subject, the choice of colours, or the circumstances that led to its being painted. Van Gogh's painting and letter-writing are two sides of the same coin. They are parallel forms of an almost uncontainable passion for self-expression.

Delacroix emphasized the value of letter-writing as an accompaniment to artistic creation and as an apt means of appreciating and describing one's own works. Delacroix himself repeatedly wrote other kinds of texts, too; he kept a diary, wrote newspaper articles, and was even the author of books. Van Gogh, on the other hand, limited his endeavours as a writer almost entirely to his correspondence. His fixa-

Bulb Fields
The Hague, April 1883
Oil on canvas on panel, 48 x 65 cm
F 186, JH 361
Washington, National Gallery of Art,
Collection Mr. and Mrs. Paul Mellon

The Sower (Study)
The Hague, August 1883
Oil on panel, 19 x 27.5 cm
F 11, JH 392
Whereabouts unknown

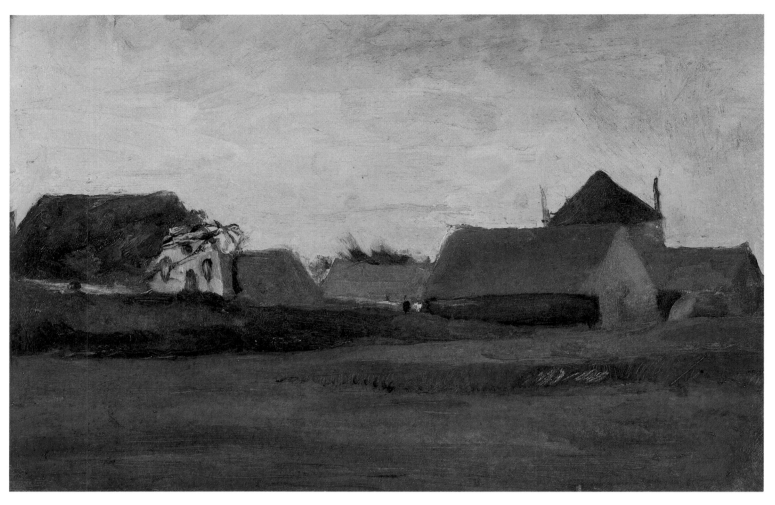

Farmhouses in Loosduinen near The Hague at Twilight
The Hague, August 1883
Oil on canvas on panel, 33 x 50 cm
F 16, JH 391
Utrecht, Centraal Museum
(on loan from the van Baaren Museum Foundation, Utrecht)

Three Figures near a Canal with Windmill
The Hague, August 1883 (?)
Medium and dimensions unknown
F 1666, JH 383
Whereabouts unknown

tion on his brother will have been an important reason for this. This fixation had the effect of focussing Vincent's attention on one person at the expense of others, thoughout his life. It was to Theo that he wrote most of his letters, including those in which he criticizes himself most severely and opens himself up most profoundly. And it was to Theo that Vincent's pictures were addressed, too: Theo was his artistic brother's public. To view the letters as a handy commentary on the paintings will thus not do. It was only in his parallel activities of writing and painting, both of them addressed to a single person, Theo, that Vincent van Gogh saw significance in his own existence. Only there did he see himself as active, useful, and productive of things of value. And this is why his confessions (it is the aptest word for his paintings and letters alike) are so highly charged with emotion.

Van Gogh signed his works with a simple Christian name: Vincent. One reason why he did so was that he was seeking to put distance between himself and his origins in a family of careerists and *petit bourgeois* piety: "I ask you quite openly", he wrote to Theo (Letter 345a) at a time when he was living at home, chafing at his parents' cast-iron moral attitudes, "how do we relate to each other – are you a 'van Gogh' too? For me you have always been 'Theo'. I myself am different in character from the other members of the family, and really I am not a 'van Gogh' at all." What mattered was not one's descent, not the loudly

Landscape with Dunes
The Hague, August 1883
Oil on panel, 33.5 x 48.5 cm
F 15a, JH 393
Private collection
(Sotheby's Auction, London, 4. 12. 1968)

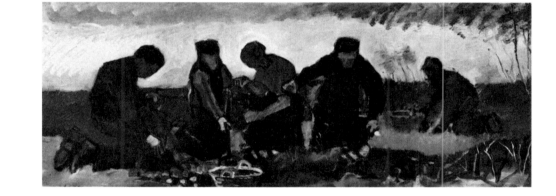

Potato Digging (Five Figures)
The Hague, August 1883
Oil on canvas, 39.5 x 94.5 cm
F 9, JH 385
New York, Collection Julian J. Raskin

Farmhouses
The Hague, September 1883
Oil on canvas, 35 x 55.5 cm
F 17, JH 395
Amsterdam, Rijksmuseum Vincent van
Gogh, Vincent van Gogh Foundation

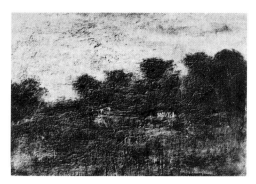

Cows in the Meadow
The Hague, August 1883
Oil on canvas on panel, 31.5 x 44 cm
F 15, JH 387
Private collection

The Heath with a Wheelbarrow
The Hague, September 1883
Watercolour, 24 x 35 cm
F 1100, JH 400
Cleveland, The Cleveland Museum of Art

proclaimed membership of some family of high social standing, but the individual pure and simple. And for the individual, the Christian name did good service. Vincent signed his paintings as he signed his letters. It was his way of declaring them the work of a man revealing his inmost self. In February 1884, when he hit upon the idea of thanking Theo for his financial and emotional support by dedicating his entire artistic output to him, his oeuvre definitively acquired the same private character as the letters. And the simple signature, Vincent, expressly attests a modesty that only recognises artistic obligations towards his brother Theo.

"Now I have nothing and am wretched, put forth from the face of Goodness, and I love my wretchedness and shudder at what is most sublime in my eyes. I have one hope, a hope for that unhappy brother of Poetry: madness. With all her charms, Poetry cannot ever give me what I have experienced in Life. Her love is no substitute. So perhaps it will be friendship, perhaps her brother; he is infinite, he comes between us and the world and never quits our side till we are with the gods." Thus the German Romantic Clemens Brentano, in a metaphorically complex passage that links the brother with madness. Vincent van Gogh's correspondence is resigned in tone, and its melancholy is the seedbed of a kind of greatness – in his view of himself; and the nature of the corres-

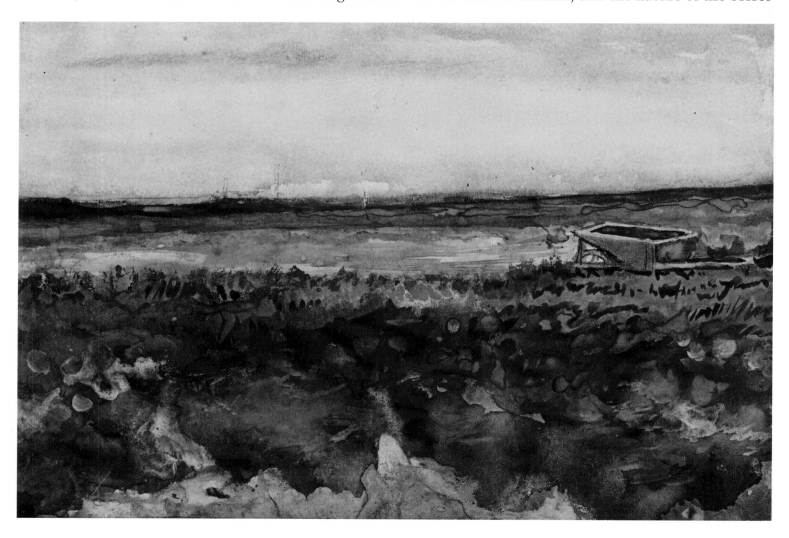

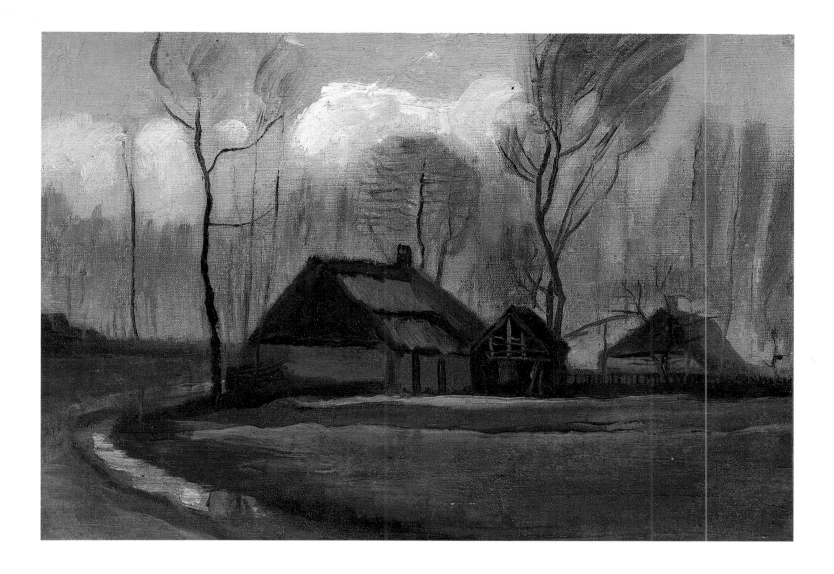

Farmhouses among Trees
The Hague, September 1883
Oil on canvas on panel, 28.5 x 39.5 cm
F 18, JH 397
Private collection
(Christie's Auction, London, 31. 3. 1987)

pondence becomes strikingly clear if it is compared with the correspondence of that fated generation of German Romantic writers. In
Letter 345, for example, van Gogh adopts a tone that is arrestingly
similar to that of Brentano's lament: "Life is a terrible reality, and we
ourselves are running straight into infinity; what is, is – and whether we
take things harder or not so hard does not affect the nature of things in
the slightest... When I was younger I inclined more than I do now to
think it was a matter of coincidences, of insignificant things, of misunderstandings. But as I grow older I am increasingly changing my mind
and seeing profounder reasons. Life is 'a strange business', brother."
Following his thoughts on infinity, and on the woes caused by Time, the
simple word 'brother' seems laden with cryptic significance beyond a
mere address to a relative. It is as if van Gogh's deep sense of loneliness
saw the sole chance of solace in his brother – much as another German
writer, Heinrich von Kleist, longed "to be understood, if only on occasion, by one other human soul."

We have the impression that van Gogh's entire will to live is being
focussed on the addressee of his letter; at the same time, it is his need to
express himself to that person which establishes his will to live in the

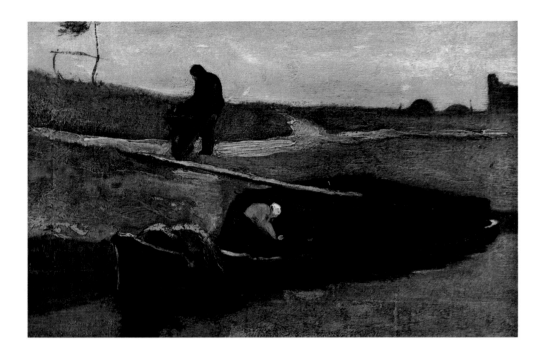

Peat Boat with Two Figures
Drente, October 1883
Oil on canvas on panel, 37 x 55.5 cm
F 21, JH 415
Netherlands, Private collection

Footbridge across a Ditch
The Hague, August 1883
Oil on canvas on panel, 60 x 45.8 cm
F 189, JH 386
Private collection
(Christie's Auction, London 3. 7. 1973)

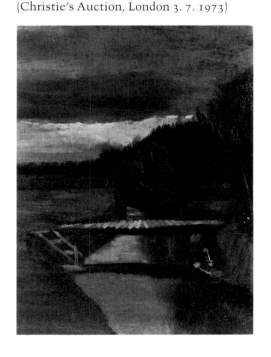

first place. The addressee is the point to which all his melancholy, but also all his confessional courage, tends. It is a precarious balancing act, since the writer becomes existentially dependent on his sense of the reader's interest; and out of that balance arises the desire for the two to become one. "That is why I long for you so much", wrote Brentano, "so that you and I together may abjure belief in everything ordinary and prosaic, so that I can write whatever occurs to me without any concern for criticism or the demands of the age. You will be so kind as to have my stuff printed above your own name; because as soon as you have made me happy I shall no longer wish to have a name, and what is yours will be mine." There is a distinct similarity in the way Vincent van Gogh viewed his relations with Theo (Letter 538): "Now I feel that my pictures are not yet good enough to compensate for the advantages I have enjoyed through you. But believe me, if one day they should be good enough, you will have been as much their creator as I, because the two of us are making them together."

Brentano's flirtation with madness, and Kleist's suicide, were attempts to bridge the gap between Literature and Life. In the intensity of his own struggles, van Gogh was to outdo them both. It would be wrong to exaggerate the similarities between his correspondence and that of the German Romantics; there was nothing conscious or imitative in the affinity. Still, it serves to highlight an important (arguably the most important) tradition in the artist: Vincent van Gogh was a thorough Romantic in terms of his emotional world and his lack of inhibition in living it to the full. And the comparison with Kleist and Brentano also underlines the close ties between van Gogh's art and his letter-writing. Both means of expression articulated the artist's entire personality, and were catalyzed by his tendency to relate exclusively to his brother Theo.

The Religious Maniac
1875-1880

"Who sees that once our first life, the life of youth and young manhood, the life of worldly pleasure and vanity, has withered away, as wither away it must – and it will do so, just as the blossoms fall from the trees – who sees that then a new life is ours, in all its strength, a life filled with love of Christ and with a sadness that causes sorrow to no one, a divine sadness?" Most of the products of van Gogh's pen up to 1880 read like this passage from Letter 82a, dating from November 1876. He had

Two Peasant Women in the Peat Field
Drente, October 1883
Oil on canvas, 27.5 x 36.5 cm
F 19, JH 409
Amsterdam, Rijksmuseum Vincent van Gogh, Vincent van Gogh Foundation

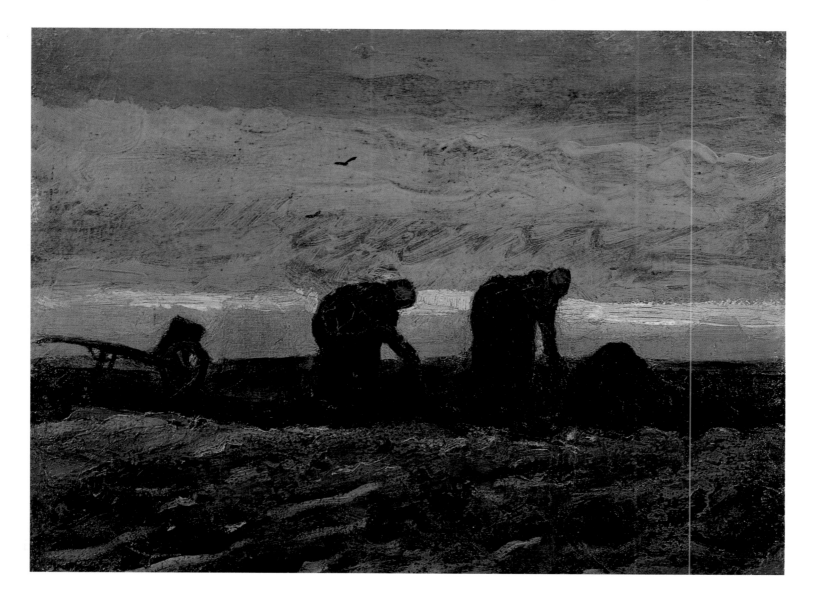

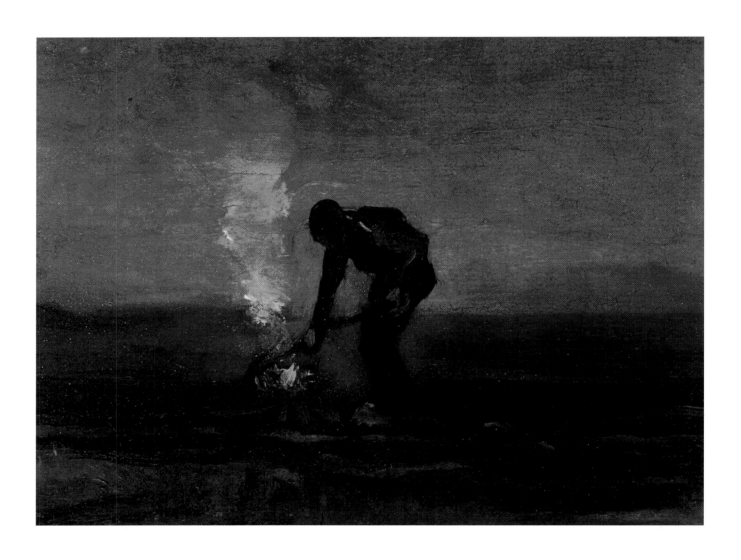

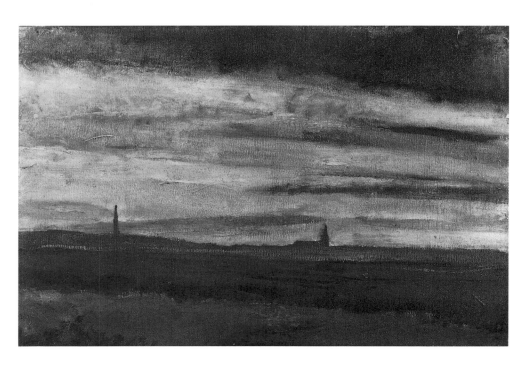

Peasant Burning Weeds
Drente, October 1883
Oil on panel, 30.5 x 39.5 cm
F 20, JH 417
Private collection
(Christie's Auction, New York, 12. 5. 1987)

Landscape with a Church at Twilight
Drente, October 1883
Oil on cardboard on panel, 36 x 53 cm
F 188, JH 413
Private collection
(Christie's Auction, London, 3. 7. 1973)

Farmhouse with Peat Stacks
Drente, October-November 1883
Oil on canvas, 37.5 x 55.5 cm
F 22, JH 421
Amsterdam, Rijksmuseum Vincent van
Gogh, Vincent van Gogh Foundation

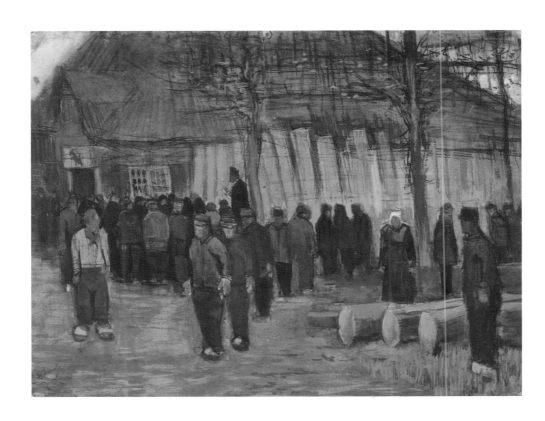

A Wood Auction
Nuenen, December 1883
Watercolour, 33.5 x 44.5 cm
F 1113, JH 438
Amsterdam, Rijksmuseum Vincent van
Gogh, Vincent van Gogh Foundation

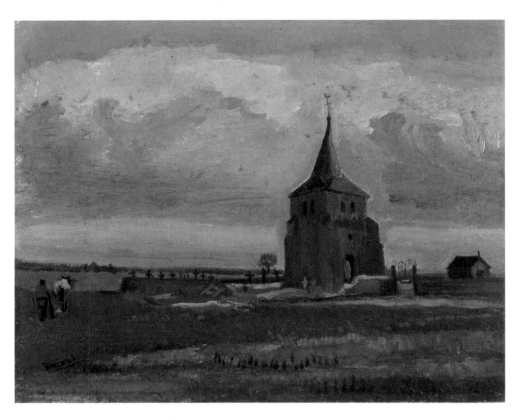

The Old Tower of Nuenen with a Ploughman
Nuenen, February 1884
Oil on canvas, 34.5 x 42 cm
F 34, JH 459
Otterlo, Rijksmuseum Kröller-Müller

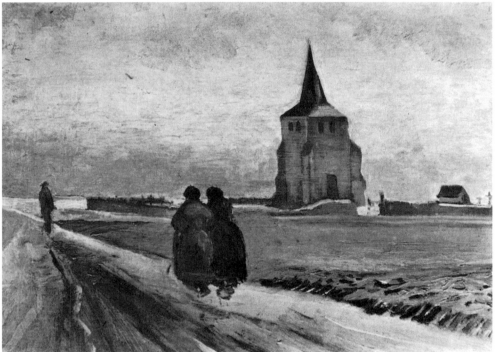

The Old Tower of Nuenen with People Walking
Nuenen, February 1884
Oil on canvas on panel, 33.5 x 44 cm
F 184, JH 458
Private collection

developed what can only be described as a religious mania, and it involved excessive mortification of the flesh: van Gogh cudgelled his back, went around wearing only a shirt in winter, and slept on the stone floor beside his bed. It was as if he wanted to catch up on his forefathers' piety – and was doing it at double the normal pace.

Vincent lacked experience with women, and one unfortunate love seems to have given him a considerable jolt. Six months previously he had nursed a secret love for Eugenie Loyer, the daughter of his landlady in London; and when at last he dared to tell his adored young woman of

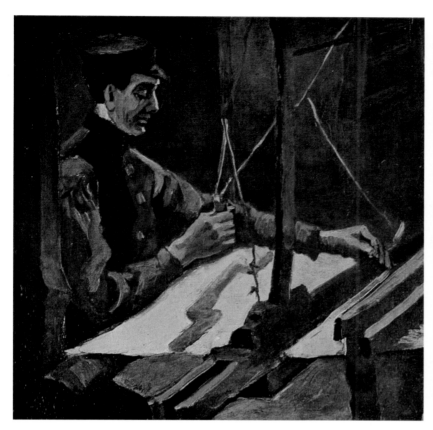

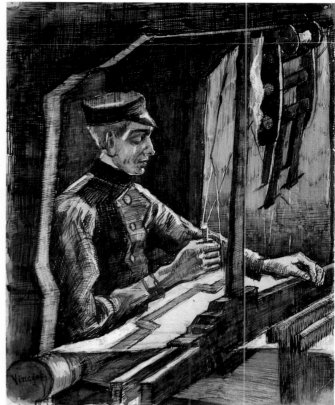

his feelings he proved to be too late – another man had got there first. Thwarted relations with women were to devastate Vincent's emotional life at later periods too. At the time of his rejection, about the end of 1873, van Gogh's behaviour underwent a complete change. Hitherto an open, entertaining and liberal-minded man, he became an eccentric, taciturn loner who substituted late-night Bible reading for contact with his fellow-beings. He now reviewed all the books he had previously read so voraciously to check their usefulness for pious purposes. In the tone of a preacher he instructed Theo (Letter 36a): "Do not read Michelet or any other book but the Bible till we meet again at Christmas."

It was of no avail when Uncle Cent arranged for his nephew to be transferred to Goupil's Paris headquarters: by spring 1876, Vincent van Gogh's career as an art dealer was at an end. Fractious advice to purchasers, suggesting they buy cheaper art, doubtless did credit to his love of truth but scarcely helped the company's turnover. After he had been dismissed, Vincent returned to England, to Ramsgate and Isleworth (near London), not far from the scene of his first love. There he worked as an assistant teacher, for a pittance, and gave full rein to his missionary tendencies. Gradually, he came to feel he had a vocation to be a clergyman like his forefathers; at this period in his life, he saw his father, Theodorus van Gogh, as an important role model.

Uncle Cent next found Vincent a job in a Dordrecht bookshop. But what had once been Vincent's pronounced taste for books was now no more than blinkered Biblical fanaticism; and he would sit in the book-

Weaver Facing Right (Half-Figure)
Nuenen, January 1884
Oil on canvas, 48 x 46 cm
F 26, JH 450
Berne, Collection H. R. Hahnloser

Weaver Facing Right (Half-Figure)
Nuenen, January-February 1884
Pen, washed with bistre, heightened with white, 26 x 21 cm
F 1122, JH 454
Amsterdam, Rijksmuseum Vincent van Gogh, Vincent van Gogh Foundation

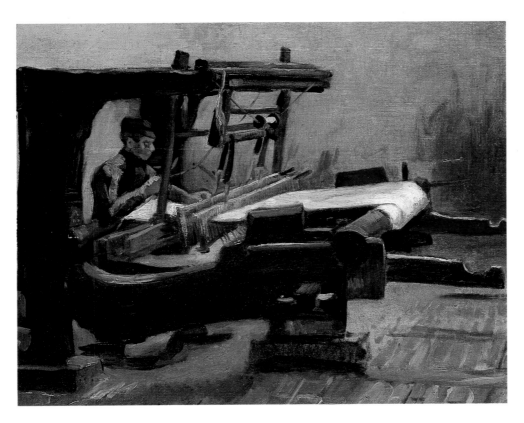

Weaver Facing Right
Nuenen, February 1884
Oil on canvas on panel, 37 x 45 cm
F 162, JH 457
Private collection
(Sotheby's Auction, London, 5. 12. 1983)

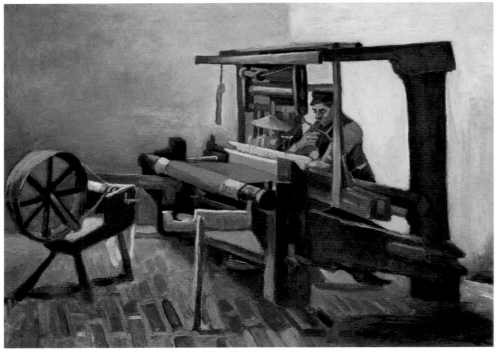

Weaver Facing Left, with Spinning Wheel
Nuenen, March 1884
Oil on canvas, 61 x 85 cm
F 29, JH 471
Boston, Museum of Fine Arts

shop store-room translating the Dutch version of Holy Scripture into English, French and German. (Van Gogh had a considerable gift for languages.) In spring 1877, Vincent went to stay with his Uncle Jan in Amsterdam, where he prepared for theology studies by tackling Latin and Greek, taking maths lessons, and generally trying to fill the gaps he felt his apprenticeship period had punched in his education. Vincent's plans to study came to nothing, and he broke off his preparations before risking failure in the entrance examinations: but at least he was taking pleasure in a variety of reading again, and he drew maps based on his

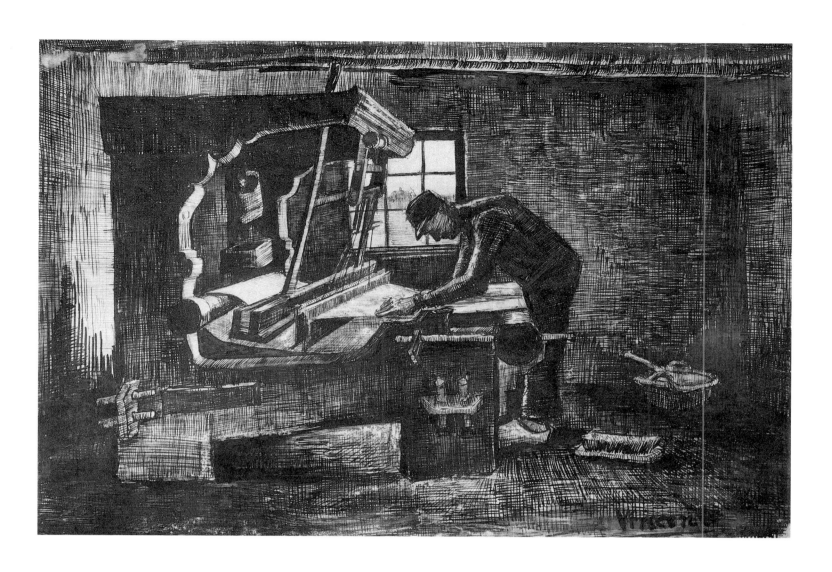

Weaver Standing in Front of a Loom
Nuenen, May 1884
Pencil, pen, heightened with white,
27 x 40 cm
F 1134, JH 481
Otterlo, Rijksmuseum Kröller-Müller

Weaver Arranging Threads
Nuenen, April-May 1884
Oil on canvas on panel, 41 x 57 cm
F 35, JH 478
Otterlo, Rijksmuseum Kröller-Müller

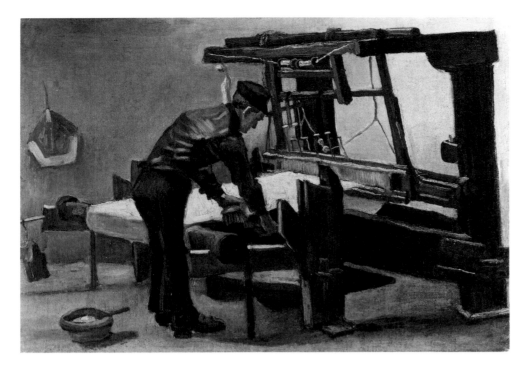

Weaver Standing in Front of a Loom
Nuenen, May 1884
Oil on canvas, 55 x 79 cm
F 33, JH 489
Private collection

Weaver Arranging Threads
Nuenen, May 1884
Oil on panel, 19 x 41 cm
F 32, JH 480
Private collection
(Sotheby's Auction, London, 2. 4. 1979)

reading, too – locations of major importance in the French Revolution (after Jules Michelet's study) or the travels of St. Paul, for instance.

Van Gogh's heady piety was based on the imitating Christ. With a humility that was veritably Franciscan, he neglected his appearance in the attempt to discover those inner values which alone constitute true holiness. He took Thomas à Kempis's devotional work *The Imitation of Christ* as his text, and identified with St. Paul. He adapted his motto at this time from St. Paul's Second Epistle to the Corinthians: "in sorrow yet ever joyful." Repeatedly he glossed the words in letters written during this period. St. Paul's characteristic thought of struggles in this world for salvation in the next was re-interpreted by van Gogh in universally applicable style as a paradox – a paradox that applied to his own state of mind, which trod an ill-defined line between melancholy and remorse, lovesickness and humility, world-weariness and sadness, in a word: between a quite commonplace inability to cope with every-day life and a Christian rejection of worldly preoccupations.

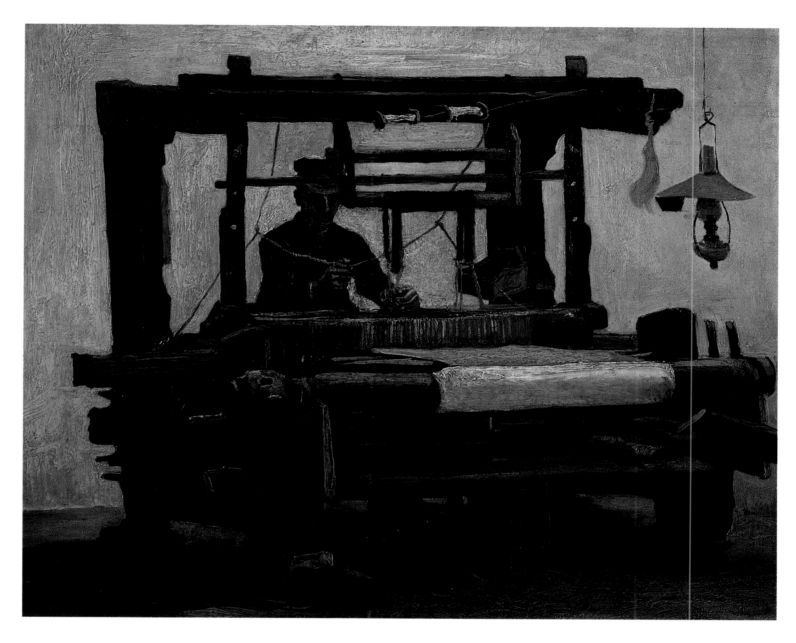

Weaver, Seen from the Front
Nuenen, May 1884
Oil on canvas, 70 x 85 cm
F 30, JH 479
Otterlo, Rijksmuseum Kröller-Müller

"There will only be a little rest ahead once one has done a couple of years' worth of work and senses that one is on the right track", Vincent wrote to Theo from Amsterdam (Letter 97). In point of fact, his own restlessness – both in terms of geographic location and within himself – was worse than ever. The more he sought religion as an escape from himself, the more his behaviour took on a compulsive character; repeatedly his father felt it necessary to fetch his difficult son home for a spell of peace and quiet. At last the family council agreed that Vincent should try his hand as a lay preacher (since this required active humanity rather than theological expertise). And Vincent's Samaritan instincts were presently to come into their own in the Borinage, an impoverished Belgian mining district.

In happy anticipation, Vincent again compared himself to the apostle (Letter 126): "Before he began his life of preaching, St. Paul [...] spent three years in Arabia. If I might be active for three years or thereabouts, in all tranquillity, in a region like that, I should not return without

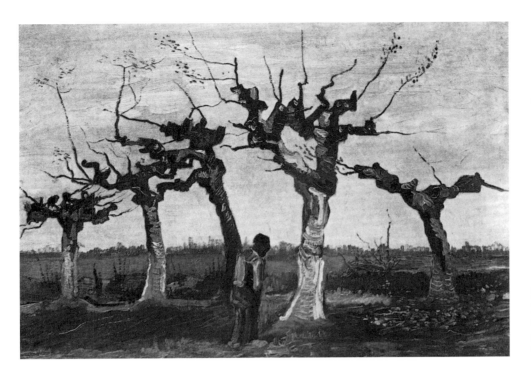

Landscape with Pollard Willows
Nuenen, April 1884
Oil on canvas on panel, 43 x 58 cm
F 31, JH 477
Whereabouts unknown

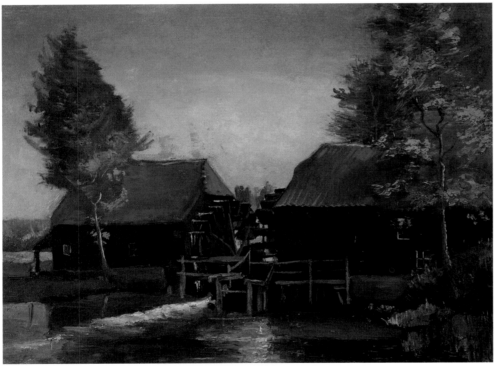

Water Mill at Kollen near Nuenen
Nuenen, May 1884
Oil on canvas on cardboard, 57.5 x 78 cm
F 48a, JH 488
United States, Private collection
(Sotheby's Auction, 6. 4. 1967)

having something to say that would indeed be worth listening to." Van Gogh's compulsive sense of being assessed in accordance with basic criteria evolved by his own tireless labours had invariably been the impulse that spurred him on, daily, to new efforts. In the Borinage, his self-sacrificing spirit once again got rather carried away; the Evangelical Committee opted not to renew Vincent's contract, claiming that he had rather overdone his zeal. He had given his clothing to the needy like St. Martin, had lived in a tumbledown hut like St. Francis, and had existed on a diet of bread and water, as demanded by the strictest of spiritual exercises. In van Gogh's view, loving one's neighbour could know no

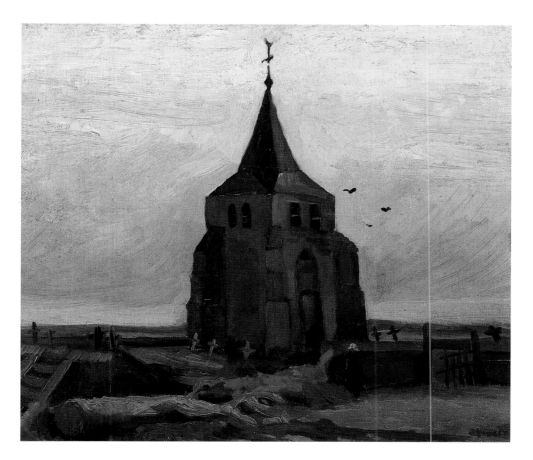

The Old Church Tower at Nuenen
Nuenen, May 1884
Oil on canvas on panel, 47.5 x 55 cm
F 88, JH 490
Zurich, Collection E. G. Bührle

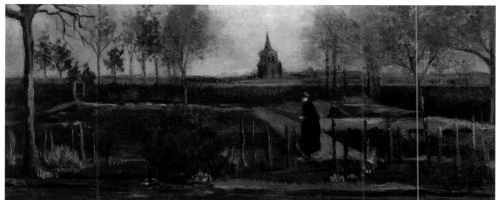

The Parsonage Garden at Nuenen
Nuenen, May 1884
Oil on paper on panel, 25 x 57 cm
F 185, JH 484
Groningen, Groninger Museum voor Stad
en Lande (on loan)

limits. He found his reward in the solidarity of the miners and the proof that they accepted him. Decades later, a legend was still being told locally to the effect that a Dutch lay preacher had guided the most notorious alcoholic in the district back to Mother Church.

Vincent touched rock bottom in the Borinage. He had found that the life of a preacher really suited him no better than that of an art dealer; now he was living without any income among the poorest of the poor, a standing reproach to the middle classes. Even Theo was daunted. From October 1879 to July 1880 their correspondence was interrupted, and it was not till Vincent finally accepted one of his brother's postal money orders that the silence was broken. In his reply, Vincent van Gogh proved to be a changed man, stripped of illusions, his head cleared, and with a new vocation – Art.

"No beginning but in God"
Van Gogh and Religion

Vincent van Gogh's brief apprenticeship in the world of art dealing gave him an early familiarity with paintings. But if we did not bear in mind the crucial part played by the years of religious mania in his subsequent development as an artist, our grasp of his work would remain superficial – indeed, it would be impossible to interpret it. His faith, his personal religion, acted as the catalyst of his creative impulses, and supplied a source of symbols, motifs and meanings that he was to draw on time and again. The harshest criticism of the notion of faith prevalent in Vincent's parental home must remain the fact that it provided the background to his own craving for security, purification and deep feeling – in a word, his own individual brand of piety.

In 1890 P. C. Görlitz, who shared van Gogh's lodgings in Dordrecht, was to recall: "In some respects he was extremely modest, extremely reticent. One day – we had known each other for a month – he asked me, smiling irresistibly as usual: 'Görlitz, you might do me an awfully big favour, if you like.' I replied: 'What is it? Do tell me.' 'Well, the room is really yours, and I'd like your permission to stick one or two Biblical scenes up on the wallpaper.' Of course I immediately gave my consent,

Weaver, Interior with Three Small Windows
Nuenen, July 1884
Oil on canvas, 61 x 93 cm
F 37, JH 501
Otterlo, Rijksmuseum Kröller-Müller

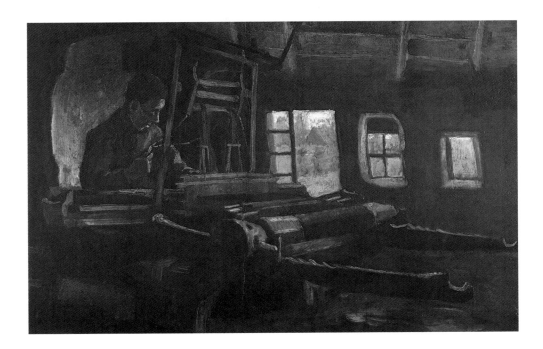

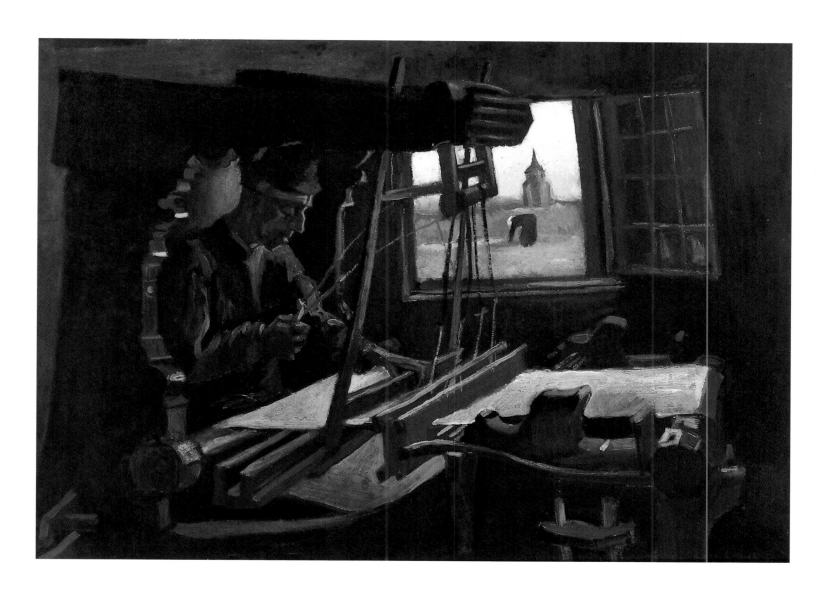

Weaver near an Open Window
Nuenen, July 1884
Oil on canvas, 67.7 x 93.2 cm
F 24, JH 500
Munich, Bayerische Staatsgemälde-
sammlungen, Neue Pinakothek

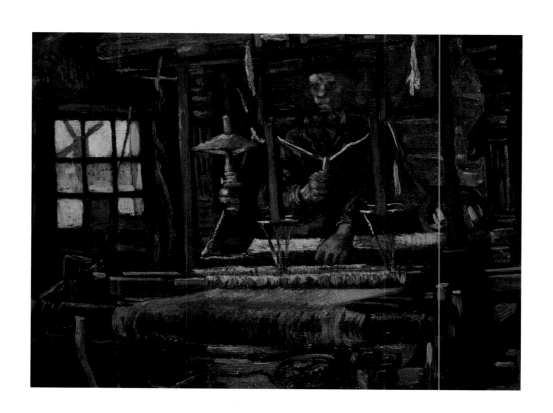

Weaver, Seen from the Front
Nuenen, July 1884
Oil on canvas on panel, 47 x 61.3 cm
F 27, JH 503
Rotterdam, Museum Boymans-van
Beuningen

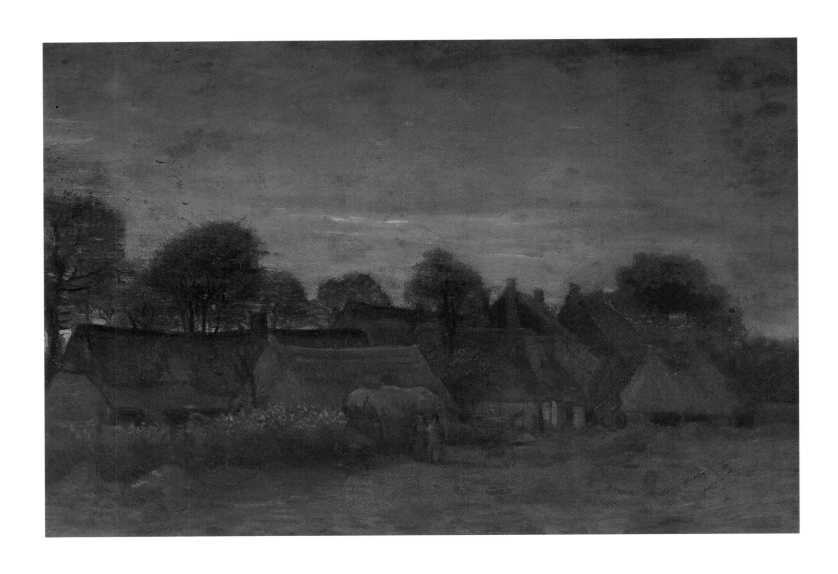

Village at Sunset
Nuenen, Summer 1884
Oil on paper on cardboard, 57 x 82 cm
F 190, JH 492
Amsterdam, Stedelijk Museum
(on loan from the Rijksmuseum)

New-Born Calf Lying on Straw
Nuenen, July 1884
Oil on canvas, 31 x 43.5 cm
No F Number, no JH Number
Private collection

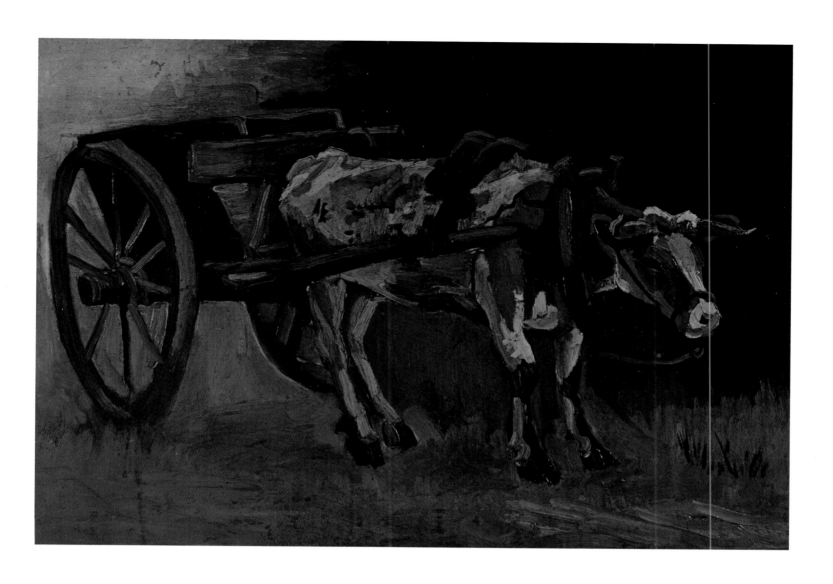

Cart with Red and White Ox
Nuenen, July 1884
Oil on canvas on panel, 57 x 82.5 cm
F 38, JH 504
Otterlo, Rijksmuseum Kröller-Müller

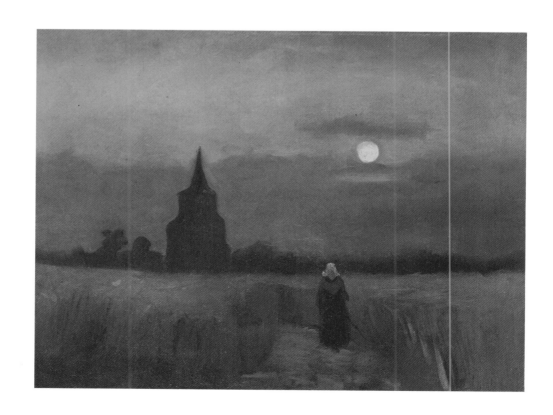

The Old Tower in the Fields
Nuenen, July 1884
Oil on canvas on cardboard, 35 x 47 cm
F 40, JH 507
Private collection
(Sotheby's Auction, London, 10. 12. 1969)

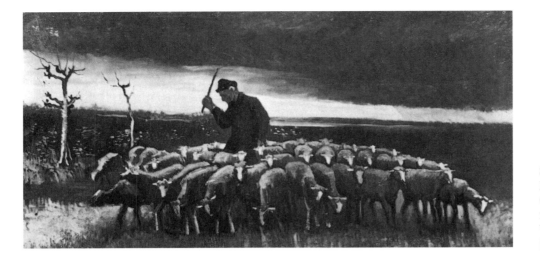

Shepherd with Flock of Sheep
Nuenen, September 1884
Oil on canvas on cardboard, 67 x 126 cm
F 42, JH 517
Whereabouts unknown
(Sotheby's Auction, London, 24. 4. 1968)

and he went to work at feverish speed. An hour later, the whole room was decorated with Biblical pictures and Ecce Homo scenes, and van Gogh had written beneath every head of Christ: 'in sorrow, yet ever joyful'."

To van Gogh, Jesus Christ was the personification *par excellence* of his own view of the world. That view was based on the paradox of suffering that is welcome, sorrow that pleases; and pictures were a means of illustrating and backing up this view. When van Gogh considered the works of art he saw, he was not applying technical or compositional standards, or assessing colour values; his criteria were not aesthetic. Instead, he was after expression of his own view of the world. His approach to art was distinctly literary in character: he expected pictures to tell stories that he could identify with. He demanded concrete visual presentations of spiritual values, in such a way as to assist his own desire for orientation. Naturally enough, Vincent took to drawing his own Biblical scenes: "Last week", he wrote in May 1877 (Letter 97), "I got as far as Genesis 23, where Abraham buries Sarah in the cave of the field of Machpelah, the plot he has bought, and without really thinking about it I drew a little sketch of how I imagine the place." Van Gogh drew the landscape purely because of its Biblical interest. Gener-

Cart with Black Ox
Nuenen, July 1884
Oil on canvas, 60 x 80 cm
F 39, JH 505
United States, Private collection

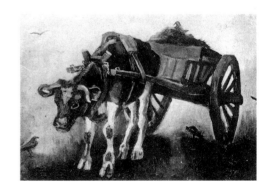

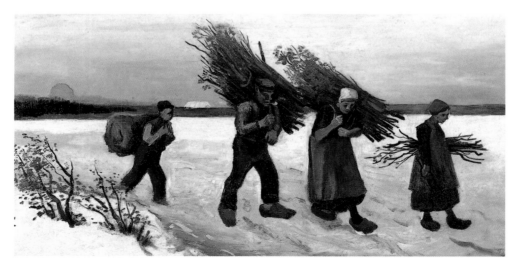

Wood Gatherers in the Snow
Nuenen, September 1884
Oil on canvas on panel, 67 x 126 cm
F 43, JH 516
Private collection

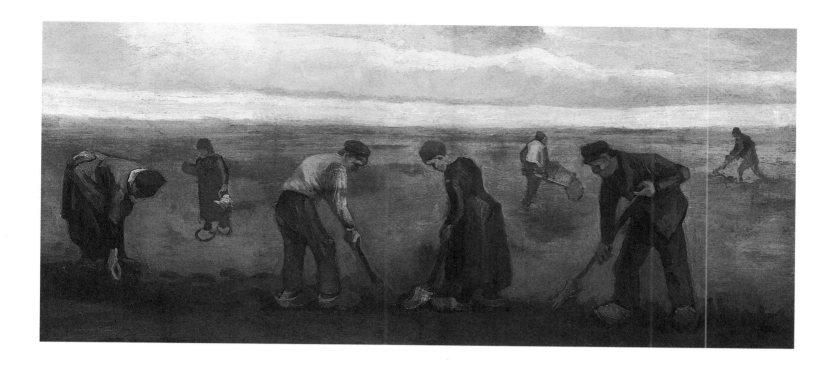

Farmers Planting Potatoes
Nuenen, August-September 1884
Oil on canvas, 66 x 149 cm
F 41, JH 513
Otterlo, Rijksmuseum Kröller-Müller

Spinning Wheel
Nuenen, Summer 1884
Oil on canvas, 34 x 44 cm
F 175, JH 497
Amsterdam, Rijksmuseum Vincent van
Gogh, Vincent van Gogh Foundation

ally speaking, his work is notable for the close inter-relations of every-day appearances (of objects, landscape) and the profounder, more fundamental levels of meaning they conceal.

At the end of October 1876, van Gogh preached for the first time, at Isleworth (England). This sermon (included as number 79a in the Letters) is of particular interest because many of the subjects that loom large in his paintings are referred to in it, motifs that are at the centre of his thinking and which (in words or on canvas, as categories of perception) he emphasizes time and again. In the passage which closes this sermon, Vincent (without ever having held a brush) arranges his motifs exactly as if they were all together in a single painting:

"I once saw a beautiful picture: it was a landscape, in the evening. Far in the distance, on the right, hills, blue in the evening mist. Above the hills, a glorious sunset, with the grey clouds edged with silver and gold and purple. The landscape is flatland or heath, covered with grass; the grass-stalks are yellow because it was autumn. A road crosses the landscape, leading to a high mountain far, far away; on the summit of the mountain, a city, lit by the glow of the setting sun. Along the road goes a pilgrim, his staff in his hand. He has been on his way for a very long time and is very tired. And then he encounters a woman, or a figure in black, reminiscent of St. Paul's phrase: 'in sorrow, yet ever joyful'. This angel of God has been stationed there to keep up the spirits of pilgrims and answer their questions. And the pilgrim asks: 'Does the road wind uphill all the way?' To which comes the reply: 'Yes, to the very end.' And he asks another question: 'Will the day's journey take the whole long day?' And the reply is: 'From morn to night, my friend.' And the pilgrim goes on, in sorrow, yet ever joyful."

The landscape with a setting sun (F720, JH1728), the flatland stretch-

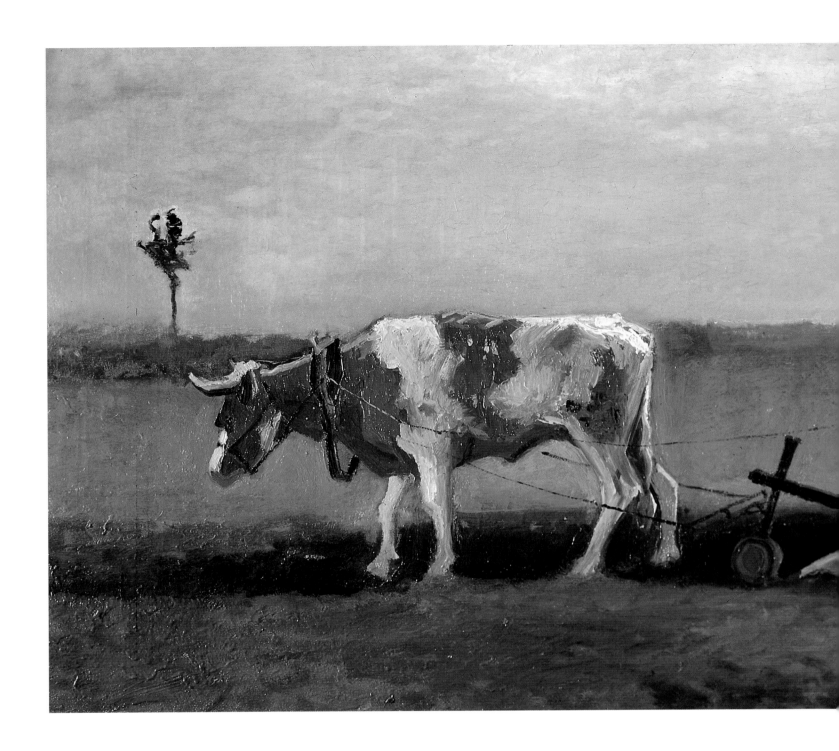

ing away to the mountains (F412, JH1440), the track crossing the landscape (F407, JH1440), the solitary wanderer (F448, JH1491), and the black figure (F481, JH1604) were to be seen again, time after time, when van Gogh put up his easel in various places. They are details seen closely and affectionately, but they also have representative or symbolic status; they are both immediate realities and timeless types. What van Gogh sees with his own eyes leads him back to projections envisioned in youth; and at the same time those projections guide the painter in his quest for motifs worthy of representation on canvas.

The contorted quality of van Gogh's ways of establishing a motif in his permanent repertoire can be effectively illustrated if we take a closer look at that figure in black. In Paris, he had often visited the Louvre.

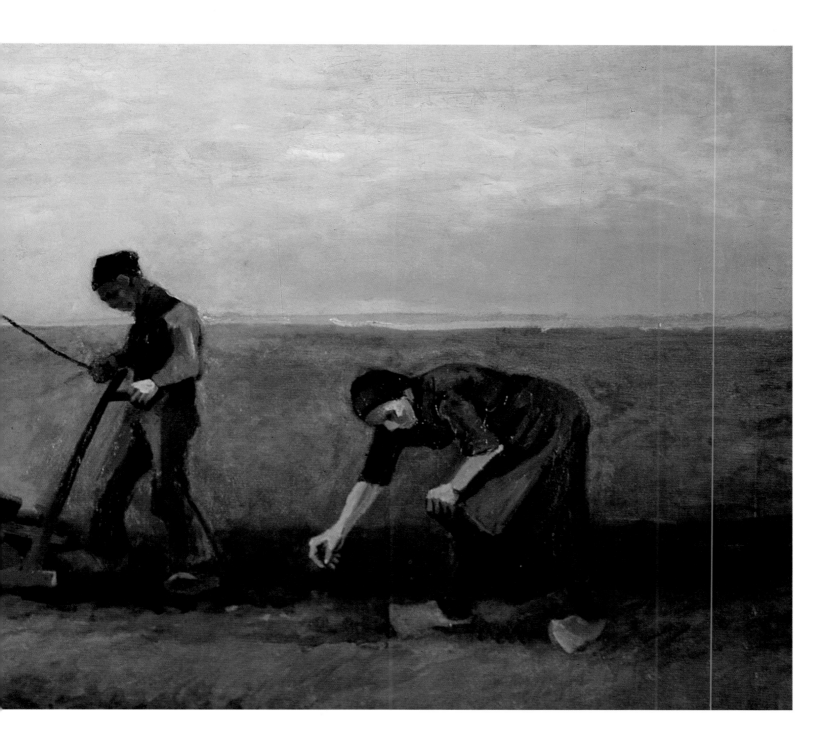

Potato Planting
Nuenen, September 1884
Oil on canvas, 70.5 x 170 cm
F 172, JH 514
Wuppertal, Von der Heydt-Museum

Doubtless he will have remembered a work then attributed to the rather bloodless Baroque painter Philippe de Champaigne, showing a halflength figure of an elderly woman dressed entirely in black, gazing sadly out of the picture. In Michelet's book *L'Amour* van Gogh would have found this description of the picture: "From here I can see a lady, in thoughtful mood, walking in a garden which, though sheltered, is not very extensive and where the blooms have withered early... She reminds me of a lady by Philippe de Champaigne who captured my heart: so honest and upright, clever enough but simple, unequal to the world's devious machinations." There is more to come. Van Gogh thought highly of Michelet's writings; but one more step needed to be taken in his mind before the lady in black could become a constant theme in his

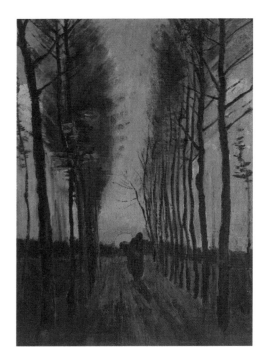

Avenue of Poplars at Sunset
Nuenen, October 1884
Oil on canvas, 45.5 x 32.5 cm
F 123, JH 518
Otterlo, Rijksmuseum Kröller-Müller

Avenue of Poplars in Autumn
Nuenen, October 1884
Oil on canvas on panel, 98.5 x 66 cm
F 122, JH 522
Amsterdam, Rijksmuseum Vincent van
Gogh, Vincent van Gogh Foundation

art. "I am sending you a French Bible", he wrote to his brother (Letter 31), and *The Imitation of Christ*. It was probably the favourite book of that woman de Champaigne painted; in the Louvre there is a picture of her daughter, a nun, also by de Champaigne; *The Imitation of Christ* is on the chair beside her."

We know nothing about the anonymous lady's reading habits, or anything about her daughter; and the book beside the nun in Philippe de Champaigne's votive painting is certainly not Thomas à Kempi's work. Van Gogh had simply fabricated a link between things that had touched his heart and which he felt simply had to be connected. Favourite books, a painting that made a powerful impression, and an all-embracing desire for religious devotion fused to form a complex of thought that can only be described as syncretist. From childhood on, Vincent had absorbed culture, reading voraciously and acquiring pictures, and now his faith was out to subsume his diverse knowledge under an overall world-view. The simple yet complex motto remained: "in sorrow, yet ever joyful."

"Only he can be an artist who has a religion of his own, an original way of viewing the infinite." Thus Friedrich Schlegel, requiring a religious dimension in an artist. In purely biographical terms, van Gogh lived up to this requirement more completely than most artists. His art's ability to touch the hem of the Eternal was not the result of any determination to fit romantic images of the Artist; rather, it derived from a profound and genuine longing for the sheltered security of religious faith. He painted his works for the sake of that moment when, through devotion to the tiniest detail, the artist experiences a sense of total order: the very small and the omnipotently vast could only be grasped from one and the same standpoint. Deeply religious, van Gogh believed that that point lay in God.

The rare moments when he found confirmation of his convictions in the act of painting distinguish van Gogh from genuinely Romantic painting, which could only conceive its image of God in terms of a polarity: on the one hand, an omnipotent Creator dwelling hidden away within Nature, and on the other Man, trembling, conceding his frailty. A passage from Letter 242 reads like van Gogh's altogether deliberate counter-statement to the quest for a spiritual transfiguration in Nature that we see in a Caspar David Friedrich or a Turner: "How much good walking out to the desolate seashore and gazing out at the grey-green sea with the long white crests on its waves can do a man who is downcast and dejected! But if one should have a need for something great, something infinite, something one can perceive God in, there is no need to go far in quest; it seems to me that I have seen something deeper, more infinite, more eternal than the ocean in the expression in a small child's eyes when it awakens early in the morning and yells or laughs on finding the dear sun shining upon its cradle. If ever a 'beam shines down from above', that may be where it is to be found." In terms of the intensity of

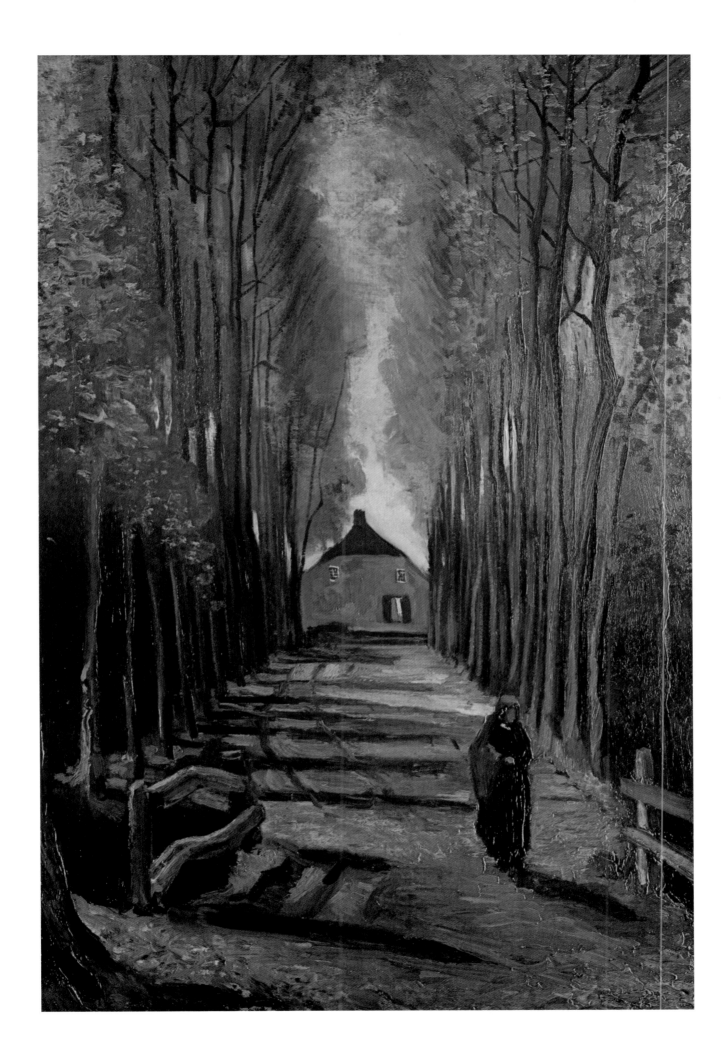

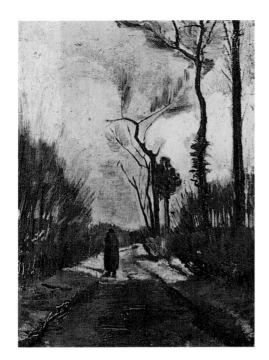

Lane in Autumn
Nuenen, October 1884
Oil on canvas on panel, 46 x 35 cm
F 120, JH 519
Fribourg (Switzerland), Private collection

Chapel at Nuenen with Churchgoers
Nuenen, October 1884
Oil on canvas, 41.5 x 32 cm
F 25, JH 521
Amsterdam, Rijksmuseum Vincent van
Gogh, Vincent van Gogh Foundation

his dejection, van Gogh was surely the equal of the Romantics; yet it was his trust in all living things, a trust we might almost call desperate, that distinguished his feel for Life from theirs. In van Gogh, an instinctive trust in God was forever at odds with his knowledge and experience of individual alienation and isolation.

"And now, when each one of us returns to everyday life, to everyday duties, let us not forget that things are not what they seem to be, that God is using the things of everyday life to instruct us in higher things, that our life is a pilgrimage and we are strangers on this earth, but also that we have a God, a Father, who offers shelter and protection to strangers." The conclusion of van Gogh's Isleworth sermon was hardly unusual for its kind, yet it is interesting if we take his subsequent career as a painter into account. These words might almost serve as an illustration to paintings such as that of van Gogh's boots (p. 201) or the chairs in his house at Arles. These things are not only what they seem; vivid and real, they yet direct our attention to something profounder, something all-comprehending, which lies beyond. In such works, van Gogh is close to allegory, which was adopted for specifically Christian purposes in order to relate all real phenomena to God. "Other speech" (the etymological meaning of Greek "allegory") was necessary if the distinction between the worldly and the heavenly realm was to be preserved and revealed. Suffering and redemption, death and salvation, frailty and exaltation are indivisibly conjoined in allegory and can be associated with realities of different kinds at one and the same moment. Allegory was always Christendom's most powerful rhetorical resource; it afforded both comfort and consolation.

There is allegorical thought in van Gogh's Isleworth sermon, in the image of the stranger. This was borrowed from *The Imitation of Christ* by Thomas à Kempis, his favourite reading at the time. "Be thou always as a stranger and a guest on this earth", we read, "and consider the things of this world as matters that concern thee not. Keep thy heart free and always directed upward unto God; for here on earth thou hast no permanent home." The greater the torment and the more inescapable the loneliness, the more Man is prepared to open himself to God and sue for redemption. God offers shelter and protection to strangers (in van Gogh's paraphrase of this passage). Again and again – and with greater urgency towards the end of his life – van Gogh was to quote the image of the stranger. The metaphor embraced his own misfortunes – his persistent lack of success, his inability to relate to people, his sickness – and offered the consolation of a better world. That hope for consolation was in fact the true mainspring of his art. It is palpable in those few moments of identification with existence which he felt when confronted with the sheer life in his chosen subjects, and it is palpable in his trust in a reward, later, somewhere, at some time: "What we need is no less than the Infinite and Miraculous", he wrote in Letter 121, "and Man does

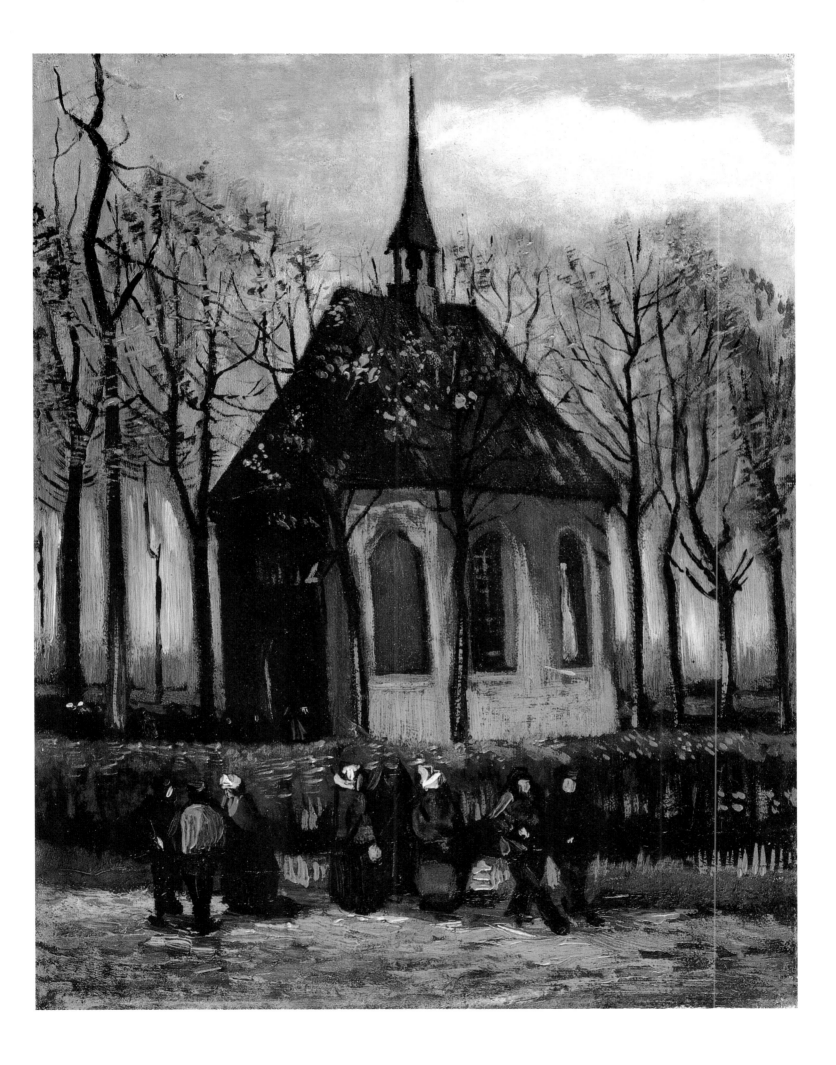

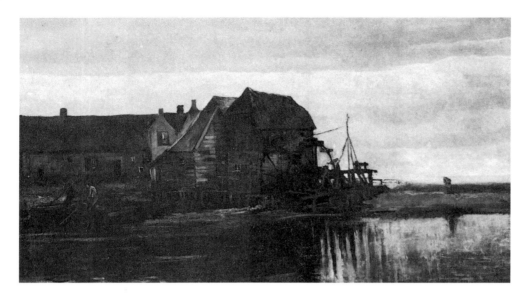

Water Mill at Gennep
Nuenen, November 1884
Oil on canvas on carboard, 87 x 151 cm
F 125, JH 525
Whereabouts unknown

well to be content with nothing less and not to feel secure until he has attained it." Van Gogh did not feel secure, nor could he, given the dimensions of the happiness he had proposed to himself: he would not have been the only one who found that in the stodgy middle-class reality of the 19th century it was all too much. Relying on his belief, he placed his trust in transcendence; we are at liberty to interpret his transcendental beliefs as a hope of paradise, of immortality, or simply of some kind of meaningful existence in the future. Doubtless van Gogh began by thinking of the Christian heaven, where he hoped for a reward. Later, with a trying life as an artist behind him, he occasionally indulged in promising himself significance for the art of the future, along the lines of this diary entry by Delacroix: "One must hope that the great men who were despised or persecuted in their own lifetimes will one day be

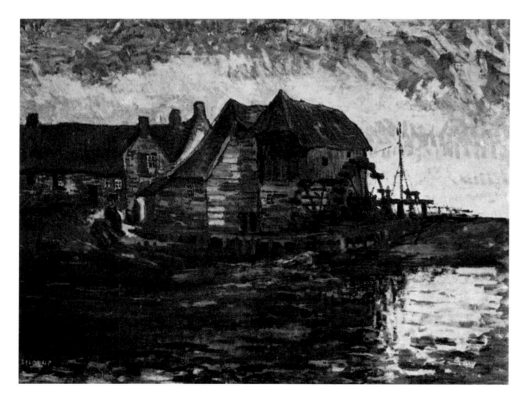

Water Mill at Gennep
Nuenen, November 1884
Oil on cardboard, 75 x 100 cm
F 47, JH 526
New York, Private collection

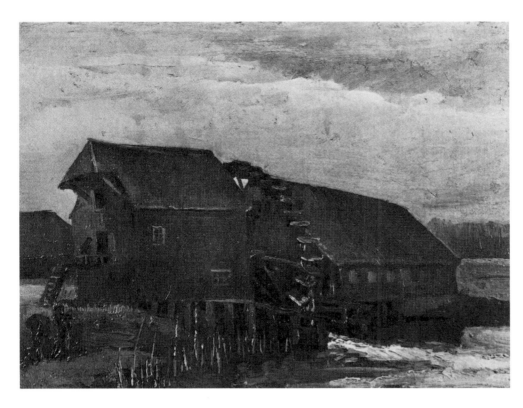

Water Mill at Opwetten
Nuenen, November 1884
Oil on canvas on panel, 45 x 58 cm
F 48, JH 527
Private collection
(Sotheby's Auction, London, 30. 3. 1966)

granted the reward that was denied them on earth when they enter into a sphere where they enjoy a happiness of which we have no conception, part of which is the happiness of looking down to witness the fairness and justice with which Posterity remembers them."

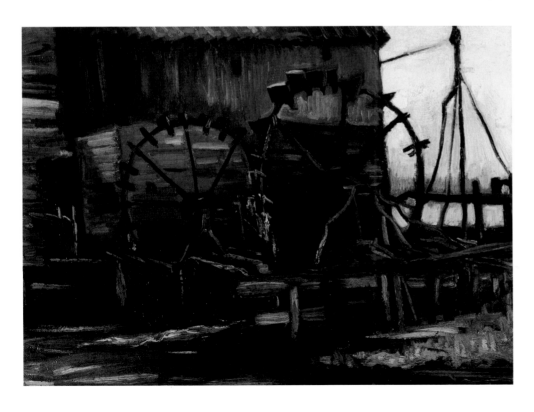

Water Mill at Gennep
Nuenen, November 1884
Oil on canvas, 60 x 78.5 cm
F 46, JH 524
Private collection

First Steps as an Artist
1880-1881

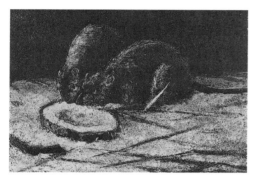

Two Rats
Nuenen, November 1884
Oil on panel, 29.5 x 41.5 cm
F 177, JH 543
Private collection
(Christie's Auction, New York, 19. 5. 1981)

Letter 133, the letter with which Vincent van Gogh resumed contact with his brother after months of silence, highlights the painter's significance as an artist with words. At infrequent intervals, perhaps once a year, his constant state of wrangling uncertainty issued in a perfectly dispassionate, almost cynical description and critique of himself and his current situation. Van Gogh's letter from the Borinage (the Belgian coal-mining district), written in July 1880, was the first in this series of level-headed analyses. Before he could make these disillusioned assessments of his ill-organized life, though, he had to put self-sacrificing toil on behalf of others behind him to an increasing extent: his early religious spirit, involving an evangelical imitation of Christ that was expressed in caring for his neighbours, was of no help in overcoming his unceasing discontent with himself and his life in general. Once he started to view the tenets of faith in a more abstract sense, as a way of seeing the world,

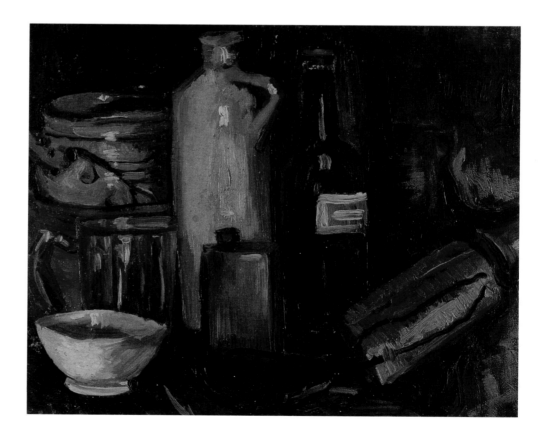

Still Life with Pots, Jar and Bottles
Nuenen, November 1884
Oil on canvas, 29.5 x 39.5 cm
F 178r, JH 528
The Hague, Haags Gemeentemuseum

a new approach to Art became possible. Hitherto he had actively practised his faith and had seen pictures as a support for it, narrating the process of redemption; but now the pattern was reversed, and the working artist set out to create pictures representing the certainty of redemption. In this process, religion served as a kind of pledge that he empowered himself to redeem at any time.

"Once I was in another environment", van Gogh told his brother in the same letter, "an environment of pictures and works of art, [...] an intense, passionate feeling for that environment overcame me, a feeling that came close to rapture. Nor do I regret it. And now, far from home, I am often homesick for that homeland of pictures [...] Instead of yielding to my homesickness I told myself that home, the fatherland, is everywhere. Instead of succumbing to despair I decided on active melan-

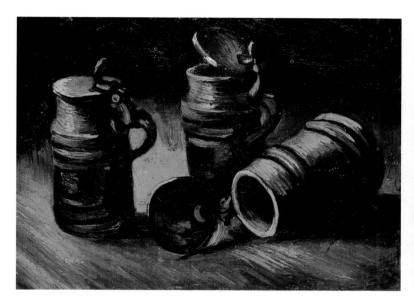 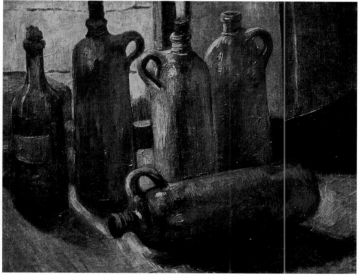

choly, insofar as being active was in my power; or, to put it differently, I put a melancholy that hopes and strives and seeks before a despairing melancholy of gloomy inaction." This passage provides us with a key phrase in his view of himself as an artist: "active melancholy". In the times to come it was to keep van Gogh going, ceaselessly, confronting his *weltschmerz* with the utopian notion of alleviating action. His art, his homeland of pictures, always kept its sights on both the impossibility and the hope of consigning his sufferings to oblivion through action.

"Now, I equally believe", he continued in the same letter, "that everything that is truly good and beautiful in Man and Man's works, everything of a moral, inner, spiritual, sublime beauty, all derives from God ... Try to understand what the great artists, the serious masters, are ultimately saying in their finest works – God is in it. One will have expressed it in a book, another in a painting. So Art is worship, or divine service, inasmuch as it places Beauty (which is the same thing as Goodness) in the heart of Man." After years of fairly ill-considered religious enthusiasm, van Gogh had achieved a position where Art and

Still Life with Three Beer Mugs
Nuenen, November 1884
Oil on canvas, 32 x 43 cm
F 49, JH 534
Amsterdam, Rijksmuseum Vincent van
Gogh, Vincent van Gogh Foundation

Still Life with Five Bottles
Nuenen, November 1884
Oil on canvas, 46.5 x 56 cm
F 56, JH 530
Vienna, Neue Galerie
in der Stallburg

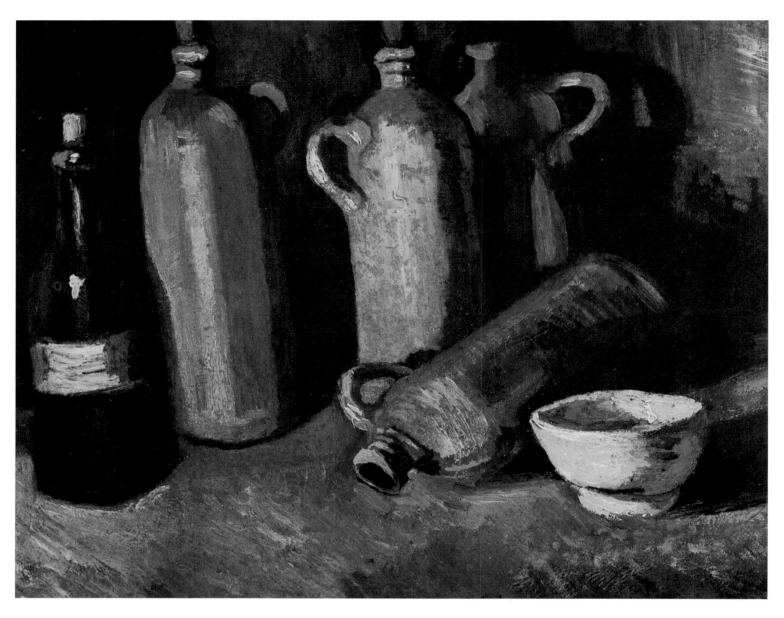

Religion, if they imposed moral obligations, were in fact one and the same thing.

It was because of this degree of abstraction in his thinking that van Gogh devoted himself to painting. It was widely agreed that Art enjoyed universal validity; and van Gogh not only wanted to do something for mankind, he also wanted recognition for what he was doing. Hitherto he had been "an idler in spite of myself; sometimes people in this position do not know themselves what they might be capable of, yet they feel instinctively: I *am* capable of something, my existence *does* mean something!" We should view van Gogh's new activity as an artist as an offer he was making to his family, in particular to Theo, to re-establish trust in each other after the months of indifference: "I am writing to you about all this because I believe you would rather I did something good than nothing at all, and this may perhaps be an occasion for restoring the fellow-feeling and heartfelt harmony between the two of us, an occasion for us to be of use to each other."

It implies no disparagement of van Gogh's artistic work if we point

Still Life with Four Stone Bottles, Flask and White Cup
Nuenen, November 1884
Oil on canvas, 33 x 41 cm
F 50, JH 529
Otterlo, Rijksmuseum Kröller-Müller

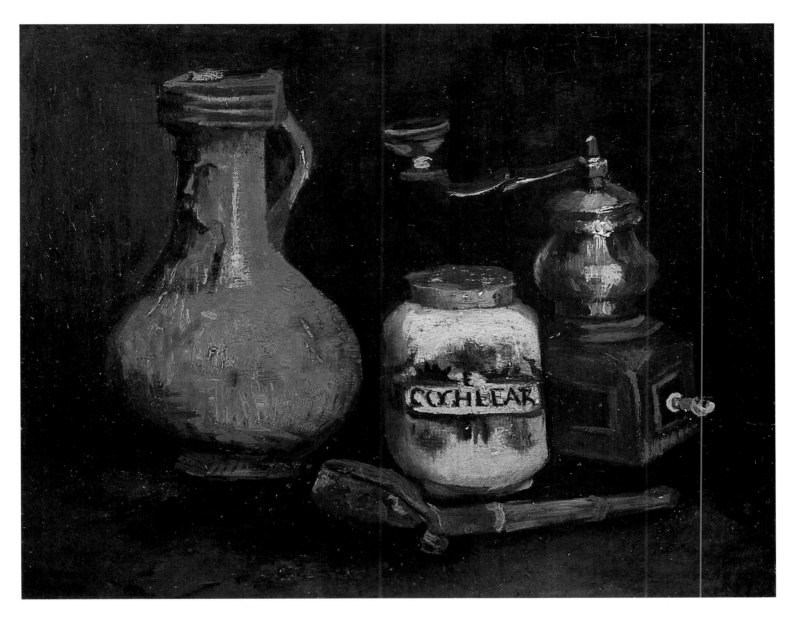

**Still Life with Coffee Mill, Pipe Case
and Jug**
Nuenen, November 1884
Oil on panel, 34 x 43 cm
F 52, JH 535
Otterlo, Rijksmuseum Kröller-Müller

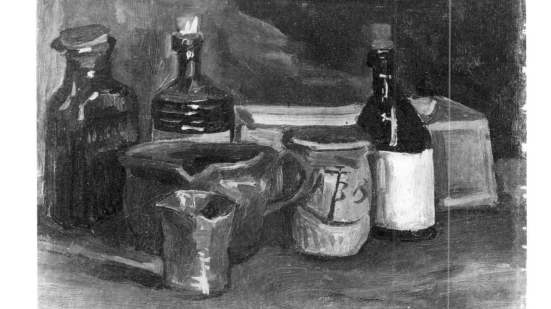

Still Life with Pottery, Bottles and a Box
Nuenen, November 1884
Oil on canvas, 31 x 42 cm
F 61r, JH 533
Amsterdam, Rijksmuseum Vincent van
Gogh, Vincent van Gogh Foundation

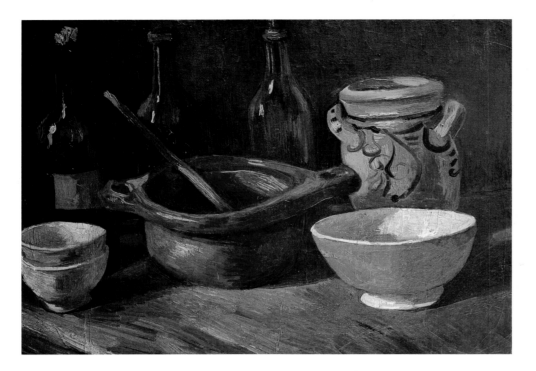

**Still Life with Three Bottles and
Earthenware Vessel**
Nuenen, Winter 1884/85
Oil on canvas, 39.5 x 56 cm
F 53, JH 538
Amsterdam, Rijksmuseum Vincent van
Gogh, Vincent van Gogh Foundation

out that there were material considerations that impelled him to take
his decision for Art. From this time on, Theo was punctual in sending off
his postal money orders; and Vincent depended on the clout of the art
dealers in the family.

In October 1880 van Gogh went to Brussels, to start on his training in
Art. He matriculated at the Academy: "Once I have mastered drawing
or watercolours or etching, I can return to mining and weaving country
and shall be better at working from Nature than I am now. But first I
have to acquire an amount of skill" (Letter 137). A model student, he
copied pictures and practised drawing exercises. He suppressed the

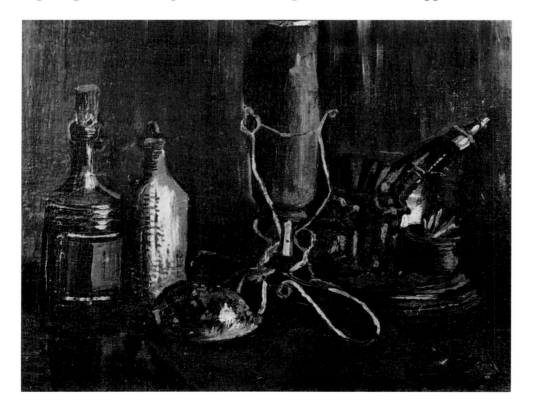

Still Life with Bottles and a Cowrie Shell
Nuenen, November 1884
Oil on canvas on panel, 30.5 x 40 cm
F 64, JH 537
Whereabouts unknown
(Sotheby's Auction, London, 3. 7. 1968)

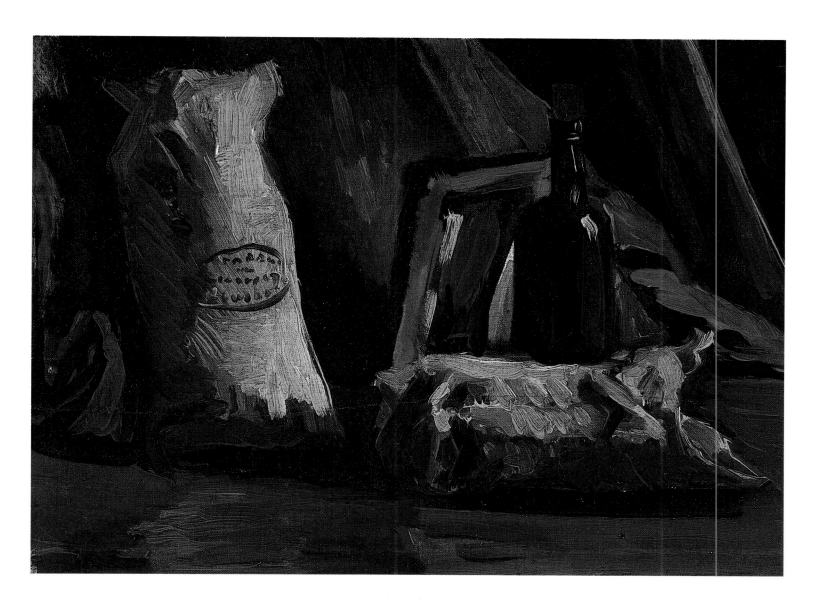

irresistible urge to go out into Nature. And he even sent his first works home, "to Pa, so that he can see I'm doing something" (Letter 138). Anton Mauve, his mother's brother-in-law and one of the best-known Dutch painters of the day, helped Vincent, introducing him to ways of handling paint and giving him essential advice. Van Gogh believed he had now discovered his true vocation, a path which might in due course earn him honour and financial rewards, and his family and relatives, tradition-minded as they were, approved. In April 1881 Vincent even went to Etten, to his parents' home, where Theodorus van Gogh was now the incumbent of the parish; and now that everything seemed to be working out he was welcomed with open arms.

Things turned out much as they had previously done, though. The career in art dealing, under the wing of his uncles, had ended in dismissal. His life as a pastor, which met his father's hopes, had come to grief in the slums of the Borinage. And now his artistic calling, approved by the whole family, presently turned out a disaster: some six months later, Vincent was thrown out of the house, and the Rev. van Gogh seemingly even decided to disown his son. All the plans van Gogh had obediently

Still Life with Two Sacks and a Bottle
Nuenen, November 1884
Oil on canvas on panel, 31.7 x 42 cm
F 55, JH 532
Private collection
(Koller Auction, Zurich, 25.-26. 5. 1984)

framed came to nothing. They were plans based on conventional bourgeois ideas of success, and they brought home to Vincent that this kind of tepid conformity was not for him. In Etten he realised that his conception of Art was not the same as society's; and inevitably he became an outsider again, even in the very province which luxury and aestheticism had marked out as the province of outsiders.

Vincent was in love. The lady in question was no other than his cousin Kee, recently widowed. She had a young son, and Vincent, with his weakness for children, soon acquired a passion for the boy's mother, too. The entire family were embarrassed by his advances, and found his protestations of love indecent, impious and lacking in sensitivity towards a woman in mourning. Vincent countered the reproaches with the sheer intensity of his feelings, disregarding the rules of convention.

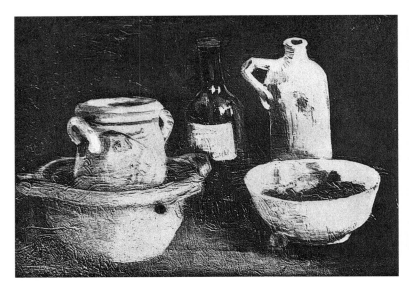 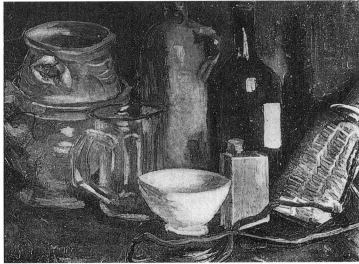

Vincent freely expressed his emotions to Theo. Writing to his new friend Rappard in Brussels, on the other hand, he was secretive about his love, and claimed that his affections were all enlisted in the service of Art: "Though you may not know it", he said (in Letter R4), "this Academy is a loved one who actually prevents a more serious, warmer, more fruitful love from awakening within you. – Let that lover go her way, and fall head over heels in love with the lady your heart truly loves, Dame Nature or Réalité. I too have fallen in love, head over heels, with a Dame Nature or Réalité, and since then I have been feeling happy although she is putting up tough resistance." Writing to Theo at the same time (Letter 157), he was less ambiguous: "Fall in love, and there you are, to your amazement you notice that there is another force that impels us to action: feeling." And he felt that his new devotion had a positive influence on his art: "To my chagrin, there always remains an element of hardness and severity in my drawings, and I believe that she (that is to say, her influence) is needed if they are to become softer." Kee's influence would supposedly purify his art and endow it with the flexibility it needed for the vital confrontation with Nature.

Still Life with Pottery and Two Bottles
Nuenen, November 1884
Oil on canvas, 40 x 56 cm
F 57, JH 539
Private collection

Still Life with Pottery, Beer Glass and Bottle
Nuenen, November 1884
Oil on canvas on panel, 31 x 41 cm
F 58, JH 531
United States, Private collection

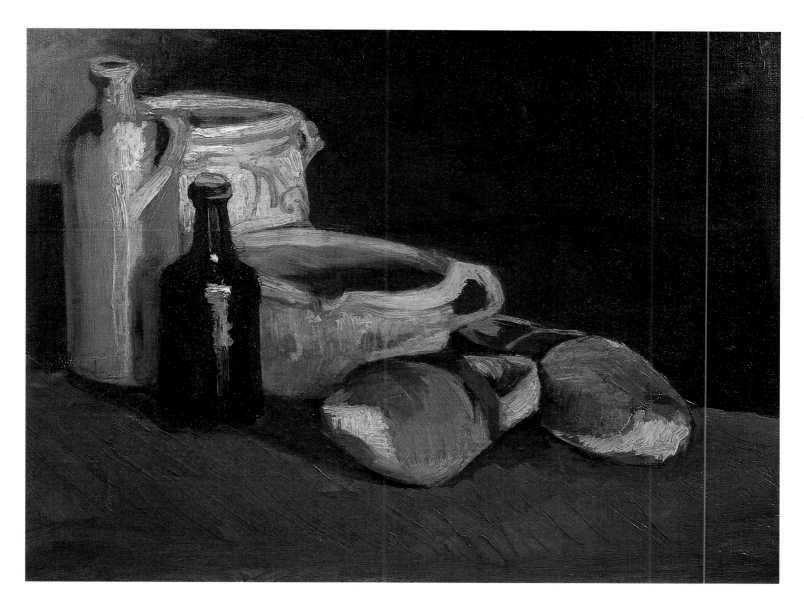

Once again we perceive van Gogh's tendency to syncretism. He had a twofold vision of his cousin – as a prim and proper clergyman's daughter rejecting his advances because the family elders expected her to do so, and as a woman he loved and intended to fight for. He projected everything he hated and loved into her. Kee became a personification of conventions and freedom alike, of the academic form of Establishment Art and of the openness of Nature, of the moral double standards of the middle class and of the immediacy of emotional life. And when Kee refused to listen to him, he wanted to thrust the propriety of his upbringing, the ridiculous rules of good behaviour away from him. It was in this connection that van Gogh first mentioned the concept that all his artistic efforts were to be devoted to and which art historians still identify him with: "May your profession be a modern one", he urged Theo (in Letter 160), "and may you help your wife to attain a modern soul, free her of the awful prejudices that shackle her." Modernity and emancipation were already inseparable in van Gogh's mind; and his emphatic calls for freedom were to be matched by the dazzling evolution of his art.

Still Life with Clogs and Pots
Nuenen, November 1884
Oil on canvas on panel, 42 x 54 cm
F 54, JH 536
Utrecht, Centraal Museum
(on loan from the van Baaren Museum
Foundation, Utrecht)

Vase with Honesty
Nuenen, Autumn 1884
Oil on canvas, 42.5 x 31.5 cm
F 76, JH 542
Amsterdam, Rijksmuseum Vincent van
Gogh, Vincent van Gogh Foundation

Vase with Dead Leaves
Nuenen, November 1884
Oil on canvas on panel, 41.5 x 31 cm
F 200, JH 541
Private collection
(Sotheby's Auction, London, 21. 4. 1971)

But he still had a long way to go. Van Gogh's first two paintings were completed at the end of 1881, under Mauve's guidance: *Still Life with Cabbage and Clogs* (p. 16) and *Still Life with Beer Mug and Fruit* (p. 16). Vincent's first steps as a painter were hesitant, tentative; he chose inanimate subjects, as he had been taught at the Academy, and tried to establish three-dimensionality and effects of light in a casual arrangement of the objects he had picked. The background remained a non-spatial brown; this approach was not a particularly good idea, since it afforded the individual items no optical purchase. But van Gogh had made a start. And in the rustic simplicity with which he took so obdurate a subject as clogs for granted we sense a foretaste of the scenes of peasant life that van Gogh was to paint in the years ahead.

Van Gogh's Early Models

Still Life with Paintbrushes in a Pot
Nuenen, November 1884
Oil on canvas on panel, 31.5 x 41.5 cm
F 60, JH 540
Private collection
(Christie's Auction, London, 26. 6. 1989)

In a distinctly new way, Vincent van Gogh's art was a product of the industrial era. The 19th century had embraced the ideal of industrial progress with enthusiasm. The multiplication of things was seen as the foundation of a better world. And works of the visual arts became subject to the process of reproduction too. Art was stored in museums, accessible to the public, and private homes had prints and books so that quiet hours of leisure could also be spent in the pursuit of Art. What the museums hoarded were paintings that had the aura of originals; and

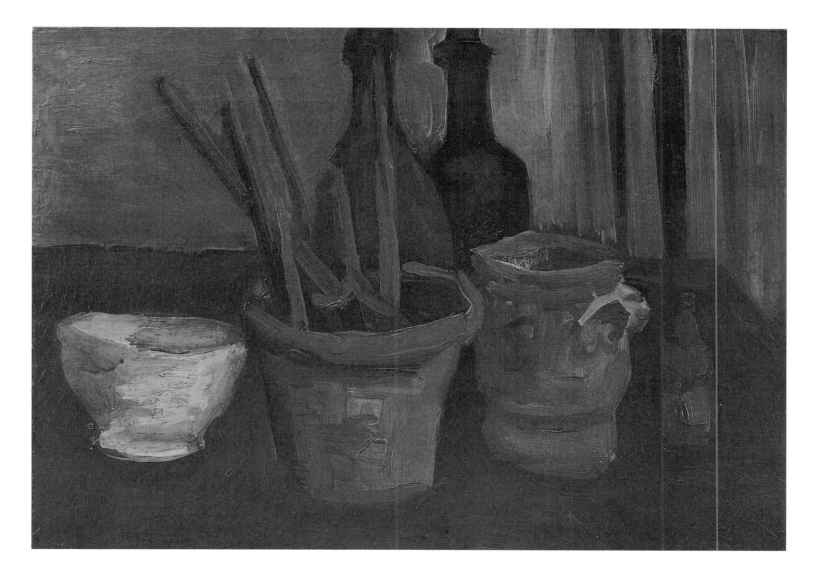

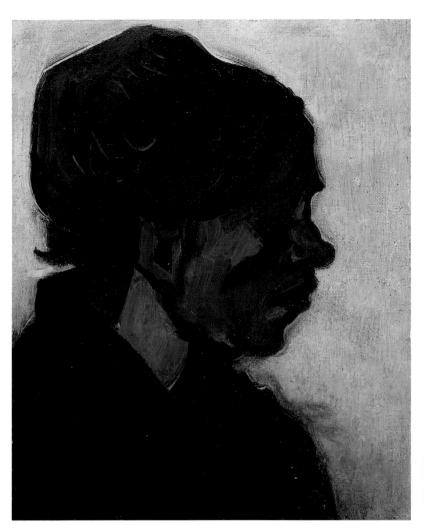
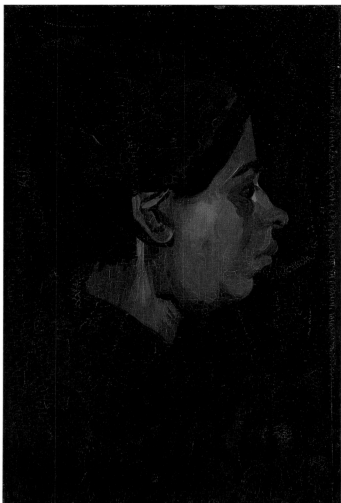

these in turn served as the prototypes for mass reproduction of a new commodity – pictures. Art began to seem banal and everyday. To a greater extent than any painter before him, van Gogh underwent his training as an artist by looking at reproductions. It was as if the autodidact needed to school his eye on the smooth impersonality of mass-produced printwork if his vision was to discover the living and universal qualities in Man and Nature.

Goupil, van Gogh's earlier employer, was the leading name in art reproduction. Definite as van Gogh was about severing ties with his past, he continued to take pleasure in the reproductions Goupil published. Confident of his ability to acquire artistic skill from prints and drawing schools, he soon quit the Brussels Academy, although it was free (which had been his only reason for matriculating there in the first place). In his view it was enough if he diligently copied reproductions and then let the fruits of his labour ripen in the warm glow of Nature. Van Gogh's tutor was Charles Bargues. Bargues's *Cours de dessin* and *Exercises au fusain* (two volumes of drawing exercises for study at home, published by Goupil) took the place of the Academy in van Gogh's training. The *Cours* included sixty nudes – of increasing technical difficulty – which the student was supposed to copy. The *Exercises* came in two parts: first there were seventy pages of sketches from

Head of a Brabant Peasant Woman with Dark Cap
Nuenen, January 1885
Oil on canvas on panel, 26 x 20 cm
F 153, JH 587
Otterlo, Rijksmuseum Kröller-Müller

Head of a Peasant Woman with Dark Cap
Nuenen, January 1885
Oil on canvas on panel, 37.5 x 24.5 cm
F 135, JH 585
Cincinnati, The Cincinnati Art Museum

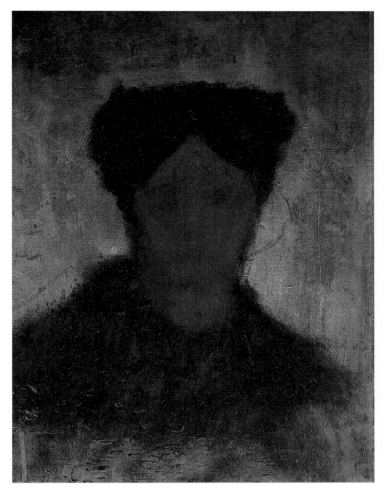

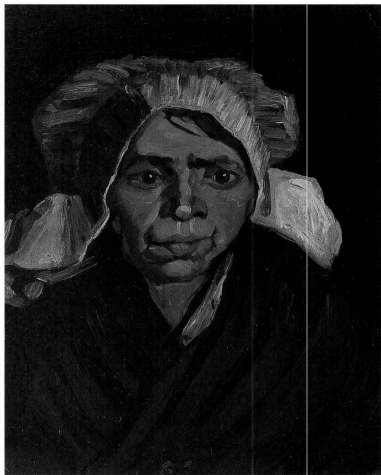

Peasant Woman, Head (unfinished)
Nuenen, December 1884
Oil on canvas on panel, 47.5 x 34.5 cm
F 159, not listed in JH
Amsterdam, Rijksmuseum Vincent van Gogh, Vincent van Gogh Foundation
(Attribution disputed)

Head of a Peasant Woman with White Cap
Nuenen, December 1884
Oil on canvas, 43.5 x 37 cm
F 146a, JH 565
Private collection
(Koller Auction, Zurich, 8. 11. 1974)

plaster models to be mastered, and then the student went on to drawing from famous paintings. Van Gogh tackled both sections repeatedly; indeed, he had amused himself in this way every day during his Borinage sojourn. In summer 1881 he went to work on them for a final time, and did not have recourse to them again till 1890, shortly before his death.

The engravings of contemporary works of art (which van Gogh also copied) made a lasting impression. Time and again he asked Theo to send him new Goupil publications. His liking for the social romanticism of a Jean-François Millet or Jules Breton matched the fashionable taste of the day; Paris society had started to value this work highly some ten years earlier. They were paintings that gave a true-to-life account of the hard facts of everyday farming or factory life while at the same time misting them over in idyllic light (sunsets, and so forth). Millet's *Angélus* (Paris, Musée d'Orsay) was the perfect example of this kind of work. It showed a farmer and his wife, forgetful of their poverty, hearing the bells of the angelus ringing from a distant belfry and pausing for silent prayer. Paintings such as this must have met van Gogh's need for an art that included religious devotion; indeed, when he was still living in the Borinage he had gone to see Jules Breton, to talk to the famous artist.

But van Gogh was not only out to copy these painters' works. They

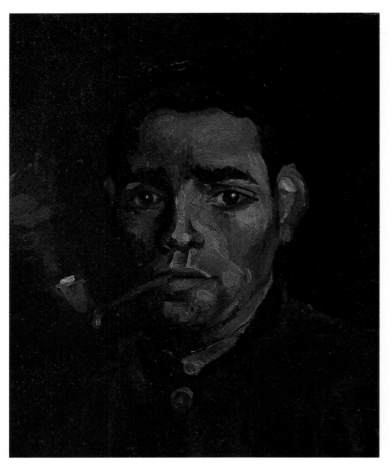

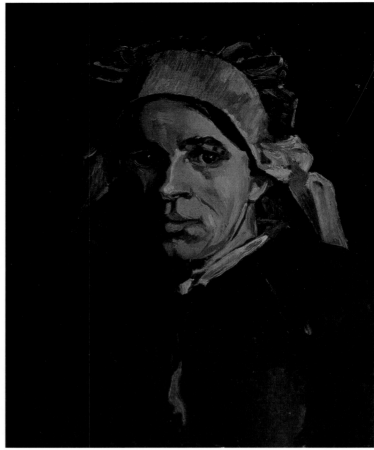

Head of a Young Peasant with Pipe
Nuenen, Winter 1884/85
Oil on canvas, 38 x 30 cm
F 164, JH 558
Amsterdam, Rijksmuseum Vincent van
Gogh, Vincent van Gogh Foundation

Head of a Peasant Woman with White Cap
Nuenen, December 1884
Oil on canvas on panel, 42 x 34 cm
F 156, JH 569
Amsterdam, Rijksmuseum Vincent van
Gogh, Vincent van Gogh Foundation

Head of a Peasant Woman with White Cap
Nuenen, December 1884
Oil on canvas on panel, 40.5 x 30.5 cm
F 144, JH 561
Montreal, Collection Mrs. Olive Hosmer

Head of a Peasant with Cap
Nuenen, December 1884
Oil on canvas, 39 x 30 cm
F 160a, JH 563
Private collection
(Sotheby's Auction, London, 1. 7. 1970)

Head of a Peasant Woman
Nuenen, December 1884
Oil on canvas on panel, 40 x 32.5 cm
F 132, JH 574
Private collection
(Christie's Auction, London, 6.–10. 12. 1968)

Head of an Old Peasant Woman with White Cap
Nuenen, December 1884
Oil on canvas, 36.5 x 29.5 cm
F 75, JH 550
Wuppertal, Von der Heydt-Museum

Head of an Old Peasant Woman with White Cap
Nuenen, December 1884
Oil on canvas on cardboard, 33 x 26 cm
F 146, JH 551. Private collection
(Sotheby's Auction, London, 30. 6. 1981)

Head of a Peasant Woman with Dark Cap
Nuenen, January 1885
Oil on canvas on panel, 39.5 x 30 cm
F 133, JH 584
Private collection

Head of a Peasant with Cap
Nuenen, January 1885
Oil on canvas, 35.5 x 26 cm
F 169a, JH 583
Collection Stavros S. Niarchos

Head of a Peasant Woman with Dark Cap
Nuenen, January 1885
Oil on canvas on panel, 25 x 19 cm
F 153a, JH 586
New York, Private collection

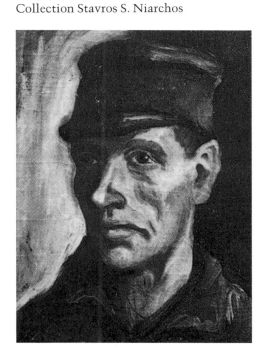

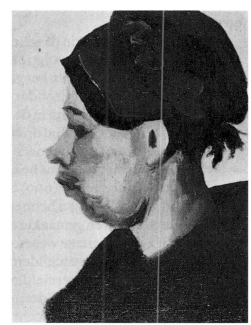

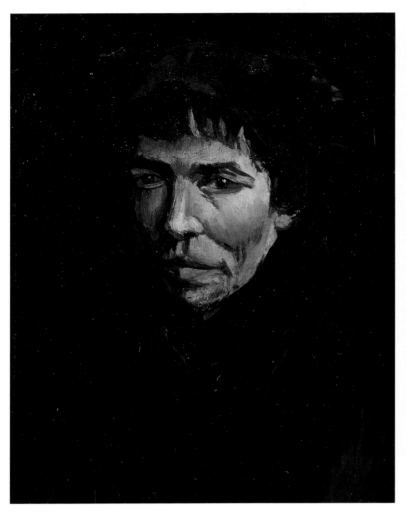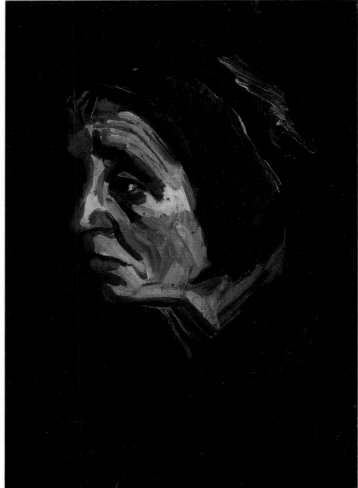

also served as models in his own life. He was given to quoting from Alfred Sensier's biography of Millet, and appropriated some of Millet's statements as a creed of his own: "I am noting down a few phrases from Sensier's *Millet* for you", he wrote to Theo (Letter 180), "phrases that impressed and affected me greatly, sayings of Millet's: Art is a fight – in Art you have to risk your very life. You have to work like a nigger: I would sooner say nothing at all than express myself feebly." These comments, put into Millet's mouth by his biographer, van Gogh took as the guidelines of his own life. And he gave them authenticity, just as he gave life to the routine lines produced in the copyist's act by applying the technique to Nature. It was as if the full vitality of his own perception only came into its own once the things he saw had become lifeless, as it were. Reproduction was almost the *sine qua non* for van Gogh's passion for appropriation.

Along with Bargues's exercises and the reproductions of Millet and Breton, a third body of graphic work influenced van Gogh's early drawings. It was an age of reproductions, and since mid-century (particularly in England) there had been a number of publications, most of them illustrated periodicals, that ran pictures showing scenes of everyday life, often with a sociocritical slant. Van Gogh had a subscription to the best-known of these periodicals, *The Graphic*. The illustrations included a

Head of a Peasant Woman with Dark Cap
Nuenen, January 1885
Oil on canvas, 40.6 x 31.7 cm
F 1667, JH 629
Private collection
(Christie's Auction, London, 28. 3. 1988)

Head of an Old Peasant Woman with Dark Cap
Nuenen, January 1885
Oil on canvas on panel, 36 x 25.5 cm
F 151, JH 649
Otterlo, Rijksmuseum Kröller-Müller

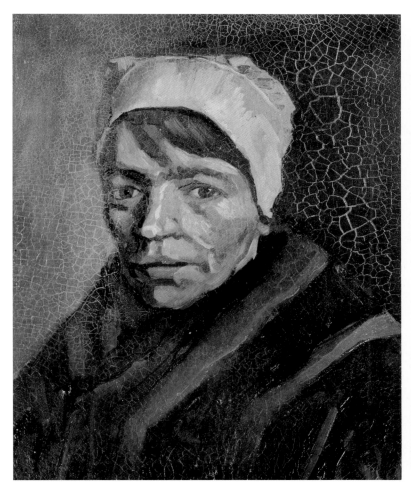

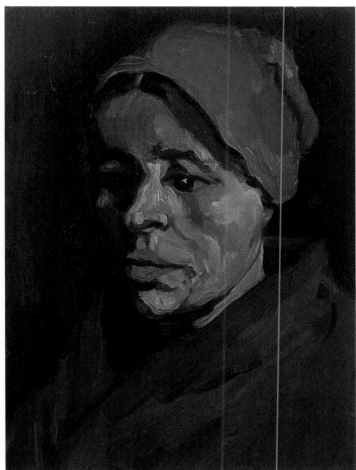

Head of a Peasant Woman with White Cap
Nuenen, January 1885
Oil on canvas, 38 x 30 cm
F 65, JH 627
Whereabouts unknown

Head of a Peasant Woman with Brownish Cap
Nuenen, January 1885
Oil on canvas, 40 x 30 cm
F 154, JH 608
Otterlo, Rijksmuseum Kröller-Müller

large number of human figures; and many of the unadorned, realistic reports made their mark on his own art. Fildes's drawing of Charles Dickens's empty chair is the most familiar example. An illustration by Helen Paterson was to prompt a painting now in The Hague, *Girl in White in the Woods* (p. 18). And the paintings of peasants done in Nuenen were closely related to William Small's portraits of working people. Van Gogh could envisage a career as a periodicals illustrator for himself: "Without presuming to suggest I could do as well as the people I have named, I do hope that if I work hard at drawing these working people and so forth I shall become more or less capable of doing illustrations for magazines or books" (Letter 140).

Only one copy dating from van Gogh's early years (and documented by references in the letters) survives: a drawing done of etcher Paul-Edmé Le Rat's reproduction of a painting by Millet. This version of *The Sower* (p. 20) is given the number 1 in Jan Hulsker's complete catalogue of van Gogh's works. Van Gogh clearly took meticulous pains to mimic the etching's style and flow – his own lines follow the lines of the needle. But in Etten van Gogh was already to put this faithful imitation, this impersonal devotion to a model, behind him.

"The first thing I have to do is find a room that's big enough, so that I can get the necessary distance. The moment he looked at my studies,

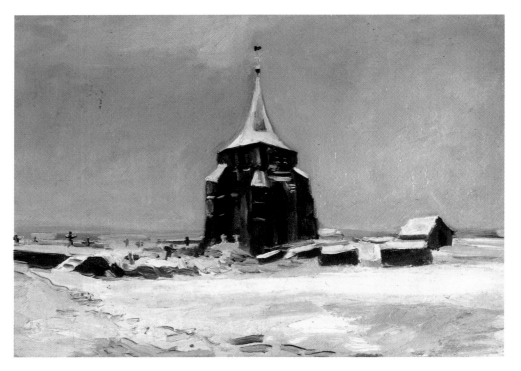

The Old Cemetery Tower at Nuenen in the Snow
Nuenen, January 1885
Oil on canvas on cardboard, 30 x 41.5 cm
F 87, JH 600
Collection Stavros S. Niarchos

Mauve told me: 'You're too close to the model.'" What van Gogh described (in Letter 164) as a problem of restricted space was to be a typical feature of his work in general: closeness to his subject. This closeness is certainly a quite literal question of physical proximity; but it is also an emotional closeness that results from an immediacy of identification with all things. Van Gogh acquired his draughtsmanship skills by schooling himself on the stereotyped objectiveness of illustrations, and in consequence his early drawings were on the dull side in terms of line and flow, with his contours tidily framing motifs he could not organically fit into the background; but nevertheless, from the very beginning those early works emanate that pleasure van Gogh must have taken in dealing with his subjects. However poor the quality of the drawings, they always have an intense note of solidarity which derives not so much from the handling of the pencil as from the perspective of van Gogh's approach. The rough love of detail, which is incapable of

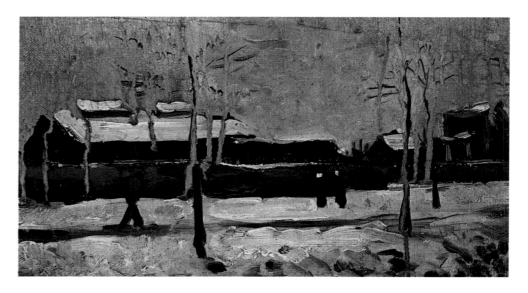

The Old Station at Eindhoven
Nuenen, January 1885
Oil on canvas, 13.5 x 24 cm
F 67a, JH 602
Private collection
(Sotheby's Auction, London, 26. 6. 1984)

reproducing tactile, material, three-dimensional effects, is balanced out from the very start by a quality that could be termed conceptual. Before committing his vision to paper, van Gogh would always evolve a sense of his subject that had a great deal of longing, sympathy and trust in it. In Letter 195 he himself left an account of this: "I have tried to endow the landscape with the same feeling as the figure. Taking firm root in the earth, frantically and passionately, as it were, and still being half torn

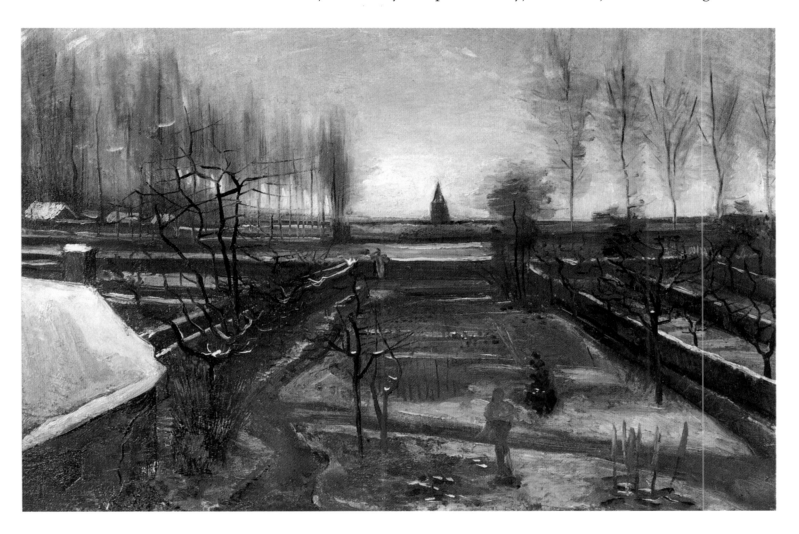

The Parsonage Garden at Nuenen in the Snow
Nuenen, January 1885
Oil on canvas on panel, 53 x 78 cm
F 67, JH 604
Los Angeles, The Armand Hammer
Museum of Art

away by the storms. In both the white figure of the woman and the black, gnarled roots I wanted to express some of the struggle of life. Or, to be more exact: because I was trying to be faithful to the natural world before me, without philosophizing, in both cases, almost in spite of everything, something of that great struggle entered in."

In his contemplation of individual motifs there is always a sense of the fate of all life, which the artist shares in. "Something of that great struggle" comes to the fore, in all its inclusive totality. There can be no doubt about the links of this way of thinking to religious mania, on the one hand, and on the other to Romantic intensity of feeling. But it is also perfectly possible that van Gogh's particular problems with artistic technique, his lack of any thorough training, and indeed (to put it bluntly) his lack of talent, played a part too. In the process of copying,

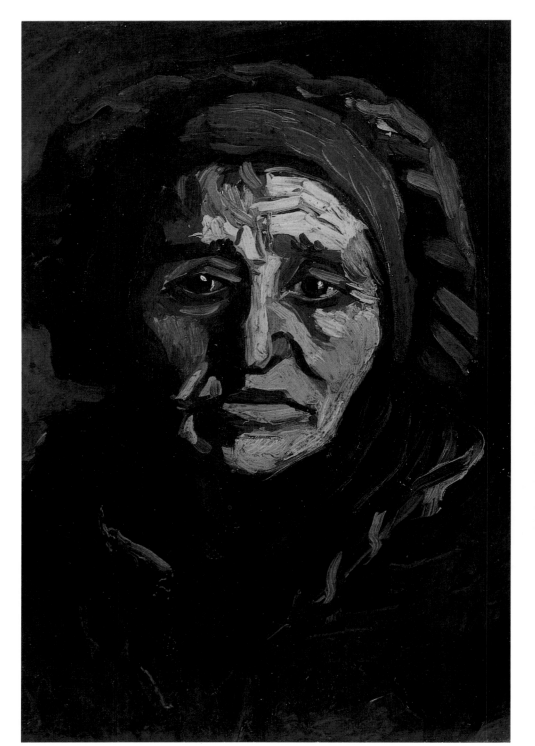

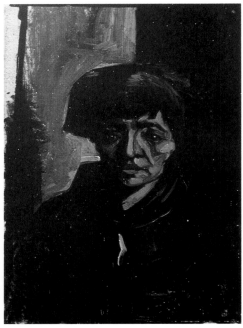

Head of a Peasant Woman with Greenish Lace Cap
Nuenen, February-March 1885
Oil on canvas, 38 x 28.5 cm
F 74, JH 648
Otterlo, Rijksmuseum Kröller-Müller

Head of a Peasant Woman with Dark Cap
Nuenen, December 1884
Oil on canvas on panel, 35 x 26 cm
F 136a, JH 548
Japan, Private collection
(Christie's Auction, New York, 15. 5. 1985)

van Gogh appropriated all his subjects complete with contexts. He found them in total, finished units which had to be grasped overall if he was to give deeper attention to the details. He was plainly unskilled, and this absence of skill made it impossible for him to take a descriptive approach to things; but this absence was compensated by an expressive vigour that enhanced all his shapes and forms and made sheer energy into an aesthetic quality. In every new work, van Gogh laid bare the roots of his creativity.

Family Life
The Hague 1882-1883

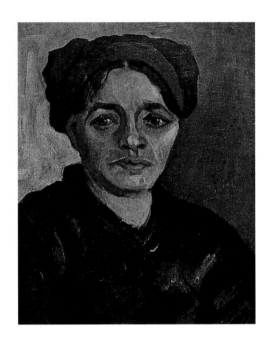

Head of a Peasant Woman with Dark Cap
Nuenen, January 1885
Oil on canvas, 40 x 30.5 cm
F 137, JH 593
Whereabouts unknown

The first two still lifes van Gogh painted (p. 16) were done in Mauve's studio in The Hague. This old city to win became Vincent's base when he travelled to Amsterdam to make a last attempt Kee. When Kee rejected him, he turned to any other woman who would have him – and found one. Van Gogh records the encounter; in Letter 164, which can be read (in its assured and distanced view of himself) as an 1881 pendant to Letter 133 from the Borinage: "Retribution comes if one lives without a woman for too long. And I do not believe that what some people call God, others the Supreme Being, and still others Nature, is both irrational and merciless. In a word, I came to this conclusion: Just for once I shall see if I can't find myself a woman. And, dear God, I didn't need to look far." Nature, both rational and merciful (the combination of rationality and humane qualities is characteristic of van Gogh's way of seeing things), supplied van Gogh with a woman. She earned a poor living as a prostitute.

Christine Clasina Maria Hoornik, known as Sien, was older than Vincent (like Kee); she had a daughter and was expecting a second child. "It is not the first time that I've been unable to resist the feeling of attraction and love towards those women in particular whom the pastors damn so vehemently, condemning and despising them from on high in their pulpits." Vincent himself brought all his powers of sympathy to bear on Sien. Solidarity with this ill-treated woman meant more to him than observing conventions that forbade contact with fallen women: "If one wakes early and is not alone, one sees a fellow human being beside one, it makes the whole world so much more of a livable place. Far more livable than the devotional books and whitewashed church walls the pastors are so in love with."

There had been a violent family quarrel, and following it Vincent had left the parental home at Etten (on Christmas Day, 1881) and moved to The Hague. The city was the centre of the art world, which meant so much to him, and he was close to Sien, too. Time after time, at the festival that marks the birth of Christ, van Gogh took decisions that changed his life. It was Christmas that prompted him to hand in his notice at Goupil's – he returned home when trade was at its briskest. And later, when his life with Gauguin in Arles was deteriorating, the

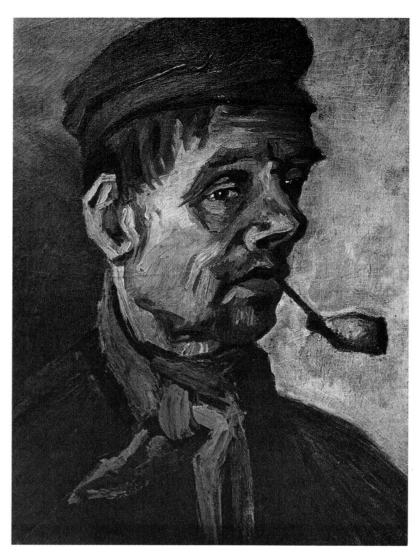

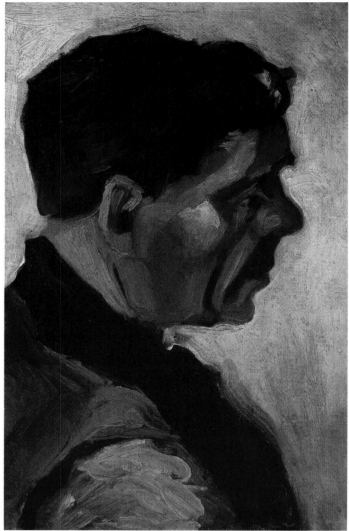

crisis was to be reached when he mutilated himself at Christmas. In The Hague he attempted to re-establish the festive tranquillity of the day with his new family: "A strong, powerful emotion visits a man's spirit when he sits beside the woman he loves, with an infant child in the cradle next to them. Even if she was in hospital and I sitting beside her where she lay – it would still always be the eternal poetry of Christmas night, with the infant in the manger, as the old Dutch painters portrayed it, and Millet and Breton – with a light nevertheless in the darkness, a brightness amidst the dark night" (Letter 213). Once again, van Gogh's innate goodness and sentimentality colours his vision; a hospital room becomes a stable in Bethlehem, and the new-born child acquires a divine sublimity.

The woman he loves is seen with an artist's eye, too: "Never before have I had so good a helper", he wrote to Rappard (Letter R8), "as this ugly??? faded woman. To me, she is beautiful, and I find in her the very things I need; life has passed her by, and she has been marked by suffering and misfortune. If the earth has not been ploughed, one cannot grow anything in it. She has been ploughed – and for that reason I find more in her than in a whole heap of the unploughed." Sien's

Head of a Peasant with a Pipe
Nuenen, January 1885
Oil on canvas, 44 x 32 cm
F 169, JH 633
Otterlo, Rijksmuseum Kröller-Müller

Head of a Peasant
Nuenen, February-March 1885
Oil on canvas, 47 x 30 cm
F 168, JH 632
Otterlo, Rijksmuseum Kröller-Müller

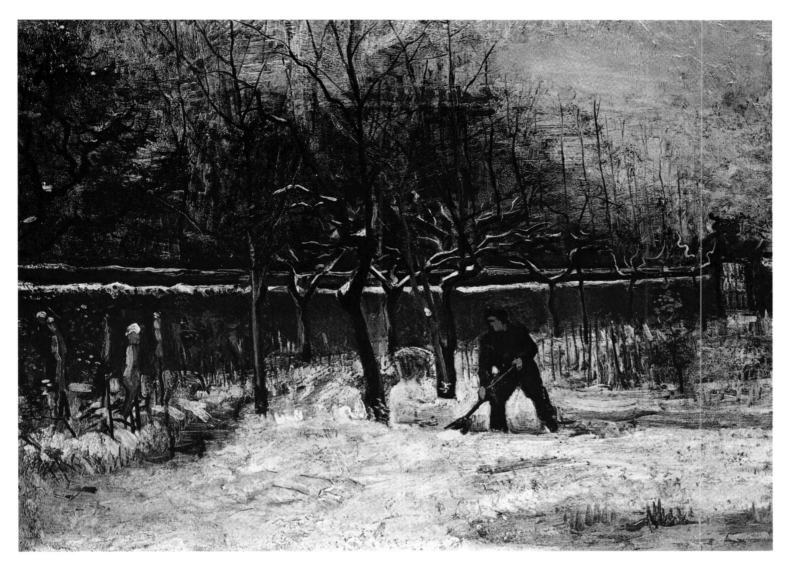

The Parsonage Garden at Nuenen in the Snow
Nuenen, January 1885
Oil on canvas on panel, 51 x 77 cm
F 194, JH 603
Pasadena (Cal.), Norton Simon Museum
of Art

pockmarked, careworn face reminded him of a tilled field. Without a trace of irony, van Gogh adapted her face to the Biblical metaphor of sowing and reaping, the same metaphor as he used to describe his own painting. Sien became his muse. She had no mythological beauty to offer him; but her incorruptible vitality was more than sufficient compensation for any lack of literary or historical status.

The help he had hoped for from his relatives was not forthcoming. They preferred to keep the good-for-nothing of the family at arm's length now that he was living with a prostitute and her two illegitimate children. (Van Gogh never learnt that Sien in fact had four children.) Van Gogh's response was a greater dedication to his work than ever. Now, with models at his disposal, he was finally able to indulge his view of himself as a figure painter. In summer 1882 he and his family moved to a larger apartment. Now he even had a studio. "To return quite specifically to the subject of Art", he wrote to his brother in Letter 215, "from time to time I feel a great desire to go back to painting. The studio is much more spacious, the light is better, I am well able to keep paint etc. without making too much of a dirty mess. And so I have promptly made a new start with watercolours." And in August 1882 he produced a

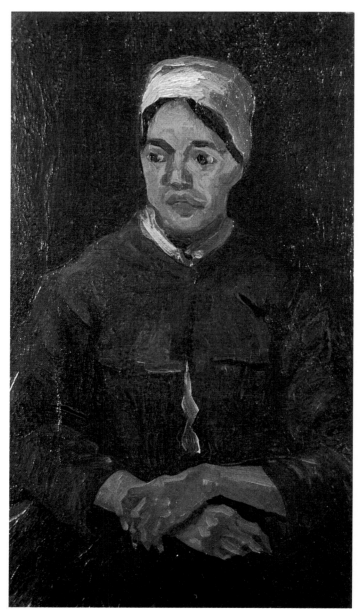

series of oil paintings, fourteen of which (out of a total that must have been double that figure) have survived.

Mauve was a member of the 1880 Movement, a Dutch school of *plein air* painters centred on The Hague, a school that were trying to reconcile the approach of the Barbizon painters with the landscape tradition of the baroque Golden Age. Théodore Rousseau had founded an artists' colony around the middle of the century in the woods at Fontainebleau. Tired of the busy Parisian bustle, these artists were out to reform landscape painting, which was in an ailing condition, crushed by the dogmas of the academies. Painters such as Charles-François Daubigny and Camille Corot took to setting up their easels in the open, hoping to capture the fleeting play of light, the life and atmospherics of their subjects, to restore to those subjects a certain lightness and directness, indeed joyfulness. The Barbizon School's programme was influential, and artists' associations that spurned the cities were appearing everywhere by the end of the century. Mauve's group in The Hague – including painters

Peasant Woman, Seated (Half-Figure)
Nuenen, February 1885
Oil on canvas on panel, 46 x 27 cm
F 127, JH 651
Private collection
(Sotheby's Auction, 26. 5. 1976)

Head of a Young Peasant Woman with Dark Cap
Nuenen, February-March 1885
Oil on canvas, 39 x 26 cm
F 150, JH 650
Otterlo, Rijksmuseum Kröller-Müller

such as Jozef Israëls, the brothers Jacob Henricus and Matthijs Maris, and Johannes Bosboom – practised a Barbizon escapism on Dutch soil. But in addition they were drawing upon a second tradition, a line that had achieved the sheer élan of liberation even in times of prescriptive rules laid down by the pontificating Guardians of Art: this was the line of 17th century Dutch landscape art. In the works of Jacob van Ruisdael or Meindert Hobbema, communion with Nature had always been valued above all things. And the artists of The Hague aimed to combine the direct approach of the Barbizon painters with the close attention to the motif that was characteristic of the Dutch old masters.

Van Gogh closely resembled them in his choice of subjects. He too was attracted to the outskirts of The Hague, a transitional area that was neither city nor countryside, where the light was dimmer, the air freer, the motifs lighter of heart, and the mood unclouded by the full melancholy of rural parts. In the main, he painted sea scenes: views of the beach at Scheveningen and of the subjects that presented themselves there, such as dunes, fishermen, boats, and crashing waves. But this coincidence of subject matter represents the only common ground between van Gogh and the 1880 Movement, as two examples will show.

"Otherwise, the scenery is very simple on the whole", wrote van Gogh in Letter 307, describing the vicinity, "flat and level, with

Peasant Woman Sweeping the Floor
Nuenen, February-March 1885
Oil on canvas on panel, 41 x 27 cm
F 152, JH 656
Otterlo, Rijksmuseum Kröller-Müller

Peasant Woman Sewing
Nuenen, February 1885
Oil on canvas, 42.5 x 33 cm
F 126a, JH 655
Schweinfurt, Collection Georg Schäfer

 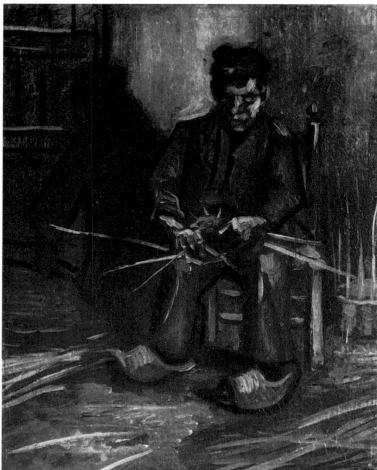

weather-beaten dunes, and at best waves. I think that if we were there together the area would create a mood in which we would have no doubts about my work but would sense for certain what we must aim for." In the dunes he used as subjects, as in all things, van Gogh was seeking consolation, an opening for communication, an option on some kind of identification. To a far greater extent than the enlightened artists of his time he withdrew into Nature, searching for its anthropomorphic side, the image of himself and of the gloomy frame of mind he was in. That is why his dunes look so monumentally close (p. 17). "Theo, I am definitely not a landscape painter; if I paint landscapes, there will always be something figural in them" (Letter 182). Landscape was a model for van Gogh. He did not want it to be unapproachable and remotely beautiful; he wanted it open, harmonizing with the painter's situation by virtue of its capacity for symbolic expression. In this, van Gogh was far closer to a Ruisdael, with his religiously motivated approach to Nature, than to the disillusioned snapshot scenes of a Mauve.

"I have been in Scheveningen frequently and have brought two small seascapes home with me. There is a great deal of sand in the first – but when it came to the second, with a storm blowing and the sea coming right up to the dunes, I had to scrape it totally clear twice because it was completely caked in sand. The storm was so rough that I could hardly

Peasant Woman Peeling Potatoes
Nuenen, February 1885
Oil on canvas on panel, 43 x 31 cm
F 145, JH 653
Private collection

Peasant Making a Basket
Nuenen, February 1885
Oil on canvas, 41 x 35 cm
F 171, JH 658
Switzerland, Private collection

PAGE 81, LEFT:
Peasant Sitting at a Table
Nuenen, March-April 1885
Oil on canvas, 44 x 32.5 cm
F 167, JH 689
Otterlo, Rijksmuseum Kröller-Müller

PAGE 81, RIGHT:
Peasant Woman at the Spinning Wheel
Nuenen, February-March 1885
Oil on canvas, 41 x 32.5 cm
F 36, JH 698
Amsterdam, Rijksmuseum Vincent van Gogh, Vincent van Gogh Foundation

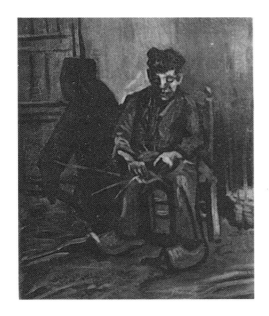

Peasant Making a Basket
Nuenen, February 1885
Oil on canvas, 41 x 33 cm
F 171a, JH 657
Whereabouts unknown

stand, and could see next to nothing because of the blowing sand." Here (in Letter 226) van Gogh is describing the creation of his two seashore scenes (pp. 20 and 21) in the teeth of the raging elements. The reckless streaks of thick paint and the impetuous lacerations of the surface convey a well-nigh palpable sense of the beach and the dunes. The painter's material (paint and canvas) and Nature's material (fine sand) are mixed, and the artist is plainly conniving at the process in the interests of authenticity. We are doubly close: close to the motif, and close to the process of creation. Van Gogh admits us to his struggle to produce the work. The distinguished craftsmanship of the 1880 Movement, the ideas of perfection and presentable finish cherished by the artists of The Hague, would have been altogether at odds with so crude a surface – it would have been seen as beneath an artist's dignity.

In the same letter, van Gogh wrote: "If in the course of time they were to see more often than they do now the trials and tribulations I go through with my work, how I am forever scraping off and making alterations – how I sternly compare with Nature and then make another change, so that they can no longer make out this spot or that figure exactly – it would always remain disappointing to them, they would not be able to grasp that painting can't be done just so, right away, and they would repeatedly conclude 'that I don't really understand what I'm

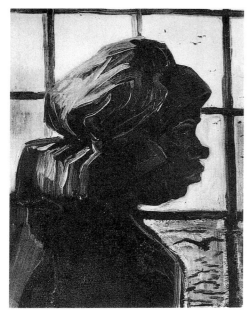

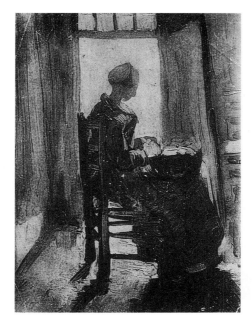

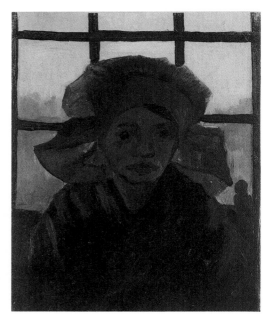

Peasant Woman, Seen against the Window
Nuenen, March 1885
Oil on canvas on cardboard, 41 x 32 cm
F 70, JH 715
Netherlands, Private collection

Peasant Woman Seated before an Open Door, Peeling Potatoes
Nuenen, March 1885
Oil on canvas on panel, 36.5 x 25 cm
F 73, JH 717
Epalinges (Switzerland), Collection Doyer

Head of a Peasant Woman against a Window
Nuenen, February-March, 1885
Oil on canvas, 38.5 x 31 cm
F 70a, JH 716
Amsterdam, Rijksmuseum Vincent van Gogh, Vincent van Gogh Foundation

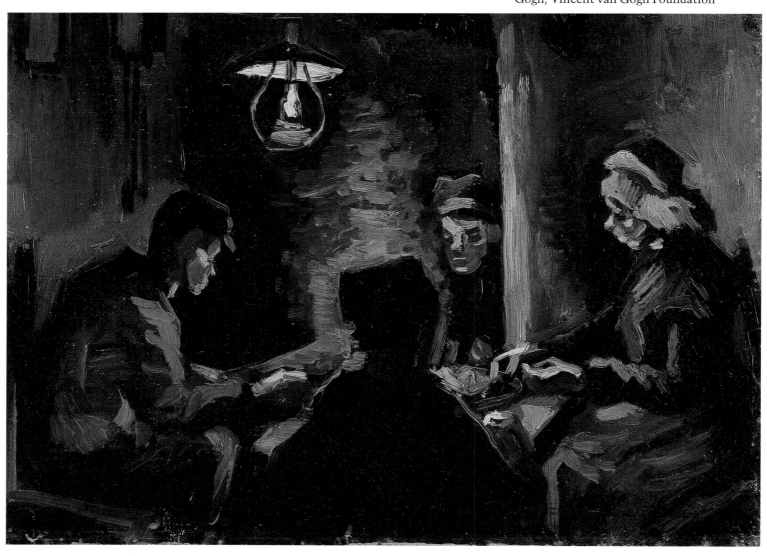

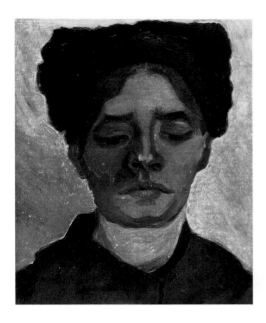 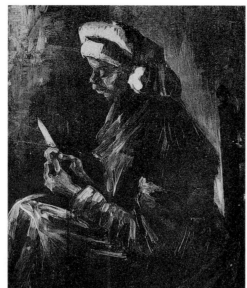 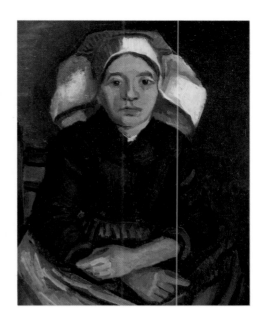

Head of Peasant Woman with Dark Cap
Nuenen, February 1885
Oil on canvas, 32 x 24.5 cm
F 138, JH 644
Private collection
(Sotheby's Auction, New York, 21. 4. 1979)

Peasant Woman Peeling Potatoes
Nuenen, February 1885
Oil on canvas, 41 x 31.5 cm
F 365r, JH 654
New York, The Metropolitan Museum of Art

Peasant Woman, Seated, with White Cap
Nuenen, December 1884
Oil on canvas on panel, 36 x 26 cm
F 143, JH 546
Whereabouts unknown

LEFT:
Four Peasants at a Meal (First Study for
'The Potato Eaters')
Nuenen, February-March 1885
Oil on canvas, 33 x 41 cm
F 77r, JH 686
Amsterdam, Rijksmuseum Vincent van
Gogh, Vincent van Gogh Foundation

doing' and that real painters go about their work quite differently." Van Gogh's "they" is society as a whole, with its fixed categories of correctness and ability. Van Gogh knew all too well that he did not fit these categories, either as an artist or as a man. His impetuous and temperamental character was inevitably expressed in these paintings – but so too was his lack of solid talent. Every brushstroke had to be a stroke of genius – and this vehemence undermined what might have been tidy painterly work.

By now van Gogh had four mouths to feed. With customary missionary zeal he had succeeded in dissuading Sien from continuing her life as a prostitute; but this moral success had a financial side effect, since she no longer earned any money. Theo's monthly allowance hardly sufficed now, and Vincent's appeals for extra funds became ever more urgent. His new and enthusiastic devotion to painting soon had to take a back seat: "For fourteen days now I have painted from early in the morning till late in the evening, and if I go on like that it will be too expensive as long as I am not selling anything" (Letter 227). In typical fashion he had got himself into a paradoxical situation: the harder he worked, the less money he had. "I cannot live any more thriftily than we are already doing; we have cut down on whatever we could cut down on, but there is always more work to do, especially these last few weeks, and I can hardly cope – that is, with the costs involved" (Letter 259). The family was literally going hungry. The spartan fare had its effect on the quality of van Gogh's work, and his hope of ever making money as an artist began to recede. It was a vicious circle of poverty, with lethargy and resignation waiting at the centre: "Essentially I have a constitution strong enough to take it", he explained to his brother (in Letter 304), "if only I hadn't had to go hungry so long; but that is how it has always been, time after time – either going hungry or working less – and whenever it was possible I've chosen the former, and now I am too weak.

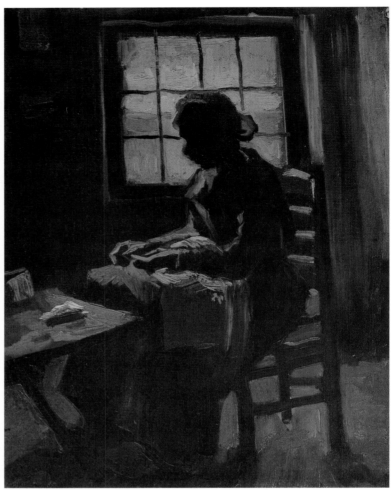

Peasant Woman, Seated, with White Cap
Nuenen, March 1885
Oil on paper on panel, 36 x 27 cm
F 144a, JH 704
s'-Hertogenbosch, Noordbrabants Museum
(on loan)

**Peasant Woman Sewing in Front of a
Window**
Nuenen, February-March 1885
Oil on canvas, 43 x 34 cm
F 71, JH 719
Amsterdam, Rijksmuseum Vincent van
Gogh, Vincent van Gogh Foundation

How can I cope? The effects are clearly to be seen in my work, and I am worried about how I am to go on."

Van Gogh clutched all the more desperately at one single straw — success as an illustrator. He had used English periodical illustrations to extend his own draughtsmanship skills, and now he hoped to produce the kind of figural representation of everyday scenes that was in demand in the illustrated magazines. After his brief excursion into painting (lasting a bare month) he returned to drawings and watercolours. He took his subjects as he found them in the streets, made hasty sketches, and then assembled the details in larger compositions. The group portraits he was now doing were broad in perspective, showed various kinds of people, and had a quality of narrative, journalistic accuracy: they are unique in van Gogh's oeuvre. He did not see them as works in their own right but as studies, steps along the way to the artistic perfection he was aiming at. Watercolours such as *The State Lottery Office* (p. 23), done in autumn 1882, are struggling with multiple problems: the difficulty of making a whole out of the individual figures, of making the figures relate to each other without simply bunching them up, and of presenting the people as an anonymous mass yet simultaneously as individuals whose situation is understood. Van Gogh nicely expressed this problematic area with the word *moutonner* (literally:

Peasant Woman with Child on Her Lap
Nuenen, March 1885
Oil on canvas on cardboard, 43 x 34 cm
F 149, JH 690
Private collection

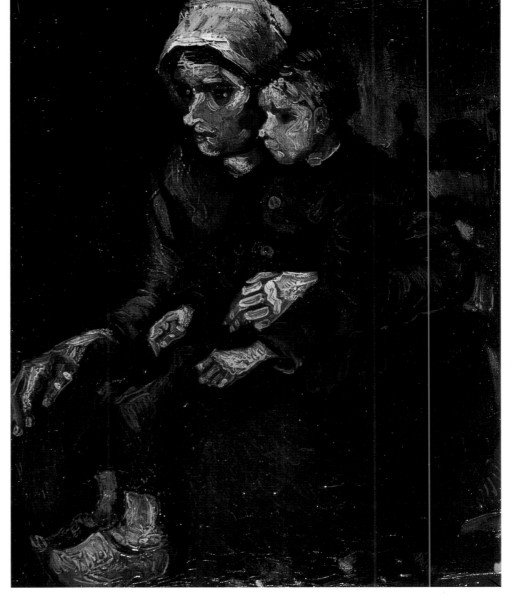

Head of a Peasant Woman with Dark Cap
Nuenen, March 1885
Oil on canvas on panel, 40 x 30 cm
F 136, JH 683
Whereabouts unknown

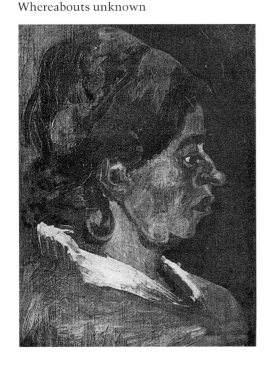

sheep-herding): "But how hard it is to put life and movement into it, to have the figures in their proper places yet distinct from each other! It is the great problem of *moutonner*; groups of figures that do constitute a whole, true, but their heads and shoulders are peeping past each other, while in the foreground the legs of the foremost figures are plainly seen, and above them the skirts and trousers come out in a confused mess that has nevertheless been drawn, for all that" (Letter 231).

Van Gogh was soon to flee the problem, without managing to solve it. He made a hurried return to his close-ups of individual people; and subsequent scenes, including several figures, were quite frankly indebted to those pictures of individuals in which he invested so much empathy. His figures are seen on a narrow foreground strip against a broad horizon, with only the land and the sky between them, each one isolated in silhouette, likelier to be absorbed in some silent task than interacting with the other people in the scene. In this respect, *Potato Digging, Five Figures* (p. 27) recapitulates van Gogh's art of his Hague

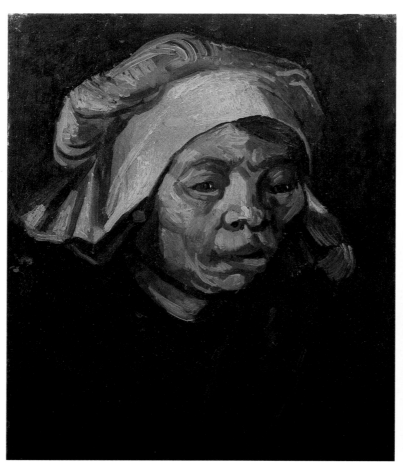
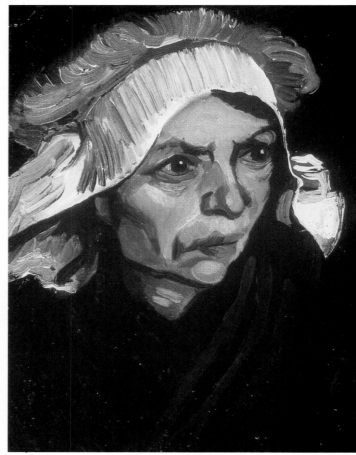

phase. The crudely sketched rustic figures hardly overlap at all; their gestures, the devotion to their work, silently absorbed in digging, are conceived in a spirit of the individual, not the group. Their different movements represent the sequence of separate actions in potato digging rather than an actual scene in the field. Van Gogh was to use this kind of multi-figural picture again; this digging scene, done in late summer 1883, was the first in a series of similar works he produced in Holland.

"Last year", he wrote in Letter 308, describing his new approach to figural representation, "I repeatedly tried to paint figure studies, but the way they turned out back then drove me to despair ... At that time it threw me totally if my sketch was no longer clear during the painting, and I would have to spend a lot of time redoing the sketch, which meant quite simply that if I could only have the model for a short while nothing whatsoever was produced. But now I don't care at all if the drawing disappears; I do it with the brush right away, and this creates enough form, so that my study is of use to me." So the group portraits, such as the potato diggers, resulted from a new approach to the subject. Instead of drawing laborious sketches and then transferring them to canvas, in oil, van Gogh was now doing his initial sketches in oil straight off. The details were now turning out more vivid, direct, and above all permanent. And this more intense kind of figure study also resulted in a more additive style of composition (compared with the watercolours); the sketch could be directly incorporated into the final work, and the

Head of a Peasant Woman with White Cap
Nuenen, Winter 1884/85
Oil on canvas on triplex board, 42 x 34.5 cm
F 80a, JH 682
Amsterdam, Rijksmuseum Vincent van Gogh, Vincent van Gogh Foundation

Head of a Peasant Woman with White Cap
Nuenen, March 1885
Oil on canvas on panel, 41 x 31.5 cm
F 80, JH 681
Zurich, Collection E. G. Bührle

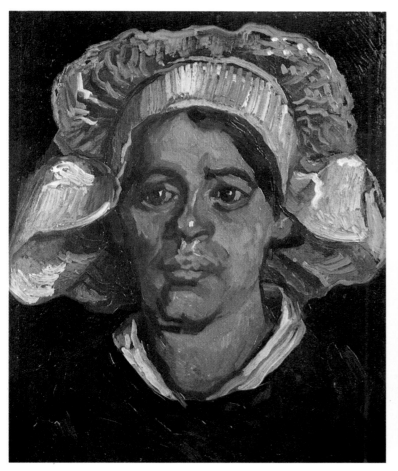 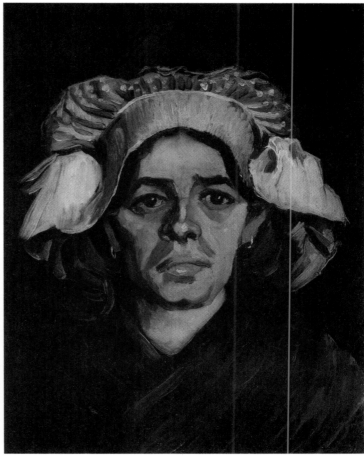

Head of a Peasant Woman with White Cap
Nuenen, March-April 1885
Oil on canvas, 44 x 36 cm
F 85, JH 693
Otterlo, Rijksmuseum Kröller-Müller

Head of a Peasant Woman with White Cap
Nuenen, March 1885
Oil on canvas, 43 x 33.5 cm
F 130, JH 692
Amsterdam, Rijksmuseum Vincent van
Gogh, Vincent van Gogh Foundation

painter scarcely needed to rework it any more. For a whole year, financial worries had kept van Gogh from painting. In summer 1883 he ventured to paint again, and in addition to *Potato Digging, Five Figures* produced landscapes in the main. The remoteness of the viewpoint in these landscapes was likewise a product of his close study of detached illustration styles in the magazines. Van Gogh also used an invention of his own, a perspective frame of the kind often devised during the Renaissance. "It consists of two long bars", wrote van Gogh (Letter 223), "to which the frame is attached by means of wooden pegs, either in a vertical or horizontal format. This provides a view of a beach or meadow or field as through a window. The verticals and horizontals of the frame, plus the diagonals and the cross-over, or a subdivision into square sectors, afford a number of fixed points that make it possible to do an exact drawing with lines and proportions." Painting always needs a means of establishing a fixed and effective standpoint; van Gogh's frame was perhaps a banal version of this, but at least it was portable, and it was a highly functional answer to the demands of *plein air* painting.

Driven into the ground, this frame henceforth provided van Gogh with that grid of lines which we can increasingly discern in his landscapes from this time onwards. If we compare the *Landscape with Dunes* (p. 27), painted in September, 1883, with the close view done a year earlier (p. 17), the change in van Gogh's view of the subject is immediately apparent. In the later picture, a horizon divides the work

 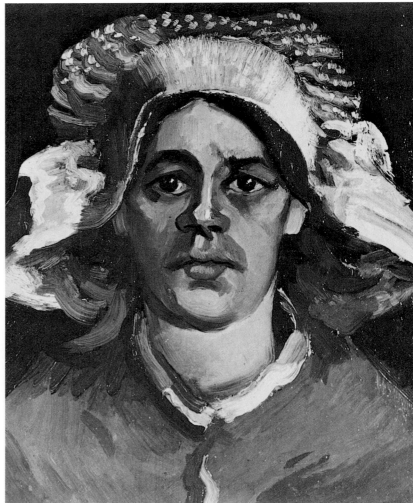

into two sections, the lower of which is further subdivided by diagonals. Perceiving lines with a new sensitivity thanks to his frame, he chose an angle on his landscape that was evidently the window view afforded by his gadget. Van Gogh's artistic resources had been increased. His dialogue with Nature could now be expressed as effectively in a broad landscape panorama as in a monumental close-up of a single motif. He was now better able to achieve nuanced articulation of feelings of exposure and loneliness, and feelings of harmony and sympathy: the period at The Hague provided van Gogh not only with the ability to handle a number of figures but also with a grip on perspective.

While his art was developing promisingly, his private life boded ill for the future. The financial problems remained undiminished, and Vincent, growing ever more confident of his artistic vocation, made no attempt to curb his expenses for the sake of Sien and the children. Faced with sheer necessity, Sien returned to her old work. Van Gogh, needless to say, was appalled that she had gone back to prostitution. A big-hearted man, he felt responsible for his loved ones. But their lives, however much he might long for security and trust, were too different. That summer Theo, the only one who had steadfastly stood by them, had visited his protégés and had been horrified by the conditions they

Peasant Woman Standing Indoors
Nuenen, March 1885
Oil on canvas on panel, 41 x 26 cm
F 128, JH 697
Belgrade, Narodni Muzej

Head of a Peasant Woman with White Cap
Nuenen, March 1885
Oil on canvas on panel, 41 x 32.5 cm
F 1668, JH 691
Private collection

Head of a Young Peasant in a Peaked Cap
Nuenen, March 1885
Oil on canvas, 39 x 30.5 cm
F 163, JH 687
Brussels, Musée Royaux des Beaux-Arts
de Belgique

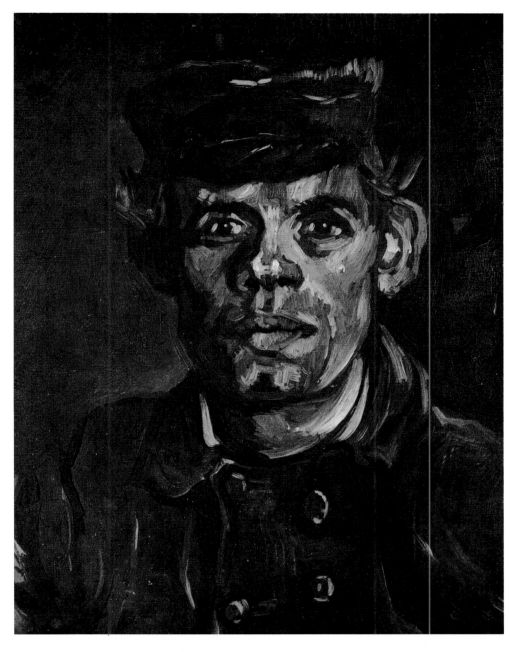

Head of a Young Peasant in a Peaked Cap
Nuenen, March 1885
Oil on panel, 44.5 x 33.5 cm
F 165, JH 688
Kansas City (Mo.), The Nelson-Atkins
Museum of Fine Art

lived in. Circumspectly he had tried to prompt his brother to take the inevitable decision: a separation would clearly be Vincent's only chance of devoting himself to his art. The painter and the head of the family were at war within him. Van Gogh was going to have to do without the woman he loved – and living with the consequences of this decision was not easy in the years ahead. From now on, all of van Gogh's intensity was focussed on a single object: his paintings. In them, he seized the world all the more firmly, the more mercilessly it evaded him. Suffering pathos in person, henceforth he was an artist pure and simple. In September he moved to Drente, a region of Holland that had preserved a plain and melancholy mood since time immemorial; like a wounded animal, he went into hiding, alone.

Art and Responsibility
Commitments for the Future

The twenty months van Gogh had spent with a woman were not without consequences. With his plans for family life in ruins and his future (he believed) gloomy, he felt he was in a corner; but the fact of it was that his oppressive sense of responsibility for every living creature under the sun underwent a change during his time with Sien. It was as if van Gogh had needed the family experience as a focus for his devotional impulses – and now he was better able to master his over-generous tendencies. Now he directed them towards his art, and concentrated in his paintings the energy he had hitherto been scattering. The way he

Head of a Peasant Woman with Dark Cap
Nuenen, March-April 1885
Oil on canvas, 43.5 x 30 cm
F 69, JH 724
Amsterdam, Rijksmuseum Vincent van Gogh, Vincent van Gogh Foundation

Head of a Peasant Woman with Dark Cap
Nuenen, April 1885
Oil on canvas, 42 x 34 cm
F 269r, JH 725
Amsterdam, Rijksmuseum Vincent van Gogh, Vincent van Gogh Foundation

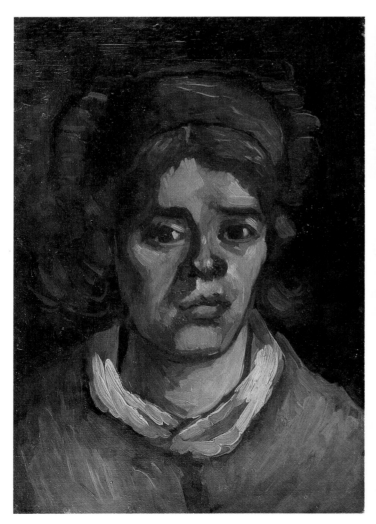

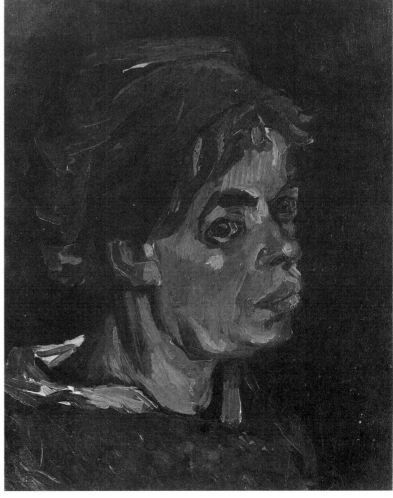

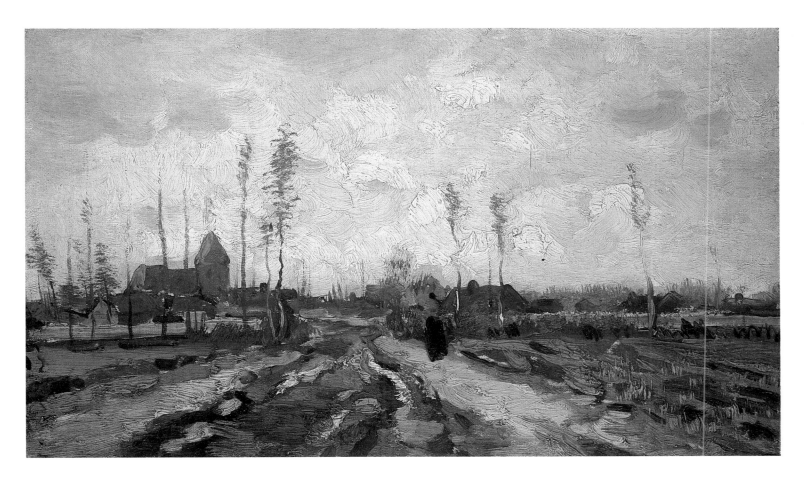

saw himself as an artist became clearer too: poverty prompted him to develop a concept of art for the underprivileged. His daily toil at his art brought home to him the toughness but also the dignity of the craftsman's life. Under constant pressure to earn money, his life came to resemble that of a pieceworker. And van Gogh now felt that his life as an artist would be lived in a spirit of solidarity with the working classes, with the craftsman's ethic and with speed of production an end in itself.

"There are some things we feel to be good and true", he wrote to his brother (Letter 259), "even if much remains inexplicable and obscure from a rational, calculating point of view. And although in the society we live in actions of this kind are considered foolish or crazy or I don't know what – there is not much to be said about it when hidden forces of attraction and love have awoken within us . . . He who has preserved his belief in a God will occasionally hear the quiet voice of conscience, and at such times it is good to obey it with the naivety of a child." This was Vincent's gloss on a statement by Victor Hugo that he had taken as his motto: "Conscience is higher than Reason." The inner qualities of Man, the loyalty of his feelings, the intensity of his affection, precede his rational capacities – and that is the yardstick of Art, too.

In this we see van Gogh's affinity to John Ruskin, the English art critic and social reformer. 'Soul' is the hallmark of Man and his works. Ruskin, writing in a spirit that anticipated van Gogh, had said that a work of beauty was created not by the art of an hour, of a lifetime, of a century, but by uncounted souls in mutual endeavour. And in looking at

Landscape with Church and Farms
Nuenen, April 1885
Oil on canvas, 22 x 37 cm
F 185a, JH 761
Los Angeles, Los Angeles County
Museum of Art

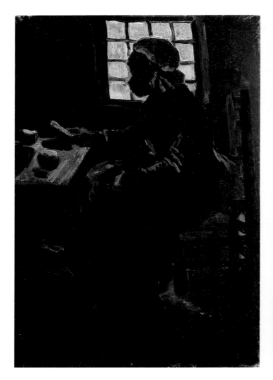
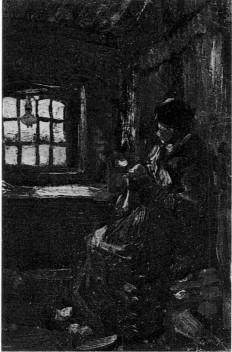

Peasant Woman Taking her Meal
Nuenen, February-March 1885
Oil on canvas, 42 x 29 cm
F 72, JH 718
Otterlo, Rijksmuseum Kröller-Müller

Peasant Woman Darning Stockings
Nuenen, March 1885
Oil on canvas on panel, 28.5 x 18.5 cm
F 157, JH 712
Whereabouts unknown

a painting (Ruskin had also insisted) we must have a discipline, understanding, and natural heart-felt emotion to equal that of the original creator. The paramount thing was to elevate the purity of the spirit, this unexpressed harmony that makes each man his fellow man's neighbour at the deepest level of feeling, above all else. Paintings serve as a vehicle rather than a focal point: the genuine human dignity of the creating artist will not leave those who behold the work unmoved.

Both Ruskin and van Gogh sang the praises of craftsmanship: "so long as men work *as* men, putting their heart into what they do, and doing their best", Ruskin had writen in *The Seven Lamps of Architecture*, "it matters not how bad workmen they may be, there will be that in the handling which is above all price". Van Gogh expressed this thought as follows (Letter 185): "Work you have slaved over, work you have tried to put your character and feelings into, can give pleasure and sell." Authenticity of expression was more important than consummate skill; virtuoso technique would tend to overshadow the simple humility of the act of creation. For van Gogh, with his difficulties in handling a brush and drawing a line, thoughts of this nature plainly suggested themselves. And van Gogh had more than enough of that vitality that demanded expression: "What my head and heart are full of must come out, in drawings and pictures" (Letter 166).

Like Ruskin, van Gogh did not see craftsmanship only in terms of reliability of production. The productive craftsman totally absorbed in his work, devoting all his physical and mental energy to it, would be aware of the hardship and the dignity of his existence in equal measure. To restore that dignity to those who were caught up in the machinery of industry and became mere anonymous ciphers as they went about their

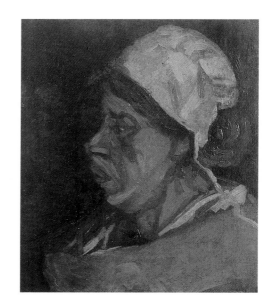

Head of a Peasant Woman with White Cap
Nuenen, March 1885
Oil on canvas on panel, 41 x 35 cm
F 131, JH 685
Private collection
(Sotheby's Auction, London, 5. 12. 1979)

labours was the lofty aim of van Gogh's own toil. "I wish very much that people who wish me well would finally realise that what I do or don't do springs from a deep feeling of love and a need for love", he wrote (in Letter 197); "for I sense that my work lies deep in the heart of the people, that I have to keep to everyday things and delve deep into life and forge ahead through many trials and tribulations." More than any artist before him, van Gogh saw his art as a way of expressing solidarity with his fellow-beings, who (he was profoundly convinced) were all equal. In a word, van Gogh's art was on the side of democracy.

Not that he was out waving banners. Sticking his tongue out at the *bourgeoisie* in self-important style, as the self-appointed king of the democrats Gustave Courbet did, was not for van Gogh. He sided with the weak, the underprivileged, and the have-nots through instinctive affection rather than for political reasons. If van Gogh was a partisan of any kind, he was contemplative, not programmatic. He had known the deprivations of poverty all too well himself – and had also been fully aware of the sublime feelings a mere glimpse into a mean hovel could prompt. Van Gogh was uninterested in the socialist utopias of his time and tended more to the position once stated by the German writer Georg

Head of a Peasant Woman with Red Cap
Nuenen, April 1885
Oil on canvas, 43 x 30 cm
F 160, JH 722
Amsterdam, Rijksmuseum Vincent van Gogh, Vincent van Gogh Foundation

Head of a Peasant Woman with Dark Cap
Nuenen, March 1885
Oil on canvas on panel, 38.5 x 26.5 cm
F 134, JH 684
Paris, Musée d'Orsay

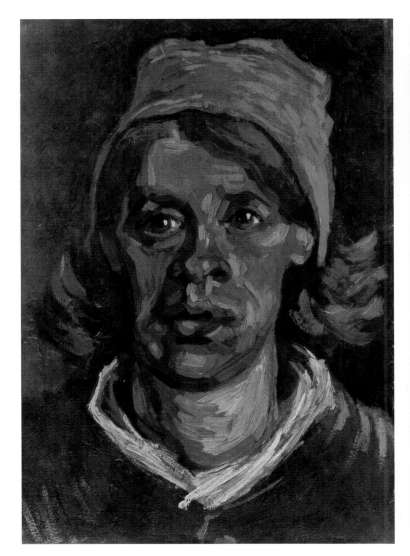

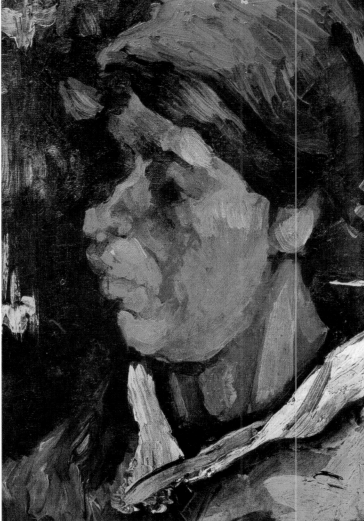

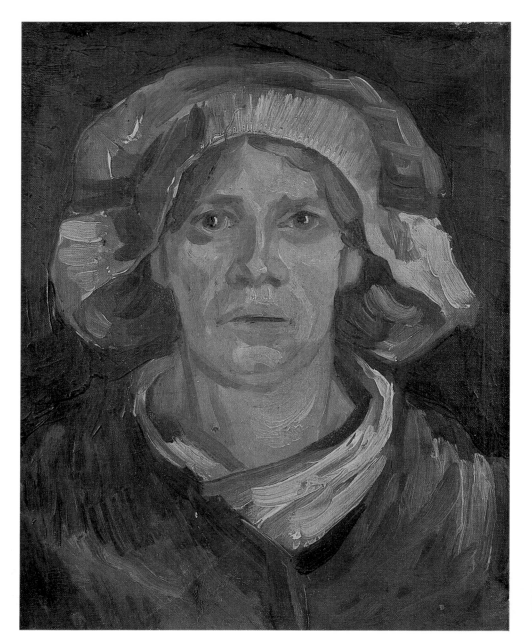

Head of a Peasant Woman with White Cap
Nuenen, March 1885
Oil on panel, 41 x 31.5 cm
F 81, JH 695
Berne, Kunstmuseum Bern

Büchner: "One should try it, immerse oneself in the life of the lowest of the low, reproduce his every gesture and twitch, his innuendoes, the whole subtle and scarcely noticeable play of his features... No man should appear too lowly or ugly for one. Only then can one understand mankind."

In The Hague van Gogh left an aesthetic credo on record, in Letter 309. There, with the prospect of seeing his plans to start a family crumble, he put his thoughts on the art he wanted to produce into clear form. As always, he had his theory ready far before he created the work to match. The thoughts expressed in Letter 309 may well be the profoundest anywhere in his correspondence and deserve quoting at some length. They deal with the artist's responsibility to work with the future in mind (though van Gogh cannot say precisely where his commitments lie). If we bear the events of the preceding months in mind, the task van Gogh was setting himself becomes a little clearer: his hopes of private

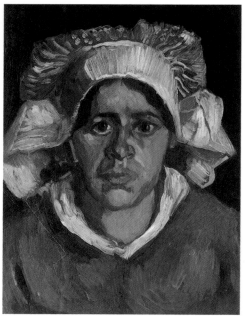

Head of a Peasant Woman with White Cap
Nuenen, March 1885
Oil on canvas on panel, 47 x 34.5 cm
F 85a, JH 694
Private collection
(Sotheby's Auction, New York, 14. 11. 1984)

Head of a Peasant Woman with White Cap
Nuenen, April 1885
Oil on canvas on cardboard, 47.5 x 35.5 cm
F 140, JH 745
Edinburgh, National Gallery of Scotland

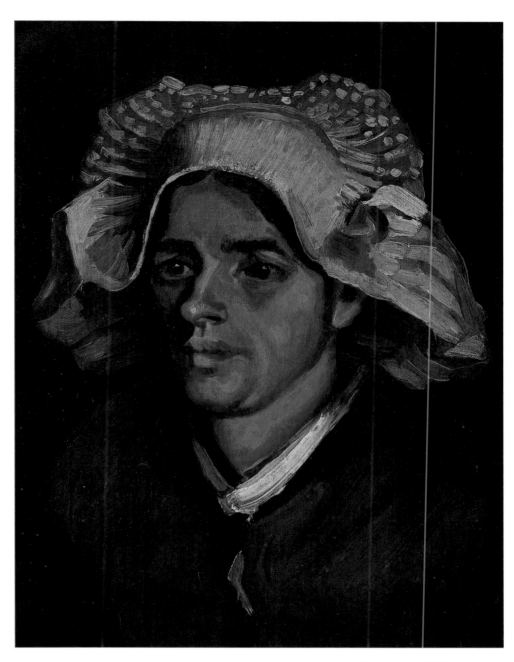

**Still Life with Copper Coffeepot and Two
White Bowls**
Nuenen, April 1885
Oil on panel, 23 x 34 cm
F 202, JH 738
Private collection

happiness and family contentment had come to nothing, and if his scope and range in life had become somewhat unclear, equally he was now intent on extending them. He was not out to love his neighbour, whether in a religious or paternalistic way; but he definitely planned the tireless production of paintings. Now, like Ruskin, van Gogh saw Art as a process of purification that could produce visions of an altered and better world. His work was now placed at the service of immutable utopianism – though without ever ceasing to pay an almost despairing attention to the here and now of everyday reality. And for all its prevarications, his work was powered by his own irrepressible needs, unbounded, scarcely articulated.

This extract from Letter 309 (written in summer 1883) reads prophetically in view of the stubborn consistency with which van Gogh made his expectations of life dependent on what he would create as an artist: "I not only began drawing relatively late, but in addition I may well not

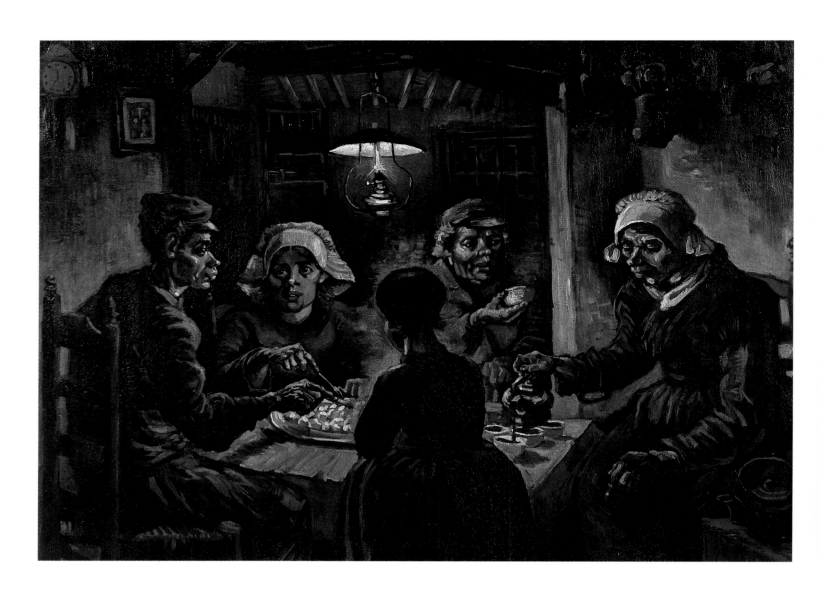

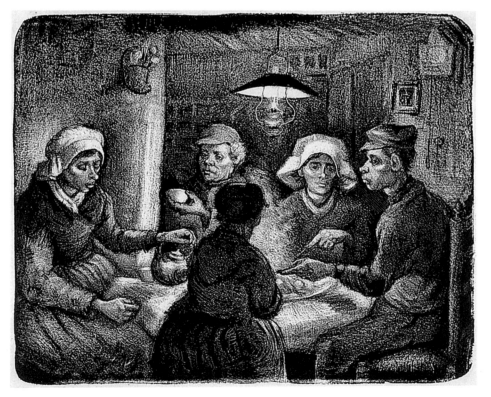

The Potato Eaters
Nuenen, April 1885
Oil on canvas, 81.5 x 114.5 cm
F 82, JH 764
Amsterdam, Rijksmuseum Vincent van
Gogh, Vincent van Gogh Foundation

The Potato Eaters
Nuenen, April 1885
Lithograph, 26.5 x 30.5 cm
F 1661, JH 737

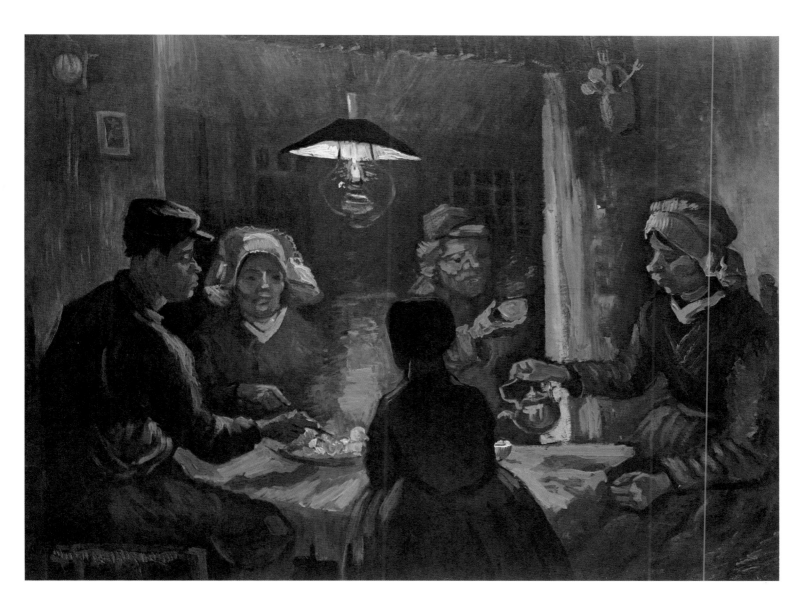

The Potato Eaters
Nuenen, April 1885
Oil on canvas on panel, 72 x 93 cm
F 78, JH 734
Otterlo, Rijksmuseum Kröller-Müller

have so very many years of life ahead of me ... As far as the time that remains for my work is concerned, I believe that without being premature I can assume that this body of mine will still keep going, despite everything, for a certain number of years yet – say, between six and ten. I feel all the more able to assume this since at present there is not yet a proper 'despite everything' in my life ... I do not intend to spare myself or pay much heed to moods or problems – it is a matter of some indifference to me whether I have a longer or a shorter life, and in any case physical mollycoddling such as a doctor can accomplish up to a point is not to my taste.

"So I am continuing in my life of ignorance, though there is one thing I do know: within a few years I must accomplish work of a certain order; I do not need to be in too much of a hurry, because no good comes of that – but I must go on working calmly and quietly, with as great a regularity and composure as possible, and as much to the point as possible; the world is my concern only insofar as I have a certain debt and obligation, so to speak – because I have been wandering about this world these thirty years – to leave a certain something in memory of me behind,

Head of a Peasant Woman in a Green Shawl
Nuenen, May 1885
Oil on canvas, 45 x 35 cm
F 155, JH 787
Lyon, Musée des Beaux-Arts

Head of a Peasant Woman in a Green Shawl
Nuenen, May-June 1885
Oil on canvas, 45.5 x 33 cm
F 161, JH 788
Amsterdam, Rijksmuseum Vincent van
Gogh, Vincent van Gogh Foundation

drawings or paintings, out of gratitude – not made in order to gratify some fashion or other but to express an honest human feeling. That work, then, is my objective... And that is how I see myself – as a man who must produce something with a heart and love in it, within a few years, and who must produce it by willpower... Something has to be created in these years; this thought is my guiding light whenever I draw up plans for my work. So now that yearning to work to the full extent of my powers will be rather more comprehensible to you, as will a certain resolve to work with simple means. And perhaps you can also understand that I do not view my studies as existing in their own right but rather always have my mind on my work as a whole."

No Soul, No Self
Drente 1883

Head of a Peasant Woman with White Cap
Nuenen, May 1885
Oil on canvas, 43.5 x 35.5 cm
F 388r, JH 782
Amsterdam, Rijksmuseum Vincent van
Gogh, Vincent van Gogh Foundation

Head of a Peasant with Hat
Nuenen, May-June 1885
Oil on canvas, 41.5 x 31.5 cm
F 179r, JH 786
Amsterdam, Rijksmuseum Vincent van
Gogh, Vincent van Gogh Foundation

In autumn 1883 in Drente, van Gogh painted practically nothing but peasants' cottages (cf. pp. 27 and 33). Like these squat, windswept cottages with slant roofs, scattered about the vast flatlands, van Gogh felt small; the cottages offered him a metaphor of his own need for an anonymity and concealment in which he could evade responsibilities. He would hardly have approached his subjects, tiny mounds in the mire, embedded into the marshes, he preferred to contemplate them in his imagination, these brown, earthy clods lying camouflaged on the plain. The artist envied them the mimetic skill with which they blended in. His flight into solitude left its mark, though, and van Gogh became more melancholy than ever.

"Theo, whenever I am out on the heath and I come across a poor woman with a child in her arms or at her breast, the tears come to my eyes. It is her that I see; their weakness and sluttishness seem only to heighten the resemblance", wrote Vincent in the very first letter he wrote from his new solitude (Letter 324). He had wanted to escape from his responsibilities; but flight had only left his conscience uneasier than ever. He saw himself as a traitor towards both Sien and the children and his own ideals. In Drente, van Gogh was trying out escapism, and testing his ability to enter Nature in quest of oblivion. The watchwords he insisted on when writing to Theo were "simplicity and truth", and – working desperately hard – he tried to project these values onto the countryside, in the hope that ideas he had evolved in The Hague, in the city bustle, would be upheld in the rural remoteness of Drente. "Recently I had a talk to the man I am lodging with, who is a farmer himself", he wrote to his parents (Letter 334). "We started talking quite by chance, because he happened to ask what London was like, he had

Landscape at Dusk
Nuenen, April 1885
Oil on canvas on cardboard, 35 x 43 cm
F 191, JH 762
Lugano-Castagnola, Fondazione
Thyssen-Bornemisza

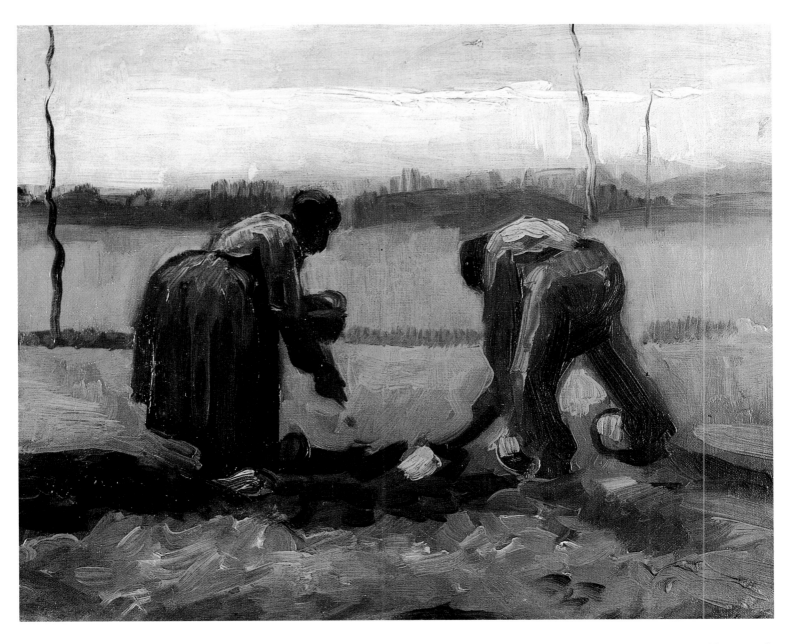

**Peasant and Peasant Woman Planting
Potatoes**
Nuenen, April 1885
Oil on canvas, 33 x 41 cm
F 129a, JH 727
Zurich, Kunsthaus Zürich

heard so much about it; I told him that a simple farmer who did his work
and thought while he was about his work was the man of true education
in my eyes, that was how it had always been and would always remain."
How much real disappointment and sought-after justification lay be-
hind van Gogh's belief in the superiority of country people! Affection for
peasants was a way of taking revenge on Sien. Still, those few pictures of
people lifting potatoes or digging peat focus on his own gloomy frame of
mind rather than on the country folk. Unlike *Potato Digging, Five
Figures* (p. 27), which he did back in The Hague, *Two Peasant Women in
the Peat Field* (p. 31) scarcely attempts any solidarity with the farming
people's arduous labours. The massive blocks of colour that serve as the
women's silhouettes have a self-referential function in the more or less
decorative way that the two figures appear in sequential rapport. They
are aesthetic means of linking the ground to the streaky, cloudy sky, and
as they bend beneath the burden of Life they seem to wish to become
invisible, much as the painter did at the time. The unity of description

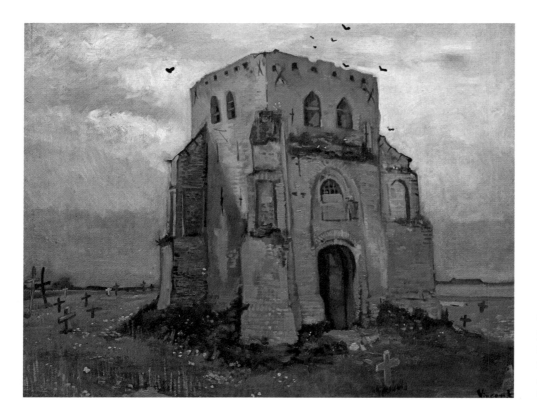

The Old Cemetery Tower at Nuenen
Nuenen, May 1885
Oil on canvas, 63 x 79 cm
F 84, JH 772
Amsterdam, Rijksmuseum Vincent van
Gogh, Vincent van Gogh Foundation

and commentary, of level-headed narrative of an event and subjective response on the part of the artist, has been dispersed by the urge to forget. Even in his early work, van Gogh was inimitably skilled at representing the fate of Man in familiar, everyday dress. The things and people in his paintings inevitably had a mood of melancholy and pity; in the act of painting, the artist's emotional world acquired independence – and objectivity, in that it could clearly be seen in the object of contemplation. The paintings van Gogh did at Drente were tautological, though. Melancholy gained the upper hand and submerged the works in the unfocussed atmospherics of a wholly personal mood. The

Landscape at Sunset
Nuenen, April 1885
Oil on canvas, 27.5 x 41.5 cm
F 79, JH 763
Switzerland, Private collection

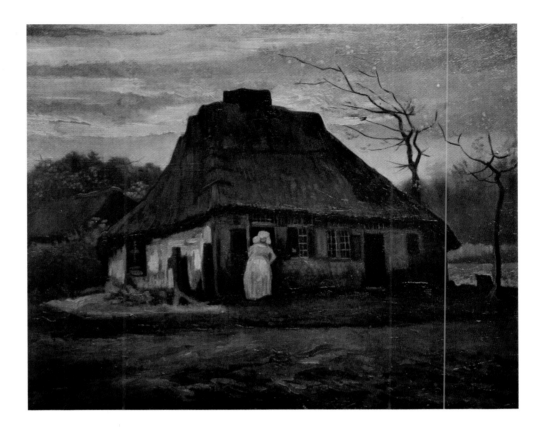

Cottage at Nightfall
Nuenen, May 1885
Oil on canvas, 65.5 x 79 cm
F 83, JH 777
Amsterdam, Rijksmuseum Vincent van
Gogh, Vincent van Gogh Foundation

Head of a Peasant Woman
Nuenen, May 1885
Oil on canvas, 40.5 x 34 cm
F 86, JH 785
Otterlo, Rijksmuseum Kröller-Müller

subjects van Gogh tackled had no autonomy; quite the contrary – this sadness had an unworldly quality. Vincent was doing his best to be a Romantic, but in reality he was not a mood painter; and whenever his pictures struck intense emotional notes it was only because the emotion was vitally present in the subjects. In Drente, however, the intensity of purely subjective sadness was his sole subject. Van Gogh was all too aware of the problem. "The weather has been dismal and rainy", he wrote in Letter 328, seeking refuge in irony at his own expense, "and when I go up to the loft I've set up in everything is remarkably gloomy; the light, entering by a single glass tile, falls on an empty paint-box, a bundle of brushes the hair of which is practically useless now, in a word: it is all so wondrously bleak that it fortunately has its funny side too, and if one doesn't want to cry about it one can be amused."

Van Gogh did not need to be isolated from the world in order to feel lonely. And Romantic, emotional bombast did nothing to further his art. The three months he spent in Drente encouraged him to recognise these two facts. The time of year when he tended to take decisions, the period before Christmas, again saw van Gogh driven to act; and in December 1883 the prodigal son returned home – this time to Nuenen in Brabant, where his father had a new living. Vincent's apprenticeship lay behind him now. He had shed his religious mania and selfless love of his neighbour, and had turned his back on the dream of family life and infatuation with isolation alike; in the process he had acquired a robust sense of autonomy that was to be the seedbed of an art independent of the facts of everyday life. Shortly, in Nuenen, he was to plan the first of his masterpieces. The first of the classic 'van Goghs'.

Still Life with Bible
Nuenen, April 1885
Oil on canvas, 65 x 78 cm
F 117, JH 946
Amsterdam, Rijksmuseum Vincent van
Gogh, Vincent van Gogh Foundation

THE YEARS IN NUENEN
1883-1885

An Artist Pure and Simple
The First Year

"If a man is not in a mental asylum, and has not shot or hanged himself either, we must take comfort in the fact, and conclude that he is one of two things: either an evil dog in human form, a lamentable creature that needs a muzzle and is distinctly amazing; or a real human being and therefore not without a morality which should either be reformed or approved of." The rather crude notion of a human soul and a dog's dwelling in the individual's breast derives from the influential English historian and theorist Thomas Carlyle, whose works van Gogh regularly read throughout his life. During the two years he spent at his parents' home, in particular, he regularly dwelt upon Carlyle's views on coming to terms with life and the past. He had hardly arrived but he felt like a dog that well-bred people would prefer to muzzle: "I sense the

Peasant Woman Sitting on a Chair
Nuenen, June 1885
Oil on panel, 34 x 26 cm
F 126, JH 800
Whereabouts unknown

Peasant Woman by the Fireplace
Nuenen, June 1885
Oil on canvas, 44 x 38 cm
F 176, JH 799
New York, The Metropolitan Museum of Art

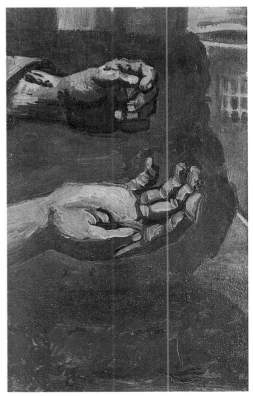

Head of a Peasant Woman with White Cap
Nuenen, May 1885
Oil on canvas, 41 x 34.5 cm
F 141, JH 783
Private collection
(Sotheby's Auction, London, 5. 12. 1979)

Two Hands
Nuenen, April 1885
Oil on canvas on panel, 29.5 x 19 cm
F 66, JH 743
Netherlands, Private collection

thoughts Pa and Ma instinctively have about me", he wrote to Theo
(Letter 346). "They are as reluctant to let me into the house as they
would be to let in a big shaggy dog. Into the parlour he comes, with his
wet paws – and how shaggy and wild he is! He gets in everybody's way.
And how loudly he barks. In a word – he's a filthy creature." Dignified
and mannerly, they did not penetrate to the heart within the repellent
exterior: "But the creature has a human history and (though it's a dog) a
human soul, and a sensitive one at that." These reservations notwith-
standing, Vincent stayed at the Nuenen vicarage longer than at any
other single place in his entire life as an artist. He was constantly at
loggerheads with his father, and even vented his unrelenting mockery of
society on his long-suffering brother Theo. But van Gogh could now
devote himself entirely to painting, using oil on canvas, which he had
previously been mostly unable to afford. He tried to perfect his com-
mand of the three types of picture he had hitherto been concentrating
on: still lifes, landscapes and genre paintings. Working on various series
at the same time, he used up all the suitable subjects he could find
around the village where his parents were living. During the first year at

Cottage with Trees
Nuenen, June 1885
Oil on canvas on panel, 32 x 46 cm
F 93, JH 805
Private collection
(Christie's Auction, London, 29. 6. 1976)

Cottage with Trees
Nuenen, June 1885
Oil on canvas, 44 x 59.5 cm
F 92, JH 810
Whereabouts unknown
(Sotheby's Auction, London, 28. 6. 1961)

Cottage with Decrepit Barn and Stooping Woman
Nuenen, July 1885
Oil on canvas, 62 x 113 cm
F 1669, JH 825
Private collection
(Sotheby's Auction, London, 3. 12. 1985)

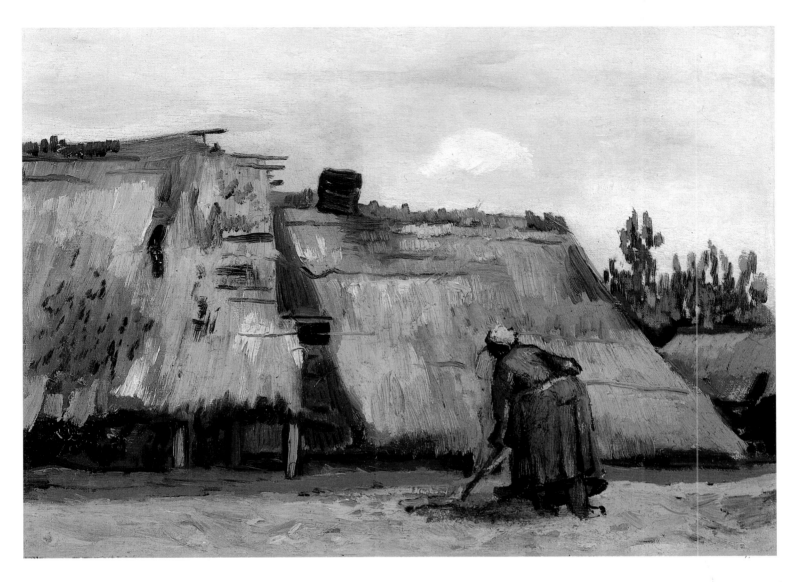

Cottage with Woman Digging
Nuenen, June 1885
Oil on canvas on cardboard, 31.3 x 42 cm
F 142, JH 807
Chicago, The Art Institute of Chicago,
Bequest of Dr. John J. Ireland

Cottage with Trees
Nuenen, June 1885
Oil on canvas, 22.5 x 34 cm
F 92a, JH 806
Whereabouts unknown

Nuenen he produced a number of everyday scenes from the life of weavers (which will be discussed in a separate chapter), paintings of the surrounding countryside, and a number of still lifes that harked back to his earliest ventures into art. In addition there was one commissioned work, the only one he ever did.

One of the first scenes van Gogh painted in Nuenen, *Chapel at Nuenen with Churchgoers* (p. 53), introduces us to the milieu he was now living in. For Vincent's father, this was the place of his spiritual ministry; in van Gogh's treatment it looks like a place of work, where goods are manufactured and a certain output achieved, as at the looms in the poor weavers' homes. Van Gogh painted this detached view of the village church for his parents, and he chose Sunday churchgoing as his subject, adopting an angle reminiscent of the figural compositions he had painted in The Hague. The simple chapel is seen close; yet the artist himself is far enough from the scene to avoid any kind of identification. His approach can be seen as a reaction to his parents' wish that he accompany them to church. In painting, he was serving "what some people call God, others the Supreme Being, and still others Nature" (Letter 133) in his own way.

Cottage
Nuenen, June 1885
Oil on canvas, 35.5 x 67 cm
F 91, JH 809
Harrison (N. Y.), Collection John P.
Natanson

Cottage with Trees and Peasant Woman
Nuenen, June 1885
Oil on canvas, 47.5 x 46 cm
F 187, JH 808
Los Angeles, Los Angeles County
Museum of Art

Van Gogh moved closer to his subject when he painted the water mills along the Brabant canal-banks. *Water Mill at Kollen near Nuenen* (p. 40), painted in May 1884, was the first in a series of mill scenes which he continued that autumn with four more paintings (pp. 54-55). Throughout the series he was essaying picturesque showpieces; his rendering of a seasonal atmosphere, with the light reflected in the flowing water, was more ambitious than anything he had previously attempted. He was also interested in the way the solid contours of the barn-like buildings related to the lines of the millwheels themselves.

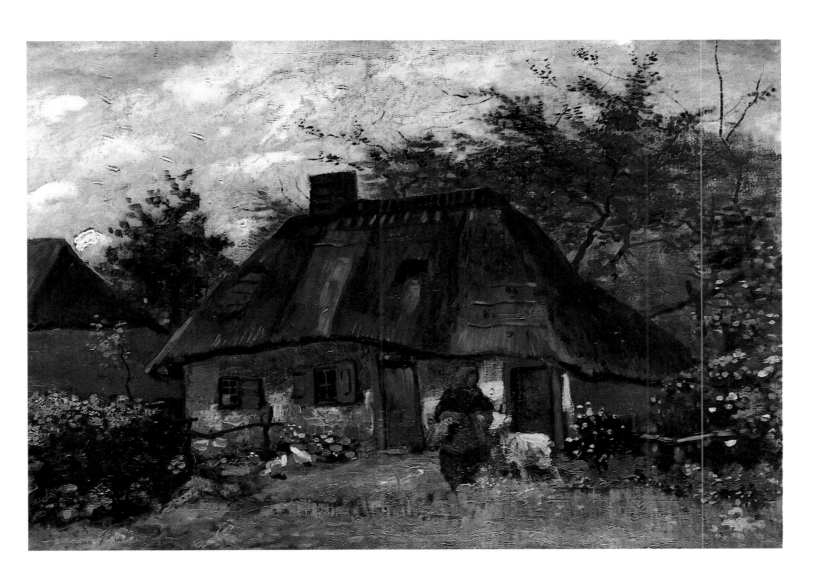

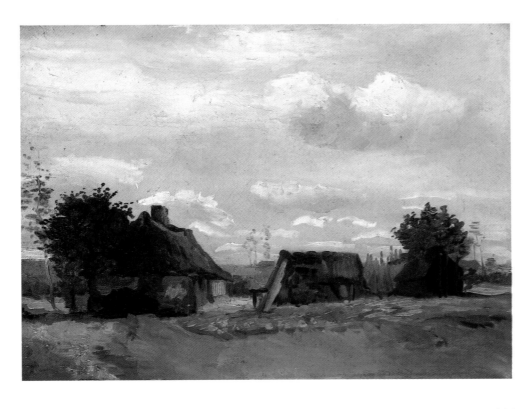

Cottage and Woman with Goat
Nuenen, June-July 1885
Oil on canvas, 60 x 85 cm
F 90, JH 823
Frankfurt am Main, Städelsches
Kunstinstitut und Städtische Galerie

Cottage
Nuenen, July 1885
Oil on canvas, 33 x 43 cm
Not included in F or JH
Private collection
(Sotheby's Auction, London, 30. 3. 1988)

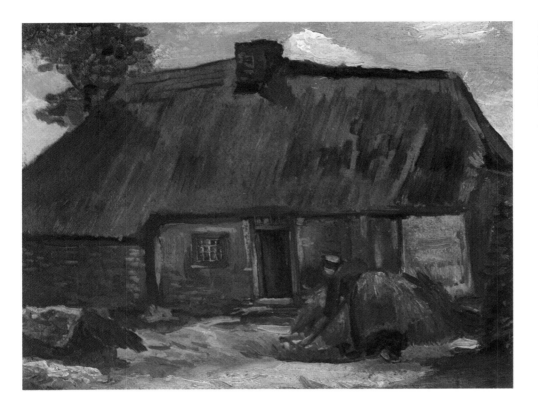

Cottage with Peasant Woman Digging
Nuenen, June 1885
Oil on canvas on panel, 30.5 x 40 cm
F 89, JH 803
Private collection
(Christie's Auction, London, 29. 6. 1976)

The impact of these paintings draws equally upon draughtsman skills (symmetry in the composition, use of silhouettes, the contrast of light open spaces and the dark huddled clusters of mill buildings) and painterly creation of mood and atmospherics. At times, van Gogh's ambitions do not quite come off, of course. In *Water Mill at Gennep* (p. 55), for instance, a doughy mass of hatching obliterates any contrasts that might have brought the scene effectively to life.

Doubtless, van Gogh chose the mills for iconographic reasons, too. The Christian metaphor of the mills of God that grind slowly was probably in his mind; and van Gogh had always been interested in sowing and reaping – a process that ends in the miller's labours. Still, the

Peasant Woman Laundering
Nuenen, August 1885
Oil on canvas, 29.5 x 36 cm
F 148, JH 908. Private collection

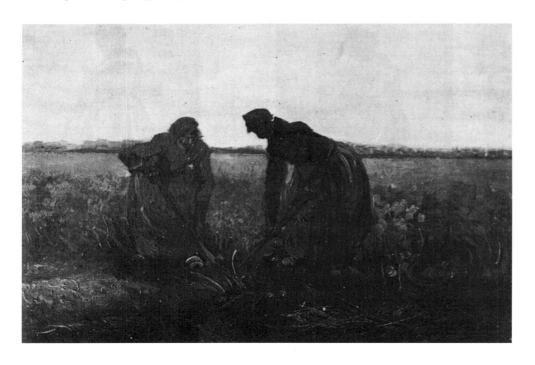

Two Peasant Women Digging
Nuenen, July 1885
Oil on canvas on panel, 39 x 55 cm
F 96, JH 878
Whereabouts unknown

views have a posed, detached, even uninterested flavour; the mills are clearly being foregrounded as simple objects. Art historian Erwin Panofsky, writing on the loving use of close-up detail in old Dutch art, coined the term 'disguised symbolism' to describe that hidden dimension beyond the mere surface of things, and van Gogh's water mills may

Peasant Woman by the Fireplace
Nuenen, June 1885
Oil on canvas on panel, 29.5 x 40 cm
F 158, JH 792
Paris, Musée d'Orsay

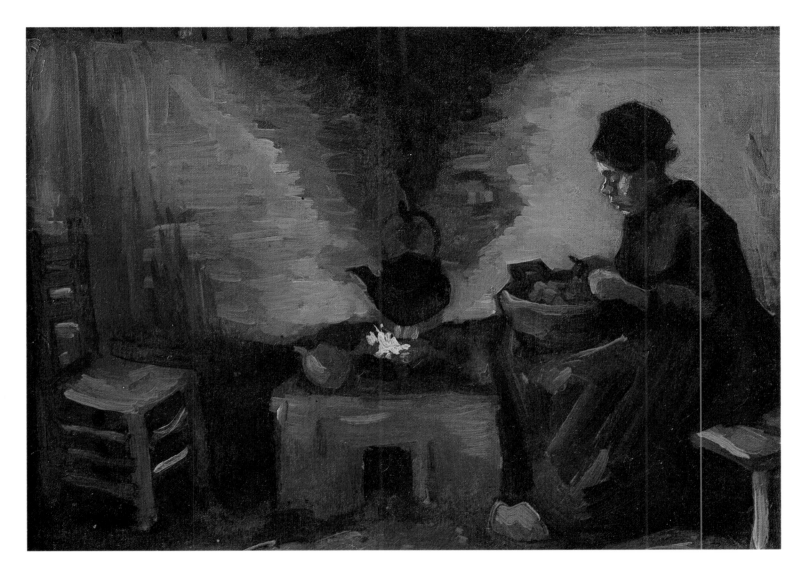

be seen as a further step in that use of extra dimensions of meaning. More than anything else in his whole oeuvre they highlight a detached lack of interest, free of intention, simple in form, that defies the quest for deeper significance.

The landscapes featuring the old tower on the outskirts of the village, on the other hand, seem far more loaded with meaning. The striking tower was all that was left of a Gothic church; the graveyard clustered about it. The metaphoric investigation of death is obvious. In the background of *Parsonage Garden* (p. 41) the tower rises impressively on the horizon, commanding that we meditate upon last things when we see spring burgeoning in the beds. In this painting, the rather dull arrangement of parallel levels (the fence-posts, a hedge, and the trees) is lent expressive dignity by the presence at the vanishing point of the squat

Cottage with Peasant Coming Home
Nuenen, July 1885
Oil on canvas, 63.5 x 76 cm
F 170, JH 824. Private collection
(Sotheby's Auction, London, 2. 4. 1974)

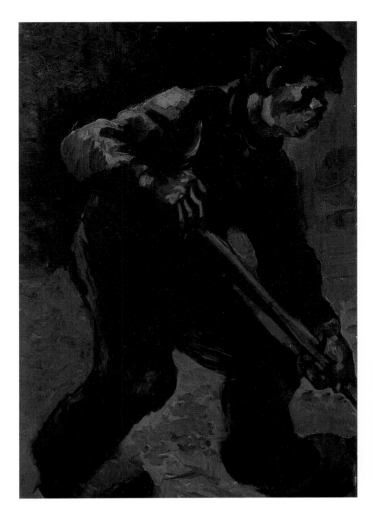

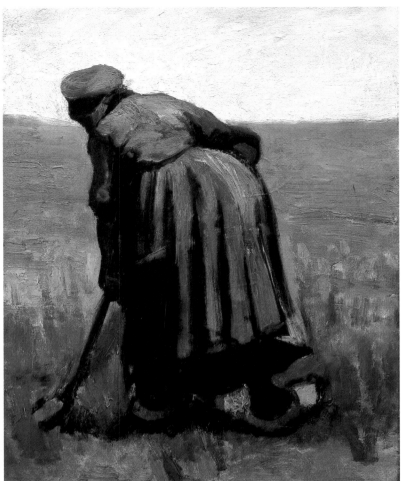

mass of the old tower. At times van Gogh still needed to use striking motifs in order to generate interest in his work.

The Old Tower in the Fields (p. 45) makes a more coherent, unified impression because van Gogh has skilfully deployed his melancholy props to create a Romantic mood with maximum efficiency. The sun, low in the sky and swathed in drapes of mist, seems to add to the hazy mystery of the woman clad in black. Her figure echoes the shape of the tower (in a way that was prefigured in the parsonage view). The sense of menace derives not so much from the awesome immensity of the elements, before which the individual is helpless, as from the dark, mighty silhouette of the tower, built by Man to express the promise of spiritual support. In this picture van Gogh is again distancing himself from typical Romantic landscapes. His tower has none of that eloquent detail that a Caspar David Friedrich so liked in a ruin. For van Gogh, the humanized landscape – Nature kept within seemingly peaceful bounds by Civilization – is enough to express feelings of anxiety and isolation. Once again a sense of paradox that eschews any kind of unambiguous statement is apparent.

Nuenen was extremely provincial, in every respect; and this son of the parson's who had appeared from nowhere struck the local people as a

Peasant Digging
Nuenen, July-August 1885
Oil on canvas, 45.5 x 31.5 cm
F 166, JH 850
Otterlo, Rijksmuseum Kröller-Müller

Peasant Woman Digging
Nuenen, July 1885
Oil on canvas on panel, 41.5 x 32 cm
F 95, JH 827
Private collection
(Sotheby's Auction, London, 2. 12. 1981)

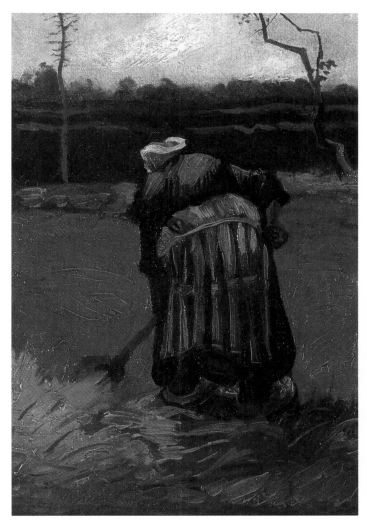

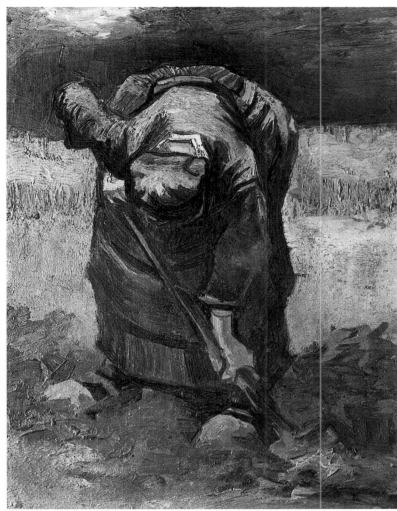

Peasant Woman Digging
Nuenen, July-August 1885
Oil on canvas on panel, 37.5 x 25.7 cm
F 94, JH 893
s'-Hertogenbosch, Noordbrabants Museum

Peasant Woman Digging
Nuenen, August 1885
Oil on canvas on panel, 42 x 32 cm
F 95a, JH 899
Birmingham, Barber Institute of Fine Arts,
University of Birmingham

little odd. Yet no one troubled him. Indeed, the stares van Gogh attracted were due not only to his unusual appearance but also to the awe in which artists were held. At this period, van Gogh even had pupils, of sorts – amateur painters who were gratified if he took a look at their work in progress. In nearby Eindhoven, the only town that had any kind of claims to urbanity, he got to know a tanner by the name of Anton Kerssemakers; and soon van Gogh was teaching the tanner and his acquaintances, in particular Charles Hermans, what he himself knew about art. Hermans was a man of means. Van Gogh started to call on him with some frequency, to use the utensils the goldsmith had in his home.

"Hermans possesses so many beautiful things", Vincent wrote to Theo (Letter 387), "old pitchers and other antiques, and I am wondering if you might be pleased with a still life of some of these articles, for instance Gothic things, to hang in your room." In autumn 1883 van Gogh did indeed paint a number of still lifes, using the earthenware vessels and bottles Hermans had (pp. 56-63). In Etten his compositions had been loose, but now the jugs, bottles and bowls jostled close together, giving the pictures a tectonic feel: every object had its place, even if its physical, material qualities almost vanished in the crush.

Sheaves of Wheat in a Field
Nuenen, August 1885
Oil on canvas, 40 x 30 cm
F 193, JH 914
Otterlo, Rijksmuseum Kröller-Müller

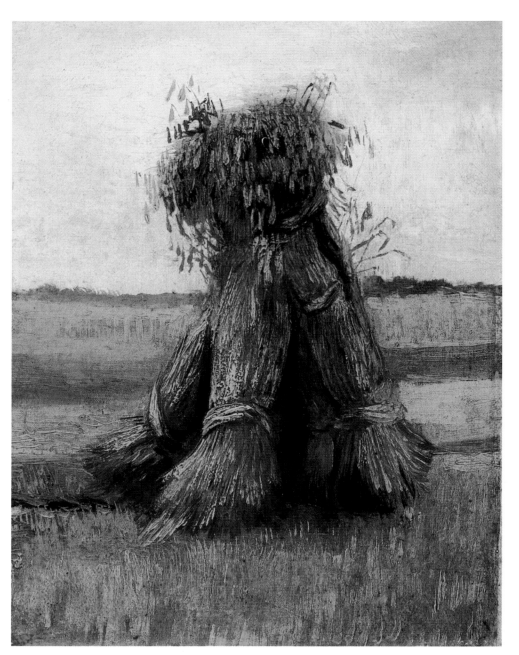

Peasant Woman Raking
Nuenen, August 1885
Oil on canvas, 38.5 x 26.5 cm
F 139, JH 905
New York, Private collection

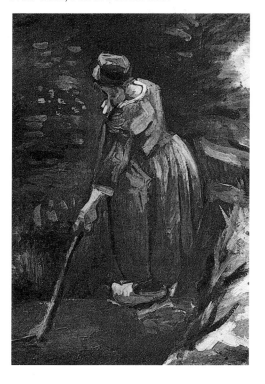

Again we are reminded of the watercolours with several figures crowded into anonymous huddles which van Gogh had done in The Hague.

What is plain is that in the preceding years van Gogh had been acquiring an eye for the arresting impact the organic unity of a composition could make. Admittedly he was still somewhat clumsy in arranging the objects at times: merely toppling a bottle on its side was no way to redeem the monotony of a row of stoneware bottles (p. 57), nor could detailed close-up rendering of ornamental faience save unimaginative positioning of vessels beside or even *in* each other (p. 62). Later, van Gogh was to re-use some of these canvases to paint self-portraits on their backs, and he well knew the loss was not great. After the progress he was to make in Paris he found that these still lifes lacked that sufficient measure of autonomy that would justify preserving them – still lifes such as *Still Life with Pots, Jar and Bottle* (p. 56; on the reverse,

Two Peasant Women Digging Potatoes
Nuenen, August 1885
Oil on canvas on panel, 31.5 x 42.5 cm
F 97, JH 876
Otterlo, Rijksmuseum Kröller-Müller

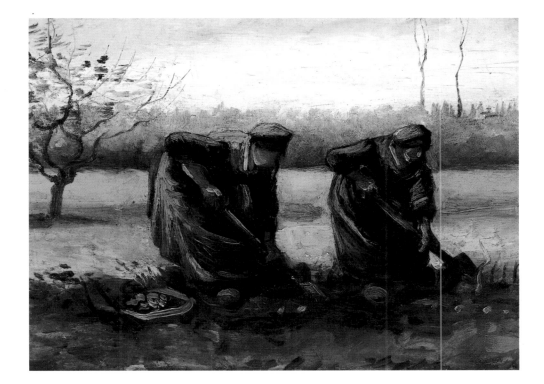

Peasant Woman Digging Up Potatoes
Nuenen, August 1885
Oil on paper on panel, 31.5 x 38 cm
F 98, JH 901
Antwerp, Koninklijk Museum voor Schone
Kunsten

Peasant Woman Digging Up Potatoes
Nuenen, August 1885
Oil on canvas on panel, 41 x 32 cm
F 147, JH 891
Private collection

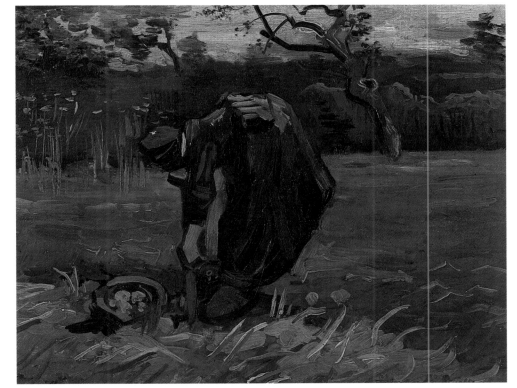

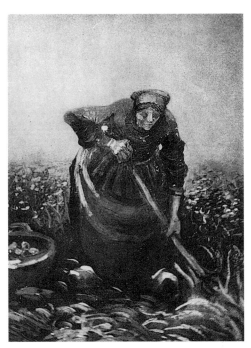

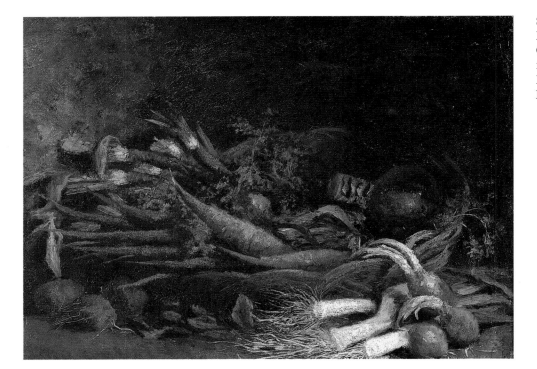

Still Life with a Basket of Vegetables
Nuenen, September 1885
Oil on canvas, 35.5 x 45 cm
F 212a, JH 929
Landsberg/Lech, Collection Anneliese
Brand

F178V, JH 1198) or *Still Life with Pottery, Bottles and a Box* (p. 59; on the reverse, F61V, JH 1302). That said, though, there are occasional gems as well, where the subjects are not submerged in a monochrome slush of earthy colours, the lighting effects are not limited to a few bright highlights, and where the objects are neither squashed up tight nor come adrift from the backgrounds and the surfaces they are on.

Arguably the finest example of his successful still-life work at this time is *Still Life with Three Bottles and Earthenware Vessel* (p. 60), traditional in spirit though it naturally is. In it, van Gogh succeeds in establishing spatial values with only a few objects. The things in the still life do not conflict with the format; rather, there is a natural air to the way they are grouped about the round bowl in the middle. The different kinds of material and different sizes of object have their own kinds of lighting; one bowl gives a mellow gleam, another is almost

Still Life with Two Birds' Nests
Nuenen, September-October 1885
Oil on canvas, 31.5 x 42.5 cm
F 109r, JH 942
Amsterdam, Rijksmuseum Vincent van Gogh, Vincent van Gogh Foundation

Still Life with a Basket of Apples
Nuenen, September 1885
Oil on canvas, 30 x 47 cm
F 115, JH 935
Whereabouts unknown

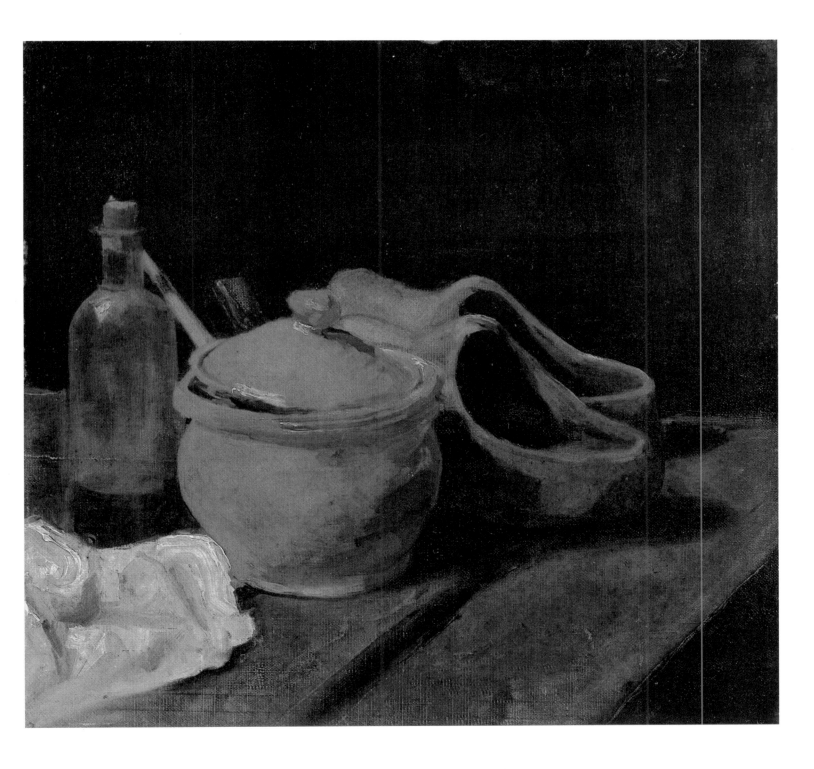

dazzling. Some critics, impressed by the conviction in this still life, have dated it to the middle of the following year (1885); but this chronological revisionism implies viewing van Gogh's progress as one of consistent technical maturing, and seeing it as a long-term development ignores the speed van Gogh worked at and also underestimates his tendency to think of paintings in series – a still life featuring earthenware would be completely on its own in his output for 1885. The simple truth is that, after a brief experimental period, the artist was now altogether capable of creating a 'classical' picture – though this does not mean the quality of every painting was as high. Every artist's oeuvre has its duds along with the masterpieces. Van Gogh was no exception.

Still Life with Earthenware, Bottle and Clogs
Nuenen, September 1885
Oil on canvas on panel, 39 x 41.5 cm
F 63, JH 920
Otterlo, Rijksmuseum Kröller-Müller

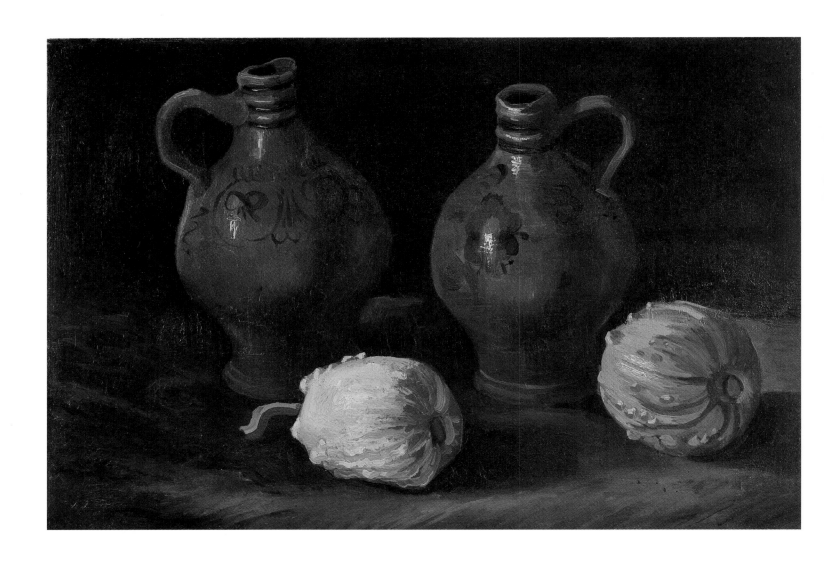

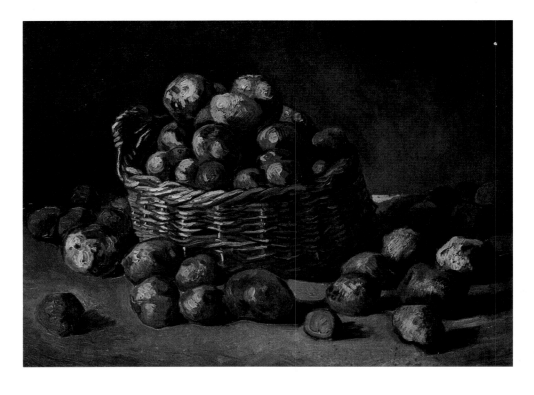

Still Life with Two Jars and Two Pumpkins
Nuenen, September 1885
Oil on canvas on panel, 58 x 85 cm
F 59, JH 921
Switzerland, Private collection

Still Life with a Basket of Potatoes
Nuenen, September 1885
Oil on canvas, 44.5 x 60 cm
F 100, JH 931
Amsterdam, Rijksmuseum Vincent van
Gogh, Vincent van Gogh Foundation

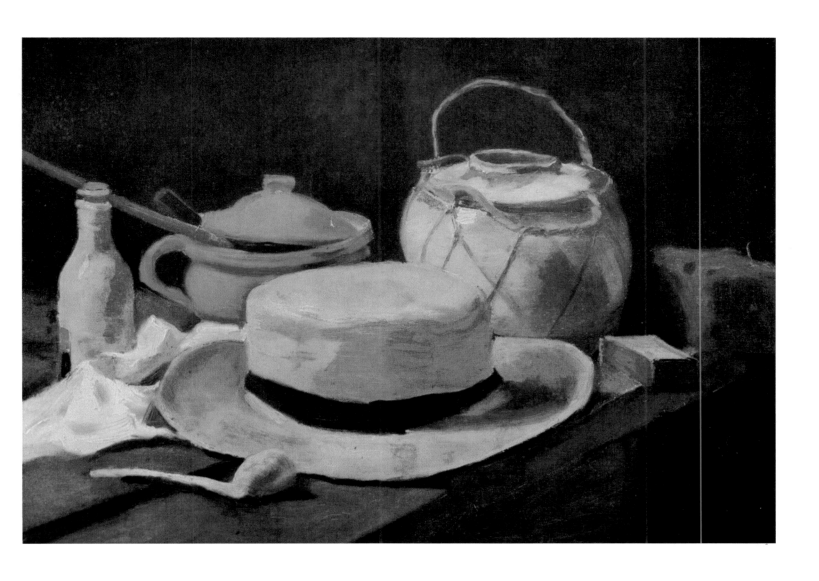

Still Life with Yellow Straw Hat
Nuenen, September 1885
Oil on canvas, 36.5 x 53.5 cm
F 62, JH 922
Otterlo, Rijksmuseum Kröller-Müller

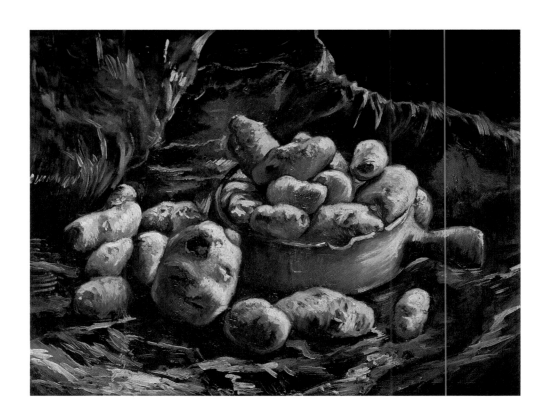

Still Life with an Earthen Bowl and Potatoes
Nuenen, September 1885
Oil on canvas, 44 x 57 cm
F 118, JH 932
Private collection
(Mak van Waay Auction, Amsterdam,
15. 4. 1975)

Still Life with a Basket of Potatoes, Surrounded by Autumn Leaves and Vegetables
Nuenen, September 1885
Oil on canvas, 75 x 93 cm
F 102, JH 937
Liège, Private collection

It was also Hermans the jeweller who gave van Gogh the only commission of his artistic career – or rather, to be exact, allowed himself to be persuaded to place the job in van Gogh's hands. A typical *nouveau riche*, Hermans was out to copy aristocratic ways, and wanted his dining room decorated by an artist. "He wanted compositions depicting various saints", wrote van Gogh in Letter 374. "I suggested that half a dozen scenes of farm life, symbolizing the four seasons, might give the good people at table more of an appetite than the aforesaid mystical gentlemen. Now that he has visited the studio the man is very taken with the idea." In the end they compromised: Vincent was to supply sketches, like a painter at court, and Hermans the dilettante would then transfer

Still Life with Two Baskets of Potatoes
Nuenen, September 1885
Oil on canvas, 65.5 x 78.5 cm
F 107, JH 933
Amsterdam, Rijksmuseum Vincent van Gogh, Vincent van Gogh Foundation

Still Life with a Basket of Potatoes
Nuenen, September 1885
Oil on canvas, 50.5 x 66 cm
F 116, JH 934
Amsterdam, Rijksmuseum Vincent van Gogh, Vincent van Gogh Foundation

Still Life with Copper Kettle, Jar and Potatoes
Nuenen, September 1885
Oil on canvas, 65.5 x 80.5 cm
F 51, JH 925
Amsterdam, Rijksmuseum Vincent van Gogh, Vincent van Gogh Foundation

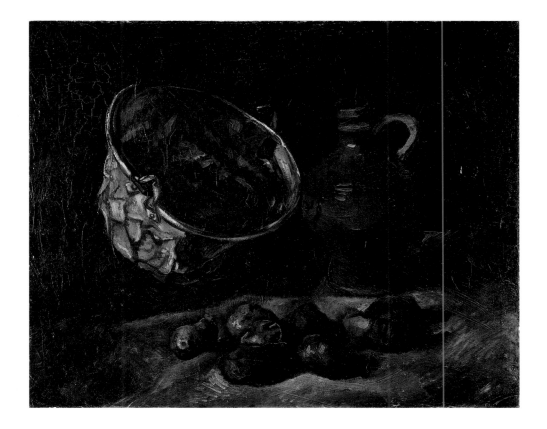

the scenes to the panelling on the walls himself. As van Gogh told Rappart (Letter R48), the following scenes were to be included: "potato planting, ploughing with oxen, the harvest, the sower, the shepherd in a storm, people gathering firewood in the snow." In other words: contrary to tradition, six scenes (the number had been fixed by Hermans) were to represent the four seasons. Van Gogh, who saw himself as an expert on farm life, ambitiously aimed at an allegorical cycle: the paintings would not only show the kind of work that was done in the country but would also communicate the ways people thought – in terms of the weather and of the natural rhythm of the solar year, which dictated that certain work be done at certain times.

Still Life with a Basket of Apples and Two Pumpkins
Nuenen, September-October 1885
Oil on canvas, 59 x 84.5 cm
F 106, JH 936
Otterlo, Rijksmuseum Kröller-Müller

Still Life with an Earthen Bowl and Pears
Nuenen, September 1885
Oil on canvas, 33 x 43.5 cm
F 105, JH 926
Utrecht, Centraal Museum
(on loan from the van Baaren Museum Foundation, Utrecht)

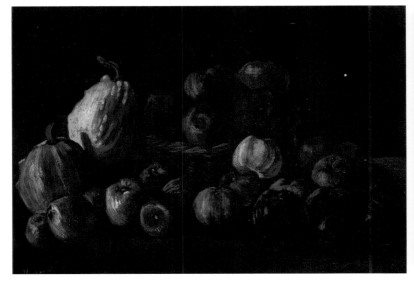

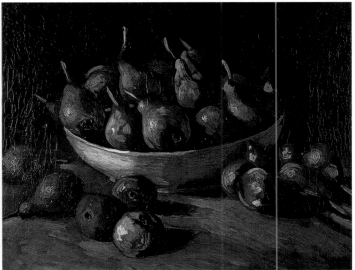

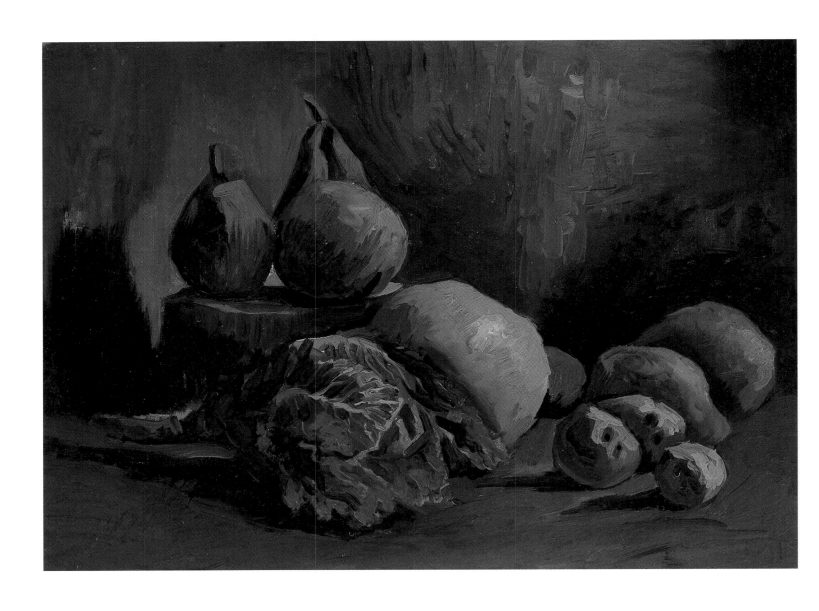

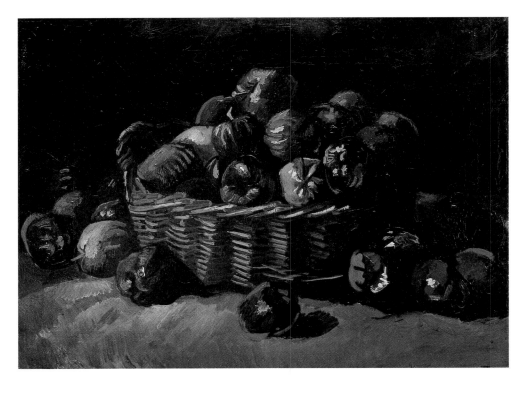

Still Life with Vegetables and Fruit
Nuenen, September 1885
Oil on canvas, 32.5 x 43 cm
F 103, JH 928
Amsterdam, Rijksmuseum Vincent van
Gogh, Vincent van Gogh Foundation

Still Life with Basket of Apples
Nuenen, September 1885
Oil on canvas, 45 x 60 cm
F 99, JH 930
Amsterdam, Rijksmuseum Vincent van
Gogh, Vincent van Gogh Foundation

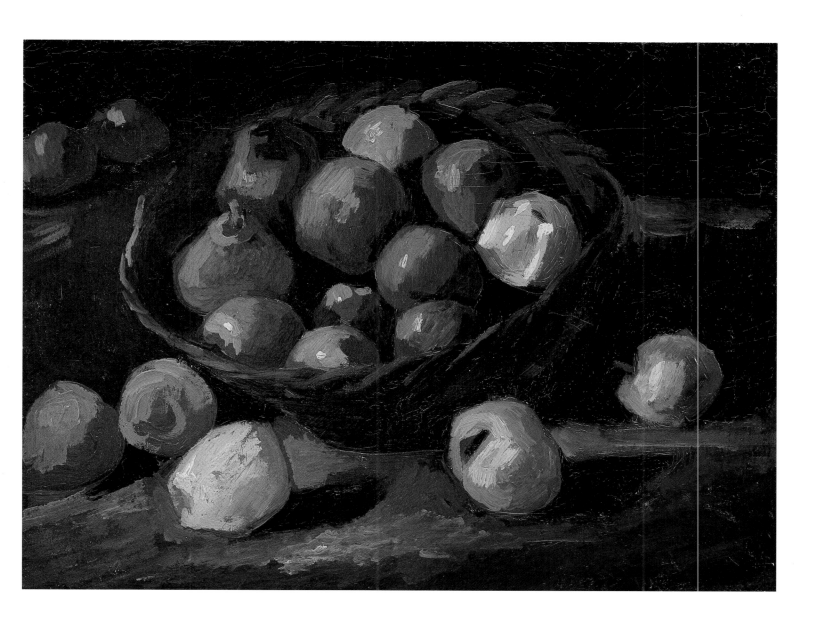

Still Life with Basket of Apples
Nuenen, September 1885
Oil on canvas, 33 x 43.5 cm
F 101, JH 927
Amsterdam, Rijksmuseum Vincent van
Gogh, Vincent van Gogh Foundation

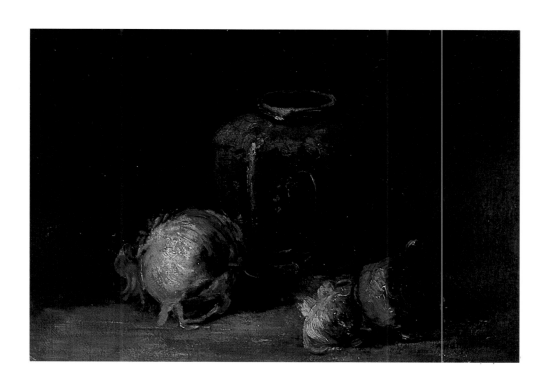

Still Life with Ginger Jar and Onions
Nuenen, September 1885
Oil on canvas, 39.3 x 49.6 cm
F 104a, JH 924
Hamilton (Canada), McMaster University,
Gift of Herman Levy Esq., O.B.E.

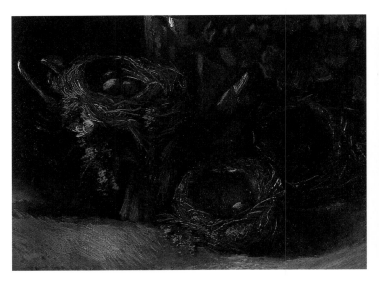

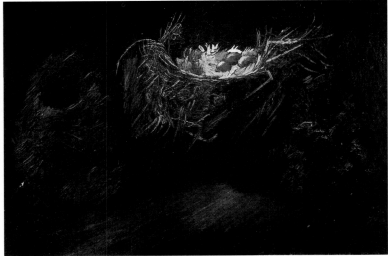

Still Life with Three Birds' Nests
Nuenen, October 1885
Oil on canvas on panel, 43 x 57 cm
F 110, JH 941
The Hague, Haags Gemeentemuseum, on
loan from the Wibbina Foundation

Still Life with Three Birds' Nests
Nuenen, September-October 1885
Oil on canvas, 33.5 x 50.5 cm
F 108, JH 940
Otterlo, Rijksmuseum Kröller-Müller

Still Life with Ginger Jar and Apples
Nuenen, September 1885
Oil on canvas on panel, 30.5 x 47 cm
F 104, JH 923
Whereabouts unknown
(Sotheby's Auction, 26. 4. 1972)

Van Gogh made paintings of these scenes himself, and four have survived: *Farmers Planting Potatoes* (p. 47), *Potato Planting* (pp. 48-9), *Shepherd with Flock of Sheep* (p. 46) and *Wood Gatherers in the Snow* (p. 46). All of them were done in late summer 1884. Treating the canvas as a stage, van Gogh presents the action unimaginatively. The landscape is flat and dreary and recedes to the horizon innocent of any relief; and against this background the figures are presented as monumental in their dignity. In van Gogh's sketches the silhouettes of a village, church tower or line of trees still marked the horizon, but now our attention is fixed completely on the people at their work. They bow their heads, they stoop, they walk bent beneath their loads and beneath the line of the horizon, and only occasionally does a head stand out against the light of the sky. In foregrounding his figures, van Gogh has also emphasized their rootedness in the soil that affords them a livelihood. It almost looks as if the ground were dropping away at their feet and they were falling into the depths of a grave. Judged by the rulebook, these paintings are little better than dilettantish; yet van Gogh, in his subtle way, has made a virtue of necessity, allowing his own rudimentary manner to be included in the primæval rituals of this work.

This cycle of the seasons constituted the only paintings that van Gogh did not place at his brother's disposal. In February 1884 Vincent had agreed to repay Theo's postal money orders with paintings. So now his works were regularly being sent to Paris; indeed, everything van Gogh produced from this time forth, till the day he died, went to Theo. Vincent considered his brother the owner of his paintings, while Theo, for his part, saw himself as a trustee – though both of them sensibly refrained from dwelling upon the exact details of ownership. The arrangement itself (which they both observed to the letter, without discussing it at any length in their correspondence) was the result of profound differences between the two brothers. Vincent had lost sight of the *alter ego* he had always assumed Theo to be. He blamed his brother for his own alienation from their parental home, and saw him as the

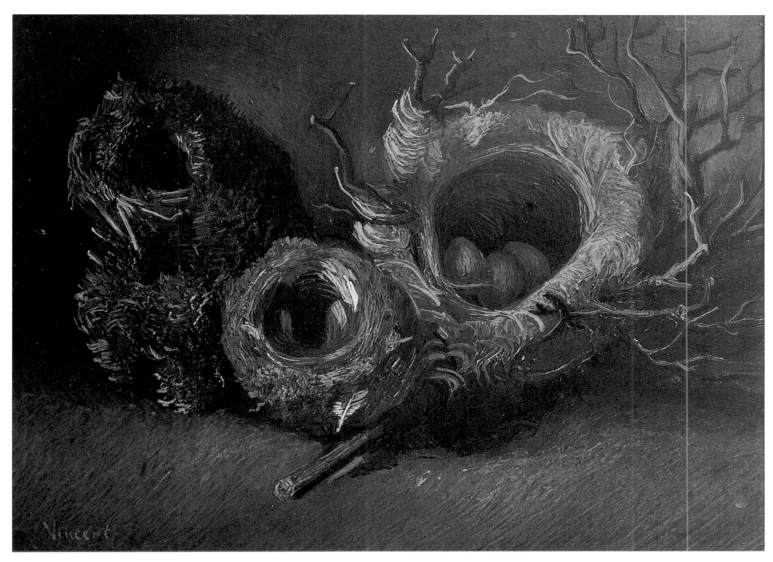

Still Life with Three Birds' Nests
Nuenen, September-October 1885
Oil on canvas, 33 x 42 cm
F 112, JH 938
Otterlo, Rijksmuseum Kröller-Müller

Still Life with Five Birds' Nests
Nuenen, September-October 1885
Oil on canvas, 39.5 x 46 cm
F 111, JH 939
Amsterdam, Rijksmuseum Vincent van
Gogh, Vincent van Gogh Foundation

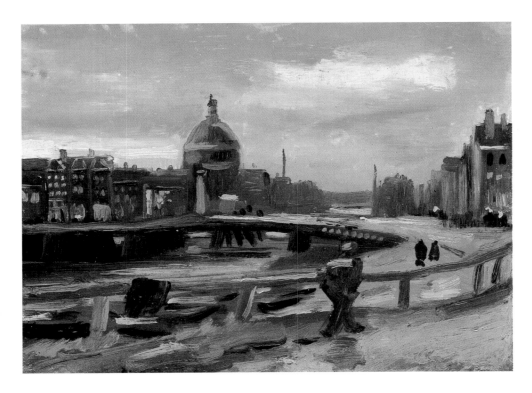

View of Amsterdam from Central Station
Nuenen, October 1885
Oil on panel, 19 x 25.5 cm
F 113, JH 944
Amsterdam, P. and N. de Boer Foundation

personification of that code of respectability that constantly brought home his own inadequacy to him. The break peaked in a superb passage in Letter 379, in which Vincent discussed Delacroix's famous painting of the 1830 revolution, *Liberty on the Barricades* (in the Louvre in Paris), showing Liberty leading the people onward. Vincent imagined himself in the days of revolutionary fighting in 1830 or 1848, and went on to picture himself meeting his brother on the other side: "If we had both remained true to ourselves, we might – with a sorrow of kinds – have found ourselves enemies, confronting each other, at a barricade like that for instance, you as a government soldier and I behind it, a rebel. Now, in 1884 (by coincidence the numbers are the same, just the other way round) we confront each other once more; there are no barricades, it is true, but our minds cannot agree."

Theo the opportunist and Vincent the rebel: it was van Gogh's way of

Landscape with Windblown Trees
Nuenen, November 1885
Oil on paper on panel, 32 x 50 cm
F 196, JH 957
Whereabouts unknown

The Parsonage at Nuenen by Moonlight
Nuenen, November 1885
Oil on canvas, 41 x 54.5 cm
F 183, JH 952
Private collection

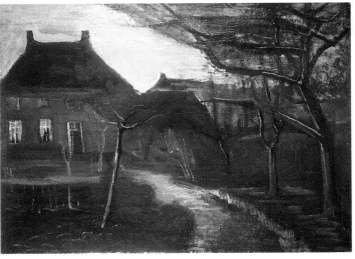

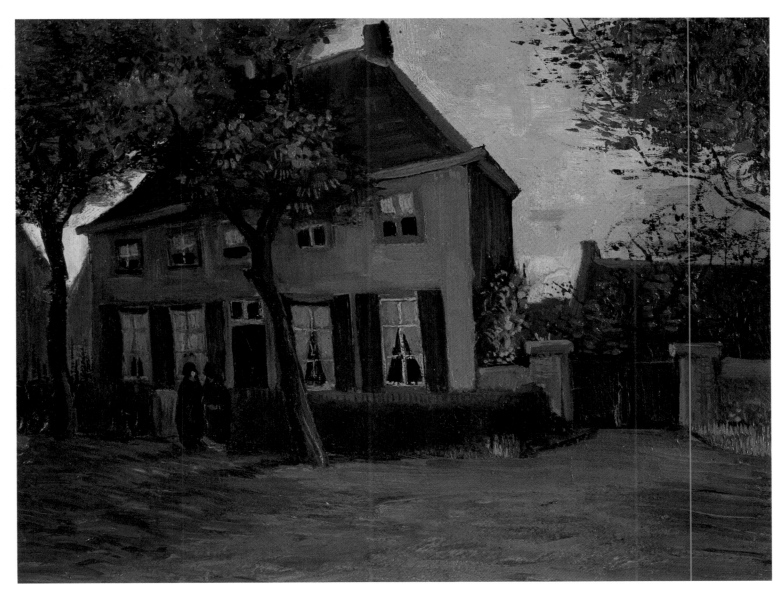

expressing a central polarity in Modernism, between the penniless artistic outsider and the corrupt and obese bourgeois philistine. The row with his brother was soon patched up; but van Gogh's view of the world remained at the very core of his identity. He dreamt the dream of revolution, and indeed he had to do so if he was not to accept the iron indifference of the uncomprehending pillars of society who blithely ignored his art. Van Gogh had to believe that his art was contributing to a better world. Two years before, in his insistence that he had to create something (in Letter 309), he had already pinpointed the problem. The simple folk he was affectionately placing at the centre of his artistic endeavours might not be able to underwrite that changed society of the future he vaguely envisaged, but still he took them as its prototypes. Showing them in their natural dignity was van Gogh's way – the only way open to him – of assisting in that change.

The Parsonage at Nuenen
Nuenen, October 1885
Oil on canvas, 33 x 43 cm
F 182, JH 948
Amsterdam, Rijksmuseum Vincent van Gogh, Vincent van Gogh Foundation

View of Amsterdam
Nuenen, October 1885
Oil on canvas on panel, 35 x 47 cm
F 114, JH 945
Amsterdam, Rijksmuseum Vincent van Gogh, Vincent van Gogh Foundation
(Attribution disputed)

Progress
The *Weavers* Series

View of a Town with Drawbridge
Nuenen, October 1885
Oil on panel, 42 x 49.5 cm
F 210, JH 947
Private collection

Van Gogh tended to be more at home in peasants' cottages than in his parents' house. Only a few weeks after the stranger had appeared in their midst, the villagers (the poor among them in particular) befriended Vincent and adopted him as one of themselves. It is tempting to draw cosy, idyllic conclusions from the fact that his first paintings in Nuenen were interiors, showing weavers at work, busy at their looms. Reality, however, was not altogether so cosy. Van Gogh, relieved of concerns for his daily bread, now had 150 francs a month; Theo's support meant that he had about three times what a weaver family (every generation of the family living together under the same roof) had by way of income. Though van Gogh doubtless felt a sense of solidarity with the weavers, his visits cannot be accounted for on those grounds alone. We should also remember that in the cold winter months it was much better to paint indoors. And above all, he had the money to pay the weavers (who tended to have large families) for posing at their picturesque looms.

Country Lane with Two Figures
Nuenen, October 1885
Oil on canvas on panel, 32 x 39.5 cm
F 191a, JH 950
Private collection
(Christie's Auction, London, 2. 12. 1986)

Autumn Landscape
Nuenen, October 1885
Oil on canvas on panel, 64.8 x 86.4 cm
F 119, JH 949
Cambridge (England), Fitzwilliam Museum

Van Gogh ascribed a certain depth to these milieu scenes, feeling they provided insight into his own work too; and indeed it is that depth which lends the series its special quality. Still, the identification of artist with weaver, and vice versa, amounted to precious little in practice. Before he had ever set foot in a weaver's workroom, van Gogh had been full of effusive social romanticism: "A weaver", he wrote from The Hague (Letter 274), "with a great number of threads to weave, has no time to philosophize about how he is to work them all together; rather, he is so absorbed in his work that he does not think, he acts, and he feels how things can and must be arranged rather than being able to explain it." In the weaver's work he had again located a metaphor for his own everyday labours; linen (or canvas), the final product of one man's work, was the starting point of the other's. Once he was on the spot, though, van Gogh had problems finding his pet idyll of the craftsman's life. The series of pictures he presently painted eloquently attest van Gogh's gradual relinquishment of his preconceived notions and his acceptance of the careworn reality of everyday life as a weaver. For the first time in van Gogh's oeuvre we can witness the artist engaging in the process of

Autumn Landscape with Four Trees
Nuenen, November 1885
Oil on canvas, 64 x 89 cm
F 44, JH 962
Otterlo, Rijksmuseum Kröller-Müller

questioning his own subjective attitudes and starting a dialogue with his subjects.

Presumably it was their unanticipated obduracy that led van Gogh to take the weavers as his subject. The series was a kind of pilot project for him. Henceforth his work would typically be conceived in series, and in this way his tireless urge to create (as an end in itself) harmonized with his systematic investigations of the unfamiliar. Carlyle too had stressed the importance of affectionate empathy in accessing the natural laws of series. The soul and conscious needed to be awoken within us, dilettantism ousted in favour of honest endeavour, the heart of stone replaced by the living heart of flesh and blood; and, once that had been accomplished, an endless number of things would be perceived, things that were waiting to be done. And once the first had been done (felt Thomas Carlyle) the second would follow, then the third, and so forth unto infinity.

Weaver, Facing Right, Half-Figure (p. 35) is the only close-up in the series. Van Gogh is trying to gaze into that tensed face, touch those lips tight with concentration, and observe the hand movements the weaver makes at his work. Van Gogh is trying to see himself in this figure, whose gestures and facial expression remind him of his own at the easel – which the loom even distantly resembles. Here, in the first painting in a series of ten, the metaphoric link between the picture and the fabric as products of related activities is effectively stated in the striking geometry of cords which van Gogh's long brushstrokes have overlaid on the surface.

In *Weaver Facing Left, with a Reel* (p. 36) van Gogh has already

The Willow
Nuenen, November 1885
Oil on canvas, 42 x 30 cm
F 195, JH 961
Whereabouts unknown

The Parsonage Garden at Nuenen with Pond and Figures
Nuenen, November 1885
Oil on panel, 92 x 104 cm
F 124, JH 955
Destroyed by fire during World War II

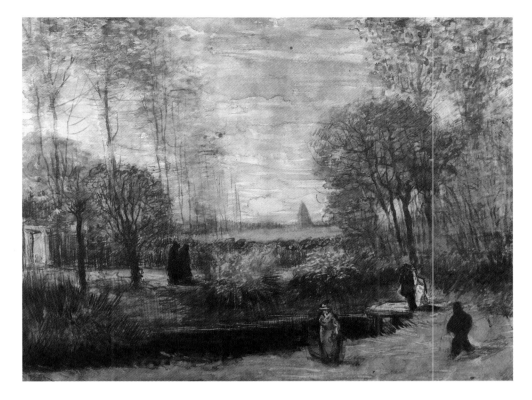

The Parsonage Garden at Nuenen with Pond and Figures
Nuenen, November 1885
Watercolour, 38 x 49 cm
F 1234, JH 954
Wassenaar (Netherlands), Collection
B. Meijer

retreated somewhat. Now he is attempting a kind of reportage, documenting the working atmosphere, trying a new approach to a recalcitrant subject. The light, bright and diffuse, fills a room which merely serves as a space in which to present a highly detailed rendering of the weaver's instruments. Van Gogh has added a reel, a commonplace attribute that confirms the everyday tone of this account of a weaver's existence. The addition shows the artist taking his bearings from the detached, anecdotal manner of the magazine illustrations he had so often admired. He was playing the part of an expert with vast, impartial knowledge of the working world.

"Imagine a black monster made of darkened oak", van Gogh wrote to Rappard (Letter R44), explaining the fascination and horror he felt for the loom, "all its crossbars standing out against the greyness of the

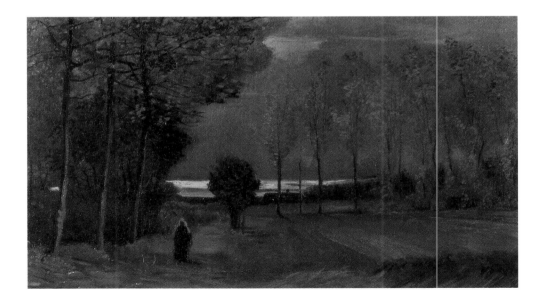

Autumn Landscape at Dusk
Nuenen, October-November 1885
Oil on canvas on panel, 51 x 93 cm
F 121, JH 956
Utrecht, Centraal Museum

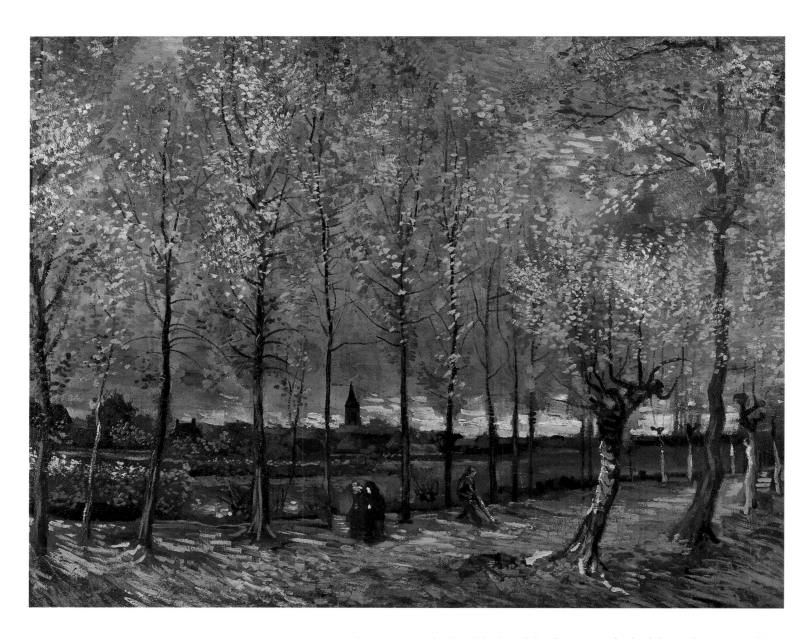

Lane with Poplars
Nuenen, November 1885
Oil on canvas, 78 x 98 cm
F 45, JH 959
Rotterdam, Museum Boymans-van
Beuningen

room, and sitting right inside it a black ape or kobold or ghost, rattling away at the shuttles from dawn till dusk. And I have recorded it by using a few scribbles and splotches to indicate a sort of weaver's figure at the place where I saw him sitting." It was in April 1884 that van Gogh wrote these lines about the ghost in the machine – a quarter of a year after his first contact with the weavers. Plainly he was not totally at ease with his material, and his rhetoric cannot disguise the fact that he had not yet fully come to terms with his subject. However, the way had been paved for an involvement in the lives of working people that accepted the unattainability of total harmony. Indeed, the curious fetishism he developed concerning the mysterious powers at work in the loom's wooden mechanism may well have been the right way to that new insight and acceptance.

Weaver, Seen from the Front (p. 39) places the "black monster's" daunting shape in the foreground. The weaver is scarcely individuated, a mere part of the complex mechanism, a figure in a geometrical construct of bars and shuttles, occupying a place in the incessant bustle of

the loom. No light illuminates his face. No colour highlights him amidst the brown monotony of the wood. Man and machine operate in tandem, not because the man (like the machine) lacks a soul but because the artist's eye has discovered life in both. It is hardly possible to overestimate the importance of this loom for van Gogh's subsequent art: for the very first time a thing or object transcends the status of a mere prop in a still life. The eloquence of his chairs (pp. 9 and 10) or shoes (p. 201) is anticipated here.

After six months of intense work, van Gogh found the solution he needed – to be exact, two solutions, marking the peak and also the finale of the weavers series: *Weaver near an Open Window* (p. 43) and *Weaver, Seen from the Front* (p. 43). In these paintings, van Gogh locates two alternative ways of expressing distance and proximity, identification and remoteness simultaneously. The window and the views it affords offer the artist's own commentary, while the weaver's person and machine confront him in a manner that seems antithetical, no longer personal.

Quayside with Ships in Antwerp
Antwerp, December 1885
Oil on panel, 20.5 x 27 cm
F 211, JH 973
Amsterdam, Rijksmuseum Vincent van Gogh, Vincent van Gogh Foundation

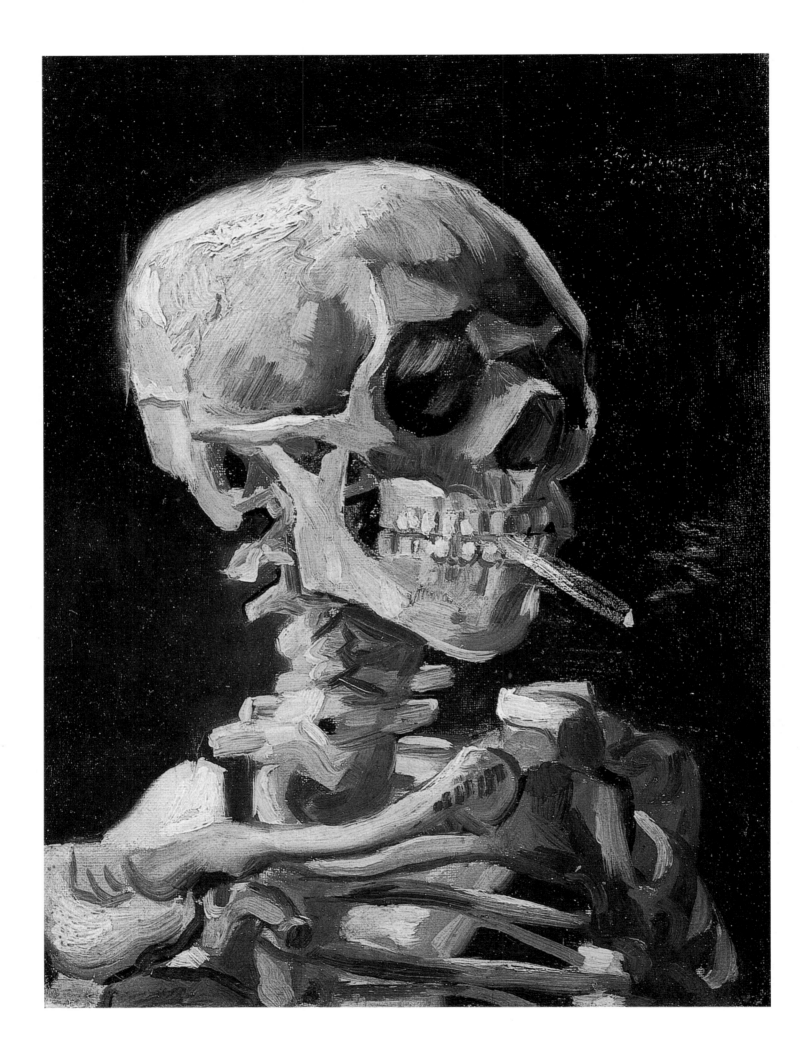

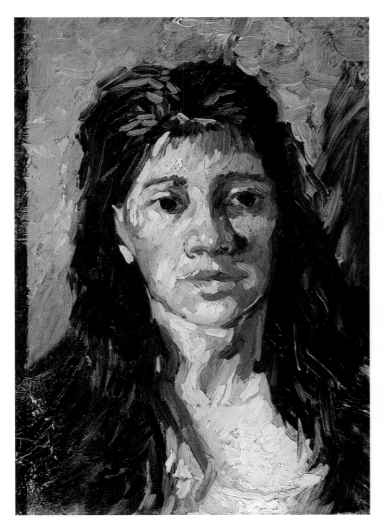

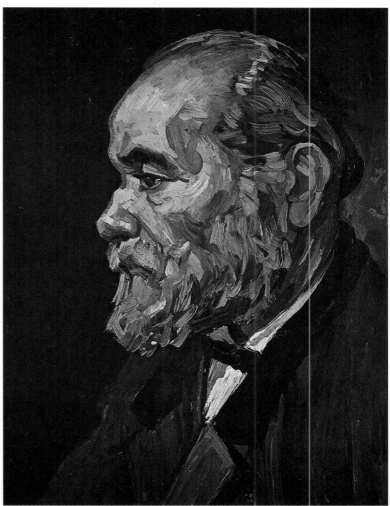

Head of a Woman with her Hair Loose
Antwerp, December 1885
Oil on canvas, 35 x 24 cm
F 206, JH 972
Amsterdam, Rijksmuseum Vincent van Gogh, Vincent van Gogh Foundation

Portrait of an Old Man with Beard
Antwerp, December 1885
Oil on canvas, 44.5 x 33.5 cm
F 205, JH 971
Amsterdam, Rijksmuseum Vincent van Gogh, Vincent van Gogh Foundation

Skull with Burning Cigarette
Antwerp, Winter 1885/86
Oil on canvas, 32 x 24.5 cm
F 212, JH 999
Amsterdam, Rijksmuseum Vincent van Gogh, Vincent van Gogh Foundation

Weaver near an Open Window is the more optimistic of the two paintings. The weaver is getting on with his work, silent, dedicated. He is protected by the higher power that appears symbolically at the perspective vanishing point. As long ago as Letter 250, van Gogh had written enthusiastically of the "little tower in the distance that looks quite small and unimportant but becomes impressive as you approach it." Now he was including it as a way of anchoring the humble, poverty-stricken life of a fellow-being he cared about in a larger context. First and foremost it was to himself that he was offering the promise of transcendent authority symbolized by the tower – himself, a man in need of affection, understanding and compassion, a man unable to cope with the social distinctions that gaped wide before him with every new day that dawned. But now he was placing the weaver and the things in the weaver's life in the midst of his own personal symbols: the ruined tower and the greyish blue figure of a woman bending. Though the bare interior might strike him as remote and alien, he had now cradled it in a bright exterior that he knew how to deal with in his art.

Weaver, Seen from the Front is more pessimistic. Awkward and unapproachable, the weaver seems as clumsy and indeed monstrous as his machine. The window is closed, and through it we see a windmill,

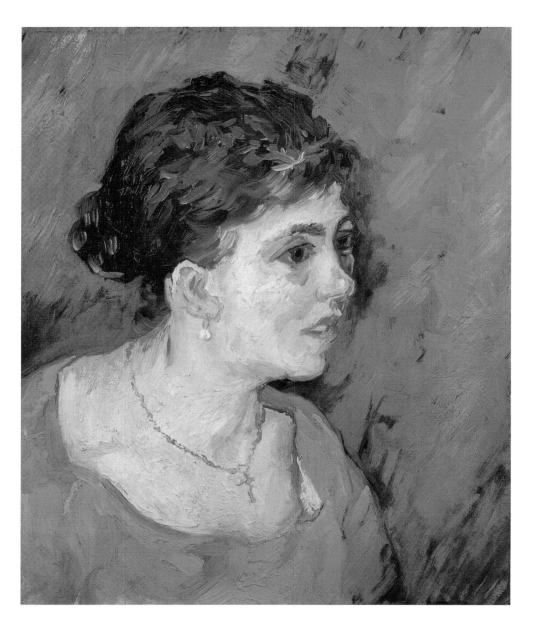

Portrait of a Woman in Blue
Antwerp, December 1885
Oil on canvas, 46 x 38.5 cm
F 207a, JH 1204
Amsterdam, Rijksmuseum Vincent van
Gogh, Vincent van Gogh Foundation

unclearly, some way off, its sails moving ineffectually. The weaver is in a prison, locked into an architectural construct reminiscent of a burial chamber. He is frozen rigid like an icon, remote and monumental, a kind of ghost. It is as if he were mummified; and the reason cannot be artistic incompetence on van Gogh's part. Though he had not yet mastered certain skills by a long way, he was well able to endow his figures with life and vitality. The weaver in this picture is singing a dirge or elegy on the passing of his own way of life. Half a century before, Carlyle had lamented that the living craftsman was everywhere being expelled from his workshop and replaced by a dead machine. Fingers of iron could move the shuttle faster than the weaver's fingers of flesh and blood. In his painting, van Gogh is showing this dismal future, vividly and awfully. Again he has abandoned all intention of making the man a component of his own subjective visual world; again he is aiming at a general presentation in which the individual can acquire symbolic meaning. The angle is different, though: there is no attempt to enter into the

Portrait of a Woman with Red Ribbon
Antwerp, December 1885
Oil on canvas, 60 x 50 cm
F 207, JH 979
New York, Collection Alfred Wyler

Backyards of Old Houses in Antwerp in the Snow
Antwerp, December 1885
Oil on canvas, 44 x 33.5 cm
F 260, JH 970
Amsterdam, Rijksmuseum Vincent van Gogh, Vincent van Gogh Foundation

other's life or identify with him; instead, the approach might almost be called political. Distress at a specific ill has temporarily displaced van Gogh's general distress at the universal ills of mankind. Shortly afterwards he was to request his brother to send him reports of the weavers' uprising in Lyon (Letter 393).

Whether the last two paintings in the weavers series are artistically the finest is debatable. Their composition, though, neatly illustrates how van Gogh, at one point in his creative life, would acquire a hold on subjects that were trying to evade his grip: by juxtaposing his personal experience with what remained so implacably alien. It may seem a crude and antithetical method; basically, though, it was to be applied unaltered throughout van Gogh's career. In due course van Gogh was to find solutions that made a more sensuous appeal, were more natural, and enabled him to establish a greater unity of impact. He took the

**Head of an Old Woman with White Cap
(The Midwife)**
Antwerp, December 1885
Oil on canvas, 50 x 40 cm
F 174, JH 978
Amsterdam, Rijksmuseum Vincent van
Gogh, Vincent van Gogh Foundation

lesson he had learnt from the weavers and applied it to his subjects, approaching them with all his love of paradox, coaxing conflict and inconsistency out of the tiniest details. Ambiguity, which had hitherto been primarily a feature of his reception, now became a hallmark of his creative work.

"With all my strength"
Winter 1884-1885

Hardly any artist's oeuvre harmonizes so thoroughly with the cycle of the seasons as van Gogh's. If critics trying to assign a work its chronological place are at odds, their discussion is likely to centre on determining the year itself rather than the season of the year. Van Gogh rarely leaves us in any doubt as to whether a work was created when the blossom of springtime was flowering, or summer's harvest being made,

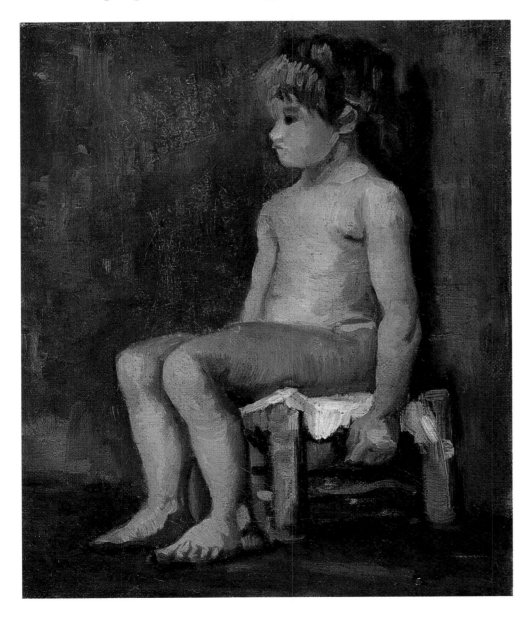

Nude Study of a Little Girl, Seated
Paris, Spring 1886
Oil on canvas, 27 x 22.5 cm
F 215, JH 1045
Amsterdam, Rijksmuseum Vincent van Gogh, Vincent van Gogh Foundation

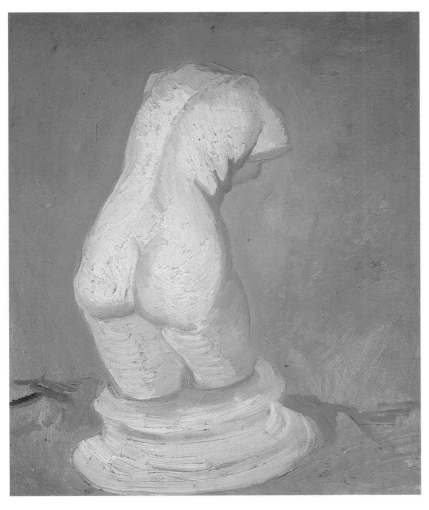

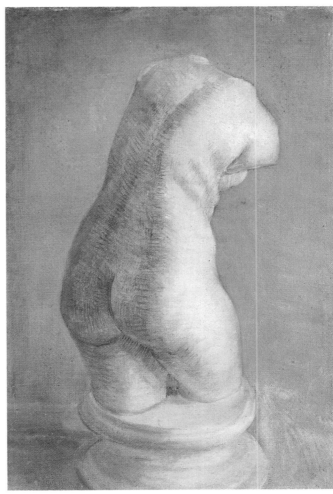

Plaster Statuette of a Female Torso
(rear view)
Paris, Spring 1886
Oil on cardboard on multiplex board,
47 x 38 cm
F 216a, JH 1054
Amsterdam, Rijksmuseum Vincent van
Gogh, Vincent van Gogh Foundation

Plaster Statuette of a Female Torso
(rear view)
Paris, Spring 1886
Oil on canvas, 40.5 x 27 cm
F 216g, JH 1055
Amsterdam, Rijksmuseum Vincent van
Gogh, Vincent van Gogh Foundation

or the leaves of autumn falling, or winter's cold biting so harshly that the painter was driven indoors to his studio. Letters document all this; but so do the indications of season van Gogh liked to include in his pictures. He wanted to live and work like the farmers he lived amidst. His emotional sense of affinity with them was accompanied and indeed almost defined by geographical closeness (they were neighbours) and the closeness of fellow workers (whose labours were timed to suit the wind and rain).

As if the cold was part of some artistic programme, van Gogh set his easel up in the snow. Painting the picture of wood gatherers in the snow for the Hermans cycle, Vincent had done the winter landscape from memory, but now he was out for complete unity of subject and work. *The Old Cemetery Tower at Nuenen in the Snow* (p. 72), *The Old Station at Eindhoven* (p. 72) or the two paintings titled *The Parsonage Garden at Nuenen in the Snow* (pp. 73 and 77) all have a genuine wintry chill about them. The snow shoveller's cold wet feet (and the painter's too), cold noses and numb fingers, snow on the spire of the tower, bare trees: we have a total impression of authenticity and can easily imagine the details we cannot see. Van Gogh bravely trudged off through the snow, thinking that the more fully he engaged with the elements of winter the more their power would fill his canvas. As in the case of the

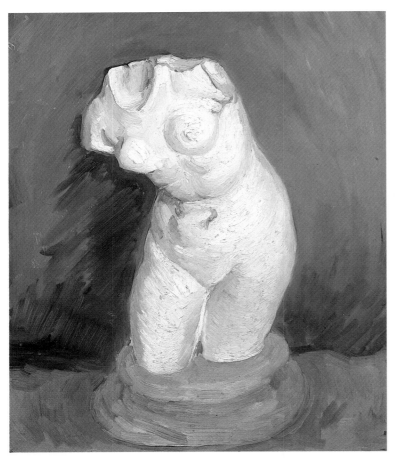

sower and reaper, the artist functioned purely as a medium for Nature's process of creation. It is as if van Gogh were holding out his unbegun picture of Creation, wanting its imprint on his virgin canvas. In this we see van Gogh experiencing the characteristic modern landscape artist's sense of being overwhelmed by the constant flux of natural creation; the artist himself is only intermittently creative and therefore holds himself in low esteem. However strong his subjective responses, the artist must suppress subjectivity if he is to allow those natural forces which are beyond his control to have full, vivid play in his work. Van Gogh, as so often in other respects as well, was more literal about this paradox than other artists. He was perfectly prepared to be self-sacrificing, even at the cost of his health, if the art he produced had a satisfactory immediacy.

The snow scenes are only an intermezzo, though, in the major series of that six-month period, at the end of which van Gogh painted his first true masterpiece. *The Potato Eaters* (p. 96) was a synthesis of countless studies of peasants' heads, of people absorbed in work and handicrafts, which van Gogh painted that winter in the poor cottages in the village. As with the weavers, he had to paint a whole series in order to achieve any real closeness with these intractable people. This time the series approach resulted in a final triumph.

"You see, if I am to get ahead at all I have to paint fifty heads, precisely because it goes so well. As soon as possible, one after the other. I have

Plaster Statuette of a Female Torso
Paris, Spring 1886
Oil on cardboard on multiplex board,
46.5 x 38 cm
F 216b, JH 1060
Amsterdam, Rijksmuseum Vincent van Gogh, Vincent van Gogh Foundation

Plaster Statuette of a Female Torso
Paris, Spring 1886
Oil on canvas, 41 x 32.5 cm
F 216h, JH 1058
Amsterdam, Rijksmuseum Vincent van Gogh, Vincent van Gogh Foundation

Plaster Statuette of a Female Torso
Paris, Spring 1886
Oil on cardboard on multiplex board,
35 x 27 cm
F 216j, JH 1059
Amsterdam, Rijksmuseum Vincent van Gogh, Vincent van Gogh Foundation

worked it out, but it can't be done, with all my strength (which I shall gladly invest, as far as effort and exertion are concerned), without putting in extra work." In Letter 384 (November 1884) he told Theo of the workload he had set himself and requested more money; after all, the models he was now using had to be paid too. Van Gogh adhered to his work schedule through to April the following year, and over forty paintings of peasants' heads plus two dozen close-up studies of various kinds of cottage work have survived from this time.

It would be difficult to put these pictures in chronological order. In the course of his efforts to include the people of Nuenen in his art, van Gogh himself made only comments of a general nature: "I want the subject to follow from the character", we read in Letter 391, or: "I am even more interested in a figure's proportions, and how the eggshape of the head relates to the whole" (Letter 394). However, if we take our reading of the weavers series as the basis of an approach to these new works, we might outline a rough description of van Gogh's methods as follows. First he would restrict himself to bust portraits. He had a preference for placing figures in profile, their silhouettes (in dark colours) set off against the monochrome gloom of the background; and he would dwell on the material of caps and kerchiefs, the folds and crinkles in the linen (cf. pp. 66-69). In the portraits where the sitters are seen fulface, van Gogh strikingly avoids meeting their careworn gaze and sim-

Plaster Statuette of a Female Torso
Paris, Spring 1886
Oil on cardboard on multiplex board,
35 x 27 cm
F 216d, JH 1071
Amsterdam, Rijksmuseum Vincent van Gogh, Vincent van Gogh Foundation

Plaster Statuette of a Female Torso
Paris, Spring 1886
Oil on cardboard on multiplex board,
32.5 x 24 cm
F 216i, JH 1072
Amsterdam, Rijksmuseum Vincent van Gogh, Vincent van Gogh Foundation

Plaster Statuette of a Kneeling Man
Paris, Spring 1886
Oil on cardboard on multiplex board,
35 x 27 cm
F 216f, JH 1076
Amsterdam, Rijksmuseum Vincent van
Gogh, Vincent van Gogh Foundation

Plaster Statuette of a Male Torso
Paris, Spring 1886
Oil on cardboard on multiplex board,
35 x 27 cm
F 216e, JH 1078
Amsterdam, Rijksmuseum Vincent van
Gogh, Vincent van Gogh Foundation

ply records that the villagers look full of mistrust; they remain in some unfathomable depths of their own, not communicating with their vis-à-vis, gazing straight past at some imaginary world (cf. pp. 69 as well as 75).

As time went by, van Gogh ventured to look his modest subjects in the eye. We can distinguish a second group of portraits in which the sitter meets our gaze; they are *en face* portraits or three-quarter profiles. Their rustic spirits become more open and mischievous, and the painter's growing intimacy with them is reflected in their facial expressions, which are expectant or possibly show a need for help but at any rate are less stubborn and timorous (cf. pp. 70 and 74). Van Gogh even painted sub-series within his series. The same person would be examined five or six times so that every detail of the face could be recorded as it became readier, more accessible. Seen very slightly from below, they are revealed in their true dignity, in the full integrity of a life lived in harmony with Nature. In their authenticity, these pictures afford a contrast to the posed and self-consciously original scenes van Gogh had painted for Hermans's commission. The subjects of his new work emerged from their social anonymity of their own accord, and established their individual personalities so clearly that in due course the critics took pains to identify the sitters. One of the most striking (pp. 87ff.) was Gordina de Groot; she re-appeared in *The Potato Eaters*.

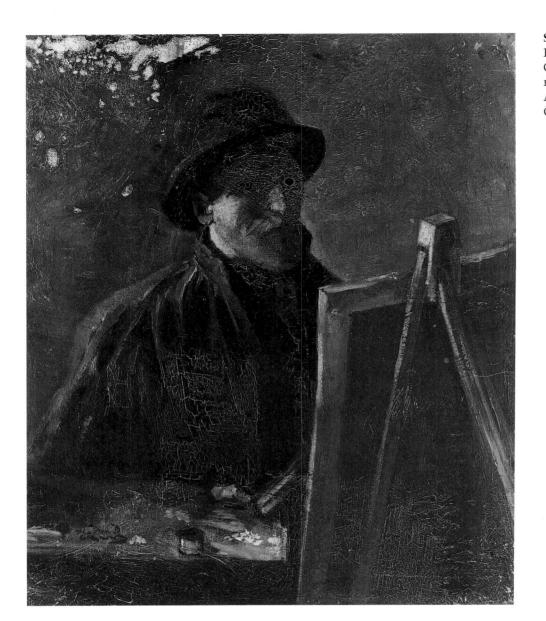

Self-Portrait with Dark Felt Hat at the Easel
Paris, Spring 1886
Oil on canvas, 46.5 x 38.5 cm
F 181, JH 1090
Amsterdam, Rijksmuseum Vincent van
Gogh, Vincent van Gogh Foundation

The third stage in van Gogh's work on this series involved the change from portraits to interiors. He observed his subjects about their domestic chores, peeling potatoes, spinning, weaving baskets. The figures and their settings now received equal attention. The light, from a single source, is now diffuse, now contrastive, and creates an atmosphere of tranquil permanence in which the figures and objects appear interdependent. Van Gogh drew upon tradition for some of his effects, borrowing from the genre scenes of the Dutch baroque, from Jan Steen or Gerard Terborch, in order to lend timeless meaning and relevance to specific views of everyday life. It is no coincidence that *Peasant Woman at the Spinning Wheel* (p. 81) recalls Jan Vermeer's enigmatic interiors. Daylight from a window off-canvas to the left has the curious effect of adding a mysterious note; and van Gogh's peasant woman acquires an almost emblematic quality as she pursues her task, as preoccupied and unknowable as the women in Vermeer's paintings. Now that van Gogh's wish to come closer to these people had been rewarded with success he was beginning to see as much significance in them as had

View of Paris from near Montmartre
Paris, Spring 1886
Oil on canvas, 44.5 x 37 cm
F 265, JH 1100. Private collection

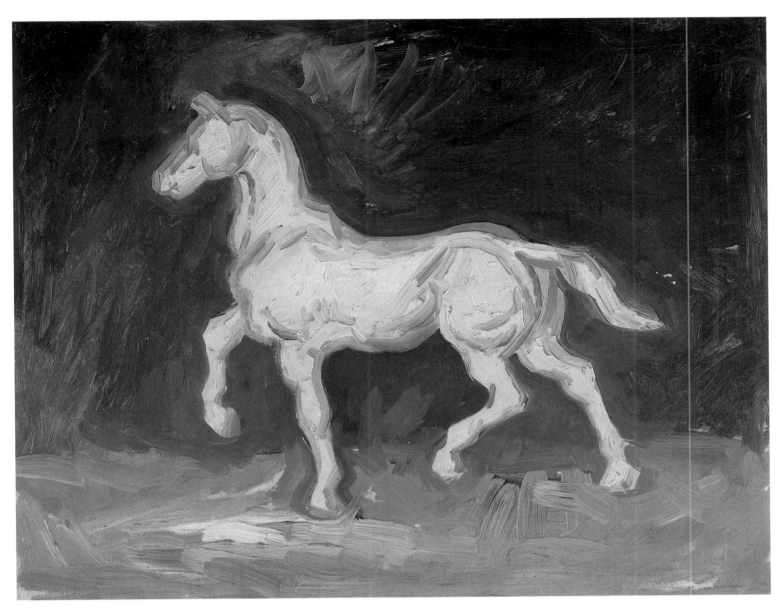

Plaster Statuette of a Horse
Paris, Spring 1886
Oil on cardboard on multiplex board,
33 x 41 cm
F 216c, JH 1082
Amsterdam, Rijksmuseum Vincent van
Gogh, Vincent van Gogh Foundation

once been seen in merchants and scholars. These interiors were the foundation of that social romanticism that van Gogh was soon to articulate, in manifesto style, in *The Potato Eaters*. The people's tools and implements still have something of attributes, the peasants still make a somewhat absent-minded impression as they do their work, their concentration still looks like a pose; but that was all entailed by the laws of series work, and the painter could still look forward to a future picture that would afford the consolation of eliminating these shortcomings.

"I have only one belief, one strength: work. All that kept me going was the immense task I had assigned myself. The work I am telling you of is regular work, a task, a duty I set myself, so that every day, even if it was only a single step, I would move forwards in my labours." In his *Speech to Young People*, Zola placed programmatic value on the idea of a regular quota of work for its own sake. Zola himself did in fact write the same amount every day; this inevitably left traces in his literary output, and it is often easy to see which passages were written on good

days and which on bad. Van Gogh went about things in much the same way. His series spurred him on, just as Zola's contracts spurred the writer on. An untiring urge to get ahead encouraged a belief in both men that they actually would make real progress if only they put pressure on themselves to work on. This belief in progress reveals both Zola and van Gogh to be typical minds of the 19th century, of course; and this professional achiever instinct was in a sense the very opposite of Romantic inwardness, devotion, and profundity of feeling. It would be a mistake to overlook this fact when examining van Gogh's oeuvre.

The painting of *The Potato Eaters* in April, 1885 marked a turning-point in van Gogh's artistic life; his private life also encountered a turning-point at the same time. On 26 March, Pastor Theodorus van

Fritillaries
Paris, Spring 1886
Oil on canvas, 38 x 55 cm
F 214, JH 1092
Whereabouts unknown

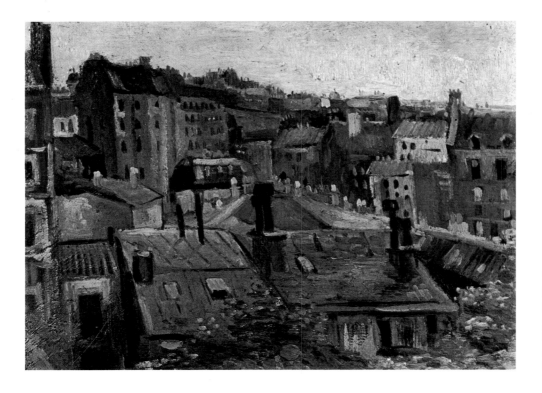

View of the Roofs of Paris
Paris, Spring 1886
Oil on cardboard on multiplex board,
30 x 41 cm
F 231, JH 1099
Amsterdam, Rijksmuseum Vincent van
Gogh, Vincent van Gogh Foundation

Gogh died suddenly, aged sixty-three, of a stroke. It may be no exaggeration to blame his son Vincent, at least in part. The vicar had been grieving ever since his artist son had come to live at home. Their characters were too different for any harmony to be possible, and the discord made a bitter man of van Gogh *père*. Everyone considered Vincent a failure, too, which did not make family life any easier. The day before he died, Pastor van Gogh had written to the financial bedrock of the family, Theo, to get his pessimism off his chest and lament Vincent's lack of success. Now, following his death, the family were able to stay on at the vicarage for the time being; but Vincent's standing in the eyes of the villagers deteriorated rapidly.

Naturally he commented on his changed circumstances in his art. *Still Life with Bible* (p. 104) is an examination of his relations with his father, whose correct reserve had always troubled Vincent. In the paint-

Self-Portrait with Dark Felt Hat
Paris, Spring 1886
Oil on canvas, 41.5 x 32.5 cm
F 208a, JH 1089
Amsterdam, Rijksmuseum Vincent van
Gogh, Vincent van Gogh Foundation

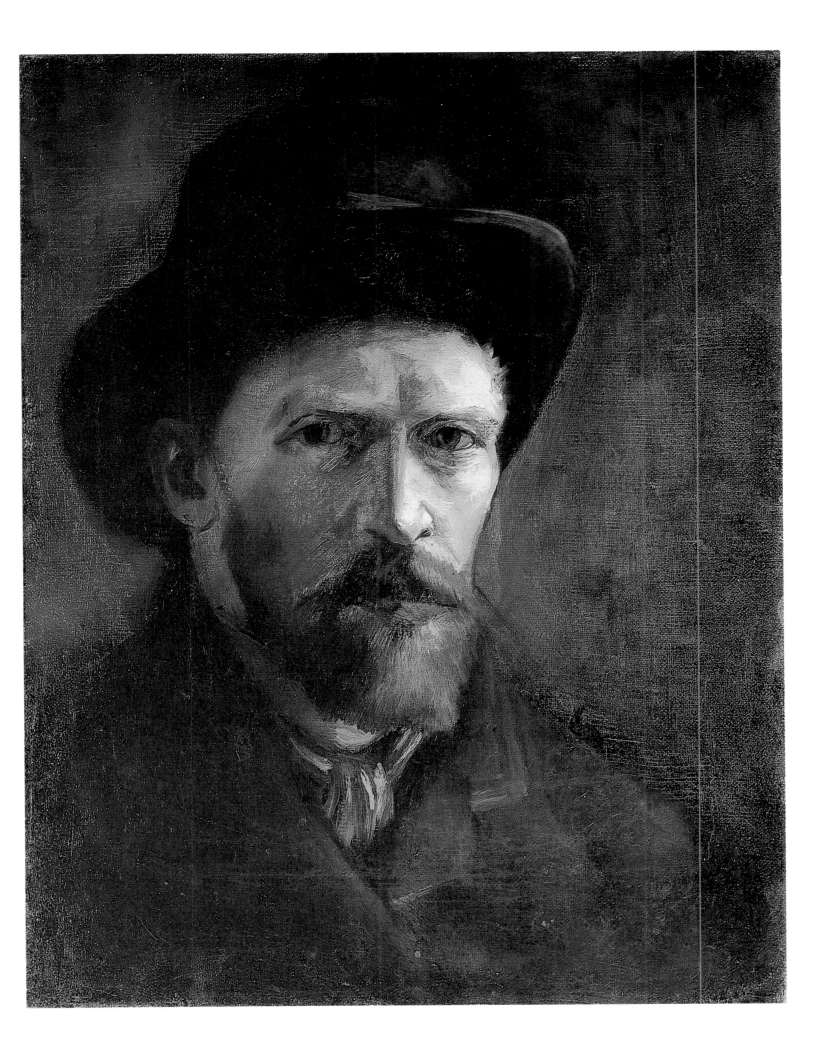

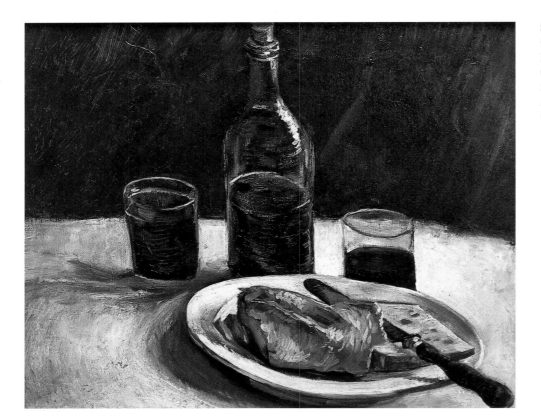

**Still Life with a Bottle, Two Glasses,
Cheese and Bread**
Paris, Spring 1886
Oil on canvas, 37.5 x 46 cm
F 253, JH 1121
Amsterdam, Rijksmuseum Vincent van
Gogh, Vincent van Gogh Foundation

ing, objects express his feelings: the books stand for the father and the son. It is no more a genuine still life than the two later paintings of chairs were, which reviewed his time with Gauguin. The painting is dominated by the Holy Scripture, a fine and huge edition, sober, melancholy, leather-bound, pathetic. Beside it is an extinguished candle, a traditional prop in any memento mori picture; this symbol of transience and death is sufficient to link the picture to the death of van Gogh's father. And in the foreground, modest yet insistent too, is a well-thumbed yellow copy of Zola's novel *La joie de vivre*. The metaphoric polarity implied by the juxtaposition of this book with the Bible is plain: the Bible was the father's source of authority in all his well-meant preaching and lecturing, while the novel represented a belief that there are other things in modern life besides wisdom that has been handed down through thousands of years.

Zola's *La joie de vivre* tells of a family in Normandy who squander their fortune, partly through greed, partly through fecklessness. Their money trickles through their fingers; their harmony evaporates; the household is ruined. The maidservant hangs herself, the mother dies of dropsy at the end of the novel, and in the midst of the cataclysm is the gouty, inflexible father, emphatically asserting the value of life, and the devoted niece, trying to keep chaos at arm's length. In the cheerful openness with which these two characters looked forward to the future, van Gogh partly saw himself – that paradoxical need for suffering which would provide a frame for any real awareness of being alive. As for the Bible, it is open at Isaiah 53, where the Old Testament prophet speaks of the exaltation that awaits those who suffer. It is a passage that promises

Glass with Hellebores
Paris, Spring 1886
Oil on canvas on panel, 31 x 22.5 cm
F 199, JH 1091
Whereabouts unknown

Sloping Path in Montmartre
Paris, Spring 1886
Oil on cardboard on multiplex board,
22 x 16 cm
F 232, JH 1113
Amsterdam, Rijksmuseum Vincent van
Gogh, Vincent van Gogh Foundation

Tambourine with Pansies
Paris, Spring 1886
Oil on canvas, 46 x 55.5 cm
F 244, JH 1093
Amsterdam, Rijksmuseum Vincent van
Gogh, Vincent van Gogh Foundation

redemption to the servants of God, vicars presumably included. The paradox of suffering and the clear promise of redemption, the inscrutability of life in this world and the clarity of life in the next, the vale of tears and the garden of paradise: van Gogh's ambitious painting is a discussion of worldviews, of hopes and expectations which had been irreconcilable till recently and now, identified as Heaven and Earth, could come closer in a spirit of acceptance.

Hitherto the picture has always been dated on the basis of a passage in Letter 429, written in October 1885: "In response to your account I am sending you a still life with an opened leather-bound Bible ... I painted it in one go, in a single day." The phrase "in one go" has been interpreted as meaning an immediate response on Vincent's part to something communicated by Theo. But three things weigh against the theory that the painting was not done till six months after Pastor van Gogh's death. First, the expression 'in one go' is a common turn of phrase that occurs frequently in van Gogh's letters and in contemporary writings on art. It was Edouard Manet who provided the remark van Gogh was responding to: "There is only one truth: to do in one go [*au premier coup*] whatever you see." Second, Vincent writes that he is sending the painting; but paintings need time to dry – van Gogh's letters often include discussion of the difficulties of sending paintings that have not properly dried – and the *Still Life with Bible* bears no scratches or scrapes that might have resulted from premature packing. We must conclude that it had been in the painter's keeping for some time. Third, of course, it seems much

Still Life with Scabiosa and Ranunculus
Paris, Spring 1886
Oil on canvas, 26 x 20 cm
F 666, JH 1094
Private collection
(Sotheby's Auction, New York, 12. 11. 1988)

Lane at the Jardin du Luxembourg
Paris, June-July 1886
Oil on canvas, 27.5 x 46 cm
F 223, JH 1111
Williamstown (Mass.), Sterling and
Francine Clark Art Institute

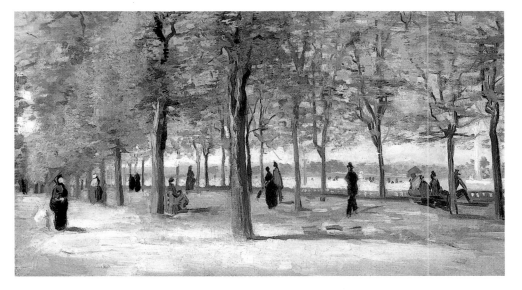

The Pont du Carrousel and the Louvre
Paris, June 1886
Oil on canvas, 31 x 44 cm
F 221, JH 1109
Private Collection

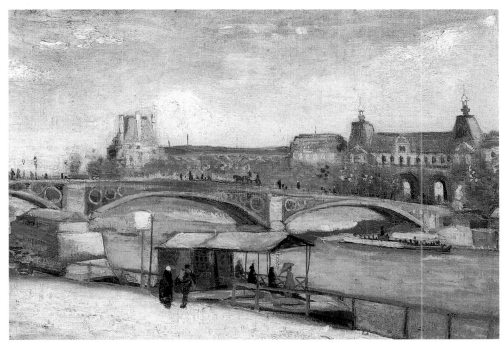

The Bois de Boulogne with People Walking
Paris, Summer 1886
Oil on canvas, 46.5 x 37 cm
F 224, JH 1112
Zurich, Private collection

likelier that the painting would have been done in April 1885, under the
full shock of his father's death. At that time he wrote in Letter 399:
"That Fortune smiles on the brave is doubtless often true, and however
things stand with Fortune, or *joie de vivre*, one must go on working and
venturing if one is truly to live." Thus alongside *The Potato Eaters*,
overshadowed by it and not mentioned for that reason, another picture
that had programmatic value in van Gogh's early work was painted in
spring 1885: his *Still Life with Bible*. And it set a classical standard that
his subsequent work would have to satisfy.

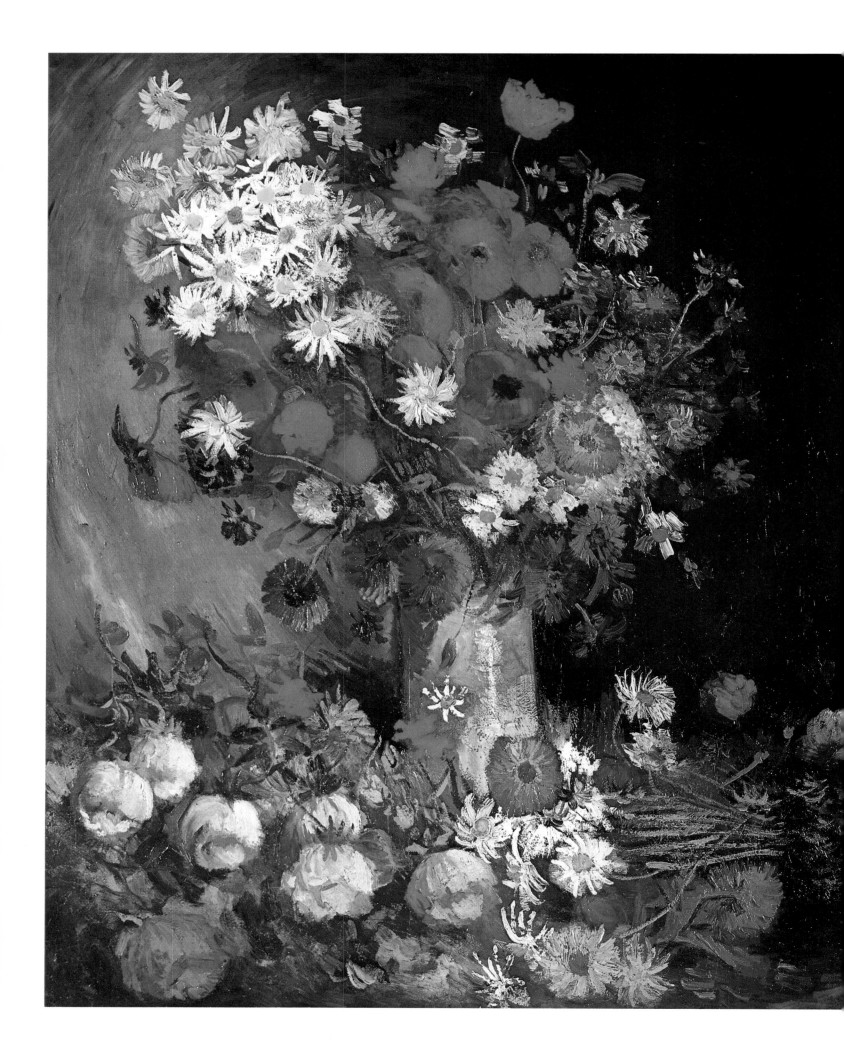

Painting as Manifesto
The Potato Eaters

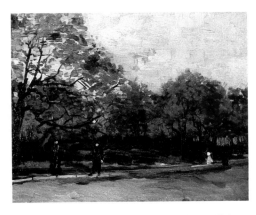

The Bois de Boulogne with People Walking
Paris, Autumn 1886
Oil on canvas, 38 x 45.5 cm
No F Number, no JH Number
Private collection

The Bois de Boulogne with People Walking
Paris, Summer 1886
Oil on canvas, 37.5 x 45.5 cm
F 225, JH 1110
United States, Private collection
(Sotheby's Auction, New York, 12. 5. 1980)

**Vase with Poppies, Cornflowers, Peonies
and Chrysanthemums**
Paris, Summer 1886
Oil on canvas, 99 x 79 cm
F 278, JH 1103
Otterlo, Rijksmuseum Kröller-Müller

"I think that the picture of the peasants eating potatoes that I painted in Nuenen is the best of all my work." Writing to his sister two years later from Paris (Letter W1), van Gogh still considered *The Potato Eaters* his most successful painting. Basically it was the only one of his paintings that he considered worth showing in public. It was the only one he could imagine taking its place in the tradition of Millet or Breton, the only one (in his view) that communicated the values that he believed Art ought to communicate; and he insisted that Theo should play the art dealer and hawk the painting about. If he was ever to make a career as an artist it would be as the painter of that picture alone. All van Gogh's ambition was invested in it. And, after all, since he lived in the country this spartan peasant repast put his own artistic authenticity to the test. It was his own life-style – as friend of the people, the passionate peasant, the compassionate ascetic – that would stand or fall by the reception accorded the painting. The man was indistinguishable from the painter,

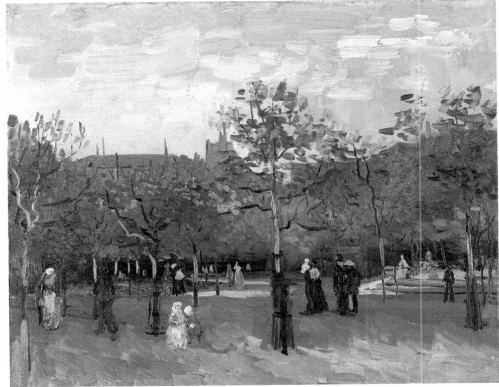

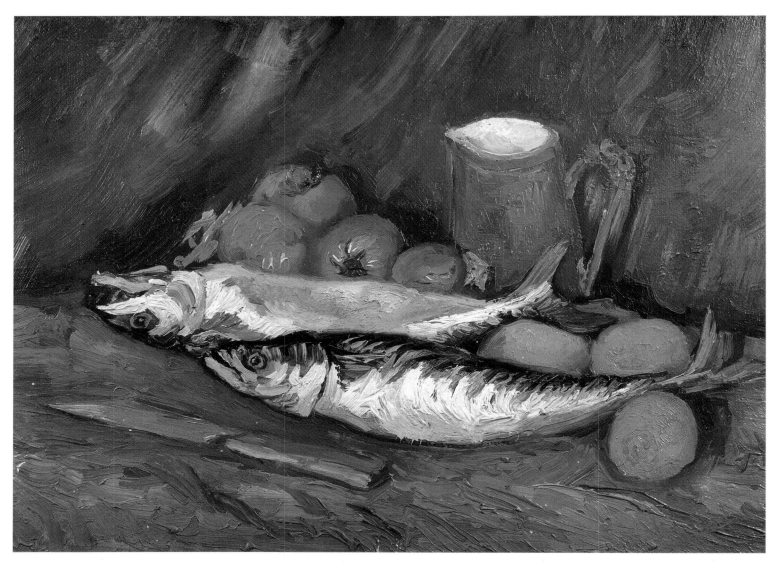

Still Life with Mackerels, Lemons and Tomatoes
Paris, Summer 1886
Oil on canvas, 39 x 56.5 cm
F 285, JH 1118
Winterthur, Collection Oskar Reinhart

Still Life with Two Herrings, a Cloth and a Glass
Paris, Summer 1886
Oil on canvas, 32.5 x 46 cm
F 1671, JH 1122
United States, Collection Scharenguival

and in this one work his worldview doubled as his fate. Inevitably the theory piled up. A whole bundle of letters deal exclusively with this painting. Every step the work involved is documented, with notes that (in van Gogh's usual syncretist manner) unambiguously forge a unity out of his attitudes to life and his brushstrokes, his social criticism and his use of colour, his analysis of the times and his choice of subject. Away in his village, van Gogh underwent one of the core experiences of modern art: in formulating a manifesto he had to face the dilemma of being accessible only to the initiated few who read the accompanying texts and of needing to supply further texts for the sake of being understood. Van Gogh was still far from the madding gallery crowd. Correspondence with a few confidants still made the nailing of theses to doors unnecessary. But there was already a wide gap between his practice and his theory, between the simple painted canvas and the load of ambitious meanings it was expected to shoulder. What a picture *was* and what it was *supposed* to be were increasingly proving to be two distinct and irreconcilable things.

Van Gogh did countless studies for *The Potato Eaters*, which was procedurally the very opposite of a work done in one go – otherwise his

Still Life with Bloaters
Paris, Summer 1886
Oil on canvas, 45 x 38 cm
F 203, JH 1123
Otterlo, Rijksmuseum Kröller-Müller

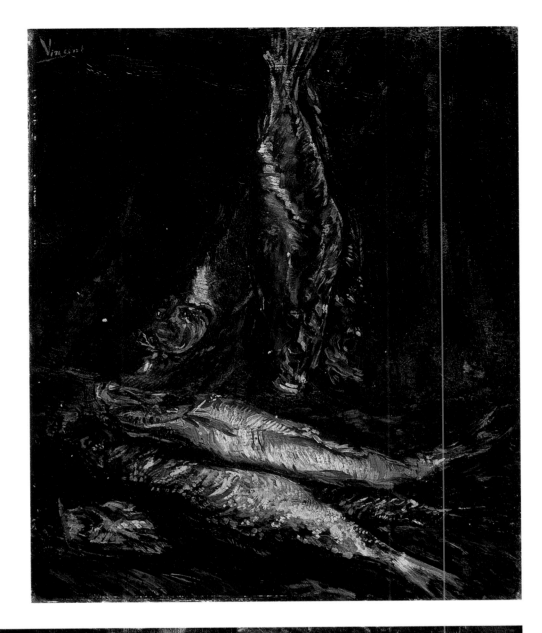

Still Life with Bloaters
Paris, Summer 1886
Oil on canvas, 21 x 42 cm
F 283, JH 1120
Basle, Rudolf Staechelin Family
Foundation

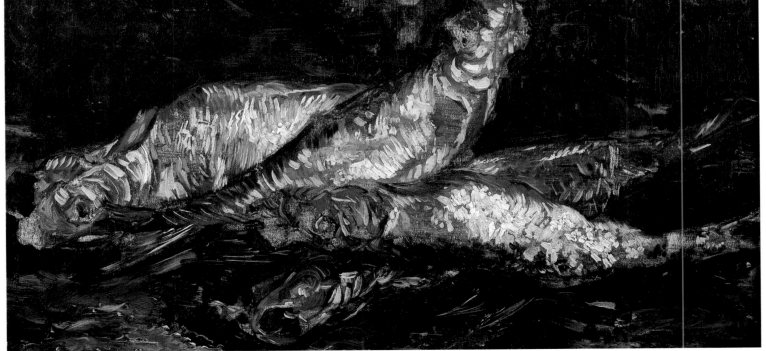

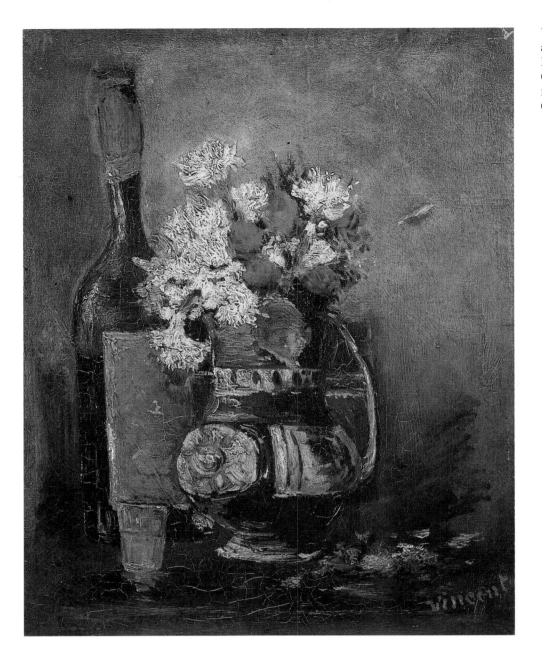

Vase with Carnations and Roses and a Bottle
Paris, Summer 1886
Oil on canvas, 40 x 32 cm
F 246, JH 1133
Otterlo, Rijksmuseum Kröller-Müller

preferred method. The studies included heads, interiors, compositional sketches, and details of hands or the coffee pot. And when he was finally done with his monumental work, van Gogh signed it: "Vincent." Sensibly he painted it in the studio. A professional by now, he felt disturbed by the nervous shifting of amateur models unable to hold a pose. He painted from memory, *par coeur* (as Delacroix taught): "For the second time", he wrote to Theo (Letter 403), "I am finding that something Delacroix said means a great deal to me. The first time it was his theory of colour. Then I read a conversation he had with other painters about the technique of making a picture. He claimed one produced the best pictures out of one's head. *Par coeur!* he said." The sheer distance van Gogh had succeeded in achieving from his hitherto sacred principle of physical closeness to his subject is in itself a measure of his seriousness in attempting a major work.

The painting (p. 96) shows five people – the potato eaters of the title –

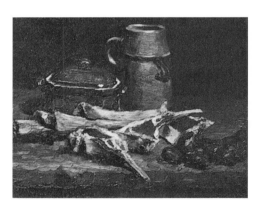

Still Life with Meat, Vegetables and Pottery
Paris, Summer 1886
Oil on canvas, 33.5 x 41 cm
F 1670, JH 1119
Whereabouts unknown

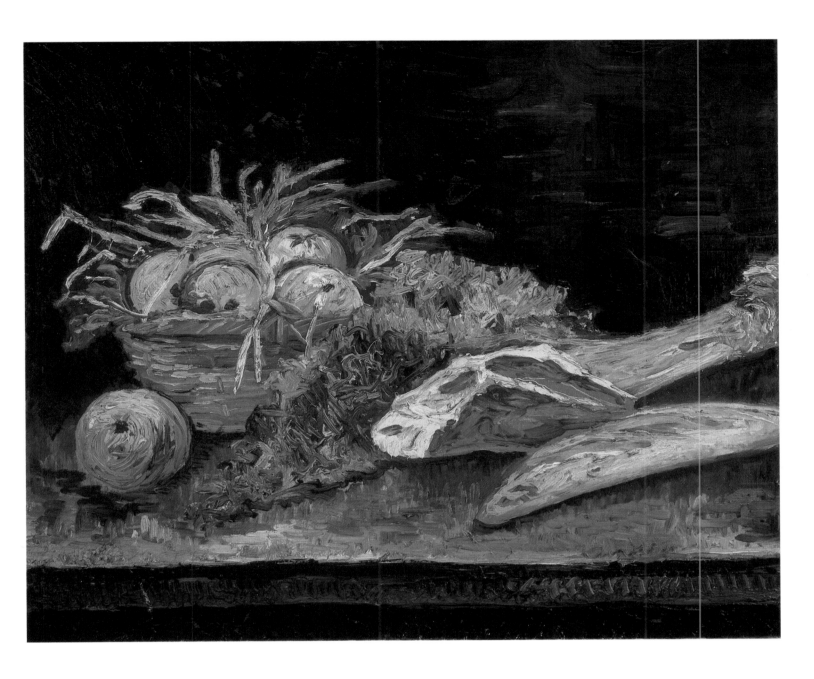

Still Life with Apples, Meat and a Roll
Paris, Summer 1886
Oil on canvas, 46 x 55 cm
F 219, JH 1117
Otterlo, Rijksmuseum Kröller-Müller

seated round a rough wooden table. The younger woman has a bowl of hot, steaming potatoes in front of her and – an interrogative expression on her face – is serving up portions. The old woman opposite her is pouring barley-malt coffee into cups. The three generations of a peasant family living together under one roof are gathered for this frugal meal. An oil lamp sheds a dim light on the scene, showing its plain poverty yet also highlighting an atmosphere of silent thankfulness. This lamp, shedding its weak and flickering light on all of them equally, establishes unity in the appearance of these careworn figures. Daily toil is visible in their faces; but their eyes signal trust, harmony and contentment with their life together, articulating a love that is also apparent in their gestures. It is as if there were no outside world to disturb their tranquil gathering with noise and bustle.

Van Gogh himself is struggling with the idyllic flavour of the scene. The figures still have something of the poses he put them in when

taking their portraits. Their almost imperceptible communication, which seems so eloquent of an atmosphere of wordless harmony, is to some extent the result of insufficient skill in transferring individual studies to a group composition. The people are looking *past* each other, for the simple reason that the painter had never seen them together. The positioning is not altogether happy, either; van Gogh has placed the five figures as if he were composing a still life, but the spatial illusion is at odds with a sense of merely cumulative juxtaposition. The visual symmetry balances the young couple with the potatoes on the left against the older couple with the coffee on the right, with the hardly original rear view of the child in the middle as a kind of axis on which the two halves hinge – a function the figure can only fulfil if it remains anonymous, a faceless and purely formal cipher.

Van Gogh's first attempt at painting a group of potato eaters (p. 82) was compositionally more interesting. It includes only four figures round the table, and the sense of their sitting in a circle is made plausible by the irregularity of the positions they are in. Nor does the lamp have to

LEFT:
The Fourteenth of July Celebration in Paris
Paris, Summer 1886
Oil on canvas, 44 x 39 cm
F 222, JH 1108
Winterthur, Collection L. Jäggli-Hahnloser

Vase with Carnations
Paris, Summer 1886
Oil on canvas, 46 x 37.5 cm
F 245, JH 1145
Amsterdam, Stedelijk Museum

Vase with Red Gladioli
Paris, Summer 1886
Oil on canvas, 50.5 x 39.5 cm
F 248, JH 1146
Private collection
(Sotheby's Auction, New York, 18. 5. 1983)

illuminate two symmetrical halves with analogous groups of people. The relaxed approach is emphasized by the sketchy brushwork; this picture is of course a preliminary study, but as such it has an unpretentious spontaneity that the final version lacks. The second attempt (p. 97) shows van Gogh already having difficulty preserving that relaxed mood. The figure seen from the rear is already in position and has even less point here than in the final painting, merely looking geometrical and stiff compared with the other four characters in the scene. The sense of a brief moment caught by chance in a cosy parlour and preserved as in a snapshot is still present, but a shift towards universal, emblematic significance is already visible in the balancing of the younger and older couples, the one with food and the other with drink, looking as if they had been conceived uniformly.

The final version now in Amsterdam, meticulously painted and then signed, has eliminated all trace of spontaneous reportage and substituted the forced authority of a historical scene. One detail serves to indicate the way van Gogh had changed his approach. In the second (Otterlo) version the old woman is holding the coffee pot so that we see it side-on, flat against the canvas, as it were, as she pours. But in the final painting she is holding the pot so that it is turned towards us as she pours; this helps create an illusion of spatial depth, and in the demands it makes on the artist's virtuoso brush technique it is evidently the more

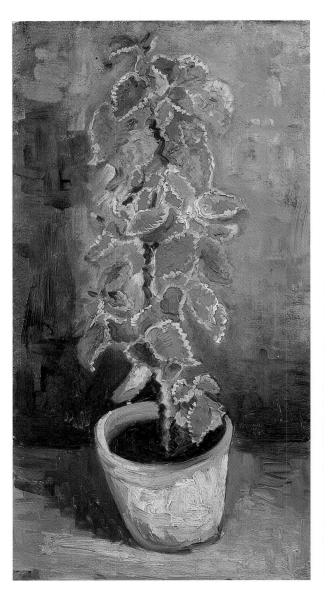

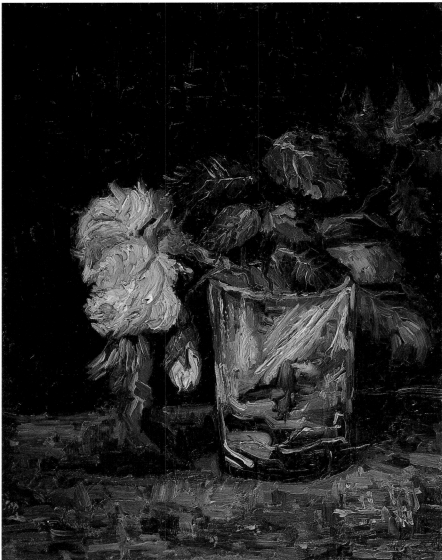

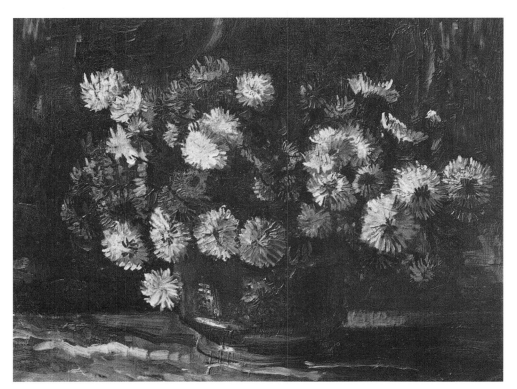

Coleus Plant in a Flowerpot
Paris, Summer 1886
Oil on canvas, 42 x 22 cm
F 281, JH 1143
Amsterdam, Rijksmuseum Vincent van
Gogh, Vincent van Gogh Foundation

Glass with Roses
Paris, Summer 1886
Oil on cardboard on multiplex board,
35 x 27 cm
F 218, JH 1144
Amsterdam, Rijksmuseum Vincent van
Gogh, Vincent van Gogh Foundation

Bowl with Chrysanthemums
Paris, Summer 1886
Oil on canvas, 46 x 61 cm
F 217, JH 1164
United States, Private collection

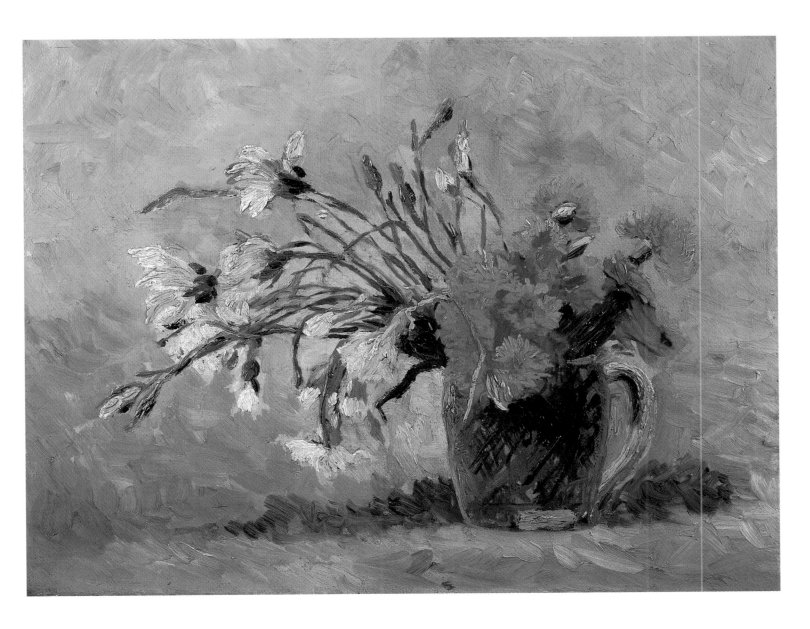

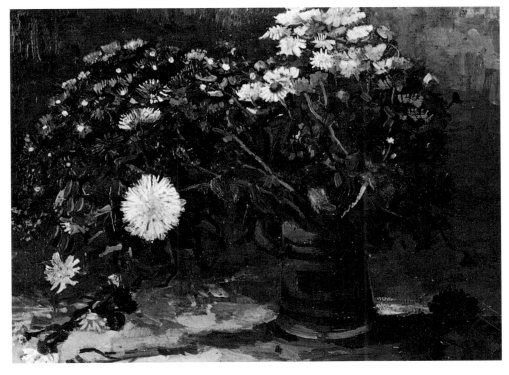

Vase with Red and White Carnations on Yellow Background
Paris, Summer 1886
Oil on canvas, 40 x 52 cm
F 327, JH 1126
Otterlo, Rijksmuseum Kröller-Müller

Vase with Daisies
Paris, Summer 1886
Oil on paper on panel, 40 x 56 cm
F 197, JH 1167
Philadelphia, The Philadelphia Museum
of Art

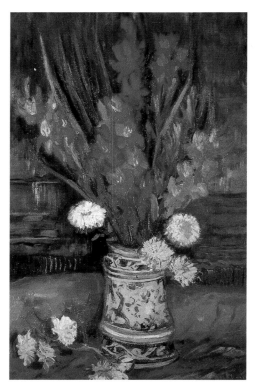

Vase with Red Gladioli
Paris, Summer 1886
Oil on canvas, 65 x 40 cm
F 247, JH 1149. Private collection
(Sotheby's Auction, London, 3. 7. 1973)

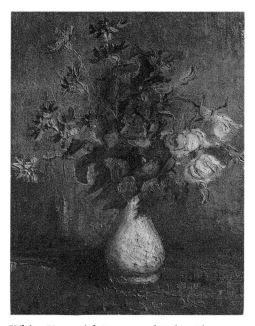

White Vase with Roses and Other Flowers
Paris, Summer 1886
Oil on canvas, 37 x 25.5 cm
F 258, JH 1141. Private collection

Vase with Carnations and Other Flowers
Paris, Summer 1886
Oil on canvas, 61 x 38 cm
F 596, JH 1135
Washington, David Lloyd Kreeger

ambitious solution. But it also betrays his wish to have the whole picture seen as a synthesis or summary of all he had learnt, technically and conceptually, in his life as a painter up till then.

"You will agree that a work like this cannot be meant seriously. Fortunately you are capable of better things; but why ever have you viewed and treated everything in the same superficial way? Why did you not study their movements thoroughly? What you have here are poses." This, and more of a similar nature, was Rappard's criticism. It has come down to us because van Gogh sent the letter (R51a) back by return in a fit of indignation. Rappard had only seen a lithograph based on the Otterlo version. But his comments are not insensitive, nor unjust; and they would have applied all the more to the final version. Of course we must bear in mind that van Gogh's young friend, who had visited Nuenen and had also been sent countless sketches in letters, was thoroughly familiar with Vincent's artistic progress, and had naturally seen work that was stylistically coarser, compositionally clumsier, and less mature in choice of subject than van Gogh's beloved *Potato Eaters*. He was finding fault with a forced quality in the ugliness of the figures, the spartan bareness of the interior, and the violence of the brushwork. He was objecting to van Gogh's sophisticated tone in discussing his own work and trumpeting a manifesto abroad. And Rappard was right: the figures *are* poses. The whole picture is a pose.

This impression is confirmed by the notable degree of success van Gogh critics have had in locating models for *The Potato Eaters*. All of these antecedents, whether by Léon Lhermitte (an imitator of Millet) or Israëls (a painter in The Hague), show groups gathered round a supper table by artificial light. It was a popular subject in the 19th century. It is only when we see van Gogh's painting in the light of his ambition (in appropriating an entire tradition for his own purposes) that we grasp the picture's real significance in his oeuvre. Van Gogh knew of the contemporary debate on the aesthetic issues he broached in the work: ugliness, truthfulness, rustic life, and (including all of this) the question of modernity. Van Gogh followed the intellectual affairs of his times alertly, offering (for example) his own critique of Zola's masterpiece *Germinal* a brief four weeks after the novel was published (in Letter 410); so he would undoubtedly have been familiar with the aesthetic debates relevant to his own art.

In his *Aesthetics*, Georg Wilhelm Friedrich Hegel had stressed that the principle of what is characteristic must include ugliness and the representation of ugliness. It was the most influential work on aesthetic theory in the 19th century; and Hegel continued to state that the artist attempting to tackle his subject without prejudice, value judgement or over-sensitive scruple could go as far as caricature in the interests of precision. Indeed, ugliness of presentation would be certain proof of the artist's commitment to honest treatment. The common folk were of

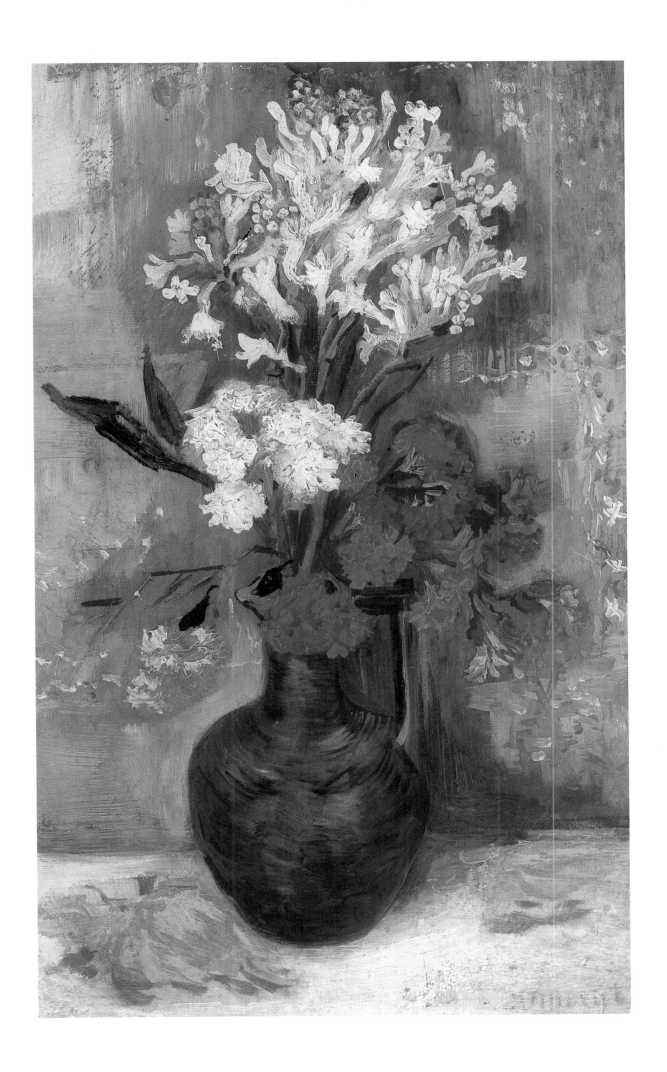

Vase with Zinnias and Geraniums
Paris, Summer 1886
Oil on canvas, 61 x 45.9 cm
F 241, JH 1134
Ottawa, National Gallery of Canada

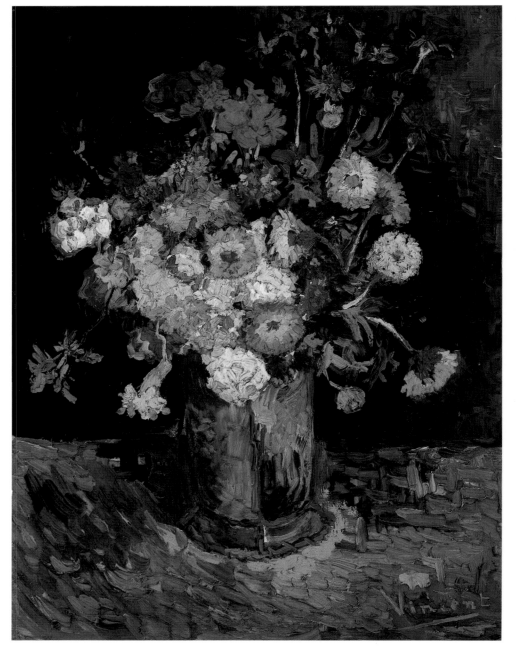

Vase with Viscaria
Paris, Summer 1886
Oil on canvas, 65 x 54 cm
F 324a, JH 1137
Cairo, Museum of Modern Art

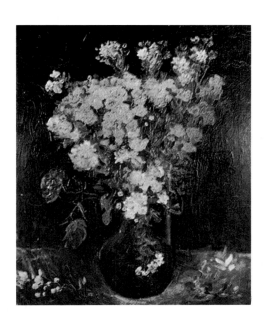

course predestined for the realm of ugly presentation; Carlyle had written that the rough, weathered, dirty face of the simple man with his straightforward intelligence was venerable because it was the face of a man living the life that Man was made for. The ill-treated worker or peasant, who had hitherto always got the dirty end of the stick and was society's beast of burden, was in demand again as the hero of democracy. On him were focussed dreams and hopes of a better world that would be uncultured but also unspoilt, simple but truthful, a life integral and entire lived in harmony with the elements: "Do not forget that I intend always to remain an artist, a novelist, in order to present all the creative power of the earth: in the image of the seasons, of work in the fields, of peasant life, of animals, of landscape that is a home to all creatures! Simply report that my presumptuous ambition is to cram the whole of peasant life into my book: work and love, politics and religion, past and

Vase with Zinnias
Paris, Summer 1886
Oil on canvas, 61 x 48 cm
F 252, JH 1140
Washington, Collection David Lloyd
Kreeger

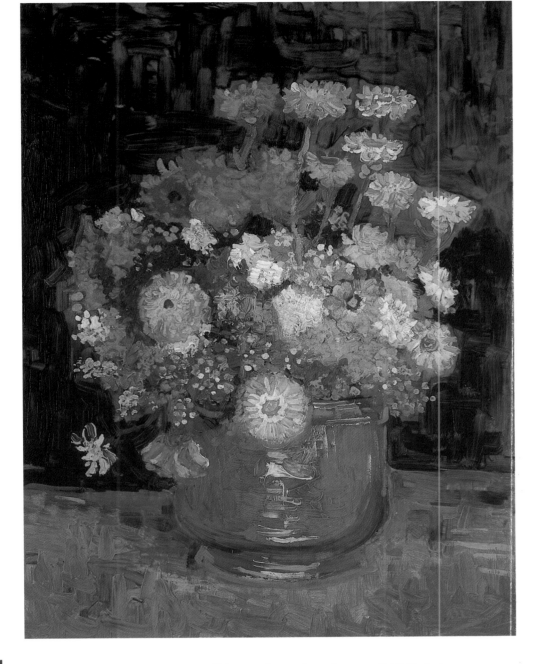

Geranium in a Flowerpot
Paris, Summer 1886
Oil on canvas, 46 x 38 cm
F 201, JH 1139
Private collection
(Sotheby's Auction, London, 4. 7. 1973)

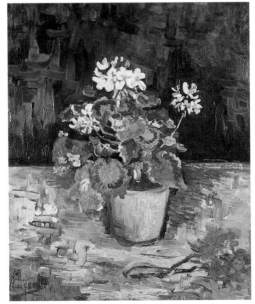

present and future too. It will be nothing but the truth!" Zola's programmatic comments on the origins of his book *La Terre* summed up the artistic creed of an entire generation. Vitality, truth, and the fundamental experiences of life, were their goals. And they could only be reached with the help of the common folk's integrity.

Soon after completing *The Potato Eaters*, van Gogh added a written manifesto to the painted one: Letter 418, in which he reviews the thoughts that guided him while he was working on the picture. Paintings, he declared, needed to be created "with willpower, feeling, passion and love" and not with the hair-splitting subtleties "of these experts who are acting more important than ever nowadays, using that word 'technique' that is so often practically meaningless." Art could meet the world it served in sensitivity towards the simple and of course positive life of the underprivileged. The technology of the machine age and the

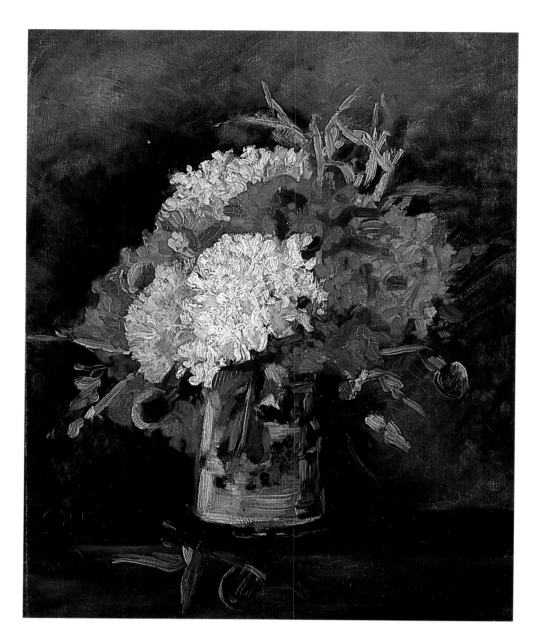

Vase with Carnations
Paris, Summer 1886
Oil on canvas, 40 x 32.5 cm
F 220, JH 1138
Rotterdam, Willem van der Vorm-Stichting

Vase with Carnations
Paris, Summer 1886
Oil on canvas, 46 x 38 cm
F 243, JH 1129
New York, Collection Charles B. Murphy

Vase with White and Red Carnations
Paris, Summer 1886
Oil on canvas, 58 x 45.5 cm
F 236, JH 1130
Whereabouts unknown

Vase with Carnations and Zinnias
Paris, Summer 1886
Oil on canvas on panel, 61 x 50.2 cm
F 259, JH 1132
Private collection
(Christie's Auction, New York, 10. 11. 1987)

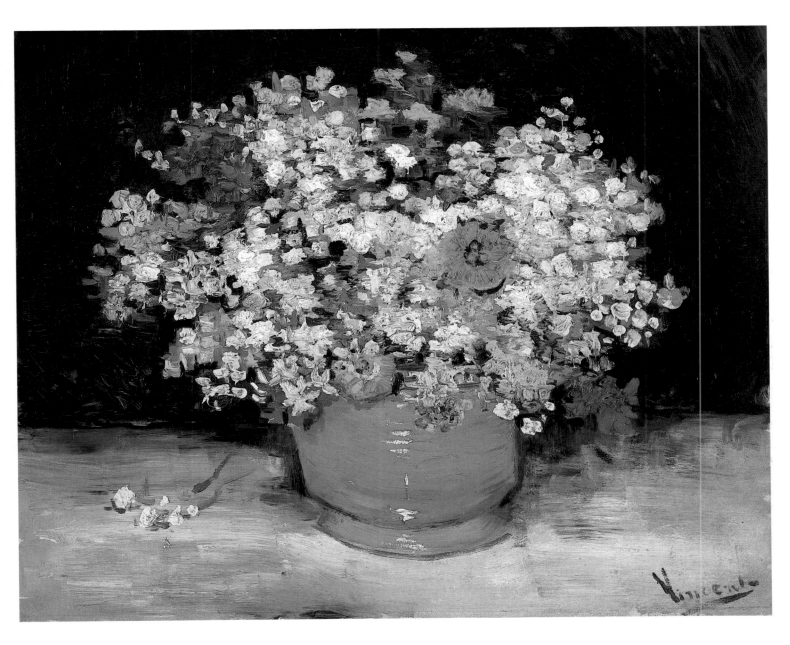

Vase with Zinnias and Other Flowers
Paris, Summer 1886
Oil on canvas, 50.2 x 61 cm
F 251, JH 1142
Ottawa, National Gallery of Canada

technique of academic rules were both aimed at destroying that way of life. Artist and worker could experience solidarity when confronted with faceless mechanisms.

In these theories, a belief in progress is paradoxically linked with hostility towards all things technical. The criticism is directed quite radically at the very roots of communal existence. If a new beginning was to be made at a profound level, the roots first had to be laid bare, cleared of the accretions of the status quo. We shall be returning to these thoughts, which became so central to Modernism. In order to understand what it is that gives *The Potato Eaters* manifesto status it is sufficient to grasp van Gogh's deliberate rejection of virtuoso technique. What Charles Baudelaire wrote in his essay on the "painter of modern life", of the city, Constantin Guys, might just as well have been applied to van Gogh: "He started out by looking at life, and only at a late stage did he go to the trouble of acquiring the means of expressing life. What resulted was striking originality, and whatever barbaric or naive qual-

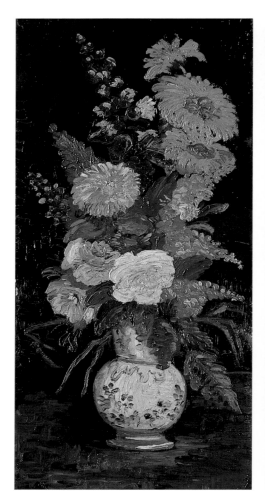
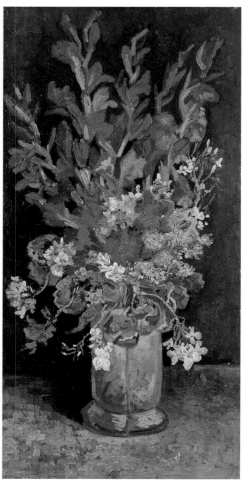
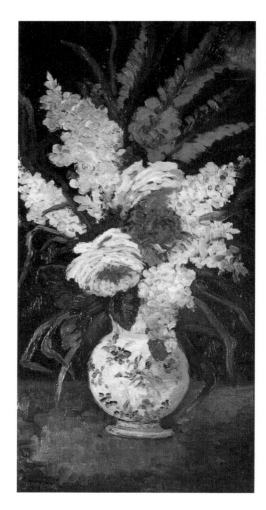

ities still remained now attested his fidelity to his impressions, a kind of flattery offered to Truth." The immemorial function of pictures, to prettify the true image, was replaced by the wish for authenticity: "flattery offered to Truth" is a magnificent euphemism for the fact that modern art was out to record ugliness.

"Instead of saying: a man digging must have character", van Gogh went on in Letter 418, "I prefer to express it in a different way, saying: this peasant must be a peasant, this man digging must be digging. Then there is something in it that is essentially modern." Everyday drudgery had left its mark on the faces of these people. Their backs were bent. Consistently enough, a painting conceived in the modern spirit would have to highlight these facts if it was to give a characteristic account of the times. It was ugly, it was coarse, it was authentic ... it was modern.

Van Gogh authoritatively incorporated all these elements into *The Potato Eaters*. The peasant as hero of a better world, ugliness as proof of verisimilitude, of his reality, and a claim to truthfulness that demanded not only solidarity but a life literally lived side by side – all of this can be seen in the painting. Hitherto van Gogh had taken all of this for granted, and had produced artistic concoctions all of his own that no one wanted to know about. But now he went over to the offensive, with a manifesto on his banner. The German classical sculptor Johann Gottfried Schadow once wrote that Rembrandt was perhaps the biggest liar in the

Vase with Asters, Salvia and Other Flowers
Paris, Summer 1886
Oil on canvas, 70.5 x 34 cm
F 286, JH 1127
The Hague, Haags Gemeentemuseum

Vase with Gladioli and Carnations
Paris, Summer 1886
Oil on canvas, 78.5 x 40.5 cm
F 242, JH 1147
Private collection
(Sotheby's Auction, London, 1. 7. 1970)

Vase with Gladioli and Lilac
Paris, Summer 1886
Oil on canvas, 69 x 33.5 cm
F 286a, JH 1128
Ballwin (Mo.), Collection Edwin McClellan Johnston

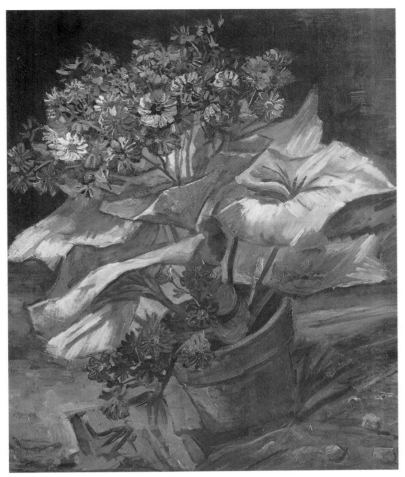 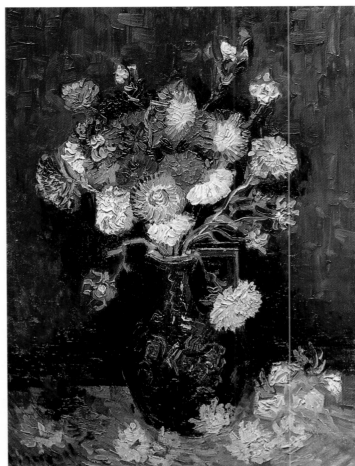

Cineraria in a Flowerpot
Paris, July-August 1886
Oil on canvas, 54.5 x 46 cm
F 282, JH 1165
Rotterdam, Museum Boymans-van
Beuningen

Vase with Asters and Phlox
Paris, late Summer 1886
Oil on canvas, 61 x 46 cm
F 234, JH 1168
Amsterdam, Rijksmuseum Vincent van
Gogh, Vincent van Gogh Foundation

history of art, but he never contradicted himself, and kept to a consistent story. In Letter 418 van Gogh addressed himself to this comment: "Tell him I long more than anything to learn how to do things wrong, how to create discrepancies, adaptations, changes to reality, so that it all becomes — well, lies if you like, but truer than literal truth." In *The Potato Eaters* van Gogh told a deliberate, posed lie — in the profound hope of articulating the truer truth all the more forcefully.

Understanding and Suspicion
Summer and Autumn 1885

"The party Vincent Willem van Gogh departed during the inventory proceedings without giving any reasons." Thus the bureaucratic version of van Gogh's sudden departure while Pastor Theodorus van Gogh's last will was being executed. In May 1885, apparently revolted by the bureaucratic arrangements that had accompanied the death of his father, and at odds with his mother and siblings, van Gogh left the

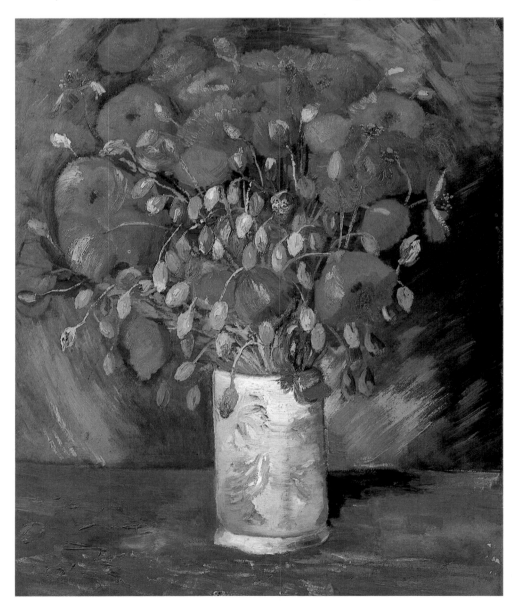

Vase with Red Poppies
Paris, Summer 1886
Oil on canvas, 56 x 46.5 cm
F 279, JH 1104
Hartford (Conn.), Wadsworth Atheneum

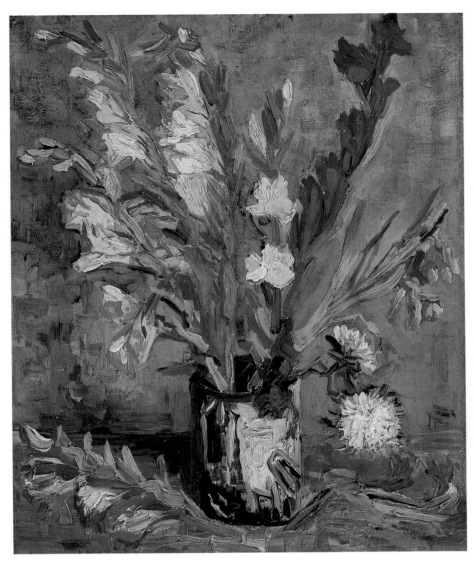

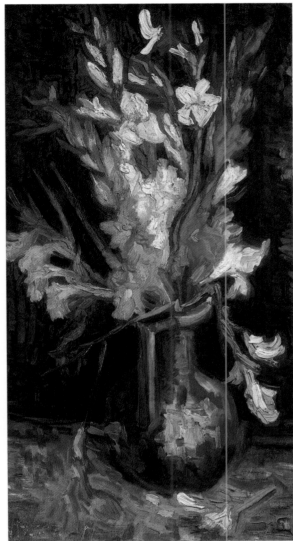

vicarage. He rented a studio from the sexton of Nuenen's Catholic community – that is to say, again from a man of the church, as if he needed the daily confrontation with his own longing for spiritual well-being. In the course of the next six months, four series were done in this studio: one showing peasants at work in the fields, one showing cottages in the vicinity, one set of still lifes, and finally – the last series of his Dutch period – a number of subtle studies of the autumn landscape.

Van Gogh's main subject in 1885 was perhaps the potato. He not only painted the eating of potatoes. He also did a number of still lifes of potatoes in baskets or crates. Furthermore, he followed the growing of potatoes, from the planting to the lifting, in a series showing people digging. *Peasant and Peasant Woman Planting Potatoes* (p. 101), for instance, was painted at about the same time as *The Potato Eaters*, in April 1885. The style and format suggest that this painting was only a preliminary study. In subject it returns to the thematic concerns of van Gogh's period in The Hague. "Peasants digging", he had written at that time (Letter 286), "are closer to my heart, and I have found things better outside paradise, where the literal meaning of 'the sweat of his brow' becomes apparent." Rural folk toiling to live off the fruits of the land

Vase with Gladioli
Paris, late Summer 1886
Oil on canvas, 46.5 x 38.5 cm
F 248a, JH 1148
Amsterdam, Rijksmuseum Vincent van Gogh, Vincent van Gogh Foundation

Vase with Red Gladioli
Paris, Summer 1886
Oil on canvas, 65 x 35 cm
F 248b, JH 1150
Morges (Switzerland), Collection J. Planque

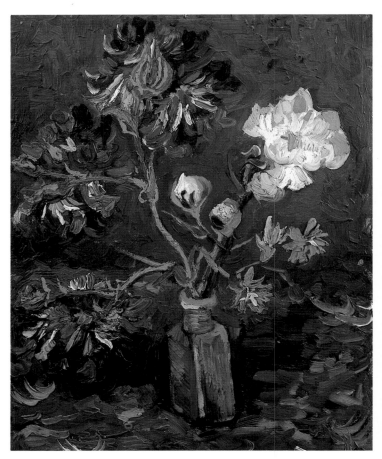 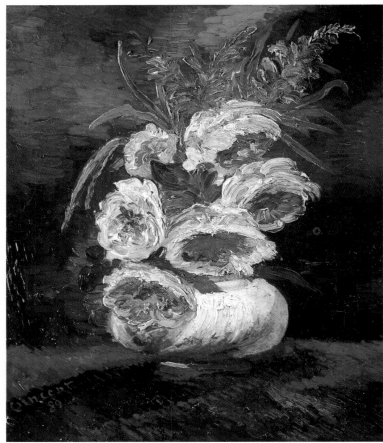

Vase with Myosotis and Peonies
Paris, June 1886
Oil on cardboard, 34.5 x 27.5 cm
F 243a, JH 1106
Amsterdam, Rijksmuseum Vincent van
Gogh, Vincent van Gogh Foundation

Vase with Peonies
Paris, Summer 1886
Oil on canvas, 54 x 45 cm
F 666a, JH 1107
Private collection
(Sotheby's Auction, London, 3. 12. 1985)

provided van Gogh with a metaphor for his own endeavours even at that date – and also with a metaphoric way of expressing his hope that one day he would be able to earn a modest living with his art. Now in Nuenen, van Gogh was all the better able to see a Biblical dignity in the labours of the poor peasantry, having seen at close quarters what was previously little more than a tenet of faith. His way of seeing, guided by allegorical concepts, discovered in rural life a realm onto which, irrespective of fashion, he could project all his own needs for comfort and consolation.

Two Peasant Women Digging Potatoes (p. 117), a summer scene, shows the fruits of toil being gathered in, and is thus a companion piece to the April painting. One simple insight makes these pictures minor masterpieces of their kind: the realization that at the beginning and the end of the process the same torture is involved – back-breaking bending, calluses on the hands, hard and stony earth to struggle with. "The sweat of his brow" is a perpetual fact of life. In this work, van Gogh has also enriched his series principle by a further quality. The motif appears unchanged and we might conclude that van Gogh had made no progress as an artist, but we should not interpret the lack of change as a sign of incompetence; the series is unchanging because the reality it describes is also inexorably and unchangingly the same. The motif, programmatically constant, underwent significant technical renewal as the series evolved. The figures in the later work have an arresting physical pres-

ence compared with those in the Zurich picture (p. 101). These peasant women's corporeal presence is heavy and emphatic, quite unlike the earlier dependence on line in their solidity. Van Gogh was abandoning the line fixation that automatically accompanied his training in drawing and in his case took the place of a thorough grounding in his craft. And again it was Delacroix who was his guide: "Currently, when I draw a hand or an arm, I am trying to practise what Delacroix says about drawing: *ne pas prendre par la ligne, mais par le milieu* [start not with the line but with the middle]", he wrote in Letter 408 (May 1885). "What I am out to establish is not that I can draw a hand but that I can capture the gesture, not that I can render a head with mathematical precision but that I can show deep feelings in an expression. For inst-

Vase with Hollyhocks
Paris, August-September 1886
Oil on canvas, 91 x 50.5 cm
F 235, JH 1136
Zurich, Kunsthaus Zürich

Vase with Gladioli and Carnations
Paris, Summer 1886
Oil on canvas, 65.5 x 35 cm
F 237, JH 1131
Rotterdam, Museum Boymans-van Beuningen

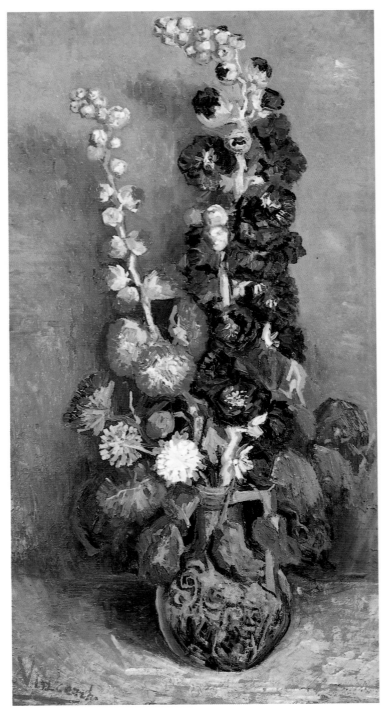

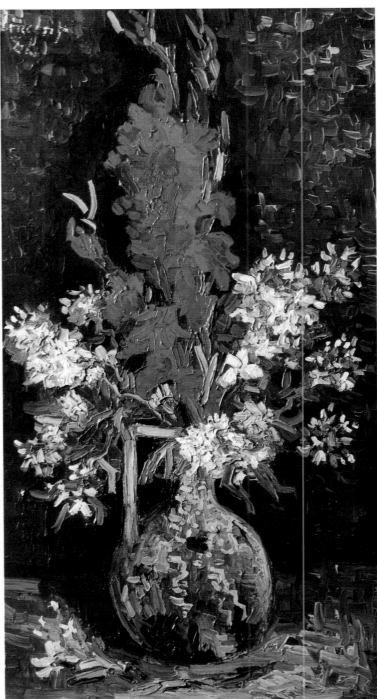

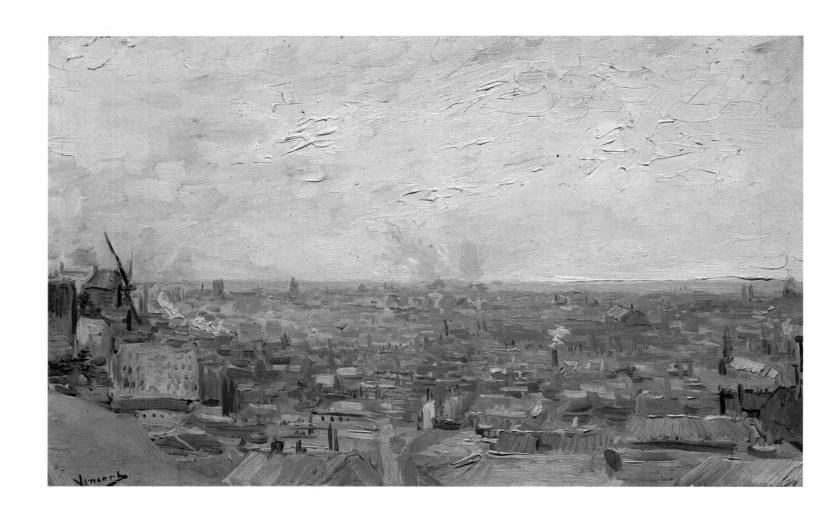

View of Paris from Montmartre
Paris, late Summer 1886
Oil on canvas, 38.5 x 61.5 cm
F 262, JH 1102
Basle, Öffentliche Kunstsammlung,
Kunstmuseum Basel

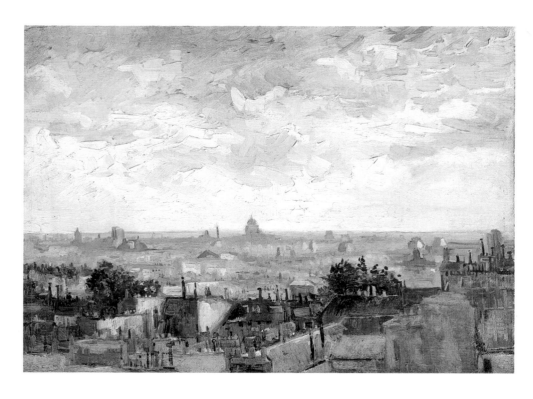

View of the Roofs of Paris
Paris, late Summer 1886
Oil on canvas, 54 x 72.5 cm
F 261, JH 1101
Amsterdam, Rijksmuseum Vincent van
Gogh, Vincent van Gogh Foundation

ance, when a man digging looks up to draw a deep breath; or speaking – in a word, life." His whole endeavour as an artist was focussed on the vitality in things. And he had chosen his side in the age-old debate between the advocates of line and the advocates of colour, a debate fought out in his own era by Jean Auguste Dominique Ingres and Delacroix. In making his choice, van Gogh also made possible the wild and unexpectedly powerful uses of colour which we nowadays associate with his name; though of course in the short term he was simply making up ground that a thoroughly-trained art student would already have covered.

"In point of fact I intend to paint the cottage picture again. I found the subject particularly absorbing: the two tumbledown cottages under one and the same thatched roof reminded me of a weary old couple that have become a single being and lend each other mutual support" (Letter 410). The change in technique and the instinct to tackle the cottages in the vicinity sprang from the same need to create a feel of vitality. Unlike

A Pair of Shoes
Paris, second half of 1886
Oil on canvas, 37.5 x 45 cm
F 255, JH 1124
Amsterdam, Rijksmuseum Vincent van Gogh, Vincent van Gogh Foundation

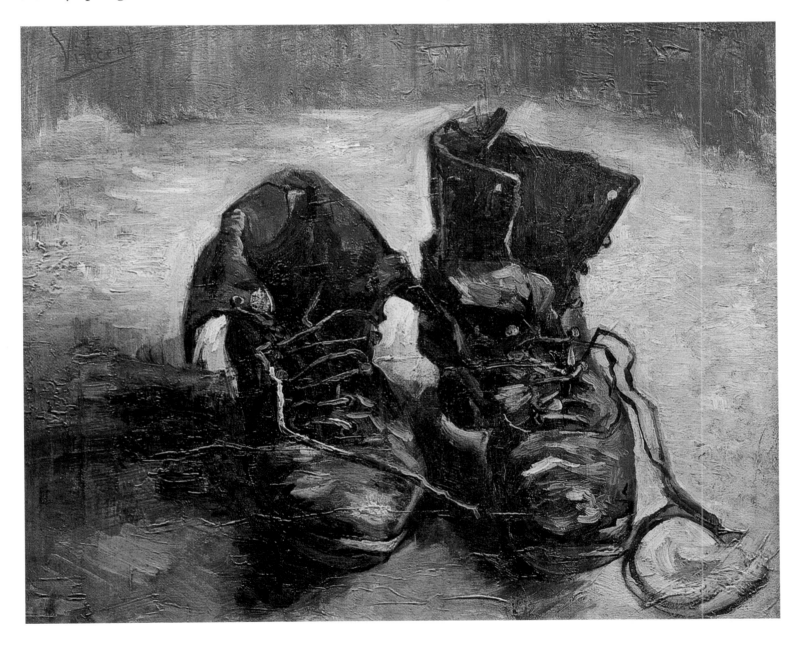

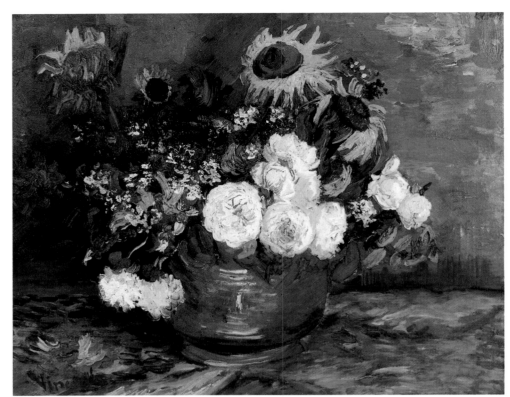

Bowl with Sunflowers, Roses and Other Flowers
Paris, August-September 1886
Oil on canvas, 50 x 61 cm
F 250, JH 1166
Mannheim, Städtische Kunsthalle

Still Life with Mussels and Shrimps
Paris, Autumn 1886
Oil on canvas, 26.5 x 34.5 cm
F 256, JH 1169
Amsterdam, Rijksmuseum Vincent van
Gogh, Vincent van Gogh Foundation

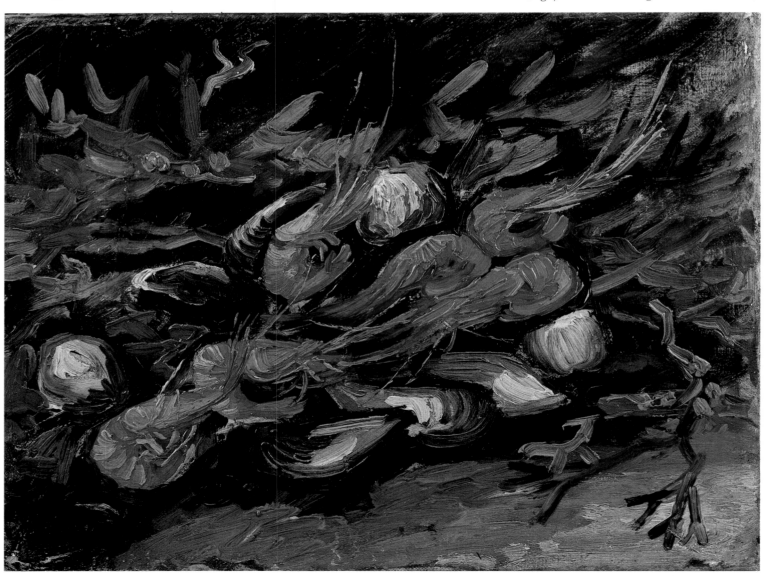

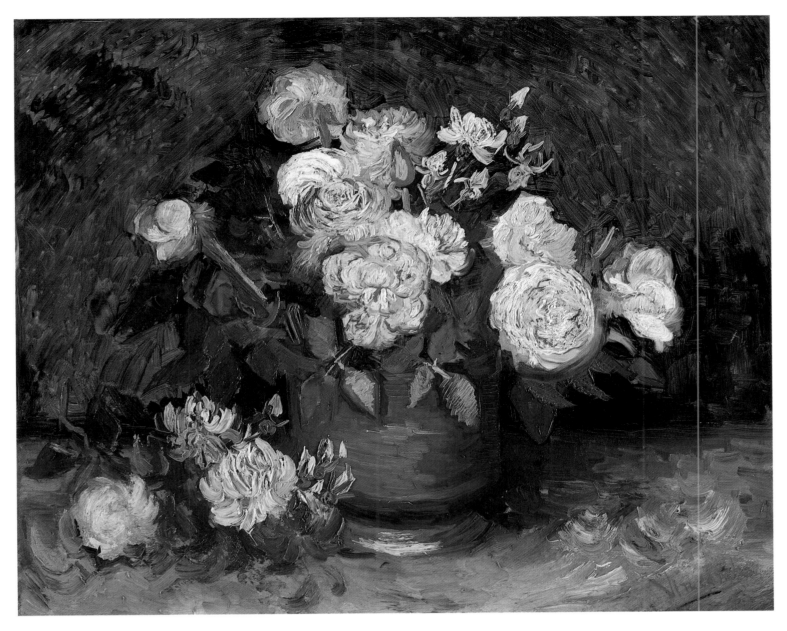

Bowl with Peonies and Roses
Paris, Autumn 1886
Oil on canvas, 59 x 71 cm
F 249, JH 1105
Otterlo, Rijksmuseum Kröller-Müller

those in Drente, these homesteads have individual personalities, and are as straightforward and self-assured as those who dwell in them. Thatched, and surrounded by trees, they form an organic unity with their natural environment and, like the peasants' work in the fields, they record the presence of human activity. Like their owners they are rustic and natural; they are like open air summer portraits following upon the studio work of the winter. The cottages are van Gogh's protagonists, and the people seen near them are like attributes. The woman, goat and hens in *Cottage and Woman with Goat* (p. 111) have no value in their own right; there is no distinction between them, and they merely serve to point up the farming milieu of the cottage. They supply the story, so to speak, and the modest building's personal background.

"The cottage with the mossy roof reminds me of a wren's nest", wrote van Gogh in Letter 411. It is no longer a very great step from this association to the series of still lifes with birds' nests that he painted the following autumn (pp. 118 and 126-7). They are indeed *nature morte*;

van Gogh's respect for living things was too great for him to disturb a nest, and he did not find them locally himself. Instead he started a collection. His detached approach, valuing the artistic arrangement above authentic portrayal of Nature, was very different from that of the English artist William Henry Hunt, who had specialized in the subject with an eye to the new life amidst the burgeoning twigs. Quite uncharacteristically, van Gogh approached these beautifully-worked objects in the same way as he was viewing fruit and potatoes in *Still Life with an Earthen Bowl and Pears* (p. 123) or *Still Life with a Basket of Potatoes* (p. 122) at the same period. He stacked them up against a dark, monochrome background, with only one or two scattered highlights to alleviate the gloom, in his quest for a way of balancing weighty solidity and lightness, amassed quantities and individual items, surface and detailed depth.

Up to this point, he had painted still lifes in the winter. Why did van Gogh retreat to his studio on those fine late summer days to agonize over artistic arrangements? The peasants who lived in the cottages were familiar to him from countless portrait sittings – why did they now appear so curiously faceless, compared with their charismatic abodes? Of course van Gogh's subjects are related to the people who live in them, who built them and take pleasure in them. Of course these pictures are

Self-Portrait with Pipe
Paris, Spring 1886
Oil on canvas, 27 x 19 cm
F 208, JH 1195
Amsterdam, Rijksmuseum Vincent van Gogh, Vincent van Gogh Foundation

Two Self-Portraits and Several Details
Paris, Autumn 1886
Pencil, pen, 31.5 x 24.5 cm
F 1378r, JH 1197
Amsterdam, Rijksmuseum Vincent van Gogh, Vincent van Gogh Foundation

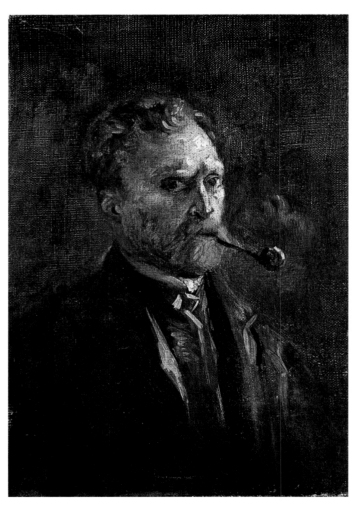

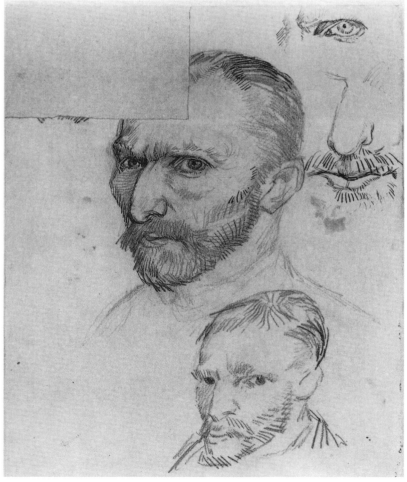

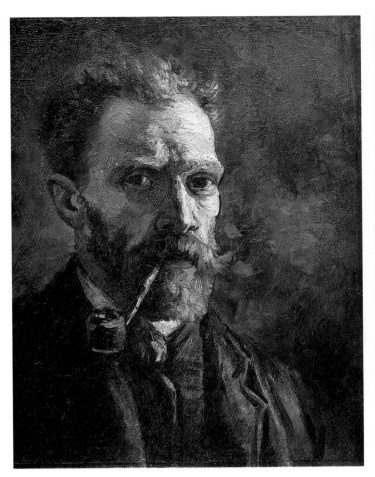

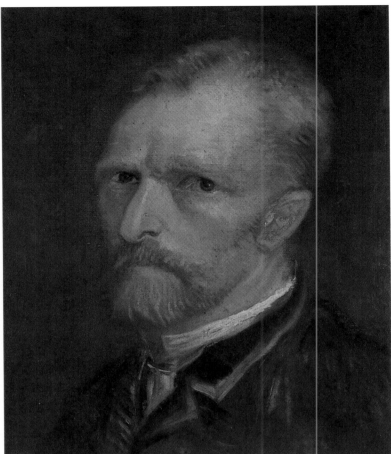

metaphoric ways of examining feelings of contentment or security. Nonetheless, the rustic pathos of the cottages and the cornucopia of fruit and vegetables seem almost too positive and assertive for them to be easily accommodated in van Gogh's oeuvre. We begin to suspect that first and foremost the artist needed the optimism these paintings express for his own purposes, to compensate for his own wrecked hopes.

After his father's death, Vincent had realized how vital a part the pastor's protecting hand and natural authority had played in his life. He had hardly moved out of the vicarage before becoming a target of hostility that soon soured his life in Nuenen. The year before he had already occasioned a local scandal when an unmarried village woman who had fallen in love with him, and could not cope with the conflict between her feelings and the pressure her family brought to bear, tried to kill herself. She had swallowed poison and then collapsed while out walking with Vincent – unfortunate timing. Her life was saved, but the blame was heaped on the artist. When there was more bad news he was blamed again: a peasant girl who had posed for him got pregnant, and, since his name had already been ruined, it was easy to see him as the guilty party. At all events, the Catholic priest had a field day, forbidding his flock to associate with the painter. The friendship with these simple people, which van Gogh (as the paintings attest) had arduously been establishing, step by step, disappeared at the behest of the churlish priest. Not

Self-Portrait with Pipe
Paris, Spring 1886
Oil on canvas, 46 x 38 cm
F 180, JH 1194
Amsterdam, Rijksmuseum Vincent van Gogh, Vincent van Gogh Foundation

Self-Portrait
Paris, Autumn 1886
Oil on canvas, 39.5 x 29.5 cm
F 178v, JH 1198
The Hague, Haags Gemeentemuseum

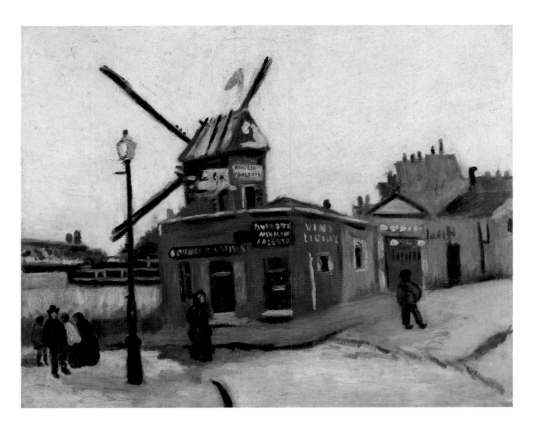

Le Moulin de la Galette
Paris, Autumn 1886
Oil on canvas, 38 x 46 cm
F 226, JH 1172
Baden (Switzerland), L. S. and J. Brown
Foundation

that there was ever any risk that his disapproval would have fallen on stony ground; several of van Gogh's neighbours already found the artist rather odd.

So the pictures of people digging, done in summer 1885, were van Gogh's last opportunity to indulge his belief that he was a figure painter. The crowning achievement and the finale of his Dutch period were the autumn landscapes painted in October and November 1885. It seems

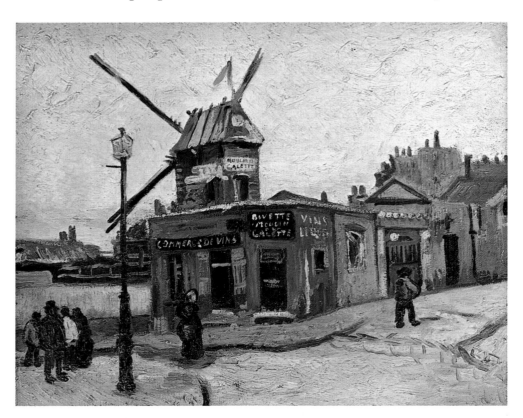

Le Moulin de la Galette
Paris, Autumn 1886
Oil on canvas, 38 x 46.5 cm
F 228, JH 1171
West Berlin, Nationalgalerie SMPK

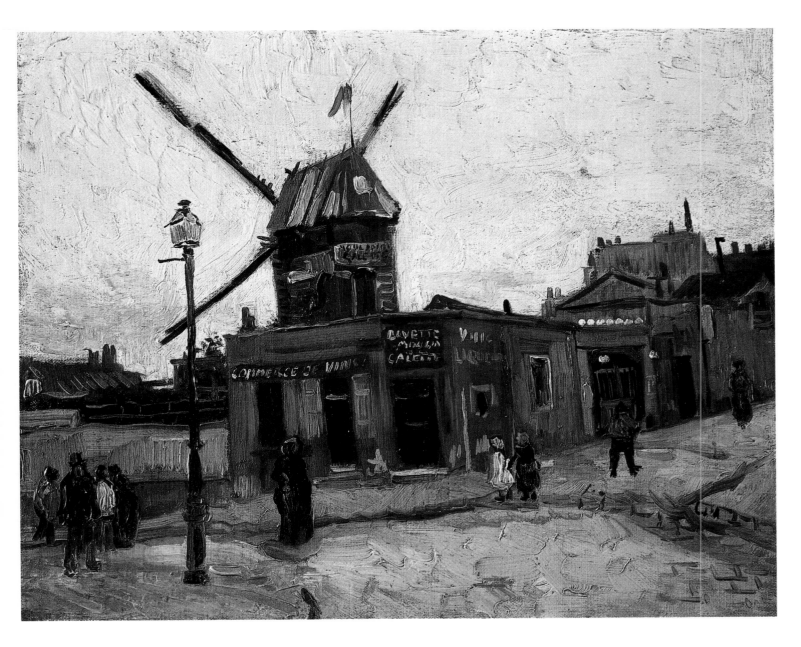

fair to describe them as his crowning achievement if we take mimetic competence or time-honoured strategies in composition and use of colour as our criteria – that is, if we view them with an eye schooled by the academies. Paintings such as *Autumn Landscape* (p. 131) or *Autumn Landscape with Four Trees* (pp. 132-3) would doubtless appeal to any academician. Van Gogh has chosen his position with care, finding a happy midpoint between proximity and remoteness. In so doing he avoids being overwhelmed by the sheer power of Nature, as often happens with him; his motifs, though, retain their vivid immediacy, maintaining a kind of direct contact with the artist and at the same time preserving their metaphoric impact. Van Gogh's gaze is neither detached nor slavish – it is well-balanced. If we consider his early work as a whole as deriving from the premise that realism (the artist's objective) consists in matching the visual impressions conveyed by the object with the visual impressions conveyed by the painting, then this work represents the sum and peak of what was then within van Gogh's power.

Le Moulin de la Galette
Paris, Autumn 1886
Oil on canvas, 38.5 x 46 cm
F 227, JH 1170
Otterlo, Rijksmuseum Kröller-Müller

**Terrace of a Café on Montmartre
(La Guinguette)**
Paris, October 1886
Oil on canvas, 49 x 64 cm
F 238, JH 1178
Paris, Musée d'Orsay

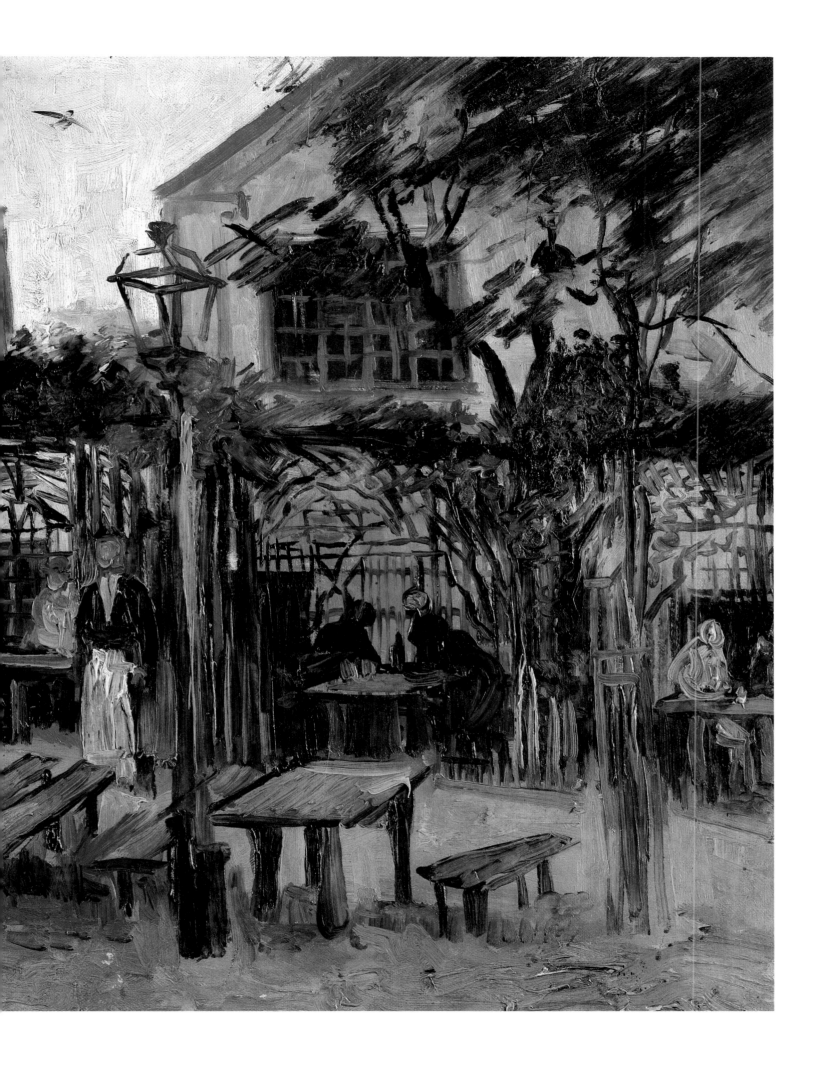

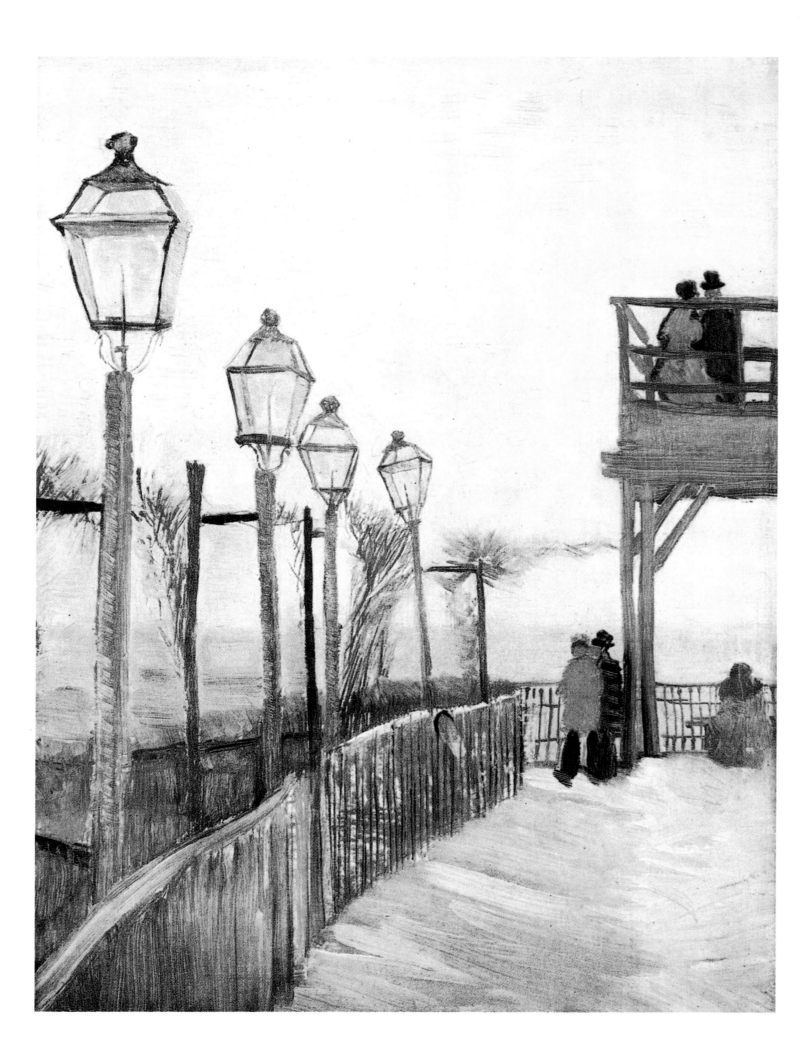

He had perfected an idiom of understanding and rapprochement, and (as the autumn landscapes prove) had learnt whatever he could learn in the province. And van Gogh was shortly to make radical changes both in his place of residence and in his artistic idiom.

Given the way his standing with the villagers had changed, departure was inevitable. In any case, van Gogh was also growing increasingly aware of a need to experience city life again. The pleasure he took in the simple life had obscured this need; but now he realized that his knowledge of the art world was all hearsay culled from Theo's Paris letters and the visits of friends. His information was all second-hand. He had never even set eyes on an Impressionist painting. And as a result his work tended to be overburdened with theory: he had to milk Nuenen's modest resources of all the subjects the village had to offer, and articulate everything he had resolved to say. We often find that there is a discrepancy between the sensuous visual impact of his pictures and that forced symbolism which his letters (rather than the works themselves) induce us to infer. The time had now come for van Gogh to enter the art world proper. Doubtlessly he had sufficient confidence in his abilities to face the confrontation with equanimity. Indeed, his confidence had been such that he had already produced a manifesto picture, *The Potato Eaters*. He now had his qualifications, and could go out into the fight for recognition. Millet, his *alter ego*, whose paintings of peasants (which he supposed could only have been done amidst simple folk) had always been a model and inspiration to him, had ventured into the capital cities too. In October, van Gogh went to Amsterdam for a few days, for the first time since moving to the country. There he wandered about the great museums, and realized that the old masters still had a great deal to tell him. And he in turn had questions to put to them. He decided to do so, starting in Antwerp, city of Peter Paul Rubens.

Windmill on Montmartre
Paris, Autumn 1886
Oil on canvas, 46.5 x 38 cm
F 271, JH 1186
Destroyed by fire in 1967

Twilight, before the Storm: Montmartre
Paris, Summer 1886
Oil on cardboard, 15 x 10 cm
F 1672, JH 1114. Private collection

LEFT:
Montmartre near the Upper Mill
Paris, Autumn 1886
Oil on canvas, 44 x 33.5 cm
F 272, JH 1183
Chicago, The Art Institute of Chicago

Colour and the Finished Work
Evolving a Theory of Art

"His art had greater depth and scope than he ever consciously realized. To a certain extent, indeed, his theories obscured his practice." Thus Kurt Badt in his study of van Gogh's theory of colour. Badt is thinking not only of the obvious difference between visual and verbal articulation of an insight; more than that, he believes van Gogh's work centres upon something essentially inexpressible. This interpretation naturally confines the work within the worldview van Gogh himself espoused: the Romantic. But in fact van Gogh wrote more eloquently than any other artist about his guiding principles in painting; and frequently the ideas he set down on paper anticipated procedures he would adopt in pictures as yet unpainted. The foundation was not the inexpressible; it was the unpaintable. Distress at his own lack of talent in converting his

View of Montmartre with Windmills
Paris, Autumn 1886
Oil on canvas, 36 x 61 cm
F 266, JH 1175
Otterlo, Rijksmuseum Kröller-Müller

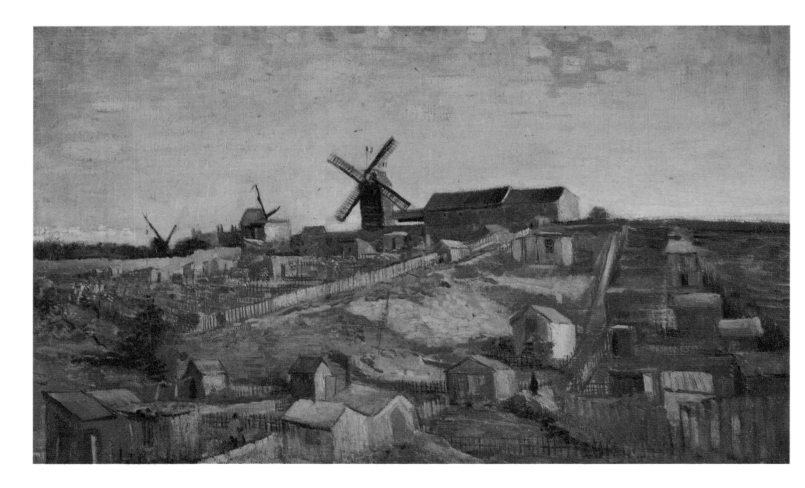

Le Moulin de la Galette
Paris, Autumn 1886
Oil on canvas, 55 x 38.5 cm
F 349, JH 1184
Newark (N.J.), Collection Charles W.
Engelhard

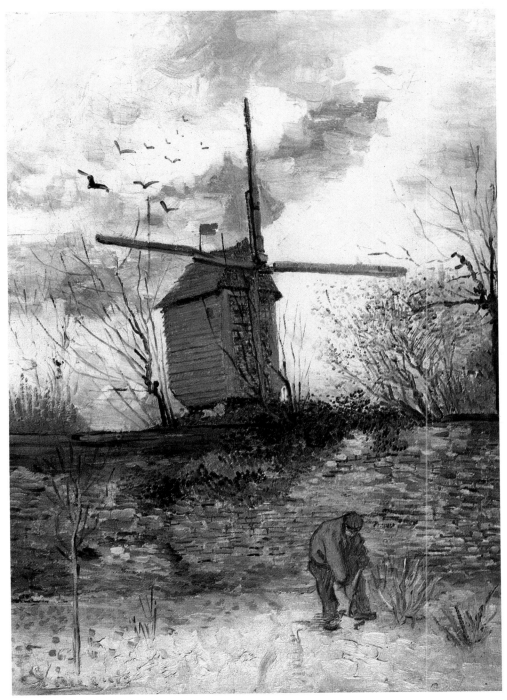

Le Moulin de la Galette
Paris, Autumn 1886
Oil on canvas, 61 x 50 cm
F 348, JH 1182
Buenos Aires, Museo Nacional de Bellas
Artes

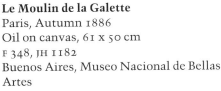

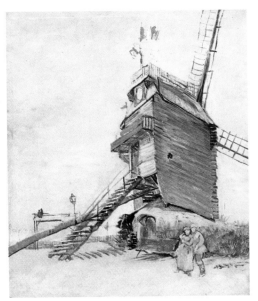

concepts into artistic practice spoilt many a day at the easel. It is time we took a closer look at the theory of art he expressed in his letters and tried to articulate in his paintings.

There was nothing provincial in his main ideas. Though he lived away from the mainstream, he was thoroughly familiar with the aesthetic preoccupations of the day, as we see from his interest in two of the central concerns of contemporary artists: firstly, how does the motif in the picture relate to its original in Nature, and (following from this) when can a painting be considered "finished"? Secondly, what part does the use of colour play? In his sensitivity to these two problems, van Gogh showed a greater affinity to his age than he did in his works. Indeed, it was that great sensitivity that had really driven him out of his

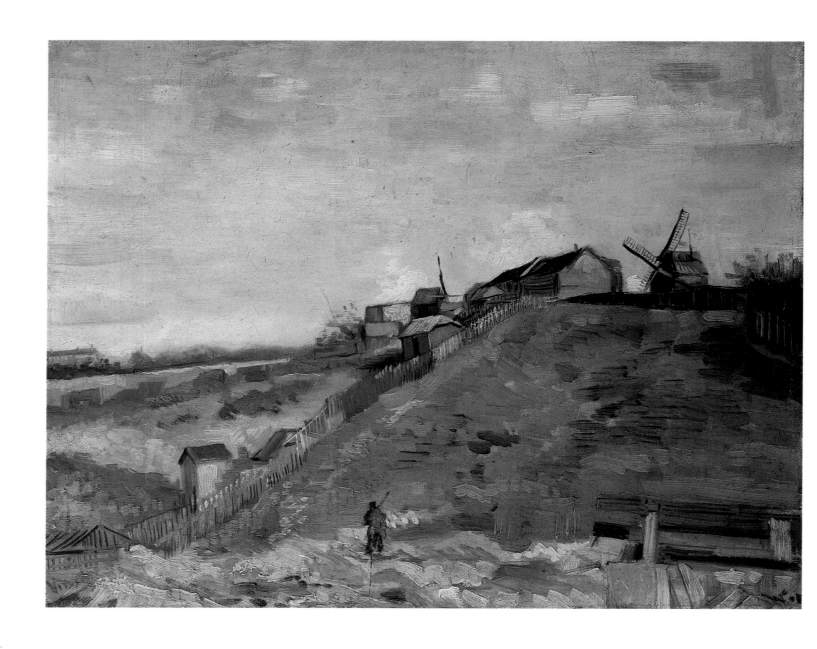

Montmartre: Quarry, the Mills
Paris, Autumn 1886
Oil on canvas, 32 x 41 cm
F 229, JH 1176
Amsterdam, Rijksmuseum Vincent van
Gogh, Vincent van Gogh Foundation

View of Montmartre with Quarry
Paris, late 1886
Oil on canvas, 22 x 33 cm
F 233, JH 1180
Amsterdam, Rijksmuseum Vincent van
Gogh, Vincent van Gogh Foundation
(Attribution disputed)

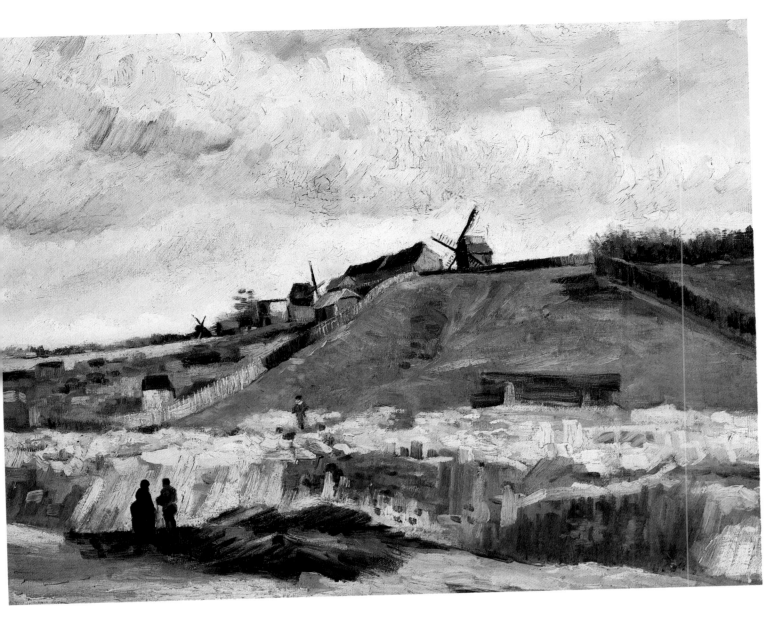

Montmartre: Quarry, the Mills
Paris, Autumn 1886
Oil on canvas, 56 x 62.5 cm
F 230, JH 1177
Amsterdam, Rijksmuseum Vincent van
Gogh, Vincent van Gogh Foundation

Nuenen retreat; books and magazines reached him in the country, but as long as he stayed there he could never look at new paintings.

"As I walked home with Grzymala we talked about Chopin. He told me that his improvisations were far more daring than his finished compositions. Doubtless this is much the same as comparing a sketch with the finished painting." In this passage in his diary, Delacroix was suggesting that a hasty study might be more effective and alive than the finished product. A sketch was spontaneous and close to real life, to Nature; it had no truck with the dignity and complacency of the perfected work. But then, a sketch was by its very nature a different artistic genre. A sketch expressed the artist's subjective view and for that reason alone could not be compared with a picture submitted to public discussion, to the critics, to a Salon jury. In the 19th century, extensive debate centred upon this question. Experts clung to their academic rules, rating decorative values above the vivid impression of life, rating traditional themes above vitality in the motif, rating an immaculate finish above a personal touch. Those who opposed the dogmatism of self-appointed

The Green Parrot
Paris, Autumn 1886
Oil on canvas on panel, 48 x 43 cm
F 14, JH 1193
Private collection
(Christie's Auction, London, 1. 12. 1987)

arbiters of taste necessarily became partisans for the sketch, since it was a more direct record of reality. Hence the uproars occasioned by the Impressionists. It was not their subjects that offended; these were largely drawn from the idyllic realm of middle-class sunny afternoons. What prompted anger was their way of dabbing and brushing patches of paint onto the canvas. Their work had a power that was provocative in its day; and this inevitably prompted the question of the relation of study to painting.

"What has impressed me most on seeing paintings by the old Dutch masters again is the fact that they were generally painted quickly. Not only that: if the effect was good, it stood. Above all, I admired hands painted by Rembrandt and Hals, hands that were alive though they were not finished in the sense that is being insisted on nowadays." Indeed, as van Gogh hazards in Letter 427, a Frans Hals would have found little favour with a Salon jury in the 1880s. But the painters of the 17th century had been incomparably successful at breathing life into their figures. Van Gogh had taken his bearings from them from the outset, and had gone on to an impulsive, crude art of vitality and energy that was so sketchy in character that there was surely a point in wondering

The Kingfisher
Paris, second half of 1886
Oil on canvas, 19 x 26.5 cm
F 28, JH 1191
Amsterdam, Rijksmuseum Vincent van Gogh, Vincent van Gogh Foundation

Stuffed Kalong
Paris, second half of 1886
Oil on canvas, 41 x 79 cm
F 177a, JH 1192
Amsterdam, Rijksmuseum Vincent van Gogh, Vincent van Gogh Foundation

whether his canvases were finished products. Van Gogh engaged with the question, and the answers he came up with were to influence the whole of modern art.

The Impressionists had found a solution that still accorded with Delacroix's view. "The original idea", he had written, "the sketch, which is in a sense the egg or embryo of the idea, is usually far from perfect. It contains the whole, in a manner of speaking, but that whole, which is no more than a unison of all the parts, needs to be coaxed forth." A picture is finished or perfect when it presents a whole unity. Totality of impact derives from homogeneity of style rather than from choice of subject and colour. In a rapidly-worked canvas, the objective presence of the motif and the subjective view of the artist become one.

It is not hard to see what van Gogh considered finished. If he considered a painting was more than a study, he signed it. There are not a great many of them; in his Dutch period they amount to a scant five per cent. *Head of a Peasant Woman with White Cap* (p. 87), for instance, bears his

Outskirts of Paris
Paris, Autumn 1886
Oil on canvas on cardboard, 45.7 x 54.6 cm
F 264, JH 1179
Private collection
(Christie's Auction, New York,
10. 11. 1987)

"Vincent". But how does that painting differ from the *Head of a Peasant Woman with Dark Cap* (p. 90), which he apparently felt to be only a character study? Both are thickly pastose, both are vehement, both were done at speed, and both evidence the affection with which the artist approached his subjects. Both were done in the same environment, for the same purpose, as part of the same work programme. It is difficult to see how van Gogh decided which work was superior. Yet he himself put a name to the essential quality: 'soul'. "It is the highest thing in Art, and in this Art is sometimes superior to Nature [...] just as, for example, there is more soul in Millet's sower than in an average sower in the field", he had written in The Hague (Letter 257). The study is plainly close to the real model; the finished picture goes beyond it, penetrating to a deeper level and examining the essential nature of the subject. Only work that succeeds in capturing 'soul' can be considered 'finished'. In espousing this view, van Gogh assigned to his private inner self the role of ultimate arbiter in Art, and thus effectively removed his work from the public arena. This anticipated the purely subjective approach that is characteristic of modern art, and also made manifestoes necessary if debate such as could once have been taken for granted was to be possible.

According to van Gogh, a painting with 'soul' is superior to natural

Three Pairs of Shoes
Paris, December 1886
Oil on canvas, 49 x 72 cm
F 332, JH 1234
Cambridge (Mass.), Fogg Art Museum,
Harvard University

Creation. From its higher vantage point, the work of art abstracts the essential in the world's phenomena in order to present a lasting impression. Though a painter may be far removed from Nature in the process, he also needs to remain close to Nature, because only Nature can correct the products of his scrutiny of the depths within. Dialogue between Nature and the work (with the painter eavesdropping, as it were) takes the place of dialogue between artist and critic.

This holds good for the second main point in van Gogh's theory of art, too: his discussion of colour. "Studies after Nature, the tussle with

Reality", he wrote in Letter 429, "I won't deny it, for years I approached the business well-nigh fruitlessly and with all manner of dismal results. I wouldn't want to have avoided the mistake ... One starts with fruitless labours, trying to copy Nature, and nothing works out, and one ends up creating in peace and quiet using only the palette and Nature is in agreement and follows from it." This is reminiscent of Paul Cézanne's famous saying that "Art runs parallel to Nature". Van Gogh had formulated the idea before the Frenchman: "That is truly painting. And what results is something more beautiful than a faithful copy of things themselves. To have one's eye on one thing so that everything else around is part of it, proceeds from this." These ideas (while very advanced in terms of colour) were still merely theoretical; van Gogh's technical skill lagged behind his theorizing. The passage from Letter 429 established the basic principles of autonomous colour – colour that is used according to its visual impact in the picture rather than its fidelity to Nature; but it would be a while yet before van Gogh was able to paint as he

Portrait of a Man with a Moustache
Paris, Winter 1886/87
Oil on canvas, 55 x 41 cm
F 288, JH 1200
Whereabouts unknown

Nude Woman Reclining
Paris, early 1887
Oil on canvas, 24 x 41 cm
F 329, JH 1215
De Steeg (Netherlands), Collection Mrs.
van Deventer

Nude Woman Reclining, Seen from the Back
Paris, early 1887
Oil on canvas, 38 x 61 cm
F 328, JH 1212
Paris, Private collection

Portrait of the Art Dealer Alexander Reid, Sitting in an Easy Chair
Paris, Winter 1886/87
Oil on cardboard, 41 x 33 cm
F 270, JH 1207
Oklahoma City, Collection A. M.
Weitzenhoffer

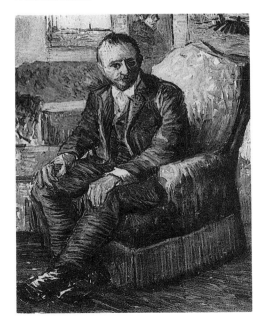

thought. For the time being he had evolved a sort of hierarchy to govern his use of colour (Letter 428): "The most serious question concerns complementary colours, contrast, and the way complementary colours cancel each other out; next in importance is the effect two related colours have on each other, say carmine on vermilion, or a red shade of purple on a blue purple. The third question concerns the effect of a pale blue on the same kind of dark blue, pink on reddish brown, etc. But the first of these questions is the most important."

Van Gogh's approach to colour in his own practice had proceeded the opposite way round. In the autumn still lifes with their laden baskets of potatoes he had been concerned with the third and least important of these issues, the interaction of lighter and darker shades of the same colours. His earliest paintings had used chiaroscuro, dwelling on the effect of light on a foregrounded motif seen against a background of deep shadow. An artificial insistence on only slightly variegated shades of brown resulted in colour stimulus being reduced almost to non-existence – an inevitable consequence of experimenting in diminished light.

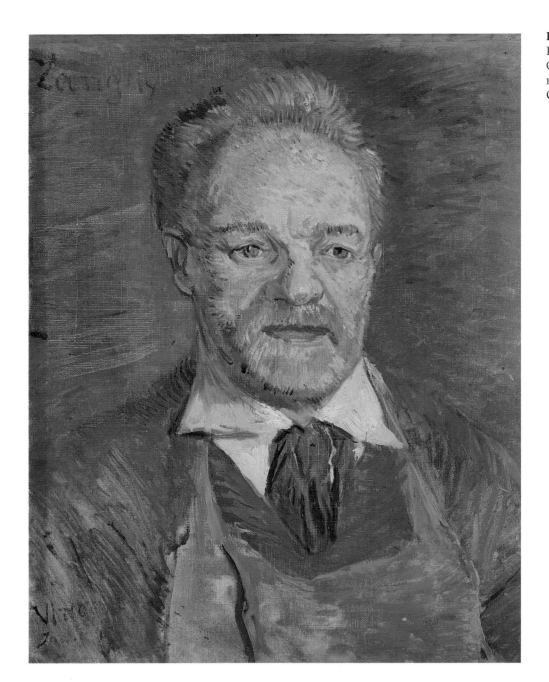

One of the most striking Nuenen pictures involves van Gogh's second principle. *Sheaves of Wheat in a Field* (p. 116) examines the effects various related yellows have on each other; that is, it explores colour analogies. The melancholy, earthy reportage pictures done in Drente had already done something of the kind; their marshy brown was the product of other considerations than the still lifes' principle of neutral lighting. The wheatsheaves have of course been done in more cheerful colours; and they dominate the canvas so thoroughly that we are inclined to overlook the fact that a colour scheme has taken precedence over the motif, the multiplicity of tonal values over the single, central status of the subject.

By far the most important principle of van Gogh's palette, a principle that was later to become a dogma with him, was that of complementary colours. This too had been taken from Delacroix, during his second year

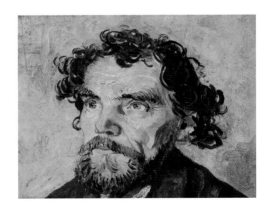

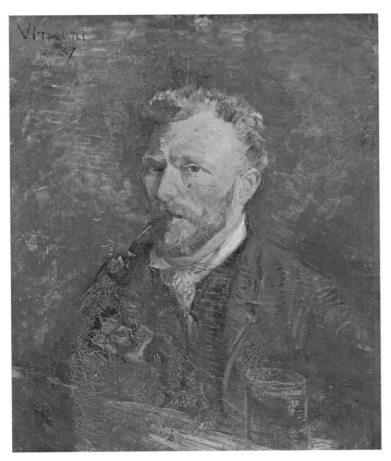
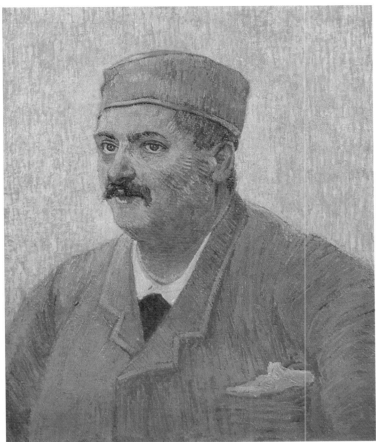

in Nuenen. Complementary colours are colours that heighten their mutual effects most intensively if they are placed contrastively: blue and orange, red and green, yellow and violet. Initially van Gogh added a fourth contrast, white and black. He had found that the principle was at work in Nature, in the cycle of the seasons, so dear to him: "Spring is tender young shoots of wheat and pink apple blossom. Autumn is the contrast of yellow leaves with shades of violet. Winter is snow, with black silhouettes. If summer is taken to be a contrast of blues with the orange of golden, bronze grain, it is possible to paint a picture in complementary colours for every one of the contrasts." (Letter 372).

In spite of his sophisticated theory, van Gogh remained a realist in his use of colours. True, his ideas abstracted away from the immediate impression made by Nature; but in practice a look at the subject sufficed to guide his use of the palette. Van Gogh was alert to complementary colours, but was satisfied if he saw them in the contrast of yellow leaves with a violet sky or red flowers with a green field. His theory paved the way for autonomous colour, but in his practice he remained close to the old masters and his solitary hero Millet. It would be another year before he shook off this fidelity.

Self-Portrait with Pipe and Glass
Paris, early 1887
Oil on canvas, 61 x 50 cm
F 263a, JH 1199
Amsterdam, Rijksmuseum Vincent van Gogh, Vincent van Gogh Foundation

Portrait of a Man with a Skull Cap
Paris, Winter 1886/87 (or 1887/88?)
Oil on canvas, 65.5 x 54.5 cm
F 289, JH 1203
Amsterdam, Rijksmuseum Vincent van Gogh, Vincent van Gogh Foundation

PAGE 206:
Agostina Segatori Sitting in the Café du Tambourin
Paris, February-March 1887
Oil on canvas, 55.5 x 46.5 cm
F 370, JH 1208
Amsterdam, Rijksmuseum Vincent van Gogh, Vincent van Gogh Foundation

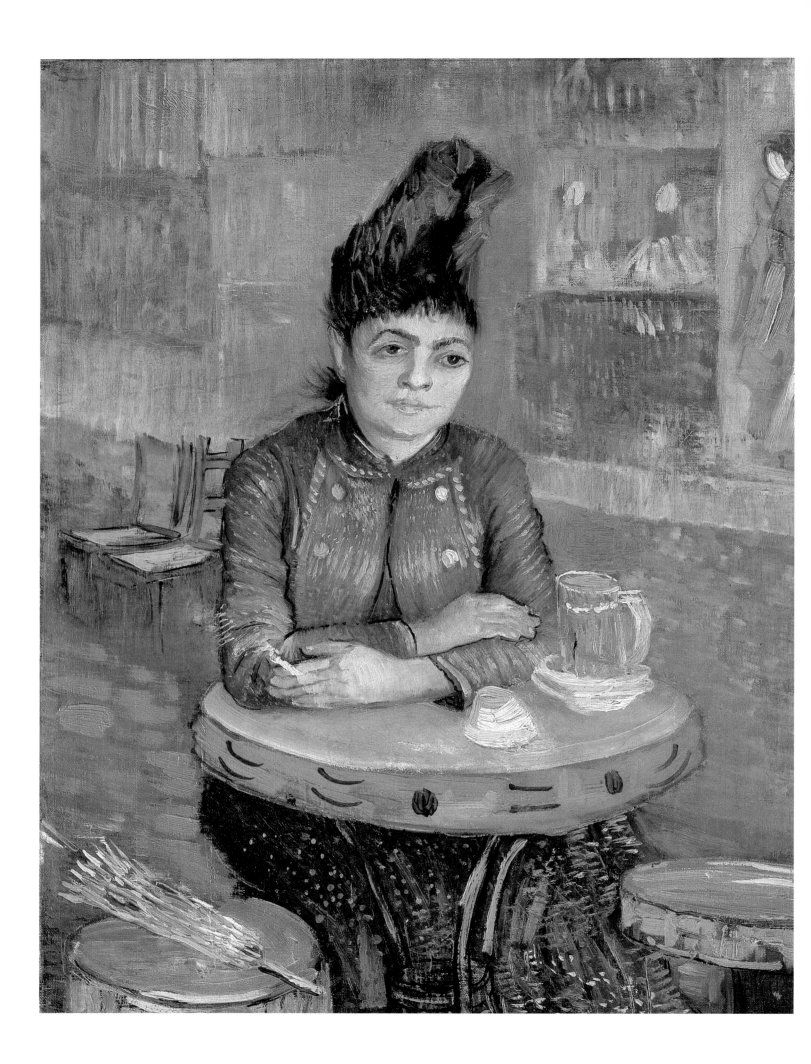

CITY LIFE
1885-1888

The Antwerp Interlude
Winter 1885-86

"It is quite certain that I shall be without a place to work in Antwerp. But I have to choose between a place to work but no work here and work without a place to do it there. I have opted for the latter. And with such joy and delight", wrote van Gogh in Letter 435, "that it feels like returning from exile." He felt that, after the past few years, he urgently

Portrait of a Woman
Paris, Winter 1886/87
Oil on canvas, 27 x 22 cm
F 215b, JH 1205
Amsterdam, Rijksmuseum Vincent van Gogh, Vincent van Gogh Foundation
(Attribution disputed)

needed to return home – to rediscover that homeground that a city provides. His concept of artistic truth, borrowed from Millet and Breton, had led him to live in the same rustic, rural environment he liked to paint; but now he felt compelled to satisfy society's notions of the artistic life. *The Potato Eaters* had heralded a new, programmatic ambition, and he was now out to present a confident public image and an urbane personality – and to succeed.

From the very start, van Gogh saw his time in Antwerp as an intermezzo before he moved on to the great metropolis, Paris, capital of the 19th century. Antwerp served as a kind of training, to prepare him for what might otherwise (after the intimacy of village life) be the rude shock of the faceless city. And Theo first needed persuading to have his brother. Van Gogh tried to give his correspondent an honest account of his progress in questions of civilized conduct. He believed he might still need improvement in three respects: first, he simply wanted to dive into the sea of people and houses and forget the everyday feuding of the

Portrait of a Woman (Madame Tanguy?)
Paris, Winter 1886/87
Oil on canvas, 40.5 x 32.5 cm
F 357, JH 1216
Basle, Kunstmuseum Basel, on loan from
the Rudolf Staechelin Family Foundation

A Pair of Shoes
Paris, early 1887
Oil on canvas, 34 x 41.5 cm
F 333, JH 1236
Baltimore, The Baltimore Museum of Art,
The Cone Collection

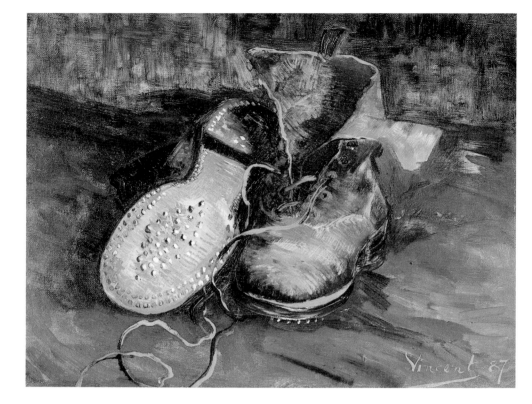

A Pair of Shoes
Paris, Spring 1887
Oil on canvas, 37.5 x 45.5 cm
F 332a, JH 1233
Brussels, Collection Emil Schumacher

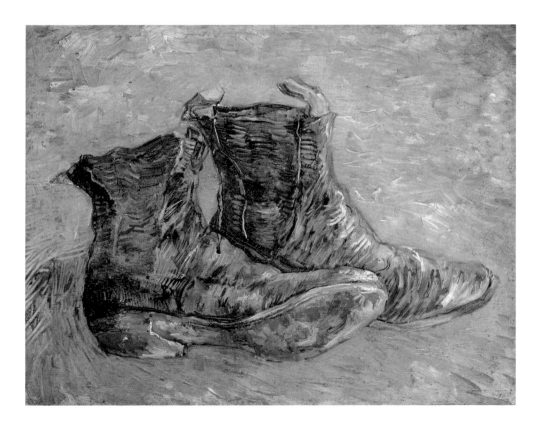

A Pair of Shoes
Paris, first half of 1887
Oil on paper on cardboard, 33 x 41 cm
F 331, JH 1235
Amsterdam, Rijksmuseum Vincent van
Gogh, Vincent van Gogh Foundation

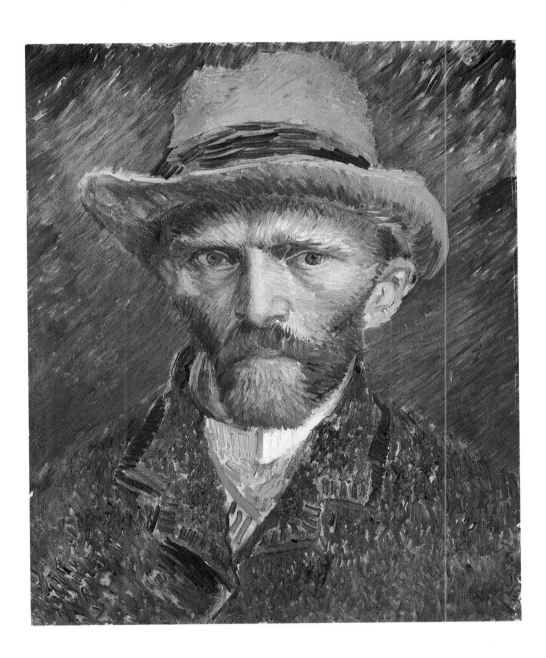

Self-Portrait with Grey Felt Hat
Paris, Winter 1886/87
Oil on cardboard, 41 x 32 cm
F 295, JH 1211
Amsterdam, Stedelijk Museum (on loan
from the Rijksmuseum)

village; second, he felt he might profit from further instruction at the Academy, in order to have the technical means to tackle his new subjects; and third, he thought that after years of neglecting his outer appearance he might be in need of a little advice in that respect.

He spent three months in the Belgian port. Rubens was the presiding spirit in this period. Van Gogh, as a follower of Delacroix, was of course destined to discover the baroque painter. Having done so, he appropriated Rubens's subtlety and allusiveness with the same energetic thoroughness as he had borrowed Millet's simple devotion to Nature years before. "Studying Rubens is extremely interesting", he wrote in Letter 444, in an attempt to locate his own interests in the old master, "precisely because he is so very simple in technique, or – to be more exact – seems to be. Because he achieves his effect with such modest means and with so swift a touch, because he paints without any kind of hesitation and above all draws as well. But portraits, heads of women and female figures are his strong points. In these areas he is profound,

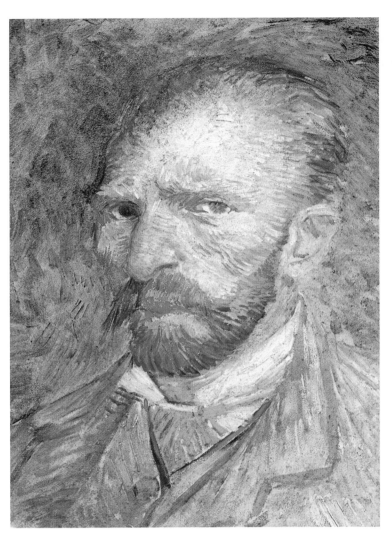

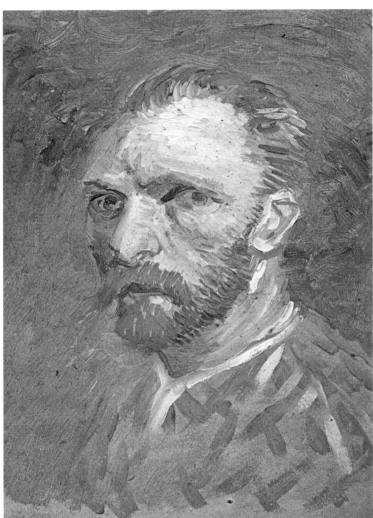

Self-Portrait
Paris, Spring 1887
Oil on paper, 32 x 23 cm
F 380, JH 1225
Otterlo, Rijksmuseum Kröller-Müller

Self-Portrait
Paris, Spring-Summer 1887
Oil an cardboard, 19 x 14 cm
F 267, JH 1224
Amsterdam, Rijksmuseum Vincent van
Gogh, Vincent van Gogh Foundation

and sensitive too. And how fresh his paintings have stayed, because of that very simplicity of technique." To paint swiftly and establish a likeness with a very few well-placed strokes had never been something he found difficult; but what he wanted to learn from Rubens was the subtlety of impeccable *hautgout*, which had been inaccessible to him in the village – delicacy and distinction.

In *Head of a Woman with her Hair Loose* (p. 139) van Gogh achieved a degree of artistic sensitivity that had hitherto been beyond him. The portrait is still vigorous, if not indeed violent, in its brushwork, but the colouring is exquisite. Sensitively patterned brushstrokes create a beautifully nuanced, detailed image in which the virtuoso technique has perhaps become more important than the subject. The woman is not rustic or picturesque like the Nuenen women in their caps. In fact, van Gogh has dispensed with everything that might tie the woman specifically to one walk of life. It is simply some woman or other, a town girl whose beauty does not last long and whose dignity will come or go, just depending, a hired model who will pose for anyone who will pay. The picture is superficial in the sense that it does not aim to explore profound depths in the woman but instead anticipates the rapid brushwork and strong colours of the Paris period. A rich red is juxtaposed with the

cool whitish shades of the flesh – an impressive effect that is supposed to be delicate rather than descriptive, to highlight the picture's colours without appearing to represent make-up. Van Gogh, in other words, was becoming fully aware of the opportunities open to the palette, and the new freedom was allowing him to put documentary presentation of subjects behind him.

"What colour is in a picture, enthusiasm is in life, in other words no mean thing if one is trying to keep a hold on it", he wrote in Letter 443, explaining his new interest in colour. Increasingly, the violent tonal clashes, streaks of colour, and patches of paint applied directly from the tube took over the function that his motifs had previously had: to reconcile the painter's subjective view of the world with the objective state of phenomena. Previously van Gogh had been offering the better life – better because lived in harmony with Nature. Now he withdrew somewhat from natural plurality, as it were, and tried to present a synthesis, his own interpretation, on canvas. The world in his pictures became more artificial because it was more consciously filtered by the perceptions and mind of an artist. "I think that in order to draw figures of peasants, for example, it is very good to draw ancient sculptures, always assuming it is not done as it normally is." (Letter 445). At the

Self-Portrait with Straw Hat
Paris, March-April 1887
Oil on cardboard, 19 x 14 cm
F 294, JH 1209
Amsterdam, Rijksmuseum Vincent van
Gogh, Vincent van Gogh Foundation

Self-Portrait with Grey Felt Hat
Paris, March-April 1887
Oil on cardboard, 19 x 14 cm
F 296, JH 1210
Amsterdam, Rijksmuseum Vincent van
Gogh, Vincent van Gogh Foundation

PAGE 214/215:
**Street Scene in Montmartre: Le Moulin
à Poivre**
Paris, February-March 1887
Oil on canvas, 34.5 x 64.5 cm
F 347, JH 1241
Amsterdam, Rijksmuseum Vincent van
Gogh, Vincent van Gogh Foundation

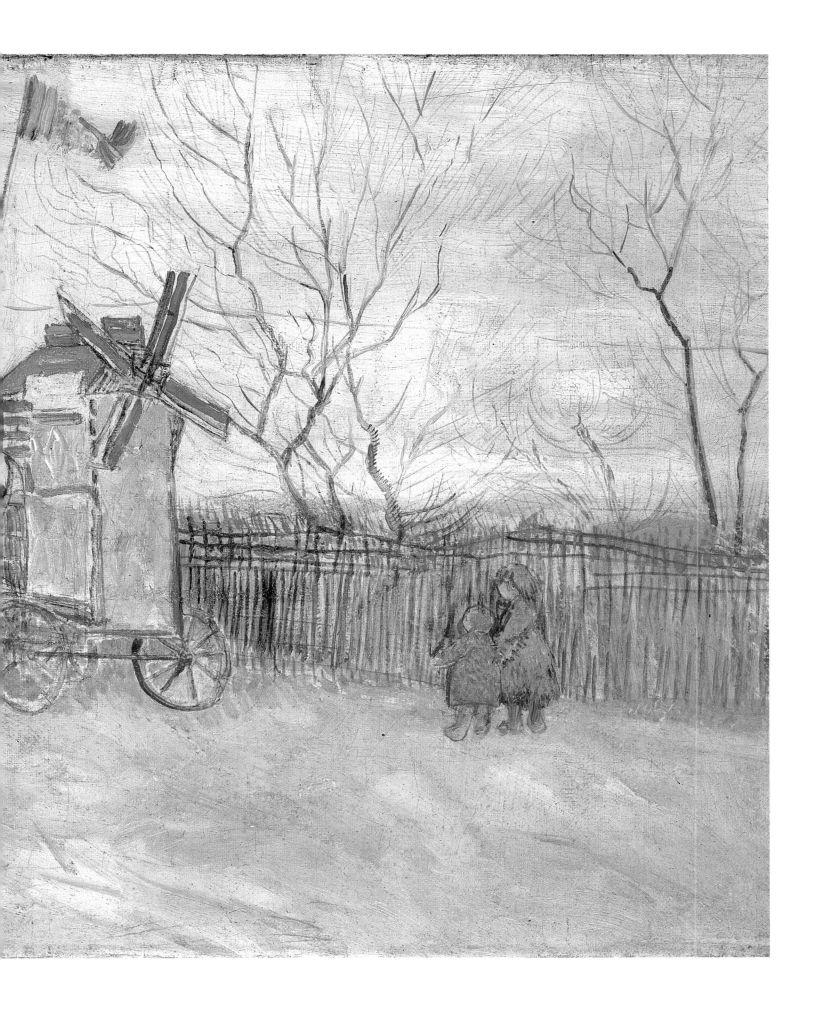

Basket of Sprouting Bulbs
Paris, March-April 1887
Oil on panel (oval), 31.5 x 48 cm
F 336, JH 1227
Amsterdam, Rijksmuseum Vincent van
Gogh, Vincent van Gogh Foundation

time of *The Potato Eaters,* van Gogh would have abhorred this idea because it was the sort of thing done in academies, which were out of touch with reality. But now he too tried his hand at painting copies of classical sculptures; what counted was the unusual approach, not the subject itself.

Consistently enough, van Gogh applied to the Academy of Fine Arts. He rapidly passed a number of courses; none of the professors quite knew what to make of this Dutchman's abstruse views. Van Gogh's concept of art had by now gained depth and weight and was incompatible with academic pedantry and didacticism, which could do nothing but assess the handling of line and contour. The categories of 'enthusiasm' and 'vitality', which van Gogh rated supreme, were dismissed

Still Life with Three Books
Paris, March-April 1887
Oil on panel (oval), 31 x 48.5 cm
F 335, JH 1226
Amsterdam, Rijksmuseum Vincent van
Gogh, Vincent van Gogh Foundation

Still Life with Bloaters and Garlic
Paris, Spring 1887
Oil on canvas, 37 x 44.5 cm
F 283b, JH 1230
Tokyo, Bridgestone Museum of Art

as expressions of inflated self-esteem. In three short months, Vincent travelled the typical Modernist road, repelled by the dogmatic inflexibility of the official custodians of art and seeking some goal of his own, off the beaten track. In February 1886 he entered a competition at the academy. The result was not announced until after he had left for Paris – and perhaps that was just as well, because the experts had apparently decided that van Gogh might join a class for 13-to-15-year-olds.

Skull with Burning Cigarette (p. 138) is in many ways the key Antwerp picture. Van Gogh was mocking the procedure in drawing classes, where a skeleton invariably served as the basis of anatomical studies, considered by the teachers to be the artist's indispensable aid in figuring out physical proportions and anatomical structure. The lifelessness of the skeleton represented the very opposite of what van Gogh wanted a picture to express. With the burning cigarette jammed in its teeth, the skeleton, though still nothing but dead bones, has acquired a grotesquely funny hint of life.

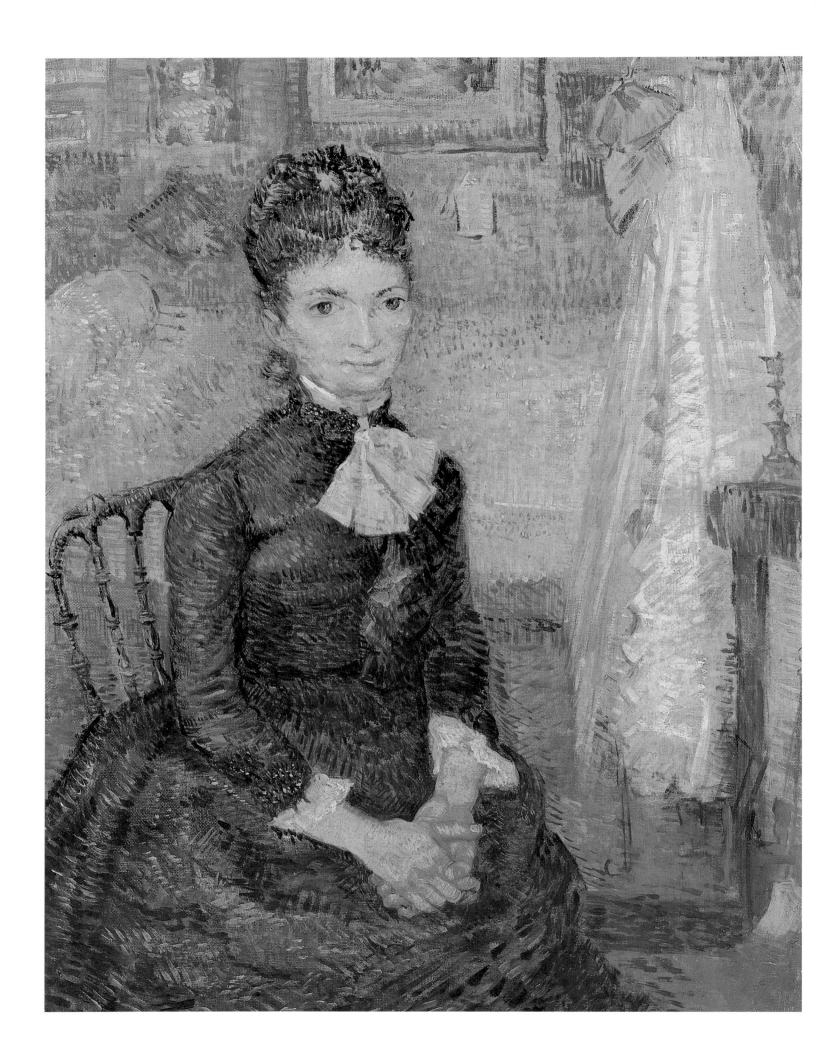

Factories Seen from a Hillside in Moonlight
Paris, first half of 1887
Oil on canvas, 21 x 46.5 cm
F 266a, JH 1223
Amsterdam, Rijksmuseum Vincent van
Gogh, Vincent van Gogh Foundation

Woman Sitting by a Cradle
Paris, Spring 1887
Oil on canvas, 61 x 45.5 cm
F 369, JH 1206
Amsterdam, Rijksmuseum Vincent van
Gogh, Vincent van Gogh Foundation

The painting is less amusing if we bear in mind van Gogh's feeling that he needed to make his outer appearance more attractive. He had just had major dental treatment. In Nuenen he had painted no self-portraits, but in Paris he tackled the task head-on – and the reason for this may well have been that van Gogh had recently acquired a touch of the upright citizen's vanity, and that he did not think himself presentable until his gap-teeth had been fixed. On the other hand, of course, if he now saw himself as a man about town, he would have developed the self-confidence needed to think he merited a self-portrait (and first some improvement of his facial appearance, which was sunken and weary). His health was not in the best of conditions: "The doctor tells me I absolutely have to keep my strength up", he wrote in Letter 449, "and until I have built it up I am to take it easy with my work. But now I have made things worse by smoking, which I did because one doesn't feel the emptiness of one's stomach then." With this in mind we can see the skull as van Gogh's first self-portrait – a cynical, merciless comment on an unkempt and unattractive appearance that had been a sign of solidarity with the peasants back in Nuenen but was now an embarrassment and a problem in the city.

Finally, we should not forget the contemporary penchant for the motif of the living dead. Fifteen years before, Arnold Böcklin had painted a *Self-Portrait with Death Playing a Fiddle*; and not long after the turn of the century the dance-of-death theme was to peak in Hugo von Hofmannsthal's play *Everyman*. It was a game the *fin de siècle* played, holding up an artificial mirror to its own eschatological fears. What did it mean to Vincent van Gogh, the hallmark of whose work tends to be a paradoxically optimistic view of progress? His death's-head represented a serious attempt to keep pace with the artistic debates of the times. The authorial ambition the picture betrays was a dead end for him, though; the exaggerated focus on a motif that did not stand for any reality but was simply available as an iconographical prop highlights the problems van Gogh was having with his repertoire of subjects. In Antwerp he explored both the extremes that were accessible to his art:

on the one hand the sheer pleasure of exuberant brushwork, on the other the highly-charged melancholy of a literary man's motif. Somehow he had to put an end to his irresolution. Earlier than planned, van Gogh left for Paris.

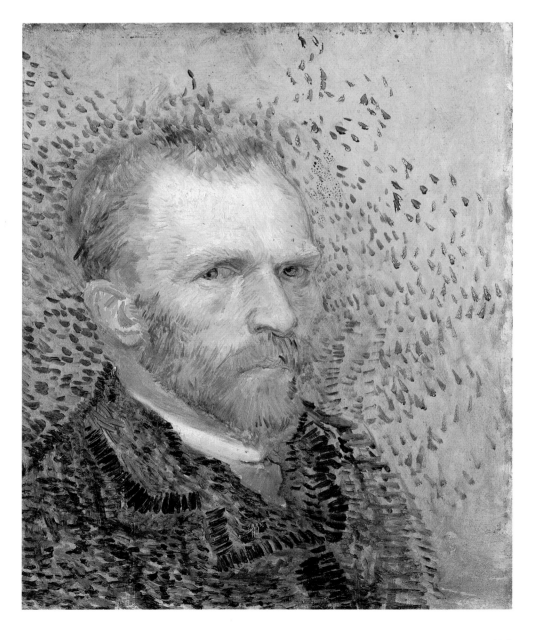

Self-Portrait
Paris, Spring-Summer 1887
Oil on canvas, 41 x 33 cm
F 356, JH 1248
Amsterdam, Rijksmuseum Vincent van Gogh, Vincent van Gogh Foundation

A Dutchman in Paris
1886-1888

For centuries artists had gone on pilgrimages to Italy, where they could find their idealized antiquity, the architectural and sculptural remains with which they pieced together an image of human perfection, literally in the streets. In the 19th century, artists who found their times too bustling, loud and obsessed with ephemera would still escape to Italy –

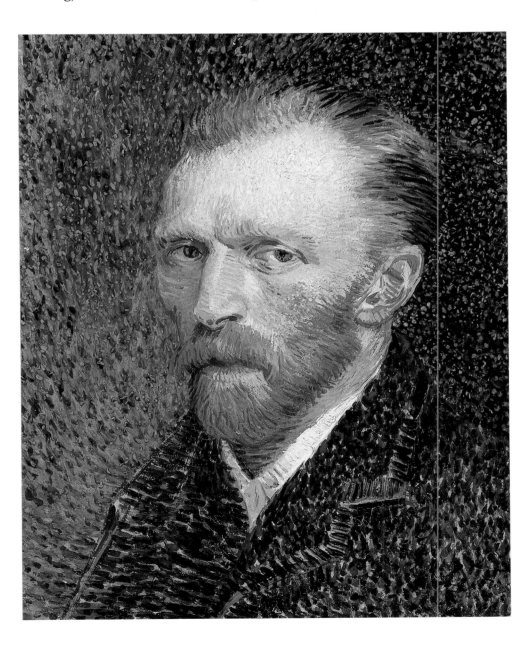

Self-Portrait
Paris, Spring 1887
Oil on cardboard, 42 x 33.7 cm
F 345, JH 1249
Chicago, The Art Institute of Chicago

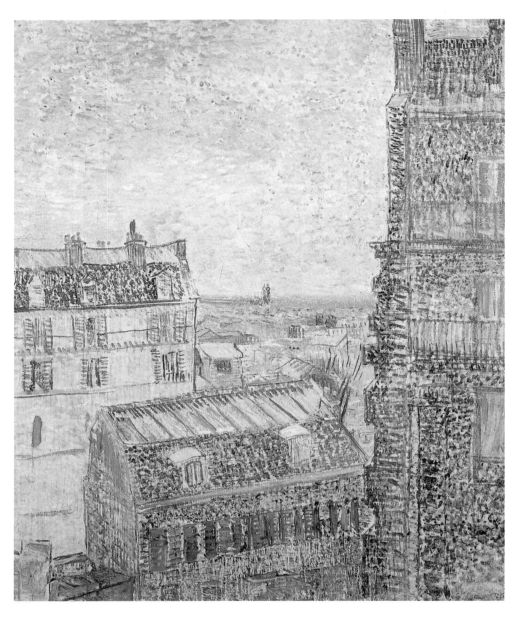

**View of Paris from Vincent's Room
in the Rue Lepic**
Paris, Spring 1887
Oil on canvas, 46 x 38 cm
F 341, JH 1242
Amsterdam, Rijksmuseum Vincent van
Gogh, Vincent van Gogh Foundation

artists such as Böcklin, Max Klinger or Hans von Marées. Perhaps in
their longing for a timeless Arcadia there was at core little more than
love of a country that was underdeveloped when compared with other
European countries.

The cutting edge of modernity was certainly not in Italy. It was in
Paris, where the Revolution had placed the city in the European van-
guard. And the problems of the age had become aesthetic problems.
Back in the period around 1700 there had been an argumentative
Querelle des anciens et des modernes, a debate that Swift had spoofed
in Britain: was Beauty to be evaluated by some eternal standard, or by
the evanescent taste of the times? The watchword 'modern' had become
controversial, and remained controversial in subsequent aesthetic dis-
putes; by the 19th century it was a kind of article of faith, pathetically
recited by artists frantic for an identity. The front ran through Paris. On
the one side were the historically-minded advocates of great subjects
sanctioned by the past, the painters of historical scenes, all those who
paid lip service to the consummate skill of the old masters; and on the

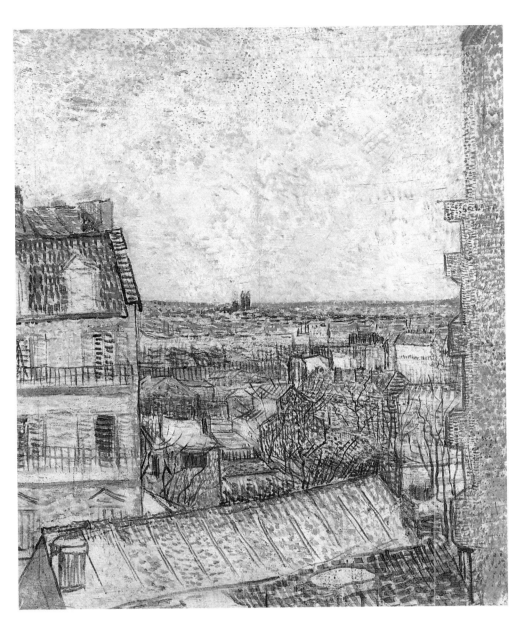

**View of Paris from Vincent's Room
in the Rue Lepic**
Paris, Spring 1887
Oil on cardboard, 46 x 38.2 cm
F 341a, JH 1243
Private collection
(Sotheby's Auction, New York, 14. 5. 1985)

other side were those who documented contemporary life with their brush and preferred the flux of passing moods, glimpses of everyday life, and freedom in the use of shape and colour. One of the things that made Paris a modern city was the very fact that the debates were fought out there; the fierceness of the fighting was an indicator of the new pluralism in Art. So they all were drawn to Paris: Max Liebermann from Germany, James Abbott McNeill Whistler and Mary Cassatt from the United States, Félicien Rops from Belgium. And of course a Dutchman, Vincent van Gogh, whose brother lived in the great metropolis. (This was important to him, but to see it as his main reason for moving to Paris would be to underestimate his commitment to his art.)

"And do not forget, my dear fellow, that Paris is Paris. There is only one Paris, and, hard as it may be to live here, even if it were to grow harder and worse – French air clears the head and does one good, tremendously good." Van Gogh is rarely as uninhibitedly enthusiastic as in this passage from Letter 459a to a young fellow-artist, Horace Lievens. Vincent had fallen under the city's spell. His customary exis-

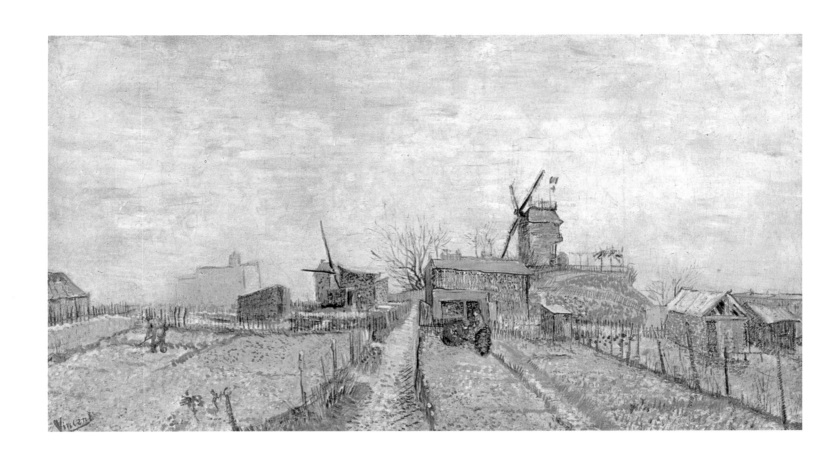

Vegetable Gardens in Montmartre
Paris, February-March 1887
Oil on canvas, 44.8 x 81 cm
F 346, JH 1244
Amsterdam, Rijksmuseum Vincent van
Gogh, Vincent van Gogh Foundation

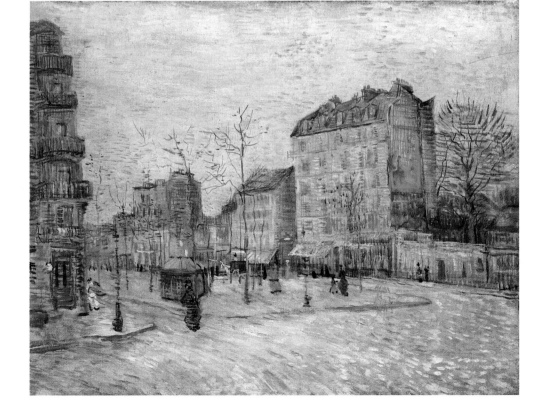

Boulevard de Clichy
Paris, February-March 1887
Oil on canvas, 45.5 x 55 cm
F 292, JH 1219
Amsterdam, Rijksmuseum Vincent van
Gogh, Vincent van Gogh Foundation

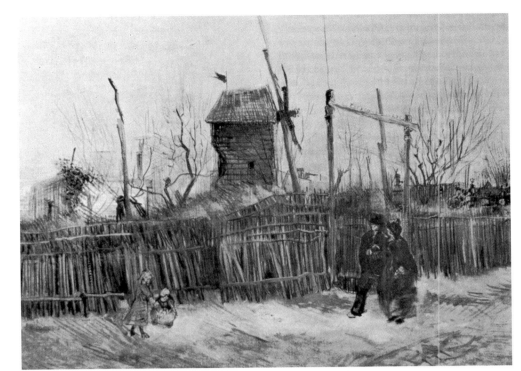

Street Scene in Montmartre
Paris, Spring 1887
Oil on canvas, 46 x 61 cm
No F Number, JH 1240
Copenhagen, Private collection

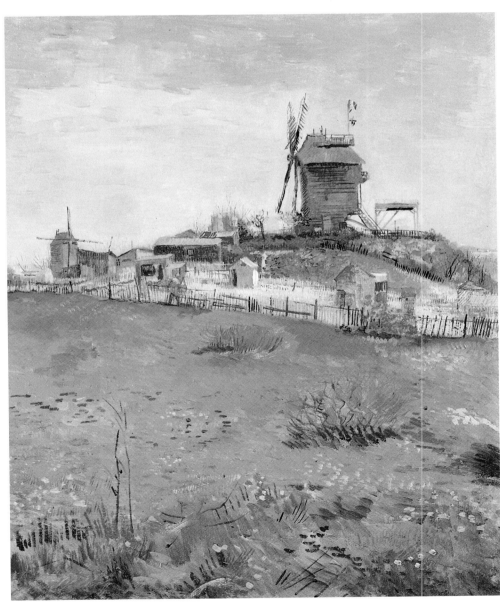

Le Moulin de la Galette
Paris, March 1887
Oil on canvas, 46 x 38 cm
F 348a, JH 1221
Pittsburgh, Museum of Art,
Carnegie Institute

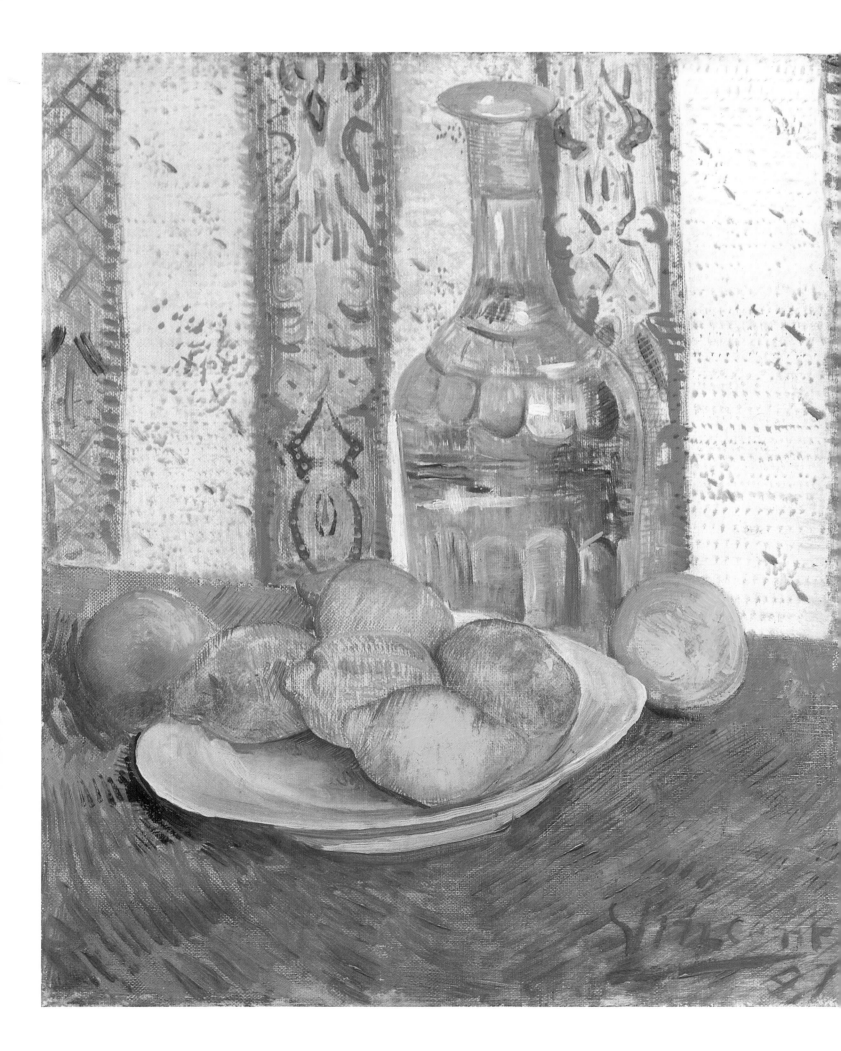

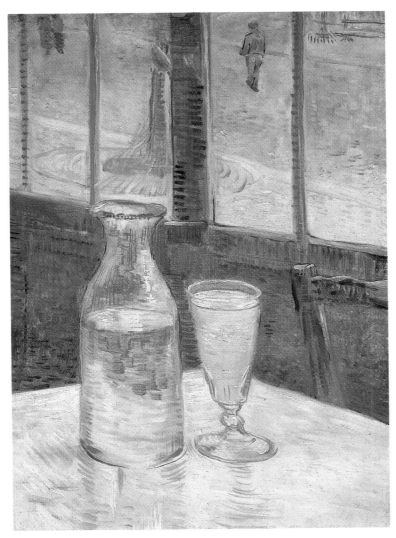

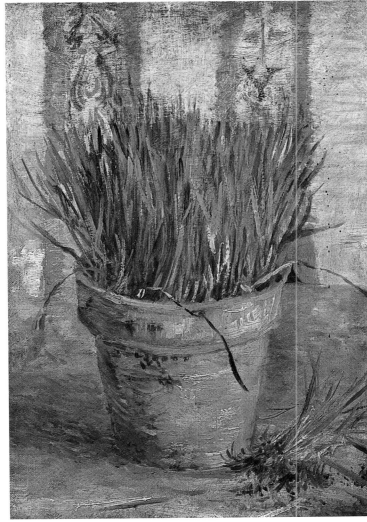

Still Life with Absinthe
Paris, Spring 1887
Oil on canvas, 46.5 x 33 cm
F 339, JH 1238
Amsterdam, Rijksmuseum Vincent van
Gogh, Vincent van Gogh Foundation

Flowerpot with Chives
Paris, March-April 1887
Oil on canvas, 31.5 x 22 cm
F 337, JH 1229
Amsterdam, Rijksmuseum Vincent van
Gogh, Vincent van Gogh Foundation

**Still Life with Decanter and Lemons on
a Plate**
Paris, Spring 1887
Oil on canvas, 46.5 x 38.5 cm
F 340, JH 1239
Amsterdam, Rijksmuseum Vincent van
Gogh, Vincent van Gogh Foundation

tential unease had not left him, but perhaps because of that he was all the readier to enter into the spirit of bright, urbane rationalism. His *weltschmerz* cast aside for the moment, he opened his heart to all the new impressions. Only seven letters survive from the two years in Paris, for the obvious reason that his principal addressee, Theo, no longer needed to be written to – they could talk again at last. But there was another reason, too: van Gogh's existential compulsion to account for himself and thus reassure himself had slackened. Now, he was deriving his sense of identity simply from making his own distinctive contribution to the life of Paris. The hymn-like tone of his letter to Lievens bears eloquent witness to his sense of belonging, his new sense of security.

For exactly two years, from February 1886 to 1888, Vincent went about the business of catching up on modern times. He learnt the ways of the city as rapidly as the new aesthetics; his human qualities and cognitive powers were both considerable. When he finally left, Theo wrote sadly to his sister: "When he arrived here two years ago I would never have thought that we could become so close. Now that I am on my own again I feel the emptiness in my home all the more. It is not easy to fill the place of a man like Vincent. His knowledge is vast and he has a very clear view of the world. I am convinced that if he has a few more

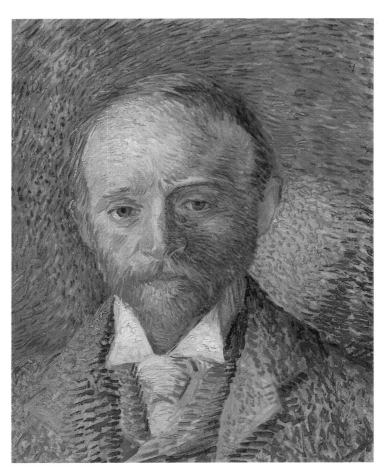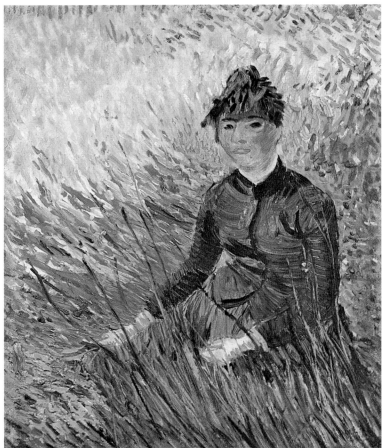

years he will make a name for himself. Through him I got to know a number of painters who value him highly. He is one of the pioneers of the new ideas, or rather he is trying to revive ideas that have been falsified in routine everyday life and have lost their lustre. And he has such a good heart, too, and is forever trying to do things for others. All the worse for those who do not want to know or understand him."

For years, Theo had felt a sense of family responsibility for Vincent; he had taken for granted that he should help his needy brother. It was only when he was carrying out this duty within the same four walls, with Vincent living at his home, that he truly began to see Vincent's personality. In the process a caring paternalism was replaced by closer personal relations; he discovered a man of integrity, and they became intimates. His brother's moods fascinated him, and he saw them as the mark of an artistic temperament. "It is as if two people dwelt within him", Theo had complained a year previously, "one of them marvellously talented, refined and tender, the other selfish and hard-hearted! They appear alternately, and in consequence he can be heard expressing one opinion one time and a quite different one the next – always with arguments for and against." What looked like inconsistency in Vincent could be seen as a paradoxical streak once his artistic nature had been accepted. After a number of disputes, Theo came to recognise this streak as an integral part of his brother's worldview – fundamentally the only view that could cope with modern times.

Portrait of the Art Dealer Alexander Reid
Paris, Spring 1887
Oil on cardboard, 41.5 x 33.5 cm
F 343, JH 1250
Glasgow, Glasgow Art Gallery and Museum

Woman Sitting in the Grass
Paris, Spring 1887
Oil on cardboard, 41.5 x 34.5 cm
F 367, JH 1261
New York, Private collection

Fritillaries in a Copper Vase
Paris, April-May 1887
Oil on canvas, 73.5 x 60.5 cm
F 213, JH 1247
Paris, Musée d'Orsay

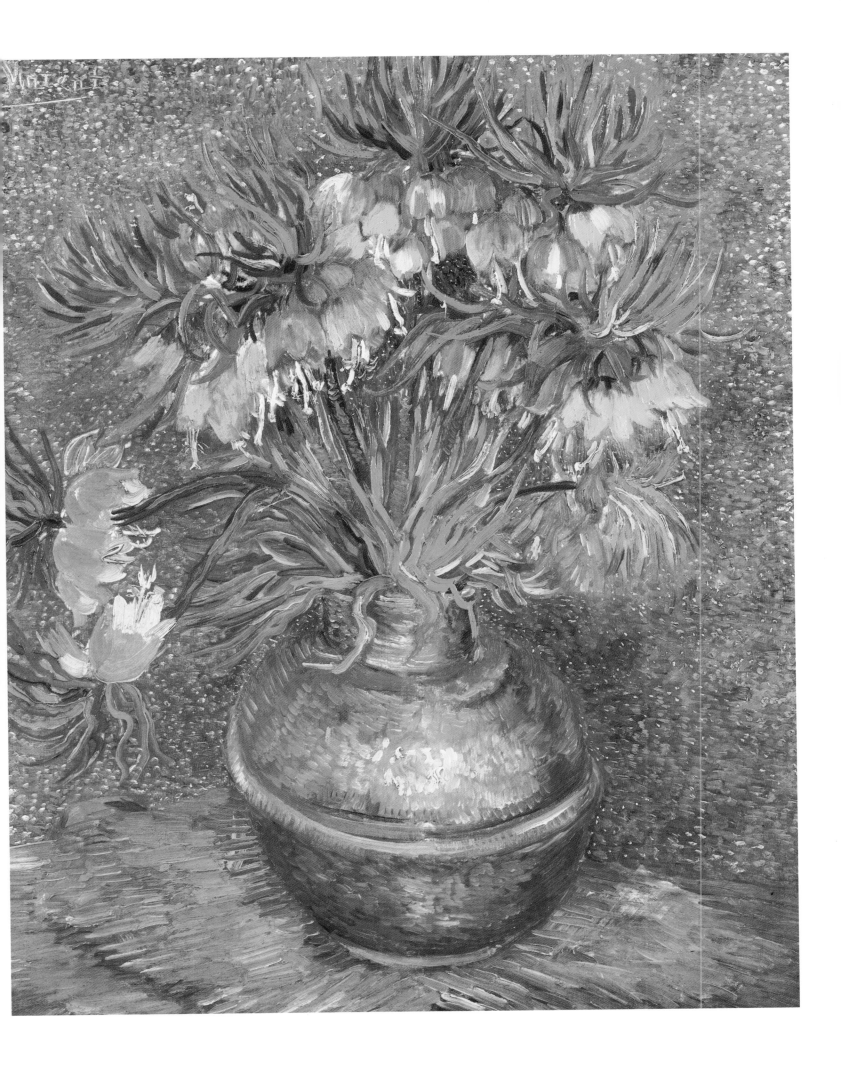

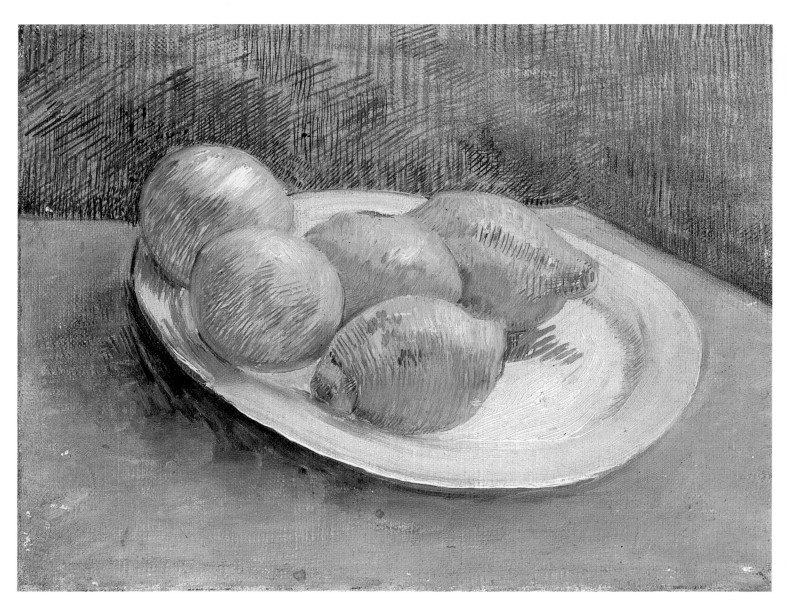

Still Life with Lemons on a Plate
Paris, March-April 1887
Oil on canvas, 21 x 26.5 cm
F 338, JH 1237
Amsterdam, Rijksmuseum Vincent van
Gogh, Vincent van Gogh Foundation

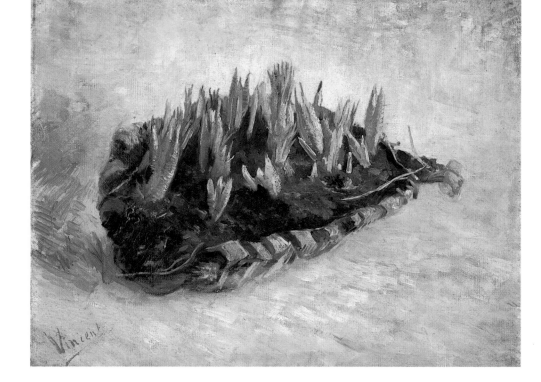

Still Life with a Basket of Crocuses
Paris, March-April 1887
Oil on canvas, 32.5 x 41 cm
F 334, JH 1228
Amsterdam, Rijksmuseum Vincent van
Gogh, Vincent van Gogh Foundation

A Plate of Rolls
Paris, first half of 1887
Oil on canvas, 31.5 x 40 cm
F 253a, JH 1232
Amsterdam, Rijksmuseum Vincent van
Gogh, Vincent van Gogh Foundation

Vase with Flowers, Coffeepot and Fruit
Paris, Spring 1887
Oil on canvas, 41 x 38 cm
F 287, JH 1231
Wuppertal, Von der Heydt-Museum

Theo was the person to whom Vincent related most closely. Once he had Theo's approval, he felt strengthened; and the pictures he painted were more cheerful and accessible. He knew he had quirky ways, but it now seemed that they were a kind of badge, and he fitted the societal stereotype of the difficult, temperamental artist perfectly. He also found support among the dreamers and reformers out to change the world, who were every bit as eccentric, enthusiastic and unknown as he was. He entered artistic circles, debating till the small hours, and proclaimed his opinions even if no one had asked them. Everyone who was still waiting for the breakthrough believed himself really one of the elite; and in Paris van Gogh saw the necessity of the outsider's life if a man was to achieve greatness as an artist.

Initially, Paris was merely the sequel to Antwerp. Some time in 1886 (the exact date is disputed) he matriculated at a private art college run by Fernand-Anne Piestre, called Cormon. Cormon was a history painter

The Entrance of a Belvedere
Paris, Spring 1887
Watercolour, 31.5 x 24 cm
F 1406, JH 1277
Amsterdam, Rijksmuseum Vincent van Gogh, Vincent van Gogh Foundation

View of a River with Rowing Boats
Paris, Spring 1887
Oil on canvas, 52 x 65 cm
F 300, JH 1275
Aberdeen, Collection William Middleton

whose archaeological detail could be seen as an evasion (by substituting scholarly precision) of the debate on the contemporaneity of Art. In 1880 his monumental painting of Cain fleeing (now in the Musée d'Orsay, Paris) had caused a sensation; it showed a group of ragged vagabonds in a desolate region – but these people were not tramps, they were Biblical characters. This man would certainly be able to teach van Gogh how to work in a conventional, craftsmanlike way and still attract attention...

Of greater importance for van Gogh, though, were the friendships he presently struck up with fellow-students who were admittedly a full ten years younger and lacked his experience of life but nevertheless were at a comparable level in their artistic training. Louis Anquetin, Emile Bernard and Henri de Toulouse-Lautrec were among them. They smoothed van Gogh's access to the art world, and soon he found theorizing more interesting than the dull routine of drawing plaster figures. Cormon's art school was van Gogh's last chance to acquire a basic grounding in the academic mysteries; but he did not stay long. Van Gogh chose not to bother with the corrective value of time-honoured

Vegetable Gardens in Montmartre:
La Butte Montmartre
Paris, June-July 1887
Oil on canvas, 96 x 120 cm
F 350, JH 1245
Amsterdam, Stedelijk Museum

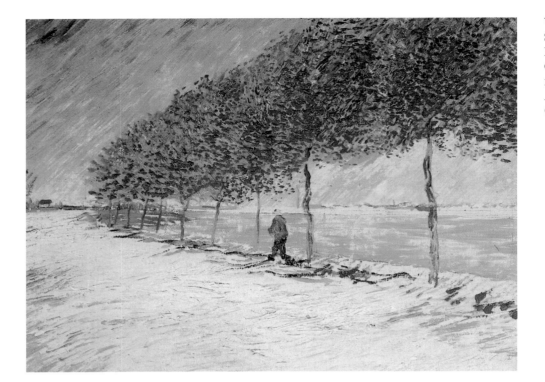

technique, a corrective which his youthful friends were accepting and
which left them, after the late-night café discussions, in the conven-
tional craftsman's rut. Van Gogh preferred to take his bearings from
theory again. He was too much a part of the art scene for his ideas to be
labelled those of an autodidact; rather, in acquiring a grip on modern
thought he was quite simply capable of assimilating more rapidly than
others. And he wanted to paint in the way he knew how, the way he had
learnt from all his discussions and all the exhibitions. As for his techni-

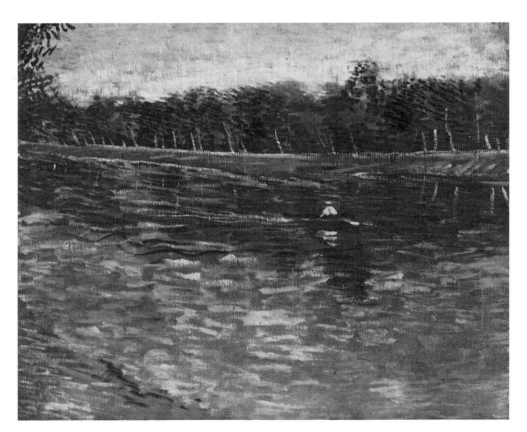

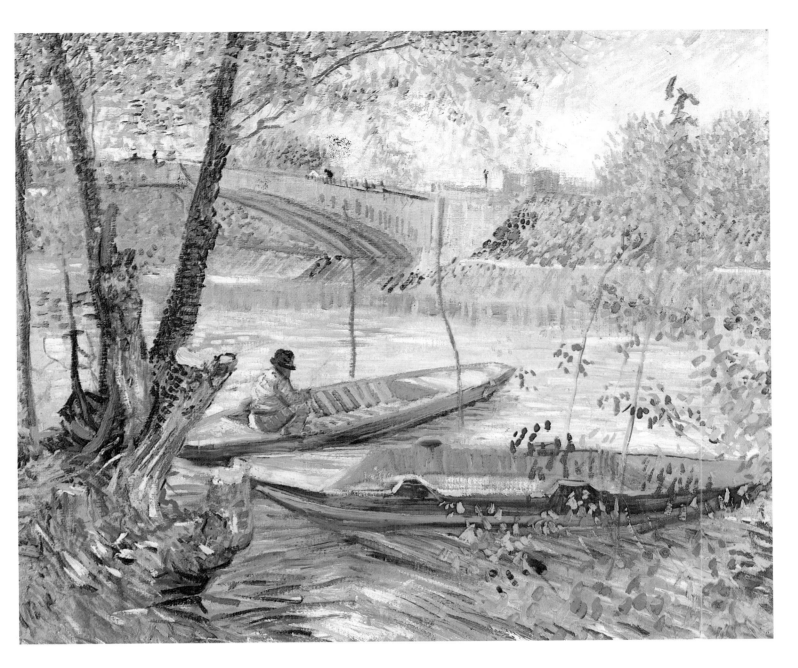

Fishing in the Spring, Pont de Clichy
Paris, Spring 1887
Oil on canvas, 49 x 58 cm
F 354, JH 1270
Chicago, The Art Institute of Chicago

cal skills, his strength was not so much a steady hand as a forceful will and a clear eye. So all his works are ad hoc creations, impetuously done, scarcely finished, and often bearing telltale signs of effort. When van Gogh adapted the various styles that were currently in vogue, he did so (it seems fair to say) without the charm or distinction that a Claude Monet or a Paul Gauguin, a Georges Seurat or a Toulouse-Lautrec all had in common, wilful as they might sometimes be.

"If you wish", Theo wrote to his brother after Vincent had departed for the south (Letter T3), "you can do something for me: you can continue doing what you have already done, and establish a circle of artists and friends, which I am quite incapable of doing on my own; since you came to France you have succeeded, more or less, in establishing a circle of that kind." Apparently Vincent was able to help Theo in his career as an art dealer. Theo's reputation as a specialist in the work of young artists, one of whom was his own brother, was growing. "Theo

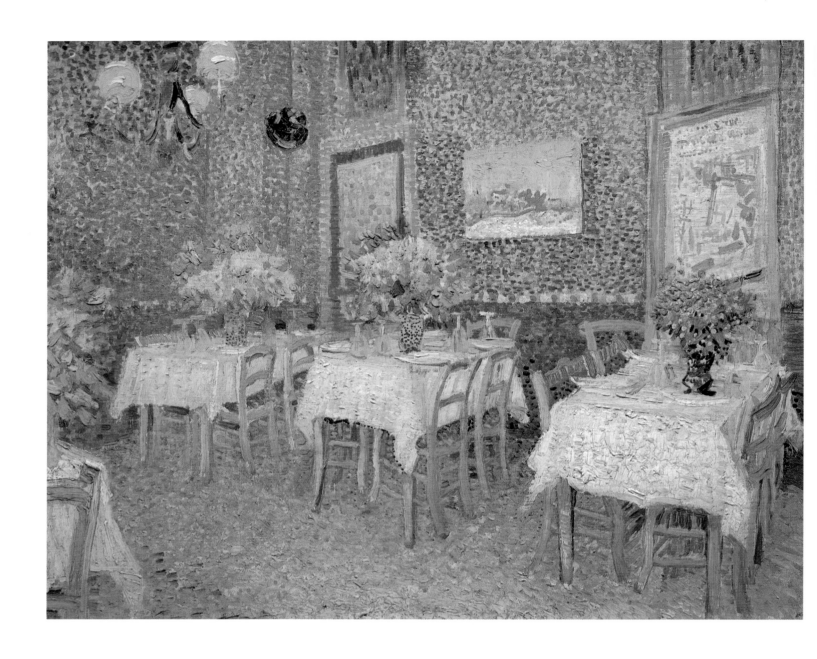

van Gogh", Gustave Kahn, one of their major theorists, later wrote, "was pale, fair-haired and melancholy. There was nothing loud in his ways. But this dealer was an excellent critic, and as an art expert would join in discussions with painters and writers." Gauguin was one of those who benefitted from the newly outward-going optimism of the brothers as they went their way amidst the throngs of would-be artists, lending each other support; it was Theo who first made a name for their mutual acquaintance.

It was Vincent's job to make contacts. His success in this cannot be accounted for by the exotic appeal of his out-of-town appearance alone. Experienced fellow-artists found him likable, and he established friend-ships with Bernard and with Paul Signac that lasted beyond the Paris years; there must have been a deeper reason for this. Van Gogh had quite intuitively (that is, in a less *voulu* manner than his friends) adopted a lifestyle that was then *de rigueur* for avant-garde artists. Naively (as it

Interior of a Restaurant
Paris, June-July 1887
Oil on canvas, 45.5 x 56.5 cm
F 342, JH 1256
Otterlo, Rijksmuseum Kröller-Müller

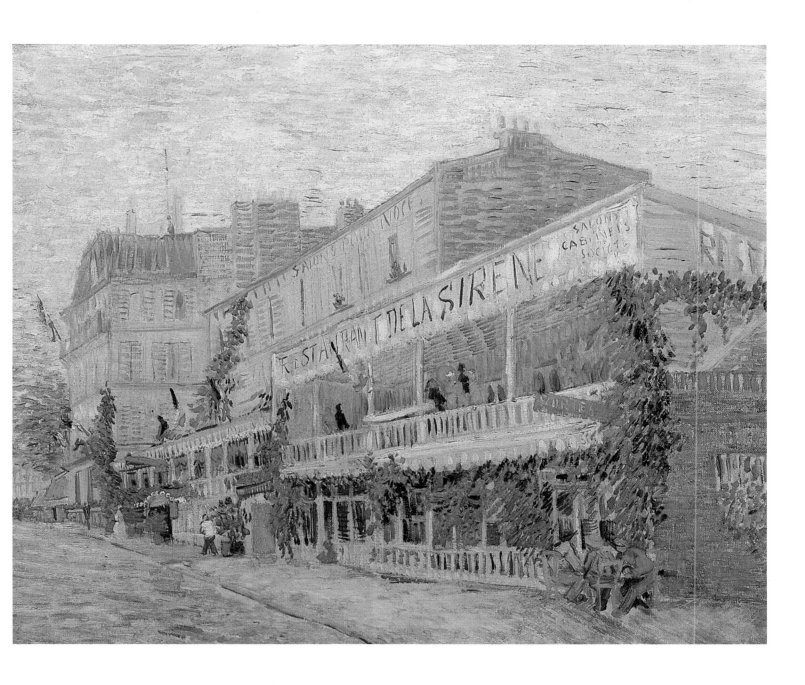

Restaurant de la Sirène at Asnières
Paris, Summer 1887
Oil on canvas, 54 x 65 cm
F 313, JH 1251
Paris, Musée d'Orsay

seemed) van Gogh had harmonized in his own behaviour traits that seemed forced or over the top when others tried them: he had reconciled artificiality and day-to-day ordinariness, the sense of vocation and life on the social periphery, conviction and playfulness, Art and Life. For two years, van Gogh was in the artistic swim, watching a scene that was infatuated with itself; and if he did not produce paintings of extraordinary importance during that time, at least his effortless ability to personify that scene's ideal of natural and deliberately aestheticized life at one and the same time made a vital contribution to the progress of modern art.

The Rispal Restaurant at Asnières
Paris, Summer 1887
Oil on canvas, 72 x 60 cm
F 355, JH 1266
Shanwee Mission (Kans.), Collection
Henry W. Bloch

Lane in Voyer d'Argenson Park at Asnières
Paris, Spring 1887
Oil on canvas, 59 x 81 cm
F 276, JH 1259
New Haven (Conn.), Yale University Art
Gallery

Through the Window
1886

Van Gogh painted almost 230 paintings during his stay in Paris, more than in any other comparable period of his life. This work is more diverse in character, the frank record of two years of continual experiment. In Paris, van Gogh put the rootedness of his apprentice years behind him. In terms of energy, what he accomplished is amazing; though of course speed, and ingenious touches, could not be as important as steady work. The theories van Gogh had adumbrated in the last letters he wrote from Nuenen were still far from being visible in his practice, and he was to spend the whole of 1886 putting the finishing touches to his early work. It took him several months before he could launch off in a new artistic direction. Van Gogh was still travelling with a good deal of the baggage he had picked up as he started on the artist's life, and could not simply throw it away in his new milieu. The main features of his Dutch output remained.

Those features might be characterized, in a word, as 'realistic'. Realism was a label that covered a multitude of artistic approaches, and still

The Seine with the Pont de Clichy
Paris, Summer 1887
Oil on canvas, 54 x 46 cm
F 303, JH 1323
Private collection
(Sotheby's Auction, New York, 10. 5. 1988)

Vegetable Gardens at Montmartre
Paris, Summer 1887
Oil on canvas, 81 x 100 cm
F 316, JH 1246
Amsterdam, Rijksmuseum Vincent van Gogh, Vincent van Gogh Foundation

**Couples in the
Voyer d'Argenson
Park at Asnières**
Paris, June-July 1887
Oil on canvas,
75 x 112.5 cm
F 314, JH 1258
Amsterdam, Rijksmuseum
Vincent van Gogh,
Vincent van Gogh Foundation

The Restaurant de la Sirène at Asnières
Paris, Spring 1887
Oil on canvas, 51.5 x 64 cm
F 312, JH 1253
Oxford, Ashmolean Museum

is; but, vague as the term may be, it can be helpful in trying to assess the diversity of van Gogh's oeuvre. Realism implies first and foremost a willingness to trust what is out there, what can be seen by the eye in everyday life. "First I draw a rectangle, of any size at all, on the surface where I am going to paint, and this I see as a window through which I can see what is to be painted." Trust in what the eye could see was the cornerstone of all painting according to *Della pittura [On painting]* (1435), a treatise by the Italian architect and aesthetics theorist Leon Battista Alberti. Ever since, the image of pictures as windows onto life had been used to vindicate inclusive presentation of the sheer plurality of phenomena and equally to sensitize responses to the near and the far, both the horizon and the detail seen close-up. Alberti was the first to formulate a principle that applied to all art after the Middle Ages: pictures were directly linked to the natural appearance of the world, and their qualities were to be assessed in proportion to their mimetic success. In this sense, van Gogh was a realist. His paintings were windows

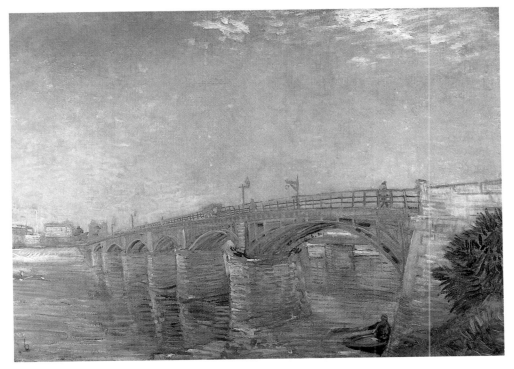

The Seine Bridge at Asnières
Paris, Summer 1887
Oil on canvas, 53 x 73 cm
F 240, JH 1268
Houston, Collection Dominique de Menil

onto the visible world. But increasingly (this is a point we shall be returning to) he was to be looking through tinted, darkened glass.

In the mid-19th century, the sociocritical pathos of Courbet and his disciples had made realism a programmatic position. The artist's eye was merciless; the reality he saw was rendered without any prettifying. Art took the side of the awkward angles of life that academic ornamentalism had smoothed out of existence. The new heroes were workers, beggars, and all the have-nots – the masses who had been given worthy literary treatment in Victor Hugo's *Les Misérables* for the first time. The Realist School (so said their principal propagandist Jules-Antoine Castagnary) "sees Art as an expression of every aspect and every level of Life; its pre-eminent aim is to reproduce the power and vividness of

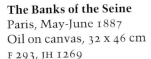

The Banks of the Seine
Paris, May-June 1887
Oil on canvas, 32 x 46 cm
F 293, JH 1269
Amsterdam, Rijksmuseum Vincent van Gogh, Vincent van Gogh Foundation

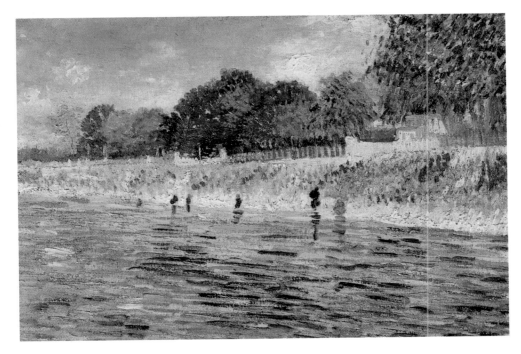

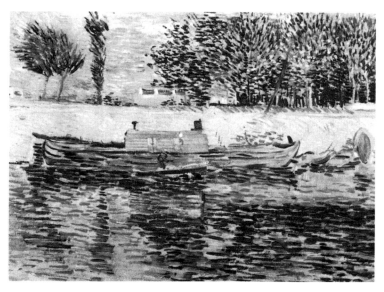

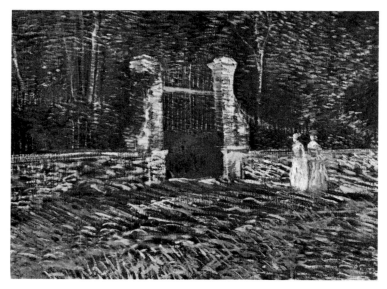

The Banks of the Seine with Boats
Paris, Spring 1887
Oil on canvas, 48 x 55 cm
F 353, JH 1271
Private collection
(Christie's Auction, New York, 15. 5. 1979)

Entrance of Voyer d'Argenson Park at Asnières
Paris, Spring 1887
Oil on canvas, 55 x 67 cm
F 305, JH 1265
Private collection

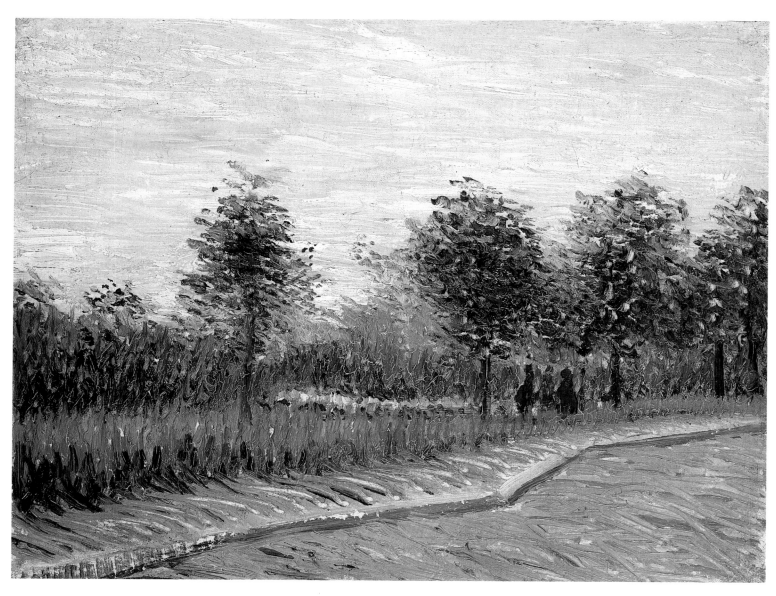

A Woman Walking in a Garden
Paris, June-July 1887
Oil on canvas, 48 x 60 cm
F 368, JH 1262
United States, Collection E. J. Bowes

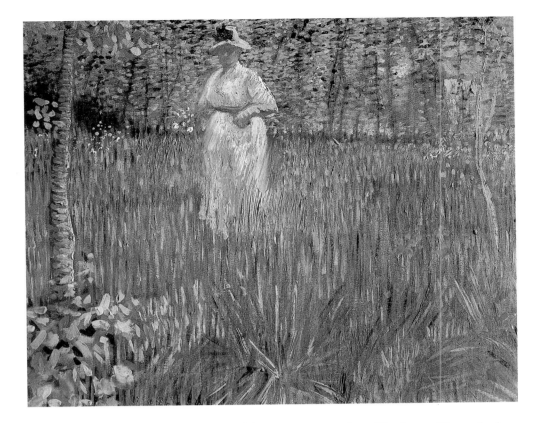

Edge of a Wheatfield with Poppies
Paris, Spring 1887
Oil on canvas on cardboard, 40 x 32.5 cm
F 310a, JH 1273
Japan, Private collection

BOTTOM LEFT:
Lane in Voyer d'Argenson Park at Asnières
Paris, June-July 1887
Oil on canvas on cardboard, 33 x 42 cm
F 275, JH 1278
Amsterdam, Rijksmuseum Vincent van
Gogh, Vincent van Gogh Foundation

Nature as forcefully as possible; it is Truth allied to Knowledge. Through its interest in rural life (which it has already proved able to present strikingly) and city life (which promises triumphs for the future), it is attempting to encompass every aspect of the visible world. In placing the artist squarely at the heart of his times and requesting him to mirror them, it is defining the true meaning and thus the moral mission of Art."

The same moral earnest, the same emphatic directness, was apparent in the manifesto van Gogh had already painted, *The Potato Eaters.* Ugliness was a token of involvement, expressive élan a means of locating the truth. Some of the best works done in his Dutch period show van Gogh to have been a committed realist. His devotion to the soil and above all to the simple, careworn people who lived off the land, and their poor homes, was essential to the dignity that is in these portraits and interiors. Courbet's creed might have been penned by van Gogh in one of his letters: "In this civilized society of ours I need to sense what the life of a savage is like; I even have to shake free of governments. My feelings are with the people; it is to the people that I must turn, and from them that I must draw my knowledge and my vitality." Courbet's practice established the concept of the *peintre ouvrier*, the painter as worker, as wage-earner. Van Gogh surely lived ont the role far more thoroughly than Courbet, though, and more expressively than other realists of the Millet or Breton brand, too – more expressively, yet in the total obscurity of the provinces.

If realism meant mimetic imitation of the given world of phenomena, and was by extension an aesthetic programme, the concept also em-

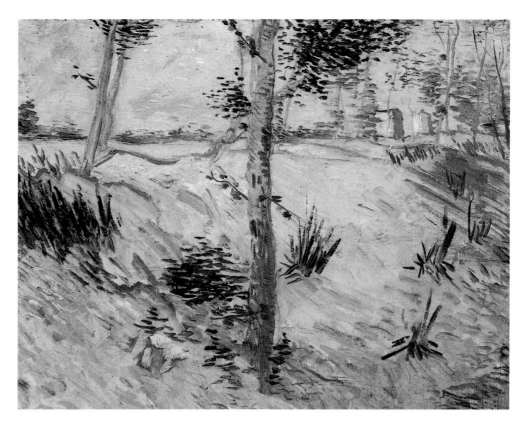

Trees in a Field on a Sunny Day
Paris, Summer 1887
Oil on canvas, 37.5 x 46 cm
F 291, JH 1314
Amsterdam, P. and N. de Boer Foundation

braced a third area: a method of direct approach to objects, a certain immediacy in the painter's confrontation of his subject. Realism, in this sense of an artistic method, remained van Gogh's watchword after he moved to the city. Seen in these terms, his entire output of 1886 was realistic.

In *Lane at the Jardin du Luxembourg* (p. 157) we find the artist among people out for a stroll on a summer's day. The scene is a tranquil one, flooded with bright sunlight. The people are strolling along the shady lane or sitting on the park benches watching the world go by. The painter can feel quite at home in this environment; there is room for his easel and he can expect to remain undisturbed as he observes people at

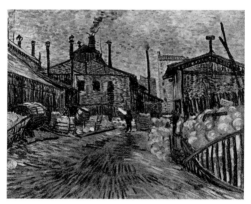

The Factory at Asnières
Paris, Summer 1887
Oil on canvas, 46.5 x 54 cm
F 318, JH 1288
Merion Station (Pa.), The Barnes Foundation
(Reproduction in colour not permitted)

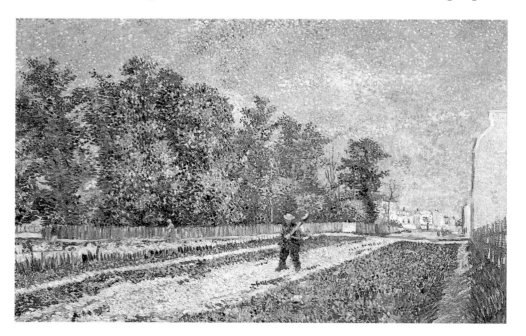

Outskirts of Paris: Road with Peasant Shouldering a Spade
Paris, June-July 1887
Oil on canvas, 48 x 73 cm
F 361, JH 1260
Fort Worth (Tex.), Collection Karen Carter Johnson

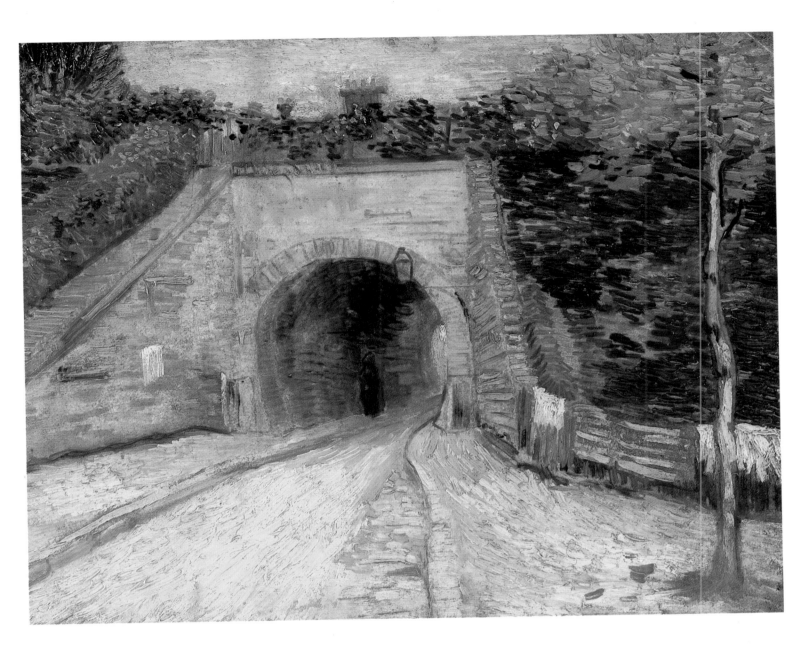

their Sunday pleasures. Even the seemingly inevitable woman in black (at left) is carrying a cheerful red parasol; she is simply a woman out for a stroll, conceived in that unforced, impartial spirit that can so often be the first casualty when van Gogh tries to inject significance into his subjects. Van Gogh has gladly acquiesced in the visual stimuli of the scene, taking his own pleasure in the colourful given world. His gaze is a semi-distant one, rendered in cheerful tones that have an Impressionist immediacy.

Trusting in what he saw with his own eyes, and believing that what he saw could be transferred with scarcely any reworking to the canvas, van Gogh created in this Jardin du Luxembourg scene one of his most attractive 'realistic' paintings. His symbolism, which could often seem forced, is still present in the picture, but it seems to have been quietly absorbed into it, without fuss, to create a new organic unity. "This hermit", Baudelaire had written about his painter of modern life, Guys, "gifted with an active imagination, forever travelling the 'great desert of

Roadway with Underpass (The Viaduct)
Paris, Spring 1887
Oil on canvas, 31.5 x 40.5 cm
F 239, JH 1267
New York, The Solomon R. Guggenheim Museum, Justin K. Thannhauser Collection

Park at Asnières in Spring
Paris, Spring 1887
Oil on canvas, 50 x 65 cm
F 362, JH 1264
Laren (Netherlands), Singer Museum (on loan from private collection)

Chestnut Tree in Blossom
Paris, May 1887
Oil on canvas, 56 x 46.5 cm
F 270a, JH 1272
Amsterdam, Rijksmuseum Vincent van Gogh, Vincent van Gogh Foundation

Wheat Field with a Lark
Paris, Summer 1887
Oil on canvas, 54 x 65.5 cm
F 310, JH 1274
Amsterdam, Rijksmuseum Vincent van
Gogh, Vincent van Gogh Foundation

Pasture in Bloom
Paris, Spring 1887
Oil on canvas, 31.5 x 40.5 cm
F 583, JH 1263
Otterlo, Rijksmuseum Kröller-Müller

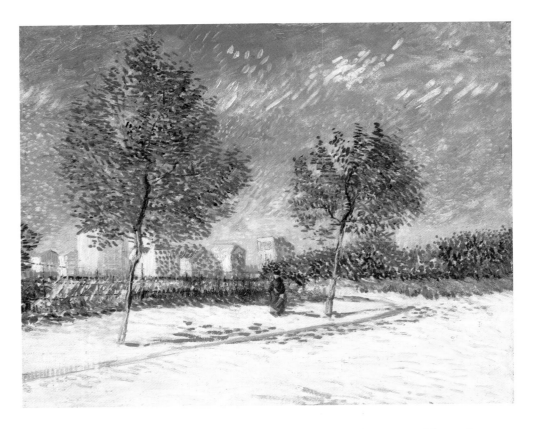

On the Outskirts of Paris
Paris, Spring 1887
Oil on canvas, 38 x 46 cm
F 351, JH 1255
United States, Private collection
(Sotheby's Auction, New York, 18.11.1986)

mankind', has a loftier goal than some idler, a different and broader aim than the fleeting pleasures of the moment. He is after that something which I shall venture to call 'modernity'.

For him, the issue at stake is to isolate the poetic quality in the merely historical, the eternal in the passing." Van Gogh had always made his approach from an eternal, poetic angle. Now (rapidly travelling the artistic line of evolution from Romanticism to Impressionism) he discovered the expressive power of the fleeting moment, of the flux of life. These pictures are not without depth; but it becomes increasingly

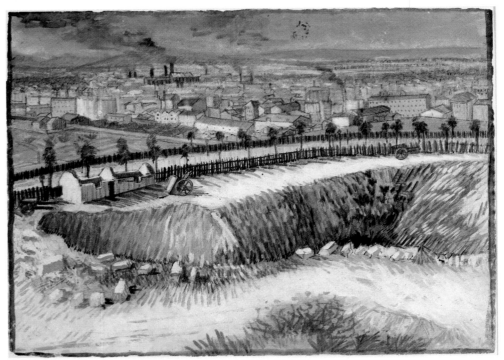

Outskirts of Paris near Montmartre
Paris, Summer 1887
Watercolour, 39.5 x 53.5 cm
F 1410, JH 1286
Amsterdam, Stedelijk Museum

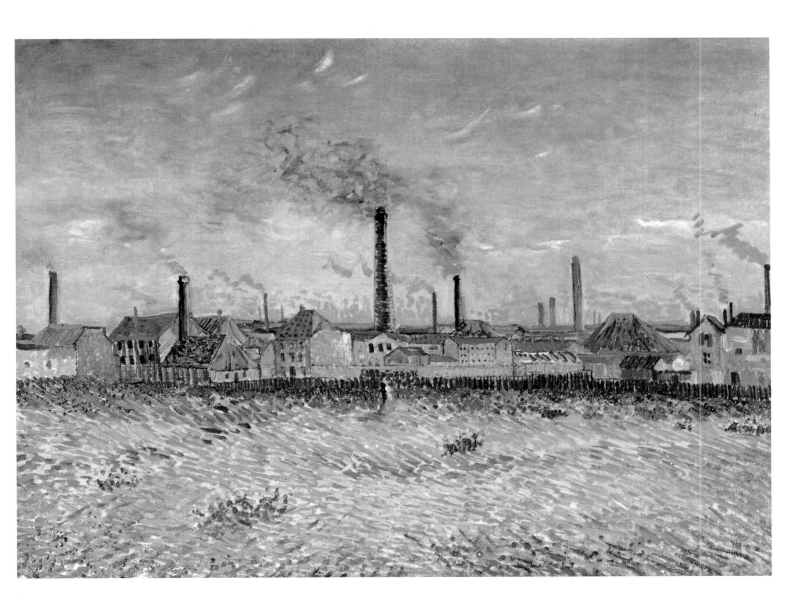

difficult to see past the recording of the moment to the timeless depths beyond. Baudelaire had called this 'modern'. And that was the very quality van Gogh was trying to make his own during 1886.

He also found symbols in the evidence of his eyes when he saw the three mills on Montmartre. Anomalous relics of a rural age within the city limits, the mills had become a popular place to go on public holidays; but doubtless they also reminded van Gogh of his homeland. One was the Moulin de la Galette, the garden restaurant immortalized by Pierre Auguste Renoir. Van Gogh's approach was altogether different. His attention was fixed not on the coffee-drinkers and dancers but on plain topography and architecture. In *Montmartre: Quarry, the Mills* (pp. 196 and 197) he offers a panoramic view of a moment of almost rural seclusion; his treatment emphasizes the mills' proud position atop the hill and directs our gaze away from the encroachments of the city. Van Gogh and his brother were living in a flat not far from the spot where Vincent made this attempt to see into the distance.

There are two scarcely noticeable figures deep in conversation in the second of these deserted landscapes – van Gogh's typically significant

Factories at Asnières Seen from the Quai de Clichy
Paris, Summer 1887
Oil on canvas, 54 x 72 cm
F 317, JH 1287
St. Louis, The Saint Louis Art Museum

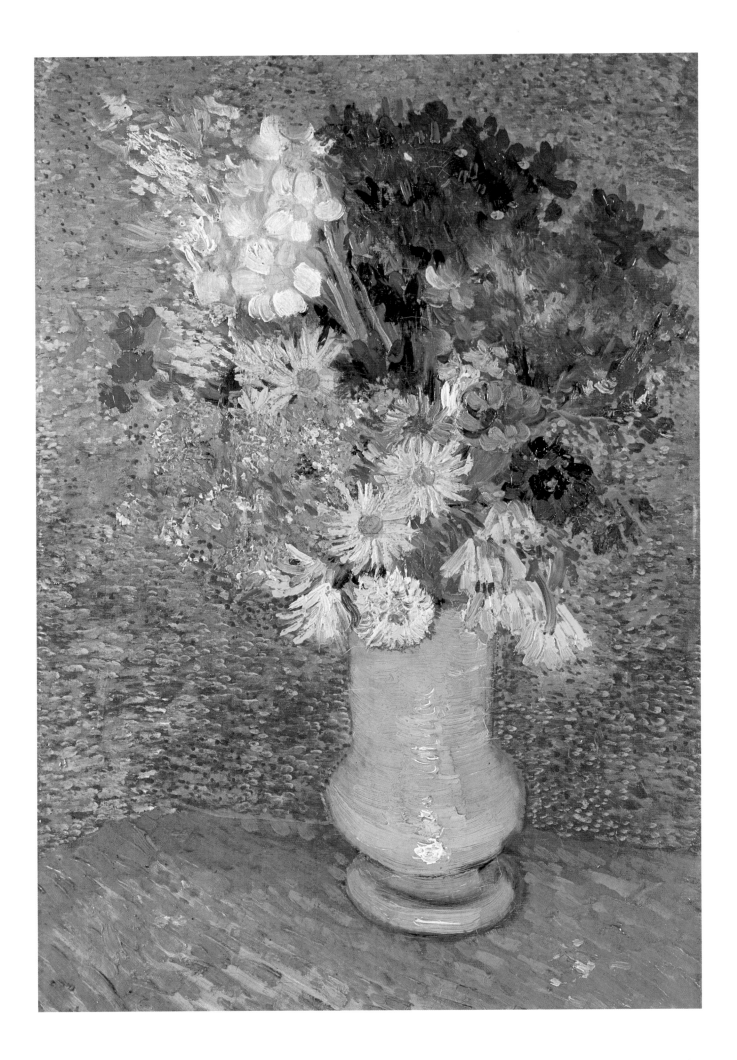

Lilacs
Paris, Summer 1887
Oil on canvas, 27.3 x 35.3 cm
F 286b, JH 1294
Los Angeles, The Armand Hammer
Museum of Art

Vase with Daisies and Anemones
Paris, Summer 1887
Oil on canvas, 61 x 38 cm
F 323, JH 1295
Otterlo, Rijksmuseum Kröller-Müller

personae, dark and anonymous, lending a touch of the mysterious to familiar surroundings. "When a painter goes out into the open country to do a study he tries to copy what he sees as exactly as possible. It is only later, in his studio, that he permits himself to rearrange Nature and introduce attributes that may be to some extent absurd. Realism leaves it at the first of these steps and disapproves of compositions that do not tell the truth." This account of 'realistic' treatment of Nature (by Hippolyte Castille, one of the spokesmen of the new response to the world) can serve as a yardstick to assess van Gogh's position. Undoubtedly he agreed with Castille in disapproving of "compositions that do not tell the truth", that used studies made on the spot as if they were more props, choosing whatever happened to suit the required effect. Van Gogh left his landscapes as the motif demanded they be painted. A *plein air* painter of a purist kind, he trusted in the fundamental effects of the light and air implicitly, and worked the atmospherics into the colours that filled his canvas. But there were times when the fascinating optical results he obtained did not satisfy him; his fondness for deep content would suspect that pleasures offered to the eye were merely superficial.

Avenue in Voyer d'Argenson Park at Asnières
Paris, Summer 1887
Oil on canvas, 55 x 67 cm
F 277, JH 1316
New York, Collection Mrs. Charles Gilman

Banks of the Seine with Pont de Clichy in the Spring
Paris, June 1887
Oil on canvas, 50 x 60 cm
F 352, JH 1321
Dallas, Dallas Museum of Fine Arts

And so he would place two black figures in the quarry, or position the forebodingly dark figure of a woman outside the Moulin de la Galette (cf. pp. 188 and 189). These iconographic afterthoughts were usually added in the studio. Castille might have damned them as absurd attributes. They appear from nowhere and are of marginal or negligible importance for the overall effect; but they keep the Romantic flag flying in the trim, open, clearly-lit world of the Realists.

That world is described, or recounted, in the picture. Van Gogh's imagination was unable to kick free; instead, he shackled it with strictly mimetic rules. These rules applied principally to the brushwork and the use of colour. It was not until after 1886 that van Gogh shed his reticence about departing from a faithful, descriptive account of his subject. If we turn once more to *Montmartre: Quarry, the Mills* (p. 197) we see that van Gogh's brushwork dutifully follows the optical impression conveyed by the motif. For the sails of the windmills he uses long, thin strokes; the heaps of stone in the foreground, by contrast, are done in broad, firm strokes; the rendering of the earthy slope is streaky and looks undisciplined; and for the intangible atmospherics of the sky van Gogh resorts to swirling brushstrokes. In all of this he is trying to capture the texture and consistency of things. This represents a development in his grasp of technique if we compare the work of his Dutch period, when a sophisticated textural approach of this kind would still

Garden with Sunflower
Paris, Summer 1887
Oil on canvas, 42.5 x 35.5 cm
F 388v, JH 1307
Amsterdam, Rijksmuseum Vincent van Gogh, Vincent van Gogh Foundation

Montmartre Path with Sunflowers
Paris, Summer 1887
Oil on canvas, 35.5 x 27 cm
F 264a, JH 1306
San Francisco, The Fine Arts Museum of San Francisco, Bequest of F. J. Hellman

Path in the Woods
Paris, Summer 1887
Oil on canvas, 46 x 38.5 cm
F 309, JH 1315
Amsterdam, Rijksmuseum Vincent van
Gogh, Vincent van Gogh Foundation

**Corner of Voyer d'Argenson Park at
Asnières**
Paris, Summer 1887
Oil on canvas, 49 x 65 cm
F 315, JH 1320
Private collection

Undergrowth
Paris, Summer 1887
Oil on canvas, 46 x 38 cm
F 308, JH 1313
Amsterdam, Rijksmuseum Vincent van
Gogh, Vincent van Gogh Foundation

have been beyond him. Van Gogh's 'realism' peaked in his first Paris phase. And it was only because he had grown confident of his command that he was able to shrug off virtuoso technique in the way he did in the years ahead.

He made the greatest leap in his use of colour. In Nuenen he had written of "creating in peace and quiet using only the palette, and Nature is in agreement" (Letter 429). Yet in 1886 he did nothing of the kind. His colours remained far from the autonomy he had envisaged; indeed, van Gogh still abided faithfully by local colour, by the appearance of his subject. His first self-portraits (pp. 153 and 187) indulged in browns reminiscent of the old masters, without a single highlight of pure, forthright colour to enliven them. It was as if the fascination of his own face crowded out all possibility of experiment with colour.

Yet van Gogh's entire attention was on colour. He painted a series of flower still lifes, setting himself the task much as he had with the series of peasants' portraits. He produced over forty of them; they are not exactly among his greatest masterpieces, but they certainly prove his

Vase with Cornflowers and Poppies
Paris, Summer 1887
Oil on canvas, 80 x 67 cm
F 324, JH 1293
Whereabouts unknown

Vase with Lilacs, Daisies and Anemones
Paris, Summer 1887
Oil on canvas, 46.5 x 37.5 cm
F 322, JH 1292
Geneva, Private collection

determination to master colour. Theo described the painting of these still lifes to their mother: "He is far more open-minded than he used to be, and very popular; for example, he has acquaintances who send him a fine bunch of flowers to paint every week. His main reason for painting flowers is that he wants to freshen his colours for later work." The still lifes represented a transitional phase for van Gogh, at the end of which he was to be profoundly aware of the power of different tones. Afterwards he would indeed be able to create using only the palette – but not before. *Vase with Hollyhocks* (p. 181) is an attempt to summarize the aims he had articulated in Nuenen. The red of the flowers contrasts with the green of the leaves. The greenish buds, though, are seen against a background only slightly different in tone. The picture is an exercise in the analogies of colours and colour contrasts; in this it is not alone in van Gogh's output at the time. However, the arrangement is a problem. Van Gogh has chosen the flowers carefully, selected a suitable vase, and positioned the whole in front of a background which, though not quite identifiable, gives a definitely spatial impression; the colours and the line of shadow clearly suggest a surface and a wall. Vincent was still painting what was out there. His fidelity to realism was as yet unwavering.

These still lifes nevertheless represent his furthest progress to date. Van Gogh might have started improvising freely from the palette, adding colour for its own sake, were it not for a figure of authority who confirmed him in his attachment to the subject: Adolphe Monticelli. Monticelli was a French painter of Italian extraction. His pictures of flowers were extremely pastose. And he was van Gogh's first artistic discovery in Paris; Vincent was to value Monticelli till the end of his days. Theo and Vincent owned one or two of the Provençal artist's impetuously painted canvases, works which made Vincent's own brushwork look tame. But Monticelli, of course, was painting mimetic copies of flowers, even trying to use thick paint as a kind of relief to convey the tactile, physical dimension of his subject as well as the visual. "I have been trying to convey intensity of colour", van Gogh wrote to Lievens (Letter 459a), referring to the flower still lifes. That was precisely it. The work he painted in 1886 was out to "convey"; it was still looking for (and in need of) the corrective reality would supply.

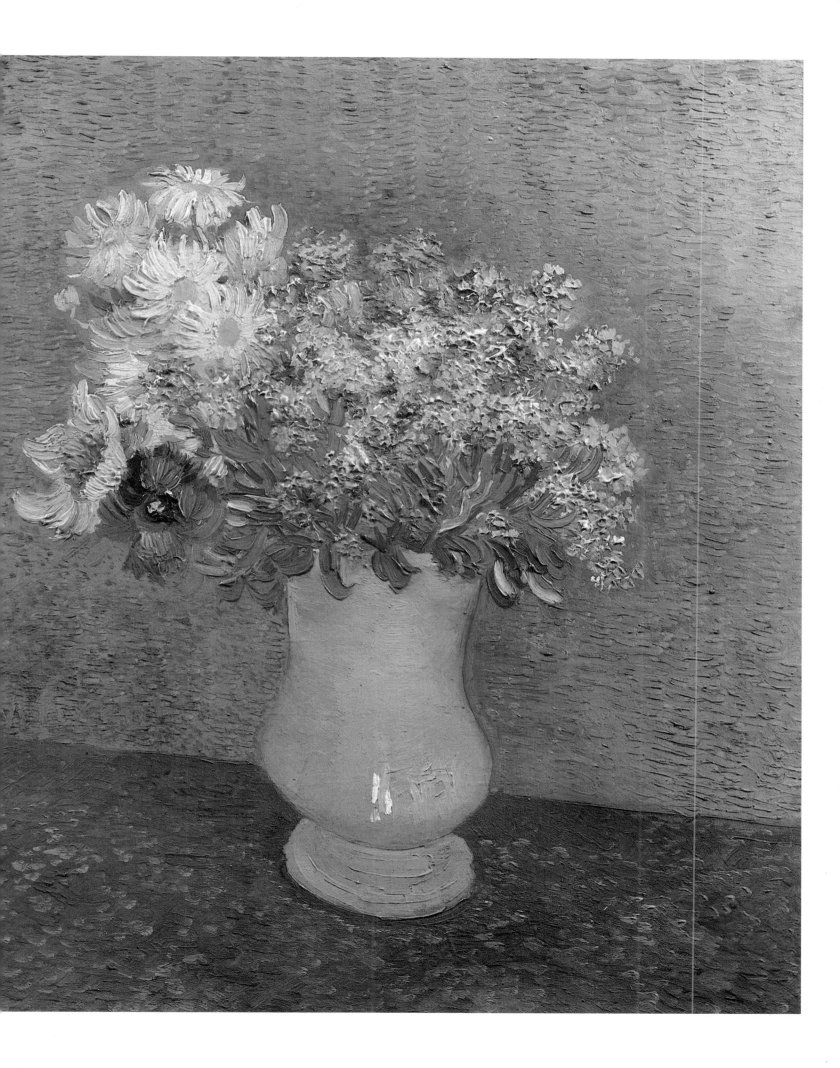

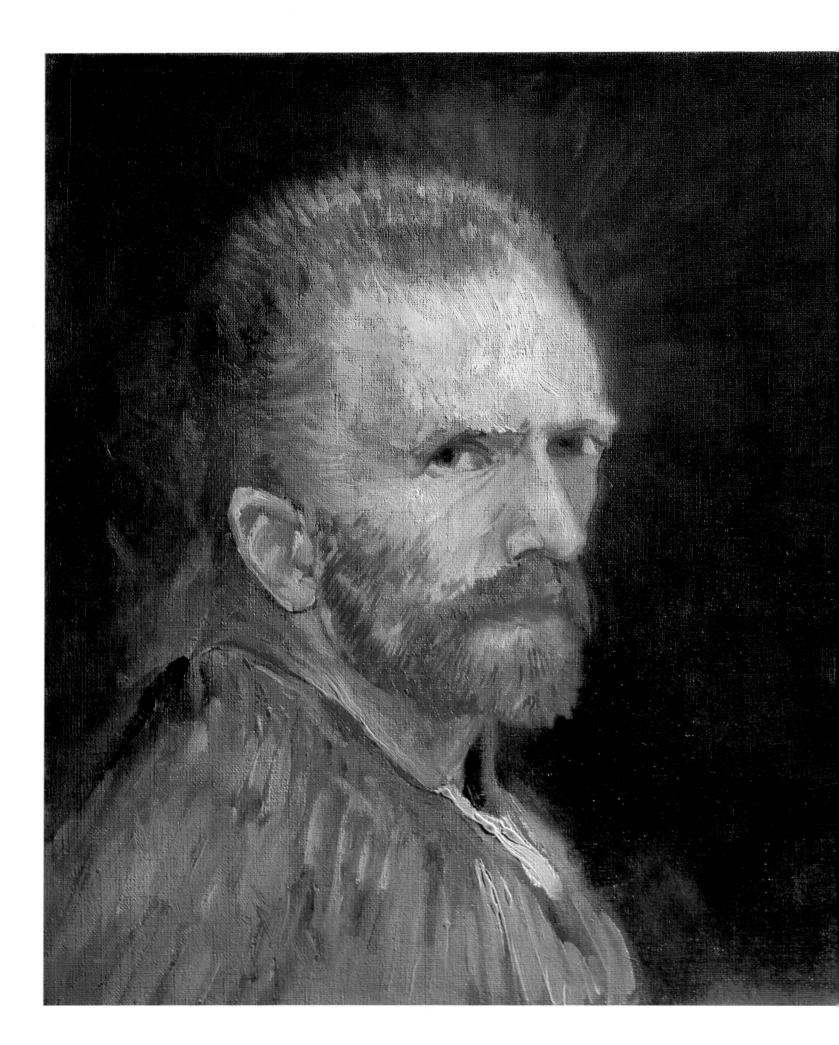

Isms, Isms, Isms
The 1887 Watershed

There they are, on a yellowish cloth: *Three Pairs of Shoes* (p. 201), well-worn footwear as the trademark of an artist who has travelled a long way. Van Gogh's attention is on the signs of heavy use. The worn leather, the ragged sole, the turned-back upper and the toe of the welt parting from the sole, are all emphatic indications of wear and tear. The shoes are seen without any illusions – a still life of fanatical mimetic fidelity. Similarly, the halfboots in *A Pair of Shoes* (p. 210, top) are by no means fashionable footwear. These, though, have a warmer orange tint and are seen contrasting against the blue of some indefinable background. White dots are used to convey the hobnails in the visible sole – though these dots also have a purely aesthetic function, as have the seemingly endless brushstrokes that do service as shoelaces. Vincent signed and (this is rare) dated the painting. He was making it quite clear that this picture was done in 1887, unlike another (p. 183) which probably dated from summer 1886. The artist's approach to colour and brushwork was now in the foreground. The earlier painting, with its love of detail, was losing the battle to a more individual approach that was unafraid of ornamental use of lines and loud colours. The two still lifes of shoes define the 1887 watershed: van Gogh was questioning his previous use of local colour and his purely descriptive style. He was quitting the analytic approach to his subjects which the 'realistic' method had impelled him to take. The *Self-Portrait with Straw Hat* (p. 271), done in summer 1887, similarly departs from the approach of earlier work. Now it is colour analogy that engages the painter's main interest, and the picture contains a cheerful, summery abundance of yellows in the shirt, face, hat and even the background. Carefully-deployed violet strokes add a subtle contrastive note. It is only in the ginger of the beard that van Gogh still retains the principle of local colour; but even here the red is used too sporadically to rate as altogether descriptive. The artist's familiar face has become a terrain for visual experiment. The basic features of his face have naturally been retained, and van Gogh's quirky blend of shyness and severity is readily identifiable. But it is no longer a portrait done merely by looking in the mirror. It records an appearance in a form created for the sake of the

Self-Portrait
Paris, Summer 1887
Oil on canvas, 41 x 33.5 cm
F 268, JH 1299
Hartford (Conn.), Wadsworth Atheneum

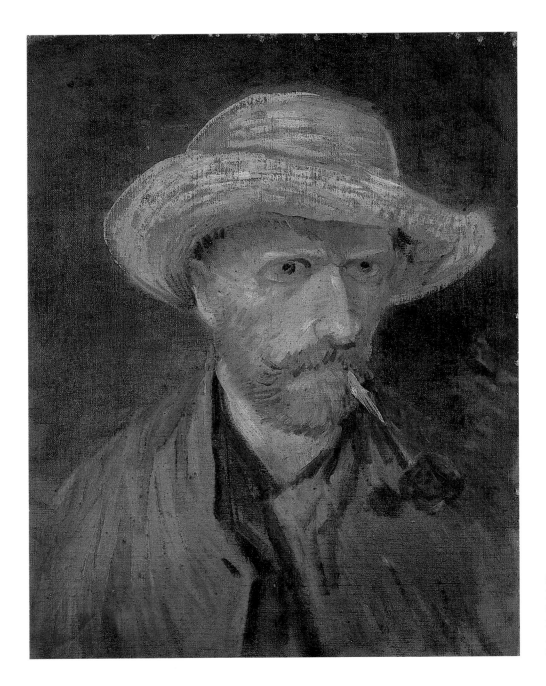

Self-Portrait with Straw Hat and Pipe
Paris, Summer 1887
Oil on canvas, 41.5 x 31.5 cm
F 179V, JH 1300
Amsterdam, Rijksmuseum Vincent van
Gogh, Vincent van Gogh Foundation

painting's effect. If we now turn to *Vegetable Gardens in Montmartre: La Butte Montmartre* (pp. 234-5) we find the canvas covered in colourful brushstrokes: the fences and sheds are treated in the same way, so that they are stylistically integrated into the overall visual effect. The landscape itself has become an excuse for spectacular stylistic showmanship which tends to obscure the subject. The lines are like iron filings being drawn to a magnet: critics have aptly referred to this chaotic approach as van Gogh's magnetic field method. As if on remote control, the brush flits about the canvas, adding here a stroke and there a stroke. "I see that Nature has spoken to me, has told me something that I have written down in shorthand. My shorthand may contain words that are indecipherable – but some of what the forest or shore or figure said still remains." Van Gogh had used this shorthand metaphor to describe his brushwork back in The Hague (Letter 228). But it was only now, six

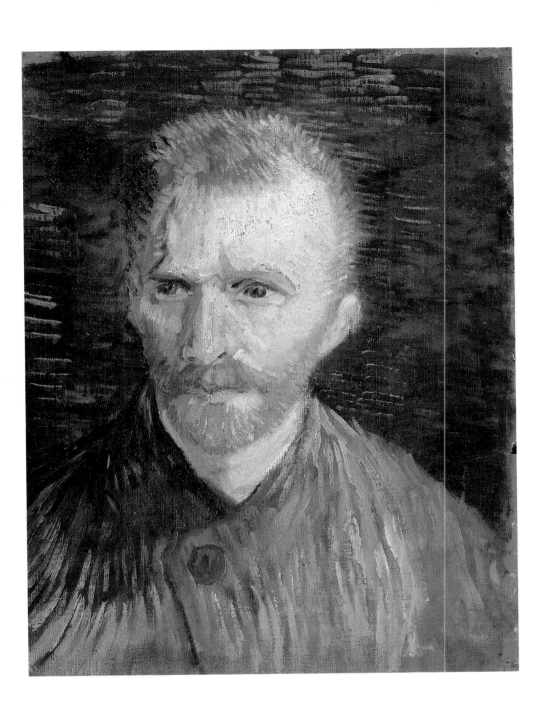

Self-Portrait
Paris, Summer 1887
Oil on canvas, 41 x 33 cm
F 77V, JH 1304
Amsterdam, Rijksmuseum Vincent van
Gogh, Vincent van Gogh Foundation

years later, that his virtuosity was such that rapidity, method and a
clearly individual touch all merged. Nature used to show things to van
Gogh and he would describe them; now, it told him things, and he re-
created the language, the syntax, the melody of the words.

In 1887 van Gogh finally discovered that autonomous value of a
painting that Cézanne referred to as a "harmony parallel to Nature."
The change did not happen with explosive abruptness; rather, it hap-
pened without deliberate volition in the wake of Impressionism. They
too were fundamentally 'realists'. They had indeed defined fidelity to
the phenomena of the world in radical terms by trying to eliminate the
influence of the subjective artistic personality. Reality (they believed)
should enter by the eye, directly, without any interference from
thought, and should leave a pure, visual impression in the resulting
picture. The main thing was speed: only speed could prevent conceptual

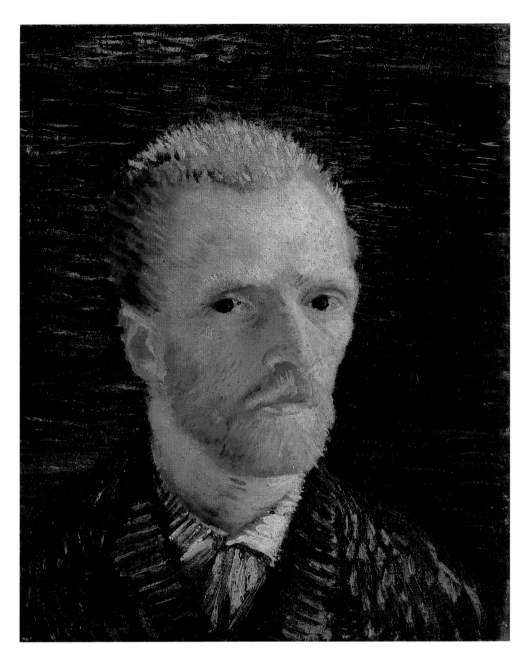

Self-Portrait
Paris, Summer 1887
Oil on canvas, 42 x 34 cm
F 269v, JH 1301
Amsterdam, Rijksmuseum Vincent van
Gogh, Vincent van Gogh Foundation

knowledge from hijacking the natural subject. To spend time and effort
re-creating the colours of things on the palette, and to establish their
contours on the canvas, would only have diminished the vitality of the
work. The characteristic sketchy style of the Impressionists was an
inevitable consequence of this attitude. Ironically, though, the method
evolved into its own opposite, using its engaging patterns of lines and
colours to interpose a veil between the world and the picture far more
than faithful realism ever did. The dabs and strokes and colourful dots
highlighted the two-dimensionality of the canvas, which came to de-
velop its own unsuspected qualities in a material sense. The painting no
longer represented Nature, it simply presented itself: it became essent-
ial to bear this obvious fact in mind. In 1887 van Gogh, too, perceived it
as a problem.

It was rarely, of course, that he painted a genuinely Impressionist
painting. *Trees and Undergrowth* (p. 277), for instance, done in summer

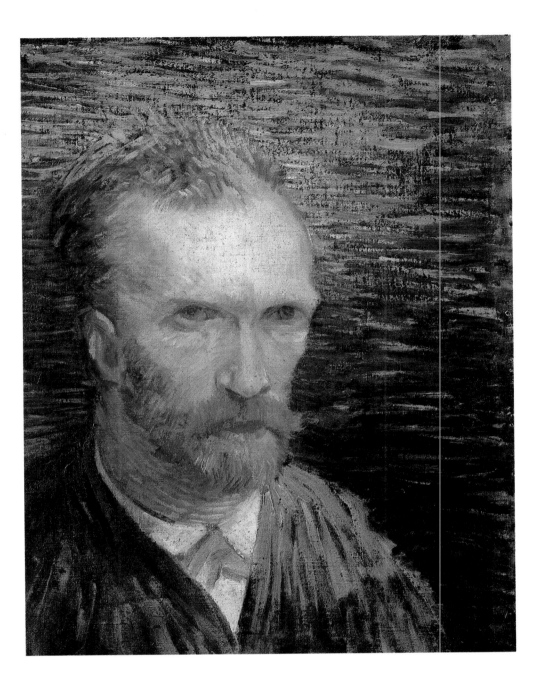

Self-Portrait
Paris, Summer 1887
Oil on canvas on cardboard, 42.5 x 31.5 cm
F 109v, JH 1303
Amsterdam, Rijksmuseum Vincent van
Gogh, Vincent van Gogh Foundation

1887, plainly picks up from work of Monet's such as the painting of an apple tree in blossom (Paris, private collection). Like the French artist, whose 1874 *Impression, soleil levant* (Paris, Musée Marmottan) had given the movement its name, the Dutchman was in a sense trying to convey a feeling of Nature. This green infinity with dabs of bright yellows and whites is not a faithful copy of a wood. Yet the sense of growth fills the canvas all the more powerfully: there is vitality in this burgeoning greenery, and the work becomes a kind of Creation in its own right. The artist is the instrument of the creative energy demanded by Nature, and witnesses with astonishment the process he is himself caught up in. His work is Nature's. His work, like Nature's, is a process of continual production, attesting evolution. The method of immediacy has become a philosophy, or at least a hymn to the power of change. The concept of art that developed from this was to need a great deal of elucidation in the times to come.

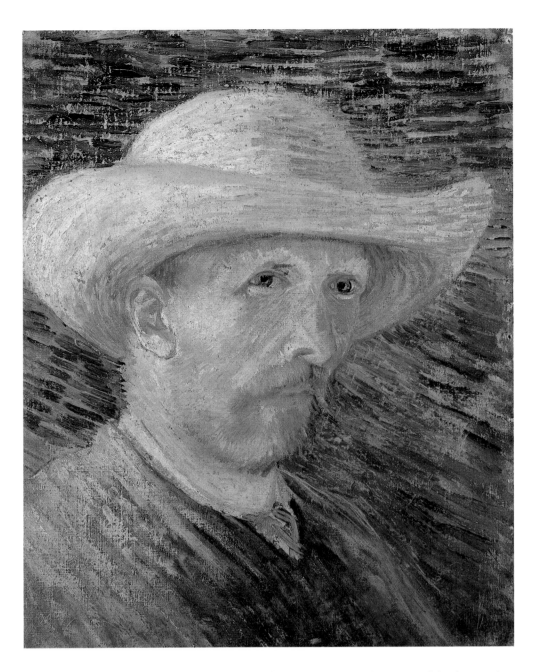

Self-Portrait with Straw Hat
Paris, Summer 1887
Oil on canvas, 41 x 31 cm
F 61V, JH 1302
Amsterdam, Rijksmuseum Vincent van
Gogh, Vincent van Gogh Foundation

The pleasure van Gogh was here sharing in the plant world, the realm of vegetative growth, presently came under attack for neglecting immutable universals and objectivity. What Impressionism had plainly achieved was now expected to make way for Post-Impressionism's goal of harmonizing flux and stasis, change and constancy. In 1887 the Pointillists had occupied all the strategic positions, which meant that van Gogh was registering the sequential progress of two different movements at the same time. No doubt he was basically uninterested in the divergences of their programmes; but the Pointillists had a leading spokesman who also happened to have become a good friend of van Gogh's – Paul Signac, the right-hand-man of the movement's leader Seurat and one of the few fellow-painters van Gogh was close to.

Self-Portrait (p. 221) was done early in 1887. The liveliness of the visual effect is not of a physical nature, as it was in the Impressionist view of trees and undergrowth; the basis is physiological. Charles Henry

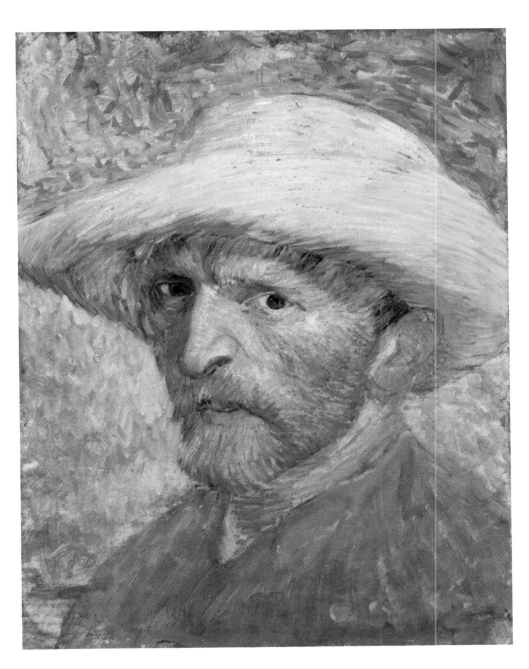

Self-Portrait with Straw Hat
Paris, Summer 1887
Oil on canvas on panel, 35.5 x 27 cm
F 526, JH 1309
Detroit, The Detroit Institute of Arts

and Charles Blanc, the Pointillists' foremost theorists, had found that juxtaposed dots of pure colour provoke a kind of visual panic: the eye compulsively tries to mix the distinct tones and see the staccato of dots as an even surface, as usual. The principle of optical mixing really does work – but it involves a constant sense of agitation. Now artists were trying to cool the overheated excitement of the dots by choosing static subjects: the timeless dignity of still lifes or portraits would help freeze matters. The plural meanings of the present moment (a truism in all modern world views) had been rendered by Impressionism in the polarity of the picture as window and the picture as surface. Pointillism expanded this polarity by adding the conflict of static and dynamic. In his self-portrait, van Gogh found a less radical way of expressing this conflict. Consistently enough, the lucid dabs of colour are used for the jacket cloth and the background but not for the living flesh of his face. Nevertheless, this painting – and the portrait of the art dealer Alexander

269 PAINTINGS: PARIS 1887

Exterior of a Restaurant at Asnières
Paris, Summer 1887
Oil on canvas, 18.5 x 27 cm
F 321, JH 1311
Amsterdam, Rijksmuseum Vincent van
Gogh, Vincent van Gogh Foundation

Reid (p. 228), done at the same time – were the closest van Gogh came to espousing the principles of Seurat and his group.

He borrowed another aspect of their programme in the two paintings titled *View from Vincent's Room in the Rue Lepic* (pp. 222 and 223). If dabs provide visual dynamics, a carefully calculated balance of verticals and horizontals can provide a static stability. We see this idea at work in van Gogh's panorama. A year before, in *View of Paris from Montmartre* (p. 182), his vision of the city's houses had been of an infinite sea; but now the sea had been dammed by walls, roofs and the horizon. To find the distance, our gaze must first negotiate a set of geometrical obstacles.

Still Life with French Novels and a Rose
Paris, Autumn 1887
Oil on canvas, 73 x 93 cm
F 359, JH 1332
Japan, Private collection
(Christie's Auction, London, 27. 6. 1988)

RIGHT:
Self-Portrait with Straw Hat
Paris, Summer 1887
Oil on cardboard, 40.5 x 32.5 cm
F 469, JH 1310
Amsterdam, Rijksmuseum Vincent van
Gogh, Vincent van Gogh Foundation

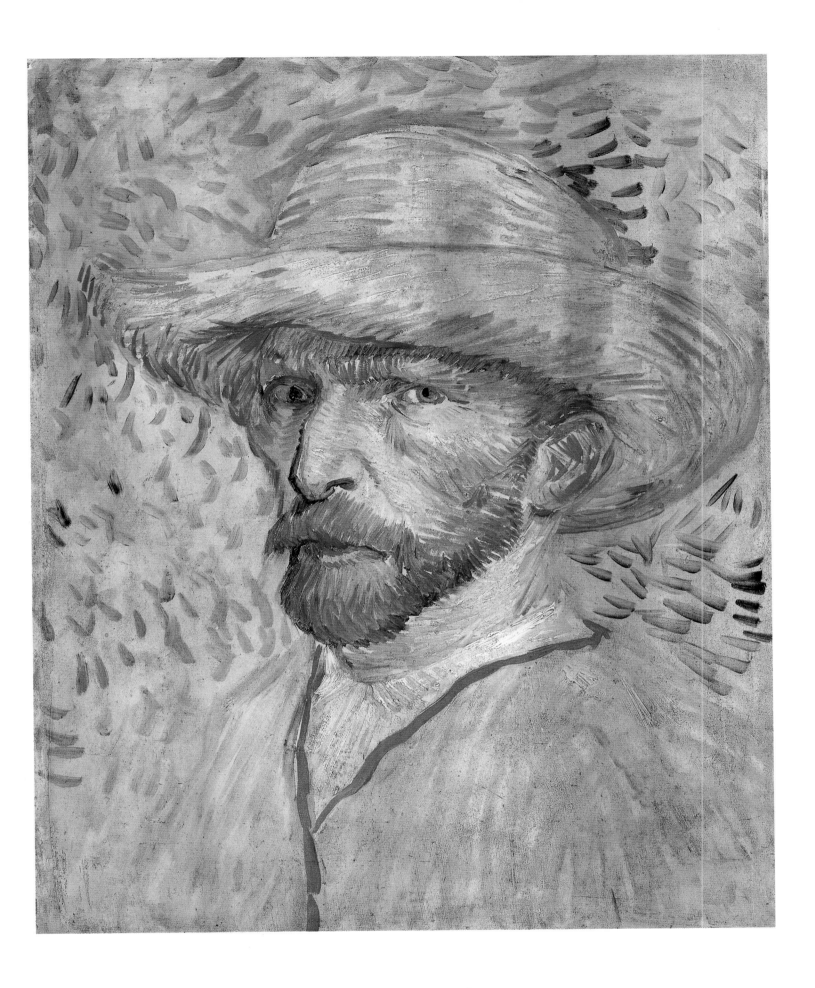

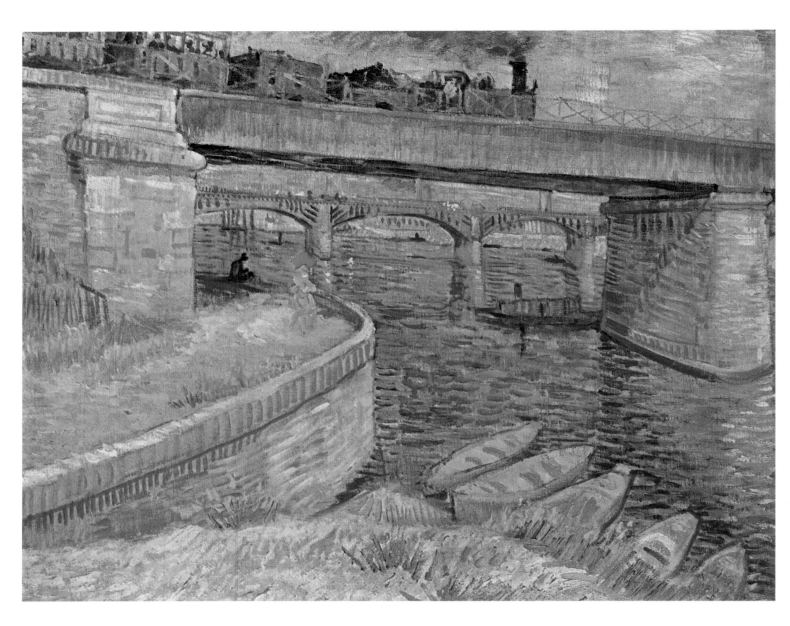

Bridges across the Seine at Asnières
Paris, Summer 1887
Oil on canvas, 52 x 65 cm
F 301, JH 1327
Zurich, Collection E. G. Bührle

Beyond, of course, lies the promise of freedom, the richness of Life. And in that beyond van Gogh has again abandoned pointillist technique.

"There is no single school", declared the Belgian writer Emile Verhaeren, considering the multiplicity of artistic persuasions in Paris at that time, "hardly even groups any more, since they are forever splitting up. The diverse tendencies remind me of movable geometrical patterns, as in a kaleidoscope, one moment opposed and the next united, merging then separating again and then crumbling, but nonetheless moving within a constant circle, that of modern art." Van Gogh was caught in this movement too, adrift in circles where everyone was hunting for the utterly new and convinced that he alone had found it. A standardized approach to Art had become as impossible as an unambiguous view of the world; so everyone was creating a language of his own, his own projects and manifestoes, and everyone subscribed to one style or another that he could believe to be universally valid. The metropolis was flooded with isms: Impressionism, Symbolism, Cloisonnism, Synthetism, Pointillism and more beside. This plurality signalled the

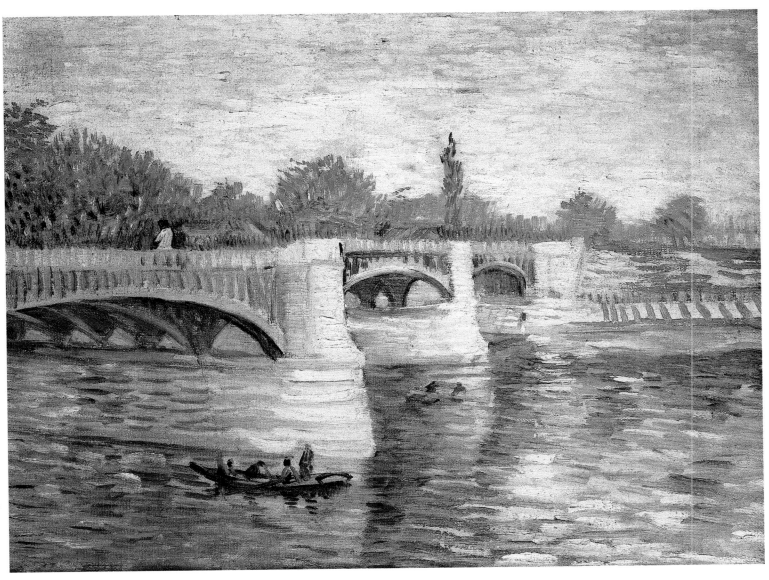

The Seine with the Pont de la Grande Jatte
Paris, Summer 1887
Oil on canvas, 32 x 40.5 cm
F 304, JH 1326
Amsterdam, Rijksmuseum Vincent van
Gogh, Vincent van Gogh Foundation

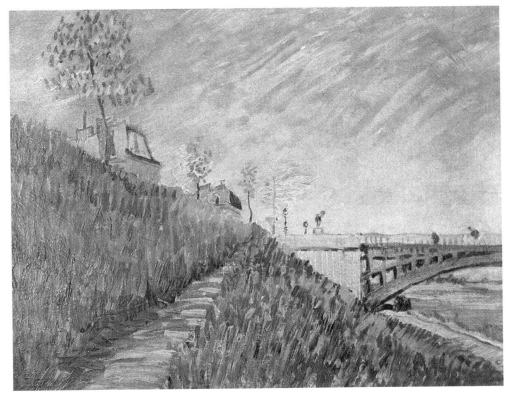

Banks of the Seine with the Pont de Clichy
Paris, Summer 1887
Oil on cardboard, 30.5 x 39 cm
F 302, JH 1322
Collection Stavros S. Niarchos

revolutionary vitality of modern art, but also the marginal role it was increasingly having to accept.

There was one thing they all had in common, as well as a conviction that they were the chosen ones: the custodians of traditional art considered them all crazy. The defamatory responses modern artists met with only fuelled their convictions. Van Gogh, for example, wrote to his sister (in Letter W4): "The dreary schoolmasters now on the Salon jury will not even admit the Impressionists. Not that the latter will be so intent on having the doors opened; they will put on their own exhibition. If you now bear in mind that by then I want to have at least fifty paintings ready, you will perhaps understand that even if I am not exhibiting I am quietly playing my part in a battle where there is at least one good thing to be said for fighting: that one needn't be afraid of receiving a prize or medal like a good little boy." The "good little boys" were the Establishment artists who pocketed the awards at the annual salons and were lionized by smart society. The isms were a product of another, excluded world. Those who had been recognised could go about their work in a liberated spirit and had little need to rely on a theoretically constructed style that was not out to account for the past but rather to enlist support for the future.

Undergrowth
Paris, Summer 1887
Oil on canvas, 32 x 46 cm
F 306, JH 1317
Utrecht, Centraal Museum
(on loan from the van Baaren Museum Foundation, Utrecht

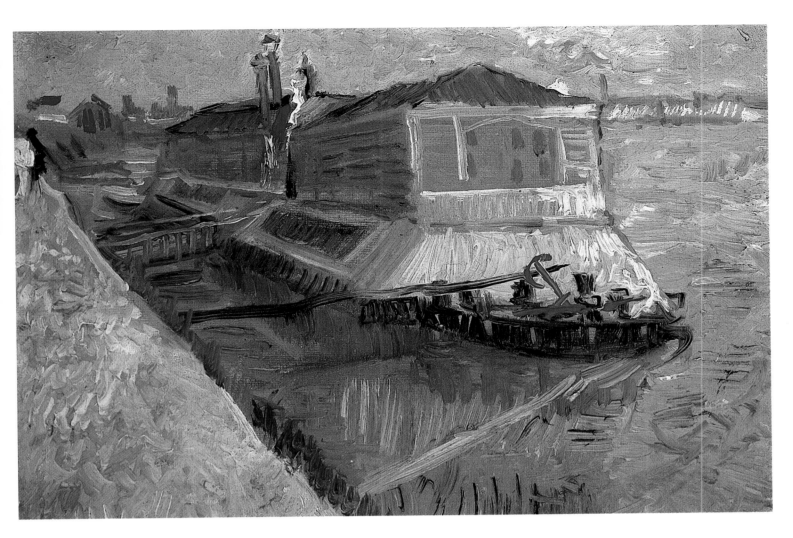

Bathing Float on the Seine at Asnières
Paris, Summer 1887
Oil on canvas, 19 x 27 cm
F 311, JH 1325
Richmond (Va.), Virginia Museum of Fine
Arts, Collection of Mr. and Mrs. Paul Mellon

The association of independent artists (the Indépendants) had been founded in June 1884. "This society", its constitution stated, "is fighting for the abolition of juries and means to help artists submit their work to the opinion of the public without hindrance." A new ism was being born: Secessionism. A profoundly democratic faith in the power of public opinion was out to end the authority of cavilling critics and replace it with the persuasive strength of discussion. Anyone who saw himself as an artist was expected to submit to it. In this there was a hint of what van Gogh termed 'soul' at the same period; though the corrective power of public opinion, by which the Secessionists set such great store, did not feature in van Gogh's thinking – and Modernism was to disavow this belief before too long, when it turned out that the people's expertise in matters artistic left much to be desired (they preferred cheap decorative art to the products of the isms).

An exhibition in November 1887, which van Gogh organized, nicely illustrated what was necessarily the semi-private character of these events. The show was at the Restaurant du Chalet in Montmartre and included about a hundred works by himself and his friends Toulouse-Lautrec, Bernard and Anquetin – artists for whom he had coined the joking label *peintres du Petit Boulevard* in contrast to the artists of the great boulevards, the Impressionists, who were now gradually reaping

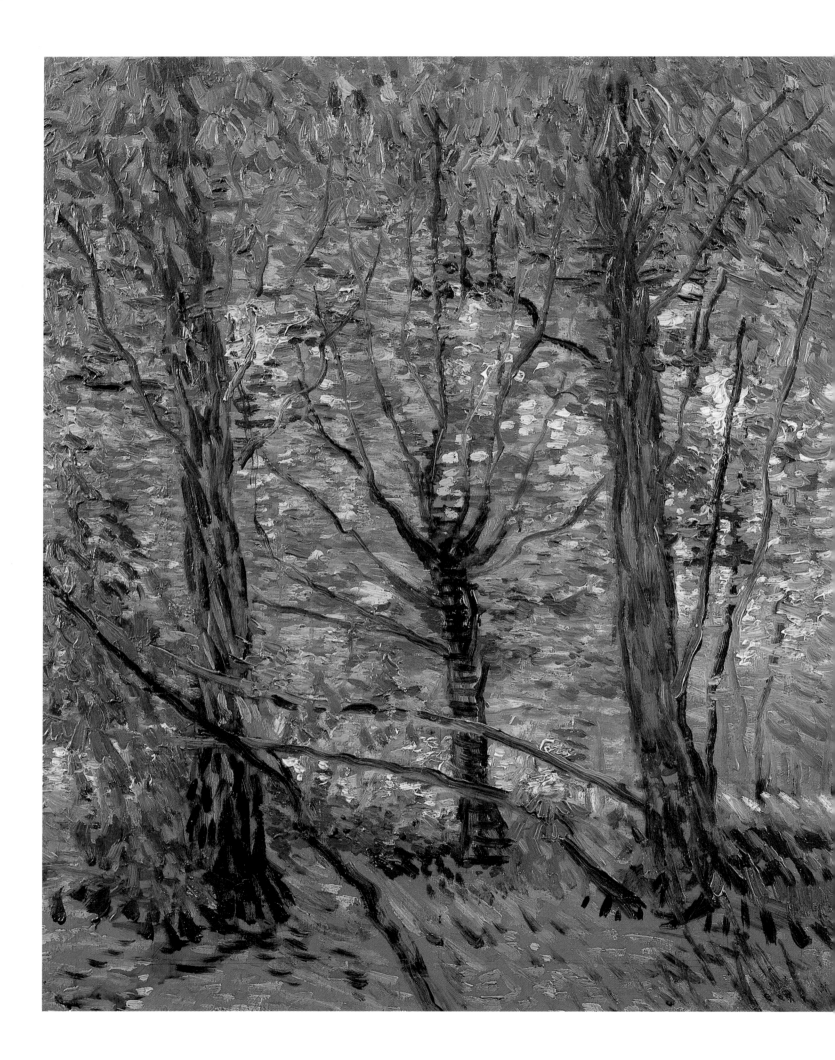

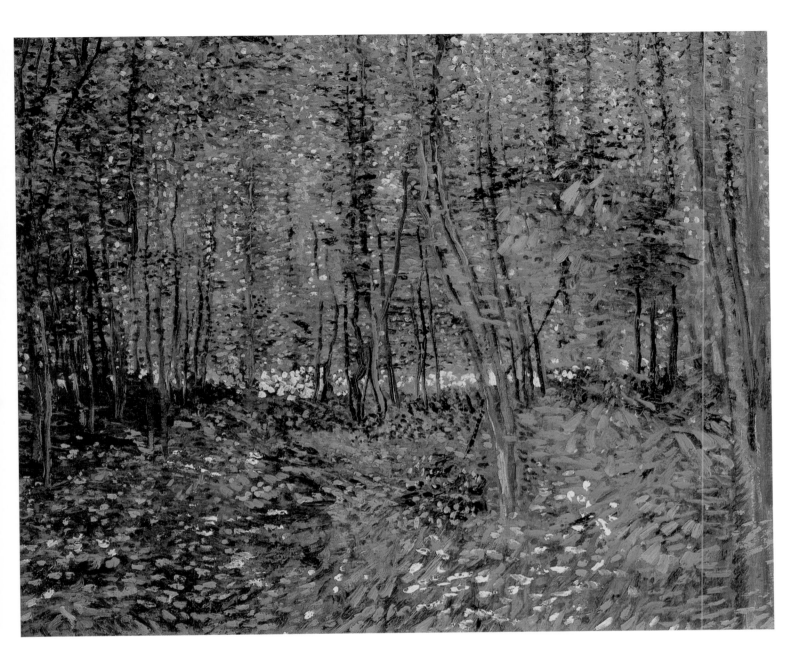

Trees and Undergrowth
Paris, Summer 1887
Oil on canvas, 46.5 x 55.5 cm
F 309a, JH 1312
Amsterdam, Rijksmuseum Vincent van
Gogh, Vincent van Gogh Foundation

Trees and Undergrowth
Paris, Summer 1887
Oil on canvas, 46 x 36 cm
F 307, JH 1318
Amsterdam, Rijksmuseum Vincent van
Gogh, Vincent van Gogh Foundation

their recognition. Bernard sold his first picture at the show, and Vincent was very proud of this modest success. The energy and commitment with which van Gogh joined the debate equipped him to reconcile warring factions, and he sounded a call to unity in a letter to Bernard (Letter B1): "Once you have reflected that Signac and the other pointillists often paint things of considerable beauty you will see that instead of attacking these pictures it is better to recognise their value and speak of them with respect, particularly if one is at loggerheads with the artists. Otherwise one will become a bigotted sectarian oneself, and be no better than the people who can see no virtue in others and believe they are the only ones who have understood what's what."

Van Gogh himself had never subscribed entirely to any one trend. He tried things out and borrowed whatever suited his artistic repertoire. He had gone to Paris to learn, and he knew there were many who had something to teach him. To the burgeoning art of Modernism, van Gogh

Two Cut Sunflowers
Paris, August-September 1887
Oil on canvas on triplex board, 21 x 27 cm
F 377, JH 1328
Amsterdam, Rijksmuseum Vincent van
Gogh, Vincent van Gogh Foundation

applied an ism that had been characteristic of the entire 19th century: eclecticism. Unlike the academics who had not scrupled to rummage in the traditional box of tricks, though, he did not stop there. He stirred the Parisian brew and fished out what he found to his taste. The ism that made the strongest appeal to him will be dealt with in the next chapter: Japonism.

"A work of art", Zola had famously asserted, "is a corner of creation seen through a temperament. The picture we see on this screen new to us consists in a reproduction of things and people on the other side of the screen from where we are; and that reproduction, which can never be completely faithful, is changed whenever a new screen is interposed between our eye and the world. In exactly the same way, differently tinted panes of glass make things appear different colours, and concave or convex lenses distort objects." To pursue Zola's terms: in Paris, van Gogh saw that there were an infinite number of tinted panes at his disposal when it came to that window known as a painting. Nevertheless (and this is of central importance in his entire oeuvre), he never

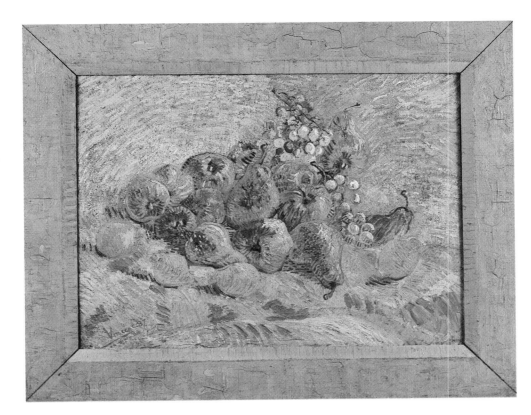

Still Life with Grapes, Pears and Lemons
Paris, Autumn 1887
Oil on canvas, 48.5 x 65 cm
F 383, JH 1339
Amsterdam, Rijksmuseum Vincent van
Gogh, Vincent van Gogh Foundation

pulled down that blind that blocks the view of the outside world and leaves pictures totally dependent on the artist's memory and imagination. Van Gogh remained a 'realist' who needed a world out there in order to paint. The subjects he tackled in Paris were typically Parisian. His windmills were not Dutch, they were on Montmartre; the women whose portraits he painted were not peasants, they were acquaintances met in restaurants and boulevards. Nor could the great Millet exhibi-

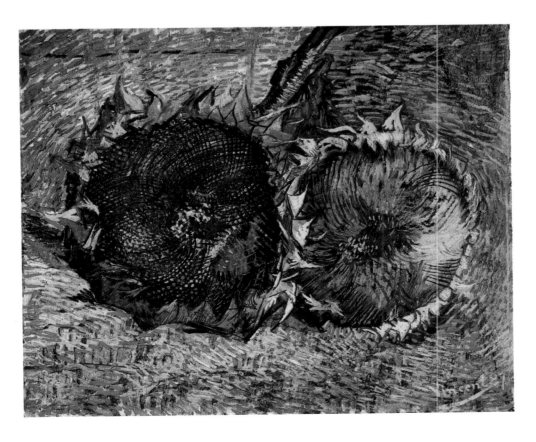

Two Cut Sunflowers
Paris, August-September 1887
Oil on canvas, 50 x 60 cm
F 376, JH 1331
Berne, Kunstmuseum Bern

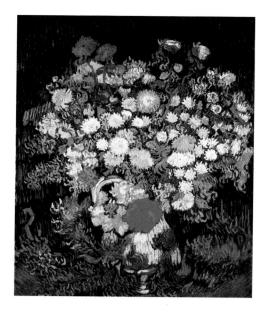

**Chrysanthemums and Wild Flowers
in a Vase**
Paris, Autumn 1887
Oil on canvas, 65 x 54 cm
F 588, JH 1335
Rancho Mirage (Cal.), Collection Mr. and
Mrs. Walter H. Annenberg

Four Cut Sunflowers
Paris, August-September 1887
Oil on canvas, 60 x 100 cm
F 452, JH 1330
Otterlo, Rijksmuseum Kröller-Müller

Two Cut Sunflowers
Paris, August-September 1887
Oil on canvas, 43.2 x 61 cm
F 375, JH 1329
New York, The Metropolitan Museum of Art

tion of spring 1887 move him to an emphatic espousal of peasant painting any longer.

Van Gogh tried his hand at new subjects. For the first time he painted the sunflowers which were to become the symbol of his artistic self *par excellence*. He placed their fiery yellow against a familiar blue contrast (cf. right) and used short strokes and dabs for the seeds; but these borrowings from the isms leave no disagreeable aftertaste of imitativeness with us. Van Gogh's way of seeing – through his own tinted panes – was committed and caring. The ragged petals, cut stems and robust close-up suggest metaphors in plenty: metaphors of menace but also of solidarity with a living thing about to wither and die. The casual atmospherics of Impressionism have been left behind, and authoritatively so. In that one year of 1887, van Gogh occasionally did seem about to be overwhelmed by the sheer mass of artistic conceptions that bombarded him, though; and some of his pictures – such as *The Seine Bridge at Asnières* (p. 245) or *The Seine with the Pont de la Grande Jatte* (p. 273) – are rather second-rate. They are studies using the perspective frame, struggling with the picturesqueness of reflections in the water and succeeding only in establishing a monochrome haze of blues.

Undoubtedly having minor masters as his mentors was an advantage. One friend was the tolerant Signac (rather than the over-theoretical Seurat); another friend was Bernard, just turned twenty (and not the obstinate Gauguin); he was unable to make the acquaintance of Monet. A Monticelli, Charles Angrand or Jean François Raffaelli (hardly the main names in the history of the avant-garde) remained with him longer than the truly eminent. It was the only way van Gogh could reach his goals. And the distance he had travelled from the well-meant emotionalism of his early period can be seen in a single statement written to his sister in summer 1887 (Letter W1): "What I find so splendid in the moderns is that they do not moralize like the old guard."

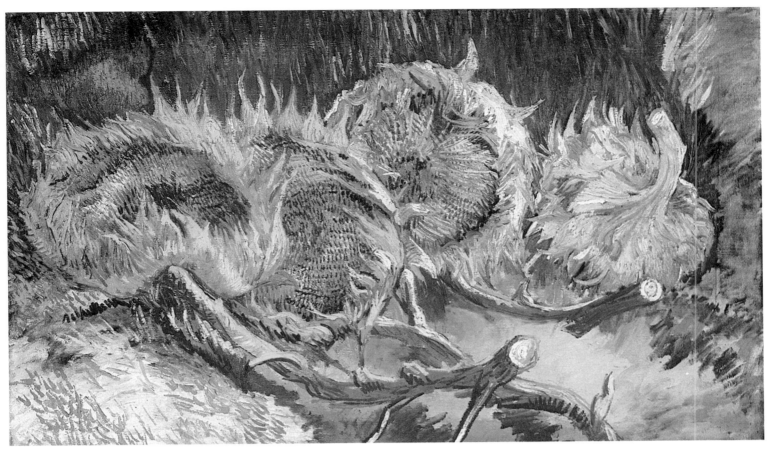

The Far East on his Doorstep
Van Gogh and Japonism

In 1891 the influential critic Roger Marx declared that Japan had been as important for modern art as classical antiquity had been for the Renaissance. Thirteen years earlier, Ernest Chesneau (in his article 'Japan in Paris') had already noted the wildfire that had been spreading throughout the studios, stores and cosmetic parlours of the city: "One was inevitably amazed at the impartiality of composition, the skill with form, the wealth of colour values, the originality of effects and at the same time the simplicity of the means used to achieve the various results." Japan meant more than the merely exotic. The Far East had conquered Europe by peaceful means, quite unlike the Occident, which was then engaged in forcibly subjugating other peoples. Japan had made its impact on 19th century culture.

In the age of the shoguns, Japan had been isolated and xenophobic. But at the 1867 Paris World Fair, Japan burst upon the scene like a bombshell, so to speak. The Japanese made skilful use of western notions of oriental mystery – and Paris gladly took object lessons from the articles

Still Life with Red Cabbages and Onions
Paris, Autumn 1887
Oil on canvas, 50 x 64.5 cm
F 374, JH 1338
Amsterdam, Rijksmuseum Vincent van Gogh, Vincent van Gogh Foundation

Portrait of Père Tanguy
Paris, Autumn 1887
Oil on canvas, 92 x 75 cm
F 363, JH 1351
Paris, Musée Rodin

Japonaiserie: Flowering Plum Tree
(after Hiroshige)
Paris, September-October 1887
Oil on canvas, 55 x 46 cm
F 371, JH 1296
Amsterdam, Rijksmuseum Vincent van
Gogh, Vincent van Gogh Foundation

Japonaiserie: Bridge in the Rain
(after Hiroshige)
Paris, September-October 1887
Oil on canvas, 73 x 54 cm
F 372, JH 1297
Amsterdam, Rijksmuseum Vincent van
Gogh, Vincent van Gogh Foundation

that were offered. Novelty always prompts a vogue; and Japan was fashionable. Society ladies wore kimonos, placed screens in their salons, and adored the tea ceremony. In the course of time the vogue evaporated and was replaced by a profounder understanding of Japan, which involved fewer people but also implied a more sensitive acquisition of knowledge. Looking back, we can distinguish four stages in the reception: firstly Japan was a treasure chest where anyone might find a few novel accessories; then the indulgence became a taste that decreed that only the Far East was acceptable and tried to reconstruct the oriental world in local homes; in the third phase people tried to reproduce that world, making their preferences a basis for a repertoire of their own making; and finally, a worldview was distilled from the language of forms and its principles followed.

These four stages of discovery, appropriation, adaptation and re-creation can be explained quite simply if we bear in mind that what was originally sequential struck the westerner far from Japan as juxtaposed and simultaneous. There were artists who were satisfied with the lure of the exotic and added conspicuous, kitschy props such as a low-level table or a woodcut to their pictures. Others stripped their scenes of genre ingredients in imitation of the purity of Japanese interiors which (in their view) were properly devoid of anything superfluous. Yet others, few in number, adopted a lifestyle modelled on that of Japan. Van Gogh was one of these few, though naturally he passed through the other

Japonaiserie: Oiran (after Kesaï Eisen)
Paris, September-October 1887
Oil on canvas, 105 x 60.5 cm
F 373, JH 1298
Amsterdam, Rijksmuseum Vincent van
Gogh, Vincent van Gogh Foundation

stages in the reception first. In Paris he went through the first three stages; and his decision to go south signalled his wish to find a true Japan of his own.

Back in Antwerp, van Gogh had already been decorating his walls with prints of the Ukiyoye (Popular) School. These scenes of everyday life were sold cheaply in thousands by a growing number of western dealers in Japanese work. From time to time there would be an Ukiyoye

masterpiece by Hokusai, Hiroshige or Utamaro among these prints of woodcuts. Their landscapes, portraits, and pictures of flowers and animals suited western ways of seeing (and indeed had themselves been influenced by European art taken to Japan by traders). In Letter 437 (written from Antwerp in November 1885) we even find van Gogh exclaiming, "Japonaiserie for ever" – quoting the brothers Jules and Edmond de Goncourt, who had been establishing Japan's literary credentials. This is the first we learn of Vincent's new penchant.

Van Gogh practically spent his first Paris winter in Siegfried Bing's shop, a short walk from his Montmartre flat. He was left to browse amongst the mysteries of oriental art to his heart's content; and he started a collection of Japanese woodcuts for Theo and himself that ran into the hundreds. In spring 1887 he included them in an exhibition he organized at the Café du Tambourin in Montmartre. A favourite rendezvous of Parisian artists, the café was happy to show it shared the

Still Life with Basket of Apples
(to Lucien Pissarro)
Paris, Autumn 1887
Oil on canvas, 50 x 61 cm
F 378, JH 1340
Otterlo, Rijksmuseum Kröller-Müller

Still Life with Basket of Apples
Paris, Autumn-Winter 1887/88
Oil on canvas, 46.7 x 55.2 cm
F 379, JH 1341
St. Louis, The Saint Louis Art Museum,
Gift of Sydney M. Shoenberg, Sr.

taste of high society. Japan was in. It was still a novel attraction. It was apparently then that van Gogh painted the portrait of the café's owner, Agostina Segatori (p. 206). She had modelled for Corot and for Jean Léon Gérôme and now sat for van Gogh a few times too; the only nudes he ever painted in oil were of her (pp. 202 and 203). We see her sitting at a table in the Tambourin that resembles the musical instrument that gave the café its name.

Edgar Degas's *Absinthe* (Paris, Musée d'Orsay) plainly inspired the setting. But in taking his bearings from Degas, van Gogh was not so much out to record the hopeless solitude of one woman seeking solace in alcohol and a cigarette as to practise an Impressionist eye for a hazy, smoky atmosphere. Van Gogh has invested the full resources of his modesty in painting an unprepossessing documentary picture: merging unclearly with the greenish background are a number of Japanese woodcuts on the wall panelling, doubtless from the collection of the brothers

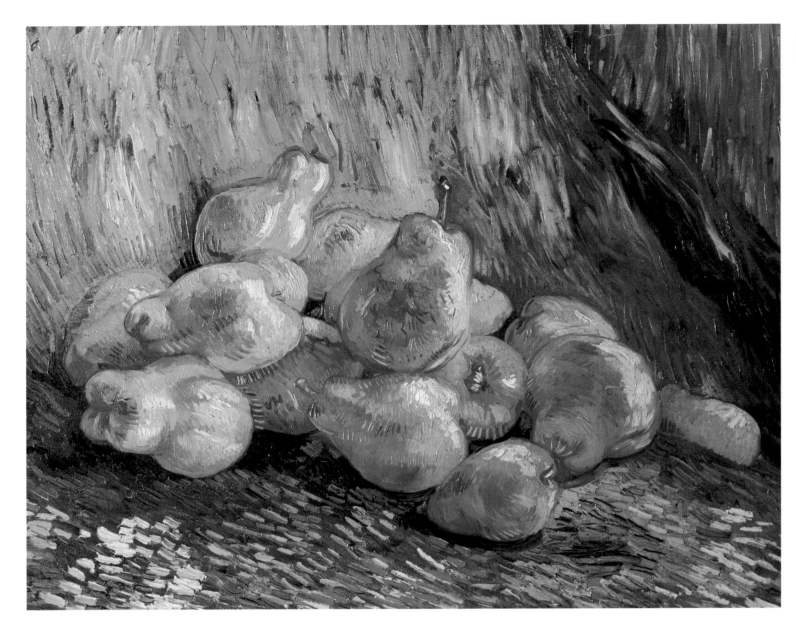

Still Life with Pears
Paris, Winter 1887/88
Oil on canvas, 46 x 59.5 cm
F 602, JH 1343
Dresden, Gemäldegalerie Neue Meister

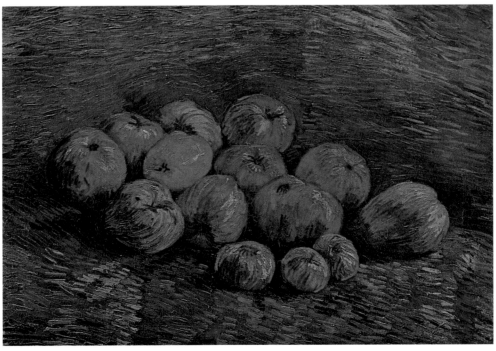

Still Life with Apples
Paris, Autumn-Winter 1887/88
Oil on canvas, 46 x 61.5 cm
F 254, JH 1342
Amsterdam, Rijksmuseum Vincent van
Gogh, Vincent van Gogh Foundation

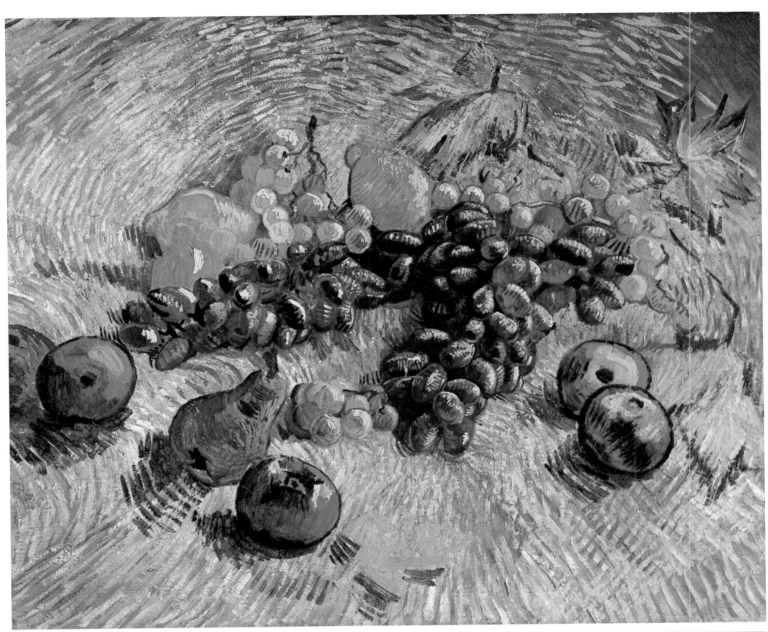

Still Life with Grapes, Apples, Pear and Lemons
Paris, Autumn 1887
Oil on canvas, 44 x 59 cm
F 382, JH 1337
Chicago, The Art Institute of Chicago

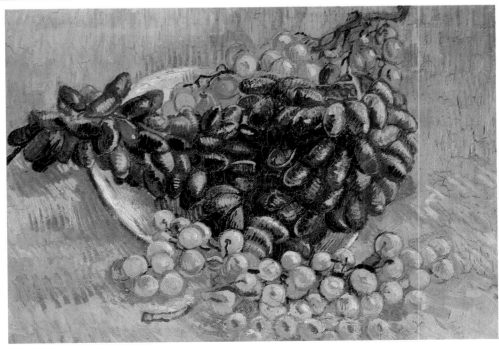

Still Life with Grapes
Paris, Autumn 1887
Oil on canvas, 32.5 x 46 cm
F 603, JH 1336
Amsterdam, Rijksmuseum Vincent van
Gogh, Vincent van Gogh Foundation

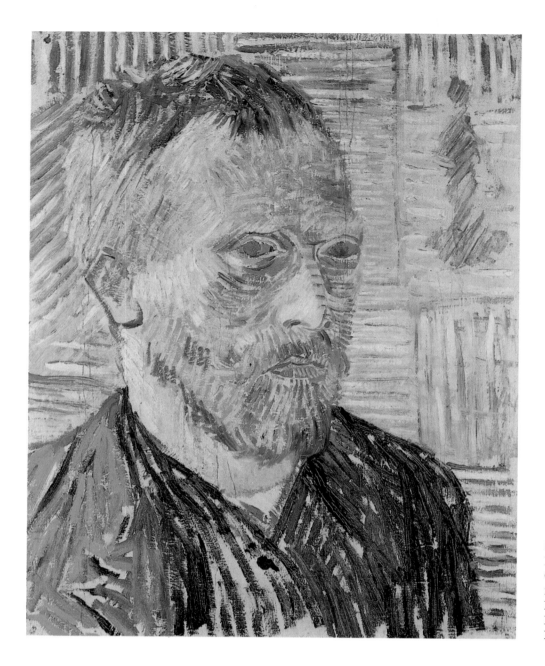

Self-Portrait with a Japanese Print
Paris, December 1887
Oil on canvas, 44 x 35 cm
F 319, JH 1333
Basle, Öffentliche Kunstsammlung,
Kunstmuseum Basel (on loan from the
Emily Dreyfus Foundation)

van Gogh. They lack the laconic eloquence Manet found in them, in his portrait of Zola (Paris, Musée d'Orsay). Van Gogh's prints look lost on the wall; they seem to match the meditative, introspective, lost look of the woman at the table. Like her hat, the prints are exotic accessories. As though ashamed of the impertinent demands being made on them, the artist leaves the prints ill-defined and nebulous, seemingly unable to make pictorial use of them.

A resolve to appropriate Japan became apparent six months later when van Gogh returned to a study method he had used in his early days as an artist: copying. He tackled three Ukiyoye subjects, fitting them into his own repertoire by imitating them – two Hiroshiges from his own collection, *Flowering Plum Tree* (p. 284) and *The Bridge in the Rain* (p. 284), and one by Kesai Eisen, *Oiran* (p. 285), which was on the cover of a Japanese number of *Paris illustré*, published by Theo's company. Copies of this kind are known as japonaiseries. As far as we know, van

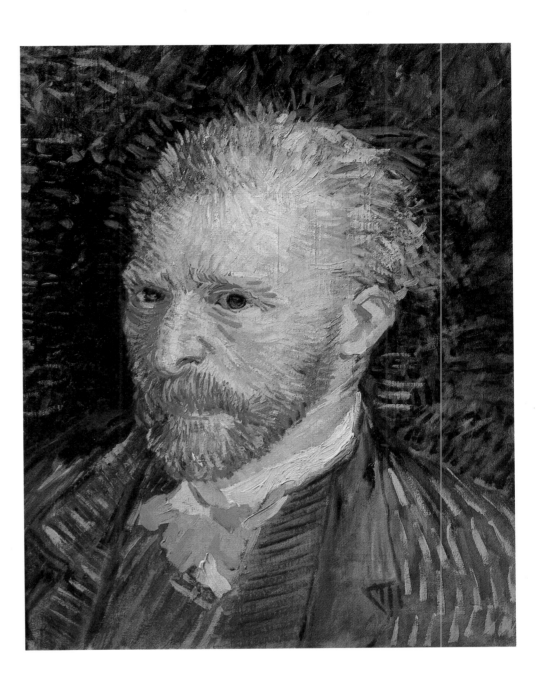

Self-Portrait
Paris, Autumn 1887
Oil on canvas, 47 x 35 cm
F 320, JH 1334
Paris, Musée d'Orsay

Gogh was the first to try his hand at them. And thus he embarked on the second stage in his response to Japanese culture.

"From time immemorial, the Chinese have been familiar with the laws of colour and have made use of them", Blanc had written, "and the tradition of those laws, handed down from generation to generation, has been preserved to this day and has spread throughout Asia, with the result that there is never a weak link in the chain of colour." Van Gogh used these models primarily to perfect his grasp of colour. He was able to juxtapose large areas of unmixed colour, relying on the familiar impact of contrast; and this brought home the full effect of monochrome blocks of colour alongside each other, where previously the setting of yellow beside violet or red beside green had depended on local colour or on small-scale brushwork. This was the first time van Gogh brought himself to use monumental areas of unmixed and unbroken colour, undimmed by questions of light and dark, in their full, vivid, radiant

Plaster Statuette of a Female Torso
Paris, Winter 1887/88
Oil on canvas, 73 x 54 cm
F 216, JH 1348
Tokyo, Private collection

Italian Woman (Agostina Segatori?)
Paris, December 1887
Oil on canvas, 81 x 60 cm
F 381, JH 1355
Paris, Musée d'Orsay

power. He had always valued his fourth, wholly uncanonical contrast very highly too: that between black and white. The Impressionists had exiled black from their palette as a non-colour, but it was vital to the prints, and the Ukiyoye School confirmed his love of the sensuousness and symbolic power of black.

Van Gogh was also attracted by the daring diagonals and jolting shifts in perspective the woodcuts used in order to establish spatial depth. Uninitiated into the greater mysteries of perspective, van Gogh had rigged up a rudimentary frame in the manner we have already described. The angles of vision that resulted from using this crude aid were not unlike those of the Japanese prints. The diagonals van Gogh's frame tended to insist on represent a distinct similarity. His Seine bridge (cf. p. 245) looks like an Impressionist version of Hiroshige's *Bridge in the Rain*; no doubt the resemblance was coincidental and not intended. At all events, van Gogh found his own spatial methods confirmed by the Ukiyoye artists. And their decorative flatness, which counteracted the pull of depth, also impressed him. This afforded an option of staying on the flat surface of the canvas or entering the depths of the picture, as he preferred – and who could say what was incompetence and what an intentional aesthetic effect? One thing was sure: the woodcuts were there as a precedent.

Japanese art provided a universal language of forms that could be used to express new things that were not worn out – modern things. So far van Gogh had imitated, without concern for his own style. There are thick streaks of paint on his canvasses, of course, and in consequence they seem a far cry from the understated originals – but that is first and foremost a question of transferring to the medium of paint. And of course van Gogh invented frames and painted in written characters without any interest whatsoever in whether or not they meant something – but this is primarily a question of the vertical format preferred by the Japanese artists, which van Gogh had to adapt to the sizes of his frames. He was simply curious, anxious to learn. And his eagerness is documented by the work he did in the third stage of his reception of Japan, the adaptation stage.

Those works mark the end of his Paris output. In them we find him engaging with the same problems as Bernard, Anquetin and Toulouse-Lautrec, who were all, in their different ways, trying to come to terms with this new visual world. Their magic masterstrokes were forced spatial depth on the one hand and decorative use of the colourful surface on the other. Each of them made fundamentally different use of these touches; but van Gogh was the only one to draw farreaching conclusions from what he learnt. He was in pursuit of some other reality where he would find the New Japan. It must be outside Paris, because the city afforded the new too few chances. That quest was to be the fourth stage in his reception of Japan; and on the threshold we find three portraits.

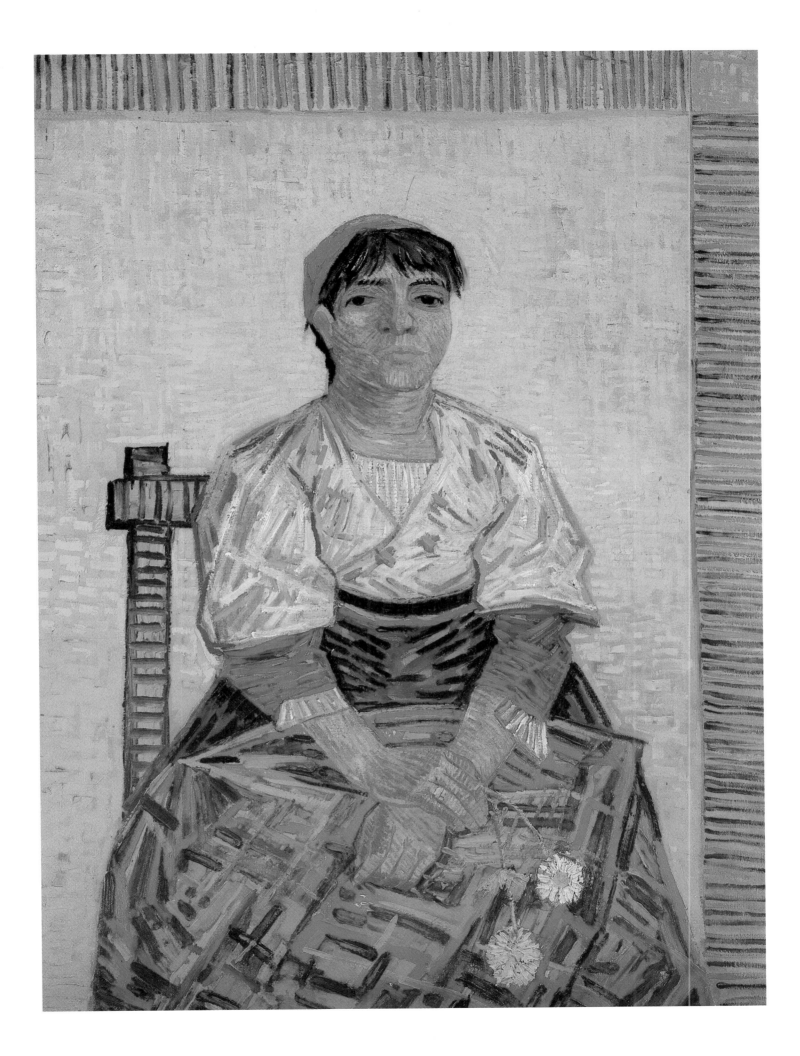

The whole of van Gogh can be found in them, in terms of his ability as a painter. In terms of his personality, the south was yet to coax his total identity into being.

Let us examine the portraits of Père Tanguy (pp. 282 and 296). Julien Tanguy, from whom Vincent bought his paint, deserved his soubriquet. He had seen the glorious days of the Commune and, as a Communard, had been sent to prison. Now, his utopian vision of a better world distinctly faded, he himself was kindness in person, giving credit, presents and support to needy artists. The back rooms of his modest store were a gallery of sorts where their work could be viewed and bought. He saw the artistic idealists of the modern movement as fellow-travellers who had been ignored, misunderstood and despised as he himself had been. Tanguy's premises provided the first opportunity ever to see works by Seurat, Cézanne, Gauguin and van Gogh together in one place: the four precursors of the 20th century who at that time were of little or no interest to anyone. Vincent admired the old man's calm serenity.

His two portraits of Père Tanguy are very similar. The earlier (p. 282) is a shade more conventional, as we might logically expect. The background is covered with woodcuts in memory of the beginnings of van Gogh's Japonism. Now they are so clear we could almost reach over and

Skull
Paris, Winter 1887/88
Oil on canvas on triplex board,
41.5 x 31.5 cm
F 297a, JH 1347
Amsterdam, Rijksmuseum Vincent van Gogh, Vincent van Gogh Foundation

Skull
Paris, Winter 1887/88
Oil on canvas on triplex board, 43 x 31 cm
F 297, JH 1346
Amsterdam, Rijksmuseum Vincent van Gogh, Vincent van Gogh Foundation

Still Life with Plaster Statuette, a Rose and Two Novels
Paris, December 1887
Oil on canvas, 55 x 46.5 cm
F 360, JH 1349
Otterlo, Rijksmuseum Kröller-Müller

Portrait of Père Tanguy
Paris, Winter 1887/88
Oil on canvas, 65 x 51 cm
F 364, JH 1352
Collection Stavros S. Niarchos

Self-Portrait
Paris, Winter 1887/88
Oil on canvas, 46 x 38 cm
F 1672a, JH 1344
Vienna, Österreichische Galerie in der Stallburg

Self-Portrait
Paris, Winter 1887/88
Oil on canvas, 46.5 x 35.5 cm
F 366, JH 1345
Zurich, Foundation Collection E. G. Bührle

touch them. Most of them are identifiable as prints from the brothers' collection. What is far more arresting than these visual quotations, though, is the presence of the sitter himself, who has the dominant quality of a figure in an icon. There is not a hint of the spatial to distract his gaze. It is as if he and Japan were one, and the Ukiyoye motifs (actor, courtesan, sacred Mount Fujiyama) were there for him alone. The portrait is not a hesitant approach; on the contrary, van Gogh boldly attempts no less than a synthesis of oriental and western art, and one that is far beyond the syncretism of his early period at that. But he still has to haul out a fine number of motifs in order to guarantee his point. He does not enact or re-create it; he tries to show it thematically.

Without a doubt, van Gogh's most daring venture is *The Italian Woman with Carnations* (p. 293). His model here may have been Agostina Segatori again, as in the Café du Tambourin portrait (p. 206) – the woman's full lips and broad nose (and the title) suggest as much. In this picture van Gogh's Japonism draws upon resources that have little to do with qualities of the sitter. "He especially drew my attention to a number of what he called 'crêpes'", A. S. Hartrick later recalled, "Japanese prints on a kind of crinkly paper that was like crêpe. They quite clearly made a powerful impression on him, and from the way he talked I am certain that in his own work in oils he was trying to achieve a

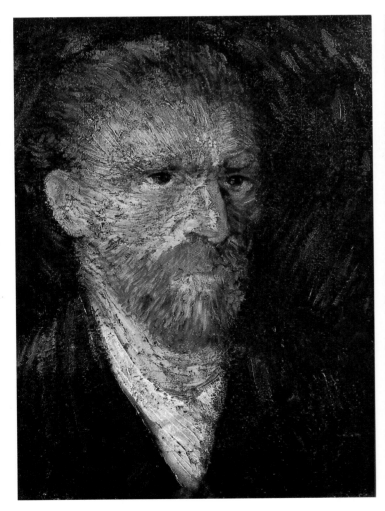

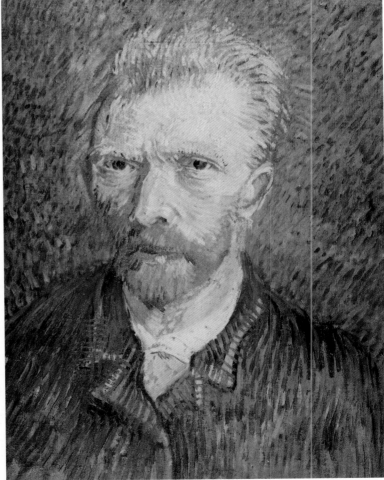

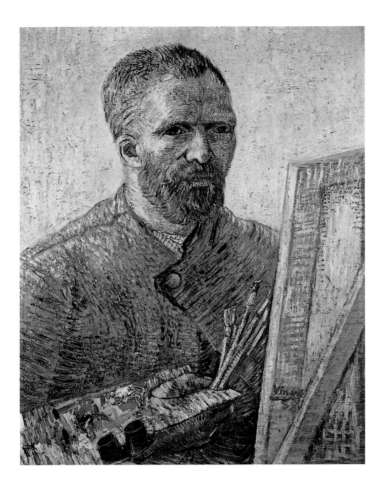

Self-Portrait in Front of the Easel
Paris, early 1888
Oil on canvas, 65.5 x 50.5 cm
F 522, JH 1356
Amsterdam, Rijksmuseum Vincent van
Gogh, Vincent van Gogh Foundation

similar effect of tiny shadows by roughing the surface, an effect he succeeded in achieving." We might add that his most notable success in this was *The Italian Woman*. But it is not only his perfect imitation of the surface effect of what was called Japanese paper that makes this painting a stylistic anticipation of a manner that later matured in Arles. We should also note two other things. One is the thrilling two-dimensionality of the painting, with its ornamental border at the top and right; this is quite simply the narrow side, the threads that attach to the frame. The other feature is the purely decorative quality of the colours, which do not so much describe the woman's skirt as offer a red and green contrast to balance the use of analogous yellow shades. Perhaps the face is not fully realised; van Gogh's parallel streaks of different colours look unmotivated. But if there is one Paris work that points the way forward to the future, it is this. Here, and here alone, van Gogh has removed all trace of the other isms that had influenced him. Even in the portraits of Tanguy his brushwork still had an Impressionist quality.

First he had been impressed. Then he had done his utmost to familiarize himself with the new method. And finally van Gogh had completed the process of assimilation. It was not in his subjects that this adaptation made itself apparent but in his procedure, his technique, his visual approach, and his emotional vigour, all of them central criteria in art, criteria that have always mattered more than questions of mere iconography. In the few years that remained, van Gogh built on

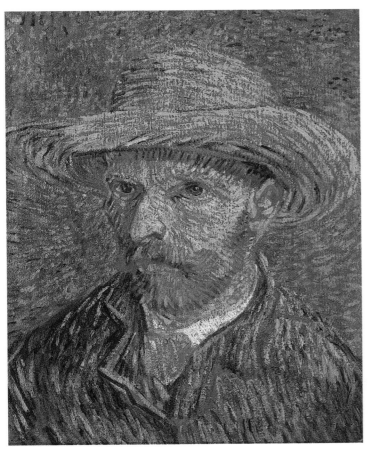
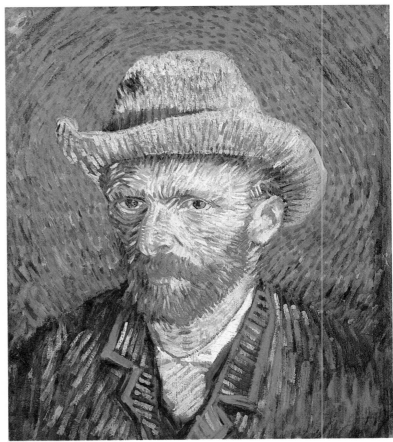

this foundation, and what resulted was a stupendous series of master-pieces arguably unequalled in any other artist's oeuvre. "My whole work is founded on the Japanese, so to speak", he wrote from Arles in summer 1888 (Letter 510), "in its homeland Japanese art is in a state of decline, but it is putting down new roots in French Impressionism." Naturally he was not thinking primarily of a Monet or a Renoir, but of the *Petit Boulevard* painters – Bernard, Toulouse-Lautrec and (modesty aside) himself. He had earned the right to think like this. In van Gogh's case, Roger Marx's observation is absolutely correct: the antiquity behind his Renaissance is Japan.

Self-Portrait with Straw Hat
Paris, Winter 1887/88
Oil on canvas, 40.6 x 31.8 cm
F 365V, JH 1354
New York, The Metropolitan Museum of Art

Self-Portrait with Grey Felt Hat
Paris, Winter 1887/88
Oil on canvas, 44 x 37.5 cm
F 344, JH 1353
Amsterdam, Rijksmuseum Vincent van Gogh, Vincent van Gogh Foundation

Vincent van Gogh

The Complete Paintings

Part II

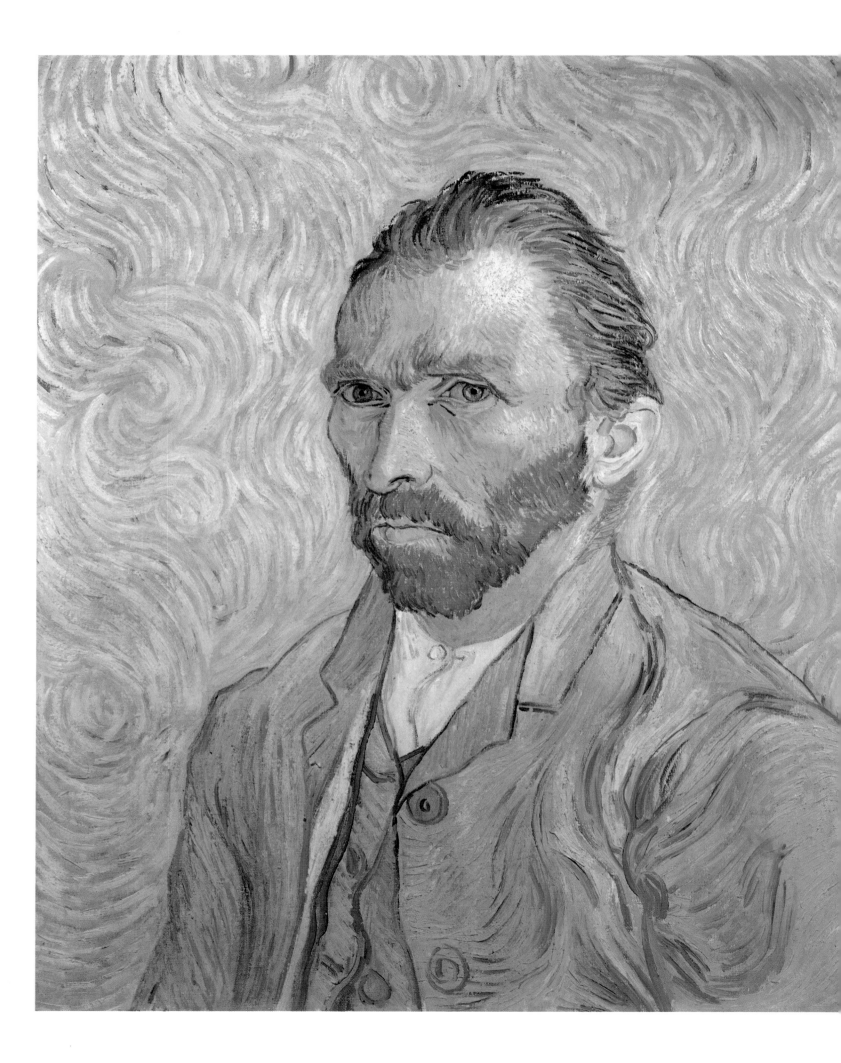

Ingo F. Walther · Rainer Metzger

Vincent van Gogh

The Complete Paintings

Part II

Arles, February 1888 – Auvers-sur-Oise, July 1890

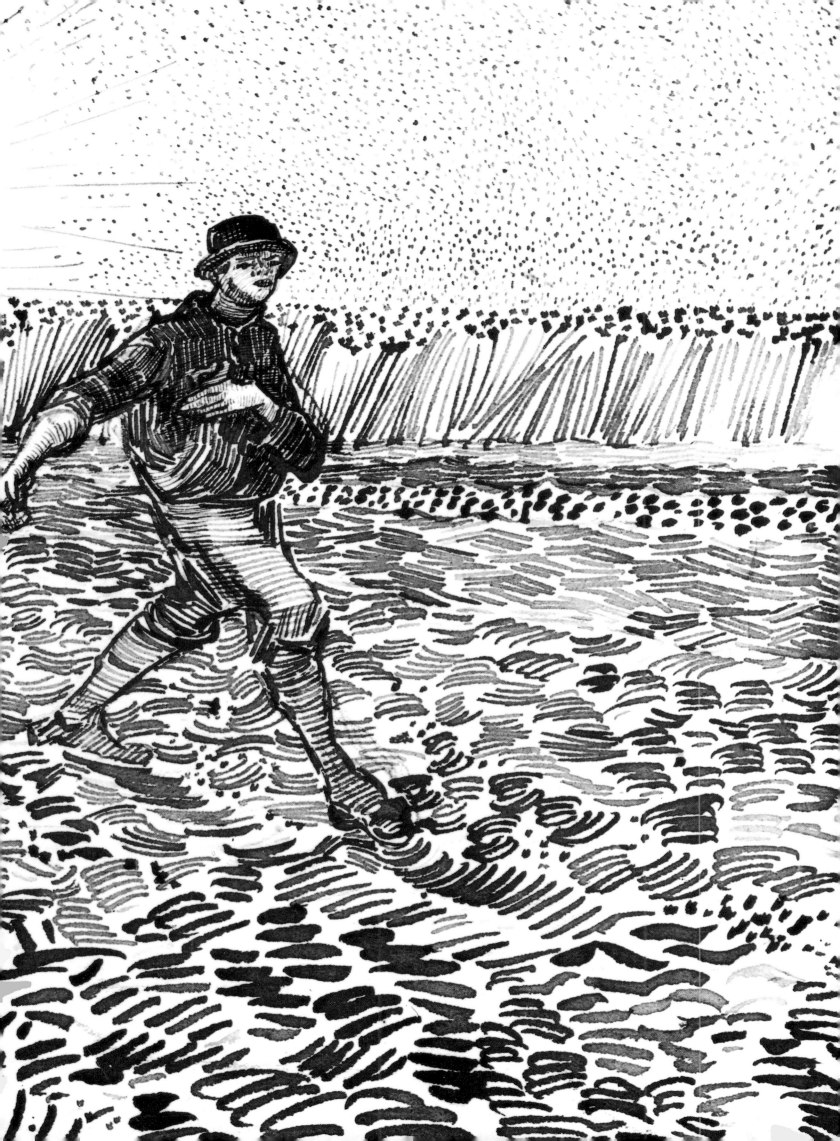

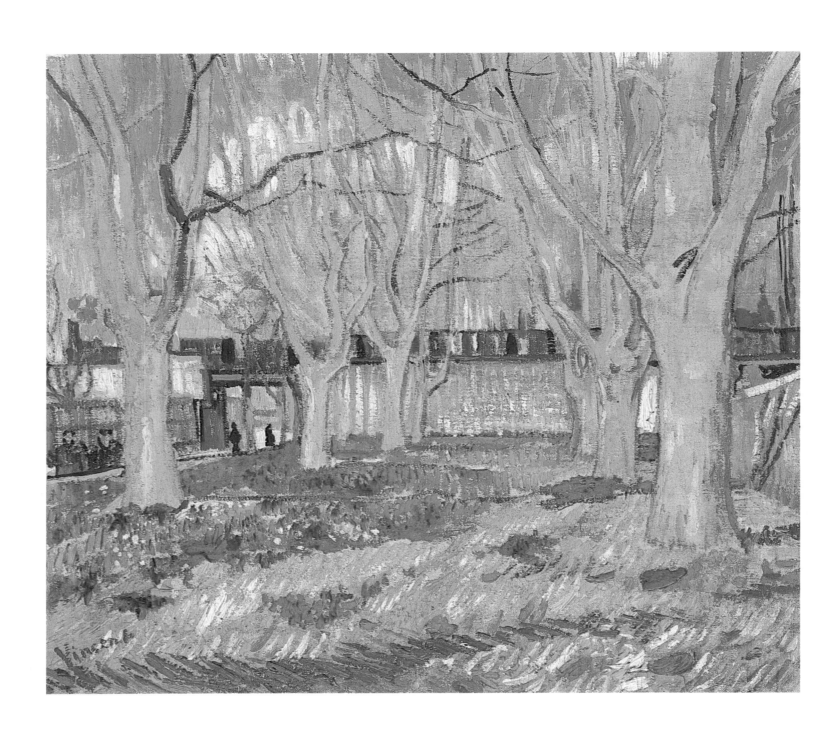

The Unity of Art and Life

Paris, 1887. Van Gogh had just managed to sell one of his pictures for a pittance; he had been paid five francs for it. "And the coin rang on the counter", Gauguin recounted in his memoirs, *Avant et Après*. "Van Gogh took it without complaint, thanked the dealer and left. He trudged along wearily. Near his flat, a wretched woman who had been discharged from St.-Lazare gave the painter a smile, hoping for a customer. Van Gogh was one of those people who read a lot. He thought of 'La Fille Elisa' and promptly his five franc coin belonged to the woman. Quickly, as if ashamed of his charitable act, he fled, still with his stomach empty." Two things emerge clearly from this episode. One is the thorough kindness of Vincent's heart, a quality that we find confirmed time and again. The other is Gauguin's tendency to create legends that positively force comparison of artist and saint; van Gogh, of course, provided him with incomparable material for this purpose.

In their novel *La Fille Elisa*, the Brothers Goncourt narrated the life story of a woman of easy virtue, fallen on hard times, who eventually dies in prison. In referring to this book, Gauguin is suggesting that Vincent wanted to save the prostitute he had just met in the street from a similar fate. A compassionate man, he would rather starve than be responsible for a cruel death. We might say that he intervened in the girl's future because he saw Elisa and her fate before him: to van Gogh, fact and fiction had merged, and the person he saw before him was simply the personification of an idea.

We can detect a great deal of his religious fervour in this moment of confrontation. The noble tradition of the Imitation of Christ is in it, and an entire imaginative realm of allegorical truths. "If one desires Truth, Life as it really is", he wrote at that time to his sister (Letter W1), "the Goncourts' *La Fille Elisa*, for instance, and Zola's *La Joie de vivre*, and so many other masterpieces tell of life as we experience it ourselves, thereby satisfying our wish to be told the truth. Is the Bible enough? I believe that Jesus Himself would today tell those who sit about consumed by sadness: He is not here, He is risen again. Why do ye seek the living among the dead? It is precisely because I find the Old beautiful that I have all the more reason for finding the New beautiful. All the

Avenue of Plane Trees near Arles Station
Arles, March 1888
Oil on canvas, 46 x 49.5 cm
F 398, JH 1366
Paris, Musée Rodin

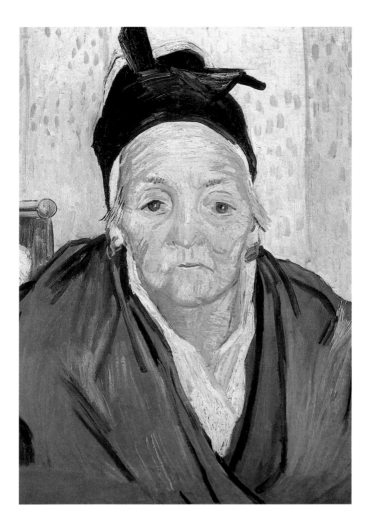

An Old Woman of Arles
Arles, February 1888
Oil on canvas, 58 x 42.5 cm
F 390, JH 1357
Amsterdam, Rijksmuseum Vincent van Gogh, Vincent van Gogh Foundation

more reason, because in our own time we ourselves are able to act." Here, van Gogh again takes up the arguments that led to his *Still Life with Bible* (p. 104). Zola and the Goncourts were providing him with the guidelines for a life in keeping with the times. The fact that they were engaged in literature and were keeping a loophole open into the realm of pure fantasy did not make any difference. Van Gogh drew no distinction between Art and Life. The feelings of sympathy and compassion he had when reading books, painting or meeting people were the same. He invariably thought along allegorical lines. He merely changed his models; the devotional, Christian pamphlets had been replaced by unremitting analytical writings of an altogether modern type.

The Bible was banished from all the still lifes van Gogh painted in Paris in 1887; but still he was forever including the books that now informed his way of thinking. *Still Life with Three Books* (p. 216) features *La Fille Elisa* along with Zola's *Au bonheur des dames* and Jean Richepin's *Braves gens*. Doubtless van Gogh was thinking in terms of colour compatibility, too, when he painted them. But his attention is so wholly on the three slim volumes that he has lost sight of the unity of the painting; so, in a sense, he has had to round off the centre and make do with an oval format. The grubby cheap editions of the novels, dog-eared and plainly well-read, are all the more striking as a result. Van

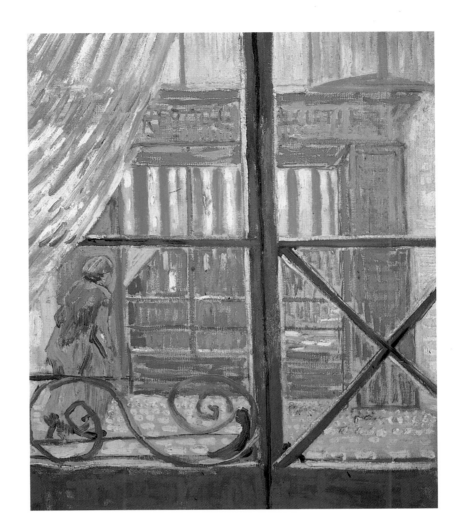

A Pork-Butcher's Shop Seen from a Window
Arles, February 1888
Oil on canvas on cardboard, 39.5 x 32.5 cm
F 389, JH 1359
Amsterdam, Rijksmuseum Vincent van
Gogh, Vincent van Gogh Foundation

**Snowy Landscape with Arles in the
Background**
Arles, February 1888
Oil on canvas, 50 x 60 cm
F 391, JH 1358
London, Private collection

Landscape with Snow
Arles, February 1888
Oil on canvas, 38 x 46 cm
F 290, JH 1360
New York, The Solomon R. Guggenheim
Museum, Justin K. Thannhauser
Collection

Gogh has recorded the titles faithfully, though the words are there not so much to portray the lettering on the spines of the books as simply to inform us of certain names and thus admit us to the artist's literary predilections.

These books are not attributes. They are not signs of erudition or great scholarliness such as we see in portraits time and again. They represent van Gogh himself – just as the chairs or shoes do. They are symbols and operate as the traditional symbolic idiom of religion operates. Van Gogh's symbols, though, no longer have any universal relevance; it is impossible to understand them in as immediate a way as the Cross or Lamb of Christianity. If we are to decode their meaning we need to be familiar with the life of the artist and the significance he saw in them; for if we do not try to grasp this background, the books will simply be objects, of no greater interest or importance than any other objects. That intense interrelation of sign and meaning which has always been characteristic of symbols relies on a foreknowledge on the part of the beholder, a knowledge which is taken for granted as it has been learned from the cradle, as it were. In van Gogh, this referential immediacy now makes sense only in relation to the artist himself. He alone possesses the key to the deeper meanings. Those who would fathom them will need his help. In van Gogh we see a fundamental feature of Modernism becoming established: the phenomenon of individual symbolism.

A Christian upbringing, Romantic intensity, socialist hopes for the future and doubtless his deficient training as an artist all played their part in this. Painting became an alter ego, the goal of all personal commitment and the focus of his intentions. Art and Life constituted a

Still Life: Basket with Six Oranges
Arles, March 1888
Oil on canvas, 45 x 54 cm
F 395, JH 1363
Lausanne, Collection Basil P. and Elise Goulandris

Blossoming Almond Branch in a Glass with a Book
Arles, early March 1888
Oil on canvas, 24 x 19 cm
F 393, JH 1362
Switzerland, Private collection

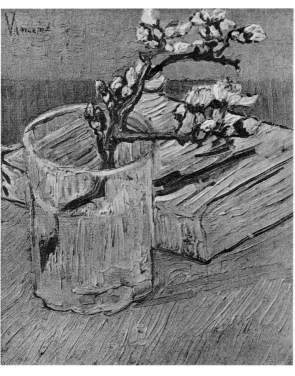

Blossoming Almond Branch in a Glass
Arles, early March 1888
Oil on canvas, 24 x 19 cm
F 392, JH 1361
Amsterdam, Rijksmuseum Vincent van
Gogh, Vincent van Gogh Foundation

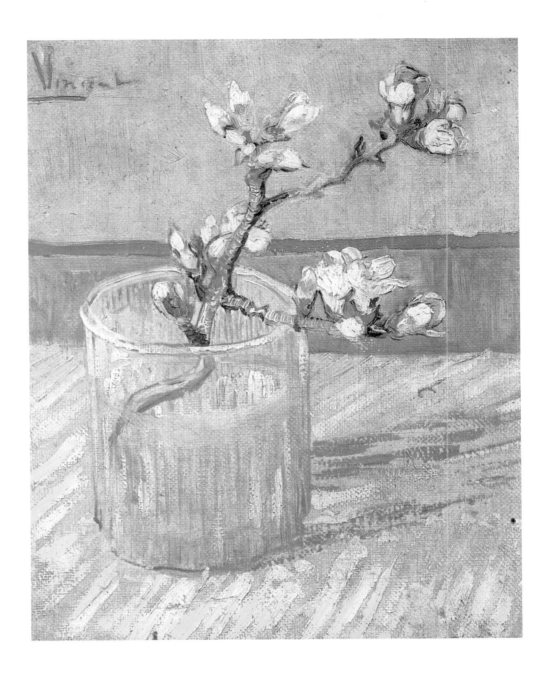

single unity. Van Gogh himself was still far from making a programme of this unity. He had, in a manner of speaking, got himself into this position against his own wishes. But Art was never to be the same again; and in van Gogh it had a figurehead who had taken this course in exemplary fashion, consistent and unwavering until his death. And that death showed the unrecognised artist remaining true to himself: if his work was worth nothing, then he too must be worth nothing. Van Gogh's suicide gave him his place in the world.

In Holland he had put his whole heart into being a peasant painter. Again and again he appropriated sayings which he believed to be authentic statements by his artistic mentor Millet: "I'll get by right enough as I'm wearing clogs", he commented, and: "One has to risk one's all in Art." To fit in with the gaunt figures who peopled his surroundings he went about unkempt, slept on straw and contented himself with crusts of bread. "When I say that I am a peasant painter, I mean it quite

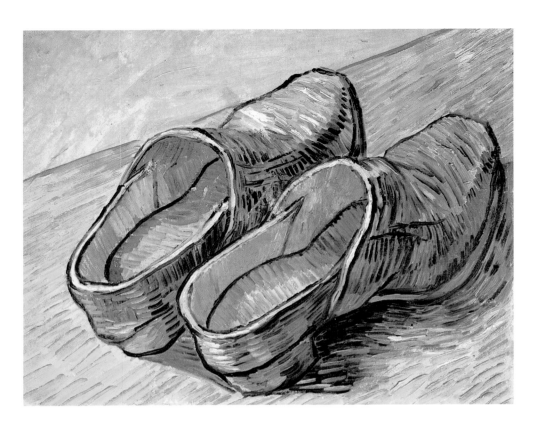

A Pair of Wooden Clogs
Arles, March 1888
Oil on canvas, 32.5 x 40.5 cm
F 607, JH 1364
Amsterdam, Rijksmuseum Vincent van
Gogh, Vincent van Gogh Foundation

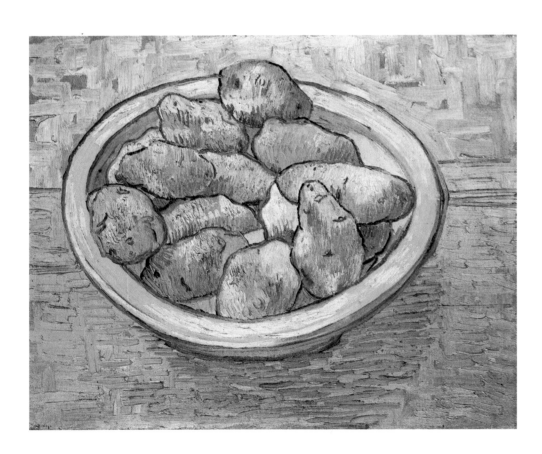

Still Life: Potatoes in a Yellow Dish
Arles, March 1888
Oil on canvas, 39 x 47 cm
F 386, JH 1365
Otterlo, Rijksmuseum Kröller-Müller

literally", he assured Theo (Letter 400). We might add that van Gogh's emphasis lay on the first word: the peasant painter was himself a peasant.

The way he saw himself underwent a change in the city. He became more vain; now he owned up to looking at himself in the mirror – and, having improved his appearance, found the mirror itself a pleasanter thing. He drifted about the boulevards, amidst the many isms. The instability of his visual images matched the flux in his everyday life. He had love affairs (such as that with Agostina Segatori) and started drinking: "When I rode away from you at the Gare du Midi", he recalled later (Letter 544), "I was desperately unhappy and almost ill and nearly an alcoholic because I had worn myself out so much. I have always harboured the dark suspicion that we sacrificed our life's blood last winter in all those discussions with interesting people and artists."

Japan set him to rights again. His visual idiom was increasingly taking its bearings from Japanese woodcuts, and at the same time his wish to experience the Far East for himself became more and more urgent: "Japanese painting is highly regarded, all the Impressionists are influenced by it; why then should one not go to Japan, or a reasonable facsimile – the south?" (Letter 500) He went to Arles because he wanted to experience the life that was in his pictures.

The unity of Art and Life, as practised by van Gogh, was founded on a deep feeling for the unfamiliar, the other. His own art was fundamentally alien to him, something for which we can once again hold his poor training responsible. At the slightest technical problem he was cast upon his own devices, wondering about the point of doing something that was so obviously causing him difficulties. The vehemence with which he asserted his concept of art was simply an aggressive manifestation of a deep-rooted artistic insecurity. His very existence was alien to him. In this he was a Romantic to the core: "What can be achieved here is progress", he wrote to Lievens from Paris (Letter 459a), "and whatever on earth that means, it is here. Anyone who is living in settled circumstances elsewhere would do well to stay where he is. But adventurers such as myself lose nothing if they put more at stake. Especially as what made me an adventurer was not free choice, but Fate; nowhere do I feel as much of a stranger as in my own family and fatherland." It is pointless debating in which respect he felt more of a stranger, the aesthetic or the existential. The two were interdependent. If Life should fall, it would take Art with it. And if Art were to fail, Life too would be at an end.

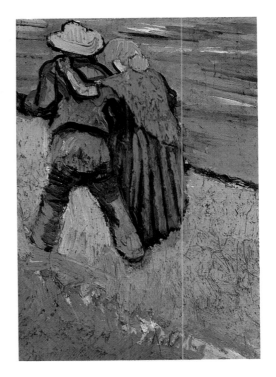

Two Lovers (Fragment)
Arles, March 1888
Oil on canvas, 32.5 x 23 cm
F 544, JH 1369
Private collection
(Sotheby's Auction, London, 25.3.1986)

PAGE 316:
A Lane near Arles
Arles, May 1888
Oil on canvas, 61 x 50 cm
F 567, JH 1419
Kiel, Pommern Foundation

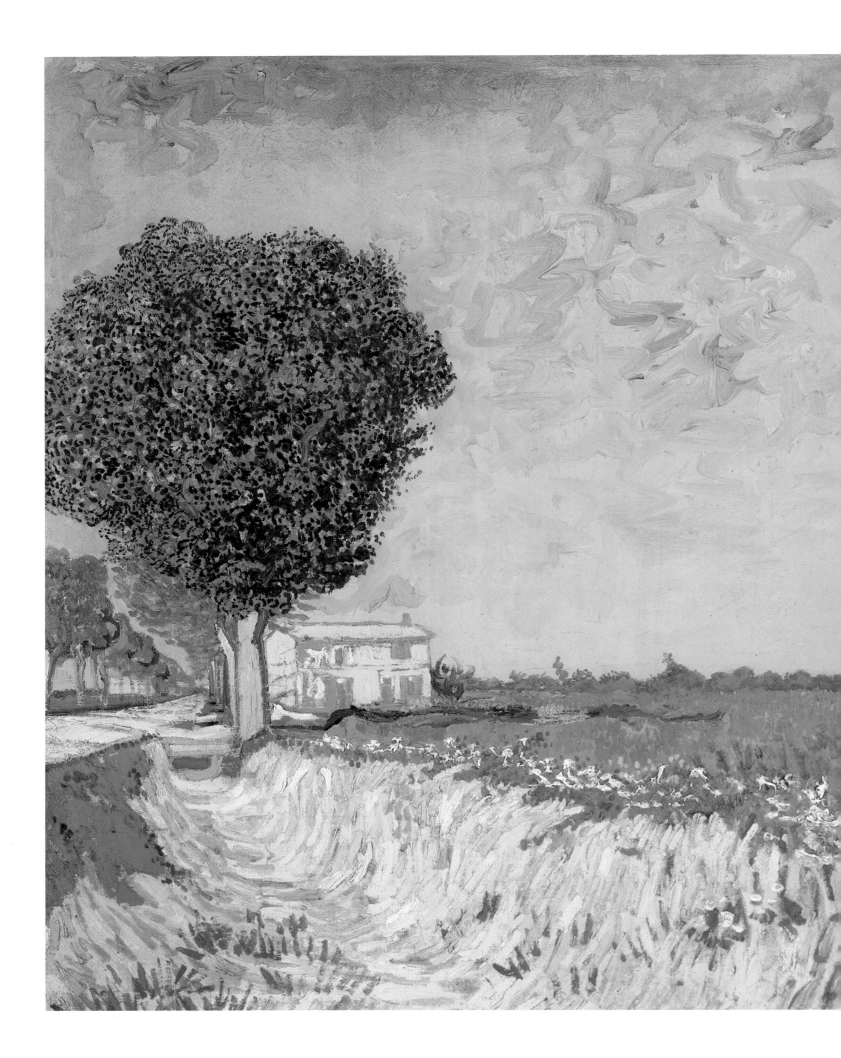

Painting and Utopia
Arles, February 1888 to May 1889

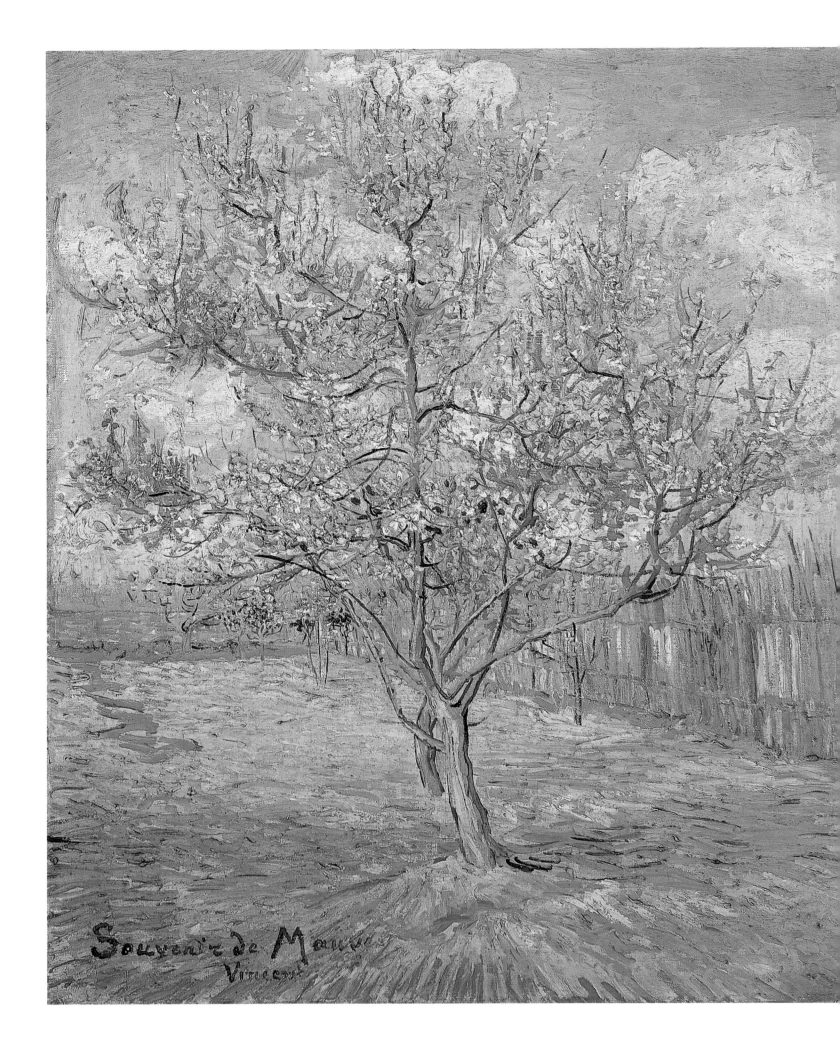

Arles: The Heart of Japan

"There is nothing but white in this area. The unceasing reflections of light swallow up all the local colours and make the shadows appear grey. Van Gogh's Arles pictures are wonderfully impetuous and intense. But they do not in any way convey the southern light. People expect to see red, blue, green and yellow in the south. The north is however quite colourful (local colours), whereas the south is full of light." Thus Signac in his diary in 1894. He was in a position to check on the spot (in Saint Tropez) that explosion of colour that was prompting the art world to "discover" van Gogh at last. The overflowing richness of his palette and the luminous power of his colours (his friend Signac had to admit) had little to do with the appearance of things, which were levelled out by the glaring light of the south. If van Gogh had gained control of colour, it was in spite of the fact that he was living in Provence, not because of it. Since Paris, he had turned his back on the realistic use of local colour. The region he had gone to in February 1888 was less a supply of motifs than a utopia, a place that demanded a new principle of Life.

"Oh no, I am not at all enthusiastic", carped Signac, "nor is it paradoxical if I maintain that the south is like Asnières: it has the same dusty paths, the same red roofs, the same grey sky. I am not being subjective, but perfectly objective. In short, apart from some local colours, the south is not all that different from our usual landscapes, and those who paint blue in the south where they would put black in the north are charlatans." This was easily said for Signac the pointillist: if they were analyzed scientifically and kept tied to the apron strings of optical laws, his pictures did indeed prove to be independent of the chance nature of local topography. But van Gogh, with all due respect, had long since moved on from the aesthetic position Signac and his friends occupied. His existence depended too much on the motifs and atmosphere of a certain place; he needed to establish a symbiotic relation with his surroundings through his work. In the north, he had not painted darker merely because there was less brightness there; amidst the wretched, gloomy figures of the weavers and rural labourers, he had simply felt the place to be too confined for brightness and colourfulness. The colours and emotions were mutually dependent. And in the south, too, they

Pink Peach Tree in Blossom
(Reminiscence of Mauve)
Arles, March 1888
Oil on canvas, 73 x 59.5 cm
F 394, JH 1379
Otterlo, Rijksmuseum Kröller-Müller

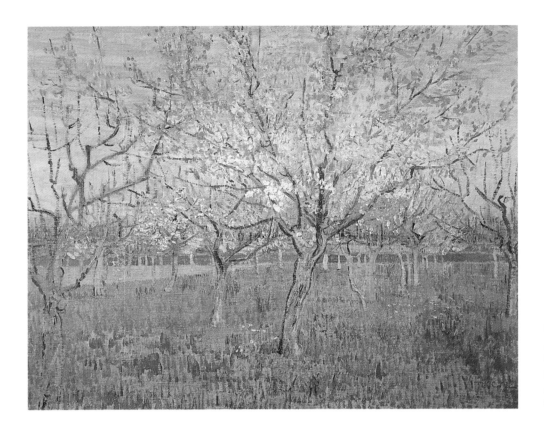

Orchard with Blossoming Apricot Trees
Arles, March 1888
Oil on canvas, 64.5 x 80.5 cm
F 555, JH 1380
Amsterdam, Rijksmuseum Vincent van
Gogh, Vincent van Gogh Foundation

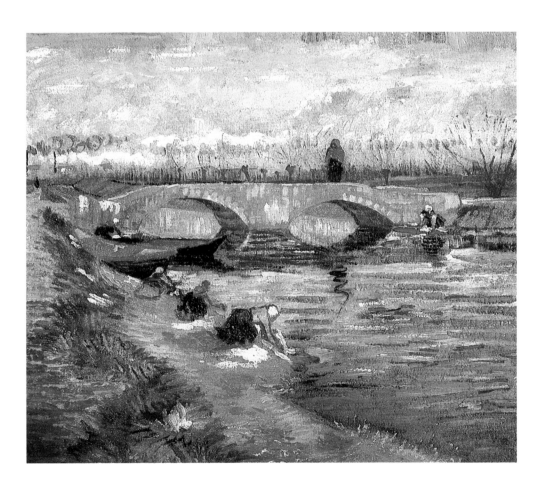

**The Gleize Bridge over the
Vigueirat Canal**
Arles, March 1888
Oil on canvas, 46 x 49 cm
F 396, JH 1367
Tokyo, Private collection

Orchard in Blossom
Arles, March-April 1888
Oil on canvas, 72.4 x 53.5 cm
F 552, JH 1381
New York, The Metropolitan Museum
of Art

afforded mutual support. Van Gogh's emotions were becoming more fictitious, as it were, more independent of the torments of actual reality – but this only in the degree to which he had adopted an autonomous use of colour that was answerable to him alone. Van Gogh was looking for Japan in the south. And he found it, too – abstracting ever more powerfully from the circumstances of his own existence and longing for that oriental paradise with the same fervour as he expressed in his colours. The months leading up to his breakdown were informed by the imagined conception of that better world promised by Japan: van Gogh was reaching for a utopia, trying to make it concrete reality by painting it. For three quarters of a year of happiness, the unity of Art and Life was a dynamic reality.

As early as 1878, Chesneau had articulated a basic truth about contemporary artists: "What they found in the Japanese was not so much

inspiration as the confirmation of their own characters, of their own personal ways of seeing, feeling, understanding things, and entering into the spirit of Nature." Viewed like this, notions based on imaginary conceptions could be approved and the idea that Art and Life would meet via the far-off island realm seemed acceptable. There, pictures were still an integral part of everyday life and beauty a yardstick for the quality of life. The Japanese embassies saw to it that their exhibits at world fairs did not go to waste in display cases but were shown in the authentic context that they would be in at home. Siegfried Bing called his show of 1888 "Le Japon artistique" (i. e. "Artistic Japan") to distinguish it from western versions of "Japanese art". The country and its pictures were felt to be inseparable. Quite apart from its motifs, accessories and life-style, Japanese culture stood first and foremost for the unity of Art and Life. Van Gogh seized upon the support this offered his own personal view of the world with all his characteristic vigour.

In the face of this, any question as to why van Gogh chose Arles in particular is of secondary interest. It is certain that he wanted to go to Provence. Monticelli had ended his life there, in Marseille; Zola and Cézanne had spent their childhoods there, in Aix-en-Provence. Provence was simply the south; and it would afford a readier means of formulating his critique of civilization. Initially van Gogh planned to make only a short stop in Arles. A "stranger" such as he invariably felt

The Langlois Bridge at Arles Seen from the Road
Arles, March 1888
Pen and reed pen, 35.5 x 47 cm
F 1470, JH 1377
Stuttgart, Graphic Collection

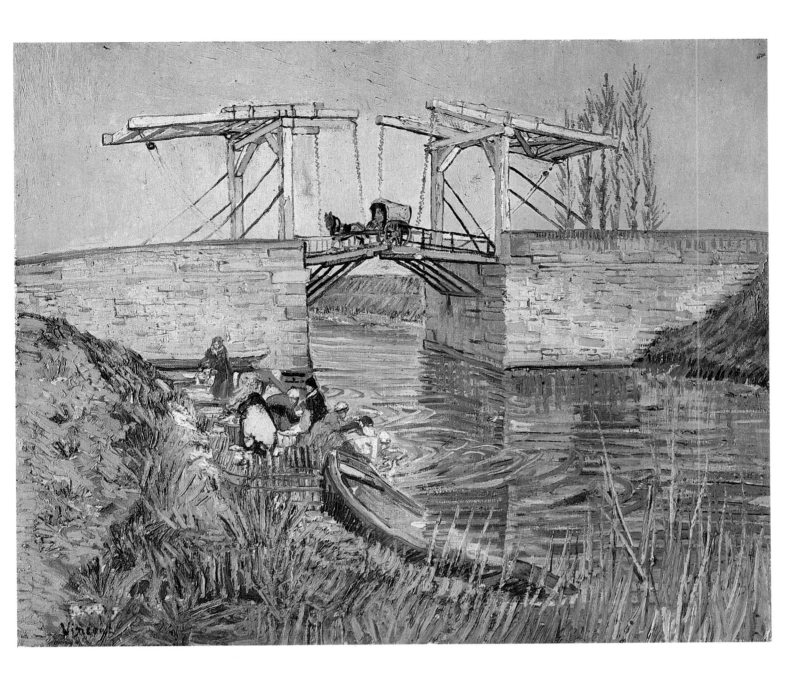

The Langlois Bridge at Arles with Women Washing
Arles, March 1888
Oil on canvas, 54 x 65 cm
F 397, JH 1368
Otterlo, Rijksmuseum Kröller-Müller

himself to be did not require any Roman ruins and testimony to a mediaeval golden age – though the town did nonetheless offer such attractions, in the form of the amphitheatre and Saint Trophime. The "stranger" was searching for refuge, security, sanctuary. And the only thing he knew about that refuge was its name: Japan.

Later he was to recall the childlike anticipation that had seized hold of him in rueful tones: "I can still remember vividly how excited I became that winter when travelling from Paris to Arles. How I was constantly on the lookout to see if we had reached Japan yet." (Letter B22) It seems that he simply stopped once he had found a place where he could abandon his lookout and enter into his Promised Land. His Japanese notions continued to hold him in thrall for the time being: "I don't need any Japanese prints", he wrote to his sister (in Letter W7), "because I always say that I am in Japan right here. And that I therefore only have to open my eyes and paint whatever is in front of my nose and makes an

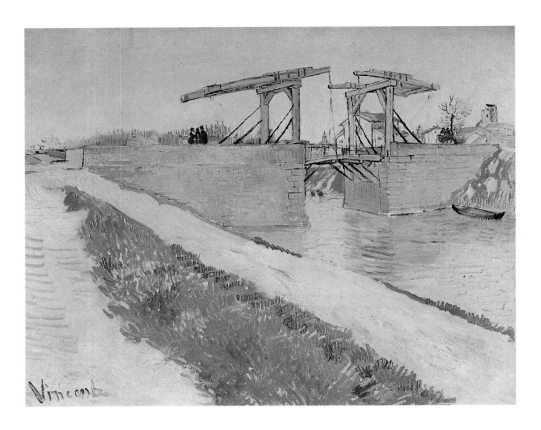

The Langlois Bridge at Arles with Road alongside the Canal
Arles, March 1888
Oil on canvas, 59.5 x 74 cm
F 400, JH 1371
Amsterdam, Rijksmuseum Vincent van Gogh, Vincent van Gogh Foundation

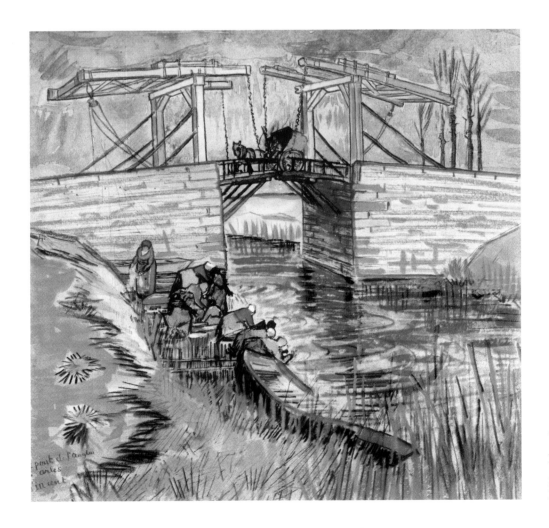

The Langlois Bridge at Arles
Arles, April 1888
Water colour, 30 x 30 cm
F 1480, JH 1382
Private collection

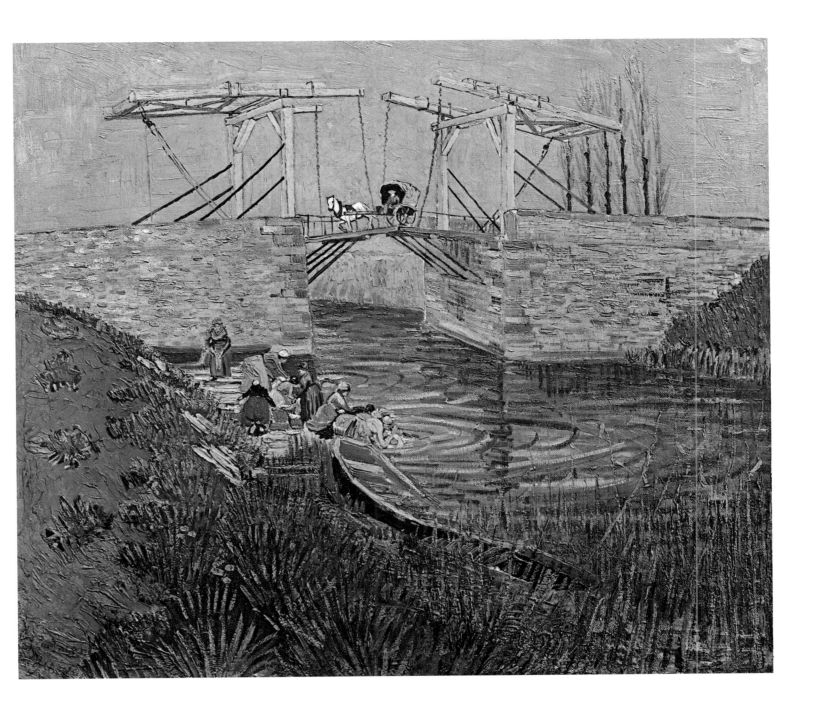

impression on me." He dedicated himself vigorously to his "impress-ions" – which no longer had anything in common with the "impress-ions" of (say) Monet. There were no casual glances at picturesque groupings; rather, he was out to record the overall visual impact. It was with this aim in mind that van Gogh inscribed over one of his drawings: "This does not look Japanese, but it is in fact the most Japanese thing I have ever done." (Letter B10) The quality of "soul" was foregrounded, that quality he himself had established as an aesthetic criterion, a quality that ties an artistic product to the individual who articulates it and thus places it beyond criticism. Van Gogh seized hold of Japan with all his natural vitality. A comprehensive synthesis that linked the individual motif and an overall view of life now replaced the analytic approach characteristic of his initial Paris response to oriental culture.

The Langlois Bridge at Arles
Arles, April 1888
Oil on canvas, 60 x 65 cm
F 571, JH 1392
Paris, Private collection

Apricot Trees in Blossom
Arles, April 1888
Oil on canvas, 41 x 33 cm
F 399, JH 1398
Johannesburg, Collection Continental
Art Holdings, Ltd.

Van Gogh had always prided himself on the speed with which he worked. Now his *premier coup* manner came into its own: "A Japanese draws rapidly, extremely rapidly, like lightning, because his nerves are finer and his feelings simpler." (Letter 500) Van Gogh could now place his own idiosyncratic style in the centuries-old tradition of an advanced civilization; the old suspicion that his haste was a way of deflecting attention from his lack of talent is now groundless – swift strokes are now typical of pure, simple, sensitive artistry. The astonishing series of masterpieces van Gogh produced in 1888 can be accounted for if we see that what was new was not the speed at which he worked but his tremendous assurance, which blithely brushed aside whatever doubts he might have had concerning the meaning of what he was doing. Masterpieces as the hallmark of Japanese art: van Gogh put this notion into practice as if it were child's play.

"The Japanese live in quite plain interiors", he wrote to his sister (Letter W15), "and what great artists they have had. Rich painters in our society live in houses that look like curiosity shops, and to my taste that is not very artistic." With this insight to encourage him, van Gogh could bear poverty more easily. Western artistic "entertainers" (he felt) have a leaning towards corruption, enjoy trinkets and glitz, and live a life that is far from the plain simplicity that the Japanese practise. From this we can infer that wealth is harmful to Art. A life of deprivation, though it may not represent a quality in itself, can at least guarantee authenticity.

Further parallels can be drawn: "For a long time now I have been interested in the fact that Japanese artists often exchanged pictures with each other", van Gogh wrote to Bernard. (Letter B18) He wrote these

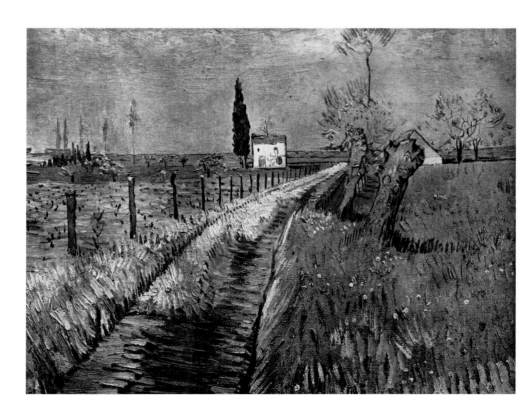

Path through a Field with Willows
Arles, April 1888
Oil on canvas, 31 x 38.5 cm
F 407, JH 1402
Whereabouts unknown

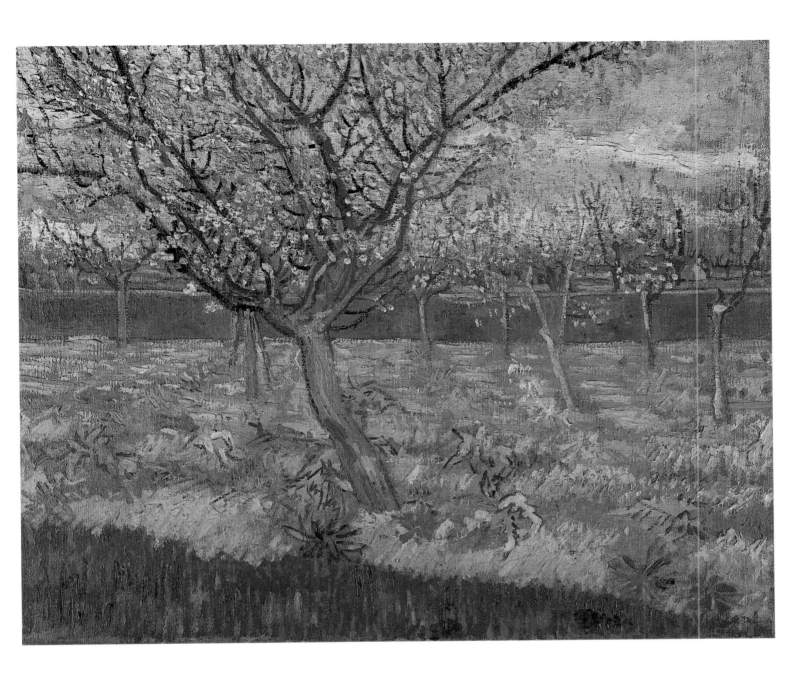

Apricot Trees in Blossom
Arles, April 1888
Oil on canvas, 55 x 65.5 cm
F 556, JH 1383
Switzerland, Private collection

words at the very time that self-portraits by Bernard and Gauguin, dedicated to him, reached him. He himself was not ungenerous in offering his own works; in return he acquired a collection of works by his friends. This habit was one more way of following in his exemplars' footsteps. "This is the proof", he went on, "that they valued and supported each other and that there was a degree of harmony amongst them; that their life was that of brothers who behaved naturally and did not plot against each other. The more we resemble them in this respect, the better for us. It also appears that the Japanese earned very little and lived like simple workers." The ideas recapitulate much that is at the core of van Gogh's view of the *peintre ouvrier*, whose highest principle is solidarity and who lives in harmony with his peers, all of them brothers in spirit sharing a single goal: a better world.

Van Gogh's ideas ranged freely during that year of 1888 spent in Arles. While his unease and nagging self-doubt did not disappear, they could

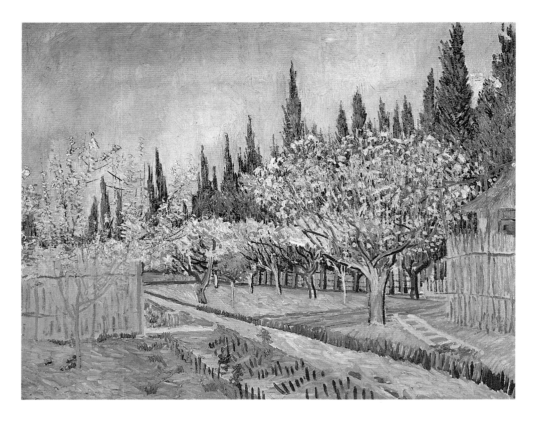

Orchard in Blossom, Bordered by Cypresses
Arles, April 1888
Oil on canvas, 65 x 81 cm
F 513, JH 1389
Otterlo, Rijksmuseum Kröller-Müller

nonetheless be integrated in a concept of the artistic life which indeed depended on these very feelings. Re-interpreting his own dissatisfaction as a sign of artistic greatness, Vincent now accepted as an integral component of his very existence that paradoxical spirit that Theo had come to value in his brother during the time they spent together in Paris. Paradox had always been at the heart of Vincent's thought and work and was his own major contribution to modern art; and of course

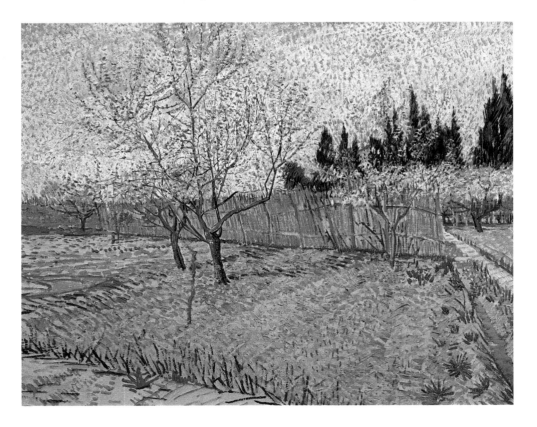

Orchard with Peach Trees in Blossom
Arles, April 1888
Oil on canvas, 65 x 81 cm
F 551, JH 1396
New York, Private collection

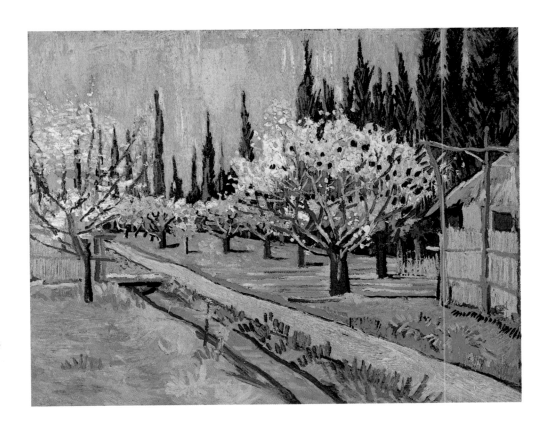

Orchard in Blossom, Bordered by Cypresses
Arles, April 1888
Oil on canvas, 32.5 x 40 cm
F 554, JH 1388
New York, Collection Richard J. Bernhard

he found it possible to detect paradox in the Japanese: "You know that the Japanese are instinctively attracted to opposites: they eat salty sweets and baked ice-cream and baked confections with ice." (Letter W7) Van Gogh's remarks on these eating habits are far from banal. In Faustian style, as it were, he had always been reaching for infinity, and had sought unity in the disparate even if it involved syncretism; now he shifted his attention to cuisine and baldly declared it an attitude to Life. Paradox had become second nature.

"Second nature", indeed, might be an apt term for van Gogh's artistic output in 1888. With sovereign assurance, he used what he had learnt in Paris, moulded it, and gave it a quality of impressive monumentality. His assurance came from his conviction that he was establishing a connection with the art he admired so much and with the exemplary lifestyle of the Orient. As if he was aware that this new harmony (which he maintained for nine months) was precarious, he tried painting anything and everything. Every day was a day full of work. His regret at having so few contacts was soon outweighed by his enthusiasm at his own creativity. Van Gogh's major works (in terms of both quantity and quality) were done in Arles – classics in the true sense of the word, artworks that had put all that was crude and immature behind them. There, and there alone, he knew his definite place in a universal concept of artistic endeavour, in a style (in a sense) that went far beyond his own individual self. No doubt that knowledge was of his own making – and by the end of the year he would have to admit the error of his fictive ways. But the profound confidence that he would be able to make his Japan come true granted him those months of real creative energy.

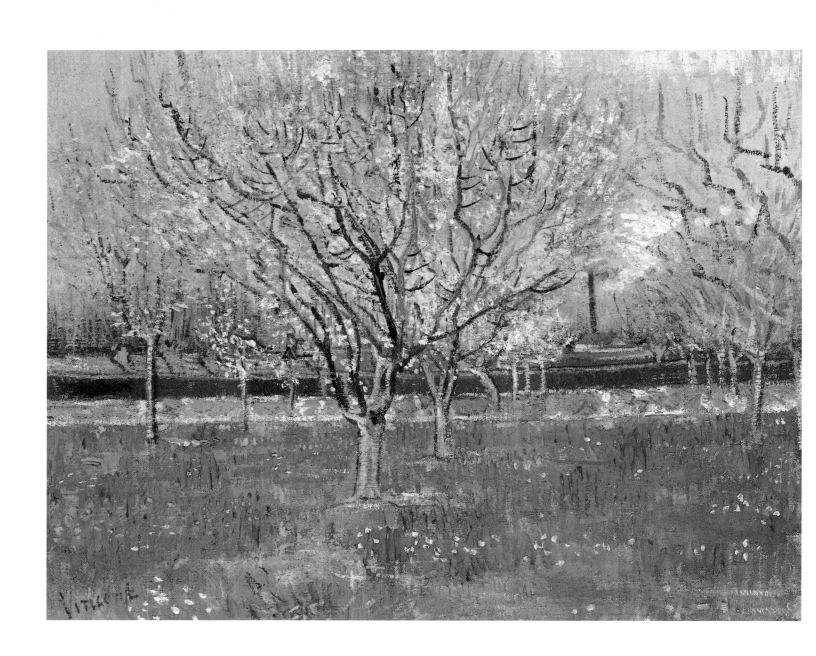

Personal Impressionism
Orchards in Blossom

Orchard in Blossom (Plum Trees)
Arles, April 1888
Oil on canvas, 55 x 65 cm
F 553, JH 1387
Edinburgh, National Gallery of Scotland

Art was always to have its everyday use: thus the Japanese motto, in accordance with which pictures had a decorative function in interiors, a function they retain to this day. Hence irises bloom on painted screens, while outside the real thing is flowering in full splendour. Hence snowy landscapes adorn the walls, while the countryside is in the icy grip of winter. Hence, too, Hiroshige's blossoming twigs only grace houses when the real buds start shooting in spring. The rest of the time they are kept from view: "The drawings and curios are kept in safe places in drawers", declares van Gogh. (Letter 509) In the course of the year, specific seasonal tasks need to be done, each with different tools. Pictures are like these tools: they too are brought out at regularly recurring intervals, and are used to create a new climatic, visual and emotional mood.

Van Gogh thus found that his fondness for seasonal change had high-level support – from the Japanese. He had always revelled in the contrasts and changes afforded by Nature; in a sense, his artistic creativity represented a pursuit of Nature. He was anxious not to miss any of Nature's moods and phenomena. Correspondingly, the views of orchards in blossom which he painted shortly after arriving in Arles have a cheerful, springtime atmosphere. But they are more than merely the product of a seasonal mood. As if he and the region had colluded on it, van Gogh found a world of motifs which could not have been more Japanese. He really did not need Japanese prints anymore as he had done in Paris, when he had borrowed the little trees and budding blossoms from Hiroshige (cf. p. 284). The orchards were his utopia: there it was, before his very eyes. True, this was also the sum total of oriental character that Arles had to offer; but this series of paintings, completed within the next few weeks, at any rate confirmed that he had taken the right decision. For one magical moment, Provence celebrated a Japanese blossom festival. Fifteen paintings remain as proof of that pleasure.

As a matter of fact, the south had welcomed him with snow. For the first few days, Japan had been a question of flower arranging. Unperturbed, van Gogh broke a budding twig off a tree and put it in a glass of water, waiting for the blossoms. *Still Life: Blossoming Almond Branch*

in a Glass (p. 313) might thus be described as a token of promise in more senses than one. Blithely van Gogh admits to having given his spring-time joy a helping hand: there is the twig, complete with the water glass. He always remained enough of a realist to show what was actually in front of him rather than something imaginary. Japan was keeping him waiting, so in its place he presented a symbol that included both his hopes and his doubts. The twig has been cut off, severed from the life-giving force of Nature, and will not be a thing of beauty for very long at all. Though the picture records van Gogh's happy anticipation, it also captures the sense of precarious tenure and danger that accompanied it.

"There is nothing else I can do", he told his brother (Letter 474); "I must strike while the iron is hot. I shall be completely exhausted after the orchards." The vigour with which van Gogh tackled his subjects is also expressed in a letter (B4) to Bernard: "Unfortunately it is raining today, and I am unable to press home my attack." If he needed to clutch at the splendour of the blossoms, wildly and feverishly, it was not only because the wind would, in the nature of things, soon be taking them from him, but also because he had to get to grips with his own vision, which (however great his imaginative powers) needed a correlative in

Peach Tree in Blossom
Arles, April-May 1888
Oil on canvas, 80.5 x 59.5 cm
F 404, JH 1391
Amsterdam, Rijksmuseum Vincent van Gogh, Vincent van Gogh Foundation

Blossoming Pear Tree
Arles, April 1888
Oil on canvas, 73 x 46 cm
F 405, JH 1394
Amsterdam, Rijksmuseum Vincent van Gogh, Vincent van Gogh Foundation

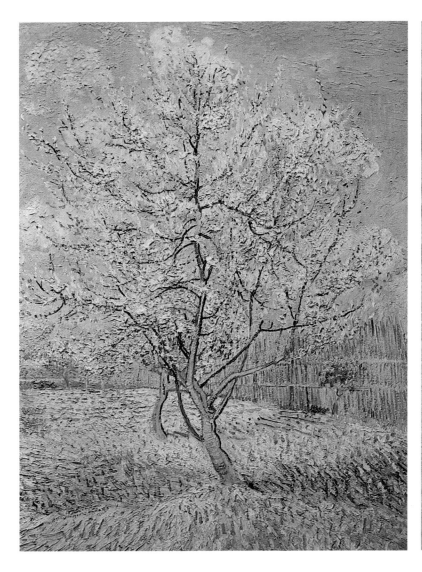

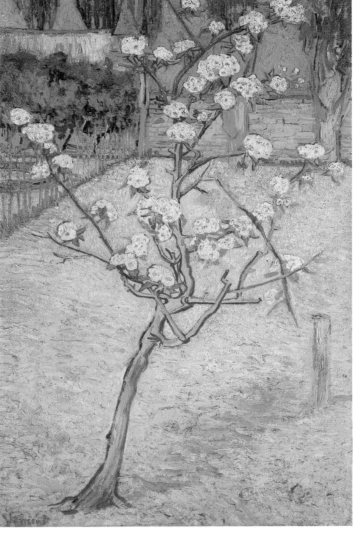

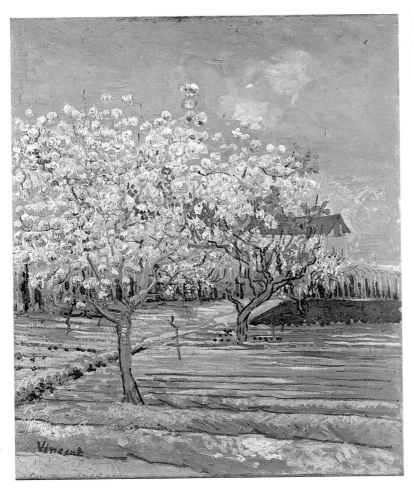

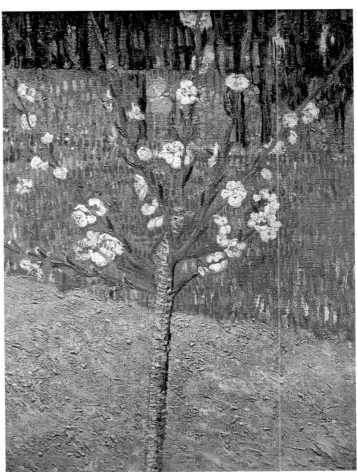

Orchard in Blossom
Arles, April 1888
Oil on canvas, 72 x 58 cm
F 406, JH 1399
Switzerland, Private collection

Almond Tree in Blossom
Arles, April 1888
Oil on canvas, 48.5 x 36 cm
F 557, JH 1397
Amsterdam, Rijksmuseum Vincent van
Gogh, Vincent van Gogh Foundation

reality. The speed with which he went to work, that speed peculiar to him which was indeed increased in Arles, opened up a new visual world almost without his intending it. In the orchard series we see an altogether personal, constantly varying version of Impressionism, an approach that bore all the signs of a wholly individual style. Van Gogh was trying to see through the atmospheric veil of light and colour, to make lasting contact with those points that could underwrite a sense of himself, a sense of security.

This, in a sense, stood Charles Baudelaire's idea of the poetic in the historic, and the eternal in the transient, on its head. Van Gogh was seeking the transient in the eternal; he was seeking that moment in reality that would validate his vision of a better life and endow his notion of Japan with plausibility. The moment would make true what had been so assiduously planned in his imagination. Van Gogh was rarely to find a subject that fitted this endeavour and also pleased the eye as thoroughly as the trees in blossom did. They were timeless yet transient, fragile yet with the solid presence of icons. The paradoxical nature of these trees matched the paradoxes within van Gogh himself. His use of light made the major contribution in the presentation of this paradoxical quality, and in this respect (once we have recorded his obvious debt to Japan) we may be nearest the mark if we describe the orchard series as Impressionist. Impressionism itself had become a

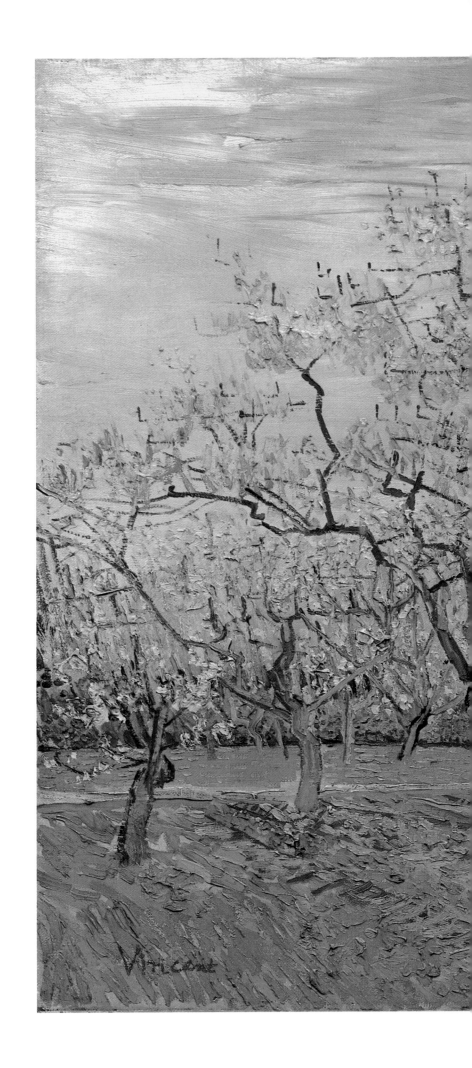

The White Orchard
Arles, April 1888
Oil on canvas, 60 x 81 cm
F 403, JH 1378
Amsterdam, Rijksmuseum Vincent van
Gogh, Vincent van Gogh Foundation

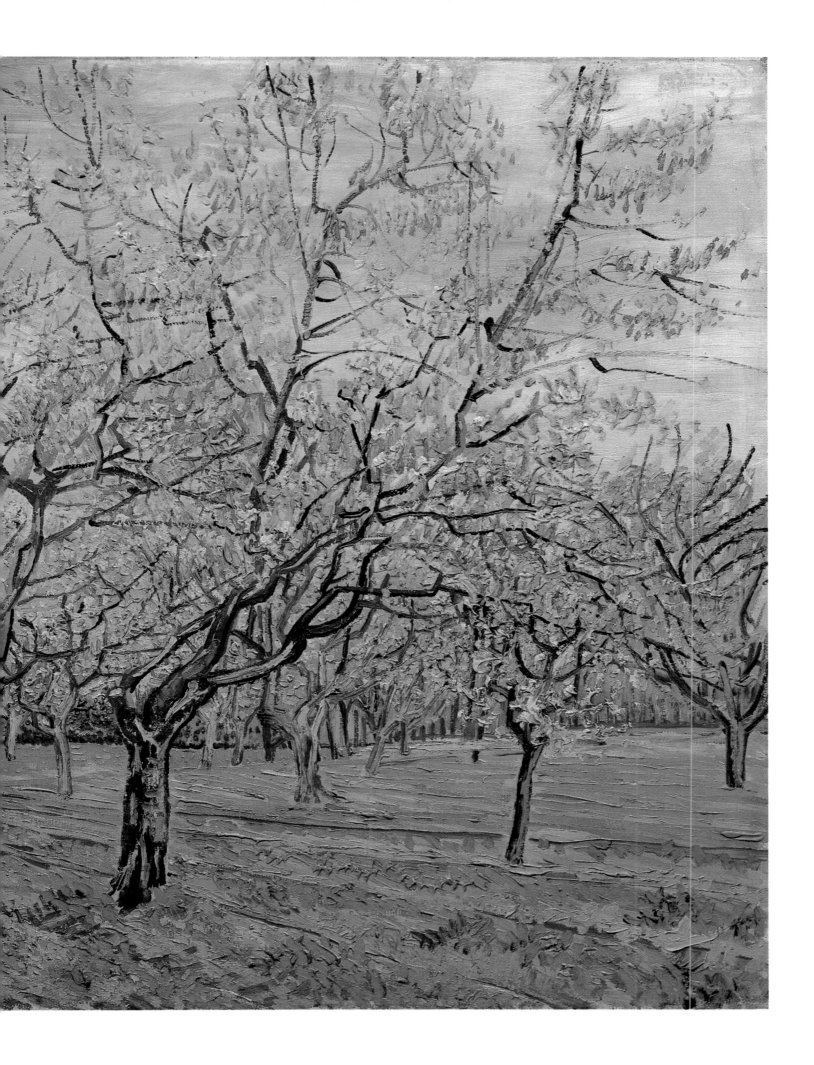

rather stale *plein air* routine by then; but van Gogh's paintings high-lighted its strengths and made exciting use of them.

There is one case in which van Gogh revealed his procedure very openly. Two versions of the view of a garden with a stream in the foreground and cypresses at the back exist. One was plainly a prelimi-nary study for the other. The earlier, small-format, less polished version (p. 329) gave its attention to recording the subject, setting out the topo-graphy, noting the two fenced-in huts at the sides. This version betrays the use of van Gogh's perspective frame in its emphasis on the left-hand vertical, the diagonals of stream and path, and the almost horizontal row of treetops receding into the background. The study remains a sketch inasmuch as it grasps the subject in terms of line rather than colour. It is still more a drawing than a painting. It makes a distinctly unfinished impression, with the blobs of thick white squeezed from the tube looking rather out of place in the trees, compared with the delicate draughtsmanship that has gone into the scene as a whole.

The later version (p. 328, top) resolves this uncertainty. The brush-strokes are now more even. The long contour lines have disappeared, as have the crude clusters of unmixed colours. The fixation on line sur-vives only in the ladder lying on the ground, which places a barely detectable emphasis on spatial depth; the ladder is one of those props van Gogh often added later as optional extras, props that tend to en-cumber his paintings somewhat. But at least the ladder is not fore-grounded. And it does serve to show that this version was the later.

Both paintings are full of light and colour, showing them to have been inspired by Impressionism. But in the later version van Gogh is more

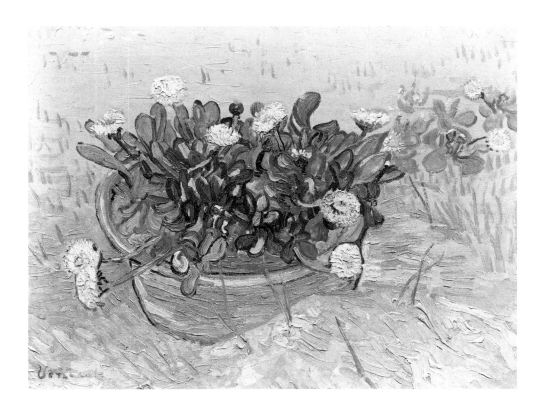

Still Life: Bowl with Daisies
Arles, May 1888
Oil on canvas, 33 x 42 cm
F 591, JH 1429
Upperville (Va.), Collection
Mr. and Mrs. Paul Mellon

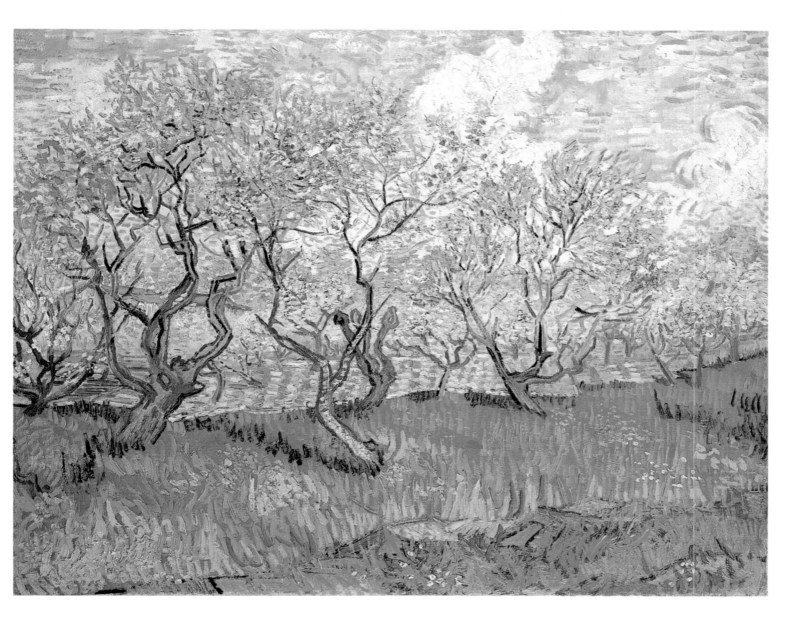

radical in his approach. In an experimental mood, he has unobtrusively eliminated the shadows from the picture. Anything which might indicate a source of light outside the picture has been deleted. The objects in the scene now appear to be lit from within, so to speak, and seem in a sense active, rather than passively immersed in the sunlight. They themselves create the cheerful atmosphere. Lack of shadows was a principle of Japanese woodcuts; the light, however, is genuinely European. Again it is the motif of a blossoming tree that prompts this juxtaposed presentation of approaches: the airy grace of sunlight is caught in the branches and endows Nature with a sacred dimension.

It is all light. The very meaning of van Gogh's fruit trees is light. Even where shadows are suggested, the darker zones are like shadows cast by the blossoms themselves – as if the blossoms were a light bulb and the trunk and branches a lampstand. The two close-ups of a peach tree (pp. 318 and 332) demonstrate this in an exemplary manner: at ground level, shadows spread out on both sides. We might expect a second tree, casting its shadow in the bare garden; but van Gogh has left it out, and

Orchard in Blossom
Arles, April 1888
Oil on canvas, 72.5 x 92 cm
F 511, JH 1386
Amsterdam, Rijksmuseum Vincent van Gogh, Vincent van Gogh Foundation

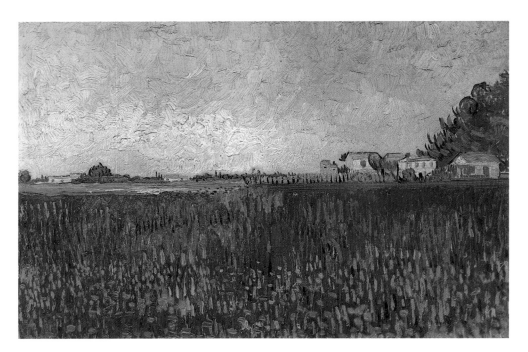

Farmhouses in a Wheat Field near Arles
Arles, May 1888
Oil on canvas, 24.5 x 35 cm
F 576, JH 1423
Amsterdam, Rijksmuseum Vincent van
Gogh, Vincent van Gogh Foundation

Landscape under a Stormy Sky
Arles, May 1888
Oil on canvas, 60 x 73 cm
F 575, JH 1422
Vaduz (Liechtenstein), Fondation Socindec

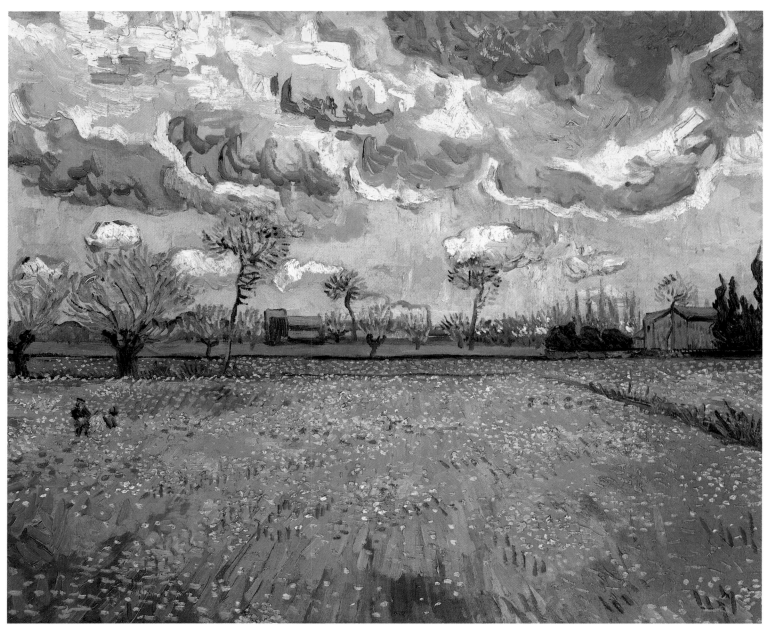

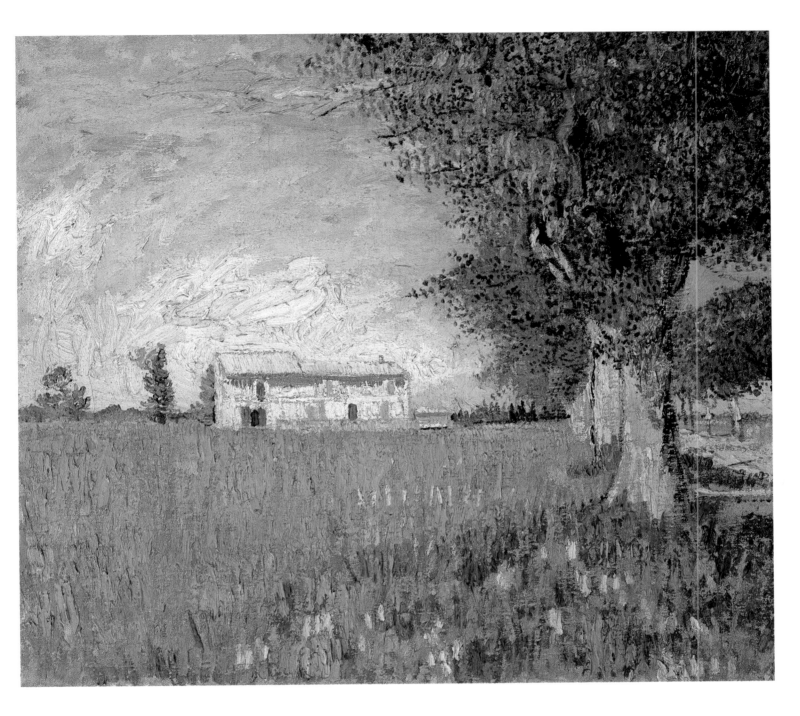

what remains is the impression of a candescent crown sending its rays skywards and laying down what is left of its earthbound nature as shade.

The two pictures of the peach tree are noteworthy in another respect. Van Gogh tackled them at different times, and both the date and the time of day differ. The trees light up their surroundings as if they were suns, the earlier version (p. 318) being a diffuse whitish colour, the later (p. 332) gleaming in an intense, pinkish way. The thickness of the foliage and blossom apparently accounts for this intensity; at an earlier stage in the blossoming, the density of blossom and thus the intensity of colour are less, whereas both are greater at the later stage. Of course these differences could be explained by the position of the sun at the time in question. But what van Gogh produces quite distinctly manifests his interest in the independence and autonomy of the tree whose

Farmhouse in a Wheat Field
Arles, May 1888
Oil on canvas, 45 x 50 cm
F 408, JH 1417
Amsterdam, Rijksmuseum Vincent van Gogh, Vincent van Gogh Foundation

Still Life: Majolica Jug with Wildflowers
Arles, May 1888
Oil on canvas, 55 x 46 cm
F 600, JH 1424
Merion Station (Pa.), The Barnes
Foundation
(Colour reproduction not permitted)

individuality is expressed in its luminous power. Some years later, and perhaps not entirely uninfluenced by van Gogh's series, Monet devoted his attention in his own Impressionist way to changes of light during the course of a single day. In his series of haystacks, though, and above all in the series showing the façade of Rouen cathedral, there is nothing that in any sense radiates light from within. Monet's attention is on the sunlight and the things it shines on, things that reflect the atmospherics and colours as mirrors might. The vital force within things, which was what mattered to van Gogh, is submerged beneath Monet's shimmering, glittering surfaces. Van Gogh's brand of "Impressionism" lent an unlooked-to quality of permanence to reflections by incorporating them into his pictures: light effects are, as it were, organs in the body of his motifs.

Vincent's former mentor Anton Mauve died in March 1888. In his memory, van Gogh wrote "Souvenir de Mauve" on the earlier picture (p. 318). At this time he attempted to clarify his relations with the master of The Hague School in a letter (W3) to his sister, in which he tried to assess his own use of colour: "You realise that Nature in the south cannot be properly reproduced by the palette of one such as Mauve – Mauve belonged in the north and remains the master of grey. But today's palette is thoroughly colourful: sky blue, orange, vermilion, bright yellow, wine red, violet. If one intensifies all the colours, one can achieve peace and harmony once again." This unmistakably reminds us of the problem Signac articulated. But Vincent was convinced that the south and colour were synonymous. Japan alone could not account for

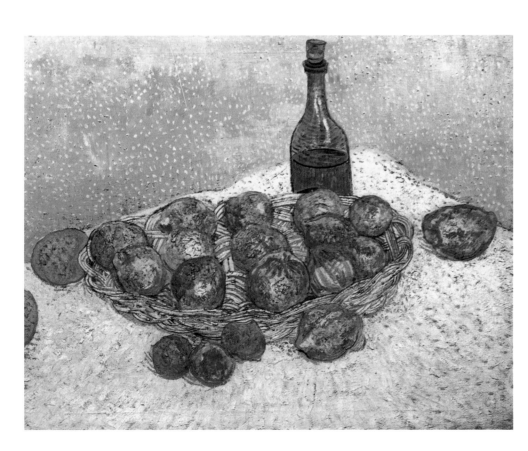

Still Life: Bottle, Lemons and Oranges
Arles, May 1888
Oil on canvas, 53 x 63 cm
F 384, JH 1425
Otterlo, Rijksmuseum Kröller-Müller

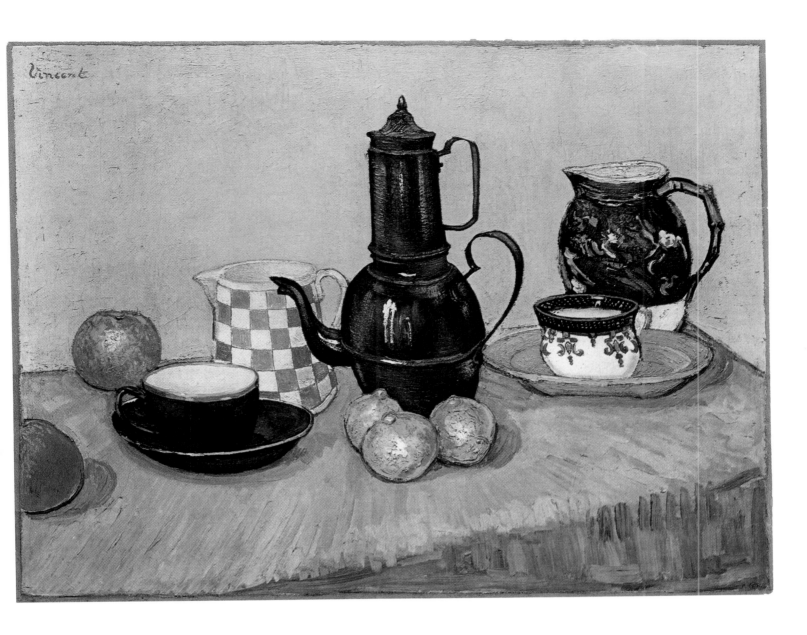

**Still Life: Blue Enamel Coffeepot,
Earthenware and Fruit**
Arles, May 1888
Oil on canvas, 65 x 81 cm
F 410, JH 1426
Lausanne, Collection Basil P. and
Elise Goulandris

the intensity of his palette. The Orient prompted the spatial flatness and the large zones of colour, the abrupt shifts in perspective, and that charming lightness of touch (which had to be reconciled to his own vehemence in the deployment of colour). The eloquent use of light in his paintings was perhaps a common ground where the differences in his influences met: the Japanese had thought the problem of light to be of fairly secondary importance, while the Impressionists subordinated everything to it. Van Gogh harmonized their concepts by distinguishing between light which came from outside and sources of light inherent in things. All his energy went into creative work that concentrated on the latter. Even the immense sun that was soon to rise in his work was depicted only in terms of its own luminous power; the fact that in reality it makes everything else visible was of no interest to van Gogh. To him, not even the sun was an outside source of light.

The blossoming fruit trees were the driving force in this development, which only took shape once van Gogh was in the south. Van Gogh himself was doubtless aware of the discrepancy between his expecta-

tions and what actually happened. Things were not themselves as glaringly bright as he had thought they would appear. So in order to show them in all the forceful colourfulness he had made himself master of in Paris, he had to suppress the effect of the natural light which damaged the intensity of colours and made shades of colour seem alike. The bright blossoms on the trees made an interim step possible. And the series of fifteen orchard paintings completed an important stage in his evolution: now, light was no longer a problem for him. He had equalled the Japanese.

Not everything he was then painting managed to handle the problem with this radical efficiency. In *Orchard in Blossom (Plum Trees)* (p. 330), for instance, the treetops dissolve into a nebulous grey; and in this picture van Gogh considered it necessary to add the factory with its tall chimney and farmer ploughing, scarcely visible on the horizon. The picture remains something of a snapshot, the more so as van Gogh fails to convey any luminous quality in the treetops – the background motifs highlight what is a rather strained attempt to juxtapose the transient with what is known to be constant. A successful companion piece is surely *Orchard with Blossoming Apricot Trees* (p. 320). The rows of trees, the comparable point of view, and the copious blossom are similar, but the colour is more intense. It offers the contrast of red and green in the orchard grass, as if the blossoms had littered the ground with little balls of light.

"Colour is actually very delicate here", he informed his sister at this time. (Letter W4) "When the green is fresh, it is a rich green such as we

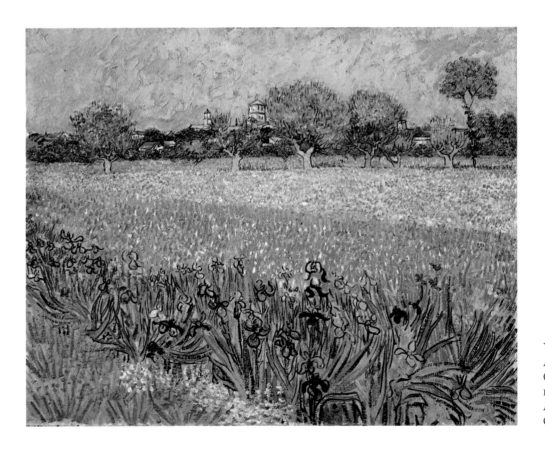

View of Arles with Irises in the Foreground
Arles, May 1888
Oil on canvas, 54 x 65 cm
F 409, JH 1416
Amsterdam, Rijksmuseum Vincent van Gogh, Vincent van Gogh Foundation

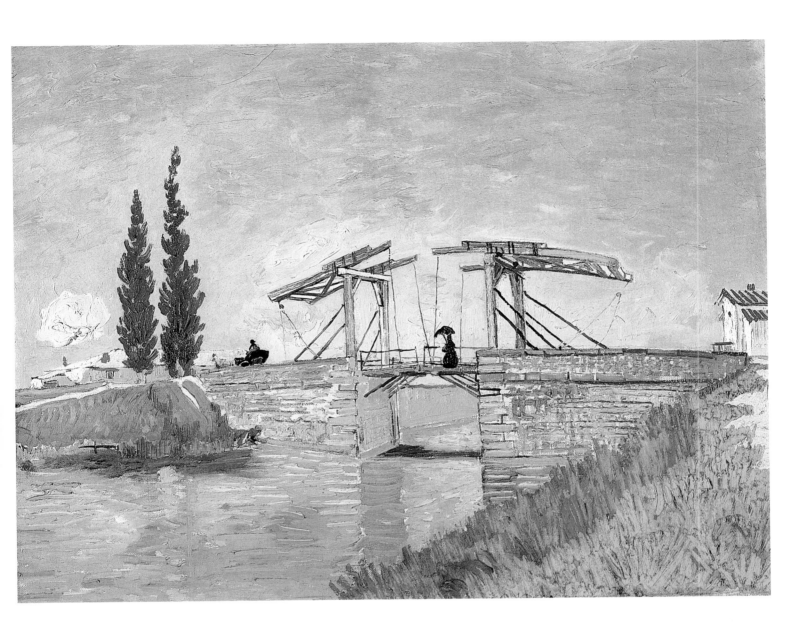

seldom see in the north, and peaceful. When it turns burnt and dusty, it does not become ugly, but the landscape then gains a wide range of golden shades – greenish gold, yellow gold, pink gold, and bronze, copper, in short everything from lemon yellow to the dull colour of a pile of threshed corn. That and the blues – from the deepest royal blue of the water to forget-me-not blue, cobalt blue, above all pale bright blue – greenish blue and violet." Unwittingly, van Gogh was registering colours in terms of contrasts: the area was golden yellow combined with various blues. Here too, then, he was seeing and describing on the assumption that the light comes from a source within phenomena – undimmed by the shimmering heat of the sun, and free of the levelling influence of temperatures or the time of day. Things were bathed in a light all their own. They had been bathed in it ever since his eyes were opened to that light in the orchards – in a series (like all his "invented" work). All he had had to do was change to a new environment – and a new visual world had instantly been his.

The Langlois Bridge at Arles
Arles, May 1888
Oil on canvas, 49.5 x 64 cm
F 570, JH 1421
Cologne, Wallraf-Richartz-Museum

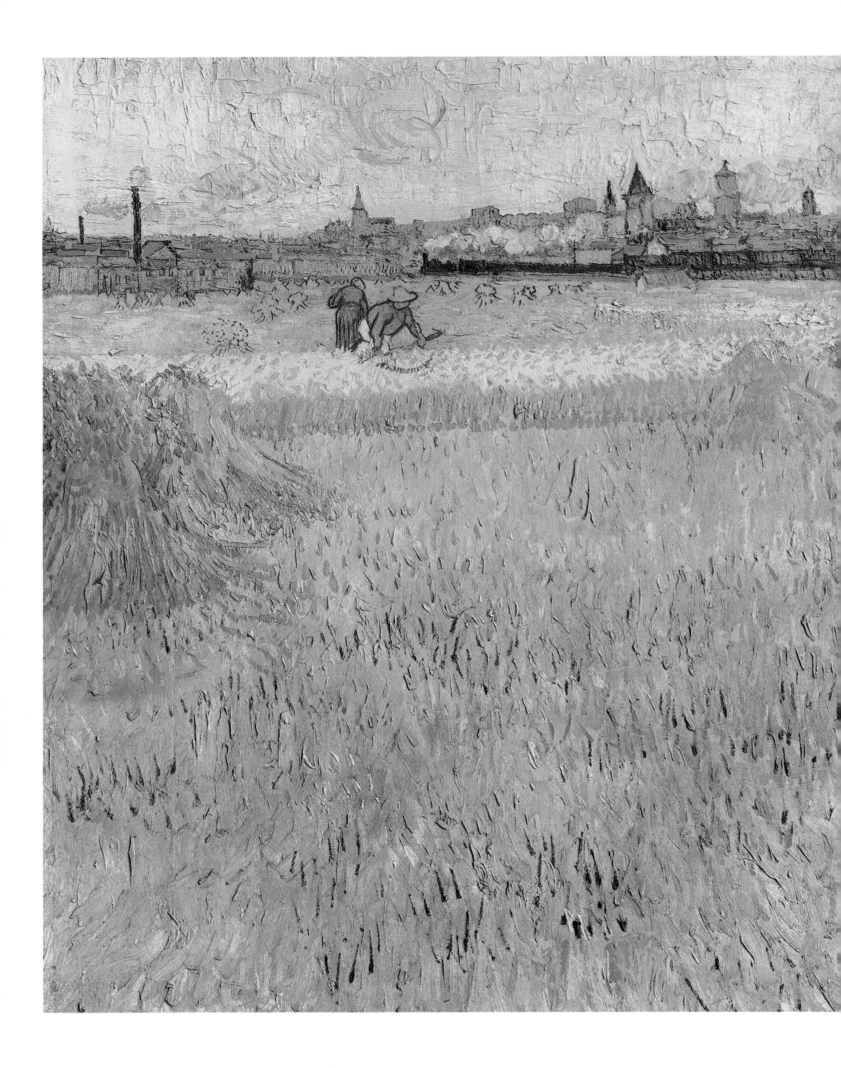

Under a Southern Sun
May to August 1888

The Painter on his Way to Work (p. 386): Off the artist trudges, heavily-laden, through the deserted countryside. In straw hat and worker's outfit, clothing suitable for a *peintre ouvrier*, he carries his brushes and palette, canvas and easel out of the town. He himself embodies the contrast that he has almost feverishly been demanding of his subjects: blue and yellow are the colours of the southern summer, and he is burning just as the landscape is burning under the baking sun. A shapeless shadow is dragging along behind him, a demon following in his footsteps, a portent that whispers warnings not to waste his time. With this voice in his ear he hurries on, tired but tireless, he knows not whither. He merely senses the places that lie along the way: pictures, a host of which he has yet to get through. The Gates of Paradise are closed to him; all he can do is try to get around them, to see if there is another way in. There he goes, burdened with original sin – the Wandering Jew, Sisyphus and Prometheus all in one. The plane trees that line the roadway afford no shade. The horizon is marked by towering, threatening cypresses. And far and wide there is not a soul to be seen. It is a self-portrait of Loneliness.

"When I am on my own", he wrote to his brother at this time (Letter 504), "I have less of a need for company than for unrestrained work, and that is why I am forever ordering canvas and paints. The only time I feel alive is when I am working like mad. In society I would be less aware of this need, or perhaps I would do more complicated things. But when I am left to my own devices I rely on the passion for work that overcomes me from time to time, and then I let myself go, beyond all the limits." Once again he had planned a workload for himself: in the near future he wanted to paint fifty pictures "good enough to exhibit". It was not that he intended to take part in an exhibition: he pressed on to confirm his own identity, his creative mission. "On days when I bring a study home with me", he wrote in Letter 498, "I say to myself: If only it was like this every day, things would be fine. But on days when one returns home empty-handed but still eats and sleeps and spends money, one feels dissatisfied with oneself and a fool, a rascal, a good-for-nothing." He wanted to prove himself worthy of Theo's unstinting support. His

Girl with Ruffled Hair
Arles, June 1888
Oil on canvas, 35.5 x 24.5 cm
F 535, JH 1467
Switzerland, Private collection

Arles: View from the Wheat Fields
Arles, June 1888
Oil on canvas, 73 x 54 cm
F 545, JH 1477
Paris, Musée Rodin

**Harvest in Provence, at the Left
Montmajour**
Arles, June 1888
Water colour and pen, 39.5 x 52.5 cm
F 1484, JH 1438
Cambridge (Mass.), Fogg Art Museum,
Harvard University

Harvest at La Crau, with Montmajour in the Background
Arles, June 1888
Oil on canvas, 73 x 92 cm
F 412, JH 1440
Amsterdam, Rijksmuseum Vincent van Gogh, Vincent van Gogh Foundation

manic painting fever was meant as a way of eliminating fears that his lack of success as an artist might have something to do with laziness or lethargy. Theo, for his part, did not have the remotest suspicion of this kind; it was Vincent who put himself under pressure, working all the more frenziedly as if he felt he was not living up to the century's ideas of "achievement". Since he had no income, his need for recognition as an artist was all the more imperative.

Van Gogh had been living in guest houses ever since he arrived in Arles. He rented a store for the pile of paintings that soon accumulated; this store was to go down in art history as the "yellow house" when he moved in that September. Every morning he would leave his lodgings, heavily laden, and roam the area in tireless quest of motifs to satisfy his creative urge. The artist set off to work day after day, into the blossoming hilly landscape of Provence – and produced one masterpiece after another. "It is the excitement, the honesty of a response to Nature, that guides our hand; and if this excitement is often so strong that one works without noticing that one is working, if brushstrokes sometimes come thick and fast like words in a conversation or letter, then one ought not to forget that it has not always been like that and that there will be many a depressing day barren of inspiration in the future." These words (from

View of Saintes-Maries with Church and Ramparts
Arles, June 1888
Pen and ink, 43 x 60 cm
F 1439, JH 1446
Winterthur, Collection Oskar Reinhart

View of Saintes-Maries
Arles, June 1888
Oil on canvas, 64 x 53 cm
F 416, JH 1447
Otterlo, Rijksmuseum Kröller-Müller

Letter 504) read prophetically in view of the breakdown van Gogh underwent before the year was out. But the tremendous vigour he now felt pointed to a better future. And the products of this creative burst may well strike us as thoroughly positive, with a *joie de vivre* that was not to be repeated in his work. The utopia he was living in, with its optimistic atmosphere, quite naturally stimulated van Gogh's "excitement". The optimism may have been more imagined than real; but "one works without noticing that one is working", and van Gogh was swept along. The moments of thought that revealed the utopia for the fiction it was scarcely made any impression on his visual world. The accuracy of *The Painter on his Way to Work* as an account of a state of mind matches its poignancy as an odd-one-out among his paintings. For the moment, van Gogh was distinguishing between the present and the promise of future happiness recorded in his paintings. And he devoted himself to the future.

The views of the Langlois bridge (pp. 323–325 and 343) offer a new interpretation of an old subject, one that is ablaze with colour. Back in

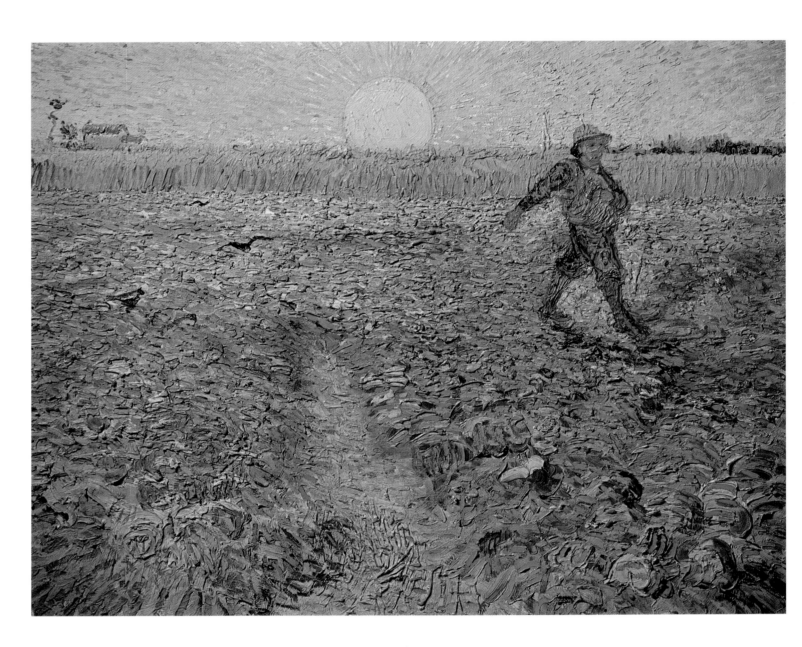

The Sower
Arles, June 1888
Oil on canvas, 64 x 80.5 cm
F 422, JH 1470
Otterlo, Rijksmuseum Kröller-Müller

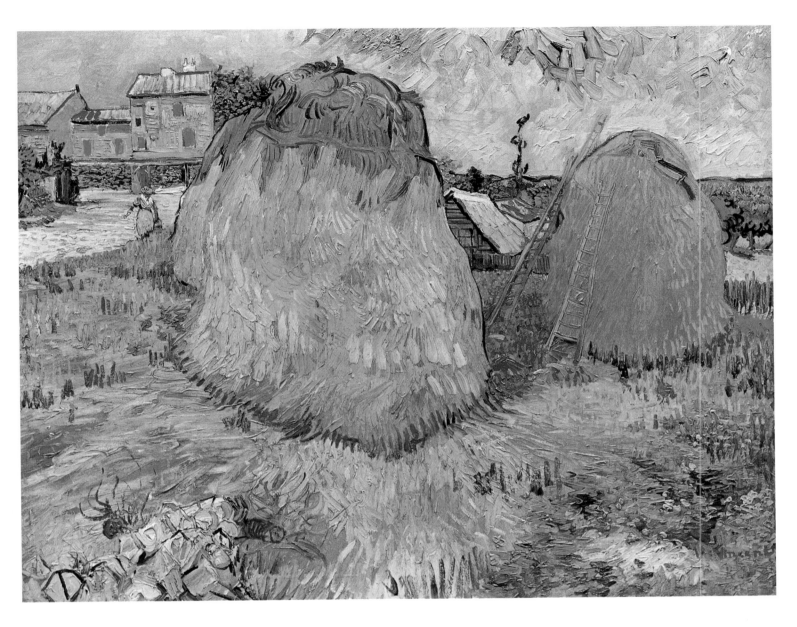

Haystacks in Provence
Arles, June 1888
Oil on canvas, 73 x 92.5 cm
F 425, JH 1442
Otterlo, Rijksmuseum Kröller-Müller

Nuenen he had already tackled another specimen of this typically Dutch kind of construction (p. 130), but at that time the suspension bridge had simply been part of a townscape. Now his interpretation of a bridge over the Rhône canal south of Arles took on the familiar idyllic quality of genre scenes. Two of the versions are only very slightly different (cf. pp. 323 and 325). Van Gogh had climbed down the canal bank to watch the washerwomen at their work beside a wrecked barge. He saw their figures in the familiar stooped postures we remember from his digging women in the Dutch paintings. In other words, it was not only the bridge that reminded him of home. If the colour were not so glowing and full, we might hardly suppose these two paintings showed southern scenes. We can grasp the foregrounded importance of the colour scheme if we pause to consider how van Gogh meticulously repeats every detail of the washerwomen, the outline of the bridge, and the touch of the pony and trap: the only significant differences between the two paintings are differences of colour. Colour, of course, is what makes the south different, as van Gogh repeatedly reminds us. The subjects might be anywhere. What counts is the intensity of feeling generated when the radiant power of the sun meets van Gogh's palette.

This does not mean that van Gogh no longer cared about the iconographic and symbolic subtleties that had hitherto always been the concern of his work. But their importance had been diminished. The somewhat later painting of the Langlois bridge (p. 343) makes the point nicely. Here, van Gogh has taken up his position on the opposite bank. Down by the water, not immediately apparent in front of the wall, is one solitary washerwoman; but now the track that crosses the bridge is

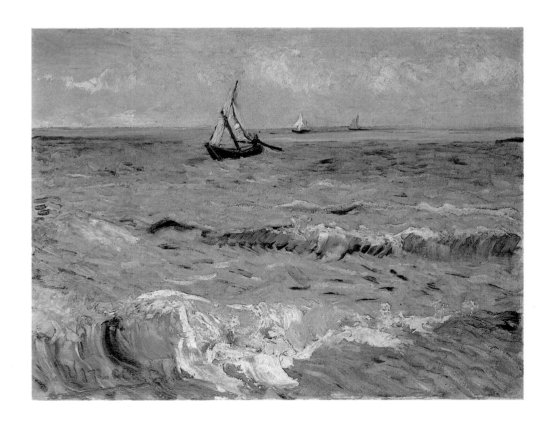

Seascape at Saintes-Maries
Arles, early June 1888
Oil on canvas, 51 x 64 cm
F 415, JH 1452
Amsterdam, Rijksmuseum Vincent van Gogh, Vincent van Gogh Foundation

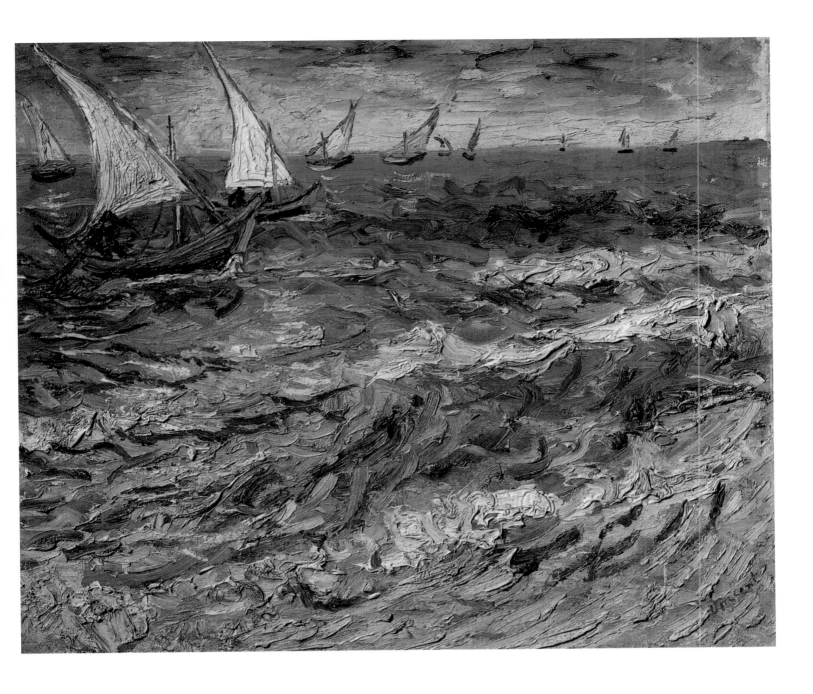

busier. With the light coming from beyond (so it appears, from the silhouette effects), we see a horse and cart heading off into the distance and a woman's figure with an umbrella crossing the bridge – both of them done in a rich black by van Gogh. But even here we cannot be sure of a source of light – in any case, the shadow cast on the surface of the water by the bridge implies a sun directly overhead. The black of the figures cannot be explained by saying that the picture was painted around midday. What we have here are once again autonomous images laden with meaning, of the kind that had peopled van Gogh's visual world from the very beginning: there is the woman in black, that relic from his religious times, posing on the bridge! She is small now and merely a background figure, part of the scenery, to be taken for granted. Her dark shape represents the price to be paid, so to speak, for the cheerful radiance of the picture; she is that necessary place on which no

Seascape at Saintes-Maries
Arles, June 1888
Oil on canvas, 44 x 53 cm
F 417, JH 1453
Moscow, Pushkin Museum

light must fall if we are to register the overall brightness as such. To be more precise: our gaze must now be more rigorous if we are to discover the significant motifs that are still there in the new brightness.

At the beginning of June, van Gogh tramped the long and tiring stretch through the Camargue to Saintes-Maries-de-la-Mer, a fishing village on the Mediterranean coast. The gypsies of Europe make an annual pilgrimage to the place in honour of their patron saint, St. Sara. According to legend, she was the servant of the three Marys the town is named after, who landed on the shores of Provence in AD 45 to spread Christianity. Waves of excitement from this pilgrim festival rippled as far as Arles, thirty kilometres away, and once the commotion was over van Gogh decided to get to know the place that was the cause of so much devotion. Again he discovered Holland, albeit with the intense colours of the south. He did three paintings on the spot (pp. 349 and 352–53), along with a number of drawings that he based paintings on once he was back in his studio.

Fishing Boats on the Beach at Saintes-Maries
Arles, June 1888
Reed pen, 39.5 x 53.5 cm
F 1428, JH 1458
Private collection

Fishing Boats on the Beach at Saintes-Maries

Arles, late June 1888
Oil on canvas, 65 x 81.5 cm
F 413, JH 1460
Amsterdam, Rijksmuseum Vincent van Gogh, Vincent van Gogh Foundation

Street in Saintes-Maries (p. 361) represents his greatest commitment (at that date) to the principle of autonomous colour. In it he lavishly indulges his fondness for contrasts, unusually using all three varieties in the picture. The contrast of red and green dominates the right of the painting; blue and orange, the left; and yellow and violet, the centre. Of the three contrasts, this last in particular derives its impact from the exciting monochrome of the sky, an unmixed, bright, pastose field of colour that flies full in the face of reality. Van Gogh based the painting on one of the sketches he had hastily made in Saintes-Maries, an affectionate drawing of snug cottages. The colours, detached from any real correlatives, were added subsequently in the studio. The fishermen's cottages (in a sense the local equivalent of the farmers' crofts in Drente and Nuenen) show him using material that was thoroughly familiar to him and embellishing it with colours that expressed his new emotional intensity: the motif was what survived from his past, while he projected all his optimism and hopes for the future into the vitality of his colours.

Boats on the Beach of Saintes-Maries
Arles, June 1888
Water colour, 39 x 54 cm
F 1429, JH 1459
Private collection

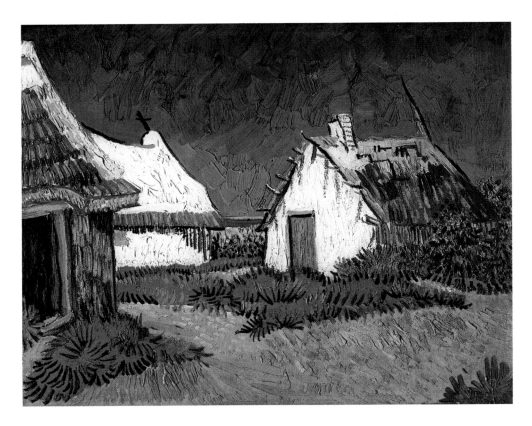

Three White Cottages in Saintes-Maries
Arles, early June 1888
Oil on canvas, 33.5 x 41.5 cm
F 419, JH 1465
Zurich, Kunsthaus Zürich (on loan)

The vehemence with which van Gogh juxtaposes heterogeneous elements is tantamount to a new kind of syncretism once again; for puffy trails of smoke are rising from the chimneys against the sky's vast expanse of yellow, realistically yet not altogether appropriately, and the squiggles conspire to make the dazzling sheet of colour seem mildly ridiculous.

There were other ways of doing it. *Fishing Boats on the Beach at Saintes Maries* (p. 355), also a reworking in paint of a sketch done on the spot (p. 354), is filled with a spirit of balance and harmony. Again his motifs recall his early works, and again it is only the use of colour that declares this a product of the southern ambience he had grown so fond of. The precision draughtsmanship still rules supreme; but the delicate contours cue the sensitive use of the palette. The colours are kept in check by the drawn lines, and the result is a subtle study that preserves a fine balance between love of detail and abstraction. One of the boats is called 'Amitié' (friendship) – suggesting that even these objects are loaded with meaning. Still, van Gogh has his disguised symbolism completely in his command in this work. *Fishing Boats on the Beach at Saintes-Maries* is one of his most accomplished attempts to establish a harmony of motif and colour, pure description and meaning.

Van Gogh also went back to familiar material in his most extensive series of that summer. As in the past, he followed the harvest closely, recording the farmers' work and the state of the fields. In Arles, thanks to the climate, the corn ripened faster. And the painter's task was tougher since it involved standing in the blistering sun. As in the north,

van Gogh took for granted that he had to take whatever the climate sent his way: the blustery mistral and the dry, exhausting heat. The *plein air* painter was as true to his programme as the *peintre ouvrier*. Authenticity was the thing. The new intensity of colour was one more proof that the true, the genuine, and whatever made a direct impact, mattered above all else.

The plain of La Crau spreads to the southeast of Arles. It is as flat as van Gogh's native country. La Crau is surrounded on all sides by hills. These offered van Gogh an opportunity to escape the flatland. Much as he liked standing right in the centre of his landscape (cf. pp. 366 and 368), he now also withdrew to a greater distance from where he commanded a panoramic view of the whole region. *Harvest at La Crau, with Montmajour in the Background* (p. 347) is a fine example of the work that resulted. This picture also established the size van Gogh preferred: with only a few exceptions in his very early and very late work, he used this 73 x 92 centimetre format (French canvas norm size 30). The painting includes just about everything we expect of a harvest scene: a haystack and farmhouse to frame the composition, people doing particular jobs (digging, raking, bringing in the harvest), and in the background a circle of hills surrounding the busy scene protectively. Van Gogh had not had such an extensive view in his Dutch period, if only for

Street in Saintes-Maries
Arles, early June 1888
Reed pen, 30.5 x 47 cm
F 1434, JH 1449
England, Private collection

Street in Saintes-Maries
Arles, mid-July 1888
Reed pen, 24.5 x 31.8 cm
F 1435, JH 1506
New York, The Museum of Modern Art

topographical reasons. But at that time he was probably not yet alert to its attractions: it was only the distanced view of Impressionism that had made this panoramic perspective accessible to him. Van Gogh brought his own perspective into line with the new panoramic view and added his own personal touches: the bright colours, the sense that light emanates from within his subjects, the total exclusion of shadows (which could only ruin the overall impression).

"I have just finished a week packed with hard work out in the fields under a blazing sun", Vincent reported (Letter 501). "What resulted were studies of cornfields, landscapes and – a sketch of a sower. On a ploughed field, a vast area of violet clods of earth reaching to the horizon – a sower in blue and white. A low field of ripe corn on the horizon. Over it a yellow sky with a yellow sun. You will gather from my simple account of the colour values that colour plays a very important part in this composition." This sower (p. 350) appears at the end of the harvest series, just as in reality he does his sowing only when the reaping has been completed and the fields are fallow.

This picture focusses the entire significance of van Gogh's work during those first few months in the south. First, it includes his reconnaissances of the surrounding area, his affectionate interest in all that was characteristic of Provence: his sower, too, is on the broad plain of La Crau. Second, the painting offers memories of his homeland, memories that prompt the artist to choose motifs that are of a familiar nature. The figure of the sower is even quoted from an early drawing (p. 20) in which he was copying Millet. Then there is van Gogh's quest for the light within things, and his tendency to banish light sources from his pictures. Even the giant sun rising over the horizon fails to spread its powerful yellow everywhere: neither the sower nor the farmstead in the background seems lit by it. And finally there is the colour autonomy, which he has now taken a striking step further: in the sower painting, the blue sky and earthy beige ploughed furrows have exchanged colours.

In fact, things have an aesthetic life of their own, a power that transcends mere representational recording of a subject. And van Gogh trusts his motif, tries to grasp it in a descriptive way, and sees a plurality of meaning in it that derives from his own life or from the universally valid iconography of Art. Increasingly, though, this traditional stock of experiences is accompanied or indeed obscured by the dearly-cherished wish to create a world of his own and take hold of it in his work. The idea of Japan lent definition to this wish; and the transforming power of colour gave it manifest substance. Colour was van Gogh's way of articulating that extra dimension that transcended the everyday, real presence of the subject. Colour made the future tangible. This approach was fundamentally utopian, since it could not exist outside van Gogh's paintings. And his ideas about the future remained in the vacuum of

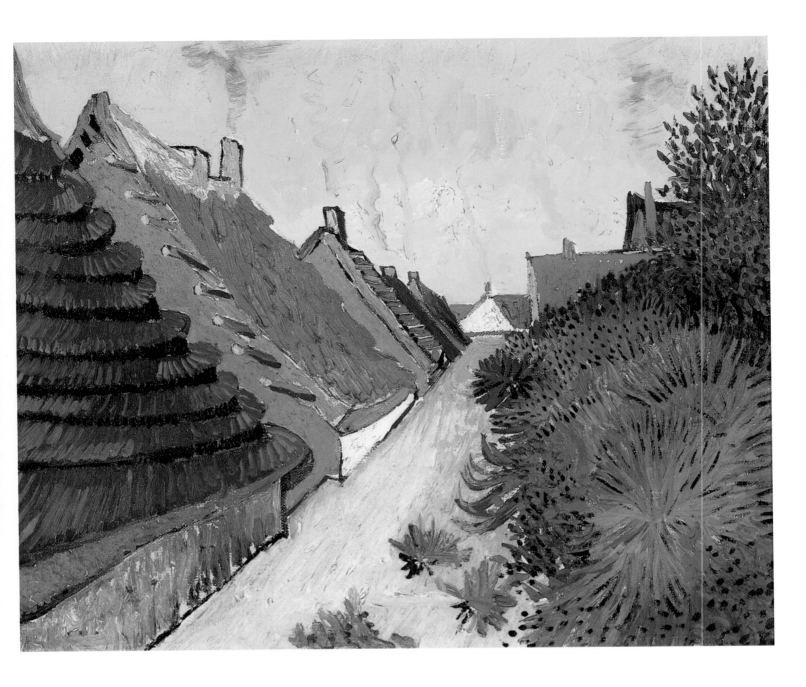

pure aesthetics. Nevertheless, he in his own person still embodied the unity of Life and Art so vividly that he very much believed in the possibility of realizing that utopian better world in the here and now.

Street in Saintes-Maries
Arles, early June 1888
Oil on canvas, 38.3 x 46.1 cm
F 420, JH 1462
Private collection
(Christie's Auction, New York, 19. 5. 1981)

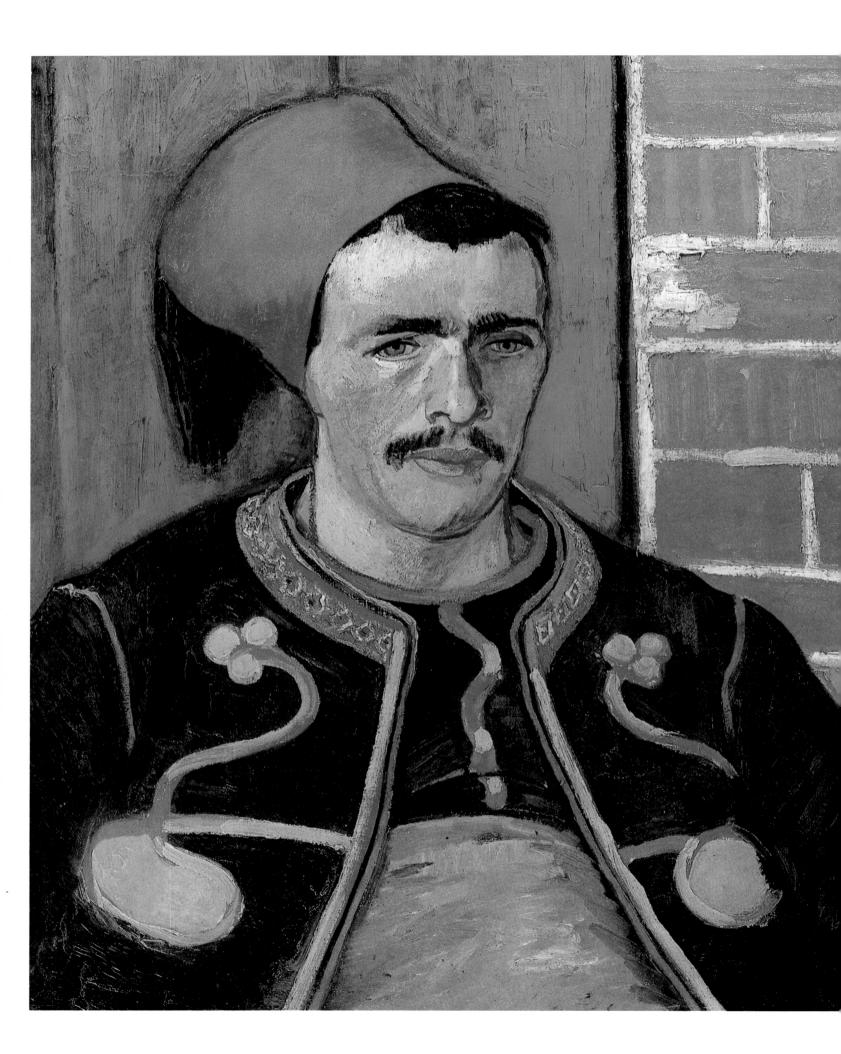

Working without Painting
Van Gogh's Drawings

"I have just sent a roll of little pen-and-ink drawings off to you, I think a dozen. They will show you that I have not stopped working, even if I have stopped painting." (Letter 480) It was not least a question of money that induced van Gogh to turn increasingly to drawing in the early summer of 1888. Theo was having difficulties with his employer and was thinking of giving notice; he was even dreaming of starting a new life in America. Vincent, the millstone around his brother's neck, had to try to become less dependent, as he was afraid the financial help he relied on so entirely might come to an end. He spent half of his money on canvas and paint; that would be where he could save the most. In any case, Vincent wanted to have savings that he could draw upon in the time he envisaged spending with Gauguin: "I think I shall be doing the right thing", he wrote in Letter 506, "if I now devote myself mainly to my drawings, so that I shall have a supply of canvas and paint in reserve when Gauguin comes. I really wish it were as unnecessary to be thrifty with paint as it is with pen and paper. I often ruin an oil study because I am afraid of wasting paint."

Like most artists' work, van Gogh's lives from the mutual influence of painting and graphics. Line and colour are utterly inseparable. What was different about van Gogh was simply the way he devoted himself exclusively to drawings for weeks at a time. Drawings had been his way of embarking on the artistic life; and, just as his paintings had adapted the motifs of his native Netherlands to a southern ambience, he was now trying to apply the favourite medium of his early years to the new situation. Even lines had to be translated into the oriental idiom he had come to love: "That does not look Japanese, but it is in fact the most Japanese thing that I have ever done", he wrote, describing two "large pen-and-ink drawings". (Letter B10)

The drawings he did in those months can be approached from a number of angles. First, we can examine the works as sketches for paintings. Second, we can view them in the light of the large-format works that were created parallel to his paintings. Third, we can consider the ways van Gogh dealt with the same subject when he did it in paintings and drawings at the same time. And fourth, there are drawings that originated as copies of paintings.

The Zouave (Half Length)
Arles, June 1888
Water colour, 31.5 x 23.6 cm
F 1482, JH 1487
New York, The Metropolitan
Museum of Art

The Zouave (Half Length)
Arles, June 1888
Oil on canvas, 65 x 54 cm
F 423, JH 1486
Amsterdam, Rijksmuseum Vincent van
Gogh, Vincent van Gogh Foundation

Harvest in Provence
Arles, June 1888
Oil on canvas, 50 x 60 cm
F 558, JH 1481
Jerusalem, The Israel Museum

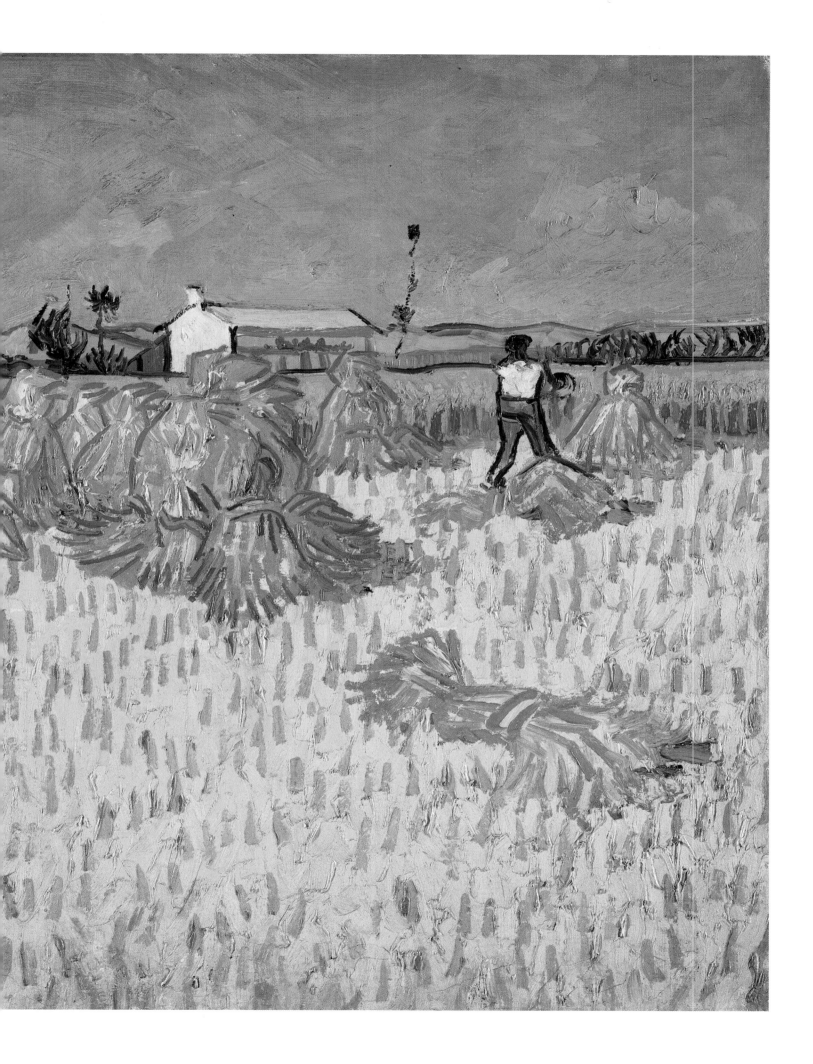

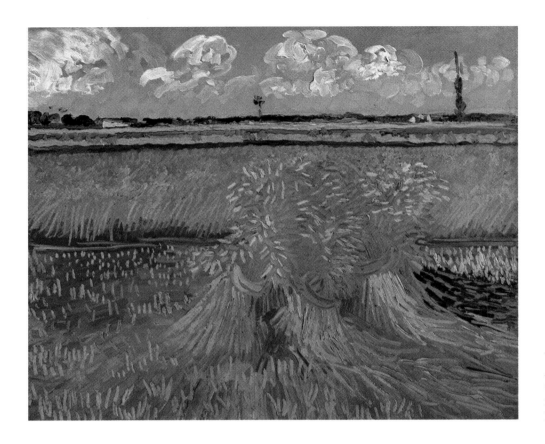

Wheat Field with Sheaves
Arles, June 1888
Oil on canvas, 55.2 x 66.6 cm
F 561, JH 1480
Honolulu, Honolulu Academy of Arts

For all their sketchy quality, van Gogh's drawings are works of art in their own right, even when they only exist as preparatory treatments for a painting. In the sketch (p. 354) of *Fishing Boats on the Beach at Saintes-Maries* he meticulously recorded the colours of the original subjects. Then in the actual picture (p. 355) he painted the hull of the boat red where he had marked his sketch *rouge*; the arabesque on the prow is white because he had marked it down as *blanc*; and equipment on board the boat, marked *bleu*, faithfully comes out blue. The graphic precision on the painted version was laid down in detail in the drawing – in this respect, the two media are closely related. Van Gogh is also trying to do justice to the specific requirements of drawings and paintings. On paper, his motifs are more emphatically foregrounded, leaving correspondingly less space for atmospheric effects of sky and sea, which are kept to a suggestive minimum. It is only on the canvas that the subtle interplay of colours can appear to advantage – and so the boats recede somewhat in favour of broad expanses of hazy blue, bathing the landscape in a typically coastal light. Van Gogh could have dispensed with his signature and explanatory comment, in order to demonstrate the autonomous value of the sketch as compared with the painting. He always meticulously gave his attention to whatever phenomena were accessible either to a line drawing or to paint.

Sometimes the drawings were alternatives to paintings. The five works van Gogh did in July, from the ruined monastery at Montmajour, illustrate this perfectly. *La Crau seen from Montmajour* (p. 369) can stand by itself; indeed, van Gogh has taken pains to take a different

The Seated Zouave
Arles, June 1888
Oil on canvas, 81 x 65 cm
F 424, JH 1488
Argentina, Private collection

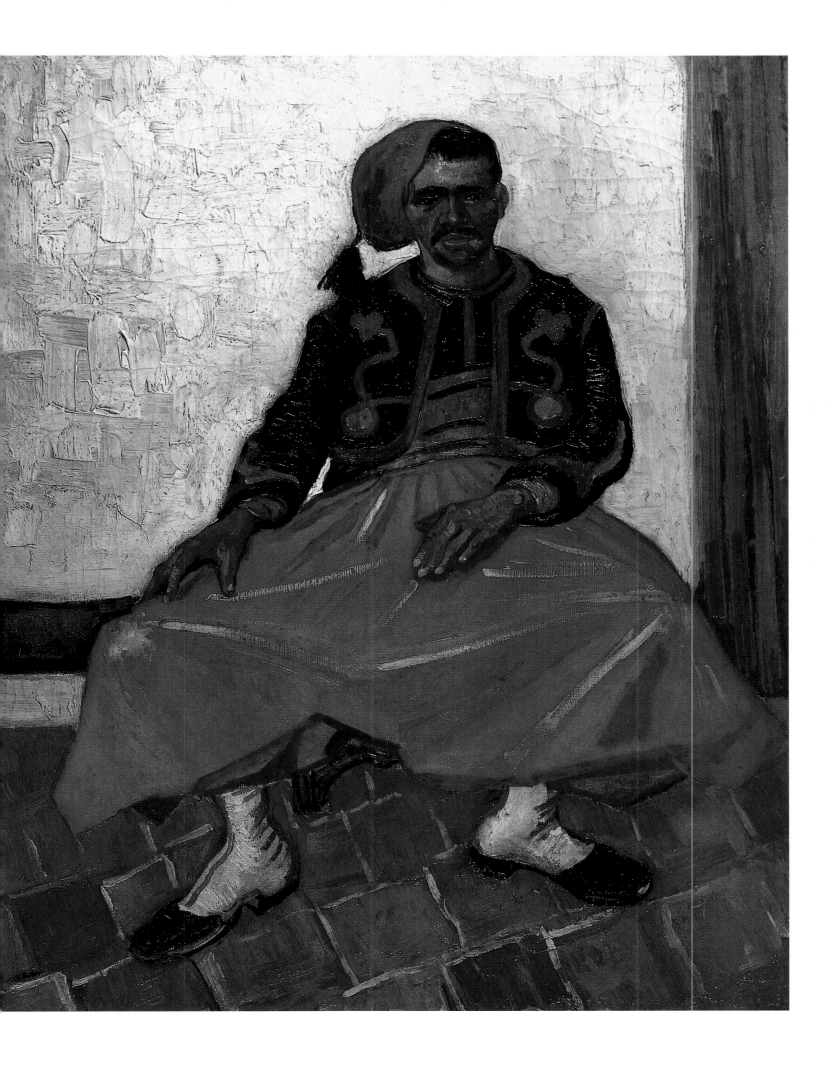

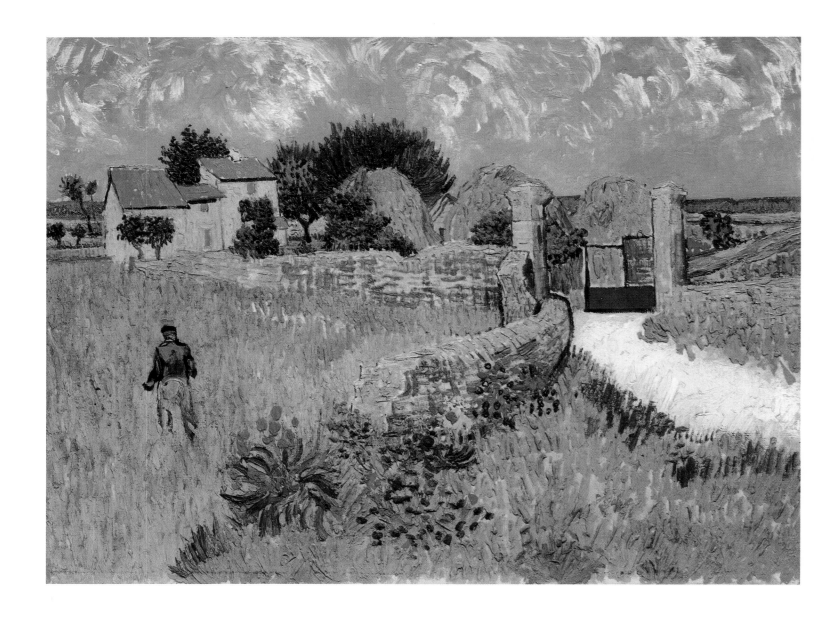

approach from that of painting. He has taken up a position he had not previously adopted, at the ruined monastery on the hills above La Crau; in the painting (p. 347) the ruins can be made out on the horizon. So van Gogh is now looking in the opposite direction. He has come a fair way from Arles – a distance he would have thought twice about walking laden with easel and frame, in fact. The sheet on which he did this drawing measures a full 49 x 61 centimetres. This format alone suggests another reason for seeing the drawing as a work in its own right. Van Gogh has made use of three different techniques to draw his subject: a rough pencil sketch outlines the position of the motifs; on this he overlays hatching in brown ink done with a reed pen; and this is then touched up in places with black ink. In other words, the master of the palette was also using three different colours in his graphic works. But his main concern was to find an equivalent for colour, and to vary the strokes so that the length, thickness or hatching of the carefully placed lines will not put us in mind of paintings. This use of lines is not necessarily of a descriptive nature; rather, it is a way of establishing a

Farmhouse in Provence
Arles, June 1888
Oil on canvas, 46.1 x 60.9 cm
F 565, JH 1443
Washington, National Gallery of Art,
Ailsa Mellon Bruce Collection

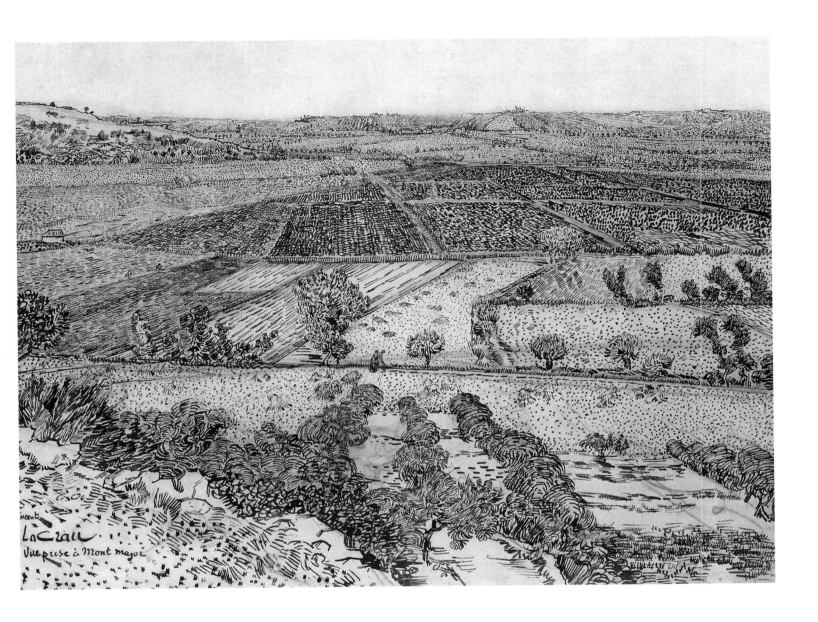

La Crau Seen from Montmajour
Arles, July 1888
Pencil, pen and ink, 48.6 x 60.4 cm
F 1420, JH 1501
Amsterdam, Rijksmuseum Vincent van Gogh, Vincent van Gogh Foundation

"harmony parallel to Nature" (Cézanne's phrase) in graphic work. Van Gogh reworked this landscape later, just as if it had been a painting. In the middle distance, scarcely noticeable, are two people walking along a path, joining the throng of iconographic additions van Gogh again and again considered necessary.

There is one more way of establishing the autonomous quality of this drawing. Vincent said it himself (in Letter 509): "That is how one ought to look at Japanese art – in a brightly lit room with bare walls and an unimpeded view of the surrounding country. Would you try it with the two drawings of La Crau? They may not look Japanese, but in fact they are more so than other drawings. Have a look at them in a café lit by bluish daylight where there are no other pictures, or out in the open. Perhaps they need a reed frame around them, like a very narrow rail." He found his works presentable only in terms of what interested him at the time: they would be ideal decorative items if placed in a Japanese ambience. Both his paintings and his drawings were aiming at a conflation of oriental and occidental ways of seeing. If van Gogh were able to

Wheat Stacks with Reaper
Arles, June 1888
Oil on canvas, 53 x 66 cm
F 560, JH 1482
Stockholm, National Museum

Wheat Stacks with Reaper
Arles, June 1888
Oil on canvas, 73.6 x 93 cm
F 559, JH 1479
Toledo (Oh.), The Toledo Museum of Art,
Gift of Edward Drummond Libbey

achieve a satisfactory result in both media, the unity of Art and Life would be palpably there – less a matter of technical sophistication than a proof of the power of the imagination.

Let us examine the selfsame garden of flowers, done both on canvas (p. 380) and on paper (p. 394). It is a chaotic confusion of shapes and colours, full of vitality – a luxuriant scene of growth, more a jungle than a garden. Van Gogh approaches Nature in flower with the eye of an Impressionist, an eye that he has trained in Paris and focussed on such subjects as undergrowth (cf. p. 259). Reverent respect for Creation has him in thrall. There is a sheer and basic vitality in the growth in his garden; it seems unbounded, forceful, like van Gogh's own vigour. This may well be the very reason he chose to do it as a drawing. In the drawing he can dispense with careful consideration entirely – that quality of thoughtful pause that enters a painting at the moment when colours have to be mixed on the palette. In the drawing, the speed and vigour of van Gogh's creative method (depending absolutely on Nature) are great-

Wheat Field
Arles, June 1888
Oil on canvas, 50 x 61 cm
F 564, JH 1475
Amsterdam, P. and N. de Boer Foundation

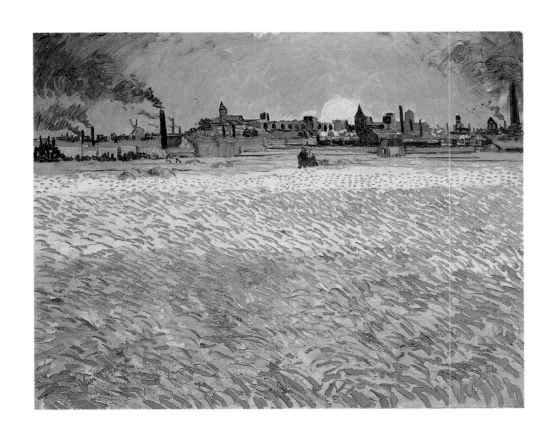

Sunset: Wheat Fields near Arles
Arles, June 1888
Oil on canvas, 73.5 x 92 cm
F 465, JH 1473
Winterthur, Kunstmuseum Winterthur

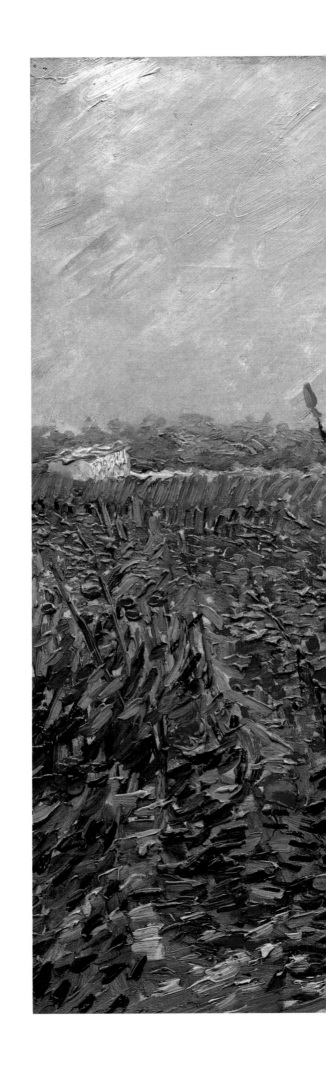

Green Ears of Wheat
Arles, June 1888
Oil on canvas, 54 x 65 cm
F 562, JH 1483
Jerusalem, The Israel Museum,
Gift of the Hanadiv Foundation

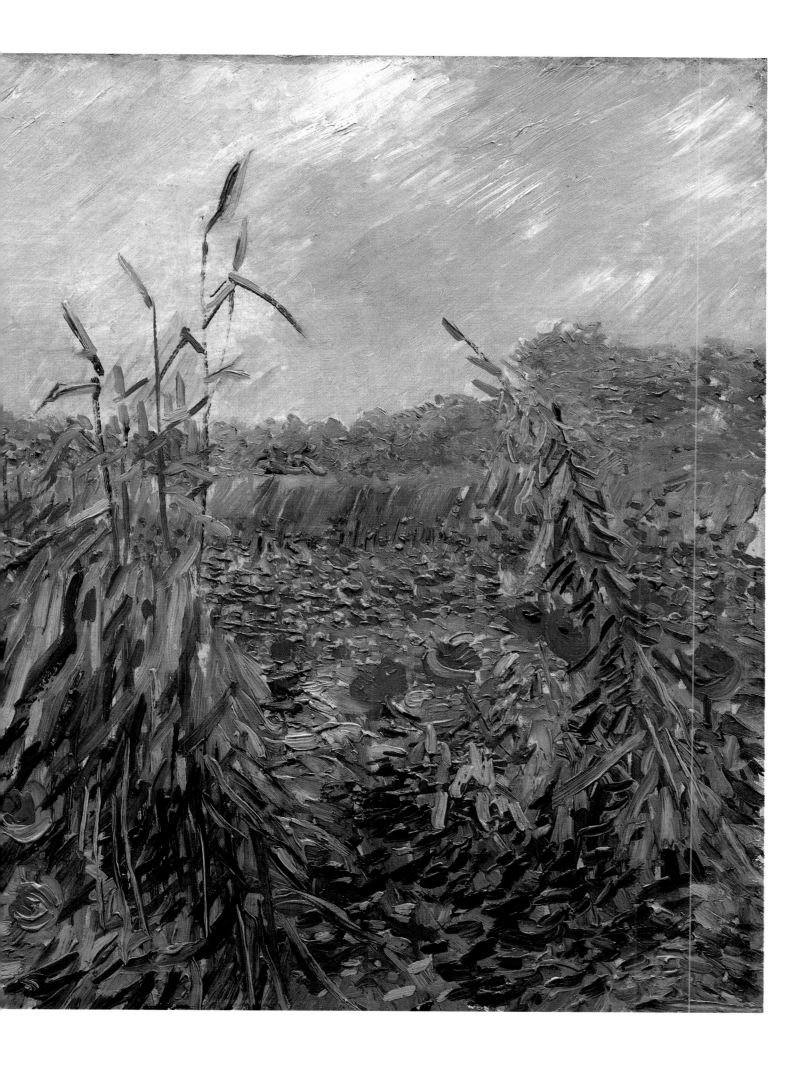

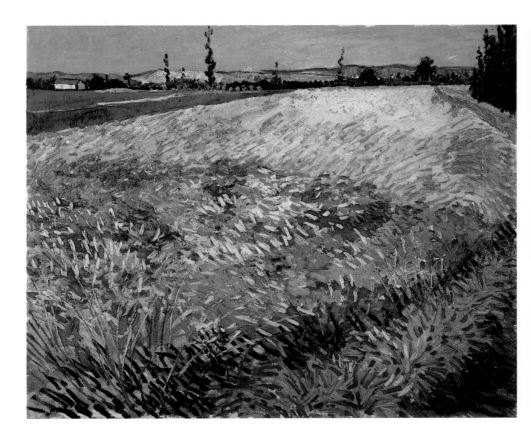

Wheat Field with the Alpilles Foothills in the Background
Arles, June 1888
Oil on canvas on cardboard, 54 x 65 cm
F 411, JH 1476
Amsterdam, Rijksmuseum Vincent van Gogh, Vincent van Gogh Foundation

er than ever. With the aid of his graphic work, van Gogh taught himself to work even more quickly than before. Speed, which mattered so much to him, was to be the decisive factor in his work both with pen and with brush; and accordingly the painted version bears all the signs of accelerated speed that were entering van Gogh's paintings thanks to his drawings. His aim here is not to differentiate the two media from each other; he has now left questions of this kind behind. Now he was pursuing speed as an end in itself.

"Do not suppose that I am artificially maintaining a fever pitch", he wrote in Letter 507. "You know, I am constantly making complicated calculations, which result in a rapid series of pictures that may have been painted fast but were in fact worked out far in advance. And so, if people say that it was done too hastily, you can reply that they looked at it too hastily." This wonderful observation once again adumbrates the conceptual nature of van Gogh's work. Much careful thought went into his pictures – and the more intensely he made his preparations, the faster he created his works. Of course it is also true that van Gogh used drawings for the same purpose as artists had been using them for centuries: to break down the work on the painting into stages, to simplify the process of appropriating the subject and to make the preliminary calculations known to art historians as *inventio*. There was one respect in which van Gogh was an innovator here too, though. The drawing was not only to help when choosing subjects or viewpoints; it was to prompt a style, an approach, and thus mediate between the inventive thought process and the act of painting. This shows that the tactile immediacy of

Rocks with Oak Tree
Arles, early July 1888
Oil on canvas, 54 x 65 cm
F 466, JH 1489
Houston, The Museum of Fine Arts

van Gogh's work on the canvas was an essential component in his concept of artistic work: it acquired programmatic status (an important point to which we shall be returning).

Graphic work has one final function in van Gogh's oeuvre, one that we can infer by comparing two drawings of the row of cottages in Saintes-Maries. (We have already discussed the painted version, p. 361.) The earlier drawing, done at the beginning of June (p. 359), was the sketch for the painting. In the later, done in mid-July (p. 360), the process is reversed, van Gogh taking his own canvas as the model for a construct of lines and dots. This drawing was intended for Emile Bernard, as were a whole series of works that Vincent had based on his own paintings. Van Gogh was planning a portfolio of drawings to keep his Paris friends abreast of his latest work. Accordingly, he rather exaggerated his progress. The earlier sketch had conventionally established a framework of motifs that could be painted in. But in the later, the line has become quite gloriously autonomous. The vegetation at right, in particular, offers a wealth of draughtsmanly sophistication, with its interplay of curves, dots, and hatchings and its multiple centres. Compared with this calligraphic exuberance, the shrubs in the earlier drawing look like a dreary descriptive account and no more. Another new feature is the tightly-packed dots in the drawing intended for Bernard – a genuinely Japanese technique which van Gogh had adopted in the south. Indeed, the dot became the chief characteristic of his Arles drawings. Used for the first time in *Fishing Boats on the Beach at Saintes-Maries* (p. 354), it afforded one possible way of translating a colourful into a colourless

The Bridge at Trinquetaille
Arles, June 1888
Oil on canvas, 65 x 81 cm
F 426, JH 1468
Private collection
(Sotheby's Auction, New York, 22.10.1980)

The «Roubine du Roi» Canal with Washerwomen
Arles, June 1888
Oil on canvas, 74 x 60 cm
F 427, JH 1490
New York, Private collection

scene, a painted surface into a pen-and-ink version. And van Gogh was especially interested in alternatives at this time.

His drawings, too, were guided by the overriding principle of invoking the better world – Japan. The obsessed van Gogh used Japanese techniques and also, in doing so, tried to follow what he believed to be the oriental way of working: "A Japanese draws rapidly, extremely rapidly, like lightning, because his nerves are finer and his feelings simpler." (Letter 500) This obsession can be seen above all in his attempt to make the drawing medium a corrective of painting. The two media were to lend mutal support in the preservation of utopian appearances. At this point van Gogh still took specific characteristics of oils and watercolours, canvas and paper for granted; what he was after was not so much the merging of the media as ways of using them as alternatives. It was only in his late work, done after his breakdown, that he turned his back on the option of alternatives – because by then van Gogh no longer had any options, any alternatives. He combined painting and drawing in the quest for an art of pure energy.

Enchantment and Affliction
The Night Paintings of September 1888

Unlike in Paris, van Gogh hardly ever sought company in Arles. For purposes of painting he preferred the open country to the lanes and back streets of the old town. At best he would stroll around the park by the Place Lamartine where he had taken rooms. Only once did he overcome his shyness and set up his easel right in the centre of town, in the Place du Forum, not far from the famous amphitheatre and Saint-Trophime. There he painted *The Café Terrace on the Place du Forum, Arles, at Night* (p. 425). The motif he was after could only be seen there: the gaslight that shone in the darkness from the outside wall of the café out over the square.

The meeting of familiar yellows and blues in this painting has a vitality it has never previously achieved. Their place is determined not so much by the principle of contrast as by the simple fact that the two colours embody light values. The loud yellow and subdued blue represent areas of arresting brightness and delicate semi-darkness exactly as van Gogh must have seen them. Passers-by link the two zones. These figures are left in complete anonymity; the lighting conditions alone make identification impossible. The glaring area around the gas lamps casts dazzling light in their faces while the unlit area down the side streets insists on shadow. And indeed, van Gogh is less concerned with the colours of things than with the way they are lit. There is only one source of light: the lamps. In the 1880s, gas had spread as far as the provinces. Gaslight had forfeited atmosphere. It lacked that romantic, shimmering gleam that made the stars in the sky and candles in windows seem somehow touched with mystery. Gaslight was artifical and representative of the glaring directness of the new. Van Gogh proves well aware of this, painting old and new meeting on the centre axis of the work. There is a kind of desolation in the way the uniform glare of the canopied area contests the glittering points of light in the darkness.

In this painting of the café terrace on the Place du Forum at night, van Gogh was illustrating two thoughts that were much discussed at the time. There were contentious debates about the monument which was intended as the crowning glory of the Paris World Fair of 1889 and which

Thistles
Arles, August 1888
Oil on canvas, 59 x 49 cm
F 447, JH 1550
Collection Stavros S. Niarchos

Flowering Garden
Arles, July 1888
Oil on canvas, 92 x 73 cm
F 430, JH 1510
New York, The Metropolitan Museum
of Art (on loan)

Garden with Flowers
Arles, July 1888
Pen and ink, 49 x 61 cm
F 1455, JH 1512
Winterthur, Collection Oskar Reinhart

was meant as part of the celebrations of the French Revolution centenary at the same time. Two alternatives had been proposed. Both were towers, intended as symbols of utopian optimism, of the spirit of progress that had inspired the 19th century. The Sun Tower (designed by Jules Bourdais) would "turn night into day", according to the publicity. The idea was that it would illuminate the metropolis from the Pont Neuf, right in the heart of Paris; its brightness would be veritably sunlike. The light it cast would be relayed by mirrors to the remotest suburbs of the city. No louder paean of praise could be sung to the industrial god than Bourdais's pompous project – though in fact the alternative, which finally won the day, was scarcely its inferior in terms of hubris.

The other project reached for the stars. And that was the tower that was built – to Gustave Eiffel's plans – and which remains the symbol of Paris to this day. Nowadays the orginal symbolism has been forgotten. It was meant to represent optimism about the future of a society that was

Flowering Garden with Path
Arles, July 1888
Oil on canvas, 72 x 91 cm
F 429, JH 1513
The Hague, Haags Gemeente-
museum (on loan)

indulging in dreams of space travel. The novels (early science fiction) that Jules Verne was writing at that time were aiming at the same goal. The universe (declared the Eiffel Tower) was the limit. The highest platform featured an observatory – in a manner of speaking, a launching pad for ideas that were already far up amongst the stars. The feeling of the age was that it was all only a question of time; and they made a start building a tower three hundred metres high. The rest would follow in time.

Van Gogh's night paintings can be interpreted as comments on the unreality of these projects. In his art he viewed the technological hubris of the age with the understated sadness of the Romantic, countering the claims of Progress with the claims of the Imagination. The unreal element in his paintings exposed the unreality of these projects. And in passing he created a new artistic genre: the *plein air* nighttime scene.

The theme of artifical lighting was quickly dealt with in his famous masterpiece *The Night Café in the Place Lamartine in Arles*

(pp. 428–29). He tackled the question in Letter 533. "To the great delight of the café proprietor, the postmaster and those who love the night, and to my own, I have stayed up for three nights and slept during the day. It sometimes seems to me that the night is much livelier, and its colours intenser, than the day. True, I shall hardly manage to earn the money I paid the proprietor with my picture, for it is one of the most jarring that I have done. It ranks with the *Potato Eaters*. I have attempted to express terrible human passions in reds and greens. The room is blood-red and a muted yellow, with a green billiard table in the middle, and four lemon-yellow lamps casting orange and green light. Everywhere there are conflicts and antitheses: in the extremely varied greens and reds, in the small figures of the night folk, in the empty, dismal room, in the violet and blue."

The clarity with which van Gogh interprets his own picture sits ill with his love of paradox. He declares the work deals with "terrible human passions" and in the next letter (534) calls the bar "a place where

Sunny Lawn in a Public Park
Arles, July 1888
Oil on canvas, 60.5 x 73.5 cm
F 428, JH 1499
Zurich , Private collection

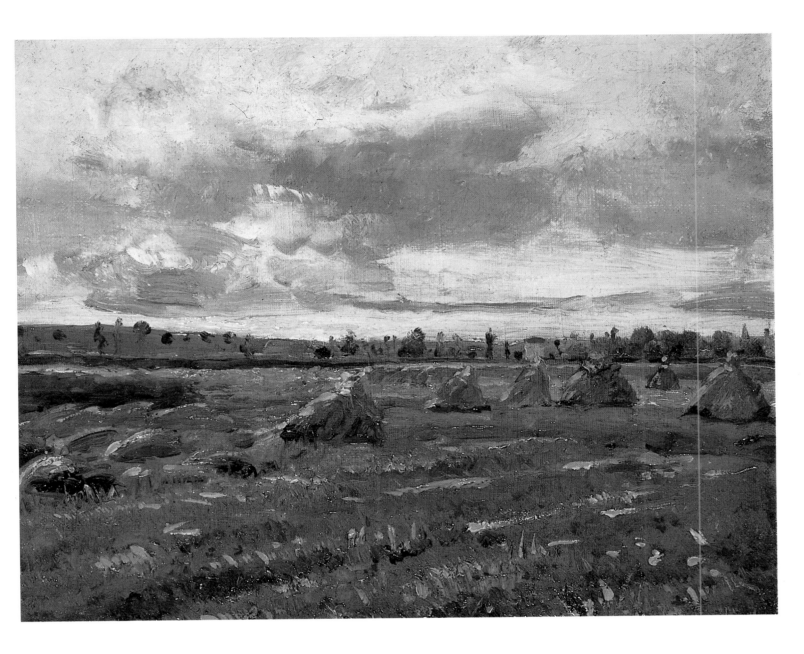

Wheat Fields with Stacks
Arles, June 1888
Oil on canvas, 28.5 x 37 cm
No F Number, JH 1478
Private collection
(Koller Auction, Zurich, 18.5.1987)

one could ruin oneself, where one could go mad and commit crimes." And indeed, the figures huddled at the tables have a lost air, and empty glasses bear witness to the excesses of alcoholism. But by the rear wall sits a couple locked in an embrace; in fact, the background affords a fair amount of comfort, with a bunch of whitish flowers and a curtained doorway opening onto a bright, cheerful room. Still, van Gogh insists on seeing the composition in negative terms. It is the lamps alone that highlight the dismal, wretched hopelessness of the atmosphere. Their glaring brightness mercilessly exposes what subdued candlelight would allow to remain hidden. The steady, impersonal light renders everything pitilessly and coldly anonymous. This, in a word, is van Gogh's commentary on the eulogies that were then being sung to artificial light: even if it meant producing unsubtle, assertive art, he wanted to show that a world that paid homage to the new lighting had lost touch with all humanity.

Typically, van Gogh could not let this pessimism stand unmitigated

The Painter on His Way to Work
Arles, July 1888
Oil on canvas, 48 x 44 cm
F 448, JH 1491
Destroyed by fire in the Second World War;
formerly in the Kaiser-Friedrich-Museum,
Magdeburg (East Germany)

The Road to Tarascon
Arles, July 1888
Pencil, pen, reed pen
and ink, 25.8 x 35 cm
F1502, JH 1492
Zurich, Kunsthaus Zürich,
Graphic collection

by redeeming optimism. The painting that followed the nighttime café scene was a sincere, emotional and diametrically opposed statement. Words of Immanuel Kant express it well: "There are two things that fill my spirit with ever new and increasing admiration and awe, the more frequently and constantly I devote my thoughts to them: the starry sky above me and the moral law within me." Thus van Gogh painted *Starry Night over the Rhône* (p. 431), a little-known but far more consistently conceived precursor of the more famous late masterpiece (cf. pp. 520–21). Here, everything lies spread beneath the sparkling tranquillity of the natural lights in the heavens. The glittering stars and wavy reflections in the water could scarcely cater better to Romantic tastes. In fact, this night scene was prompted by a genuinely moving experience of the endless darkness, an experience van Gogh describes in Letter 499: "Once I went for a walk along the deserted shore at night. It was not cheerful, it was not sad – it was beautiful." This is the only place in his letters where he is so far carried away as to invoke Beauty so emphatically – reason enough to view his enthusiasm as something more profound than a mere momentary indulgence in aesthetics. Van Gogh was drawing upon all his Romantic resources, contesting the positivist attempt to see the stars, scientifically and banally, as mere objects in the realm of the known. A deep abhorrence of this attempt can be seen in the way his religious impulses surfaced once more: "It does me good to do something difficult. But it in no way changes the fact that I have an

The Mill of Alphonse Daudet at Fontevieille
Arles, July 1888
Water colour and pen, 30 x 50 cm
F 1464, JH 1497
West Germany, Private collection

La Mousmé, Sitting
Arles, July 1888
Oil on canvas, 74 x 60 cm
F 431, JH 1519
Washington, National Gallery of Art

immense need for (should I use the word) religion; and then I go out at night into the open and paint the stars, and I always dream of such a picture with a group of lively friendly figures." (Letter 543)

Painting the stars out in the open – that was what van Gogh achieved in the night pictures. The innovation was no doubt the result of his need to devote himself to something. But it was also the product of the development of his own artistic methodology which he had developed through his debates with Bernard. Like Gauguin, his young friend was a devotee of "abstraction" – painting from memory – which countenanced neglecting the real appearance of things for the sake of visual effect. "Take a starry sky, for instance", van Gogh wrote to Bernard as early as April 1888 (Letter B3); "I would terribly like to try and do something of that kind ... But how am I to manage it if I do not decide to work at home, from imagination?" At that time he had not yet found any way of doing his night paintings on the spot. On the other hand, imitating his friends and bidding farewell to the real motif ran counter to the procedures he had become so attached to in his own work. In the summer of that year he devised a crude compromise of his own. He stuck lighted candles onto his straw hat and went about his work at the canvas in the dim light they afforded; the impression he must have made on passers-by can easily be imagined. Still: "I am tremendously gripped by the problem of painting night scenes or nighttime effects on the spot, actually at night." (Letter 537) And he threw himself into his new enthusiasm in true van Gogh fashion.

The night style peaked in his portrait of the Belgian poet and painter Eugène Boch (p. 420). All van Gogh's ideas about night painting met in this picture. "I always dream of such a picture with a group of lively friendly figures": it was not group, but at least it was one person for whom van Gogh could feel affection and onto whom he could project that sense of harmony that attracts cosmic metaphors. "I want to say something comforting in a picture, like music", he wrote (Letter 531). "I should like to paint men and women with that certain eternal quality that used to be symbolized by a halo and which we seek to invoke by means of brightness, by the tremulous vitality of our colours." And indeed his friend's skull is outlined by a gentle touch of gold. In a sense, this is what remains of the nimbus that was familiar throughout the history of art. With the starry sky as a framing background, the religious aura seems almost to be established of its own accord. Boch was a writer – a "poet", as van Gogh called him. Taking a man of letters, a creative artist, van Gogh had located a way of projecting his idea of the stars as a utopian counterworld of the imagination where the artist might find a home. The better world which his entire creative energy sought at that time was up in the stars. But we must pause a moment in order to explain this.

The Boch portrait has a companion piece, the self-portrait dedicated

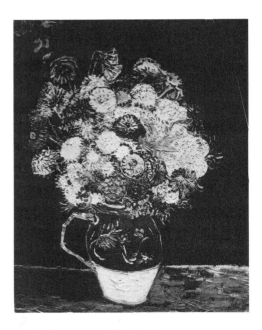

Still Life: Vase with Zinnias
Arles, August 1888
Oil on canvas, 64 x 49.5 cm
F 592, JH 1568. Lausanne, Collection
Basil P. and Elise Goulandris

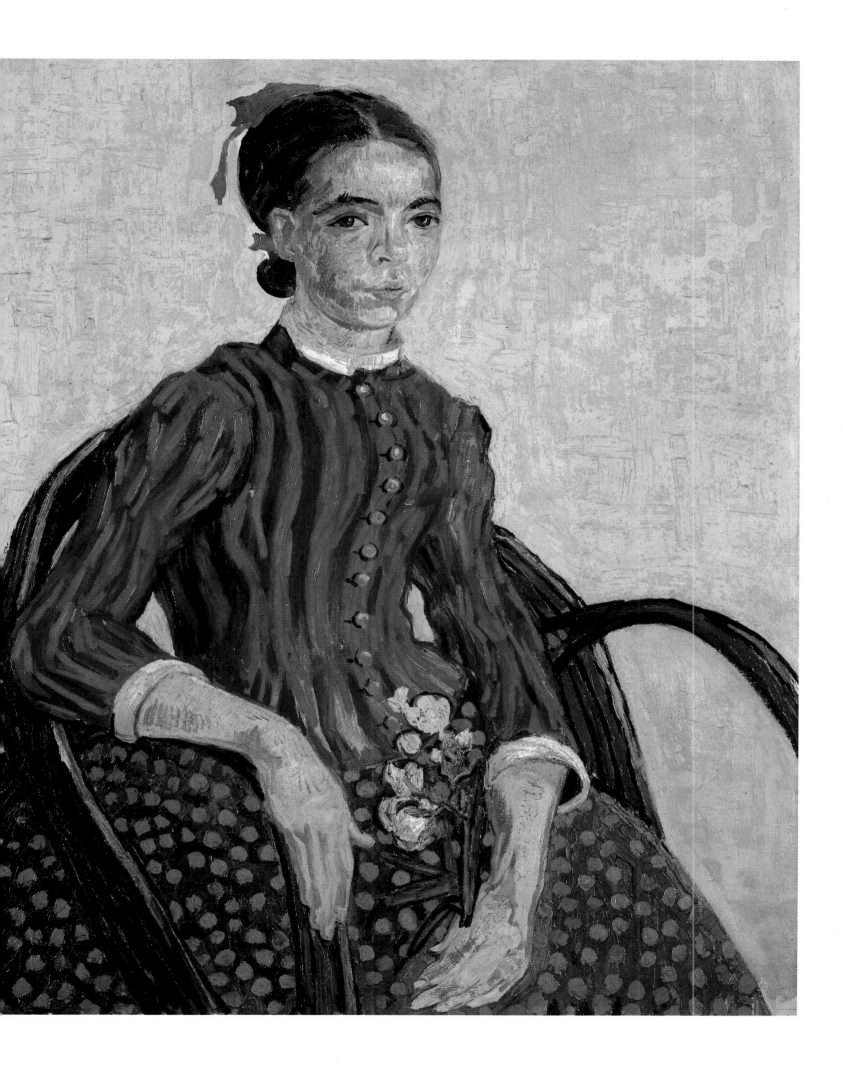

Railway Carriages
Arles, August 1888
Oil on canvas, 45 x 50 cm
F 446, JH 1553
Whereabouts unknown

Portrait of the Postman Joseph Roulin
Arles, August 1888
Pen and ink, 31.8 x 24.3 cm
F 1458, JH 1536
Malibu (Cal.), J. Paul Getty Museum

to Gauguin – like the two Paris paintings linking van Gogh with his friend Alexander Reid (cf. pp. 221 and 228) and like the two paintings of chairs he was to do later that year. The distinctly bony head, with its hair and beard fitting the skull shape perfectly and the contrast of red and green echoing that of yellow and blue, shows that van Gogh was trying (while preserving distinctions) to establish similarities in the two portraits. The painting of himself lacks the remote sublimity of a twinkling night sky; but the self-portrait anticipates, intuits and includes it. What the two have in common is the notion of a utopia available to the artist.

"It is not without its attractions to imagine that the glorious schools of the Greeks, the old Dutch, and the Japanese masters still exist somewhere amongst the stars", he meditated in Letter 511. "Where are Newton, Copernicus, Galileo, Jesus, Buddha, Confucius and Socrates?" demanded the astronomer Camille Flammarion at the same time, and, like van Gogh, he concluded: "Their stars still shine, they still exist, in other spheres; they are continuing the work that was interrupted on earth in other worlds." And here van Gogh, without knowing it, picks up the argument when he describes the intention behind his self-portrait: "I view this portrait as that of a Buddhist priest, a simple worshipper of the eternal Buddha." (Letter 545) Van Gogh was out to appear as oriental as possible: the better world on the other side of the earth and that amongst the stars were overlaid and became indistinguishable.

Any doubts about this interpretation can be allayed by a passage in one letter which, with its dark humour and the almost despairing nonchalance of tone, must surely be the most expressive he ever penned: "Death may possibly not be the hardest thing in the life of a painter. I must declare that I know nothing about them, but when I look at the stars I always start dreaming, as readily as when the black points that indicate towns and villages on a map always start me dreaming. Why, I wonder, should the shining points of the heavens be less accessible to us than the black dots on a map of France? Just as we take a train in order to travel to Tarascon or Rouen, we use death in order to reach a star. In one respect this thought is undoubtedly true: we can no more travel to a star while we are alive than we can take a train once we are dead. At all events, it does not strike me as impossible that cholera, kidney stones, cancer and consumption should be means of celestial transport just as steamers and railways are earthly ones. To die peacefully of old age would be the equivalent of going on foot." This passage from Letter 506 is crucial to an understanding of the suicide that ended van Gogh's life but for the moment we can take it as defining two areas: a remote one (longed for and unattainable) out in the universe; and one in this world, quite concretely located in Arles, involving all the routine drudgery of everyday life.

Analogies aside, though, the Boch portrait and the self-portrait can

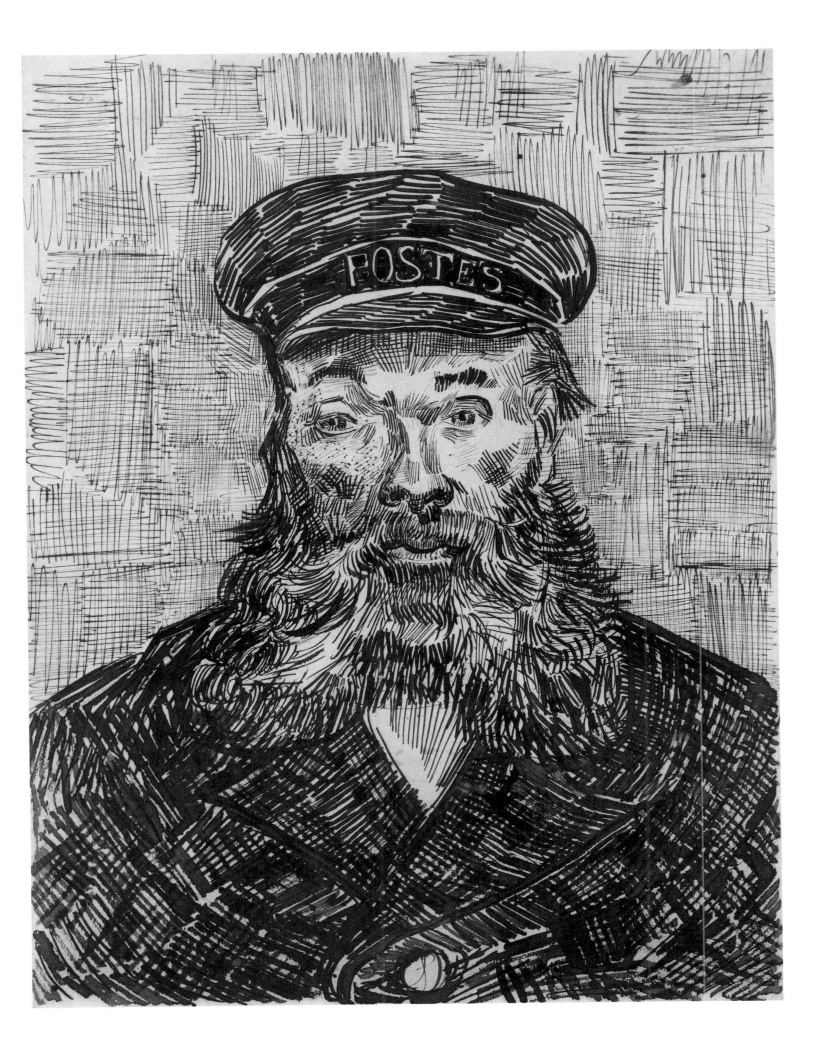

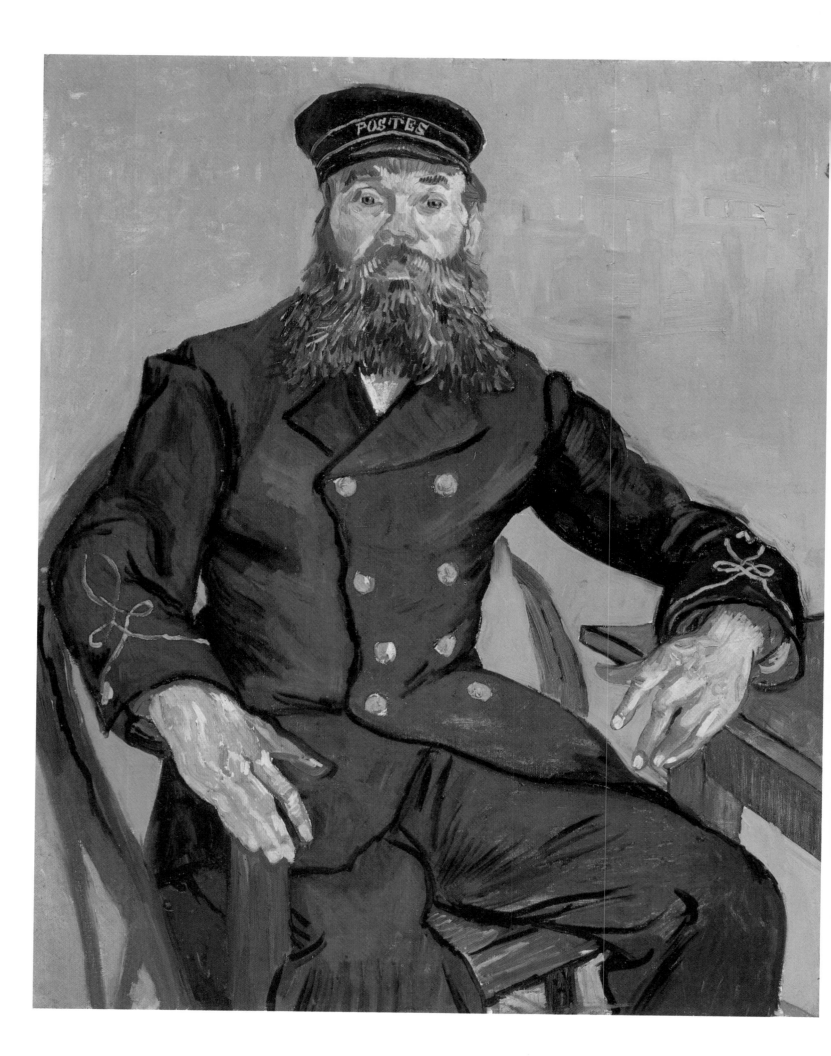

Portrait of the Postman Joseph Roulin
Arles, early August 1888
Oil on canvas, 64 x 48 cm
F 433, JH 1524
Detroit, Collection Walter B. Ford II

Portrait of the Postman Joseph Roulin
Arles, early August 1888
Oil on canvas, 81.2 x 65.3 cm
F 432, JH 1522
Boston, Museum of Fine Arts

each be assigned to a particular sphere. Van Gogh (not least through his use of almost exactly the same contrast of red and green as in the night café interior) sees himself as belonging in the same menacing world as that of *The Night Café in the Place Lamartine in Arles*. He is too aware of the visionary quality of his faces – appealing to the stars and reaching for a better life – to forget the precarious nature of his existence. And indeed, the two pictures work in the same way as the two chair still lifes: as a diptych invoking friendship and harmony. Seen in isolation from each other, they express the impossibility of being reconciled to Life: after all, they define the very polarity of day and night.

For one month – that month of September 1888 – van Gogh had a second message to communicate to the world and (above all) to himself. Japan alone was no longer the symbol of utopia; now Japan had been joined by the starry night sky. Once again a range of alternatives were being used to guarantee Art's ability to grasp a better world. In its way

Montmajour
Arles, July 1888
Pencil, pen, reed pen and ink, 49 x 60 cm
F 1447, JH 1503
Amsterdam, Rijksmuseum Vincent van
Gogh, Vincent van Gogh Foundation

the starry sky was more concrete and realistic than van Gogh's obsession with a sojourn in the Far East. Accordingly, the lights far out in the universe suggested their own antithesis closer to home: the gaslight that was there in the streets of Arles every night. There was nothing at all utopian in this. And so van Gogh's night paintings were inevitably destined to remain an episode in his oeuvre – though an episode of pioneering, innovative significance.

A Garden with Flowers
Arles, August 1888
Reed pen and ink, 61 x 49 cm
F 1456, JH 1537
Private collection

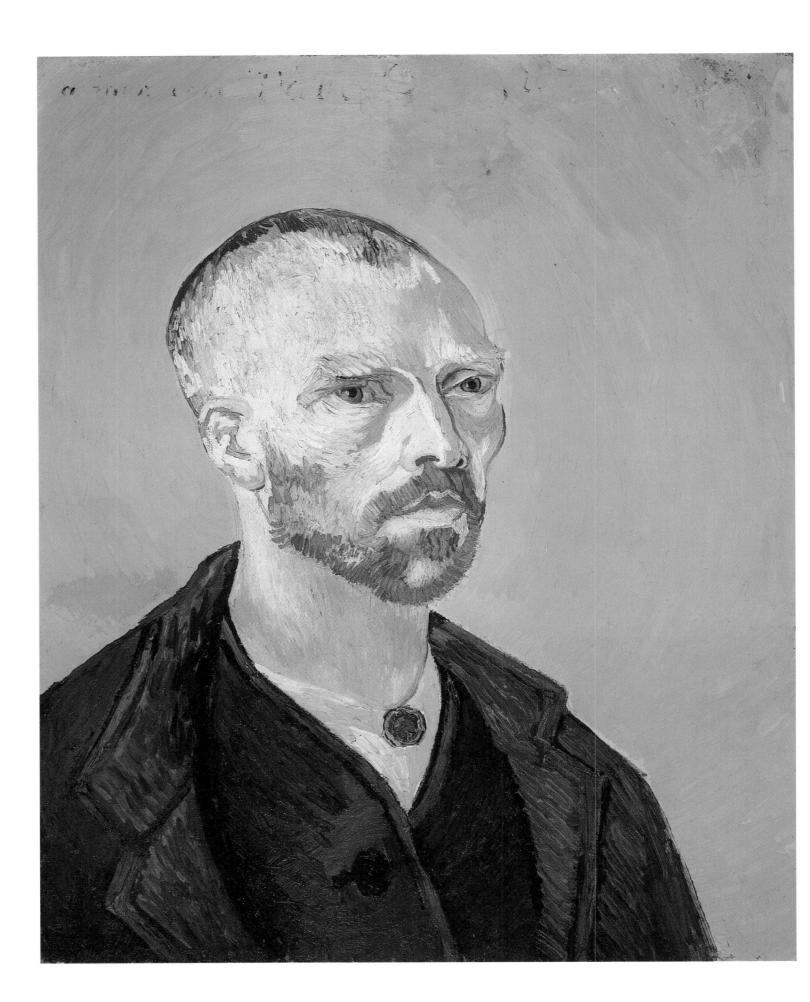

The Dream of an Artists' Community
September and October 1888

At the end of July there was another blow for van Gogh: Uncle Cent, the wealthy art dealer, died. He left a large amount of money in his will, but there were strings attached. Vincent, who was his godson and the heir designated by the family council, was explicitly to receive nothing; but, on the other hand, Theo, who had become what his elder brother had shown himself incapable of, was to receive all the more. But Theo put matters straight, and sent part of his bonus to Arles. This enabled Vincent to fulfil a long-cherished wish: the rooms that had hitherto served as his studio and as a storeroom for his paintings could now be renovated, refurbished, and finally lived in. As of mid-September, a proud Vincent van Gogh was lord and master of his "yellow house".

This also gave his utopia a specific location. All those plans that had so far come to nothing, notions of imaginary Japans and unattainable stars, could now be realised in concrete form in that little house. Van Gogh could now imagine his future in quite definite terms: "My idea", he wrote (in Letter 538), "would be that one might finally establish a studio and then bequeath it to posterity for a successor to live in. I do not know if I am expressing myself clearly enough, but in other words, we are engaged in work on art, on projects that are not for our own times alone but can be continued by others." The better world meant tireless devotion to art, constantly – a project that would serve the new beyond any single individual. Van Gogh maintained a persistent silence concerning the characteristics of this newness; but it can be defined as a process. The road travelled is itself the destination: in this, once again, van Gogh anticipated a central feature of Modernism.

The yellow house was itself programmatic – a manifesto in brick and mortar. Van Gogh immortalized it in a painting and a watercolour (pp. 422-23). It was an inconspicuous building on the corner of the Place Lamartine in the north of the town. It had a double frontage, with a small shop in the other half. An entry separated it from the much bigger building behind it. As if this view were too unimportant in itself to be recorded on canvas, van Gogh has added a train in the background. In the overall contrast of the various yellows of the houses with the vast blue of the sky there is of course no overdone modesty, though. For van Gogh,

Self-Portrait (Dedicated to Paul Gauguin)
Arles, September 1888
Oil on canvas, 62 x 52 cm
F 476, JH 1581
Cambridge (Mass.), Fogg Art Museum,
Harvard University

Self-Portrait with Pipe and Straw Hat
Arles, August 1888
Oil on canvas on cardboard, 42 x 30 cm
F 524, JH 1565
Amsterdam, Rijksmuseum Vincent van
Gogh, Vincent van Gogh Foundation

this contrast was synonymous with the south: "Everywhere the heavens are a marvellous blue, the sun is shining a pale sulphurous yellow, and it is as delightful and exciting as the juxtaposition of sky blue and yellow in the paintings of Vermeer van Delft. I cannot paint so beautifully, true; but I abandon myself to it so totally that I let myself go without paying attention to any rules." (Letter 539)

The architecture and colour of the yellow house are related in precisely the same way as motifs and colour are in van Gogh's paintings. Just as colour is overlaid onto real appearances in his other work, so in this painting subtle colouring is overlaid on the building. Simple and natural as van Gogh's world may be in itself, his use of colour gives it a special aura, a quality of mystery, the shimmering gleam of the utopian. The yellow house we see on the canvas is a painting turned architecture. The difference is quite baldly one of utility, and that is what makes it closer to that better life van Gogh pursued in his art. The yellow colour of the house operates programmatically: it is both housepaint and a message, a real coat on a real building and an aesthetic statement. In that monochrome treatment van Gogh was expressing his entire conception of his own role as an artist of the south.

Yellow is the colour of the sun: "The heat now is glorious and immense, without any wind, which I like. A sun, a light, which for want

Garden Behind a House
Arles, August 1888
Oil on canvas, 63.5 x 52.5 cm
F 578, JH 1538
Zurich, Kunsthaus Zürich (on loan)

Portrait of Patience Escalier
Arles, August 1888
Pencil, pen and ink, 49.5 x 38 cm
F 1460, JH 1549
Cambridge (Mass.), Fogg Art Museum,
Harvard University

Arles, View from the Wheat Field
Arles, August 1888
Pen and ink, 31.5 x 24 cm
F 1492, JH 1544
Switzerland, Private collection

of a better term I can only call yellow, a pale sulphurous yellow, a pale lemon yellow. Ah, that yellow is beautiful! And how much better I shall see the north now!" (Letter 522) Yellow was also the preferred colour of one of van Gogh's great exemplars: "Monticelli was a painter who painted the south all in yellow, orange and sulphur colours. Most painters do not see these colours because they are not really experts in colour." (Letter W8) He leaves us in no doubt about who he considers the real "experts in colour": "I do not know if anyone has spoken of suggestive colours before, but even if they did not talk about them, Delacroix and Monticelli certainly painted them." (Letter 539) And he had this to say about the greatest of them all: "Why did the greatest colourist of all, Eugène Delacroix, consider it imperative to go south, even as far as Africa? Plainly because there – and not just in Africa but from Arles onwards – those lovely contrasts of red and green, blue and orange, sulphur yellow and lilac occur naturally." (Letter 538) At this point van Gogh comes full circle. His urge to go south had the blessing of the highest authorities, Monticelli and Delacroix; and the works of these two artists reminded him of his own goal – "suggestive colour". Delacroix's province was contrast and Monticelli's the dominance of yellows; it was to Delacroix that van Gogh paid homage in presenting the overall view of his house, and to Monticelli in recording its colour.

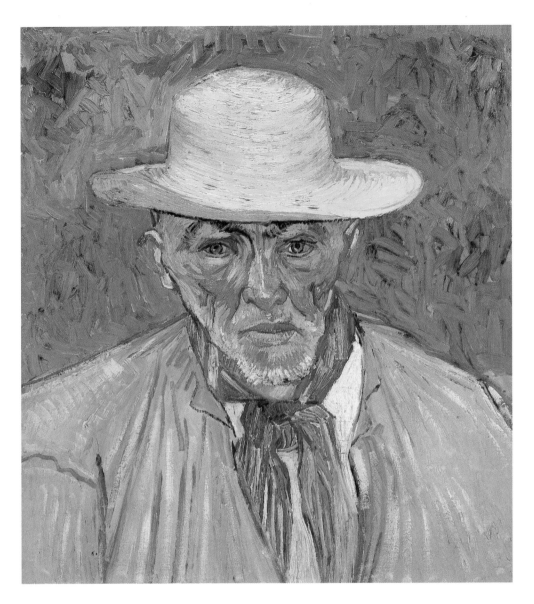

**Portrait of Patience Escalier,
Shepherd in Provence**
Arles, August 1888
Oil on canvas, 64 x 54 cm
F 443, JH 1548
Pasadena (Cal.), Norton Simon
Museum of Art

The southern sun guaranteed the artist's real colours. The south was awash with yellow.

That defined his position. Van Gogh could now set about fulfilling a dream that had always been in his mind as the goal of all his preparatory labours: he could create his *atelier du Midi,* with the yellow house at the very heart of a new artistic era. Everyone, sooner or later, would be going there – all his acquaintances and fellow artists from the Paris art world. There they would establish a community and support and encourage each other in their efforts to create a better art and, through it, a better world. The south, with its broad plains and its landscape still largely unspoilt, would provide the ambience: it was already radiant with the promise of utopia. They would all free themselves of the excess burden of civilization, and of their vanities and prejudices, and would serve the great task in a spirit of harmony and solidarity. Theo would handle the financial arrangements and present the fruits of their happy toil to an astounded public back in the capital. He would take it upon himself, as their agent and manager, to wallow in the mire of materialism which they themselves had quit in their quest for the new.

Portrait of Patience Escalier
Arles, August 1888
Oil on canvas, 69 x 56 cm
F 444, JH 1563
Collection Stavros S. Niarchos

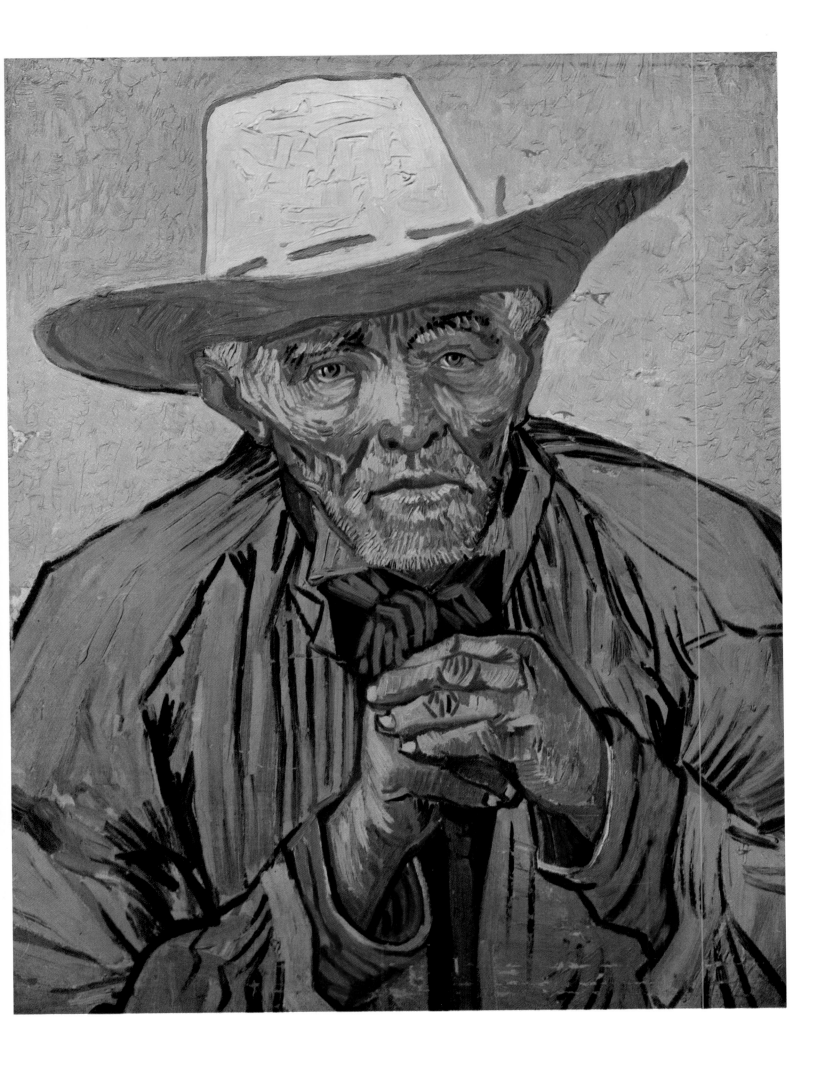

To indicate the pure-minded integrity of the venture, van Gogh availed himself of a metaphor taken from the life of devoted Christian seclusion: "People suppose painters to be either madmen or wealthy; a cup of milk costs a franc, a sandwich costs two, and pictures don't sell. That is why we must get together, as monks did in olden times, those brothers who lived together in the heathlands of Holland." (Letter 524) An artist took holy orders, as it were: "I don't want any better status for myself, but if we are talking of several artists living together we must definitely have an abbot to keep us in order, and that would of course be Gauguin." Thus van Gogh in Letter 544, firmly convinced that his plan would succeed: "And for that reason I would prefer Gauguin to come before any of the others."

At this time he already knew that Gauguin would shortly be coming to Arles; only he did not know the exact date of his arrival. Van Gogh was engaging in a kind of self-fulfilling prophecy; the more he brought his project into line with given facts, the easier it would be to prove the efficacy of the venture he had conceived. And so van Gogh put out his bait – though in point of fact he himself was attracted by it more than any fellow artist was. The metaphor of the monastic community was one of his baits; no one (he himself undoubtedly included) was proof against the myth of the artist as holy man. He took a traditional image and used it to enlist support for the future.

The idea that Art possessed religious force was essentially a Romantic idea. In one form or another it can be traced to Coleridge, Tieck or Wackenroder; the German writers had spoken of "the great blessed

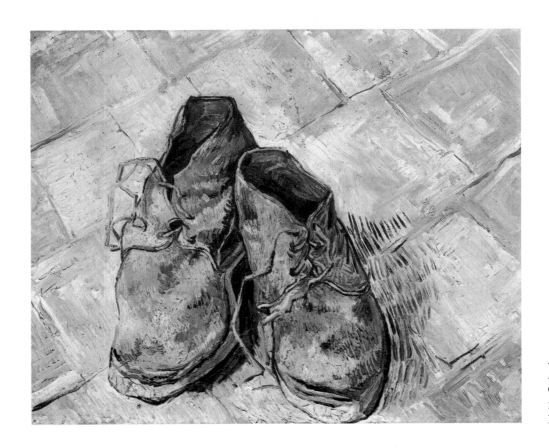

A Pair of Shoes
Arles, August 1888
Oil on canvas, 44 x 53 cm
F 461, JH 1569
New York, S. Kramarsky Trust Fund

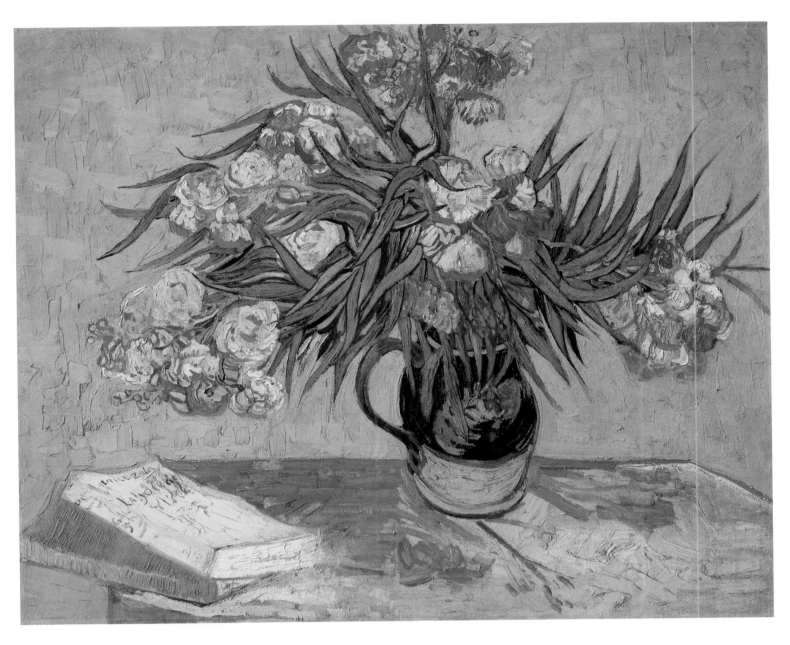

saints of Art" and of "Art's Holy of Holies". And none other than Johann Wolfgang von Goethe had felt compelled to take issue with this pseudo-religious intensity: "This monkish, star-struck nonsense was supposed to have something to do with Art, and aimed to establish piety as the sole foundation of Art. We were not very affected by this news; how, after all, could there be any validity to the conclusion that since some monks had been artists, all artists should therefore be monks?" But still, ideas of this kind were attractive enough to prompt many artists to found communities along religious lines. We think, for instance, of the Nazarenes or the Pre-Raphaelites.

Gauguin, of course, was a staunch atheist, and one who liked the things of this world. He was not to be tempted by the prospect of monastic rules and observances. And in any case the intensity of the early Romantics now lay almost a century in the past, and what had remained was a simplified image of the artist as a chosen one sent by God; though he no longer painted pictures of saints, he still insisted on

Still Life: Vase with Oleanders and Books
Arles, August 1888
Oil on canvas, 60.3 x 73.6 cm
F 593, JH 1566
New York, The Metropolitan Museum of Art

his life as a chosen one. Gauguin was a past master at this role. "The one and only way to God is to do what our Divine Master does: to create", he meditated in a letter dated August 1888. Gauguin had a predilection for crucifixion scenes, in which he portrayed his own position as an unacclaimed outsider. To the self-portrait he sent van Gogh, he appended this comment: "Here you have a picture of me and at the same time of us all, the poor victims of society, who repay everything with kindness." The image of the artist as a Christ figure, with the power to create and the ability to endure suffering, lay behind Gauguin's frequent crucified poses.

Van Gogh played along with this game, partly in a shrewd calculating spirit, but partly because he identified with his friend: "You must try to acquire a thick skin, the kind of constitution that promises a ripe old age", he wrote to Bernard, who was intimate with Gauguin. (Letter B8) "You must live like a monk who goes to a brothel every other week." His young friend had just sent him his sonnet 'La Prostitution'. Bernard's obsession with brothels had also found an outlet in a series of drawings which (some time before Toulouse-Lautrec) gave an altogether clear-sighted account of the life of whores. Van Gogh, acting on a rather curious conception of compatibility, was now trying to combine his own asceticism with Bernard's penchant for brothels – a novel syncretism, certainly, and one which might have recommended a life under southern skies to his fellow artist. In his letters to Theo, Vincent smoothed over the inconsistencies: "I would sooner lock myself away in a monastery like a monk, and be as free as a monk to go to a brothel or an inn, just as I please. But our work requires a home." (Letter 522)

Even without a Gauguin, van Gogh was of course a deeply religious man, an ascetic who could literally live on bread alone. Furthermore, van Gogh had needed no Bernard to help him discover brothels. But whenever he detected traits of his own in friends, he exaggerated them;

Interior of the Restaurant Carrel in Arles
Arles, August 1888
Oil on canvas, 54 x 64.5 cm
F 549, JH 1572
Providence (R.I.), Collection Murray S. Danforth, Jr.

Interior of a Restaurant in Arles
Arles, August 1888
Oil on canvas, 65.5 x 81 cm
F 549a, JH 1573
Zurich, Collection V. Margutti, and Neuchâtel, H. Vaucher

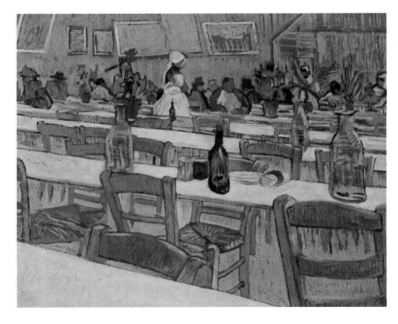

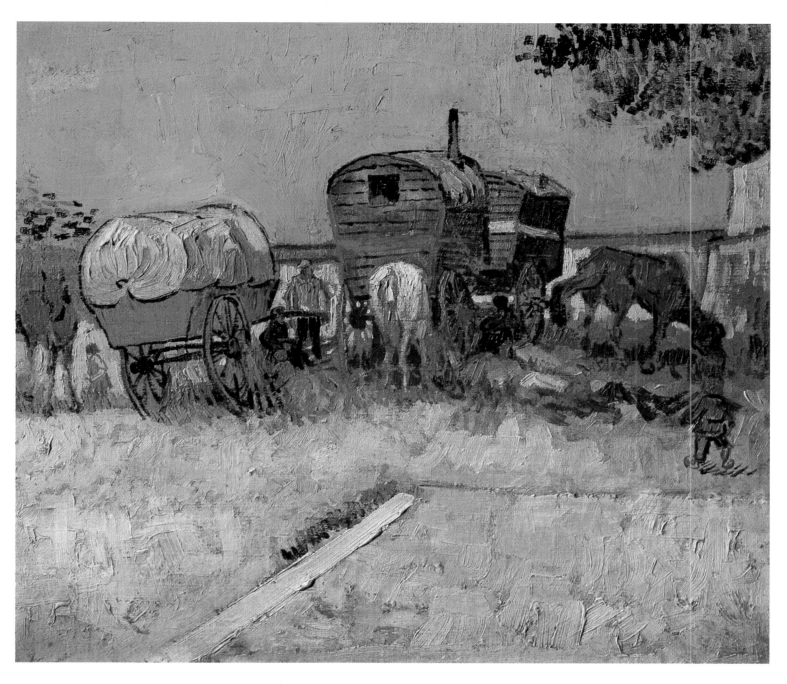

and then he threw himself heart and soul into the attempt to be what he felt was expected. He wanted to be the perfect personification of that artistic life which they were pursuing. For Gauguin it had always been a game, a whim, a part to be played the more eagerly, the more it conferred an aura of genius – but van Gogh entered into it with his customary emotional commitment. Gauguin toyed with his moods; but for van Gogh it was all in deadly earnest. We must bear this in mind if we are to understand the breakdown that shortly followed. As yet, however, he was still merely trying to cut a favourable figure, and to find the common ground between his painting and his sense of identity in a way that would prompt discussion amongst his friends and indeed the artistic community at large.

"It is my ambition", he insisted to Theo in Letter 544, "to make a certain impression on Gauguin with my works, I can't help it. I want to

Encampment of Gypsies with Caravans
Arles, August 1888
Oil on canvas, 45 x 51 cm
F 445, JH 1554
Paris, Musée d'Orsay

Still Life: Vase with Twelve Sunflowers
Arles, August 1888
Oil on canvas, 91 x 72 cm
F 456, JH 1561
Munich, Bayerische Staatsgemälde-
sammlungen, Neue Pinakothek

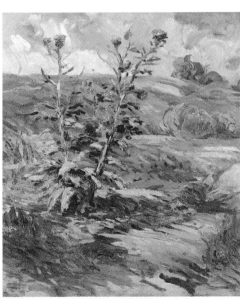

Two Thistles
Arles, August 1888
Oil on canvas, 55 x 45 cm
F 447a, JH 1551
Whereabouts unknown
(Sotheby's Auction, London, 31.3.1987)

complete as much as I can before he comes here. His coming will influence my way of painting, I believe to the good, but I am nonetheless rather attached to the way I have decorated my house, which is almost like a piece of painted pottery." For the first time in a long while, since the work of his months in Nuenen (cf. pp. 46-49), van Gogh was able to ascribe a specific function to his pictures: he was painting in order to show what he could do. The paintings were to make an impression on Gauguin, to elicit reactions from him and (in the resulting discussions) to point up his own artistic capabilities. Two series were meant to initiate debate: the *Poet's Garden* pictures, and (most famous of all) the sunflowers. These pictures reminded van Gogh of "painted pottery". One explanation of the ambitious way in which they display his fondness for colourful surfaces and strikingly placed accessories is that they were decorative, meant for the walls of the yellow house and in particular for the room that was meant to be Gauguin's.

The poet's garden was across from van Gogh's house on the Place Lamartine, a municipal park complete with people out for a stroll and picturesquely clipped bushes and hedges. Basically it was nothing special. The artist had often used motifs from the park when he felt like acting the part of the *plein air* painter. But his tireless imagination, stimulated by Gauguin's imminent arrival, gradually stylized it into a place of poetry: "Isn't it true, is there not something curious about this garden, cannot one imagine the Renaissance poets Dante, Petrarch and Boccaccio walking amongst the bushes on the flower-strewn lawn?" (Letter 541) After all, he wanted to offer his friend something: a kind of *genius loci* had to be revealed, a southern magic that Gauguin would not be able to resist – not Gauguin, the poet in person. "You are absolutely right to think of Gauguin", he wrote to Bernard (Letter B5); "that is sublime poetry [. . .] everything he creates has a gentle, painful, astounding quality. He is not yet understood, and he suffers terribly from being unable to sell anything, like any other poet." The pictures painted in his park, the "poet's garden", would spur his inspiration. His stay would be all the more stimulating.

Van Gogh conferred the title *The Poet's Garden* on four paintings (pp. 416 and 432–33), if we include one that is now missing and can only be imagined from a surviving sketch (p. 416). They were intended to adorn Gauguin's room, to keep his eyes (even in the small world of a framed canvas) firmly on the lyrical pleasures the south had to offer. Indeed, the four views possess a poetical charm that is rare in van Gogh's works. They seem particularly even, particularly inviting. They offer us a distinctive sense of harmony. The thrusting forcefulness of Nature is only of secondary interest; now, the mood of Nature matches the peaceableness of the people out strolling. These people are couples – that is to say, the subject is an open invitation to lyrical tones. The garden itself is accessible, domestic, bespeaking the human touch in its

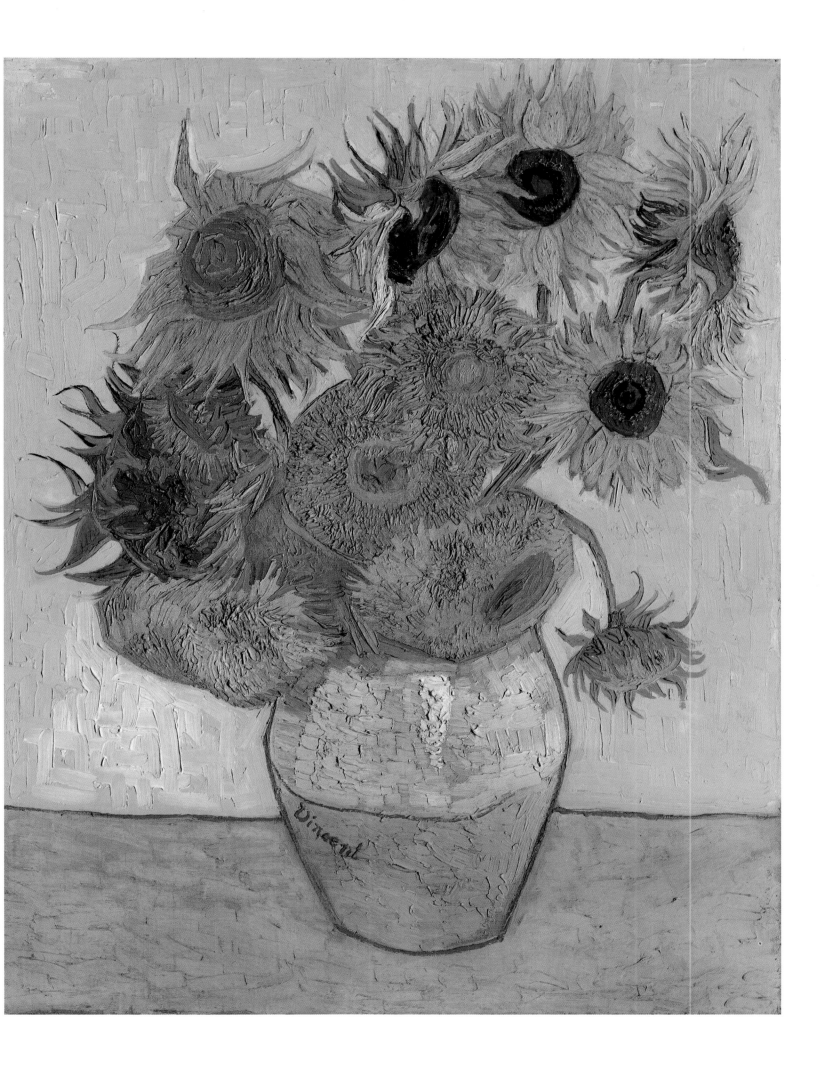

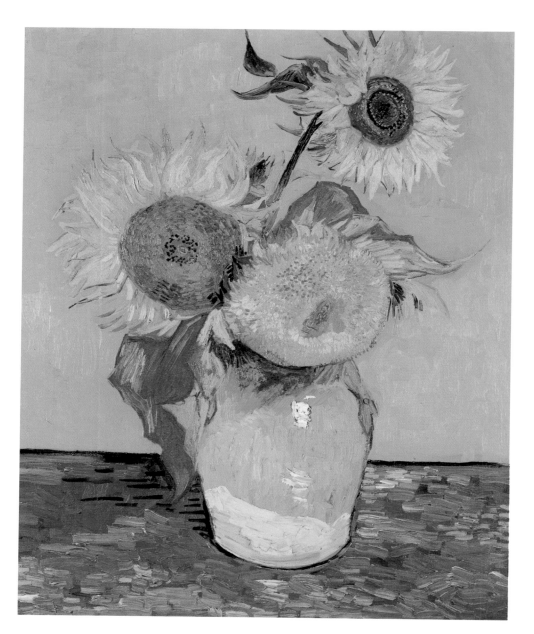

Three Sunflowers in a Vase
Arles, August 1888
Oil on canvas, 73 x 58 cm
F 453, JH 1559
United States of America,
Private collection

Still Life: Vase with Oleanders
Arles, August 1888
Oil on canvas, 56 x 36 cm
F 594, JH 1567
Whereabouts unknown; possibly
stolen in 1944

trained shrubs, friendly paths, and lack of hostile and impenetrable undergrowth. Man and Nature are in harmony, as if they always had been and always would be. When ever did van Gogh indulge in such feelings of harmony with existence? The evocatively timeless realms of Gauguin's art doubtless prompted this serenity. It is a mood that we may perhaps explain by van Gogh's attempt to establish a common ground between his own art and Gauguin's. Gauguin was not yet there; but we are made powerfully aware of his presence in van Gogh's heart and mind, on his canvas and on his palette.

This series of compliments he paid his fellow artist was matched by a second series of paintings focussed more on himself. At first, van Gogh produced four versions of the sunflowers, too (pp. 409–11); three more followed in 1889. He was to remember these paintings with a pang of longing after his breakdown (Letter 573): "You know Gauguin was especially taken with them. One of the things he said about them was:

Still Life: Vase with Fourteen Sunflowers
Arles, August 1888
Oil on canvas, 93 x 73 cm
F 454, JH 1562
London, National Gallery

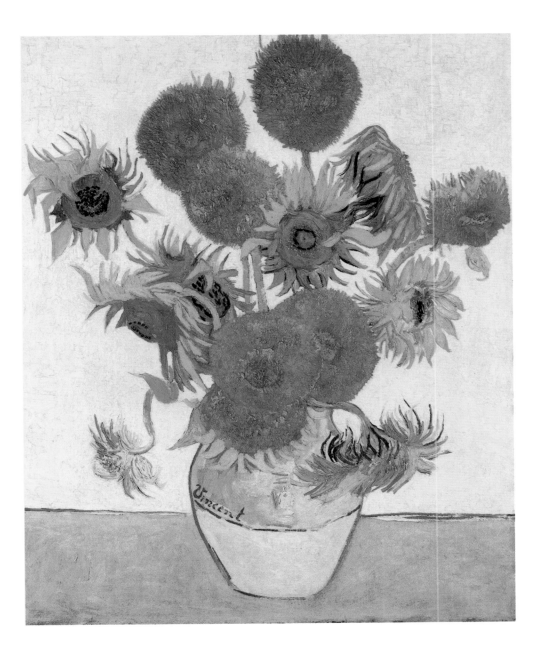

Still Life: Vase with Five Sunflowers
Arles, August 1888
Oil on canvas, 98 x 69 cm
F 459, JH 1560
Destroyed by fire in the Second World War

'That... that is... the flower.' As you know, peonies are Jeannin's, hollyhocks are Quost's, and sunflowers, well, sunflowers are mine." Everything that was dear to Vincent the artist could be symbolized in that one subject. And it was there that affinities and distinctions became palpable when Gauguin compared himself with van Gogh. He was very well aware of what van Gogh showed him: the only picture he managed to paint during his stay in the yellow house was *Vincent Painting Sunflowers* (now in the Rijksmuseum Vincent van Gogh in Amsterdam). He, too, identified his friend with the flower. And van Gogh did his utmost to encourage the identification.

The individual symbolism of the sunflowers, the burden of meaning that van Gogh (as usual) loaded upon his subject (and to which we shall return in the next chapter), was of secondary importance here. Rather, they enabled him to display his working methods, how he approached his subjects, and what his particular concerns were in painting. "I

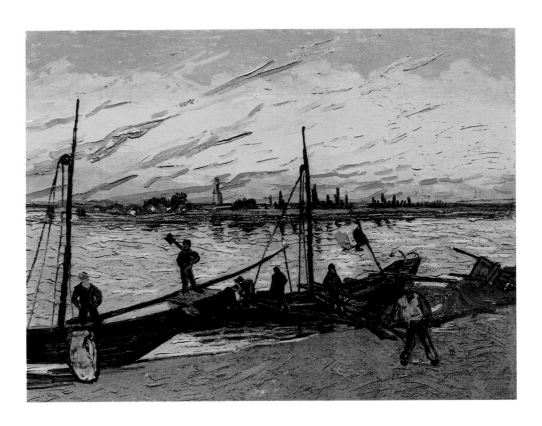

Coal Barges
Arles, August 1888
Oil on canvas, 71 x 95 cm
F 437, JH 1570
Annapolis (Md.), Collection Carleton
Mitchell

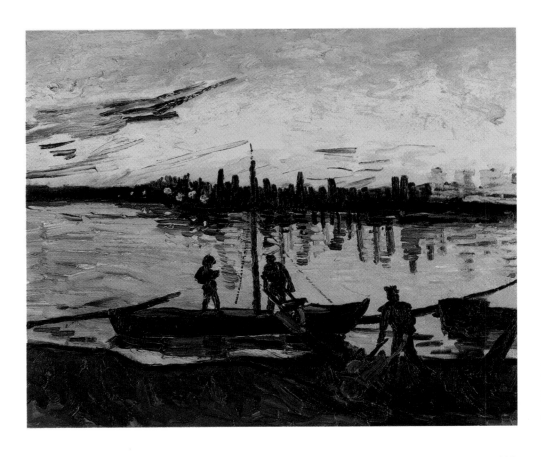

Coal Barges
Arles, August 1888
Oil on canvas, 53.5 x 64 cm
F 438, JH 1571
Lugano-Castagnola, Fondazione
Thyssen-Bornemisza

propose to paint a series of pictures for the studio in the hope of living there together with Gauguin. Nothing but a lot of big sunflowers... If I carry out my plan there will be a dozen pictures. The whole thing a symphony in blue and yellow. I start working every day at dawn because the flowers wilt very quickly, and it has to be painted in one go." This passage in Letter 526 highlights his intentions. Van Gogh set himself a target, and hoped to achieve it at the greatest possible speed. The sunflowers he positioned in a vase early in the morning naturally called for urgency since they would wilt within hours. This provided van Gogh with the justification (as it were) for a procedure which in fact he was only too glad to consider an end in itself; he was now being rewarded for his long-standing devotion to speed. A painter unaccustomed to rapid work would never manage to seize the beauty that was wasting away minute by minute. It was the yellow of the sunflowers that was so magical, that colour of the south to which van Gogh had already paid

Quay with Men Unloading Sand Barges
Arles, August 1888
Oil on canvas, 55.1 x 66.2 cm
F 449, JH 1558
Essen, Museum Folkwang

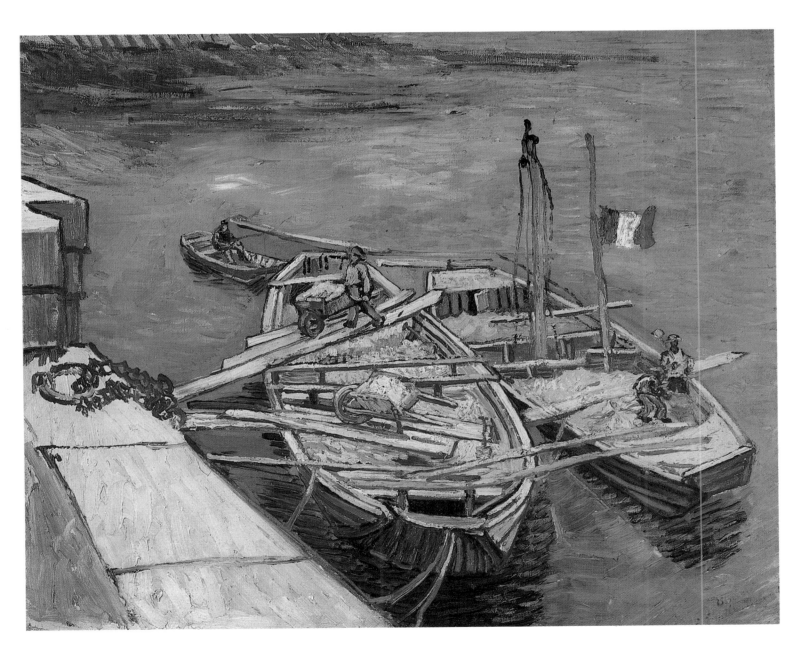

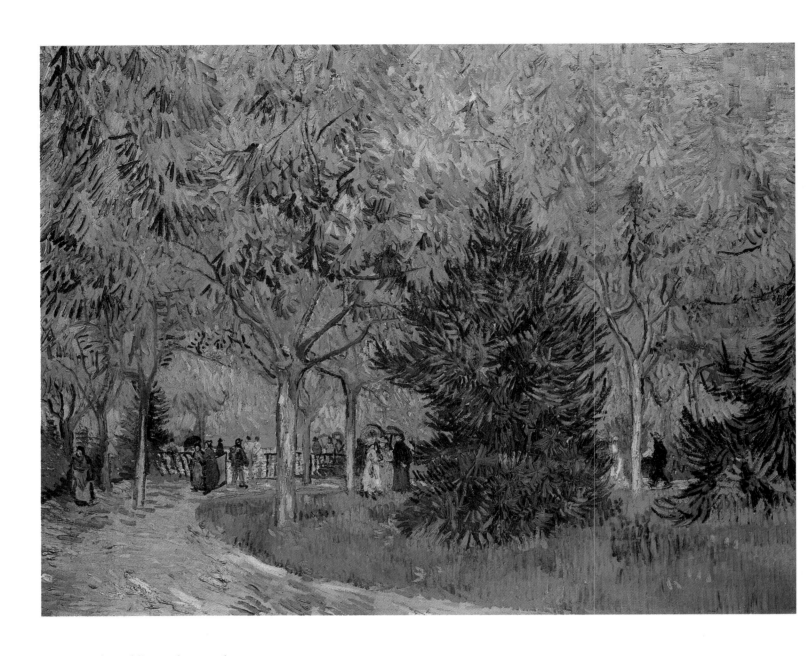

A Lane in the Public Garden at Arles
Arles, September 1888
Oil on canvas, 73 x 92 cm
F 470, JH 1582
Otterlo, Rijksmuseum Kröller-Müller

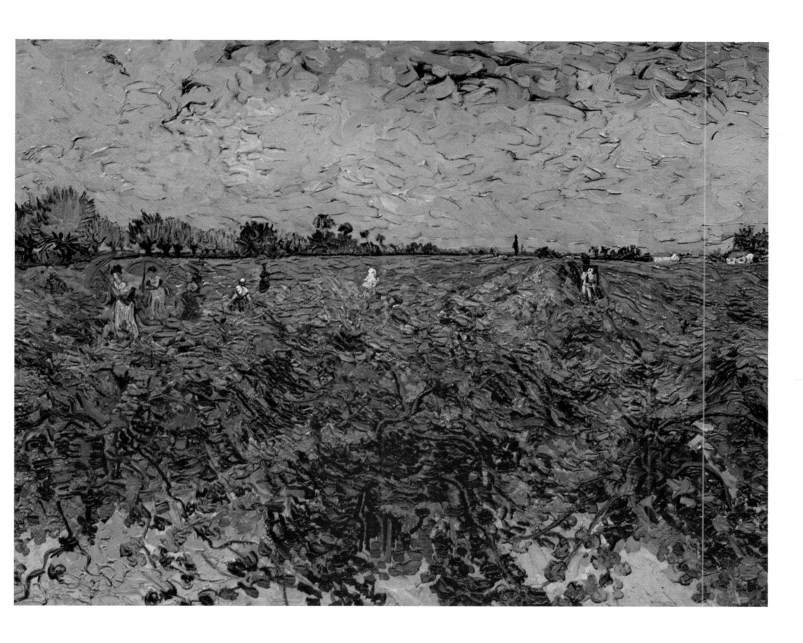

The Green Vineyard
Arles, September 1888
Oil on canvas, 72 x 92 cm
F 475, JH 1595
Otterlo, Rijksmuseum Kröller-Müller

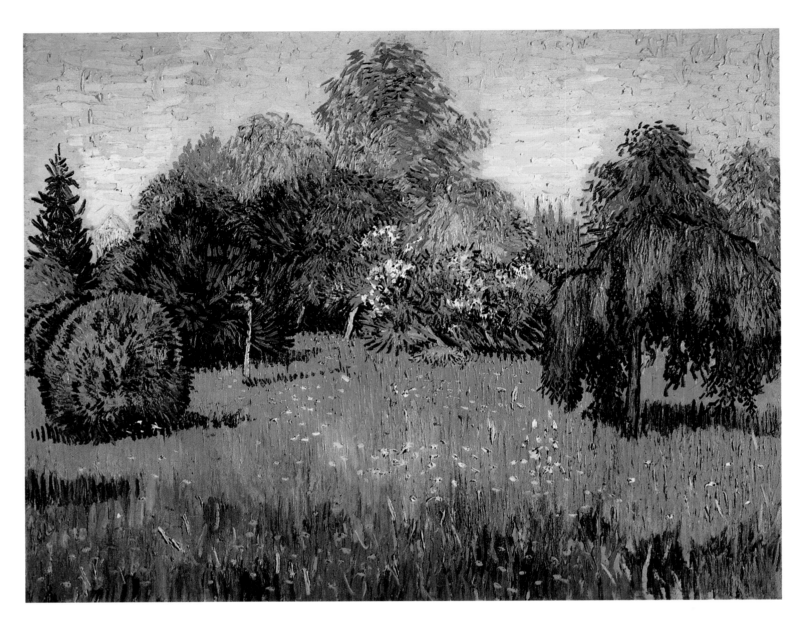

**Public Park with Weeping Willow:
The Poet's Garden I**
Arles, September 1888
Oil on canvas, 73 x 92 cm
F 468, JH 1578
Chicago, The Art Institute of Chicago

**Bush in the Park at Arles: The Poet's
Garden II**
Arles, September 1888
Pen and ink, 13,5 x 17 cm
F 1465, JH 1583
Private collection

Entrance to the Public Park in Arles
Arles, September 1888
Oil on canvas, 72.5 x 91 cm
F 566, JH 1585
Washington, The Phillips Collection

homage in painting his house yellow. Placed in front of a dark background, the colour prompted associations of the typical contrast of the south, that contrast of blue and yellow which he had used in the painting of his house. The sunflowers and the yellow house were related by virtue of their contrastive role; the flowers were the natural motif, the building their man-made counterpart.

"I am going to cover the white walls of the room that you will sleep in, or Gauguin, when he comes, with nothing but paintings of large yellow sunflowers", Vincent promised Theo in Letter 534. "And then you will see these large pictures of bunches of twelve or fourteen sunflowers, filling the tiny room along with a pretty bed, everything else all very elegant." As he goes on he makes a vitally important statement: "There is no hurry at all, but I do have my own definite ideas. I want to make it into a real artist's house, nothing contrived, quite the opposite, nothing should be at all contrived, but everything – from the chairs to the pictures – should have character." The sunflower series and the poet's garden series are both parts of an overall decorative concept. In the

417 PAINTINGS: ARLES 1888

Ploughed Field
Arles, September 1888
Oil on canvas, 72.5 x 92.5 cm
F 574, JH 1586
Amsterdam, Rijksmuseum Vincent van
Gogh, Vincent van Gogh Foundation

artist's house, everything is a work of art, including kitchen utensils, furniture, the decorations on the walls, the very architecture. Van Gogh had not forgotten his Japan yet, not his programme to weld Life and Art together into an indissoluble unity. Only in this way would his *atelier du Midi* be adequate to its utopian purposes. Only in this way could he tempt fellow artists to join him, to work together. Van Gogh created his artist's villa with the extremely modest means at his disposal; by way of analogy we might cite the ingenious theatre of the self-conceived by Hans Makart in Vienna or Franz von Lenbach in Munich in their time. Van Gogh's villa existed more in his imagination than in reality. His modest little house would only have elicited a weary smile from an Art Prince who had made it to the top of the heap. But van Gogh, at any rate, was dreaming the dream of a synthesis of all the arts, the dream of the *Gesamtkunstwerk*.

The Old Mill
Arles, September 1888
Oil on canvas, 64.5 x 54 cm
F 550, JH 1577
Buffalo (N.Y.), Albright-Knox Art Gallery

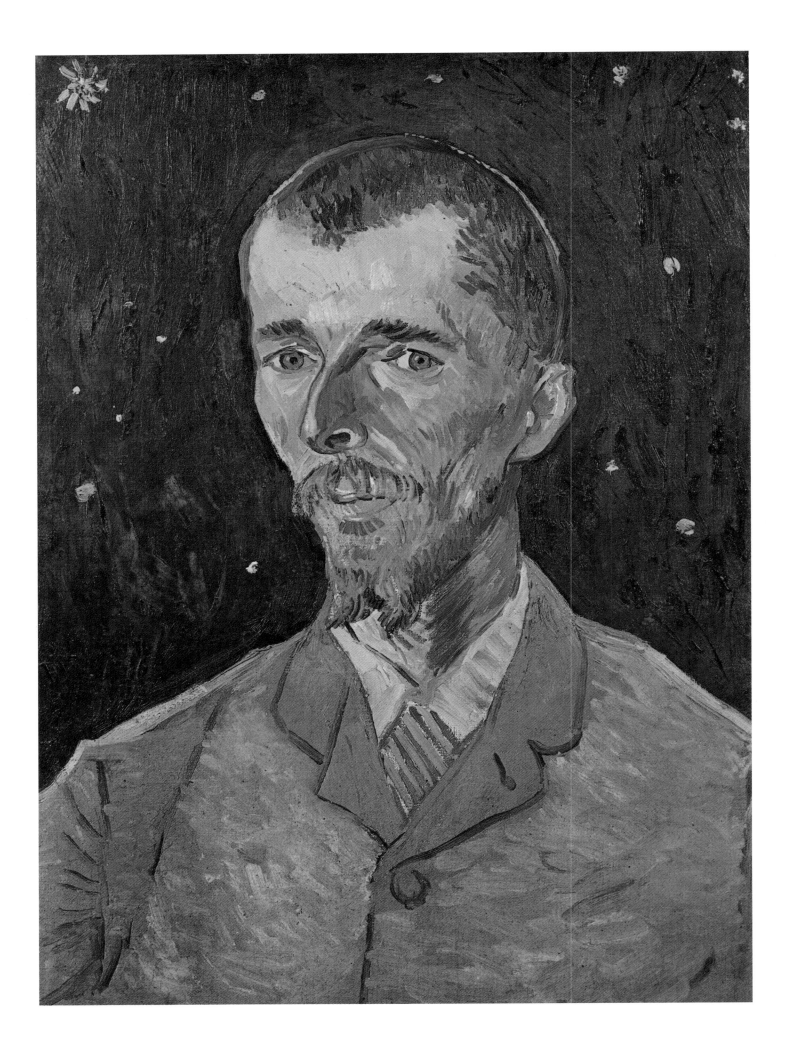

Aesthetic Subtlety
Van Gogh and Symbolism

The dream of the *Gesamtkunstwerk* ruled sovereign in a world whose highest principle was Beauty. *L'art pour l'art* was the slogan of the Belle époque: for high society, art for art's sake was a question of good style. But the dream was much older. A first major occurrence (albeit in purely literary form) was Tommaso Campanella's utopian *Sun State* (1623), which proposed an ideal system in which painting and sculpture, architecture and town planning would all play their parts in the making of the New Man. The idea survived through different epochs. In the Baroque Age it served to celebrate the Christian God, and produced magnificent stages for the sacred drama of the *theatrum mundi*. The Romantics, with their emphasis on inner values of the spirit, rediscovered it – particularly the Germans Philipp Otto Runge and Novalis, with their secular cult of pure aestheticism. And so it became the hallmark of an era. In the *fin de siècle* decades the dream of the *Gesamtkunstwerk* prospered in the heyday of the isms, a period so inward-looking that in many ways it can be seen as a Romantic revival. Its most characteristic excesses were the creations of Bavaria's King Ludwig II or the Barcelona architect Antoni Gaudí, the narcissism of Des Esseintes (the hero of J. K. Huysmans's novel *A Rebours*) or Richard Wagner's metaphysical operas. The unity of all the arts was enlisted in support of the unity of Art and Life.

The dream naturally presupposed audiences who could be conditioned to respond in the right way. Without the active connivance of the beholder or listener, of audiences that thought and felt as fellow spirits, the ecstatic use of sound, colour and fragrance would remain mere theory. In the *Gesamtkunstwerk* of the late 19th century there was no longer any god to whom homage had to be paid. Now the spectacle of artistic creation had become an end in itself, whereas at one time it had merely provided the props and the set. Rhetoric now had to be all the louder, all the more compelling, since it no longer had anything to offer but itself. The magic word was synaesthesia. Decades earlier, Edgar Allan Poe had declared that the greatest compliment a poet could be paid lay in saying he seemed to see with his ear. In using all of their senses simultaneously, the artist and the well-disposed audi-

Portrait of Eugène Boch
Arles, September 1888
Oil on canvas, 60 x 45 cm
F 462, JH 1574
Paris, Musée d'Orsay

ence could share in the higher mysteries of synaesthesia. The uniniti-
ated were excluded; the public was confined to the chosen few who
debated the aesthetic issues of the age. Symbolism, a tremendously
vague term, resembled the other isms in offering connoisseurs and
artists who were brimful with aesthetic theories an arena for their
debates, one which (in the case of Symbolism) served the ideal of the
Gesamtkunstwerk. Its trademark was an alertness to the possibilities
implied in synaesthesia.

During his stay in Paris, van Gogh had been a debater in that arena for
at least a year. So, was van Gogh a Symbolist? A painter to his fingertips,

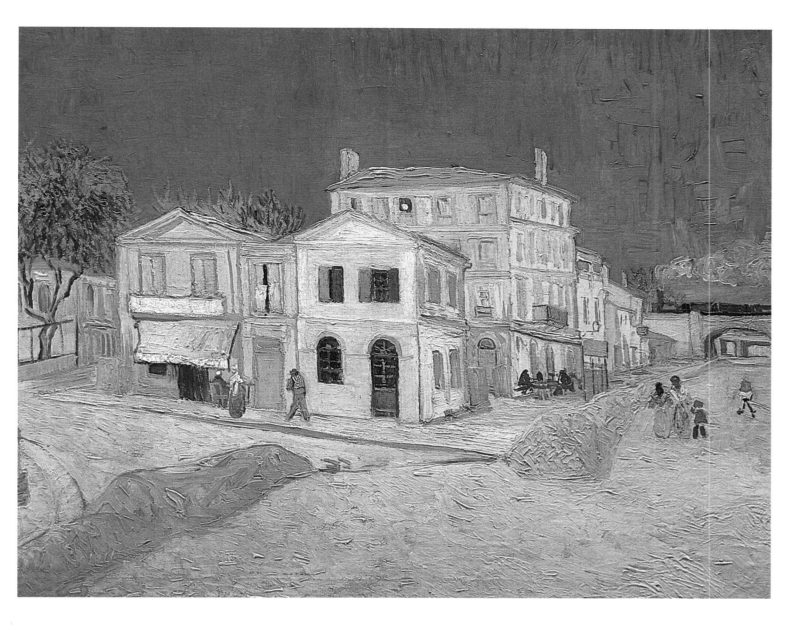

van Gogh never tried his hand at sculpture, limited his literary output to letterwriting, and never so much as mentioned the theatre (quite apart from music). Can it be possible that he shared in the dream of the *Gesamtkunstwerk*? Were his comments on the overall decorative system that governed his yellow house in fact more than simply words to clothe his naked misery? The fact is that van Gogh's relations with Symbolism are highly ambivalent. His personal appearance was quite enough to mark him out from the narcissistic fops, dandies and bohemians who took longer to get dressed in the morning than van Gogh did to produce a painting. He had neither led the life nor did he have the money to rival them. His sympathies were too much on the side of the common people, and the natural simplicity of their lives, for him to have much taste for the self-advertising and exhibitionism the Symbolists often went in for. Nevertheless, once he was far from the metropolis, from its aestheticism and world-views, van Gogh repeatedly called to mind things that indicate his affinity with the movement. Gauguin probably played some part in this.

**Vincent's House in Arles
(The Yellow House)**
Arles, September 1888
Oil on canvas, 72 x 91.5 cm
F 464, JH 1589
Amsterdam, Rijksmuseum Vincent van Gogh, Vincent van Gogh Foundation

The Café Terrace on the Place du Forum, Arles, at Night
Arles, September 1888
Oil on canvas, 81 x 65.5 cm
F 467, JH 1580
Otterlo, Rijksmuseum Kröller-Müller

The Café Terrace on the Place du Forum, Arles, at Night
Arles, September 1888
Reed pen, 62 x 47 cm
F 1519, JH 1579
Dallas, Dallas Art Museum

"It would be absurd not to concede the degree of decadence that we have reached", stated one of the Symbolist journals that had appeared around the year 1886. "Religion, morality and justice are in a state of decline. The sophistication of desires, feelings, taste, luxury, amusements – neurosis, hysteria, hypnotism, morphine addiction, scholarly charlatanism – they are all symptoms of a particular social evolution. The first signs appear in language. Changed requirements are met with new, infinitely subtle ideas of many and various kinds. This explains the need to coin new words in order to express the diversity of mental and physical sensations." This Décadence manifesto is of course too hymn-like in its praise of sophistication and the artificial to serve as a definition of van Gogh's art. But it is not so very different from what he himself wrote in Letter 481: "My poor friend, this neurosis of ours is partly due to our artistic way of life, but it is also a fateful part of our inheritance, for people in our civilization are becoming weaker generation by generation. Take our sister Wil. She neither drank nor led a debauched life, yet still there is a photograph of her where she has the look of a lunatic – proof that we, too, (let us not fool ourselves about our real state of health) are among those who suffer from a neurosis that has been a long time in the making." Charles Darwin's theory of evolution was present in van Gogh's mind and in that of the anonymous magazine writer. People felt degenerate, the products of a genetic mismanagement that was affecting the very spirit. The neurosis had spread throughout their souls. It came to be the hallmark of the artist; there was agitation in his use of pen or brush, and his language had necessarily to be new because it arose from deep urges that would no longer be repressed. Van Gogh once referred to his own work as "painting in the natural state". (Letter 525)

Anyone would groan under the burden if civilization chose him to offload its ballast onto; and it would be no coincidence if the sounds produced were like those primitive, rudimentary sounds made beyond the realms of education and society. It is but a short step from the decadent to the primitive. The world evolves in mysterious, cyclical ways, and the modern found itself once again at the starting point of all communication, having come full circle back to zero to begin anew. Modernism began to take its bearings from the dignified, natural simplicity of peoples who had hitherto merely served as subjects of ethnological study. Modernism discovered itself by discovering primitivism – in other words, by making a new start. Gauguin was its first hero, doing in reality (in the Caribbean and the South Seas) what for others remained mere theory.

"What we must copy from peoples of non-European origin", wrote Gottfried Semper, architect and presiding genius of the crafts movement, "is the art of capturing those simple and comprehensible melodies of form and colour which instinct establishes in the works of

Portrait of Milliet, Second Lieutnant of the Zouaves
Arles, late September 1888
Oil on canvas, 60 x 49 cm
F 473, JH 1588
Otterlo, Rijksmuseum Kröller-Müller

Man when they are at their simplest, but which are increasingly difficult to locate and record once the available means are greater." Semper speaks of "melodies", making a typical intellectual leap that re-applies the sophisticated principle of synaesthesia to the primitive. Van Gogh indulged in much the same kind of sophistry when paying homage to Wagner: "If one intensifies all the colours, one regains peace and harmony. It is similar to what happens in Wagner's music – it is played by a large orchestra but is not any less intimate because of that. But one prefers to choose sunny and colourful atmospheres, and I often think that in future many painters will work in the tropics." (Letter W3) He, too, thought dialectically, conceiving Wagner's emotionalism as serene simplicity. For the Symbolists, this was the great mystery of synaesthesia: once artifice is at its peak it suddenly reverses into its very opposite, becoming the basis of a new simplicity. Intensity and calm, a subtle sensibility and a taste for the coarse and unfinished, all play a part in this. Huysmans, writing an encomium on Stéphane Mallarmé, the Symbolist poet *par excellence*, defined synaesthesia in these terms: "He notices the remotest of correspondences and often, by means of a single word that conveys the form, scent, colour, characteristics and splendour by a process of analogy, he presents an object or being for which one would have needed many and various epithets if one had wanted to describe its every nuance and feature by technical means." It was not only in literature that synaesthesia availed itself of analogies. Allusion is used as a way of appealing to memories of very different kinds of perception; the simple prompts associations with the complex by introducing an extensive repertoire of cultural information. This is where van Gogh comes in: his art is an art of analogy – analogies of meaning and analogies of form.

The Night Café in Arles
Arles, September 1888
Water colour, 44.4 x 63.2 cm
F 1463, JH 1576
Berne, Collection H.R. Hahnloser

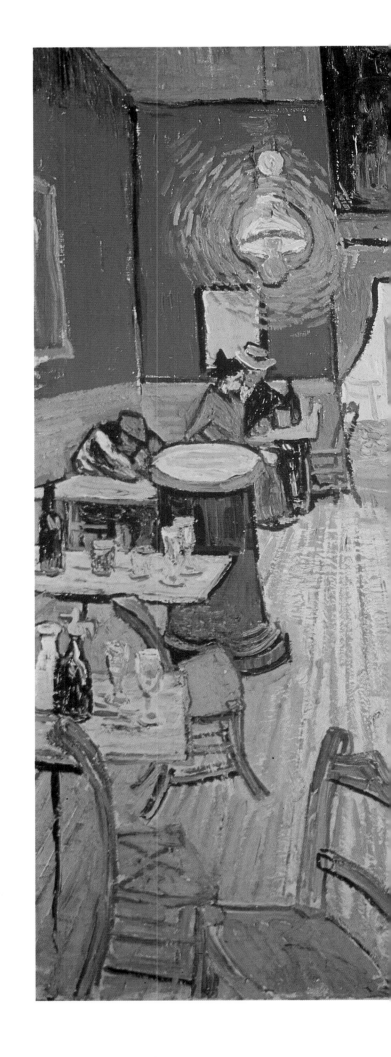

The Night Café in the Place Lamartine in Arles
Arles, September 1888
Oil on canvas, 70 x 89 cm
F 463, JH 1575
New Haven (Conn.), Yale University Art Gallery

Let us take another look at *The Café Terrace on the Place du Forum, Arles, at Night* (p. 425). In it, van Gogh presents a classic example of his use of analogous forms. Three parallel lines lead from the left-hand side to the centre of the composition: the lowest is the lintel of the window-frame at left, next comes the reddish edge of the awning, and topmost is the gable of a house, pointing into the blue infinity of the heavens. The fact that these lines are parallel defies all the rules of perspective, according to which they ought all to be converging on a vanishing point. Van Gogh, however, quite deliberately sets out to flout the rules – only to establish new laws of his own within the picture. Lines (he seems to be saying) have other functions beyond the mere description of edges and frames and lintels. They also convey a message concerning themselves; they spin a self-referential graphic web over the canvas, attesting to the two-dimensionality of painting. Two years later, Maurice Denis was to sum this up in the following well-known statement: "One must be absolutely clear about the fact that a picture, before it is a warhorse,

The Sower: Outskirts of Arles in the Background
Arles, September 1888
Oil on canvas, 33 x 40 cm
F 575a, JH 1596
Los Angeles, The Armand Hammer Museum of Art

Starry Night over the Rhone
Arles, September 1888
Oil on canvas, 72.5 x 92 cm
F 474, JH 1592
Paris, Musée d'Orsay
(on loan)

nude or anecdote, is a surface covered with colours arranged in a particular way."

The fact that the use of lines freed from the confines of compositional laws do not merely occur by chance is made apparent in *The Seated Zouave* (p. 367), which van Gogh painted in June 1888. The vast area of red alone is an acknowledgment of the autonomy of form. This autonomy is at odds with the principle of a descriptive account and can be seen as an intermediate step on the way to the actual goal: the use of formal analogy. The man's right shoulder, neck, cap and tassel frame an area that resembles the shape of his foot. Again, the curvature of his boot-sole echoes the shape of the base of the stool (almost entirely concealed by the man's voluminous attire). The massive area of colour that represents the traditional skirt is crisscrossed by yellowish lines that echo the chequered tiling of the floor. Echoes: there are numerous examples of this use of formal analogy in the painting. It was the principle of synaesthesia that prompted van Gogh to use them. Painting

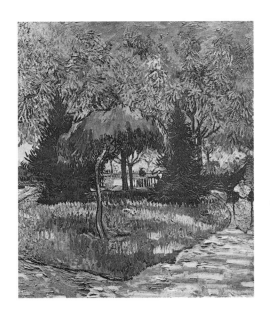

**The Park at Arles with the Entrance
Seen through the Trees**
Arles, October 1888
Oil on canvas, 74 x 62 cm
F 471, JH 1613
Destroyed by fire in the Second World War

is aspiring to the condition of music: a rhythmic pattern of colours and shapes, constantly repeated, with subtle variations or syncopated breaks in the pattern, is establishing an impression. Van Gogh was deploying the components of his composition in an abstract, geometrical fashion, on a level which suggested comparison with the impalpable, indefinable realm of music. His motifs were there as themselves; he was not using them to represent a given reality. Van Gogh was to continue his work on this problem during the period with Gauguin. It would become increasingly urgent, since it implied a necessary final relinquishment of reality in favour of abstraction.

In his definition of synaesthesia, Huysmans had spoken of the "word" that could convey "an object or being". Van Gogh translated this thought into a visual idiom and produced some superb work as a result. One fine example is *The Langlois Bridge at Arles* (p. 343), which we have already examined in a different context. The use of colour zones is a means of penetrating the very essence of the subject. Of course the architecture, the ropes, and the timber frame of the lifting gear are meticulously recorded – but the painting also articulates a remarkably precise metaphor. Just as the subject is quite literally a bridge connecting two sides of a canal, so too there is a metaphoric bridge: the blue quadrilateral area of the inside wall beneath the bridge. This blue area cannot be explained as reflections from the water or as atmospherics. Its function is to link the two areas of water and sky, to provide a figurative bridge to complement the literal bridge recorded in the two dimensions of canvas. It mediates between the blues in the lower and upper halves of the painting just as, in its representational function, it connects left and

The Lovers: The Poet's Garden IV
Arles, October 1888
Oil on canvas, 75 x 92 cm
F 485, JH 1615
Whereabouts unknown
(declared to be «degenerate» by the Nazis
and confiscated in 1937)

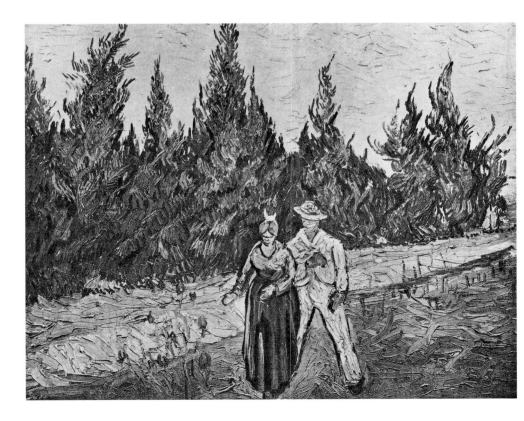

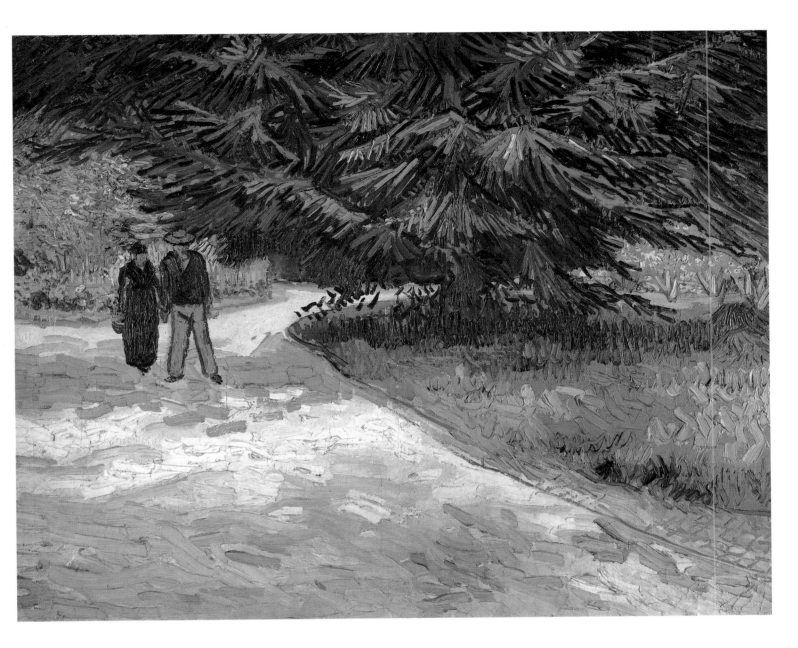

Public Garden with Couple and Blue Fir Tree: The Poet's Garden III
Arles, October 1888
Oil on canvas, 73 x 92 cm
F 479, JH 1601
Private collection
(Christie's Auction, New York, 13.5.1980)

right. In this work, van Gogh doubtless remained truer to himself than in other, more experimental approaches; for he still has his gaze fixed on the verifiable appearance of familiar objects, and achieves a characteristic personal synthesis of the autonomous and the representational. The real subject and the purity of form are complementary, two ways of approaching the same phenomenon.

"Symbolist poetry", wrote Jean Moréas, "aims to clothe the Idea in a sensitive form which is not an end in itself but is subordinate to the Idea it is to express. On the other hand, when the Idea appears it should not be stripped of the elaborate adornments of allusive analogies, for it is of the very essence of Symbolist art never to state the idea directly." So many Symbolists, so many manifestoes! The literary quality of the movement can be seen in the sheer mass of publications, periodicals, statements and creeds. Time and again, the Symbolists used written forms – books, poems and so forth – to launch an "idea". This method was tacitly adopted by all, and it consorted well with van Gogh's artistic

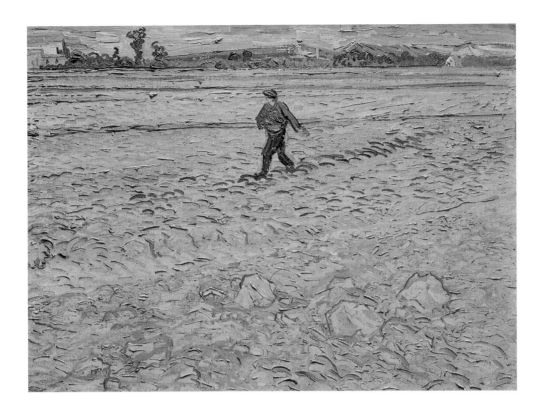

The Sower
Arles, October 1888
Oil on canvas, 72 x 91.5 cm
F 494, JH 1617
Winterthur, Collection L. Jäggli-Hahnloser

practice. He too was a conceptual artist. A thought or subject would have been in his mind a long time by the time he chose his motif. Van Gogh's paintings are veritably awash with meaning. He, too, followed the principle "never to state the idea directly". And we can only decode his disguised symbolism if we are familiar with the literary sources he drew on in order to invest his work with significance. All his subjects – the sunflowers and sower, the diggers and boats alike – are more than mere objects or people; they come complete with literary associations.

This was indeed the occasion for a violent disagreement with Bernard at the end of 1889. Bernard had sent van Gogh a sketch for a painting of Christ on the Mount of Olives. Christ appeared as a visionary figure racked by awareness of the agony to come. Van Gogh's response was distinctly agitated: "I have been at work out in the olive groves this month", he wrote to Theo (Letter 615), "because they really incensed me with their Christs on the Mount of Olives, where nothing is properly observed. Do not misunderstand me, my concern is not the making of Biblical art – I have written to Bernard that in my opinion it is our duty to think and not to dream." For van Gogh, the Christian theme of the Mount of Olives was perfectly conceivable without the main character. The olive grove would convey as much meaning in itself as his fellow artist was so laboriously trying to pack into a historical scene. Doubtless the old Protestant ban on images lay behind this. Van Gogh could be satisfied with some metaphoric or symbolic substitute, while a Bernard needed to present the sacred person of Christ. Van Gogh naturally took the Bible for granted; it was the foundation of his thinking, not a treasure-chest of motifs waiting for the artist to choose. Indeed, he never

felt the need to state ideas drawn from Holy Scripture directly. Van Gogh made his art out of analogies of meaning.

Van Gogh was claiming for himself certain qualities – nervous energy, a preference for simplicity, a taste for delicacy of colour and line and for hidden symbolism – that were characteristic of the Symbolist movement in his day. Indeed, these features came to have compelling force for him. For a whole year he was too much involved with the aesthetes to be able to fight free of their views. Indeed, van Gogh wanted to join in, with all the vigour that was naturally at his command, and fight the good fight for the new art with the rest of them – making the fight his own, personal struggle in the process.

The *non plus ultra* of the Symbolists was the *Gesamtkunstwerk*. The more stylish the aesthetic statements became, the more inseparable music and literature, cosmetics and interior design, creative artwork and the cult of self became; and the notion that the world could be changed by Beauty alone began to seem plausible. With all its playful and compulsive sides, the concept of the unity of the arts was an *ersatz*

The Public Park at Arles
Arles, October 1888
Oil on canvas, 72 x 93 cm
F 472, JH 1598
Private collection
(Christie's Auction, New York, 13.5.1980)

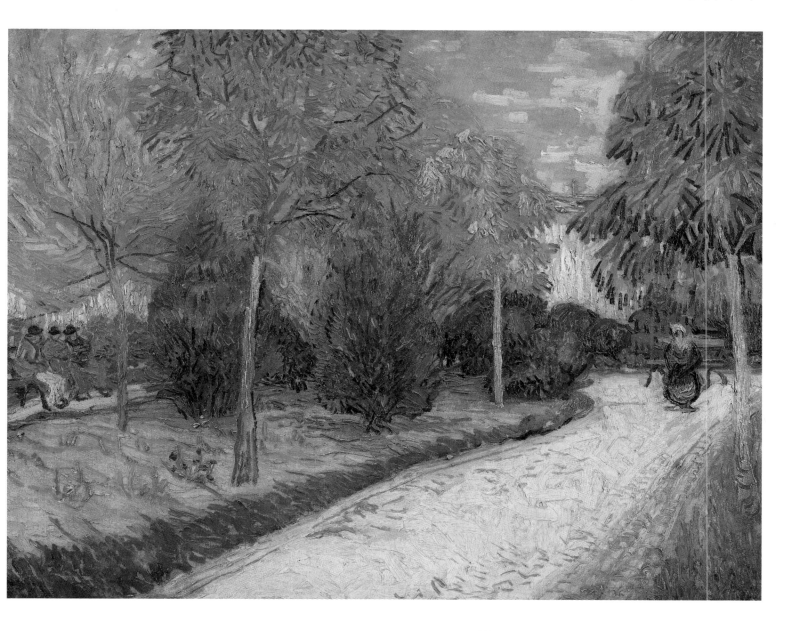

Still Life: French Novels
Arles, October 1888
Oil on canvas, 53 x 73.2 cm
F 358, JH 1612
Amsterdam, Rijksmuseum Vincent van
Gogh, Vincent van Gogh Foundation

for the unity of Art and Life. Pure aestheticism was the order of the day. Van Gogh, though, translated it all into terms of himself. He was familiar with the fashionable neurasthenia; but van Gogh's neuroses were soon out of control, leaving his mind shattered. He, too, dreamed of new stimuli in the tropics; but contact with simple people in his own part of the world was far more to his taste – to van Gogh, they already *were* what the aesthetes sought to stylize primitive peoples into. Like his fellow artists, van Gogh was tempted by synaesthesia, by the autonomous use of line, by the analogous use of form; but he was reluctant to abandon the everyday familiarity of real things altogether. Van Gogh was fighting for an "idea" of his own. He was out to express the essence of things. If he was ever to succeed, it would not be through some complex construct of subtle literary thought, but rather by drawing upon the ineffable qualities to which we apply such words as "infinity" or "consolation". When van Gogh availed himself (however implicitly) of the *Gesamtkunstwerk* approach, it was not in order to turn from everyday reality to an alternative, purely artificial world. Van Gogh's unceasing touchstone was the bare, forked animal that was himself. The arts were the straws at which he clutched – at times in desperation. Compared with van Gogh's manner, the nonchalant dandyism of his fellow artists had an arabesque, effete quality of concealing the life of the inner self beneath a heap of elaborate ornament. The presence of Gauguin was to bring the contrast home to van Gogh.

"A watering can, a harrow left out in a field, a dog in the sun, a humble churchyard, a cripple, a small farmhouse, any of these can be the vessel that contains my revelation. Every one of these objects, and thousands of a similar kind that are normally registered with indifference by the

eye, if at all, can suddenly, at some moment which is in no way in my power to determine, appear sublime and moving in a way that words seem too impoverished too express." Thus Hugo von Hofmannsthal in the famous *Chandos Letter*, describing the metaphysical impact the hidden symbolism of things can make on the sensitive initiate. No doubt in 1902, when he wrote this fictional letter, Hofmannsthal was familiar with some of van Gogh's work. It is conceivable that he was partly inspired by the striking presence which even the most ordinary of objects have in van Gogh's paintings. And the metaphor of a vessel containing revelation is certainly an apt way of expressing that presence. But one point crucial to our understanding of van Gogh is not included in the Austrian writer's account. It is not that van Gogh's

Willows at Sunset
Arles, autumn 1888
Oil on cardboard, 31.5 x 34.5 cm
F 572, JH 1597
Otterlo, Rijksmuseum Kröller-Müller

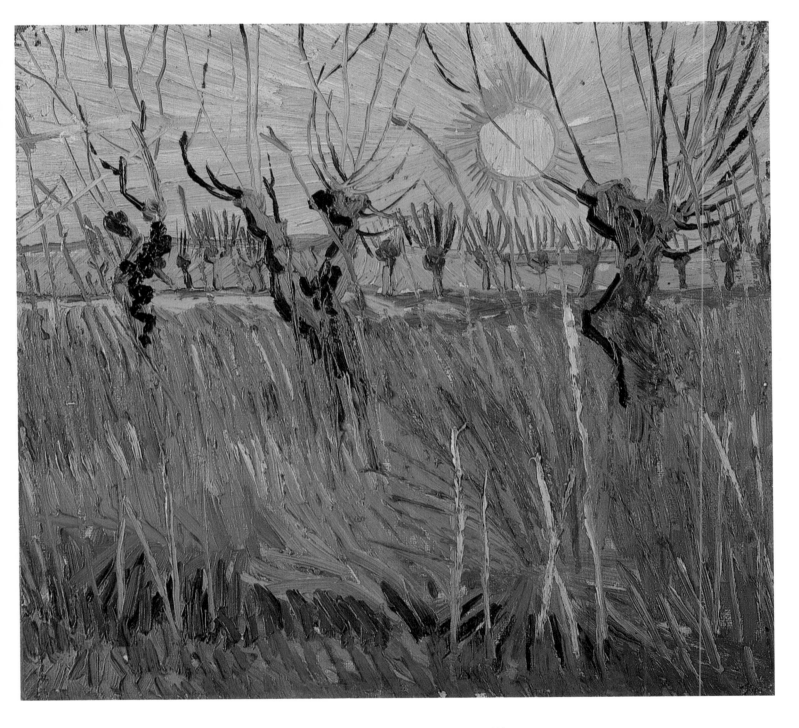

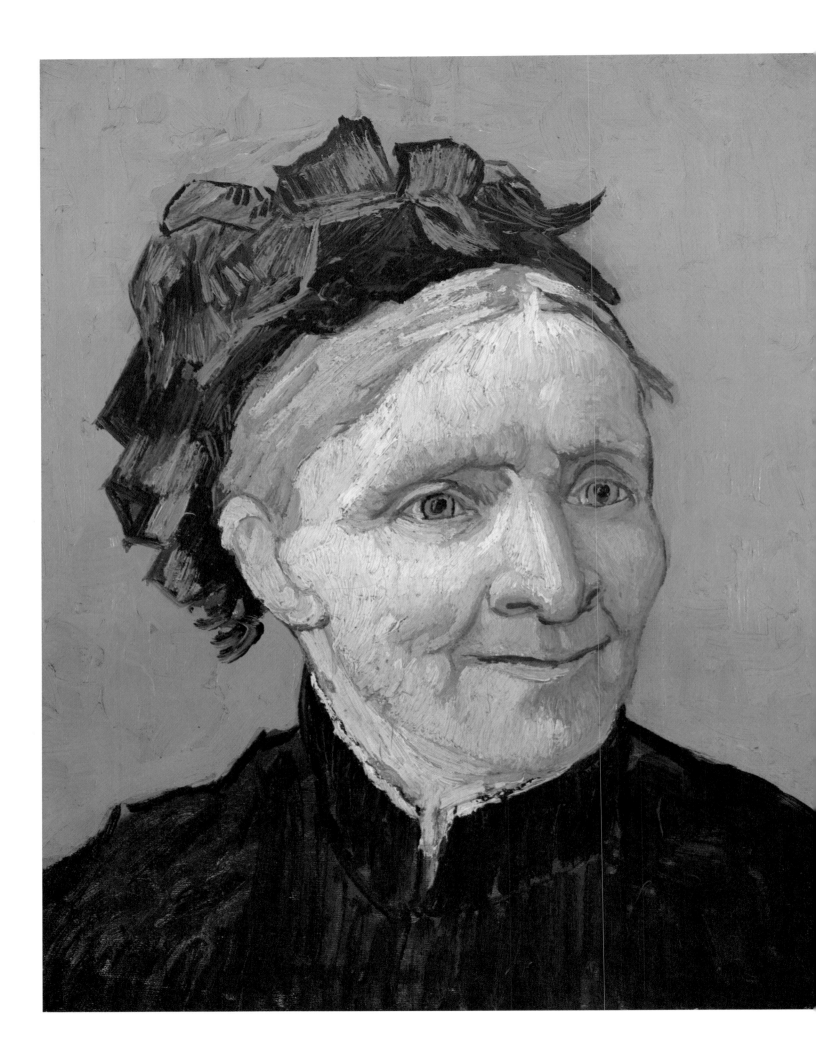

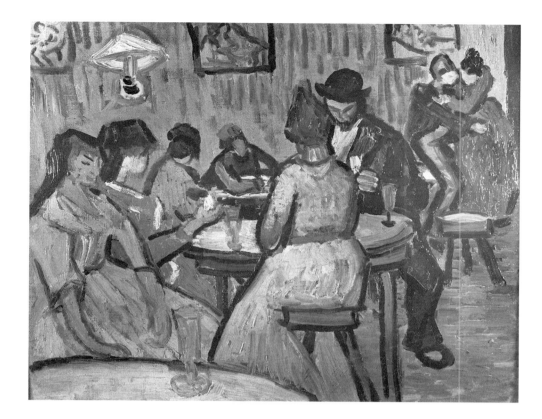

The Brothel
Arles, October 1888
Oil on canvas, 33 x 41 cm
F 478, JH 1599
Merion Station (Pa.), The Barnes
Foundation
(Colour reproduction not permitted)

Portrait of the Artist's Mother
Arles, October 1888
Oil on canvas, 40.5 x 32.5 cm
F 477, JH 1600
Pasadena (Cal.), Norton Simon Museum
of Art

things "can [...] appear sublime"; they *must*. If the artist does not succeed in grasping all-powerful Creation in a single painted thing, his endeavours have been pointless. This is why van Gogh, in the final analysis, is not a Symbolist at all (unlike the Viennese writer, for example). He takes no pleasure in juggling meanings about like so many balls, delighting in his own skill at teasing subtleties out of the given world.

"Ah, my dear friend", van Gogh wrote to Gauguin (Letter 573a), pouring out his heart, "to make of the art of painting what the music of Berlioz and Wagner already is – an art of consolation for broken hearts! There are few who feel this as you and I do." In van Gogh's view, Wagner was not the Romantic who revived emotionalism in opera and welded the arts together – Wagner's was an art of consolation, and for that reason alone was of consequence. The fact that he was creating a *Gesamtkunstwerk* was only incidental to human fellowship and communication. Van Gogh's own art was comparable: "My only true concern", Vincent told Theo in Letter 576, "is to present you one day with about thirty studies of some significance that will give you a genuinely consoling impression of the artist's craft." The meaning of Art was human solidarity, comfort and compassion. Compared with van Gogh's personal creed of humanity, the aesthetic subtleties of the Symbolists look like trivial games. Van Gogh was not reluctant to join in the games; but whatever he did became all too rapidly deadly serious.

Genius and Error: Gauguin in Arles
October to December 1888

On October 8, 1888, Gauguin wrote to his friend and supporter Emile Schuffenecker: "Theo van Gogh has sold some ceramics for me, for three hundred francs. So I shall be going to Arles at the end of the month and will probably remain there for a long time, since the point of the stay will be to work without financial worries until I am launched. In future he will be paying me a modest allowance every month." A week later his euphoria had already evaporated: "Even if Theo van Gogh were in love with me, it wouldn't be my good looks that prompted him to support me down south. He's a cool Dutchman and has seen how the land lies, and he intends to take matters into his own hands as far as possible, and that exclusively." Gauguin was evidently uneasy about his agreement with Vincent's brother. It was indeed a kind of prostitution. He was financially dependent on the sums that Boussod & Valadon had offered him. This was the gallery for which Theo van Gogh organized exhibitions of young painters. The price Gauguin himself had to pay was to live with the other van Gogh, the oddball, in Arles. True, he valued his art highly; but he found the company of Vincent van Gogh rather beneath his dignity. It had in fact been only at Vincent's insistence that Theo had agreed to the arrangement. The artists' community would capture the south on canvas and then conquer the capital – that was Vincent's idea. Gauguin was wary from the start, feeling that his own future lay in the tropics. But he needed the money; and, once Theo had actually begun selling his work, things started moving.

Vincent himself had been in a state of excitement ever since the summer when the possibility of Gauguin's joining him was first raised. His childlike impatience mounted steadily with every delay devised by his uneasy fellow artist. Gauguin distrusted the whole business. He felt his own light was being hidden under a bushel, and feared his talent was being sacrificed to business interests. Nonetheless, on 23 October he finally arrived in Arles. In the two months that he was to spend there, Gauguin was not to show himself from his most attractive side; he behaved brusquely and arrogantly, and surely had a share in the blame for van Gogh's fiasco. But Gauguin was cornered, and felt he had been manœuvred into a hopeless situation in which his lack of success

Paul Gauguin:
L'Arlésienne (Madame Ginoux)
Arles, November 1888
Crayon and charcoal, 56.1 x 49.2 cm
San Francisco, The Fine Arts Museum,
Aschenbach Foundation for Graphic Arts

Paul Gauguin:
Night Café in Arles (Madame Ginoux)
Arles, November 1888
Oil on canvas, 73 x 92 cm
Moscow, Pushkin Museum

Vincent's Bedroom in Arles
Arles, October 1888
Ink drawing in letter 554
No F Number, JH 1609
Amsterdam, Rijksmuseum Vincent van
Gogh, Vincent van Gogh Foundation

combined with a sense that van Gogh had exiled him to a provincial, uninspiring region to produce extreme frustration. He quickly recognised that in Arles he would never achieve the success he craved. Gauguin was discontented from the start. And it was in that frame of mind that he encountered the anxious, well-meaning van Gogh – and found that he went terribly on his nerves.

From the outset, Gauguin fell in with the role of abbot that he was expected to play in van Gogh's monastic yellow house. He ran the household and insisted on the same kind of orderliness in their life as we can see characterizes his work when we compare it with van Gogh's. Van Gogh the monk was demoted to a novice, with his own consent.

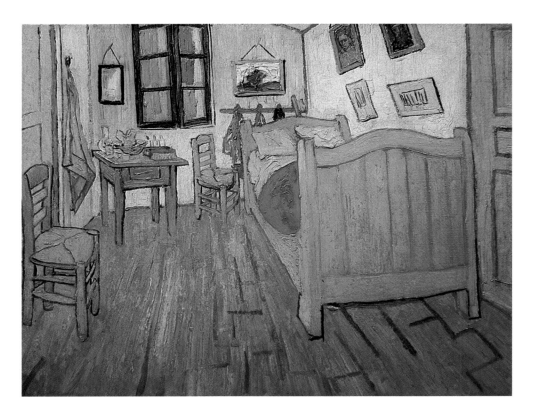

Vincent's Bedroom in Arles
Arles, October 1888
Oil on canvas, 72 x 90 cm
F 482, JH 1608
Amsterdam, Rijksmuseum Vincent van
Gogh, Vincent van Gogh Foundation

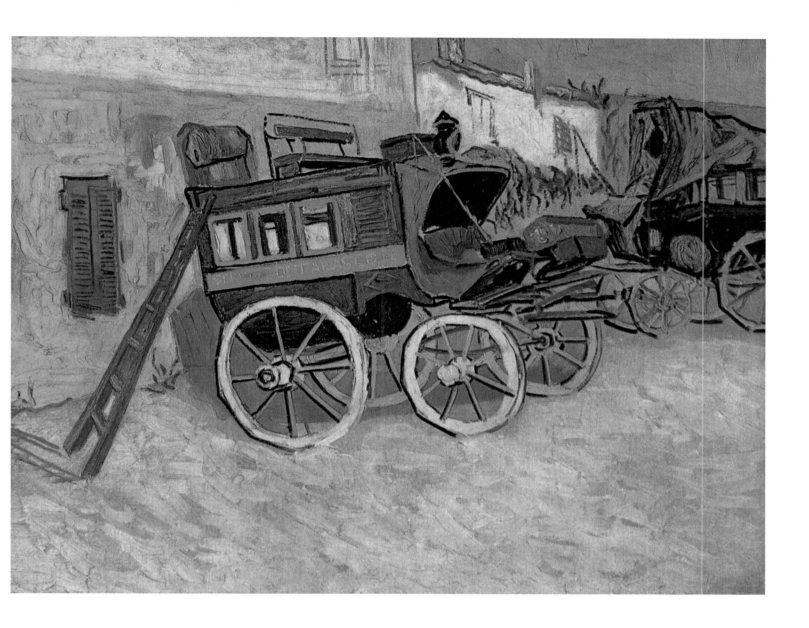

With complete dedication he tried to comply with the authority of Gauguin – whose dictates took over his everyday life much as they took over his art.

The very first paintings he did in this two-month period – the four views of Les Alyscamps (pp. 444–45, 447 and 449) – reveal remarkable changes. The two earlier versions (pp. 447 and 449) are still in van Gogh's usual style. The artist allows himself to be captivated by his subject. He takes up his position in the middle of the lane, with its ancient sarcophagi, relics of a time when Les Alyscamps (to the south of the town) had been the burial ground. Two diagonals converge on a low horizon, bordered by poplars, which lend an air of solemnity. The sarcophagi are kept discreetly in the background. To suit his main subject (the trees), van Gogh has chosen a vertical format, which also enables him to paint a pastose, monochrome sky in contrasting colour. As usual, the canvas is covered with thick, writhing streaks of paint, proof that the picture was painted on the spot, in defiance of the elements.

Tarascon Diligence
Arles, October 1888
Oil on canvas, 72 x 92 cm
F 478a, JH 1605
New York, The Henry and Rose Pearlman Foundation, Inc.

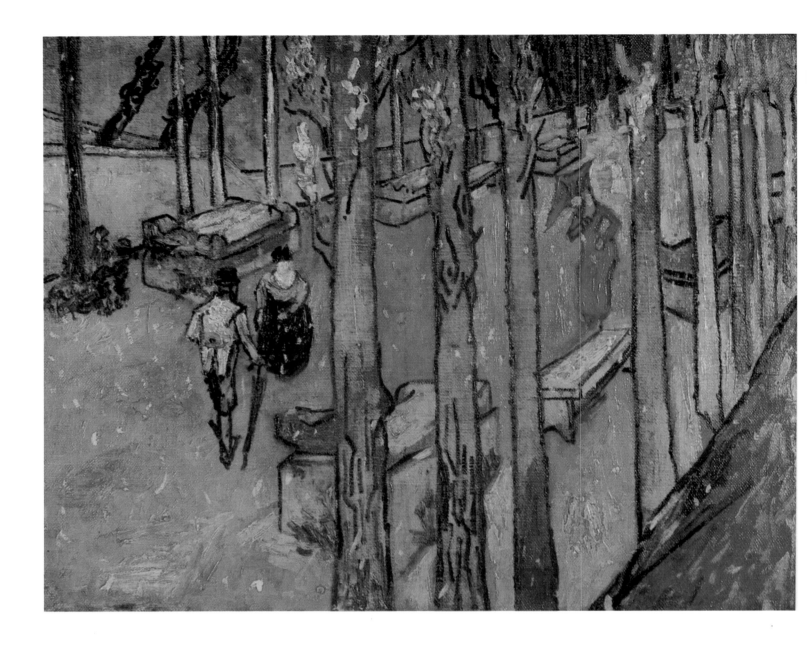

The next two versions (pp. 444–45), in contrast, clearly betray the influence of Gauguin. Gauguin had procured several metres of coarse, rough canvas; and Vincent painted his two views on this, too, sacrificing the dense power of his style for a smooth-as-varnish finish. He also changed his position, moving from the centre to a point further off on the embankment, above the sarcophagi. In these later paintings, the trees have been rendered in fragmentary style, cut back in favour of an air of antiquity and of the burial ground (with the extra dimension of artifice that this implies). Now the horizon is almost at the top of the composition (p. 445); and the spatial qualities of the scene are further obscured by the crisscrossing verticals of the tree trunks and diagonals of the lane. In short, van Gogh has retreated from the familiar appearance of things and has subordinated them to considerations of visual impact; he has opted for a sophisticated composition using an autonomous formal construct. As in Paris, he has undergone an astonishing change within an extremely short time. If it were not for the familiar

Les Alyscamps, Falling Autumn Leaves
Arles, November 1888
Oil on canvas, 73 x 92 cm
F 486, JH 1620
Otterlo, Rijksmuseum Kröller-Müller

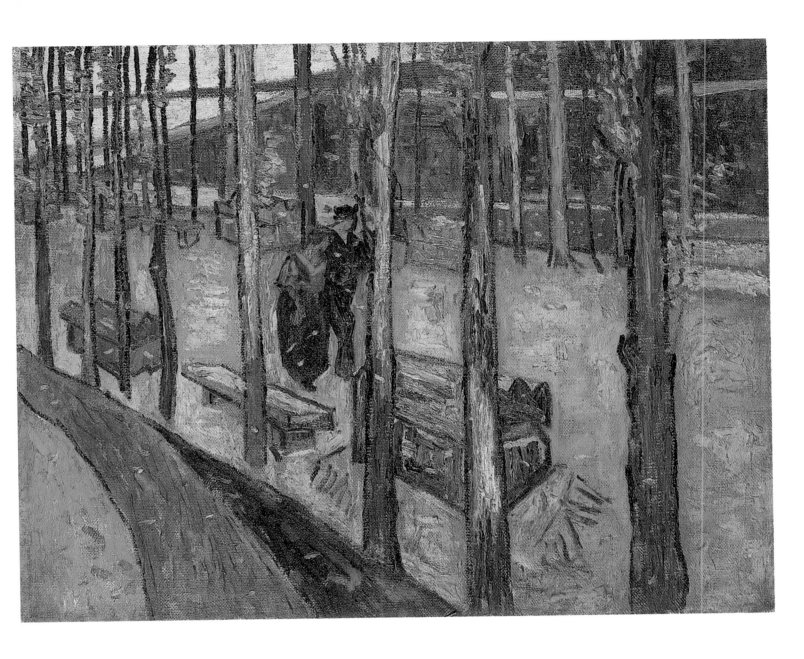

Les Alyscamps
Arles, November 1888
Oil on canvas, 72 x 91 cm
F 487, JH 1621
Collection Stavros S. Niarchos

stock figures of a strolling couple or a lady with an umbrella, we would indeed have no proof that this was in fact the work of van Gogh himself. The pressure to conform must have been immense, particularly in the first few weeks. It appears that Gauguin wanted a pupil, perhaps indeed an imitator – and van Gogh's awe-struck respect for the Master knew no limits.

Apart from his own work, Gauguin also had an extremely important painting with him: Bernard's *Breton Women* (France, private collection). Bernard had painted it when the two artists were together at Pont-Aven in Brittany. That summer, Gauguin and Bernard had pitted their skill and wits against each other; and now the competition was being repeated in Arles. But Bernard and Gauguin had been far closer in terms of their aesthetic beliefs. At Pont-Aven they had spurred each other on in their daily labours, with the result that each artist produced a manifesto painting: Bernard's *Breton Women* and Gauguin's *The Vision after the Sermon* (Edinburgh, National Gallery of Scotland). Later they were

Les Alyscamps
Arles, November 1888
Oil on canvas, 92 x 73.5 cm
F 569, JH 1623
Private collection
(Christie's Auction, New York, 15.5.1985)

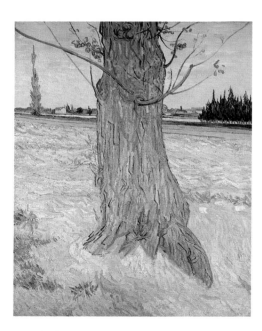

Trunk of an Old Yew Tree
Arles, late October 1888
Oil on canvas, 91 x 71 cm
F 573, JH 1618
Private collection
(Christie's Auction, New York, 14.11.1989)

to quarrel bitterly over which of the two works deserved the credit for inaugurating a new ism: "cloisonnism".

Van Gogh must have immediately recognised the originality of Bernard's masterpiece, for he included it among his personal repertoire of great works (by Millet, Delacroix, etc.) that he copied. His watercolour version (p. 472) is the sole surviving work on paper dating from the two Gauguin months – which is on the one hand an indication of the respect he had for drawings, and on the other, suggests a defiant determination not to obliterate the memory of these trying times. Van Gogh must have immediately grasped the central problem that Bernard was tackling in his *Breton Women*: the analogies of shapes. The gently undulating lines that snake across the picture disregard the outlines of the figures and, starting in the hems of the traditional skirts, intertwine. The women's headwear, widening into broad shawls, defines free-flowing forms that recur in similar style in a dog stretched out pleasurably on the ground. A figure in the background and the threesome in the upper right are included in the interplay of contours.

It is a prime example of synaesthetic painting. And of course the artist must pay the price for his rhythmic delicacy. Bernard's colours are unimaginative, and his sparingly used focal areas of unmixed paint do little to change this. Van Gogh, the colourist *par excellence*, retains these areas in a despairing manner in his own version; indeed, he follows the original very faithfully – even if his lines lack precision, the flow is at times interrupted, and the relations of the figures to each other are unclear. The almost total relinquishment of colour is in itself sufficient to prove van Gogh's emulation of Bernard's aesthetic principles. He was in a sense "rehearsing" what he felt Gauguin demanded of him; van Gogh was doing what he had always liked doing – copying.

In their idyllic summer retreat at Pont-Aven, Gauguin and Bernard, with Anquetin and Charles Laval, had been working together on a project to establish a kind of art that was independent of nature and interested solely in delicacy of visual impact. They had hardly done their first experiments, but they had also produced a manifesto. It was written by Anquetin's school-friend Edouard Dujardin and, appearing in the *Revue indépendante* (probably the most important of the numerous Symbolist periodicals), it introduced the term Cloisonnism. Mediaeval goldsmiths had evolved the *cloisonné* technique in enamelware. The new ism was concerned with the outlines that give objects in a picture – the motifs that are seen on the canvas – a solid presence, and thus independence and autonomy. Centuries before, craftsmen had used fine metal strips to separate areas of enamel from each other; now, by analogy, an exact and indeed authoritarian use of line was to fix things quite unmistakably in their places and implant them permanently in the two-dimensional nature of a painting.

"What must be expressed", wrote Dujardin, "is not an image but the

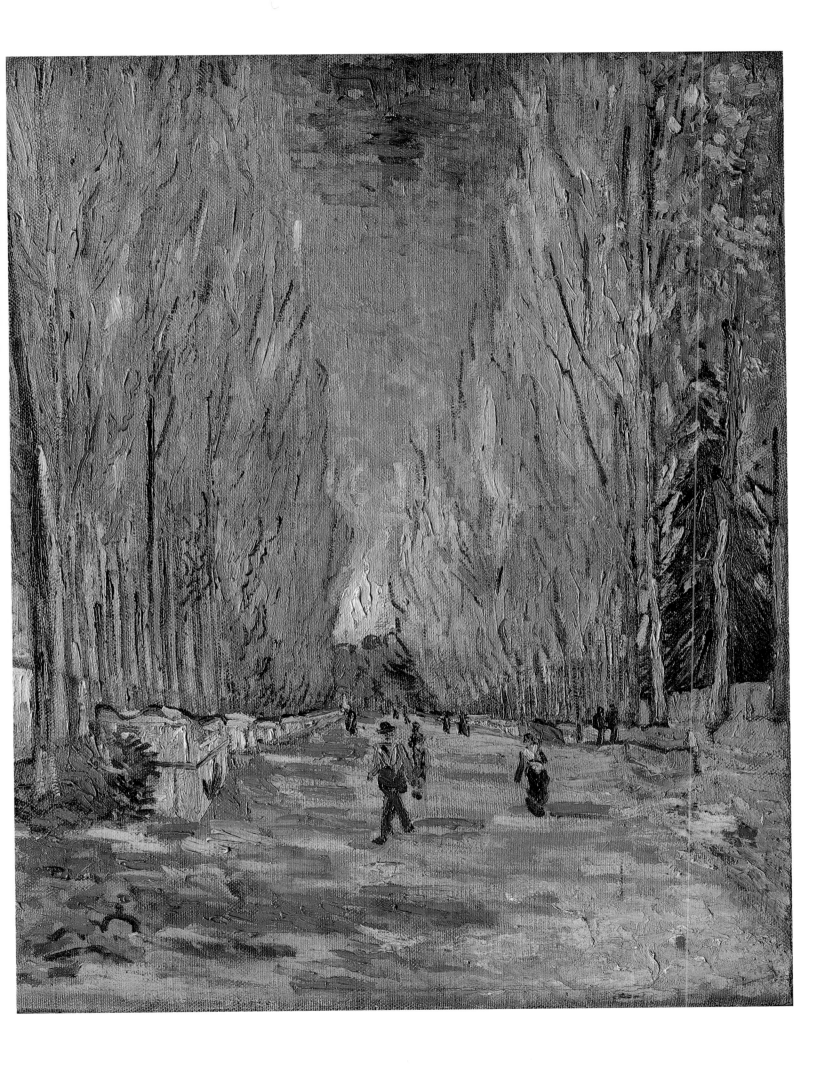

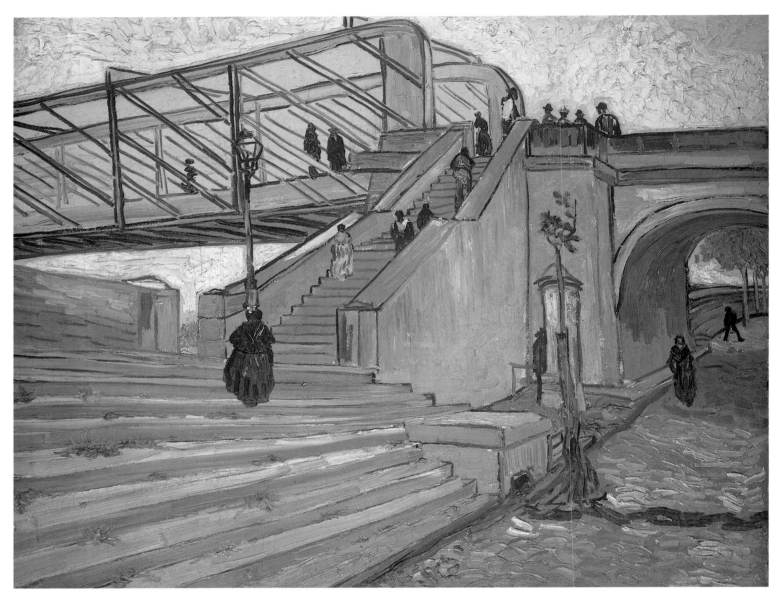

The Trinquetaille Bridge
Arles, October 1888
Oil on canvas, 73.5 x 92.5 cm
F 481, JH 1604
Zurich, Kunsthaus Zürich (on loan)

**The Railway Bridge over Avenue
Montmajour, Arles**
Arles, October 1888
Oil on canvas, 71 x 92 cm
F 480, JH 1603
Zurich , Kunsthaus Zürich (on loan)

Les Alyscamps
Arles, late October 1888
Oil on canvas, 93 x 72 cm
F 568, JH 1622
Lausanne, Collection Basil P. and
Elise Goulandris

essence. Why should one record a thousand insignificant details that the eye can see? An outline is enough to represent a face. An artist can grasp the heart, the inner reality of the chosen subject in a minimum number of lines and colours if they are truly characteristic, and can thus escape photographic imitation. Primitive art and folk art are symbolic in this sense, as is Japanese art. What practical lesson can we learn from this? First, strict distinction of line and colour: lines express the constant, colour the fleeting. Lines, which are signs of an almost abstract nature, reproduce the character of a thing, while the total effect of colour determines the overall atmosphere and the impression conveyed." Dujardin is clearly drawing on the long-standing dispute between linearists and colourists; and he makes his own position clear. Lines (he feels) are superior to colour because they stand for what is permanent and general, whereas colour can only capture momentary sensations.

This represented a development that was not at all what van Gogh himself intended. He gave Bernard an account of his own interpretation

of contour in spring 1888, and in doing so arguably encouraged a development that was now turning against him: "I always do my work on the spot", he stated (in Letter B3), "and attempt to record the essentials in my sketches – I then fill in the areas that are outlined with contours (whether present or not, at any rate felt to be there) with equally simplified colours, so that all the earth is the same violet, all the sky is the same shade of blue, and all the greenery either blue-green or yellowish green, with either the blue or yellow toning exaggerated as appropriate. In short, my friend, it is certainly not an art to deceive the eye!" Outlines helped van Gogh locate his motifs and transfer them to the canvas entire. Outlines also helped him regulate the flow of colour and keep it from becoming over-impetuous. In other words, outlines served to underwrite the real: they checked his vehemence and provided a kind of pattern that could discreetly and efficiently mask his draughtsmanship shortcomings. Their abstract qualities could then be appreciated all the more.

The Red Vineyard
Arles, November 1888
Oil on canvas, 75 x 93 cm
F 495, JH 1626
Moscow, Pushkin Museum

Memory of the Garden at Etten
Arles, November 1888
Oil on canvas, 73.5 x 92.5 cm
F 496, JH 1630
Leningrad, Hermitage

Meanwhile, though, van Gogh had forgotten what he had once believed. Now he attempted to follow Gauguin's concept of art in paintings such as *Memory of the Garden at Etten* (see above). Everything is subordinated to a visionary mood, to the implication of an invisible world. There is no horizon to establish a verifiable spatial sense. Van Gogh's bold foreshortening is not so much a riposte to logic and sequence as a way of making the picture a graphic exercise in surface two-dimensionality; the notion of space seems to have become irrelevant. Everything in the picture has been framed in contour lines – even the dahlias growing from out of the foreground arrangement (so like a still life) are simply iridescent discs. The people passing are lost in thought and remote from us. No gesture or glance establishes any contact with the world outside the canvas – they remain quite emphatically in their two-dimensional counterworld, quoted almost verbatim from Gauguin's view of the park opposite, *Women in the Garden* (Chicago, Art Institute of Chicago). All that recalls van Gogh's own aesthetic princi-

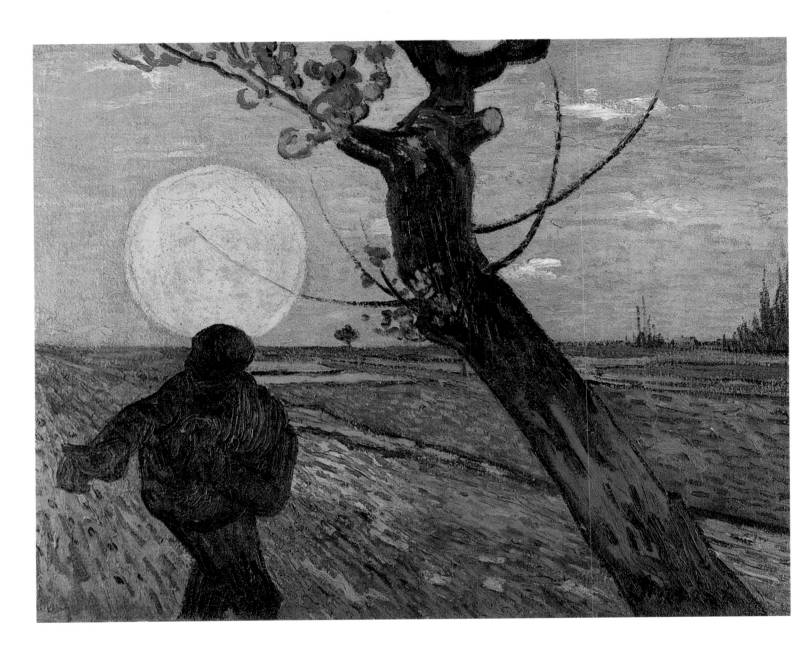

ples is his defiant use of dabs of paint; but they have an anachronistic flavour. They seem rather forced reminders of his discovery of colour, and appear somewhat out of place.

He described his intentions in this painting to his sister (Letter W9): "I do not know if you can understand that it is possible to express poetry by means of a good arrangement of colours and nothing more, just as one can express consolation by means of music. In addition, the bizarre, contrived and repetitive lines that twist through the whole picture are not meant to represent the garden as it normally looks, but to render it as we might see it in a dream, in its true character, yet at the same time stranger than in reality." As he himself puts it (in words that could have been Gauguin's and probably *were*), van Gogh was concerned with the "bizarre, contrived" lines which removed his scene from everyday reality. The painting was a deliberate exercise in the analogy of forms. There was a high price to be paid, because in painting like this van Gogh had to desert the original motifs and delve into his own imagination. To an

The Sower
Arles, November 1888
Oil on burlap on canvas, 73.5 x 93 cm
F 450, JH 1627
Zurich , Foundation Collection E.G. Bührle

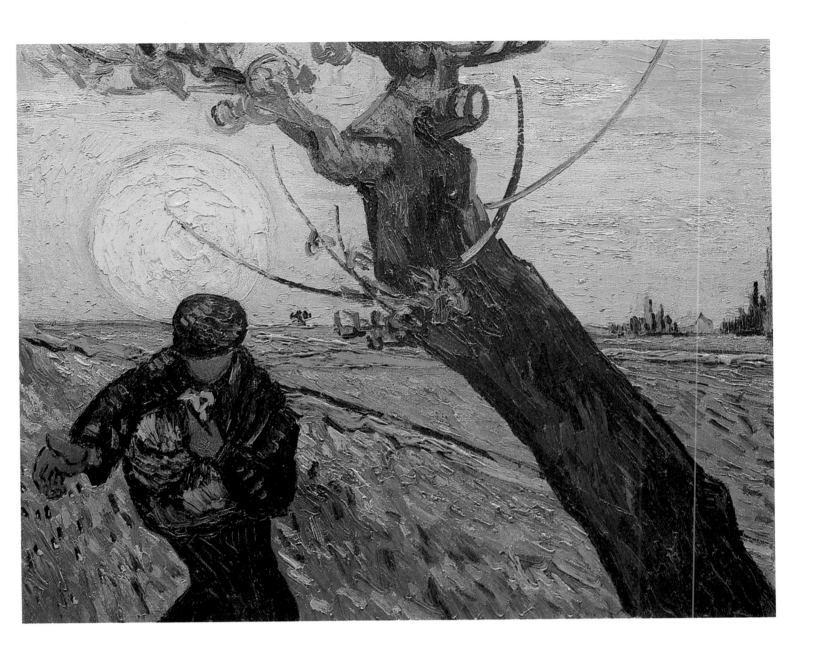

The Sower
Arles, November 1888
Oil on canvas, 32 x 40 cm
F 451, JH 1629
Amsterdam, Rijksmuseum Vincent van
Gogh, Vincent van Gogh Foundation

extent, he was producing from deep within himself images which other-
wise would have been supplied by the things of the world themselves.
As the title points out, the picture is an exercise in memory, recalled
from the past. This links it to other paintings done at the same time,
such as *The Sower* (pp. 452 and 453), *The Dance Hall in Arles* (pp.
470–71) and *Spectators in the Arena at Arles* (p. 472). "Art is abstrac-
tion", was Paul Gauguin's definition, "you should derive the abstrac-
tion from Nature as you dream, and think more about your own creative
work and what comes of it than about reality." And van Gogh abided by
this dictum with grim determination.

But there is another respect in which his *Memory of the Garden at
Etten* is a key work of the period with Gauguin. It was the striking
imitativeness of the painting, the derivative affinity to his revered
Master's work, that made van Gogh realize the incompatibility of their
aesthetic ideas. His memory, after all, was again trying to retrieve a
quite specific fragment of the real. What his memory came up with was

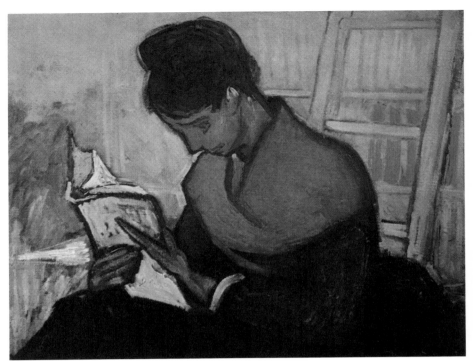 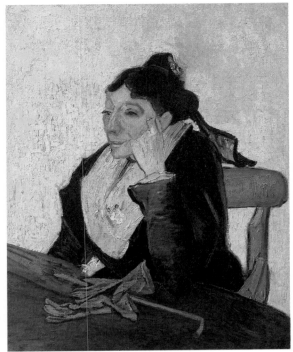

not a perception modified by thought nor a matrix to be filled out with meanings; van Gogh was quite specifically remembering his own past and dreaming of his mother and sister taking a walk in the vicarage garden he knew so well. "Assuming that the women out walking were you and Mother", he wrote to his sister in the same letter (W9), "even if there were not the slightest, most everyday and unimportant of resemblances, the deliberate choice of the colour, the dark violet set off by the lemon-yellow dahlias would convey Mother's personality to me." His ability (and compulsive need) to use individual symbolism was asserting itself again. There were forces of identification at work that related every motif he used in a picture to himself. While van Gogh's painting may be the very image of Gauguin's, the intentions are diametrically opposed. Paul Gauguin, after giving the matter careful thought, had evolved a method of making painting independent of the obsessions, spontaneous reactions and passing moods of the artist; and Vincent van Gogh, appropriating the method, used it for his own immature purposes, his own self-admiring ends, his need for intense dedication! These memory paintings of van Gogh's were also to signal an abrupt change in the way the two artists lived. Henceforth, they were rivals.

Since he arrived, Gauguin had taken his subjects from motifs that van Gogh had already worked on. Thus he produced alternative interpretations of van Gogh's harvest pictures, of *The 'Roubine du Roi' Canal with Washerwomen* (p. 378), of the poet's garden, and of *The Red Vineyard* (p. 450). In due course he tackled Vincent's pride and joy, the *Night Café*, which van Gogh thought was equalled only by *The Potato Eaters*. Gauguin's version (p. 440) dispenses entirely with the desolate mood of isolation which van Gogh recorded. The drinkers in the corners now

The Novel Reader
Arles, December 1888
Oil on canvas, 73 x 92 cm
F 497, JH 1632
Japan, Private collection

L'Arlésienne: Madame Ginoux with Gloves and Umbrella
Arles, early November 1888
Oil on canvas, 93 x 74 cm
F 489, JH 1625
Paris, Musée d'Orsay

L'Arlésienne: Madame Ginoux with Books
Arles, November 1888 (or May 1889?)
Oil on canvas, 91.4 x 73.7 cm
F 488, JH 1624
New York, The Metropolitan Museum of Art

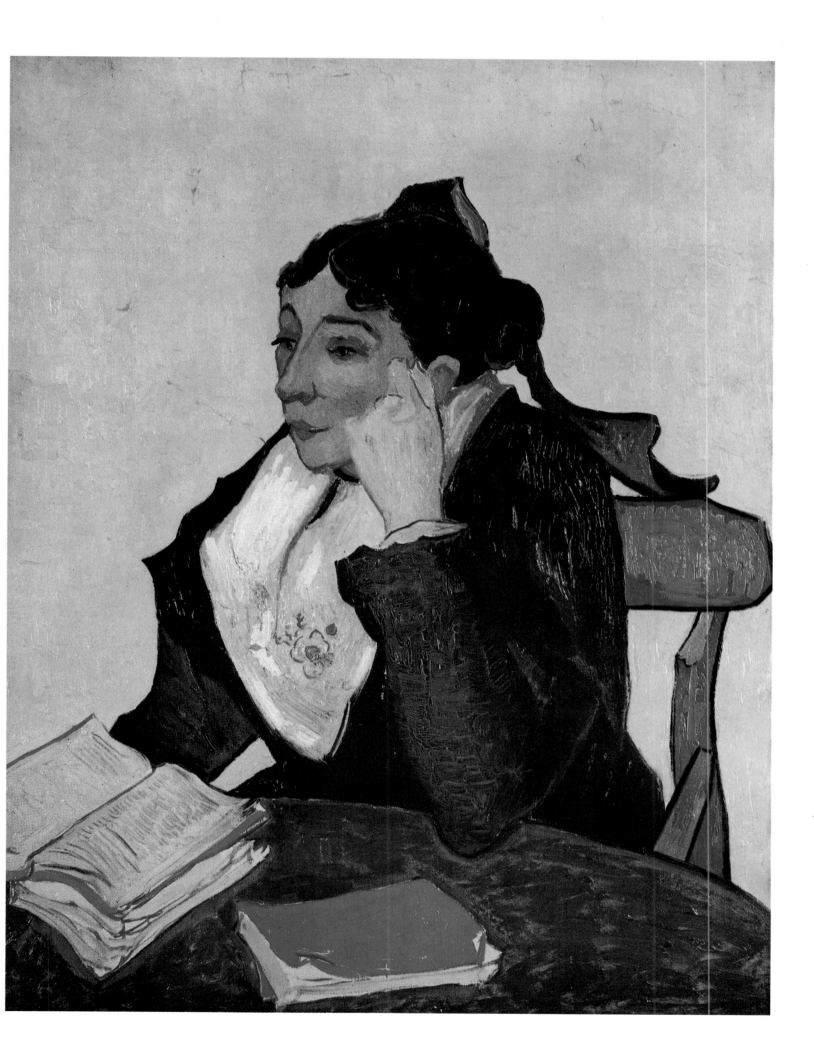

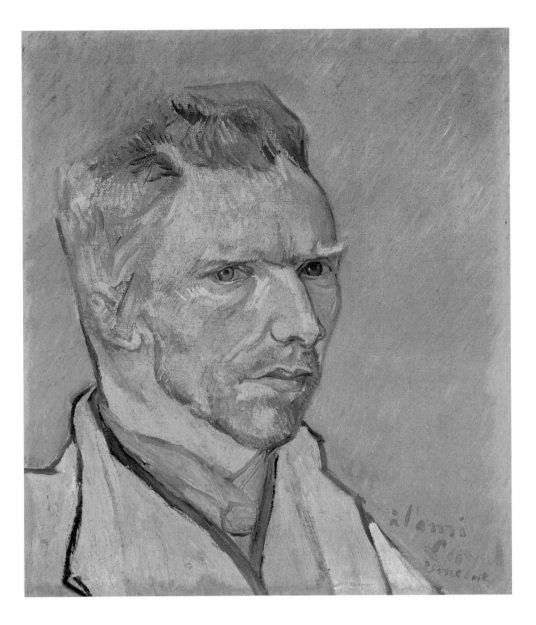

Self-Portrait
Arles, November-December 1888
Oil on canvas, 46 x 38 cm
F 501, JH 1634
New York, The Metropolitan Museum
of Art

fade in importance beside the foregrounded figure of Madame Ginoux, the proprietress. She is gazing out of the painting, which makes contact easier and releases the interior scene from that oppressive sense of isolation van Gogh had established. Van Gogh's was a nighttime scene if only because of the black despondency of its mood. Gauguin, by contrast, simply shows a café – we need to be told that it is a café that stays open at night. He did not paint the picture on the spot, but in his studio, and accordingly the painter's mood is not conveyed by the work. Gauguin worked in far too controlled and cerebral a way for his works to be mere descriptive accounts of situations. That said, though, his night café is not without that atmosphere of desolation which the place surely must have had. For this reason, van Gogh loved the picture, while Gauguin despised it: "It's not my style", he wrote to Schuffenecker, "the local colours of some bar do not appeal to me." He would inevitably have had to abandon his own principles if he had followed van Gogh in his investigations of the seamier side of human life. He wanted his

paintings to remain pure; even cigarette smoke drifting across the hazy room was too realistic.

Gauguin's painting of the night café was two pictures in one: the café itself serves merely as a background for the portrait of the proprietress, and is a kind of attribute to indicate the status of the subject. Madame Ginoux had often sat for portraits in the yellow house; Gauguin was building up a stock of drawings (cf. p. 441) that he intended to use for a painting. Van Gogh, on the other hand, would put up his easel, reach for his palette and brush, and have his painting finished (cf. pp. 454–55) in the time it took Gauguin to draw a sketch. Both artists have Madame Ginoux in the same pose, leaning on her left elbow, her head resting on her left hand. Gauguin painted her in frontal pose, something which preempted van Gogh, who had always valued eye contact with his models so highly; and van Gogh's readiness to be outmanoeuvred is a powerful reminder of the deep respect he had for his fellow artist. But he was his old self once he started painting: monumental monochrome areas of colour, arresting contrasts, and thick streaks of paint squeezed straight from the tube.

The letters van Gogh wrote at the time played down the mounting difficulties. But a few simple questions suffice to show how things in the yellow house really stood between the two artists. Why did van Gogh, who so relished the encounter of painter and sitter, not do a

Mother Roulin with Her Baby
Arles, November-December 1888
Oil on canvas, 63.5 x 51 cm
F 491, JH 1638
New York, The Metropolitan Museum of Art

Mother Roulin with Her Baby
Arles, November-December 1888
Oil on canvas, 92 x 73.5 cm
F 490, JH 1637
Philadelphia, The Philadelphia Museum of Art

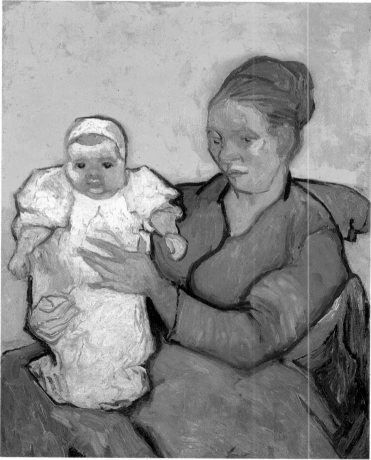

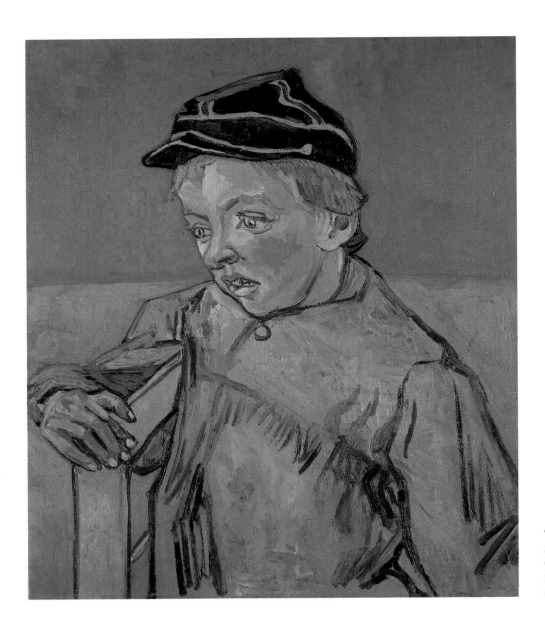

The Schoolboy (Camille Roulin)
Saint-Rémy, November-December 1888
Oil on canvas, 63.5 x 54 cm
F 665, JH 1879
São Paulo, Museu de Arte de São Paulo

portrait of Gauguin? Why did Gauguin, by contrast, deign to paint a portrait of van Gogh, even though he did not especially value direct confrontation with a motif and indeed detested that quality of the palpably physical which linked the work to the subject? Why (by way of atonement) did van Gogh paint the two chairs, one of them a vacant throne – as if the old ban on images applied to Gauguin's person and he could only be portrayed symbolically? The answer to all the questions may run something like this: Gauguin was tending to assume the lofty airs of an artistic genius, and rammed home his position by threatening to leave. Van Gogh became more and more unsure of himself, and felt obliged to question the value of his own work when faced with the increasingly apparent incompatibility of their approaches. Gauguin claimed the infallibility of an aesthetic pope, with the encyclicals of Symbolists such as Dujardin to back him up. What could van Gogh claim as his own? The two chairs illustrate the irrational climax of the two artists' dealings with each other. They do so, though, with the full rationality of a formal idiom evolved over years of hard work.

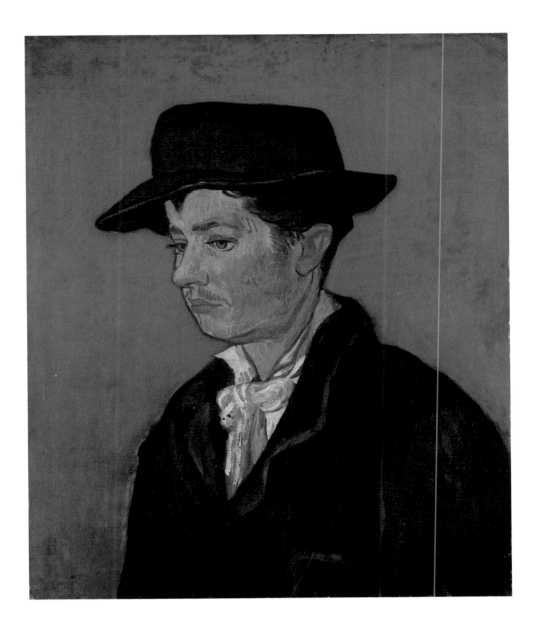

Portrait of Armand Roulin
Arles, November-December 1888
Oil on canvas, 65 x 54 cm
F 493, JH 1643
Rotterdam, Museum Boymans-van
Beuningen

Gauguin's predicament was no less serious than van Gogh's. He gave
Schuffenecker a forceful account of their differences: "I feel a complete
stranger in Arles. It is all so petty and wretched, the region and the
people alike. Vincent and I rarely agree on much, least of all where
painting is concerned. He admires Daudet, Daubigny, Ziem and the
great Rousseau, all of them people I cannot stand. On the other hand, he
detests Ingres, Raphael and Degas, all of them people I admire. I say to
him. 'You're right, boss', for the sake of a quiet life. He likes my
paintings very much, but when I am at work on them he is forever
saying that I am doing things wrong somewhere or other. He is a
Romantic, whereas I have a taste for the primitive. As for paint, he
pursues the chance element in pastose application (as Monticelli did)
whereas I loathe this hodgepodge of techniques etc." In this passage,
Gauguin was facing up to the situation far more openly than van Gogh
did. The latter's letters tended to gloss over the problems and repress his
awareness that the project was failing. For Gauguin, the cost was not too
great: he would simply have to leave, writing off two wasted months.

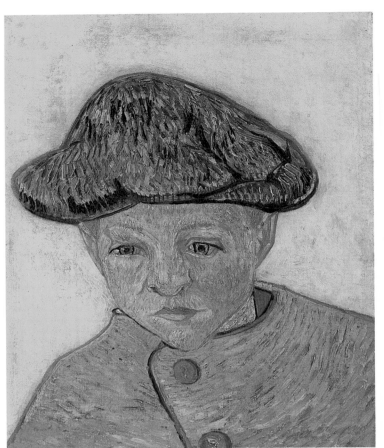
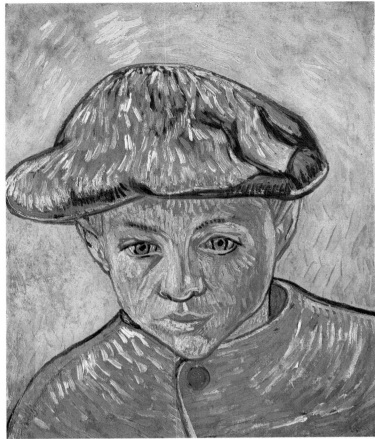

But for van Gogh it meant the destruction of a world-view if the utopia all his toil was meant to establish finally proved unattainable. A large part of his own identity would be disappearing along with Gauguin.

Van Gogh's identity was inseparable from the art which articulated it. If the differences their pictures showed up were the first to be noticed, the incompatibility of their ways of life soon became apparent, too. "He is a Romantic, whereas I have a taste for the primitive", wrote Gauguin. What he objected to was that monastic trait Goethe had also lamented in another context. Gauguin was a family man, with a wife and five children living in poor circumstances in Denmark and weighing on his conscience, and he had no great use for an ascetic life of seclusion in the service of the art of the future. However euphoric he sometimes felt about the new world of tomorrow, Gauguin was an artist because he wanted a pleasant life in the here and now. His later escape to the tropics was indicative of the impatience deep within him; he wanted the paradise he longed for *now* – a possible utopian counterworld was of little interest to him. Van Gogh, on the other hand, had broken off all his contacts, and indeed had basically never entered into any commitments that might have brought the artificiality of his ideas and vague raptures home to him. Both of them wanted a return to the simplicity of a natural life; but van Gogh had fashioned a far more specific world of images, and supposed himself to be living in that world. Van Gogh was far more the unity of Art and Life personified than Gauguin. As for Gauguin, he saw

Portrait of Camille Roulin
Arles, November-December 1888
Oil on canvas, 43 x 35 cm
F 537, JH 1644
Philadelphia, The Philadelphia Museum of Art, Mrs. Rodolphe Meyer de Schauensee, from the private collection of Mr. and Mrs. Walter H. Annenberg

Portrait of Camille Roulin
Arles, November-December 1888
Oil on canvas, 40.5 x 32.5 cm
F 538, JH 1645
Amsterdam, Rijksmuseum Vincent van Gogh, Vincent van Gogh Foundation

Portrait of Armand Roulin
Arles, November-December 1888
Oil on canvas, 65 x 54.1 cm
F 492, JH 1642
Essen, Museum Folkwang

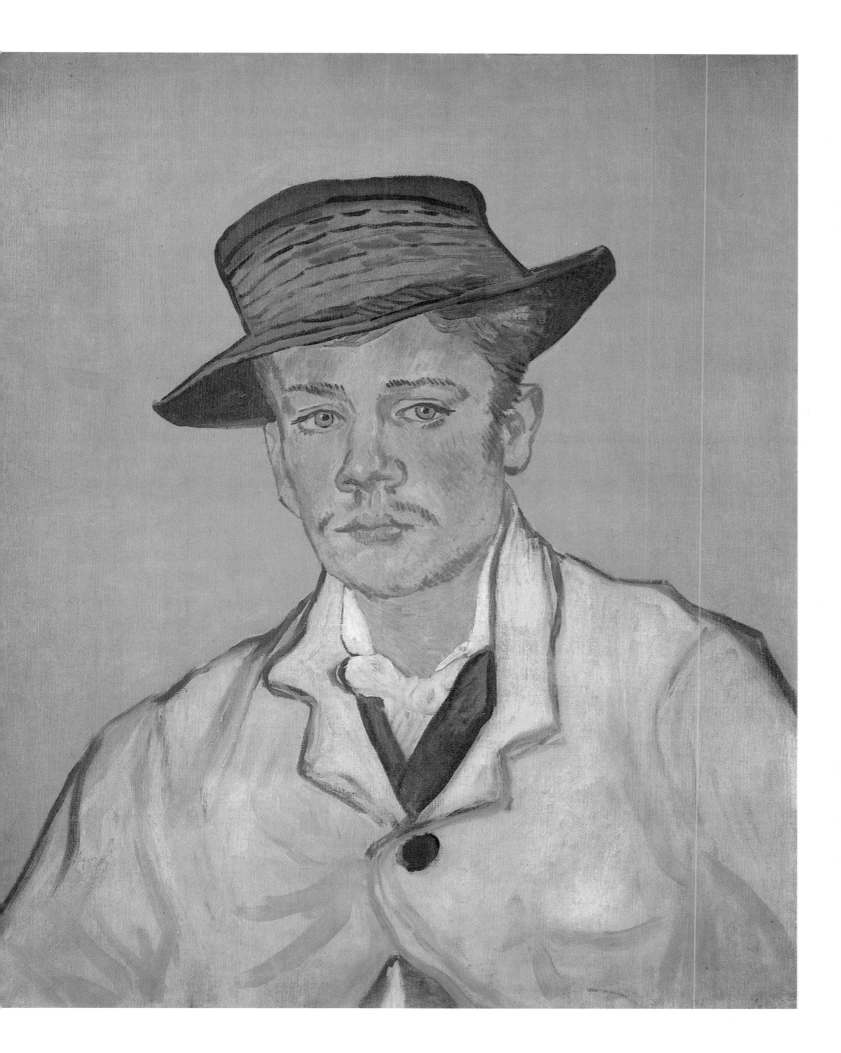

the evocative scenes of harmony he painted as being light years away from the bleakness of his life in Arles. For all his solidarity, he could not help thinking there was something crazy in van Gogh's ideas of life.

In other words: for Gauguin the concept of a unity of Art and Life, which van Gogh had been evolving perfectly naturally, had no validity. No doubt he too believed that that unity might be possible; but in provincial Arles, in that wretched yellow house, there was small prospect of it in his view. The world van Gogh's pictures rendered palpably present by affecting to portray it was a fiction, a fantasy, a product of art and artifice rather than reality. Van Gogh's subsequent life can be seen as a self-fulfilment of these prophetic thoughts. The periods of mental derangement that presently followed did, in a sense, highlight the manic lack of realism in a concept of art that proposed to create a unity of reality and artwork, fact and fiction. If this aesthetic was indicative of a confused mind, then it followed quite consistently that his life would be confused as well. Gauguin was the catalyst. And Gauguin must share the blame for the disastrous events that took place in Arles on the evening of 23 December – at Christmas, of all times.

For some time, Gauguin had been threatening to turn his back on

The Baby Marcelle Roulin
Arles, December 1888
Oil on canvas, 35 x 24 cm
F 440, JH 1639
Washington, National Gallery of Art

The Baby Marcelle Roulin
Arles, December 1888
Oil on canvas, 35 x 24.5 cm
F 441, JH 1641
Amsterdam, Rijksmuseum Vincent van Gogh, Vincent van Gogh Foundation

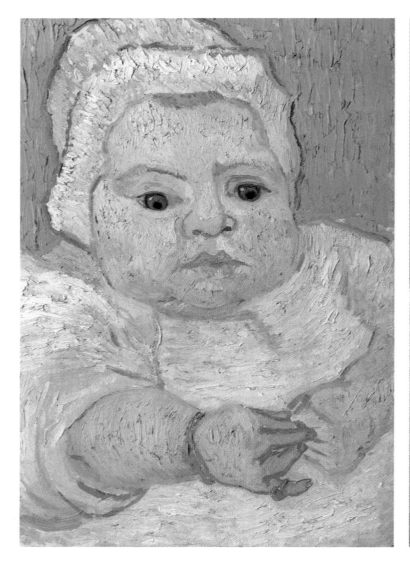

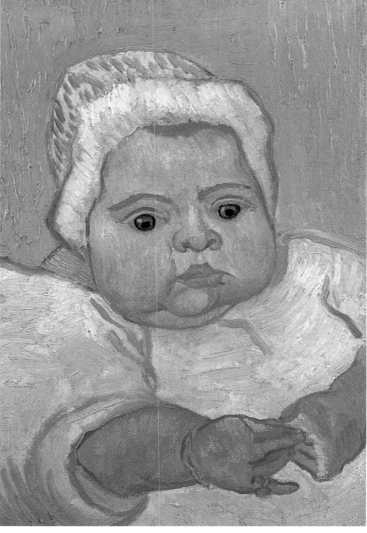

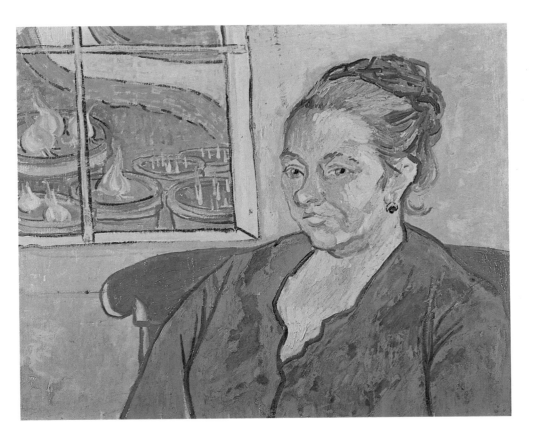

Portrait of Madame Augustine Roulin
Arles, November-December 1888
Oil on canvas, 55 x 65 cm
F 503, JH 1646
Winterthur, Collection Oskar Reinhart

Arles, the artists' community, and his friend. On the evening of 23 December he left the house without saying where he intended to go. Vincent, who had recently burst into Gauguin's room at night to make sure he was still there, suspected that the hour of Gauguin's departure had come – and followed him. Gauguin, hearing a familiar footfall behind him, turned – and caught sight of a distraught van Gogh, doing an about-turn himself and hurrying back to the house. Gauguin now felt disturbed himself, and decided to spend the night in a guesthouse. Next morning, when he set off home, all of Arles was in a state of great excitement.

It transpired that van Gogh, on the night before Christmas Eve, had mutilated himself with a knife: he had cut off his earlobe, wrapped it in a handkerchief, and, in his injured state, gone to the brothel to give the lobe to a prostitute. Once he returned home he lost consciousness through loss of blood. And thus he was found by the police, who had been alerted by the recipient of the bizarre gift. Vincent was taken to the town hospital; and meanwhile Gauguin made himself scarce, without exchanging another word with van Gogh. The two artists were never to meet again.

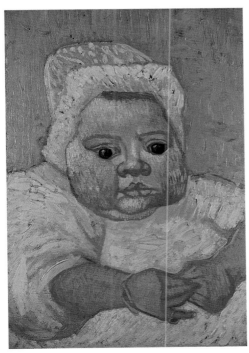

The Baby Marcelle Roulin
Arles, December 1888
Oil on canvas, 36 x 25 cm
F 441a, JH 1640
Vaduz (Liechtenstein),
Fondation Socindec

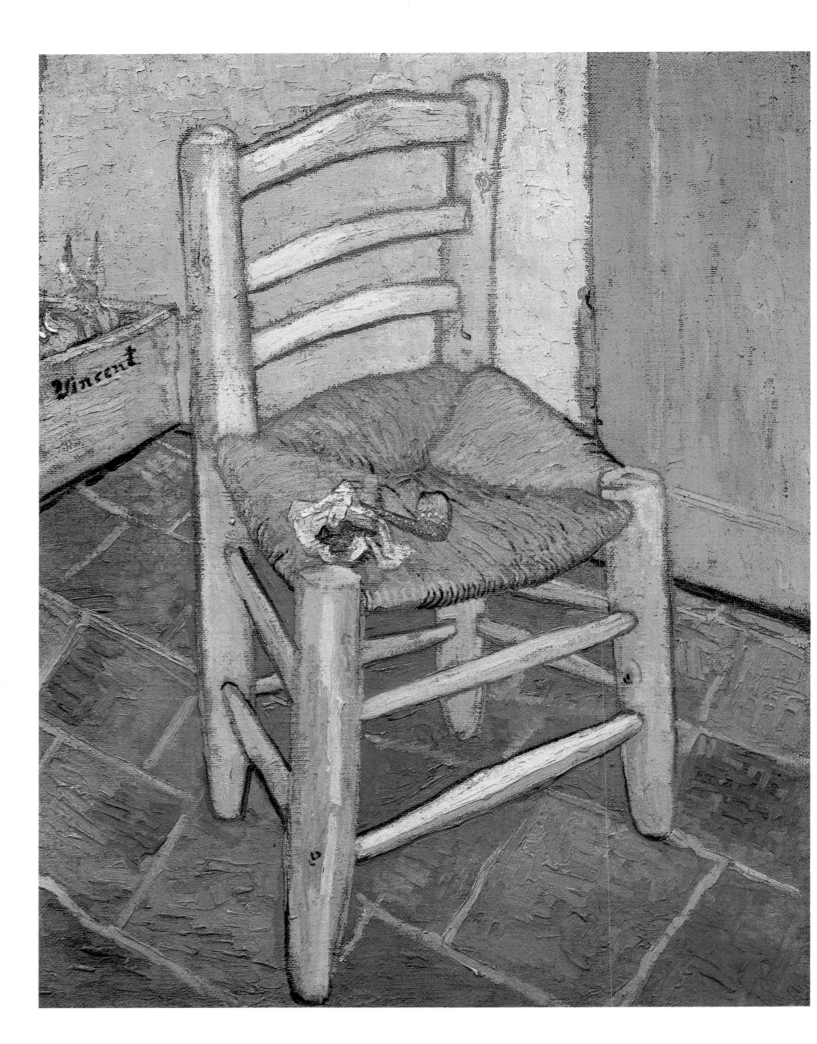

Art and Madness

For centuries, the more entertaining side of art history has been busy telling anecdotes. The tale of the young shepherd Giotto di Bondone, who was drawing sheep in the sand at the very moment the great master Cimabue happened to come by, thus discovering a great talent; or the tale of a contest where the artists competing were all trying to outdo each other in the sophistication of their compositions till Albrecht Dürer drew a freehand circle so perfect that it might have been done with compasses and thus naturally emerged triumphant – for art historians, such tales are the stuff that dreams are made of. The story of van Gogh warring over Truth with a fellow artist till in the end he went mad and cut off his ear is ideal material for another legend of this kind. The collection of tales is forever being added to and embroidered, and suited to the taste of the times; but we should also note that the legends of Giotto, Dürer and van Gogh, and countless others of a similar kind, achieve popularity in direct proportion to the ability of the historical facts to perpetuate the image of true Art's timeless quality. Each of these tales contributes to the public image of the artist.

We do well at this point to question whether it is right to dwell on the well-known story of that fateful evening of 23 December, or indeed to treat his recurring bouts of madness, his suffering, as an artist's typical case. Rather than discuss the stereotype of the wayward artist enduring agonies of the soul, we might look for a different way of explaining van Gogh's conduct. Psychologist and art historian Eckhard Neumann has established that by 1973 no fewer than 93 publications had attempted to diagnose van Gogh's illness. Thirteen of them suggested schizophrenia; the same number, epilepsy; five proposed that both were present in the artist; some inclined to think alcohol the culprit; others, syphilis; and others again were unable to discern pathological causes of any kind. The list of explanations is a lengthy one. Nevertheless, we must take the plunge and add to it.

Plainly, Gauguin's sojourn in Arles was of central importance in van Gogh's breakdown. It was a model case of two strong personalities at war, as it were – fighting to the death. In *Avant et après*, the memoirs he

Vincent's Chair with His Pipe
Arles, December 1888
Oil on canvas, 93 x 73.5 cm
F 498, JH 1635
London, National Gallery

The Smoker
Arles, December 1888
Oil on canvas, 62 x 47 cm
F 534, JH 1651
Merion Station (Pa.), The Barnes
Foundation
(Colour reproduction not permitted)

Paul Gauguin's Armchair
Arles, December 1888
Oil on canvas, 90.5 x 72.5 cm
F 499, JH 1636
Amsterdam, Rijksmuseum Vincent van
Gogh, Vincent van Gogh Foundation

published in 1903, Gauguin claimed to have seen a knife in van Gogh's hand when the other man followed him that night. Was van Gogh thinking of murder? Did he then turn his aggression upon himself, intimidated by the authority of his friend? Or was Gauguin, in memory, trying to evade responsibility by translating a psychological crisis into a literal threat? Their conflict, surely, lay deep within the two men. For both it represented a throwback to a basic existential state. Arguably, there was no more to it than that Gauguin was the more balanced of the two at that time, able to turn his back on the existential either-or by the simple stratagem of departure. What of van Gogh, then? Was he unable to find a way of escape? Gauguin was expressing fundamental doubts concerning van Gogh's art, while Vincent, for his part, clung to his beliefs, defied the other's ideas – and knew there would be a price to pay for his insistence. He knew (and this was why he could not take evasive action as Gauguin could) that the day of reckoning was at hand, a day he had long seen coming.

The concept of reckoning, of paying a price, is typical of the way the materialist 19th century thought. We see it in Darwin's theory of evolution, for instance, where the survival of species is independent of the individual life: by its sacrifice, the individual creature pays what is owed to Nature in return for ensuring the survival of the whole. We see it in the theory of the conservation of energy, which states that the force required for an action must be taken from elsewhere. Fear that the sun would burn out became widespread: surely it would have to pay for the rays it was emitting? In the decadence of the *fin de siècle* there was ample evidence of the idea of payment: progress in human civilization would inevitably (it was believed) exact its tribute from the individual, in the form of neurasthenic debility, the destruction of the soul.

Van Gogh, too, felt that he was forever paying. "The devil take it", he wrote in summer 1888 (Letter 513), "a canvas I paint something on is worth more than an empty canvas. I do not have any greater demands to make, I assure you – but I do have a right and a reason to paint, by God! It has cost me no more than a ruined body and wrecked brain to live as I was able, to live as I had to, as a friend to all humanity. And it has cost you no more than, say, fifteen thousand francs advanced to me." And in Letter 557 (also written before Gauguin's arrival in Arles) we read: "I sense that I must go on creating till I am shattered in spirit and physically drained, precisely because I have no means of ever earning the amount we have spent." And shortly after his breakdown he once again observed (in Letter 571): "My pictures are of no value; though of course they cost me a very great deal, at times even my blood and my brain."

Van Gogh was prepared to make physical reimbursement of the costs he occasioned. It was a textbook case of materialism. In the scales, money could be balanced out with the body. He had taken the risk of being ruined the very moment he invested in his art; and the debts he

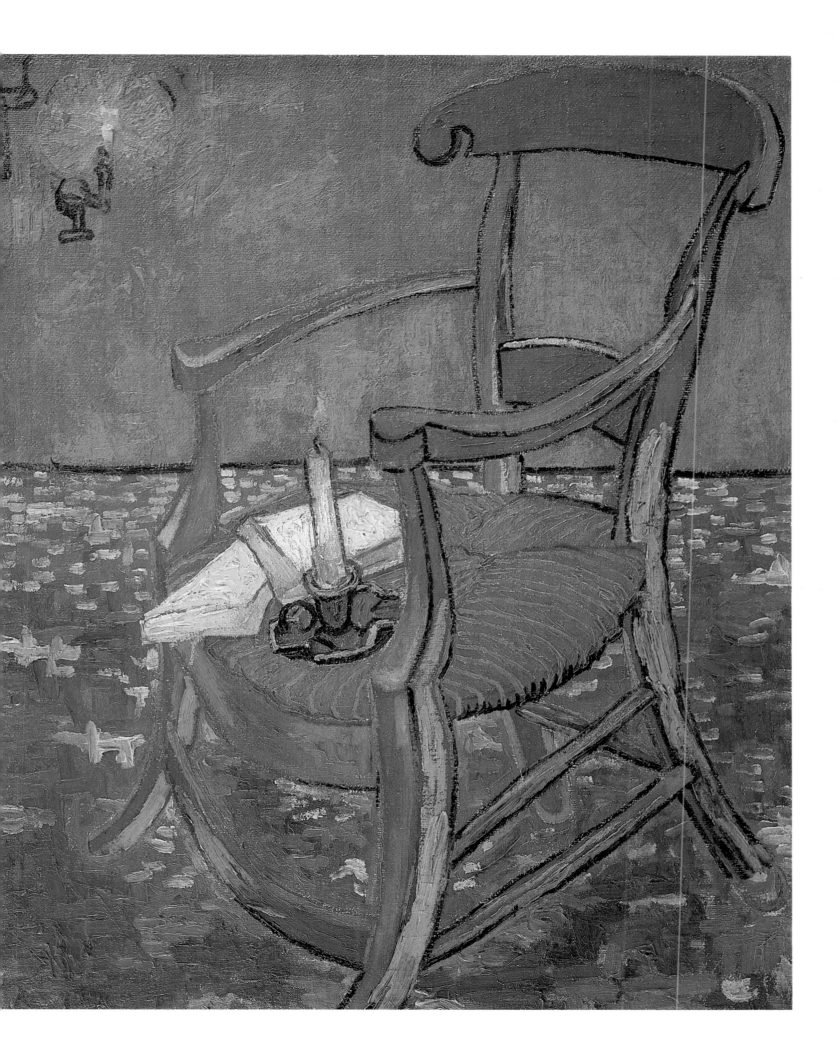

was now burdened with could not be paid off in bank notes. Van Gogh paid with his own natural resources of health and clarity of thought. Even before the Gauguin fiasco he had been well aware of the punishing regimen he was submitting to in order to finance his artistic life. He was consuming large quantities of alcohol, coffee and nicotine: his drugs doubtless benefitted his paintings, but he also realised that he was paying the price of productivity in physical terms. "Instead of eating sufficiently and regularly I kept myself going (they said) with coffee and alcohol." Thus van Gogh described the conclusions of the clinic staff (in Letter 581). "I admit it; but in order to achieve that noble shade of yellow I achieved last summer I simply had to give myself quite a boost."

As if this weren't enough, that December night he went an important step further. The damage caused by his everyday drugs was in a sense reversible, given that whenever his hangover had passed, van Gogh invariably took the decision to mend his ways. But now he did irreparable damage to his body. He was to remain mutilated till the day he died. Gauguin had called his artistry in question more than ever before; and van Gogh felt compelled to raise the stakes. In doing so, he was acting in a way that contemporary theorists would have identified as the mark of the creative personality. Friedrich Nietzsche, for example, had declared "that mutilation, deformity, or serious deficiency in an organ often occasions unusual development in another organ, since it has to

Portrait of the Postman Joseph Roulin
Arles, November-December 1888
Oil on canvas, 65 x 54 cm
F 434, JH 1647
Winterthur, Kunstmuseum Winterthur

Portrait of a Man
Arles, December 1888
Oil on canvas, 65 x 54.5 cm
F 533, JH 1649
Otterlo, Rijksmuseum Kröller-Müller

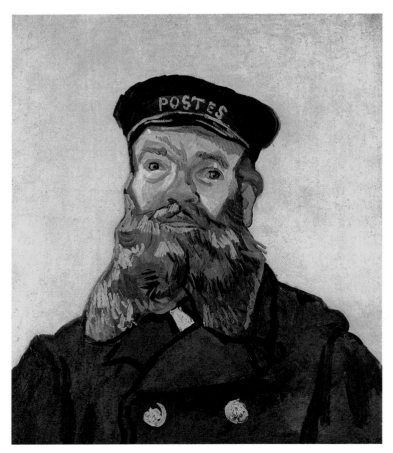

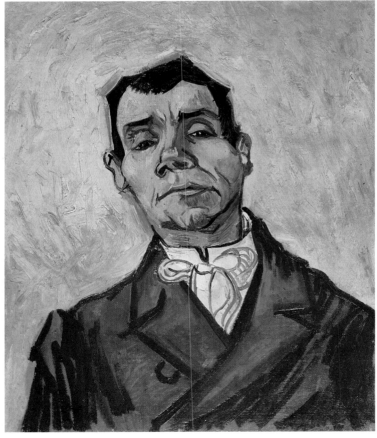

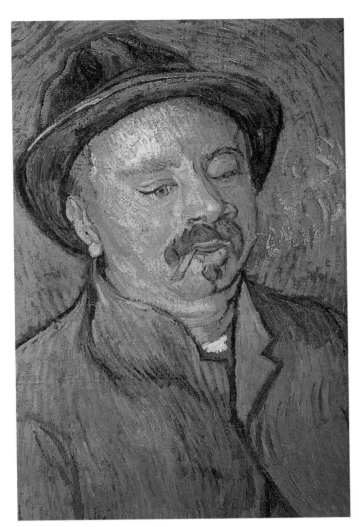

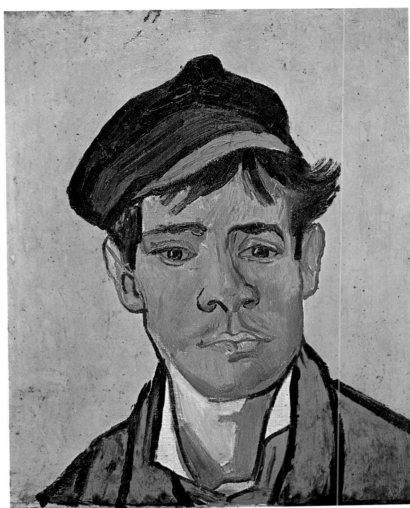

Portrait of a One-Eyed Man
Arles, December 1888
Oil on canvas, 56 x 36.5 cm
F 532, JH 1650
Amsterdam, Rijksmuseum Vincent van
Gogh, Vincent van Gogh Foundation

Young Man with a Cap
Arles, December 1888
Oil on canvas, 47.5 x 39 cm
F 536, JH 1648
Private collection

perform its own task and that of another. This is the origin of many a salient talent." The earlobe van Gogh cut off was the price he paid for his productivity – and he was resolved to keep up his output. He was subsequently to describe the hallucinations he experienced during his bouts of madness. He heard noises and saw visions: "It was hearing and seeing at once in my case", he wrote in Letter 592. If van Gogh mutilated his ear, is it so very wrong to imagine that that sacrifice was subconsciously intended as a way of saving the organ a painter can never do without – his eye?

In trying to explain his behaviour, it would be wrong to imply that van Gogh was fully aware of what he was doing. Nevertheless, ideas were then in the air which (inspired by the theory of the conservation of energy, and by the balance of income and expenditure) ascribed to those with any kind of physical disability increased creative potential. Van Gogh found it suited his own purposes very nicely if he lived as this notion implied. "The pearl is the oyster's sickness, and a style may thus be the product of deep-seated pain", wrote Gustave Flaubert. Van Gogh also availed himself of the metaphor of the pearl of price: "It is no easier [...] to paint a good picture than to find a diamond or a pearl [...] In the midst of my suffering this thought of the pearl came to me, and I would

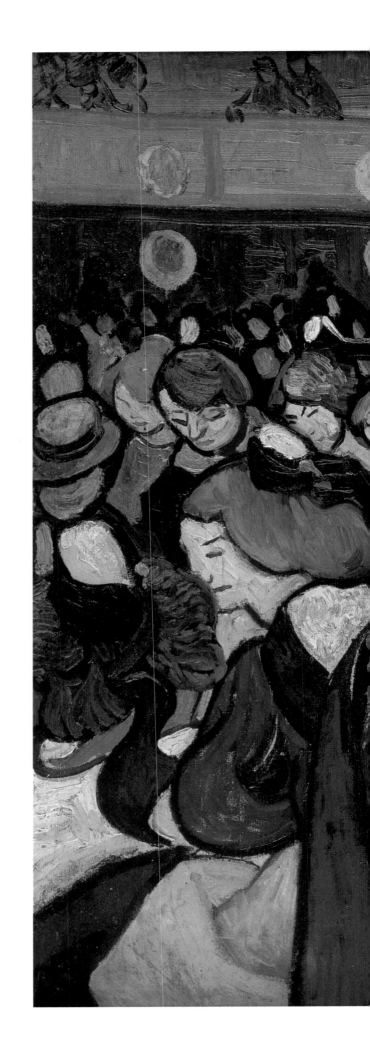

The Dance Hall in Arles
Arles, December 1888
Oil on canvas, 65 x 81 cm
F 547, JH 1652
Paris, Musée d'Orsay

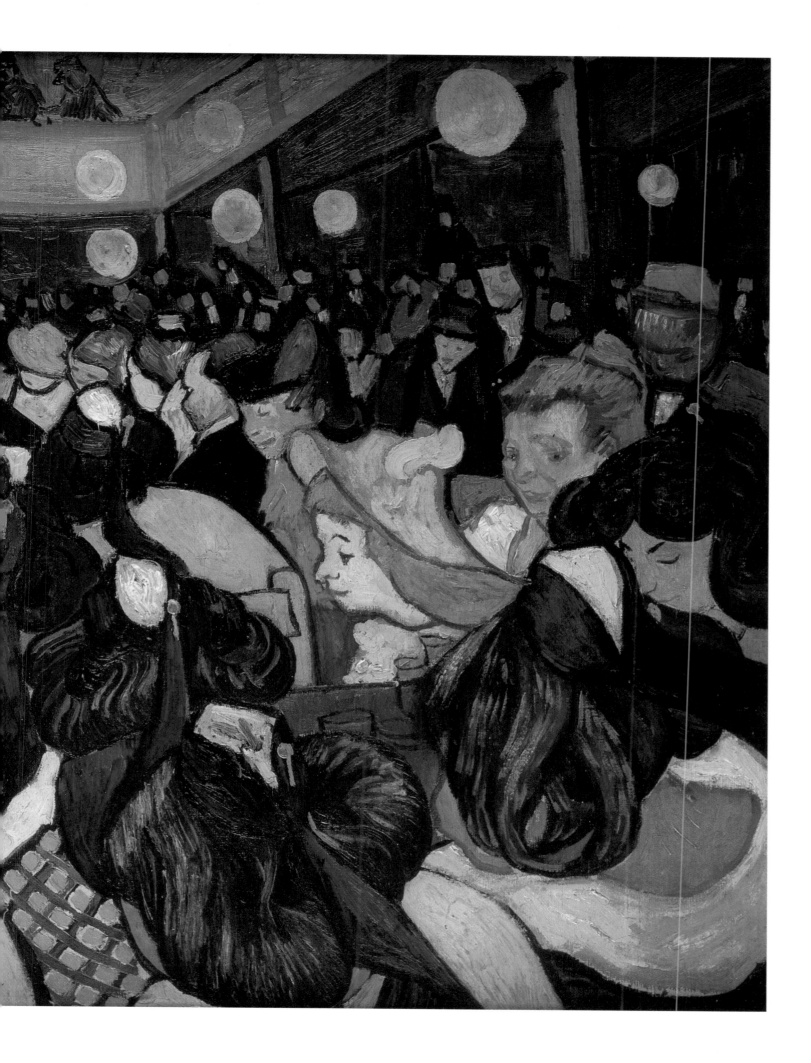

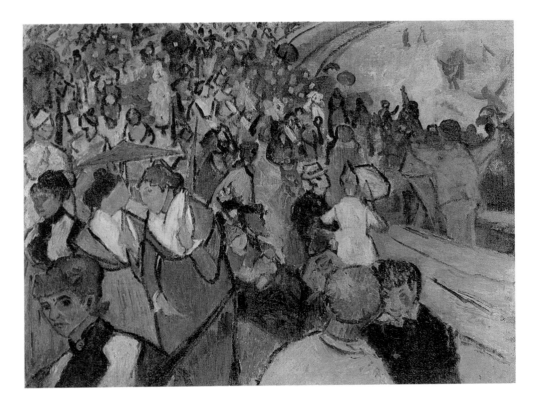

Spectators in the Arena at Arles
Arles, December 1888
Oil on canvas, 73 x 92 cm
F 548, JH 1653
Leningrad, Hermitage

not be in the least surprised if it afforded you comfort in times of dejection, too." (Letter 543) In Arles, van Gogh was as involved in debate of aesthetics and artistic concepts as ever. He took part with all his characteristic verve, and, taking things too far as so often, he extrapolated a principle from the discussion and applied it to his own life.

What complicated his novel action was the fact that he took the bloody earlobe to the brothel. Van Gogh seemed to be thinking that his deed would be met with understanding there and he would receive a

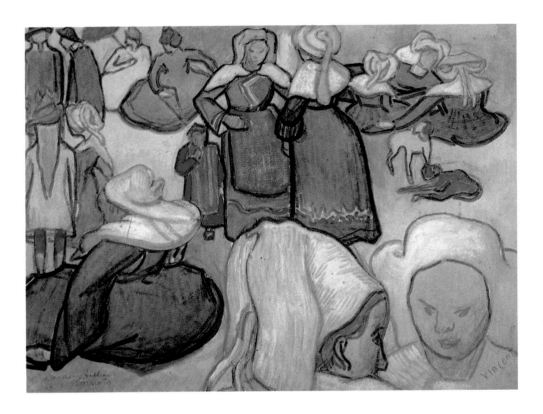

Breton Women (after Emile Bernard)
Arles, December 1888
Water colour, 47.5 x 62 cm
F 1422, JH 1654
Milan, Civica Galleria d'Arte Moderna

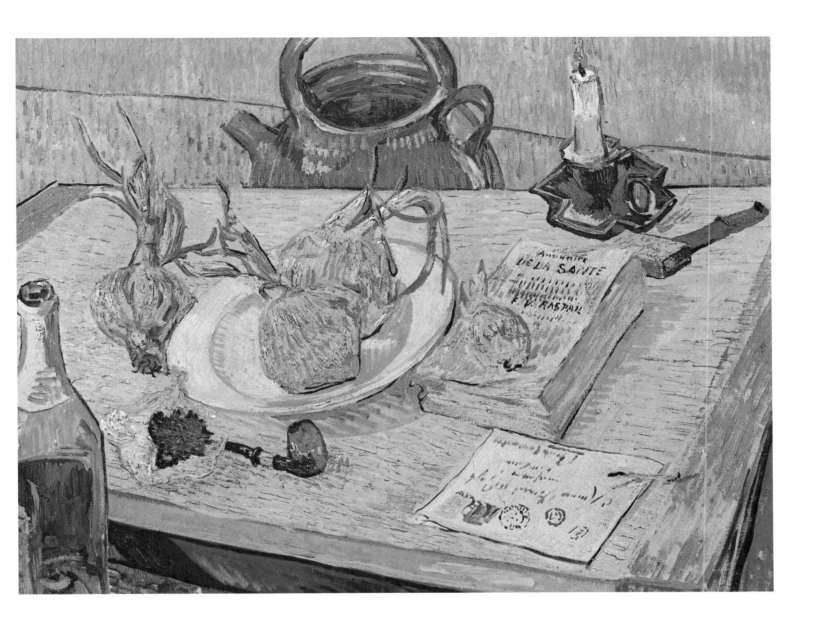

Still Life: Drawing Board, Pipe, Onions and Sealing-Wax
Arles, January 1889
Oil on canvas, 50 x 64 cm
F 604, JH 1656
Otterlo, Rijksmuseum Kröller-Müller

sympathetic response. Nature has made the artist and the whore accomplices: "Our friend and sister is assuredly banished and rejected by society just as you and I are as artists," he told Bernard (Letter B14); the idea is a characteristic one in the 19th century. "The artist", wrote Carl Ludwig Fernow, "is merely tolerated. Like the Jews, he lacks the rights of the ordinary citizen. The academies are his ghetto. The prostitute is his female counterpart." Mutilated, bearing his trophy, van Gogh got himself off to the prostitutes' ghetto, the one place that would not close its doors on him. (It is no coincidence that the crippled Toulouse-Lautrec felt most at ease in the brothels of Paris during the same period.) Vincent wanted to be a monk "who visits a brothel once a fortnight". The artist's cell and the house of pleasure were the retreats to which the loner (though it was not what he would have chosen) could withdraw.

If the ladies of the brothel had grasped van Gogh's problem, the events of 23 December would have remained private in character. But they notified the police; and it was they who mobilized the crowd that gathered outside the yellow house the following morning. There was

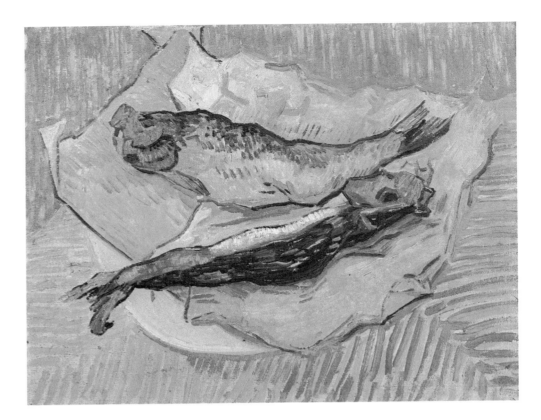

RIGHT:
Crab on Its Back
Arles, January 1889
Oil on canvas, 38 x 46.5 cm
F 605, JH 1663
Amsterdam, Rijksmuseum Vincent van
Gogh, Vincent van Gogh Foundation

**Still Life: Bloaters on a Piece
of Yellow Paper**
Arles, January 1889
Oil on canvas, 33 x 41 cm
F 510, JH 1661
Private collection

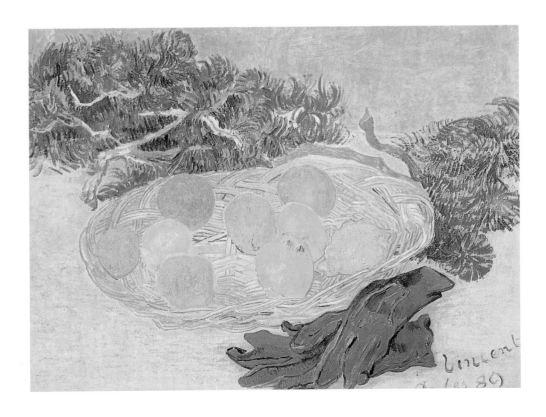

**Still Life: Oranges, Lemons and Blue
Gloves**
Arles, January 1889
Oil on canvas, 47.3 x 64.3 cm
F 502, JH 1664
Upperville (Va.), Collection
Mr. and Mrs. Paul Mellon

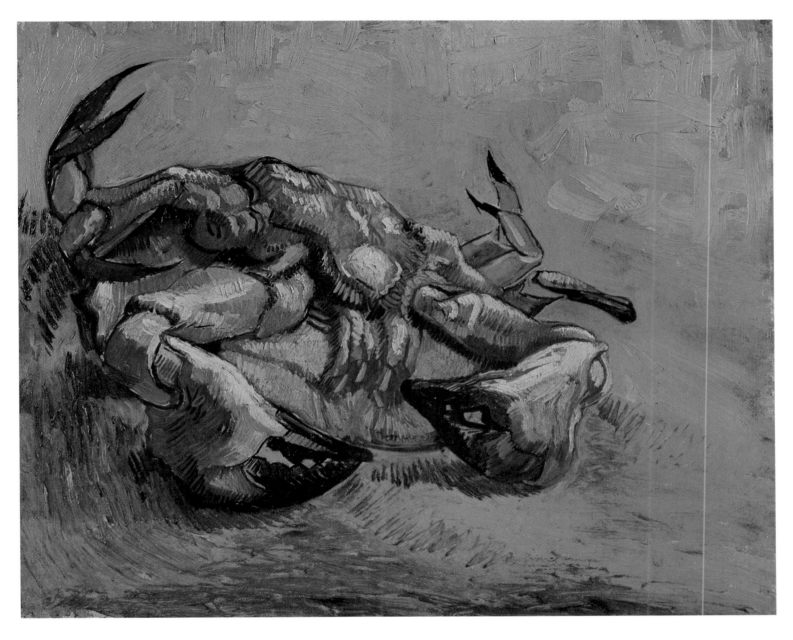

Still Life: Two Red Herrings
Arles, January 1889
Oil on canvas, 33 x 47 cm
F 283a, JH 1660
France, Collection Francis Junker

Two Crabs
Arles, January 1889
Oil on canvas, 47 x 61 cm
F 606, JH 1662
Whereabouts unknown

Still Life: Vase with Fourteen Sunflowers
Arles, January 1889
Oil on canvas, 100.5 x 76.5 cm
F 457, JH 1666
Tokyo, Yasuda Fire & Marine
Insurance Company

Still Life: Vase with Twelve Sunflowers
Arles, January 1889
Oil on canvas, 92 x 72.5 cm
F 455, JH 1668
Philadelphia, The Philadelphia Museum
of Art

nothing else they could do, of course, and their action probably prevented Vincent from bleeding to death. Hitherto his crises as an artist had remained personal, or had been expressed in his countless letters and thoroughly individual paintings. They had been of no concern to the public whatsoever. But now events were being acted out on a public stage, and society dictated that he would play the part which, in a sense, he was made for. Van Gogh was now a lunatic.

Two weeks later, van Gogh was discharged from hospital. He had not been hospitalized on grounds of insanity but in order to stop the loss of blood caused by the wound. He returned to his house, resumed painting, and continued to see a small number of acquaintances in the neighbourhood. But a month later, at the beginning of February 1889, the case entered a new phase. Vincent suffered a bout of paranoia, was hospitalized once again, and remained in medical care for ten days. When he was discharged once more, it turned out that his incipient persecution mania had perhaps not been as ill-founded as it appeared. The good citizens of Arles had petitioned the authorities to lock up van Gogh on the grounds that he was a "public menace". In late February, he was hospitalized again. Of perfectly sound mind, he found himself under lock and key, with no books, nothing to paint with, not even his pipe. He was in a prison. But, since he had been labelled a lunatic, his solitary confinement was termed hospitalization. *Suicide by Society* was the

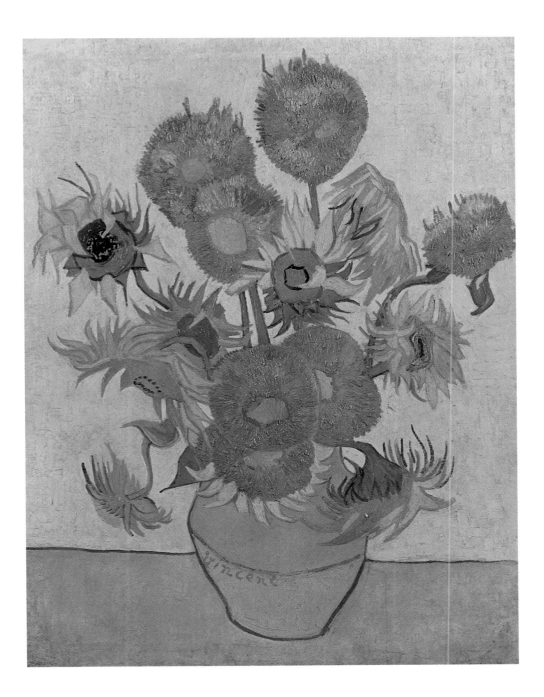

Still Life: Vase with Fourteen Sunflowers
Arles, January 1889
Oil on canvas, 95 x 73 cm
F 458, JH 1667
Amsterdam, Rijksmuseum Vincent van
Gogh, Vincent van Gogh Foundation

title of Antonin Artaud's prose study of van Gogh. But before Vincent could be driven to suicide, he first had to be mad. So now he personified a different, age-old stereotype: that artistry and insanity are synonymous.

"Great wits are sure to madness near allied", Dryden had written, and the Romantics everywhere took up the theme. In the early 19th century, the German philosopher Arthur Schopenhauer insisted on the affinity of poetry and madness. To Schopenhauer's classicist way of thinking, all intensity, subjectivity, and non-rational dwelling on pain and sadness were wrong-headed. These phenomena could not be banished from the real world; but they could at least be placed on the sidelines, as the hallmark of the outsider, the proof of unsuitability for social intercourse. Once the word "genius" was brought into play, the realm of the pathological came to mind. Schopenhauer took for granted the "influence of a Higher Being on the individual, intermittently taking posses-

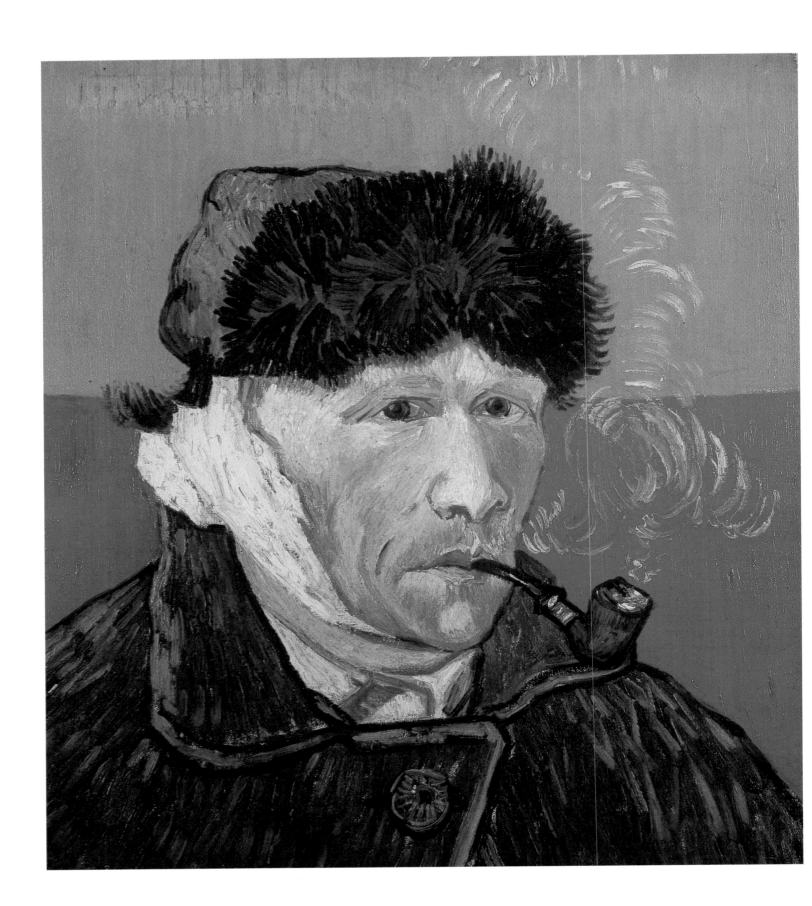

sion of him". The Romantic artist, his soul full of existential disquiet, was the sacrificial victim *par excellence*; and from Blake and Hölderlin to Schumann there was a good deal of talk about madness. The greatest of them all, Beethoven and Goya, had serious problems, too. As Schopenhauer put it, restating Dryden and a tradition stretching back to antiquity: "Genius and madness have a common ground where they border and indeed overlap."

This idea gave society a perfect way of classifying an oddball such as van Gogh, carrying his easel all over the place, drinking, going to the brothel, and painting things that no one wanted to hang in his living room. Philistine common sense always has a taste for philosophical insight that panders to society's prejudices. Schopenhauer had meant his theory as a serious contribution to contemporary aesthetic debate and had certainly not intended it as an excuse for the building of lunatic asylums: "To be of no use is an essential characteristic of the work of genius", he wrote. "That is its patent of nobility." But the 19th century loved calculation and thoughts of cost and payment, and the artistic life was seen as a provocation. The best thing artists could do was disappear from view.

Van Gogh shared the ideas of his times, but he was well able to adapt them to his own advantage. In a sense, his own sacrifice was thus rendered objective. He was now paying for his creativity with periods of delirium. And now, consistently enough, his physical health began to improve; the strain was transferred from his organic to his mental constitution. Furthermore, van Gogh opted for the exiled position society was manœuvring him into, a position which defined him as an outsider and which involved inhumanity and violence, but which nevertheless was one in which no one could ask any more questions concerning the meaning of what he did – questions that had in any case long tormented him. Van Gogh made his peace with society – and voluntarily entered the asylum at Saint-Rémy, in a spirit of apparent selflessness. Van Gogh had officially been designated a *peintre maudit*, so to speak; and now his *weltschmerz* discovered a safety valve. So-called lunatics can call nothing their own – except the suffering they are caused, by the real world and by their own natures. That suffering becomes their defining characteristic. Society, for its part, cannot conceive that life beyond its orderly regimen might be worth living. Van Gogh had struggled with his own inability to conform, and had endured the agonies that resulted; and now non-conformity became a core feature of his role as madman.

Passages from his letters indicate that van Gogh was well aware of the processes by which he was labelled mad. He saw clearly that the scandal he had occasioned would provide superb publicity for the cause of modern art: "From the very outset I have had malicious enemies here", he wrote (Letter 580); "but all the uproar will naturally be of benefit to

Self-Portrait with Bandaged Ear and Pipe
Arles, January 1889
Oil on canvas, 51 x 45 cm
F 529, JH 1658
Chicago, Collection Leigh B. Block

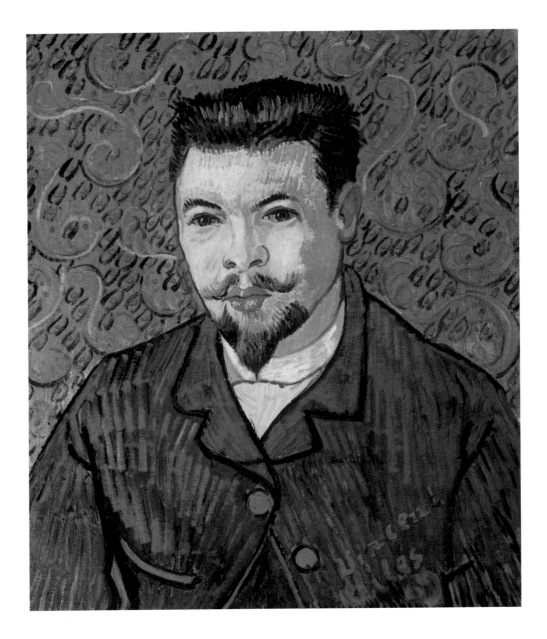

Portrait of Doctor Félix Rey
Arles, January 1889
Oil on canvas, 64 x 53 cm
F 500, JH 1659
Moscow, Pushkin Museum

'Impressionism'." And he speculated whether his abilities as an actor (as it were) would be good enough: "I mean to enter into my calling as lunatic with as much composure as Degas practises his as a notary. But I do not feel I quite have the strength that is needed to play such a part." (Letter 581) It was fully apparent to him that he could serve to warn middle-class society of its own inherent dangers: "The terrible superstition certain people have concerning alcohol, people who pride themselves on never drinking or smoking – we are of course commanded not to lie or steal, etc., or to commit other greater or lesser crimes, and it is too hard to have nothing but virtues in a society we have our roots in, whether it is good or bad." (Letter 585)

There is no doubt that van Gogh's bouts of insanity were genuine. He suffered fits of paranoia and impenetrable depression. And of course there were serious defects in his spirit. But (and this is the point) those defects ought to interest us from an aesthetic rather than a psychiatric point of view. Van Gogh had inherited the Romantic sickness and

La Berceuse (Augustine Roulin)
Arles, January 1889
Oil on canvas, 93 x 73 cm
F 506, JH 1670
Chicago, The Art Institute of Chicago

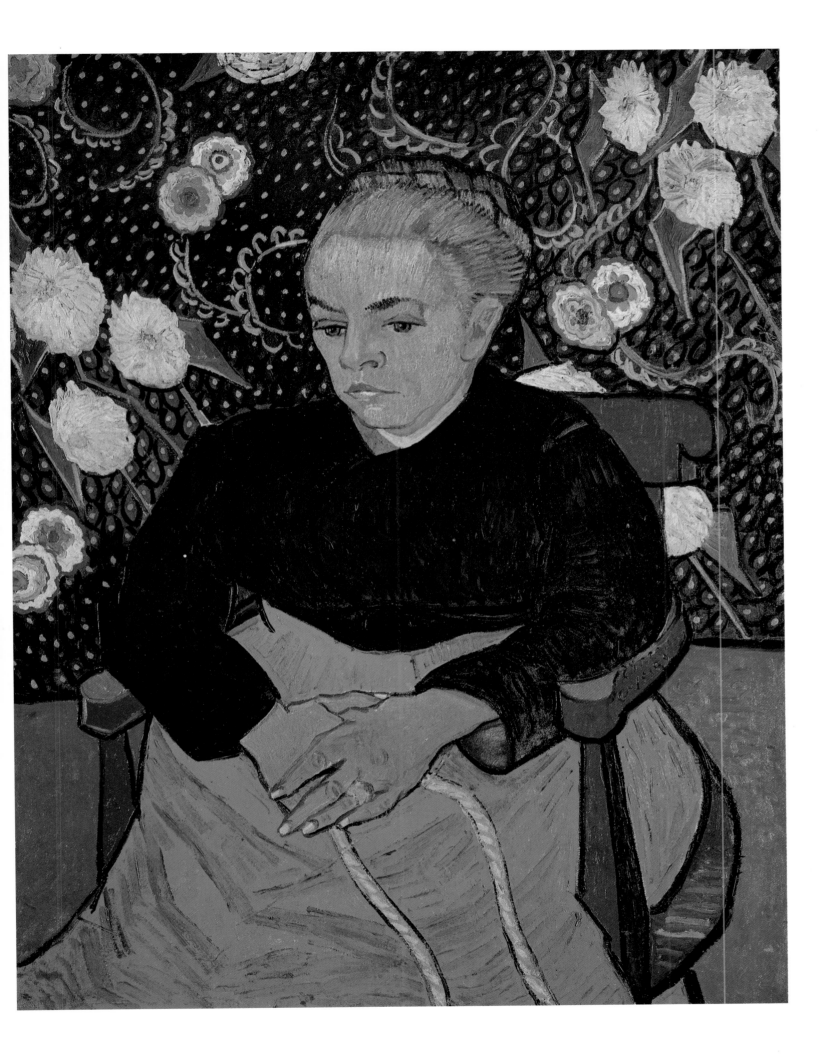

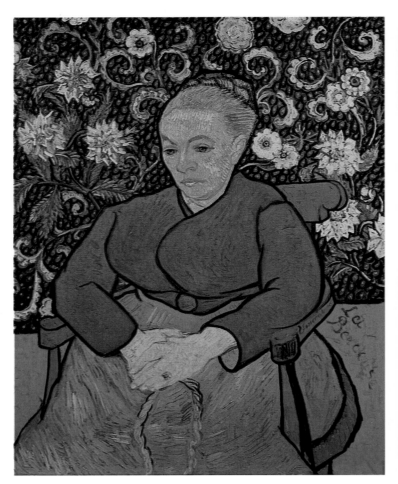

weltschmerz and suffered the ills of his time. His recurring bouts of madness were a way of evading the overpowering experience of solitude, a solitude born of his hypersensitive responses to the strangeness and contingency of Life. Van Gogh's fits were moments of convulsive inner unity that could scarcely be comprehended by outsiders and which the artist himself was hard put to describe: "Hours when the Veil of Time and Immutability seemed to be raised for a moment", was the expression he used in a letter to Theo (582).

What was uniquely individual, his own existential experience, and the timeless pattern were inextricably linked. "There are moments when I am shaken by enthusiasm or lunacy or a visionary gift like a Greek oracle", he wrote. (Letter 576) The ancient quality of enthusiasm (characteristic of the artistic maker) and its modern counterpart of madness were united in the visionary gift of the prophet or oracle. Van Gogh was aware of the irony in his fate, that ironic twist which prevented him from experiencing his madness solely as an individual. There had always been someone before him, some passage in literature, some picture or piece of music, that expressed the things that had reduced him as well to this extremity. Van Gogh could identify with the stereotype. This conscious awareness is at the heart of his individual greatness and is also the hallmark of his role in the second wave of Romanticism. In a sense, van Gogh was now living through something

La Berceuse (Augustine Roulin)
Arles, December 1888
Oil on canvas, 92 x 73 cm
F 504, JH 1655
Otterlo, Rijksmuseum Kröller-Müller

La Berceuse (Augustine Roulin)
Arles, January 1889
Oil on canvas, 93 x 74 cm
F 505, JH 1669
Rancho Mirage (Cal.), Collection
Mr. and Mrs. Walter H. Annenberg

La Berceuse (Augustine Roulin)
Arles, February 1889
Oil on canvas, 92.7 x 72.8 cm
F 508, JH 1671
Boston, Museum of Fine Arts

La Berceuse (Augustine Roulin)
Arles, March 1889
Oil on canvas, 91 x 71.5 cm
F 507, JH 1672
Amsterdam, Rijksmuseum Vincent van
Gogh, Vincent van Gogh Foundation

that Art had already mapped out for him. He was converting a literary cliché into a fact of life. He was his own legend. And this, of course, added a new slant to the unity of Art and Life, since both could be subsumed into previous experience in the history of mankind. It was only in madness that a true unity was established, beyond the petty battles of everyday life, in imitation of the great who had gone before. Imitation, too, of Monticelli the painter, who was said to have drunk himself mad. And of course van Gogh had his comrades in insanity: Nietzsche, August Strindberg, Arthur Rimbaud.

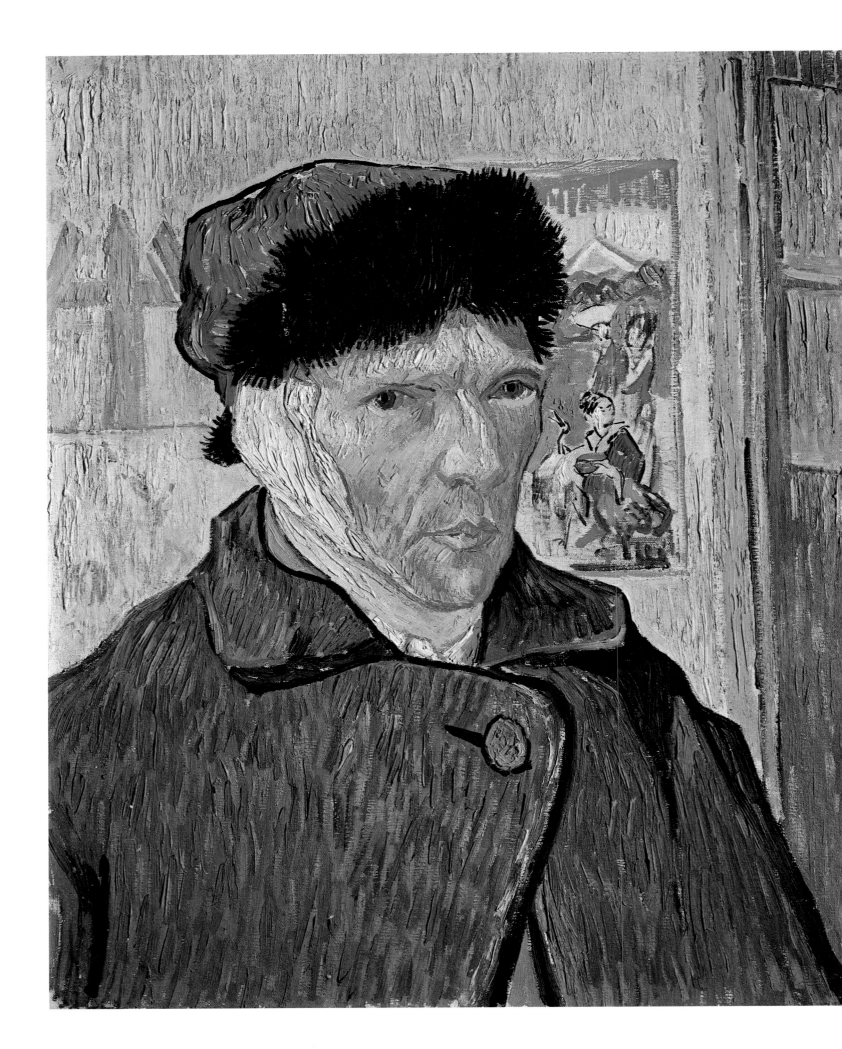

The Supportive Power of Pictures
January to May 1889

"As far as I can judge", van Gogh wrote to his brother (Letter 580), attempting to reassure him, "I am not actually mentally ill. You will see that the pictures I painted in the period between my two attacks are calm and no worse than others I have done. Having no work to do is more serious than its tiring effects." Here we see the artist himself engaging in the debate that has preoccupied critics ever since: do the works themselves betray the fact that they were painted by a man struggling with bouts of mental instability? The critics' answers to this question have often been curious, to say the least; in the chapter on van Gogh's stay at Saint-Rémy (see below) we shall examine some of them. But after what has been said already it should be clear that van Gogh's work was quite naturally and inevitably influenced by his "insanity". It does *not*, however, share any of the features of the work schizophrenic patients occasionally produce, which is sometimes labelled art; van Gogh's creative work was as carefully conceived and artfully constructed as it had ever been. What *is* true is that the work van Gogh painted from the end of 1888 onwards added a whirling, spiralling, undulating use of line to his emphatic use of colour; attempted to articulate the mania the painter felt was besetting him; no longer took its bearings from utopias of any kind; and was more compact and personal, though at times its gesticulatory qualities seem forced. But we shall return to these points later.

Van Gogh tried to reassure Theo by claiming he was much as he had always been; and it was true that the more striking changes in his nature were only to become apparent at Saint-Rémy, when van Gogh deliberately adopted his "lunatic" role. Nevertheless, the traces the bouts of madness had left in van Gogh's spirit were perfectly apparent in his modest output of the last months in Arles. He took four subjects in his attempt to come to terms with affairs. First, he quite specifically tackled the events of 23 December; second, he tried to express the sense of confinement and the resulting claustrophobia in his pictures; third, his need to establish trust and familiarity by means of his paintings acquired a new urgency; and, finally, van Gogh returned to some of the methods of his early days, especially his habit of copying, which now became of central importance.

Self-Portrait with Bandaged Ear
Arles, January 1889
Oil on canvas, 60 x 49 cm
F 527, JH 1657
London, Courtauld Institute Galleries

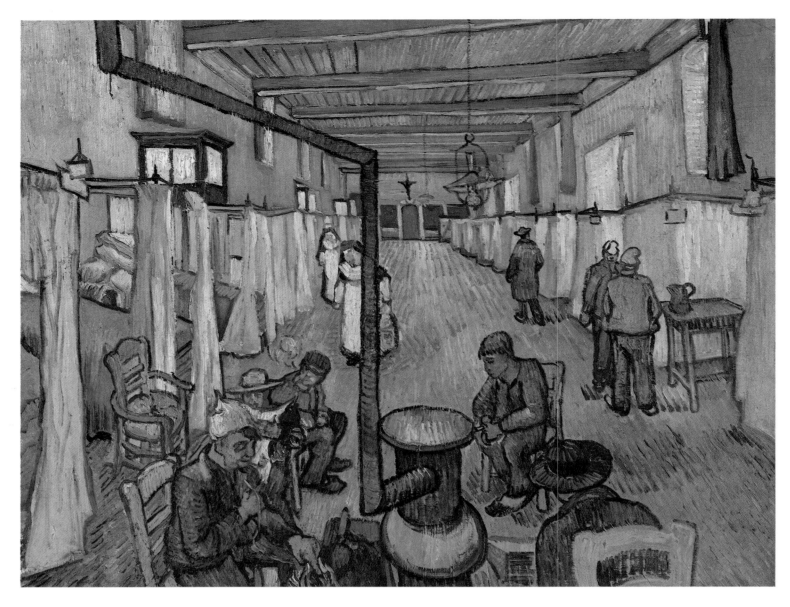

The tranquillity, the consolation and the life expressed by everyday things became a particular concern, and van Gogh steadily aimed to translate the plurality of things into a coherent visual texture (cf. p. 473). In arranging the objects he selected as motifs, he bore in mind what was helpful and pertinent in his present condition. We see François Raspail's *Annuaire de la Santé*, a medical self-help annual; onions (which Raspail recommended for sleeplessness); his beloved pipe and tobacco pouch; a letter addressed to the artist, standing for the affection and support of his distant brother; a lighted candle, defiantly stating that the flame of life has not been extinguished yet; red sealing-wax beside it, attesting confidence that he will remain in touch with his friends; and an empty wine bottle to suggest he has given up alcohol. In compositional terms, the principle of juxtaposition is none too successful. Van Gogh is simply recording in meticulous detail an emotional affection for the things that afforded him consolation, that gave promise of happiness and instilled new optimism and hope in him, a hope he was trying to preserve by expressing it on canvas. The individual symbolism in his motifs be-

Ward in the Hospital in Arles
Arles, April 1889
Oil on canvas, 74 x 92 cm
F 646, JH 1686
Winterthur, Collection Oskar Reinhart

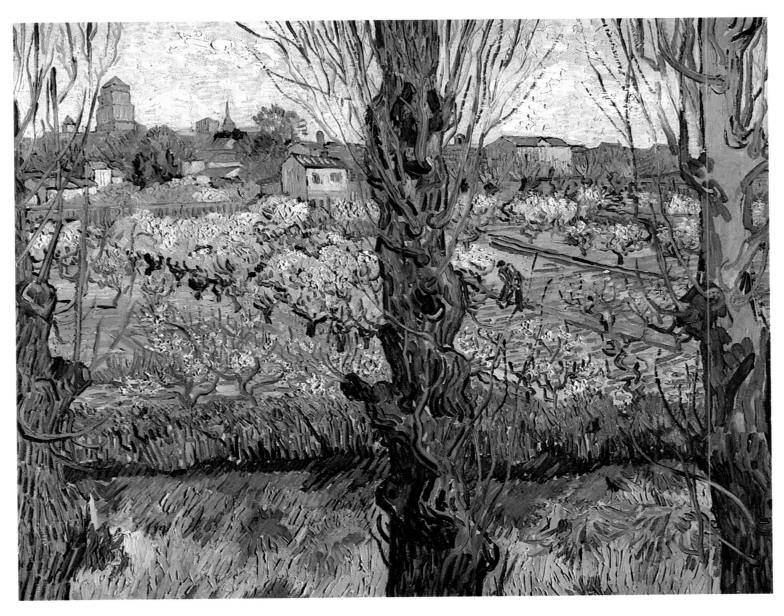

Orchard in Blossom with View of Arles
Arles, April 1889
Oil on canvas, 72 x 92 cm
F 516, JH 1685
Munich, Bayerische Staatsgemäldesammlungen, Neue Pinakothek

comes more significant in proportion to the diminishing reference to the objective outside world. Van Gogh's objects are no longer first and foremost the everyday, functional things they seem to be; now their magical qualities are foregrounded.

Then there are three pictures that express the trials and sorrows of isolation: *Orchard in Blossom with View of Arles* (above), *The Court-yard of the Hospital at Arles* (p. 495) and *Ward in the Hospital at Arles* (p. 486). Weeks of detention separate the reticently cheerful tone of the still life from the mild resignation of these works. Van Gogh's subject is his experience of confinement (though the style of the paintings remains unaffected at this point). *Orchard in Blossom with View of Arles* is a masterpiece of calm, sensitive examination of the artist's predicament. It merely hints (though it does so eloquently) at the facts of a man's life when he has been labelled a "public menace". The attractive view of the town, and the blossoming fruit trees with their promise of a fine future, are seen beyond three gnarled poplar trunks. Unlike the tree trunks in the Alyscamps pictures (pp. 444–45), these verticals have no

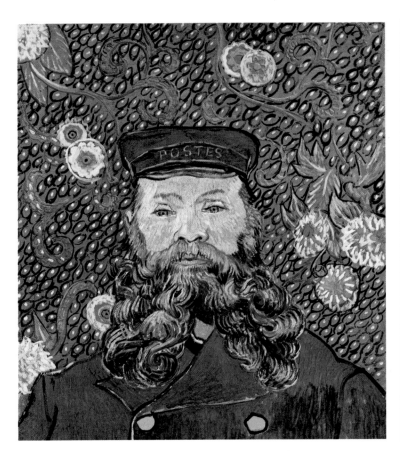
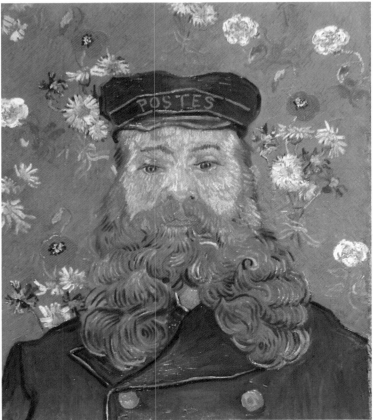

qualities of aesthetic subtlety: they are not so much a compositional device as barriers, marking the boundary beyond which the artist may not go. Placing bars across the line of vision was an approach he had learnt from Gauguin, and it is not offered as a compositional innovation; rather, it quite literally expresses the claustrophobia van Gogh inevitably experienced in solitary confinement. The springtime grace of Nature and the town only made his own situation worse. He had no way of escape. The utopian vision of a better life (which lies concealed in the garden and which van Gogh had been able to articulate only a year before) had now become inaccessible. Van Gogh was always concerned to establish spatial continuity in his paintings, but here he broke with his own convention and brought the different spatial levels up against each other with a jolt, destroying any bridges that might have linked foreground and background.

Ever since his first months in Paris, the digger working in the fields had disappeared from van Gogh's repertoire of figures and had been replaced by others engaged in more pleasant pursuits – a lady out for a stroll or a couple arm in arm. Now his emblematic figure of bygone days made a reappearance. We see a man at work in the orchard, using a spade to turn the utopian seed into the soil, seed that will never grow. "In the sweat of thy brow shalt thou eat bread" (Genesis 3, 19): we recall the religious meaning van Gogh had always associated with the symbolic digging man. For two years he had been planning a possible, more positive life. The details he added in his studio expressed his hopes of

Portrait of the Postman Joseph Roulin
Arles, April 1889
Oil on canvas, 64 x 54.5 cm
F 436, JH 1675
New York, The Museum of Modern Art

Portrait of the Postman Joseph Roulin
Arles, April 1889
Oil on canvas, 65 x 54 cm
F 439, JH 1673
Otterlo, Rijksmuseum Kröller-Müller

Portrait of the Postman Joseph Roulin
Arles, April 1889
Oil on canvas, 67.5 x 56 cm
F 435, JH 1674
Merion Station (Pa.), The Barnes
Foundation
(Colour reproduction not permitted)

that possibility. The reappearance of the digger foregrounds toil and suffering once again. *Orchard in Blossom with View of Arles* is almost too explicit in the way it demolishes van Gogh's hopes: the traumatic intensity has even ousted Vincent's love of paradox.

In *Still Life: Drawing Board, Pipe, Onions and Sealing Wax* (p. 473) van Gogh, needing consolation and new confidence, had ventured very close to his subjects. And in some of the nature studies he did that spring of 1889 he was practically producing close-ups of the green world: *Two White Butterflies* (below), *Grass and Butterflies* (p. 498), *Rosebush in Flower* (p. 498), *Clumps of Grass* (p. 492) and *A Field of Yellow Flowers* (p. 493). These are early examples of what was to be a major characteristic of his work at Saint-Rémy: an extremely close-up view coupled with his customary reverence for natural creation. "The reassuring, familiar look of things" (Letter 542) had always been one of his main concerns, and he had often positioned his canvas immediately in front of his subjects, with everything in reach. Van Gogh did not change in this respect; indeed, he now took proximity to such extremes that spatial

Two White Butterflies
Arles, Spring 1889
Oil on canvas, 55 x 45.5 cm
F 402, JH 1677
Amsterdam, Rijksmuseum Vincent van
Gogh, Vincent van Gogh Foundation

View of Arles with Trees in Blossom
Arles, April 1889
Oil on canvas, 50.5 x 65 cm
F 515, JH 1683
Amsterdam, Rijksmuseum Vincent van
Gogh, Vincent van Gogh Foundation

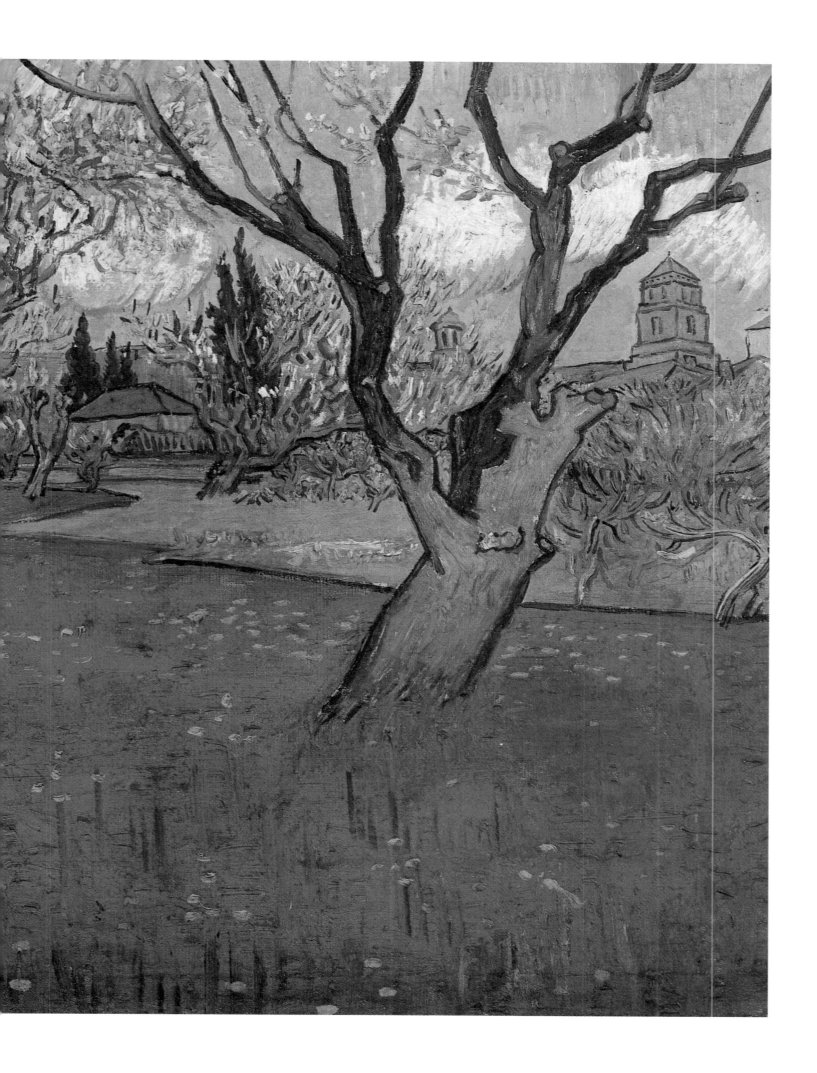

Clumps of Grass
Arles, April 1889
Oil on canvas, 44.5 x 49 cm
F 582, JH 1678
Japan, Private collection
(Sotheby's Auction, London, 3. 12. 1975)

values became very difficult to grasp. But what *was* new was the application of this method to Nature, and the emphasis he placed on vigour and growth.

Clumps of Grass (above) is an extreme example of this. It looks as if two of van Gogh's tried and tested principles were being used to achieve effects that are the very opposite of what might normally be expected. The close-up fails to produce intimacy, and the growth almost conveys a sense of menace, precluding a reverent response. The greenery is like a jungle. It looks tentacular and threatening. It is turbulent and dizzying. The painting is a perfect example of van Gogh's method of articulating distress and manic compulsion. All he needs in order to convey an entire existential condition is a subject as simple and basic as clumps of grass. At this point it should be emphasized once again that this work has nothing whatsoever in common with the kind of artworks produced by the mentally ill. Van Gogh is using a sophisticated, stylized idiom to express the inexpressible.

Throughout those long weeks when he was kept in detention and under supervision, van Gogh was only allowed to paint within limits, and being deprived of his art was torture to him. Even when he was granted his palette and brush, there could be no question of roving the surrounding countryside in quest of a motif as he had so often done in the past. The doctors had decided that he was not to be left unattended. So van Gogh had to turn to other subjects. He might have borrowed

Gauguin's method of ransacking memory and imagination for images to record on the canvas; but he was still deeply shocked by the turn his relations with Gauguin had taken, and preferred a different alternative. It was his only option if he wanted to bridge the gap between his own isolation and the realm of the real: van Gogh began to paint copies of his own pictures.

Yet again we see the clarity and conviction with which he thought out his position. Van Gogh did not simply copy anything. He selected two motifs. He painted three more versions of the sunflowers: two of them (pp. 476–77) were copies (with minor variations) of the original with fourteen flowers (p. 411), and a third (p. 476) was a copy of the original with twelve (p. 409). It was an attempt to define his personality, to sound his own depths, by concentrating on his own personal symbol: that flower "that belongs to me" (as he put it in Letter 573). His use of colour still lends a sense of stunning immediacy to his subject – and the paintings, differing only marginally from the originals, stake a tentative claim to a better life. And, just as the originals were intended for the yellow house, so too the copies were meant for decorative use. Two of them were to serve as wing panels in a kind of triptych whose centre panel (also a copy) was to be the portrait of Madame Augustine Roulin, *La Berceuse*. Van Gogh painted no fewer than five versions of the portrait (pp. 481–83). The first of them had still been on his easel, unfinished, at the time of his breakdown. The woman, who appears to

A Field of Yellow Flowers
Arles, April 1889
Oil on canvas on cardboard, 34.5 x 53 cm
F 584, JH 1680
Winterthur, Kunstmuseum Winterthur

be enduring rather than enjoying sitting, is holding a cord in her hands. Madame Roulin had brought her baby with her and was rocking the cradle by pulling the cord while van Gogh painted. To van Gogh, she was the epitome of the good mother, representing comfort and security: "Concerning this picture I told Gauguin", he recalled in Letter 574, "when we were talking about the men who fish the Icelandic waters, and their melancholy solitude exposed to the dangers of the desolate seas – I told Gauguin that in the course of one of these conversations I had the idea of painting a picture that would give seamen, who are both children and martyrs, the feeling of being rocked in a cradle if they saw it in the cabin of a fishing boat, as if a lullaby were being sung to them again." Arranged in a triptych with the sunflowers flanking it, the picture would also console poor van Gogh, the longing child and martyr.

Augustine was the wife of Joseph Roulin the postman, who was a neighbour and became Vincent's closest friend in Arles. He took great care of Vincent, visited him in hospital, and kept Theo abreast of

The Courtyard of the Hospital at Arles
Arles, April 1889
Pencil, reed pen and ink, 45.5 x 59 cm
F 1467, JH 1688
Amsterdam, Rijksmuseum Vincent van Gogh, Vincent van Gogh Foundation

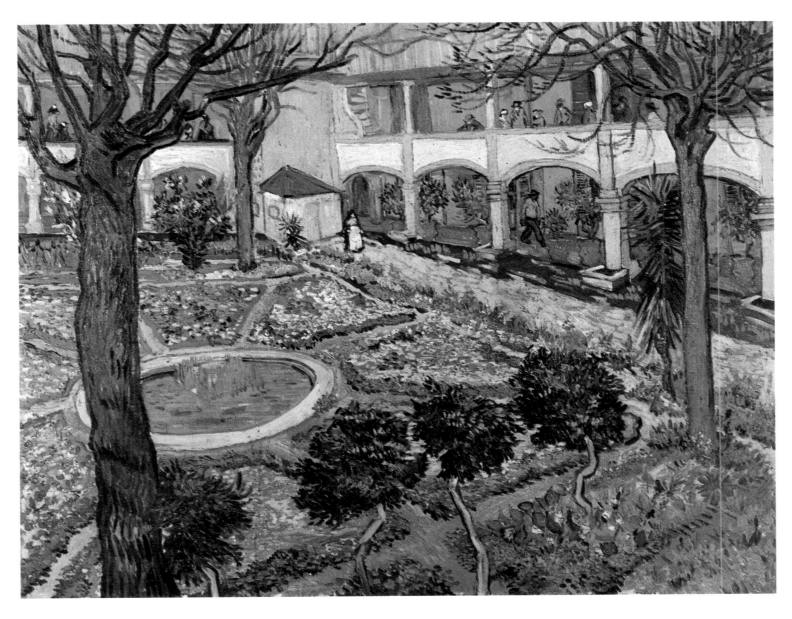

The Courtyard of the Hospital at Arles
Arles, April 1889
Oil on canvas, 73 x 92 cm
F 519, JH 1687
Winterthur, Collection Oskar Reinhart

developments when the artist was in the throes of mental derangement. Vincent saw the two of them as images of each other: Roulin was an alcoholic and a committed socialist, and not only shared certain of van Gogh's characteristics but also, as a family man with children, personified one of van Gogh's deepest wishes. The Roulins, and several of their children, sat for van Gogh time after time. It was no wonder, then, that he copied those pictures, trying to relive the sole fruits of his quest for affection. Van Gogh painted three copies (pp. 488–89) of a shoulder-length portrait of Joseph Roulin that he had done back in summer 1888 (p. 393). As in the paintings of La Berceuse, what strikes us when we compare the copies with the original is the new, decorative background. It is as if the artist had tried to abandon one of his most important principles – the principle of speed. As if to prolong his work on people he had developed a liking for, he painted countless tiny circles onto the background (p. 488, left), meticulously added dots, and established a pattern of plants and flowers, arabesques of stems and blossoms forming abstract geometrical designs. Here, too, we are not far from van Gogh's

La Crau with Peach Trees in Blossom
Arles, April 1889
Oil on canvas, 65.5 x 81.5 cm
F 514, JH 1681
London, Courtauld Institute Galleries

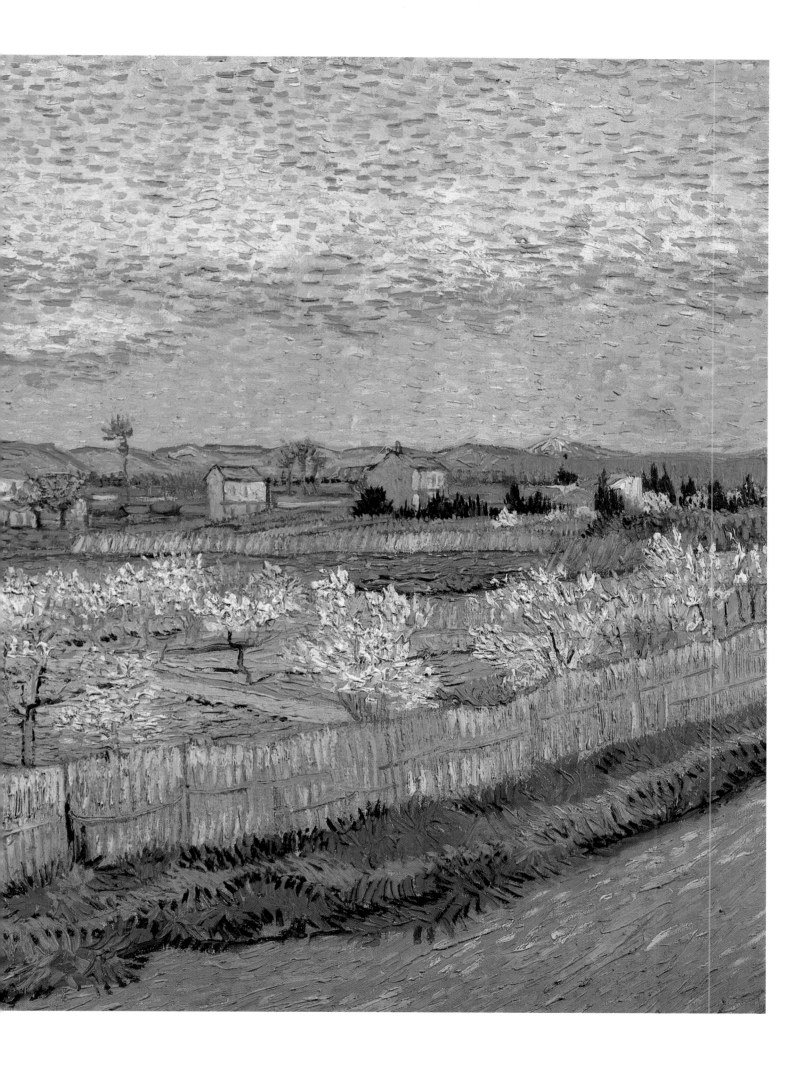

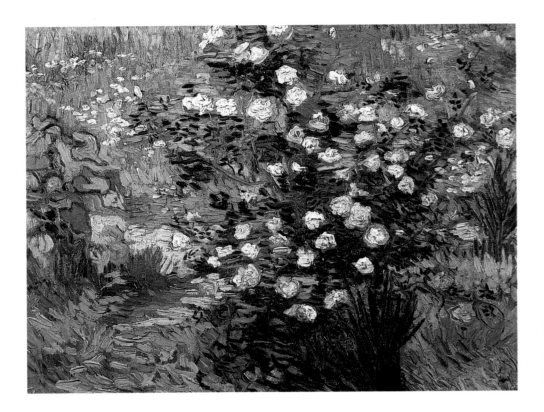

Rosebush in Blossom
Arles, April 1889
Oil on canvas, 33 x 42 cm
F 580, JH 1679
Tokyo, National Museum of Western Art

own personal symbol; flowers are the common denominator in all his copies and attempts to record feelings of security, friendship and support.

Almost all the paintings van Gogh did in 1889 before moving to Saint-Rémy related to the totally changed situation he necessarily found himself in. Many of them anticipated the themes and perspectives of the work he did in the short time that still remained to him – his late work, as it were. Van Gogh was to pursue the use of vivid close-ups and copies in particular; both kinds of work held a promise of trust and intimacy, bridging the gap between the world outside (be it Nature or his fellow-beings) and the world within, which had become such an ordeal for van Gogh. He knew that paintings were the only means of true communication left, and, as the last pictures he produced in Arles show, he set about pursuing the possibility.

Red Chestnuts in the Public Park at Arles
Arles, April 1889
Oil on canvas, 72.5 x 92 cm
F 517, JH 1689
Whereabouts unknown

Grass and Butterflies
Arles, April 1889
Oil on canvas, 51 x 61 cm
F 460, JH 1676
Private collection

Pollard Willows
Arles, April 1889
Oil on canvas, 55 x 65 cm
F 520, JH 1690
Collection Stavros S. Niarchos

The Park at Arles
Arles, April 1889
Chalk, pen, reed pen and ink, 49 x 61.5 cm
F 1468, JH 1498
Chicago, The Art Institute of Chicago

PAGE 500:
The Iris
Saint-Rémy, May 1889
Oil on paper on canvas, 62.2 x 48.3 cm
F 601, JH 1699
Ottawa, National Gallery of Canada

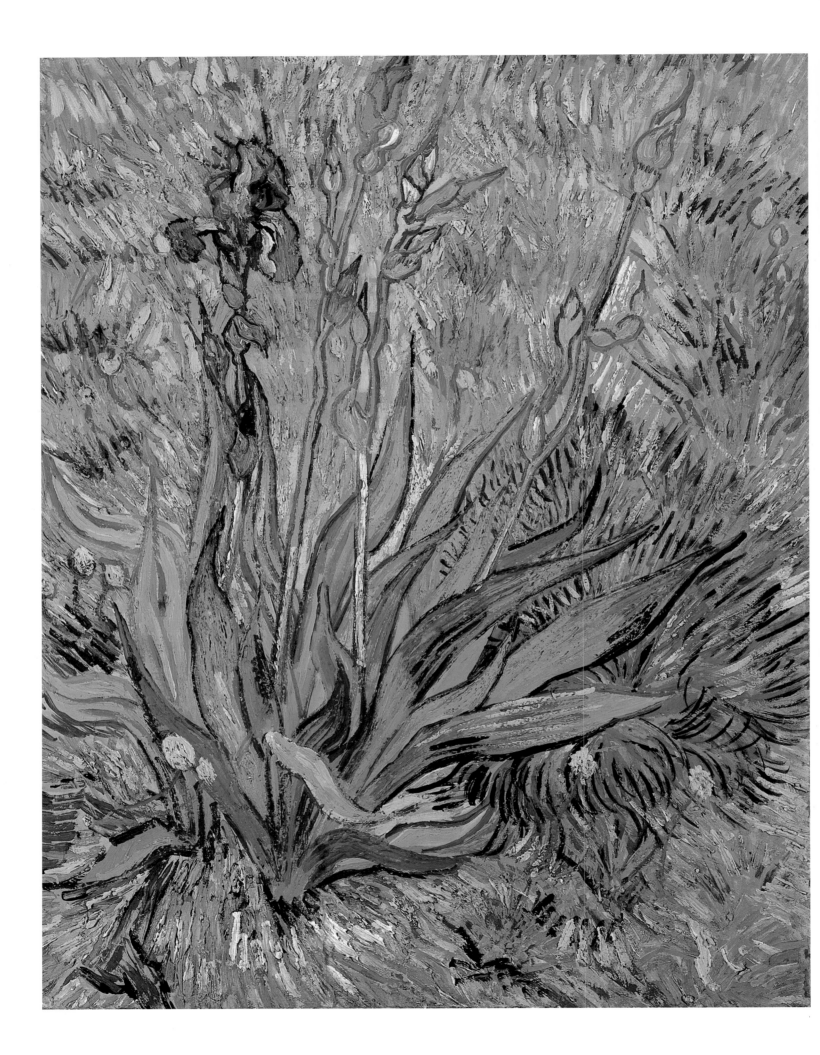

"Almost a Cry of Fear"
Saint-Rémy, May 1889 to May 1890

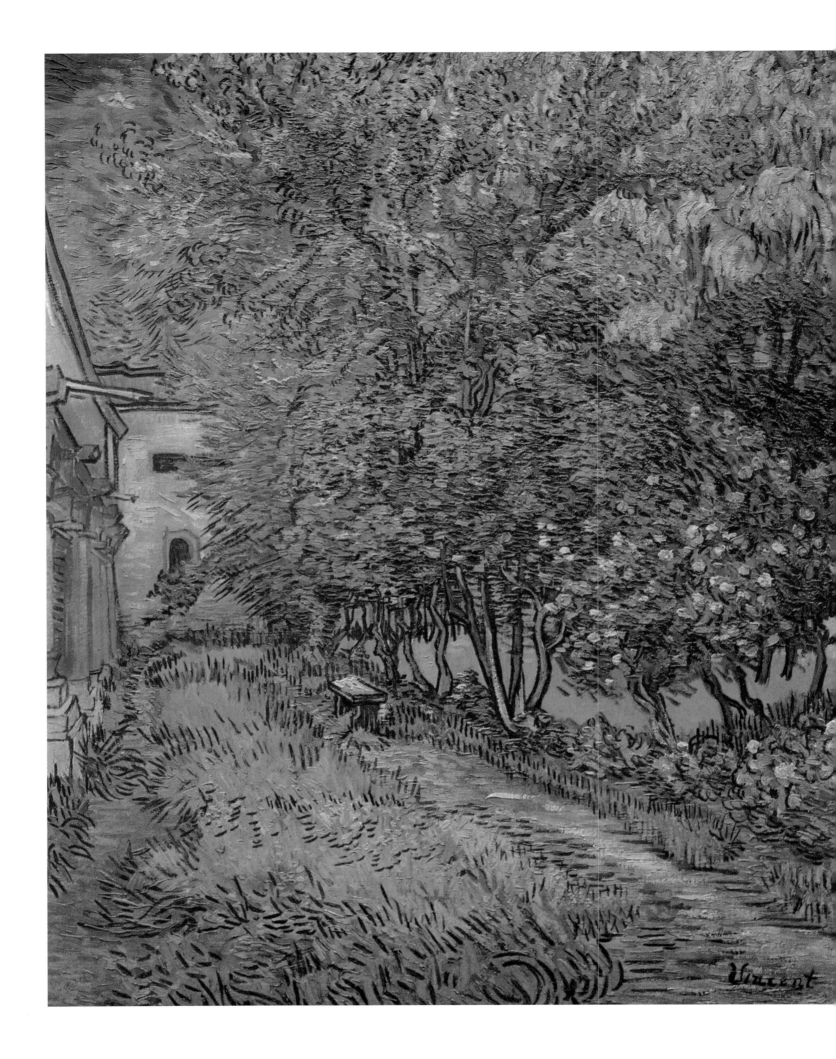

The Monastic Life

Tormented by fiendish visions, staring wildly and wide-eyed, hands clenched, the painter is flinching back into his seat in the choir. He has been living in a monastery for years, but his depressions are torturing him more terribly than ever and he has already tried to kill himself. The painter is Hugo van der Goes. The Dutch Gothic painter is seen as the first north European representative of the individualism that ultimately became the hallmark of modern times (and produced the complexities of autonomous art). It is Hugo van der Goes, in ecstasies of torment – as seen on canvas by the Belgian artist Emile Wauters. As early as 23 July 1873 (Letter 10), van Gogh made his first reference to this work. It was to remain with him throughout his life, and he tended increasingly to see the tortured Hugo as his own *alter ego*. Shortly before Gauguin arrived in Arles he wrote to his brother (Letter 556): "Once again I am close to Hugo van der Goes's madness in the picture by Emile Wauters. If I did not have a kind of dual nature, a monk's and a painter's, I should long since have been quite totally in the aforesaid condition." Six months later he accepted that condition. Bearing his "dual nature" in mind, he preserved his artistic life intact and entered the monastery: Saint-Paul-de-Mausole, an asylum at Saint-Rémy, originally a 12th century Augustinian monastery, some twenty kilometres north of Arles.

Saint-Paul-de-Mausole was an asylum, monastery and studio all in one, which was why van Gogh so gladly opted for the isolation. Isolation was what he wanted; the ascetic in van Gogh could indulge in whatever mortification he pleased, and the painter, playing the part of a patient, was in a place that supposedly sought to encourage art. In the mediaeval world, monasteries had been the true home of images; and the modern age was fascinated by the metaphor of life in a cell as an aid to artistic creativity. "Nature", Nietzsche wrote, "entraps the genius in a prison and stimulates his wish to break free to the utmost." Doing without the stimuli of everyday reality was of course an excellent way of paying what one owed: van Gogh's mode of payment was his detention itself rather than madness. His bouts of mental instability reinforced his resolve to turn his back on the world. Indeed, they were to make communication with the world beyond impossible for him.

Death's-Head Moth
Saint-Rémy, May 1889
Oil on canvas, 33.5 x 24.5 cm
F 610, JH 1702
Amsterdam, Rijksmuseum Vincent van Gogh, Vincent van Gogh Foundation

The Garden of Saint-Paul Hospital
Saint-Rémy, May 1889
Oil on canvas, 95 x 75.5 cm
F 734, JH 1698
Otterlo, Rijksmuseum Kröller-Müller

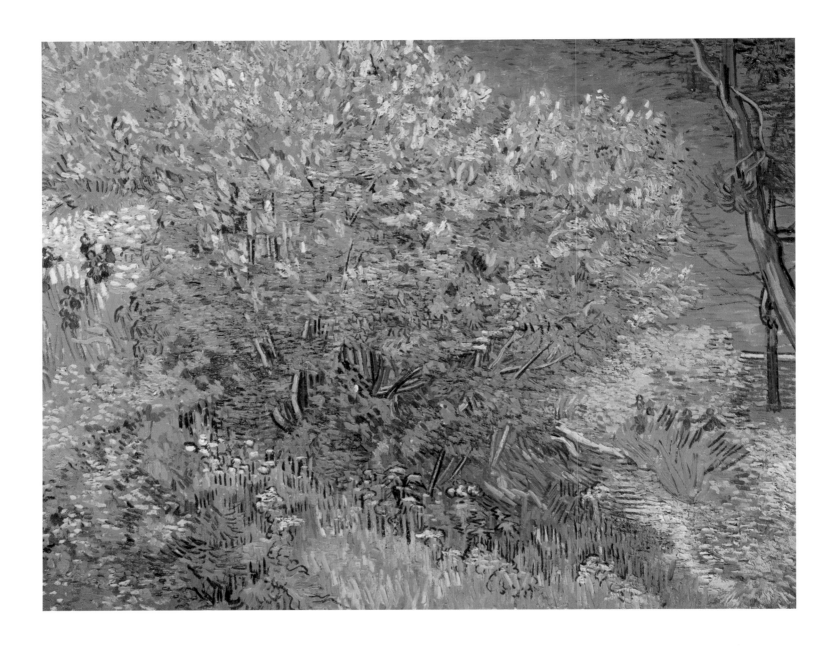

Lilacs
Saint-Rémy, May 1889
Oil on canvas, 73 x 92 cm
F 579, JH 1692
Leningrad, Hermitage

Irises
Saint-Rémy, May 1889
Oil on canvas, 71 x 93 cm
F 608, JH 1691
Perth, Collection Alan Bond
(Sotheby's Auction, New York, 11. 11. 1987)

"It is very likely that I have a good deal of suffering still ahead of me", he wrote to his sister (Letter W11) shortly before committing himself to the asylum. "This is not at all to my taste, to be honest, because I really do not want a martyr's life. I have always been after something other than heroism [...]; of course I admire it in others, but I repeat that I consider it neither my duty nor my ideal." This notwithstanding, van Gogh had chosen to lead the kind of life that Gauguin, for all his

Fountain in the Garden of Saint-Paul Hospital
Saint-Rémy, May 1889
Black chalk, reed pen and ink, 49.5 x 46 cm
F 1531, JH 1705
Amsterdam, Rijksmuseum Vincent van Gogh, Vincent van Gogh Foundation

flirtations with images of crucifixion, would never have put up with. Van Gogh was revolted by his own martyrdom; but it was of his own making. And he was perfectly aware that by entering the remote, "holy" world of a monk he might be doing greater damage to his mental state than ever: "I am astonished", he wrote in Letter 607, "that with all my modern views, so passionate an admirer of Zola and the Goncourts and all artistic endeavour [...], I have attacks of rank superstition and am full of confused, repellent religious notions of a kind I never entertained in the north. If a man responds to his environment with great sensitivity, a lengthy stay in old monastic buildings such as the hospital in Arles and this asylum is quite sufficient to explain these attacks." Or on the other hand (we might add): the attacks explain the stay. The brooding melancholy of the monastic environment was just the thing to heighten van Gogh's mood and leave him more radical than before. Saint-Rémy was a vacuum. Sealed off from airy, colourful life, the artist could devote his whole attention to himself and the psychological forces that had him in their grip. He attempted to come to terms with them in his paintings, and was the better able to explore the depths of his life and art because he had no distractions, no contact with other people, and none of the drink or tobacco he had been addicted to.

Van Gogh realised immediately that the asylum was a place of punishment rather than pleasure, and recorded the realisation in three gouaches that are masterful in the simplicity with which they record his disillusionment and distress; two of them are reproduced in this book (p. 565). *The Entrance Hall of Saint-Paul Hospital* shows the doors wide open, apparently inviting the patient to step out into the bright and cheerful garden where a fountain is splashing merrily. A few paces will be enough, and he will be out in the peace and calm and light of Provence. But van Gogh cannot take those few paces. For him, springtime and the realm of hope beyond that threshold exist solely in picture form. Framed by the arcading of the entry and by the wall, the view of the garden is like the centre panel of a triptych whose wings might fold prohibitively shut at any moment. This picture is merely a picture, nothing more – a canvas, like the canvases stacked out of the way at right. Freedom, van Gogh is unmistakably telling us, only exists in the realm of Art, and in moments of light in the mind that produces it.

Corridor in Saint-Paul Hospital is even more depressing and hopeless. Before Franz Kafka wrote a word, this painting earned the epithet "kafkaesque". It is a world of endless labyrinthine passages, the architectural incarnation of monotonous and perpetual repetition. There is a figure in brown darting across the corridor, in flight from the threat of confinement. Added afterwards, the figure is not necessarily one of the wretched inmates of the asylum; rather, it is one of those restless characters that so often people van Gogh's scenes. Hitherto, these figures had never been attempting to go beyond the area defined in the

A Corner in the Garden of Saint-Paul Hospital
Saint-Rémy, May 1889
Oil on canvas, 92 x 72 cm
F 609, JH 1693
Whereabouts unknown

Le Mont Gaussier with the Mas de Saint-Paul
Saint-Rémy, June 1889
Oil on canvas, 53 x 70 cm
F 725, JH 1744
London, Private collection

Les Alpilles, Mountainous Landscape near Saint-Rémy
Saint-Rémy, May-June 1889
Oil on canvas, 59 x 72 cm
F 724, JH 1745
Otterlo, Rijksmuseum Kröller-Müller

visual space of the picture; but it is quite plain that this man is attempting to escape from this prison but will never succeed in doing so. The setting is not so much a building as a metaphor of his life, and he will be trying to escape till the end of his days.

It is worth pursuing the comparison with Kafka. The impact of a writer derives from time: the act of reading takes minutes and hours, in the course of which words express situations. Van Gogh, by contrast, is able to use means of great simplicity; and we see once again how very alert his art is in spite of the turmoil in his spirit. If it survives, this sheet will illustrate the desolation of empty interiors forever: hopelessness is defined in terms of timelessness, or perpetuity. When schizophrenics create pictures, their proverbial *horror vacui* is reminiscent of the act of writing, and the whole sheet is covered. For schizophrenics, too, hopelessness is expressed through duration (that is to say, through the time they need to cover the sheet, stamping it with their own physical presence). Van Gogh's gouache, though, could hardly be more precise. What makes it so superb is the compact density, and not any quality of multiplication and quantity.

He had now set himself a final task: "So life goes by, and time will not return, but I am getting to grips with my work, precisely because I know that there will not be another opportunity to paint. Least of all in my case, since a more serious attack may do permanent damage to my ability to work." (Letter 605) The extremity of his situation, continually confronted with his own end, surely supplied motivation enough for van Gogh to tackle the motifs and series that he had not yet worked at. Previously he had justified his efforts in terms of learning, apprentice-

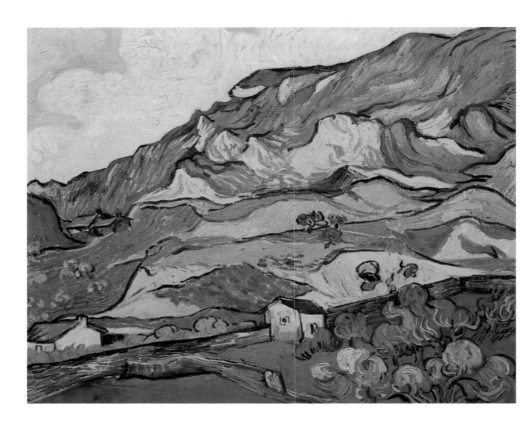

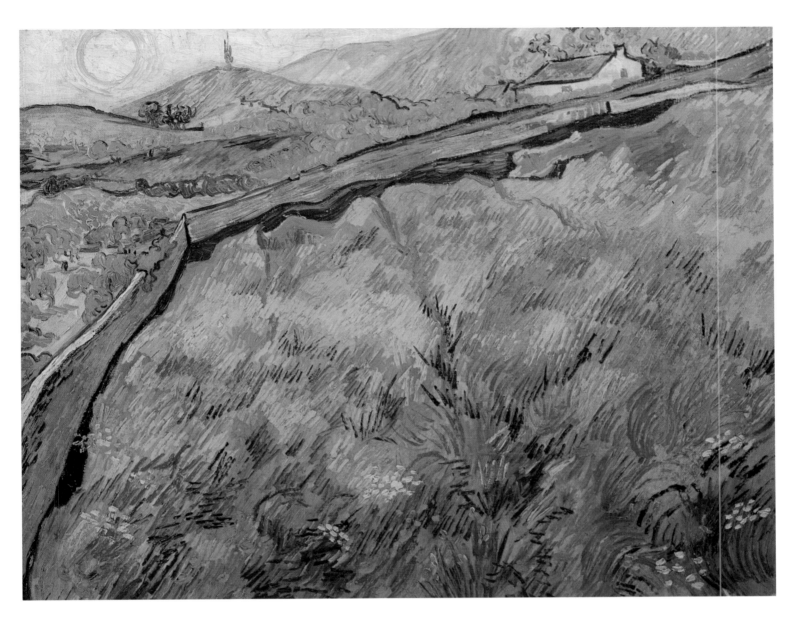

Field of Spring Wheat at Sunrise
Saint-Rémy, May-June 1889
Oil on canvas, 72 x 92 cm
F 720, JH 1728
Otterlo, Rijksmuseum Kröller-Müller

ship, paying a price, or sheer contact. But now, on the edge of the abyss, setting himself a quota of work was simply an act of self-preservation. As long as he could still paint, as long as he could still plan further projects, all was well. It was an art of and for survival. His work quota was no longer an end in itself, or a way of paying homage to his century's obsession with numerical concepts: now, one picture staked a whole day's claim on the future, and a series represented belief in the continuation of life. Van Gogh's indefatigable determination to paint had never been greater than in the asylum at Saint-Rémy.

And the intensity of his work took on weighty, palpable quality. Theo recognised this immediately and expressed it in one of the forty letters or so that have survived from this closing period: "Your latest pictures have made me think a great deal about your state of mind at the time when you painted them. All of them exhibit a forcefulness in the use of colour that you never achieved before, which is curious in itself; but you have gone even further, and if there are painters who seek to establish their symbols by doing violence to form, then you are one of them in

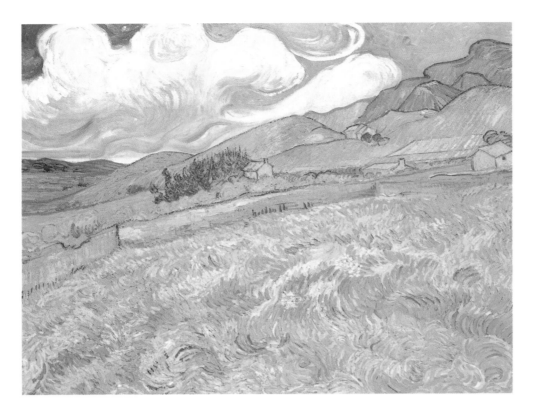

Mountainous Landscape behind Saint-Paul Hospital
Saint-Rémy, early June 1889
Oil on canvas, 70.5 x 88.5 cm
F 611, JH 1723
Copenhagen, Ny Carlsberg Glyptotek

many of these paintings [...] But what work you must have been doing with your head, and how you ventured to the utmost limit, where one inevitably reels with giddiness." (Letter T10; letters written by Theo that survived are denoted by a T.) For decades, Theo had been extremely close to his brother, and was sensitive to his needs and approaches; and in this passage he perceptively expresses what lay at the heart of van Gogh's Saint-Rémy output. Van Gogh was trying to escape from lunacy into the conceptual world of complex art, and in doing so to accept

Green Wheat Field
Saint-Rémy, June 1889
Oil on canvas, 73 x 92 cm
F 718, JH 1727
Zurich, Kunsthaus Zürich (on loan)

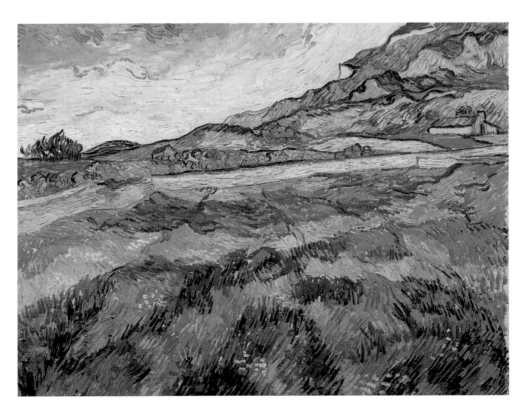

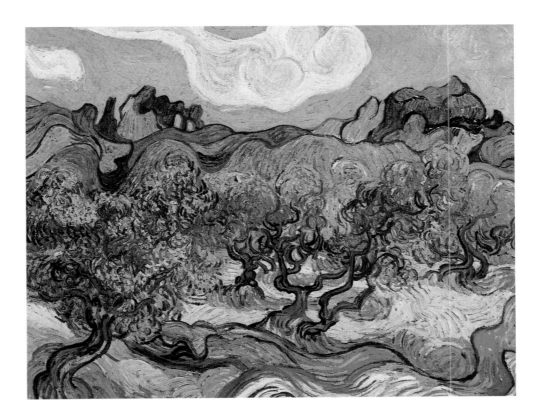

Olive Trees with the Alpilles in the Background
Saint-Rémy, June 1889
Oil on canvas, 72.5 x 92 cm
F 712, JH 1740
New York, Collection Mrs. John Hay Whitney

madness as the driving force of his creativity. To put it differently: he was circling around insanity in the hope of offering centrifugal resistance to its magnetic force. It is time we examined some of the characteristic features of this phase in his work.

In 1794 Jacques-Louis David painted his *View of the Jardin du Luxembourg in Paris*. At the time he painted it, the great Classicist lacked access to more interesting subjects, since he was behind bars, one of the victims of the Revolutionary turmoil. What he could see from the window of his cell was a simple scene, hardly worthy of note; and David painted it. Van Gogh will have been familiar with the work from his frequent visits to the Louvre, and he borrowed the prisoner's viewpoint in the numerous variations he painted on the motif of the walled field behind the asylum. In *Enclosed Field with Ploughman* (p. 532), for instance, van Gogh (like David) registers two areas separated by a wall or enclosure: the shut-in asylum with its modest piece of land, and beyond the wall the free world, the bright and sunny realm of liberty. Within, there is work to do. There is soil to be ploughed and grass to be mown. Beyond lie the trees and homesteads of carefree everyday existence. The enclosure is broken only by the margin of the composition, and renders any exchange of the two realms, of within and beyond, impossible. The two artists used their motifs in a strikingly similar fashion. But in van Gogh's approach there is great power. The streaks of paint are thick, his use of line reckless. It is not the enclosure, or the man at work, or the distant trees alone that express the experience of confinement and the unattainability of happiness. Van Gogh is putting his statement into his materials once again, and just as his colours and brushwork acted as

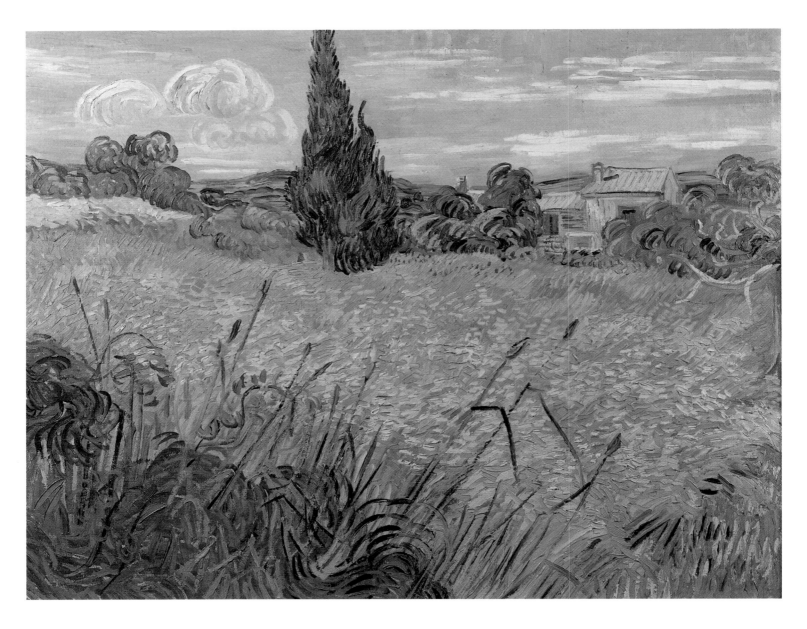

utopian metaphors in Arles, so now they record the loss of hope and his fears for the future. Without van Gogh's transformational handling of paint, the motifs alone could not be so expressive.

"Seeking to establish symbols by doing violence to form": Theo's neat description of the approach does indeed define the nature of Vincent's work at this time. The urge to remake form was growing stronger and stronger in him. His versions of the real were becoming twisted and distorted, much as the perceptions of the mentally sick register the absurd and demonic. But van Gogh was still trying to record a diseased way of seeing; it was not the case that when he himself stood before his easel he was afflicted with it. Writing to Bernard, he described his painting *The Garden of Saint-Paul Hospital* (cf. pp. 586–87) in detail and then continued in these terms: "You will realize that this use of red ochre, green, darkened by grey, the black strokes that define the contours, all this tends to convey a sense of *angst*, of a kind many of my companions in wretchedness often suffer. And the motif of the big tree struck by lightning, and the sickly, pink-and-green smile of the last

Green Wheat Field with Cypress
Saint-Rémy, mid-June 1889
Oil on canvas, 73.5 x 92.5 cm
F 719, JH 1725
Prague, Národní Gallery

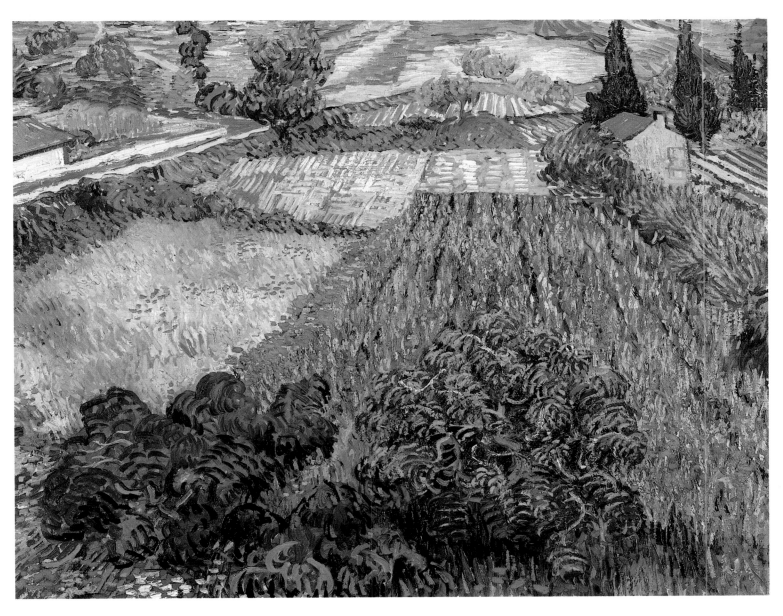

Field with Poppies
Saint-Rémy, early June 1889
Oil on canvas, 71 x 91 cm
F 581, JH 1751
Bremen, Kunsthalle Bremen

flower of the autumn, serves to heighten this impression." It was the task of colour to convey suffering through the motifs the artist painted. Van Gogh still had a sense of solidarity with things, though now it had expanded into that empathy often experienced amongst the dying.

His use of line was subject to the same exacting standards. "Everything else says nothing to me", van Gogh wrote in Letter 607, criticizing his own work, "because it does not express the personal will, the feeling that informs the line. Once the line is firm and purposeful, the picture really begins, even if it is overdone." At Saint-Rémy van Gogh's work acquired a new characteristic in the obsessive circular strokes and twisting, snaking lines. The possible variations on these stylistic devices are endless. When they are smooth and decorative, they lend some of his paintings a tapestry-like delicacy. One example is *Olive Trees with the Alpilles in the Background* (p. 511). Alternatively, they may be wild and inchoate, so that the painting becomes a relief of thick streaks, as in some of the pictures of cypresses (cf. p. 516). The line is used to remake forms and thus to mediate between the familiar look of given

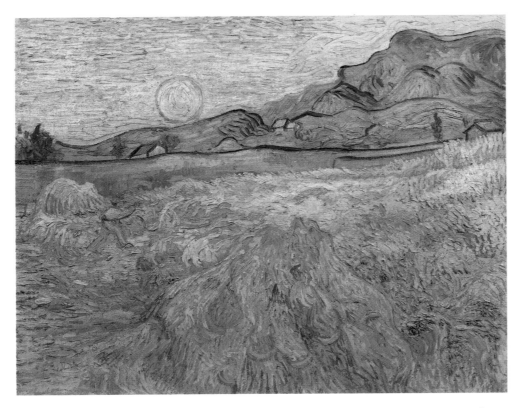

Wheat Field with Reaper and Sun
Saint-Rémy, late June 1889
Oil on canvas, 72 x 92 cm
F 617, JH 1753
Otterlo, Rijksmuseum Kröller-Müller

reality and the extreme state of mental derangement. Van Gogh is attempting to grasp sickness and health at one and the same time, by registering the world as the product of a tried and tested yet mistaken mode of perception. His eye as clear as ever, he records his motifs at the easel and allows his thoughts to return to times when his gaze was not as clear.

On one occasion (it is argued) his grasp of perspective failed entirely. In Letter 607 van Gogh, referring to *Entrance to a Quarry near Saint-Rémy* (p. 569), writes: "I was working on it when I felt the attack coming

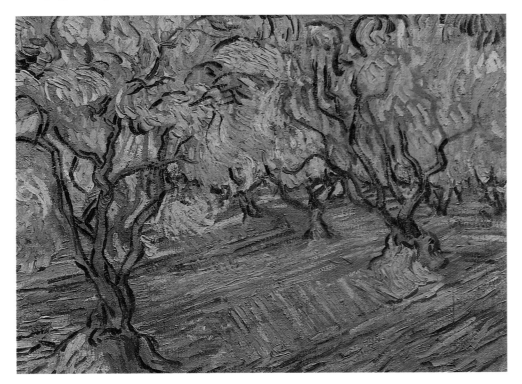

Olive Grove: Bright Blue Sky
Saint-Rémy, June 1889
Oil on canvas, 45.5 x 59.5 cm
F 709, JH 1760
Amsterdam, Rijksmuseum Vincent van Gogh, Vincent van Gogh Foundation

on." Critics have tended to interpret the painting as a document of breakdown, and have tried their hardest to identify features that point to van Gogh's imminent derangement such as the combination of colours, the close-up view, the spatial confusion. Then the English art historian Ronald Pickvance produced excellent reasons for believing that a different painting with the same title (p. 529) was the one that preceded van Gogh's attack. Here, of course, the same infallible signs of impending madness can once again be detected. The vertiginous depths are even more giddying than in the other picture. But pedantic contention cannot resolve the issue, and it would be refreshing if academics stopped trying to see indications of insanity in almost every painting. There are plenty of signs in van Gogh's Saint-Rémy works that the artist was in a serious condition. But his condition was chronic, not acute.

Van Gogh signed only seven of some 140 paintings done in this monastic life at Saint-Rémy. Doubtless he was dissatisfied with what he had achieved; and his dissatisfaction may not be too incomprehensible if we bear in mind how very remote his goals were. Long before Modernism programmatically adopted the strategy, van Gogh tried his hand at *art brut*, deliberately approximating to the visual world of the mentally sick. Equally certainly, though, van Gogh's refusal to sign most of these works bespeaks a wish for a quiet, humble, anonymous life. Van Gogh identified with life inside those walls much as he had felt at one with life on the boulevards or beneath a Japanese sun. At all events, his present state permitted total concentration; he could explore himself, indeed meditate. And of course that inner life he was giving his full attention to clamoured to be heard on the outside – and was expressed in art of new and uninhibited power.

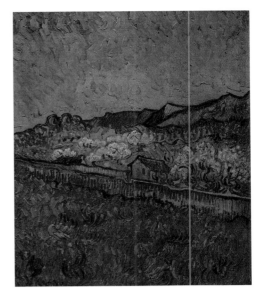

At the Foot of the Mountains
Saint-Rémy, early June 1889
Oil on canvas, 37.5 x 30.5 cm
F 723, JH 1722
The Hague, Rijksbureau voor
Beeldende Kunst

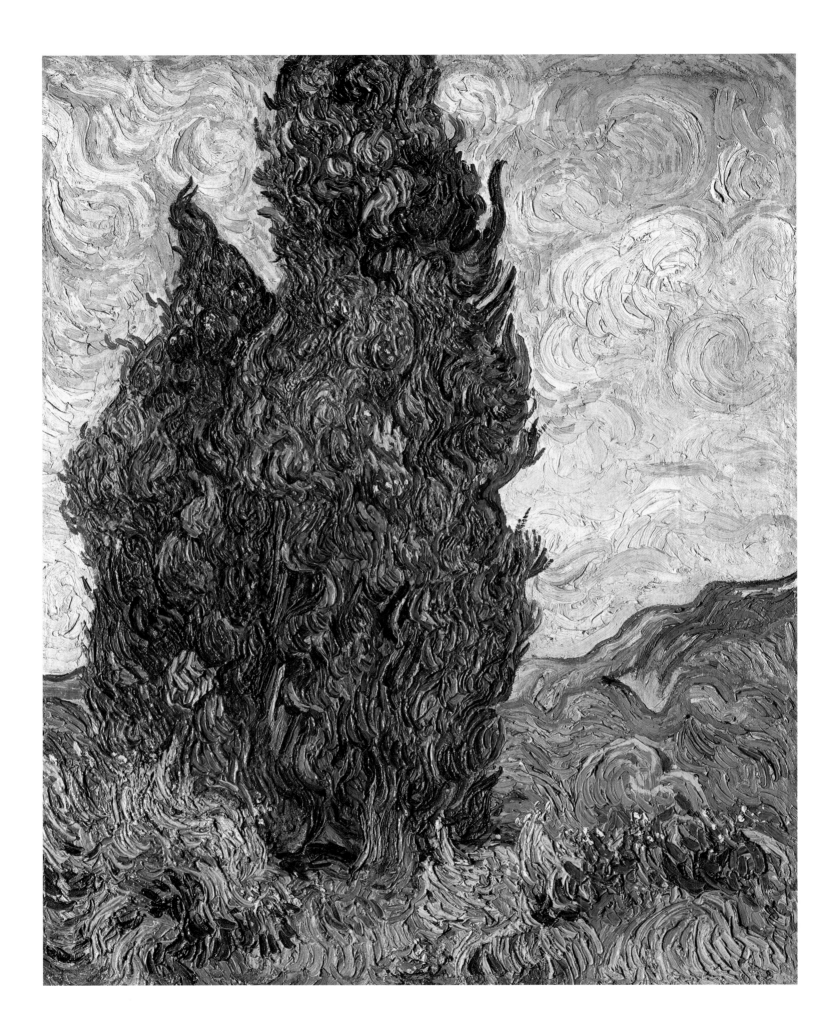

Olives, Cypresses and Hills
Van Gogh's Compacted Landscape

Unlike his fellow inmates, van Gogh had not been committed to the asylum. He could leave the cloistered halls once the day's work was done and retire to his cell. He was under as much supervision as was thought necessary and had as much independence as was considered feasible; and van Gogh believed that the therapy would help. Even if he described ever-widening circles around it in those months, the Saint-Paul-de-Mausole asylum was the centre of his life. He needed subjects. At first he was satisfied with what he found in the immediate vicinity. The low wall that enclosed the asylum remained for weeks a mental borderline that he would not cross. Concerned for his own recovery, the voluntary patient stayed inside bounds that he was not obliged to observe. The fact of it was that he hoped to find security there. security there.

And so he repeatedly turned his attention to the no-man's-land between the wide and exciting world out there and his own smaller, confined world. He painted the field and the stone wall, his mental barrier. Beyond it, though, was an absorbing landscape whose distinctive features he was only now beginning to register. From afar he focussed on points that were typical of the landscape of Provence, points that he had found disturbing when he was in Arles because they did not fit in with the beauty of his Japanese utopia. It was only now that he acquired his fondness for what was characteristically Mediterranean in the region: the cypress trees, the olive groves and the sparse vegetation on the hills. What attracted van Gogh was not the picture-postcard picturesqueness of a geographical area which even at that time threatened to be overrun with tourists. He was fascinated by the grotesque shapes of the vegetation and rocks; and rather than adapt them to a picturesque impression he took them as they were, because they afforded a natural version of his own need for the distorted and deformed. All he needed to do was look; the motifs already had that quality of bizarre originality, of darkness, of the demonic, which he increasingly sought in his art.

So when he looked across the wall (cf. p. 509), he found a whole world of subjects awaiting him. There was a range of hills, the Alpilles, with countless olive trees at their feet and an occasional solitary cypress

Cypresses
Saint-Rémy, June 1889
Oil on canvas, 93.3 x 74 cm
F 613, JH 1746
New York, The Metropolitan Museum of Art

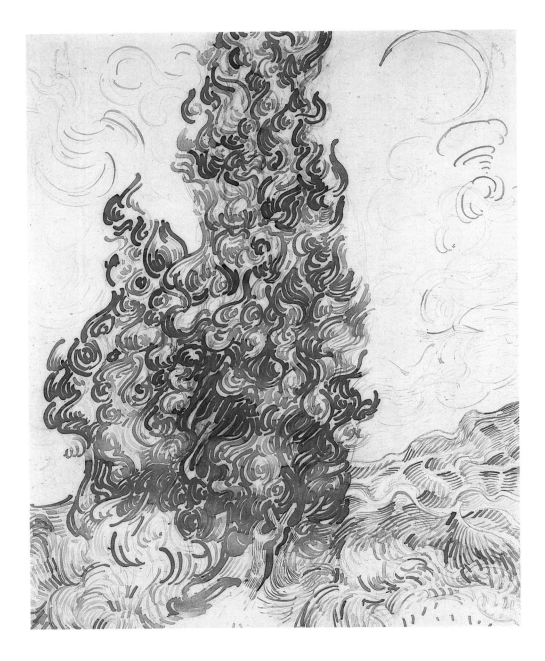

Cypresses
Saint-Rémy, June 1889
Pencil, reed pen and ink,
62.3 x 46.8 cm
F 1525, JH 1747
New York, The Brooklyn Museum

crowning them to counteract the gentle ups and downs of the hills with a bold vertical. Little by little, van Gogh ventured closer to his new find: there was less of the field in his pictures and the landscape beyond came within reach. *At the Foot of the Mountains* (p. 515) identifies the crowns of individual trees merging into the foothills – a presentation possible only once the artist came closer. The immense cypresses on page 516 are seen so close that the top of one is cropped by the upper edge of the picture. Only the field remains to add an element of distance. Before van Gogh overcame that distance he first painted all his new discoveries in a single canvas, and (characteristically, given his wariness of closer contact) he did it from memory and imagination. The painting was to become one of his most famous works: *Starry Night* (pp. 520–21).

The artist is looking down on a village from an imaginary viewpoint. It is framed by his newly-discovered motifs: at left a cypress towers skywards, at right a group of olive trees cluster into a cloud, and against

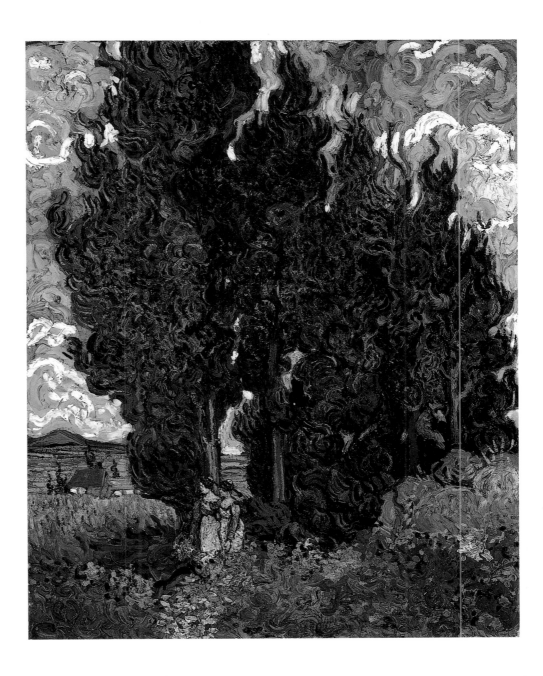

Cypresses with Two Female Figures
Saint-Rémy, June 1889
Oil on canvas, 92 x 73 cm
F 620, JH 1748
Otterlo, Rijksmuseum Kröller-Müller

the horizon run the undulating waves of the Alpilles. Van Gogh's treatment of his motifs prompts associations with fire, mist and the sea; and the elemental power of the natural scene combines with the intangible cosmic drama of the stars. The eternal natural universe cradles the human settlement idyllically, yet also surrounds it menacingly. The village itself might be anywhere, Saint-Rémy or Nuenen recalled in a nocturnal mood. The church spire seems to be stretching up into the elements, at once an antenna and a lightning conductor, like some kind of provincial Eiffel Tower (the fascination of which was never far from van Gogh's nocturnes). Van Gogh's mountains and trees (particularly the cypresses) had hardly been discovered but they seemed to crackle with an electric charge. Confident that he had grasped their natural appearance, van Gogh set out to remake their image in the service of the symbolic. Together with the firmament, these landscape features are singing the praises of Creation in this painting.

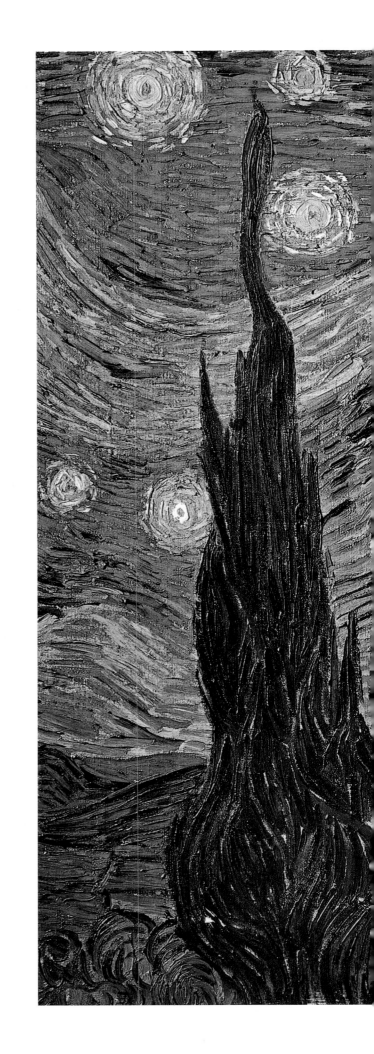

Starry Night
Saint-Rémy, June 1889
Oil on canvas, 73.7 x 92.1 cm
F 612, JH 1731
New York, The Museum of Modern Art

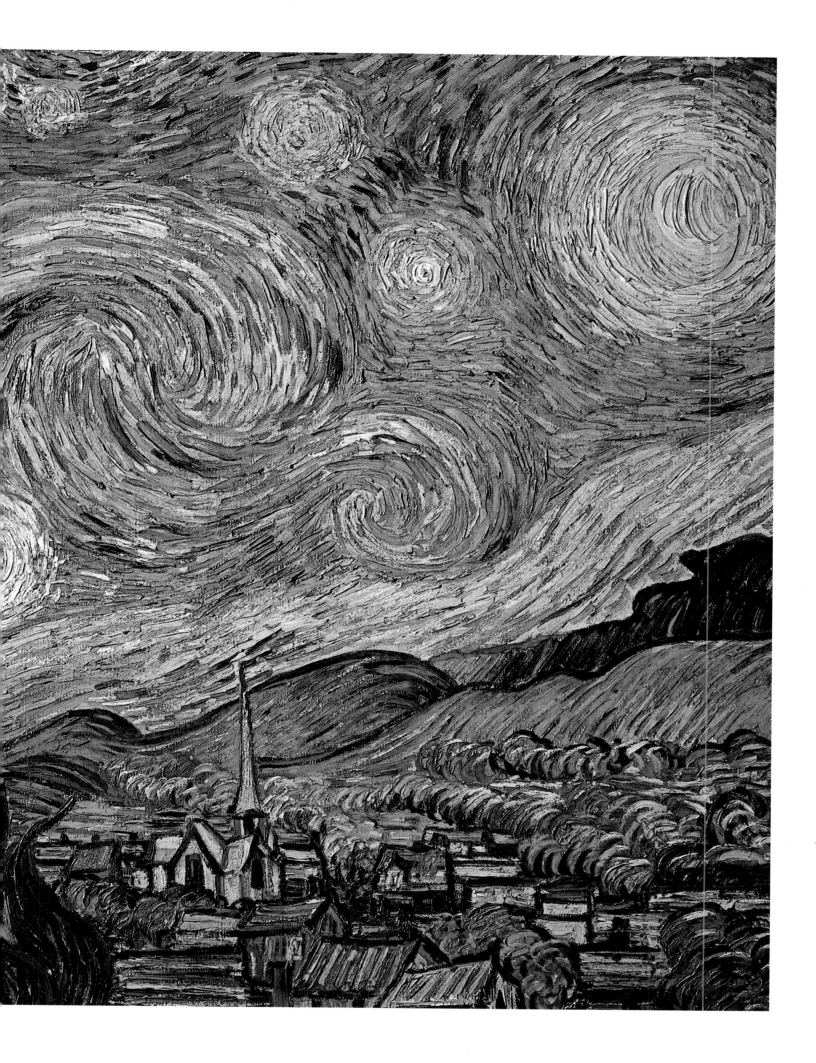

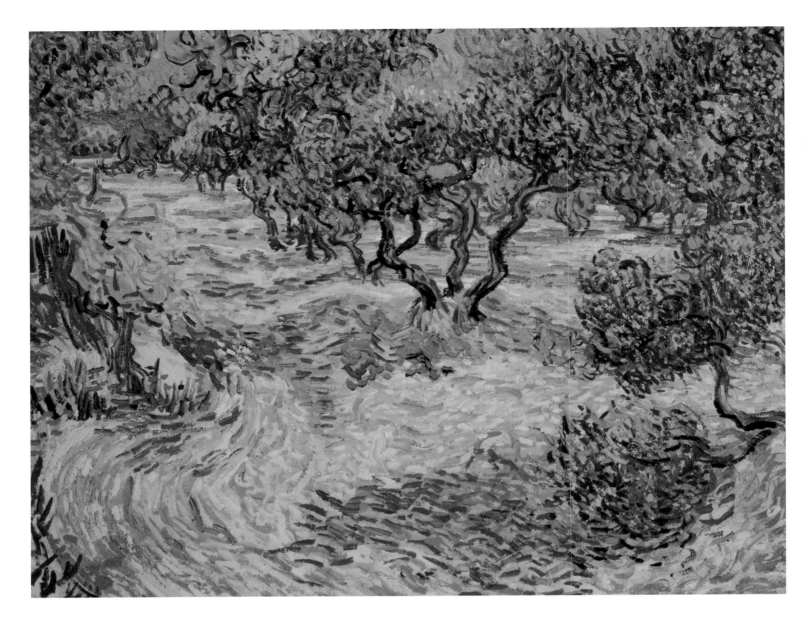

"I have done another landscape with olive trees, and a new study of the 'starry sky'", was van Gogh's way of describing the painting (in Letter 595). "Although I have not seen the new pictures by Gauguin and Bernard, I am fairly certain that these two studies are similarly conceived. When you see them some time [...] I shall be able to give you a better idea of the things Gauguin, Bernard and I often used to talk about and occupy ourselves with than I can do in words; it is not a return to Romanticism or to religious ideas, no. But via Delacroix one can express more of Nature and the country, by means of colour and an individual drawing style, than might appear." Van Gogh is making various points here. First, his synthesis of motifs was his first echo of work with Gauguin since his breakdown. The nighttime scene (this is something that had only just become important to van Gogh) offers the visual imagination its most distinctive, unique field of activity, since the lack of light requires the compensatory use of visual memory. Van Gogh used the memory method in his nocturnal scene; his discovery of the luminous power of darkness was a personal aesthetic discovery and

Olive Grove
Saint-Rémy, June 1889
Oil on canvas, 73 x 93 cm
F 715, JH 1759
Kansas City (Mo.), The Nelson-Atkins
Museum of Fine Art

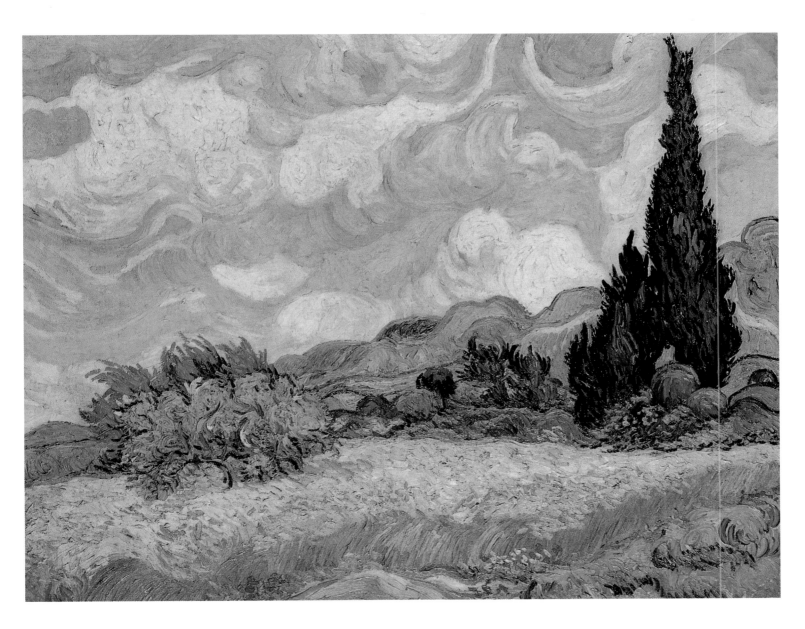

**Wheat Field with Cypresses at the Haute
Galline near Eygalières**
Saint-Rémy, late June 1889
Oil on canvas, 73 x 93.5 cm
F 717, JH 1756
Zurich, Private collection

needed no Gauguin as catalyst. Second, van Gogh was drawing upon his long-lost model Delacroix again, and the principle of contrast; once he paused to reflect on what he had achieved in recent weeks he found his attention drawn back to the colourist techniques which he himself had developed so far. Third, he was searching for the essence of the landscape, its very being – a way of registering its symbolic power, its vitality, its flux and constancy, all in one.

Interpretations of this painting are legion. Some claim it is a perfectly realistic account of the position of the stars in June 1889. This, needless to say, is perfectly possible. But the twisting, spiralling lines have nothing to do with the Northern Lights or the Milky Way or some spiral nebula or other. Others say that van Gogh was expressing a personal Gethsemane; they back this up by referring to the discussion of Christ on the Mount of Olives that he was currently engaged in, in his correspondence with Gauguin and Bernard. This too may be so; it is possible that premonitions of sufferings to come are articulated in the picture. But Biblical allegory is present throughout van Gogh's œuvre, and he

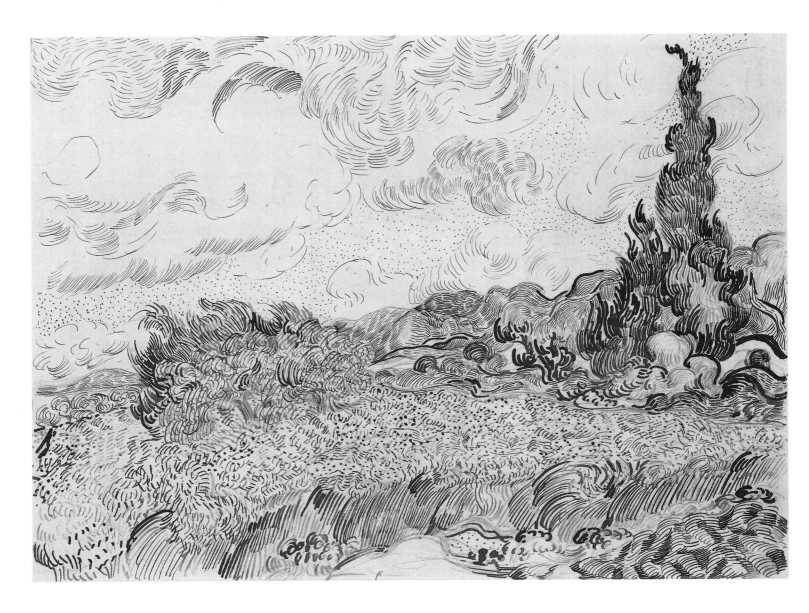

had no need of a special motif, least of all a starry sky, with all its associations of Arles and utopian visions. Rather, van Gogh was trying to summarize; and his resumé juxtaposed natural, scientific, philosophical and personal elements. *Starry Night* is an attempt to express a state of shock, and the cypresses, olive trees and mountains had acted as van Gogh's catalyst. More intensely, perhaps, than ever before, van Gogh was interested in the material actuality of his motifs as much as in their symbolic dimensions.

There had been hills in Arles too, of course. But they entered his panoramic scenes as idyllic touches. His landscapes included the harvest, passing trains, isolated farmsteads and distant towns; and the hills were simply one more detail. In Arles, van Gogh's dream had been of the harmony of things and of the spatial dimensions in which that harmony could be felt. None of that remained. The hills rose up steep and abruptly now, menacing, threatening to drag the lonesome soul down into vertiginous depths. *Entrance to a Quarry near Saint-Rémy* (p. 569) irresistibly drags us down, and the greenery can afford no salvation. It is a picture that shows van Gogh's affinity to Romantics such as Caspar

Wheat Field with Cypresses
Saint-Rémy, June 1889
Black chalk and pen, 47 x 62 cm
F 1538, JH 1757
Amsterdam, Rijksmuseum Vincent van Gogh, Vincent van Gogh Foundation

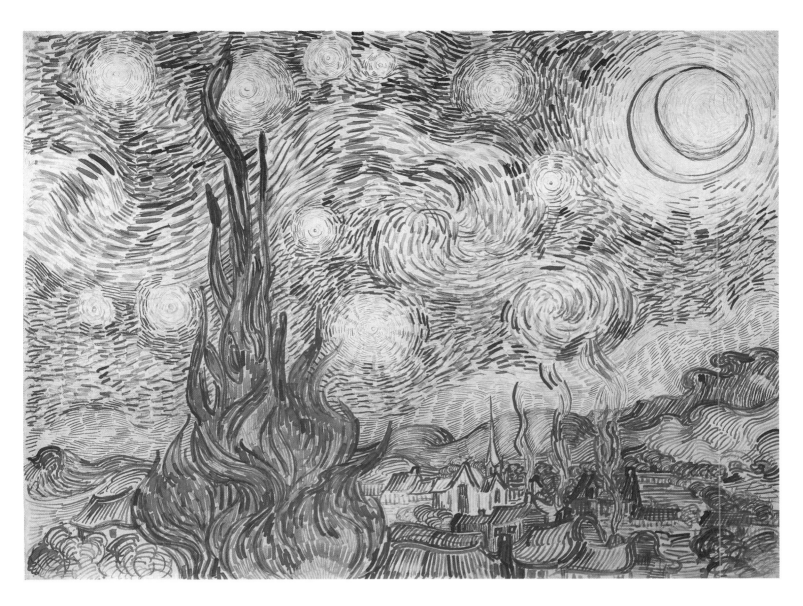

Starry Night
Saint-Rémy, June 1889
Pen, 47 x 62.5 cm
F 1540, JH 1732
Lost (formerly in the Kunsthalle Bremen)

David Friedrich; he is speechless before a natural, wild scene that leaves him cold with fear. And the confrontation has a grip on him. *Mountains at Saint-Rémy with Dark Hut* (p. 529) impresses us with its tumultuous massifs, and has nothing of that picturesque, craggy mellowness that was characteristic of the Alpilles. The hut, half hidden behind trees and bushes, is a mere token of protection and in reality the works of mankind appear paltry beside the grandeur of natural creation.

Even when they are merely a background, the mountains can be menacing. *Enclosed Wheat Field with Peasant* (p. 555) shows the mountains so close that our fear of confinement is automatically redoubled. The stone wall and the rocky crags complement each other; the mountainside makes it impossible for us to see the blue sky and eliminates the sense of a horizon, so essential to our acquiescence in the harmony of a picture. Instead of that balance, we have instability. This instability is created by the diagonal that marks off heaven and earth from each other. Indeed, nearly all the Saint-Rémy landscapes are compositionally unstable. This can be traced to the motif of mountains, which is used less as a phenomenon with a symbolism of its own than as a focus of

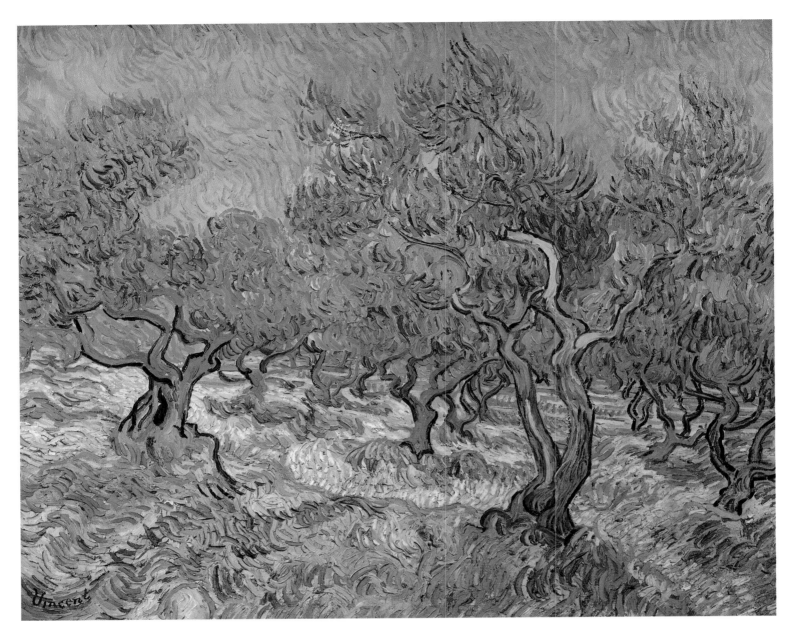

chaos in the overall compositional structure. It was his need for distortion, for the remade image, that alerted van Gogh to the destabilizing power of mountains when deployed as visual motifs; and he proceeded to deploy them with a will.

The series of olive groves also harks back to Arles. At that time, van Gogh painted fruit trees in blossom, using nicely nuanced lighting and subtle colour combinations to approximate a Japanese ideal. The principle of light emanating from within survived into the fifteen Saint-Rémy paintings of olive trees. But now it had become of secondary importance. *Olive Grove* (p. 526), for instance, is altogether lacking in optimism, and there are no blossoms on these trees. There is a quality of lament, almost of agony, in the twisted, knotted look of the olive trees; and the natural setting responds with an awareness of complicity – there are deep, furrowed gashes or wounds in the ground, and even the very air bears the violent signs of turbulence and unrest. The agitated brushwork places the various components of the composition on a par,

Olive Grove
Saint-Rémy, mid-June 1889
Oil on canvas, 72 x 92 cm
F 585, JH 1758
Otterlo, Rijksmuseum Kröller-Müller

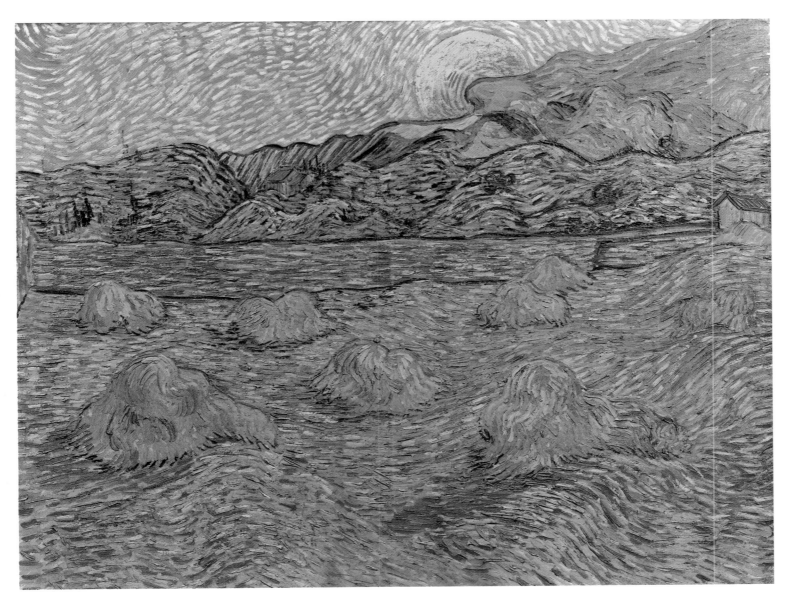

Evening Landscape with Rising Moon
Saint-Rémy, early July 1889
Oil on canvas, 72 x 92 cm
F 735, JH 1761
Otterlo, Rijksmuseum Kröller-Müller

as it were, and conveys a vitality that depends heavily on the thickness and vigour of van Gogh's oils. The paint is a universal, used for the leafage, bark, ground and sky in the same way: this standard treatment has the drawback of robbing the different motifs of their individuality. It is as if their lament were a lament for the injustices of (artistic) creation.

In *Olive Trees with Yellow Sky and Sun* (p. 574) the sun is merciless and the trees look as if they are trying to flee – but a dragging shadow is holding them back. This is an existence of slavery and mere endurance: there is not a trace of free, green burgeoning. Quite the contrary, the knotty trees look as if they are engaged in a wearisome struggle for a place in the sun. They are gnarled, almost deformed: their suffering lies within their own natures.

In Letter 615 van Gogh had told his brother that Bernard and Gauguin were currently occupied with historical scenes on Biblical themes, first and foremost Christ on the Mount of Olives. Van Gogh himself had no need of this kind of anachronism in his art. In a letter to Bernard (B21) he

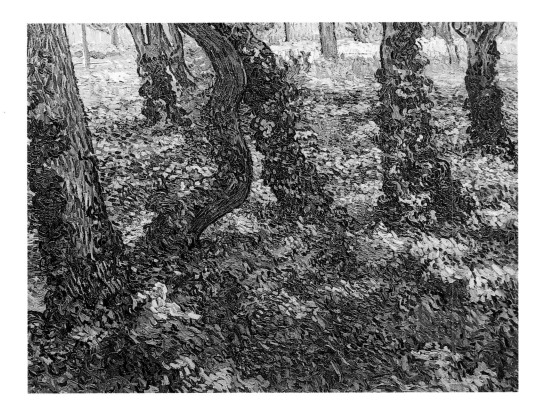

Tree Trunks with Ivy
Saint-Rémy, July 1889
Oil on canvas, 73 x 92.5 cm
F 746, JH 1762
Amsterdam, Rijksmuseum Vincent van
Gogh, Vincent van Gogh Foundation

restated his view and offered a brief analysis of the aims of his olive grove series: "I am telling you about these pictures in order to remind you that the impression of fear can be produced without immediately having recourse to the Garden of Gethsemane; if one intends to offer tenderness and consolation, it is not necessary to present the main character in the Sermon on the Mount." Van Gogh was trying to articulate both fear and consolation in his series. The series, in other words, was another way of responding to Gauguin's attempts to downgrade his art. Van Gogh was not clinging to the repertoire of art history and its attendant conventions. Academic predilections for large-scale historical panoramas had in any case always been anathema to him. He wanted the laments and consolations of his work to speak directly from the canvas, not muffled by the allegories of ages. Eschatological premonitions were second nature to him; and they gave him an uncanny sense of the essence of all things in creation.

This is why van Gogh allowed people into the olive grove setting, a setting which so entirely lacks the comfort of a garden. These people are not out for a stroll or otherwise idling; they are hard at work (cf. p. 592). In the fruit orchards of Arles as seen by van Gogh, the hand of the worker had not been needed, or at least was not seen. But the metaphor of the Biblical story of Gethsemane required the peasant. To bring it home, van Gogh had to present the olive grove as a place of agricultural use, rather than an ideal, arcadian or paradisiacal place. Gethsemane is synonymous with the Passion of Christ and His followers' belief in redemption. In this series, van Gogh was aiming to appropriate the paradox for his own ends. The motif of the olive tree stood for his own

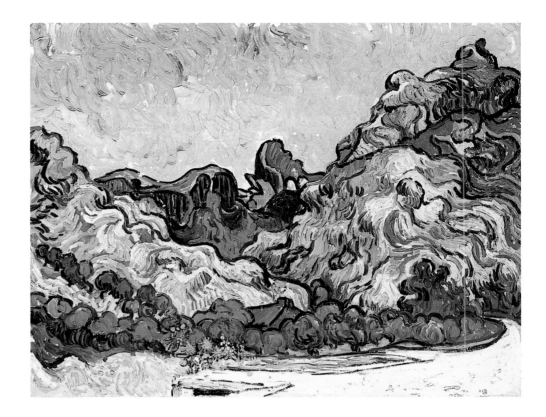

Mountains at Saint-Rémy with Dark Cottage
Saint-Rémy, July 1889
Oil on canvas, 71.8 x 90.8 cm
F 622, JH 1766
New York, The Solomon R. Guggenheim Museum, Justin K. Thannhauser Collection

capacity for suffering, and for his work, his art, which still set him carrying his easel and palette off to work in the open, and thus still represented hope.

And then there is the cypress tree: "as beautiful as an Egyptian obelisk", wrote van Gogh (Letter 596), linking the tree to the sun symbolism of an ancient civilization. In van Gogh's immediate Mediterranean environment, though, the tree tended rather to prompt

Entrance to a Quarry
Saint-Rémy, mid-July 1889
Oil on canvas, 60 x 73.5 cm
F 744, JH 1802
Amsterdam, Rijksmuseum Vincent van Gogh, Vincent van Gogh Foundation

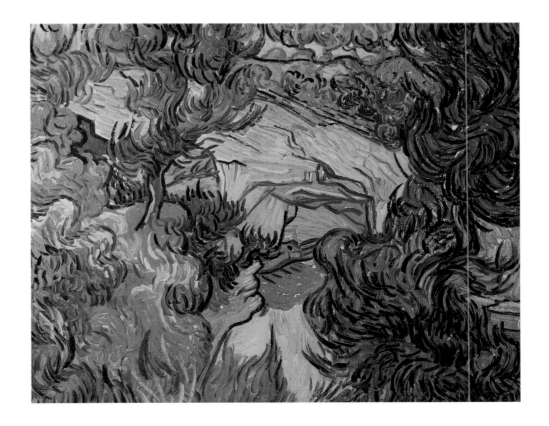

thoughts of death; cypresses, after all, were generally planted in cemeteries. This traditional association of cypresses with death was of course known to van Gogh: "It is the black mark in a sunlit landscape, but it is one of the most interesting shades of black, for I can think of none more difficult to paint." The cypress, with its tandem symbolism of life and death, sunlit cheer and black gloom, was obviously predestined for van Gogh's pictorial universe. There are only a few views of the tree alone, without the landscape it so strikingly tends to dominate. But those few are compacted, rich and pastose. The two trees in *Cypresses* (p. 516), for instance, are not so much two-dimensional features in a picture as reliefs modelled from countless streaks of green. The sky and greenery in the painting are arrestingly luminous, yet they still somehow lack the almost palpable physicality of the trees. It is as if van Gogh had needed to grasp his subject in a tactile way. It is by no means coincidental that he chose to return to the thick, streaky brushwork he had sometimes used in his early days.

The destabilizing effect of his mountains, the pathos and suffering he projected into his olive groves, and the torrents of colour that course

Undergrowth with Ivy
Saint-Rémy, July 1889
Oil on canvas, 49 x 64 cm
F 745, JH 1764
Amsterdam, Rijksmuseum Vincent van Gogh, Vincent van Gogh Foundation

Tree Trunks with Ivy
Saint-Rémy, Summer 1889
Oil on canvas, 45 x 60 cm
F 747, JH 1763
Otterlo, Rijksmuseum Kröller-Müller

through his cypresses, suggest that van Gogh's new motifs were serving a cause of reassurance. With their help, the artist kept a constant reminder of his artistic function before him. Van Gogh had by now shed all trace of naivety – though he still had that characteristically vehement vigour in his treatment of subjects. A subtle sophistication in his art, and nonetheless intent on identification with real phenomena, he continued to use the real as metaphors of the self, of his precarious psychological state, and of his confrontational energies. "The cypresses occupy me continually", he wrote in Letter 596, "I should like to use them for something along the lines of the sunflower pictures." Similarly, he said of the olive trees (in Letter 608): "The olive trees are highly characteristic [...]. One day I may make something wholly personal of them, as I did with the sunflowers." Van Gogh, in the asylum at Saint-Rémy, saw cypresses and olive trees (these two trees alone) in the same way as the utopian enthusiast had seen sunflowers in Arles – as symbols of himself and of his art.

But these motifs do not only represent the artist himself. They indicate the immense deliberation that went into van Gogh's Saint-Rémy

work, and are the defining characteristics of the landscape art he created there. Now the region – which in Arles had still been a vehicle for his visions of the future – was finally and unmistakably there. In being brought down to earth, van Gogh had his eyes opened to the landscape. It was only now that he could write: "Little by little I am coming to be aware of the whole of the landscape I am living in" (Letter 611); "to

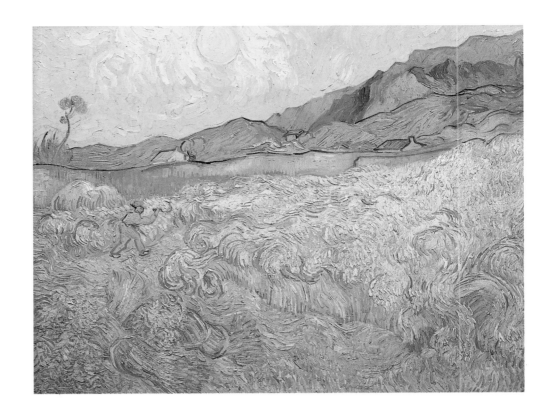

Wheat Fields with Reaper at Sunrise
Saint-Rémy, early September 1889
Oil on canvas, 73 x 92 cm
F 618, JH 1773
Amsterdam, Rijksmuseum Vincent van
Gogh, Vincent van Gogh Foundation

convey some impression of Provence it is essential to paint a few more
pictures of cypresses and mountains" (Letter 622); "I see a way of
making my work rather more complete, so that you will have a series of
Provence studies that are really thoroughly felt" (Letter 617).

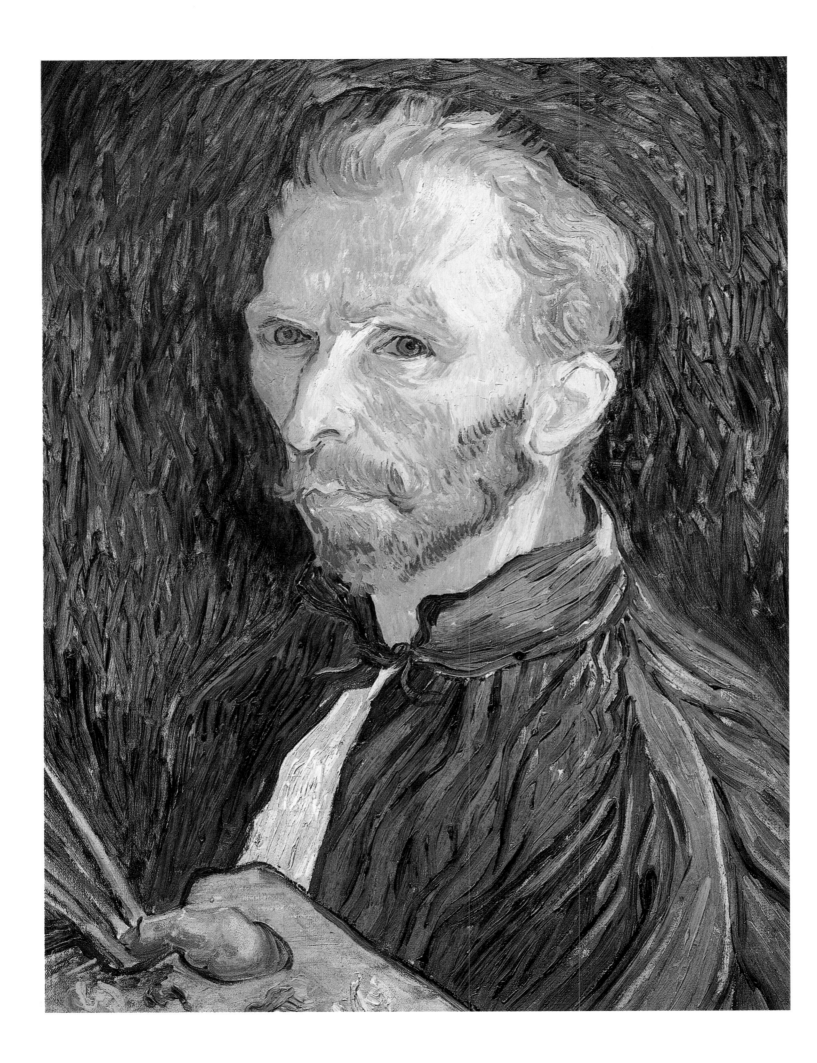

The Portraits

"My work is a far better distraction than anything else at all, and if I were able to plunge into it, with all my strength, it would probably be the best cure. The impossibility of having models, and a number of other things, prevent me from doing so." When van Gogh penned these words (from Letter 602), he had just recovered from a bout of insanity, the first he had suffered at Saint-Rémy. Suddenly paranoia had seized hold of him, just as he was standing at the easel and starting work on the ominous *Entrance to a Quarry* which critics have been taking as documentary proof of his mental instability ever since. For five weeks that July and August, van Gogh lay in mental darkness. He had tried to swallow the paint from his tubes. This has often been seen as a suicide attempt; but the action seems rather to have been a regressive mode of appropriation, the infantile urge to absorb the material that ruled his work and life alike. Needless to say, the governors of the asylum took his painting materials away from him. Once he had regained his wits, van Gogh decided to make a fresh start.

Fearfully, he avoided all excitement. He was wary of leaving the asylum. Restricted to motifs selected from within it, and feeling a need to justify himself, not only to the governors, but also to himself, van Gogh did the obvious thing and began a series of portraits. There were six of them in all, the only ones he did at Saint-Rémy; and they stand out as isolated yet imposing achievements of the art of portrait painting. Van Gogh sought the eyes of his subject, the mirror of the soul in which he would find a reflection of himself. His subject's gaze came to have greater importance than ever before. For three of the portraits, van Gogh took himself as the subject, thus avoiding the problem he had lamented in Letter 602 (the lack of models) and making a virtue of necessity.

In the self-portrait on page 534 (left), van Gogh's bony head still bears evident signs of the recent struggles. It is not only the contrastive colours that make his face look paler than usual; the pale yellowish green apparently gave a faithful account of his condition at that time. "I began it the day I got up", he wrote in Letter 604, "when I was lean and pale, a poor devil." Unusually for his self-portraits, van Gogh has equipped himself here with the attributes of the artist, partly by way of

Self-Portrait
Saint-Rémy, late August 1889
Oil on canvas, 57 x 43.5 cm
F 626, JH 1770
New York, Collection Mrs. John
Hay Whitney

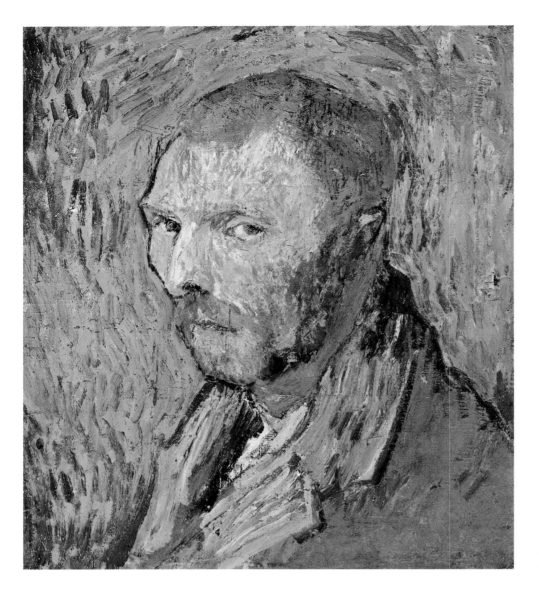

Self-Portrait
Saint-Rémy, September 1889
Oil on canvas, 51 x 45 cm
F 528, JH 1780
Oslo, Nasjonalgalleriet

demonstrating his profession and partly for the concealment and support afforded by the painter's smock and palette. His gaze is wary and cautious, meeting ours with a reluctance that suggests that the world of the canvas is a safer place than the outside world. In recording that gaze, van Gogh used one of the oldest tricks in the painter's book: his eyes are not focussed parallel, and this palpable divergence introduces an ambiguity into the object of their gaze. We have the impression that those eyes are not so much looking at any real thing as gazing inwardly upon imaginary worlds where literal vision is not required. At once wary and visionary, they are eyes that reflect the soul of a man who has been labelled mad.

The painting on the facing page (p. 537) is both more confident and more aggressive. It is a surly, almost rude and choleric face – as if the sitter had had enough of examining his features for signs of madness. There are deep creases by the nose and cheekbones, the eyebrows are thick and prominent, the corners of the mouth have turned down: it is the face of a man with no more time for friendliness. The snaking and swirling lines that denote the background are used for the person and

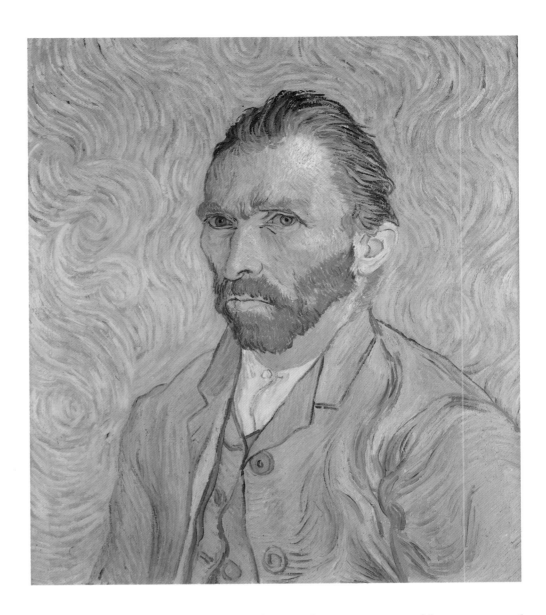

Self-Portrait
Saint-Rémy, September 1889
Oil on canvas, 65 x 54 cm
F 627, JH 1772
Paris, Musée d' Orsay

clothing of the artist, too, and the restless rejection of harmony and tranquillity to which these lines attest sets the keynote of the subject's facial features: the need to deform and remake has created a new disorder in his physiognomy. The face is not so much meant to be coarse or angry as full of vitality, of the sense of the moment. Painter and sitter being one and the same person, there is (as it were) no need for the model to keep still. The picture is not a pretty pose nor a realistic record; rather, the face van Gogh is here setting down on canvas is one that has seen too much jeopardy, too much turmoil, to be able to keep its agitation and trembling under control. It is not, in fact, an unfriendly face. This portrait articulates vitality. And the approach is plainly incapable of idealistic posing.

There is one more self-portrait, the most distorted, cruel and merciless of them all (p. 536). In a letter to his mother (612), van Gogh wrote bluntly: "The self-portrait I am sending will show you that, although I lived in Paris, London and other cities for years, I still look more or less like a peasant from Zundert [...] and sometimes I even take to supposing I feel and think like one, except that peasants are of greater use in this

**Portrait of Trabuc, an Attendant
at Saint-Paul Hospital**
Saint-Rémy, September 1889
Oil on canvas, 61 x 46 cm
F 629, JH 1774
Solothurn, Kunstmuseum Solothurn,
Dübi-Müller Foundation

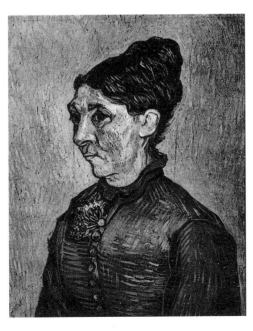

Portrait of Madame Trabuc
Saint-Rémy, September 1889
Oil on canvas on panel, 64 x 49 cm
F 631, JH 1777
Whereabouts unknown

world. It is only when they have everything else that people acquire a feeling for pictures, books, and so forth – and a need for them. In my own estimation I rank distinctly lower than peasants. Well, I plough my pictures as they plough their fields." And indeed the face in this self-portrait is furrowed with the toil of years. It is a face like the potato faces of Dutch peasants, though one wholly lacking in rustic naivety. Van Gogh looks worn and emaciated, and marked by knowledge of profound things. And it is thus that van Gogh presents himself to his mother, apparently expecting the eye of family love and familiarity to see beyond the alarming appearances. In its use of thick streaks of muddy, earthy paint, the picture is visibly and palpably true to van Gogh's (artistic) origins. But if the post-Romantic avowal of the ugly which gave the Nuenen pictures their emotional pathos had a quality of self-indulgence, that dimension has now been stripped away: here, van Gogh is using his own face to convey hopeless nothingness and pitiless sarcasm, qualities that had taken a back seat in the years of hope and optimistic utopianism. The picture lacks bright colours, it lacks light, it shows a van Gogh with a mutilated ear and an underhand louring look on his face. This, his penultimate self-portrait, shows van Gogh finally rejecting himself as a suitable portrait subject.

Théodore Géricault, the great French Romantic painter, did five portraits of the mentally ill. A doctor friend encouraged him to visit an asylum, where he painted people suffering from paranoia, claustrophobia and kleptomania. At that time it was widely believed that mental disease could be read in the facial features. Van Gogh, on the other hand, though surrounded by unfortunates suffering from various forms of mental illness, only once painted a fellow patient. And when he did so it was not in the service of physiognomical pseudo-scientific pursuits, but because he was a compassionate fellow creature – and a painter in need of a model. In his own way, van Gogh translated Géricault into the idiom of Modernism.

The work that resulted was *Portrait of a Patient in Saint-Paul Hospital* (p. 564). The man's blue eyes are fixed on an imaginary world. Once again the eyes are not focussed on the same place, though this time the discrepancy is on the horizontal axis, with one pupil somewhat above and the other somewhat below the mean. The man seems to be an intermediary between the earthbound realm and the higher, spiritual ether; and the painting technique reproduces this quality nicely. His shirt and jacket are done in thick, furrowing brushstrokes, and his face is a knotty, craggy mass of palpable, earthy matter (comparable to the facial features of the self-portrait on page 536). At the upper margin, though, a glazed blur supersedes, and the top of the man's head seems to merge into the intangible vagueness of the background. This part of the painting makes an unfinished and fragmentary impression, and by transference this impression is associated with the subject. Presumably

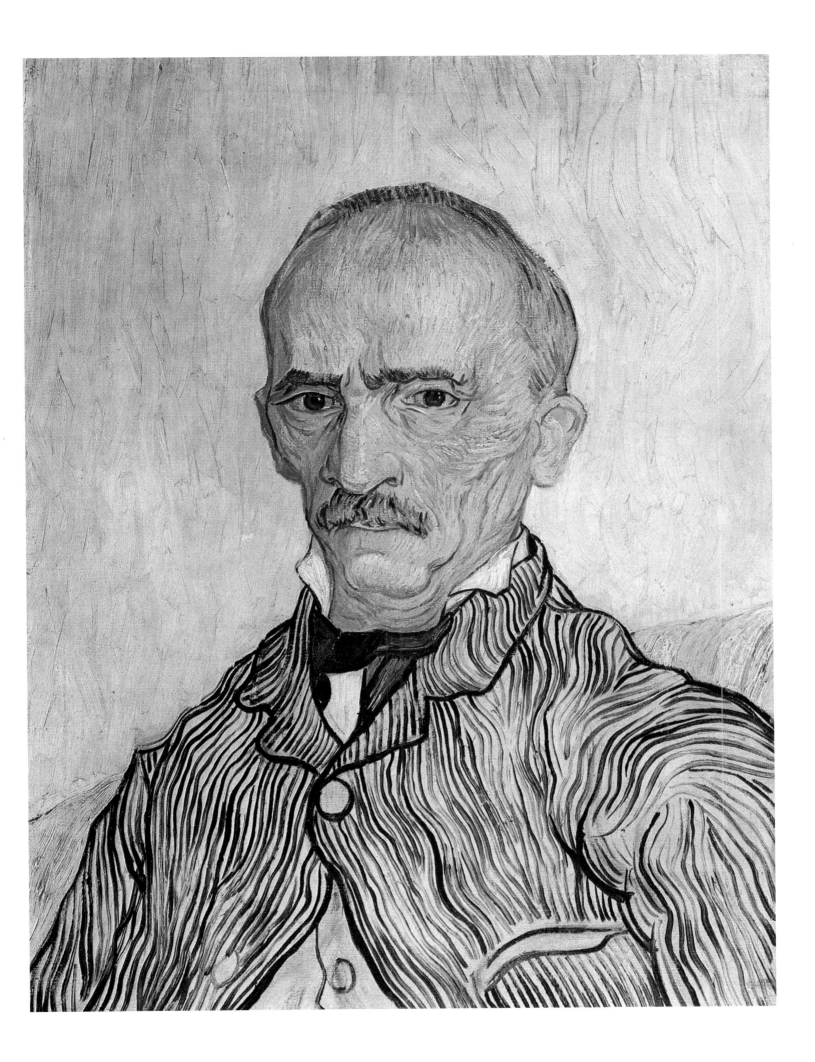

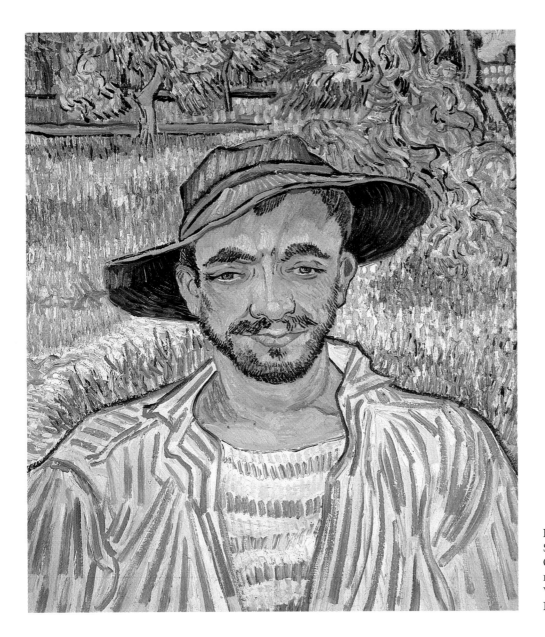

Portrait of a Young Peasant
Saint-Rémy, September 1889
Oil on canvas, 61 x 50 cm
F 531, JH 1779
Venice, The Solomon R. Guggenheim
Foundation, Peggy Guggenheim Collection

that is why van Gogh ceased work on the picture. The incompleteness of the image matches that of the man's mind. The picture represents another step in the evolution of a new view of mankind: Géricault, an enlightened man, had shown compassion and sympathy in his choice of an unusual subject, and now van Gogh was recording the deep abysses in the human spirit. Van Gogh showed us the madman in order to point up the parallel threats to Man and Art alike; the art of the 20th century no longer troubled with this kind of realistic legitimation.

"A man who has seen a tremendous amount of dying and suffering" (Letter 604) was van Gogh's model for *Portrait of Trabuc, an Attendant at Saint-Paul Hospital* (p. 539). This picture, together with that of Trabuc's wife (p. 538), makes up the total of van Gogh's Saint-Rémy portraits. The old man was chief attendant at the asylum. His stern but not hostile expression suggests a certain affection for the artist, and van Gogh in turn has tried to paint a fairly detailed, faithful portrait. Once again the lines marking the sitter's chin and eyes are picked up in the

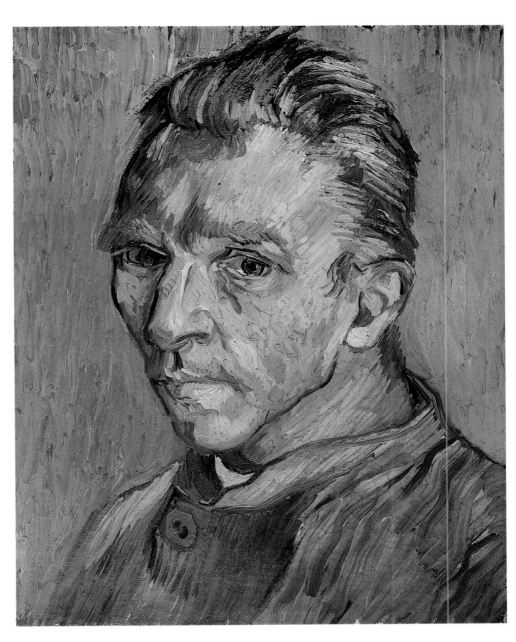

Self- Portrait
Saint-Rémy, September 1889
Oil on canvas, 40 x 31 cm
F 525, JH 1665
Bolligen (Switzerland), Collection J. Körfer

pattern of the jacket, which is ornamental rather than functional in character. The contrast between the photographic realism of the head and the abstract patterning of the torso could scarcely be greater. It is as if van Gogh had postponed the decision on painting as a system of autonomous values and painting as a close representation of given reality. Of course, Monsieur Trabuc's position in the asylum conferred a certain authority; and van Gogh may well have felt unable to indulge in that freedom of interpretation that he assumed he could take when painting his fellow patient. But this means that that measure of identification which made a pitiless revelation of the soul possible at all was absent in the painting of this picture. Van Gogh was not seeing himself in his model; rather, he was confronting the real state of affairs he currently found himself in. It is an unresolved painting, recording both distance and a willingness to communicate, and all his doubts are apparent in the antithesis of detail and sketchiness.

In the same month of September 1889 that saw the painting of the

Pietà (after Delacroix)
Saint-Rémy, September 1889
Oil on canvas, 73 x 60.5 cm
F 630, JH 1775
Amsterdam, Rijksmuseum Vincent van
Gogh, Vincent van Gogh Foundation

Pietà (after Delacroix)
Saint-Rémy, September 1889
Oil on canvas, 42 x 34 cm
F 757, JH 1776
Los Angeles, Collection Bernard
C. Solomon

portraits, van Gogh did two copies of the famous *Pietà* (shown above) by Delacroix. Nothing could convey more clearly his need to record his own crisis in the features of another than these two copies. The face of the crucified Christ in the lap of a grieving Mary quite unambiguously has van Gogh's own features. In other words, a ginger-haired Christ with a close-trimmed beard was now the perfect symbol of suffering, the (rather crude) encoding of van Gogh's own Passion. The painter was to attempt this daring stroke once more, in his interpretation of Rembrandt's *The Raising of Lazarus* (p. 626). Here, van Gogh gave his own features to a Biblical figure who, like Christ, passed through Death into new Life. It was as if, in his work as a copyist, van Gogh was pursuing the kind of oblique allegory he disapproved of in Bernard and Gauguin. Five weeks of mental darkness demanded artistic expression – and even that incorrigible realist Vincent van Gogh could not be satisfied with landscape immediacy alone.

Just as he sought to articulate his crisis of sanity in the symbolical

Half-Figure of an Angel (after Rembrandt)
Saint-Rémy, September 1889
Oil on canvas, 54 x 64 cm
F 624, JH 1778
Whereabouts unknown

terms of a Biblical story, so, too, van Gogh was trying to express the spirit of convalescence in the features of his models, whether the model was himself or someone whom circumstances had brought him together with. He was afraid of the contingent, afraid that the centre could not hold; and these canvases were a way of dispelling that fear. Thus the momentary confrontation with a sitter was transformed into something lasting and monumental; and the sense of communication that informs the portraits is like a spoken, human word in the new abyss of silence.

Space and Colour
Metaphors of Paradox

Wheat Field with Cypresses
Saint-Rémy, early September 1889
Oil on canvas, 72.5 x 91.5 cm
F 615, JH 1755
London, National Gallery

Van Gogh's watchword of the early years, to put a cheerful face on things at all times no matter how sad he might be at heart, remained his motto throughout his life. Indeed, from the asylum he wrote: "The difference between happiness and misfortune! Both are necessary and of use, as are death and decay – it is all so relative – and life, too." When he wrote these words (in Letter 607), he was a weary man. But the fundamental experience of the multiple ambiguities and paradoxes of life was the same as that of a younger, naive Vincent in the old days, with his book learning and precocious sermons. What had survived of his religious sense now served as an artist's means of translating visions into the power and glory of painting. Van Gogh's universal bearers of paradox (the figure in black, the people out walking, the couple) were now intensified or indeed replaced by means of genuine visual energy. And space and colour (the constants of all painting everywhere) now heightened and concentrated the statements and meanings of van Gogh's art, which had hitherto been the task of iconographical elements.

Naturally van Gogh remained true to the world of things, and the choice of motif continued to be decisive in capturing ambivalence and polarity. His was conceptual art, an art of content. Still, he had grown more careful in his choice of motifs. He added less and less in retrospect, in his studio. His attention was now commanded by immense subjects that filled his canvas in monumental manner – such as the cypress, surging skywards, the symbol of death so popular in graveyards, yet also a symbol reminiscent of the Egyptian obelisks and thus a sun symbol. A single motif could now include an entire world-view, all the sadness and joy in the universe.

Shortly after his arrival, van Gogh had already taken a corner of the Saint-Paul asylum garden as a subject (p. 507). The composition is dominated by a number of tree trunks seen in close-up, the verticals cropped by the upper edge of the canvas. Van Gogh was less interested in the cracked bark and knotty roots than in the ivy clinging to the trunks and wrapping the other vegetation in the picture. Ivy was a paradox in the green world of growth, providing a cosy nest for those that needed it ("perpetual retreats in the greenery for lovers", Letter 592), but also

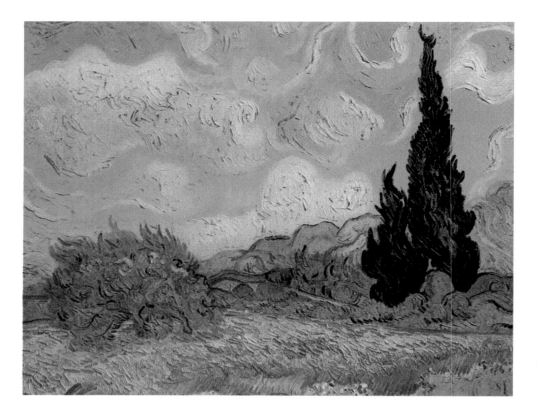

Wheat Field with Cypresses
Saint-Rémy, September 1889
Oil on canvas, 51.5 x 65 cm
F 743, JH 1790
Private collection
(Sotheby's Auction, 25. 2. 1970)

representing the diseased side of a healthy forest ("nevertheless I shall try to console myself with the thought that illnesses like this are for Man what ivy is for an oak tree", Letter 587). Everything in creation is ambivalent – and that includes the seemingly innocuous plant and the snug moods it prompts. Van Gogh's painting attempts to express that ambivalence. What he lacked in physical distance from his subjects, he made up for in mental detachment, scrutinizing things with remarkable rigour. If the perspective of such pictures was unclear, so was that of his own mind: the world had become both intimately familiar and utterly and irretrievably alien to him.

"The green trees near the bridge, wreathed in ivy; unfortunately the ivy wrapped about them, which looks so pretty, is eating them away and will have destroyed them before very long." Thus Delacroix in his diary. Van Gogh's interpretation of the ivy, in other words, was scarcely an unusual one. But it is the very familiarity of many of his thoughts which highlights the innovative elements in van Gogh's quest for visual ways of representing paradoxical ideas. His motifs might be conventional props in the artist's repertoire, occasionally adapted to syncretistic ends or his need to remake. But what was new was the *mise-en-scène*: the ivy, for instance, is not tucked away in a corner, but foregrounded in a manner both cosy and threatening. As if by instinct, van Gogh designs his compositions (if the word still applies) to fulfil a single task: that of conveying the disorder, the copiousness, and the ambiguous plenitude of the given world.

The most fundamental common denominator of Art and Nature is the role they both play in the mysteries of living and dying. Just as ivy, so

gloriously alive, is in fact the bringer of death, so too painting, by capturing Life on a canvas, fixes it in a single moment of eternal death. If a thing cannot change, it is dead. Van Gogh wonderfully describes this in an account he gives (in Letter 592) of the painting of *Death's-Head Moth* (p. 503): "Yesterday I drew a very big and quite rare moth that is known as a death's-head, a moth of astonishing and very choice colouring. To paint it I should have had to kill it, which would have been a pity, as the creature was so beautiful." The motif once again acts as a symbol: the moth's wings suggest a death's-head. The symbolism seen by mankind in the living creature is then transferred to the act of painting; and van Gogh would have had to kill it to produce a detailed version. Instead, he transferred the sketch to the canvas, added leaves and flowers, and so created a hymn to the vitality of Creation. Even here, though, unease at the fixing process remains.

The conviction that informed the self-portrait on page 537 has a still

The Spinner (after Millet)
Saint-Rémy, September 1889
Oil on canvas, 40 x 25.5 cm
F 696, JH 1786
Geneva, Collection Moshe Mayer

The Reaper (after Millet)
Saint-Rémy, September 1889
Oil on canvas, 43.5 x 25 cm
F 688, JH 1783
Rochester (N.Y.), Memorial Art Gallery
of the University of Rochester

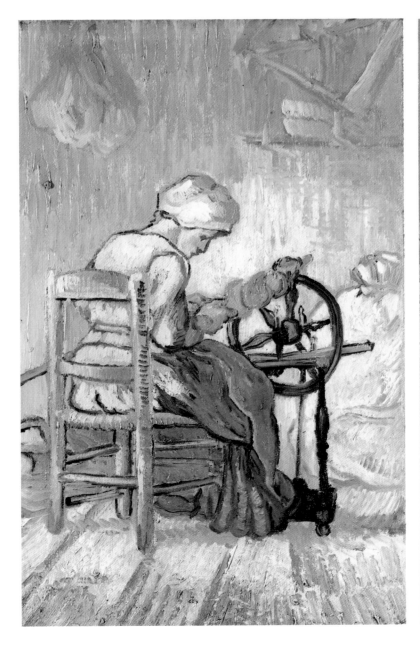

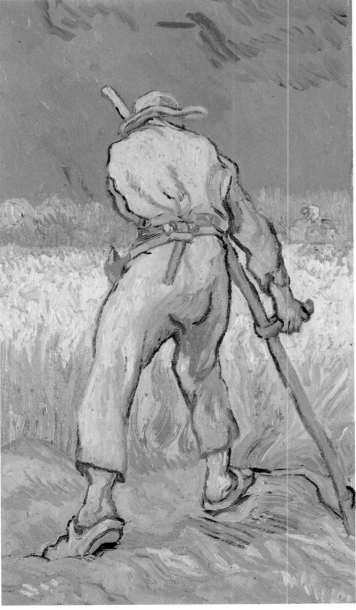

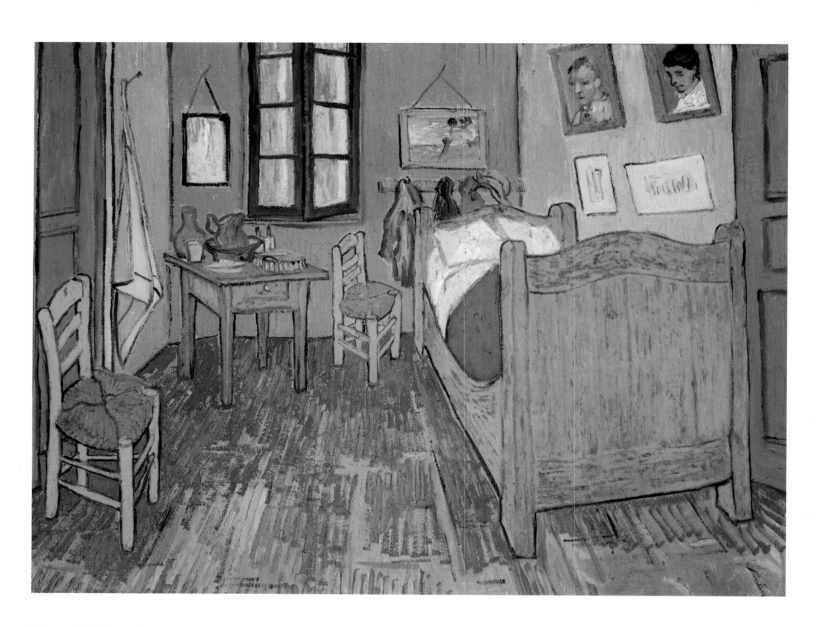

Vincent's Bedroom in Arles
Saint-Rémy, September 1889
Oil on canvas, 56.5 x 74 cm
F 483, JH 1793
Paris, Musée d'Orsay

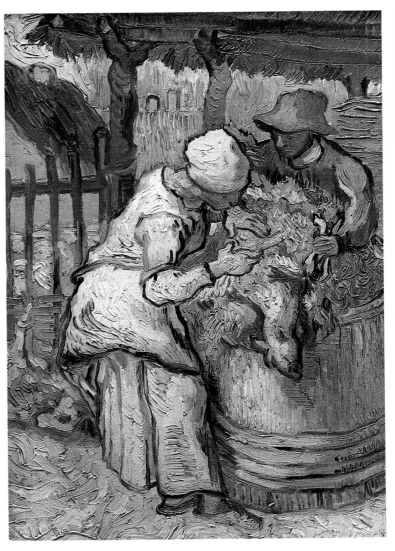

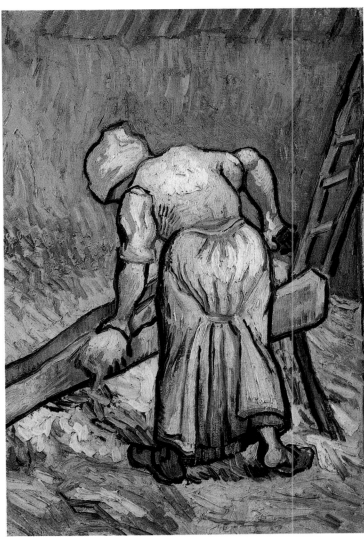

The Sheep-Shearers (after Millet)
Saint-Rémy, September 1889
Oil on canvas, 43.5 x 29.5 cm
F 634, JH 1787
Amsterdam, Rijksmuseum Vincent van
Gogh, Vincent van Gogh Foundation

Peasant Woman Cutting Straw
(after Millet)
Saint-Rémy, September 1889
Oil on canvas, 40.5 x 26.5 cm
F 697, JH 1788
Amsterdam, Rijksmuseum Vincent van
Gogh, Vincent van Gogh Foundation

tance – it is easy to grow giddy in attempting this", wrote van Gogh in Letter 597. "Nonetheless, at times we do intuitively sense that perhaps, on the far side of Life, there is a purpose in pain, which, viewed from here, sometimes dominates the horizon so entirely that it looks like a hopeless flood to us. We know very little about how these things are related, and we do better to look at a cornfield, even if it is only painted." It was in order to offer the cornfield as a source of strength, as consolation in the despondency that inevitably accompanies suffering, that van Gogh painted his enclosed fields. For the time being, the dark horizon of sorrow is lost to view. The field and the horizon as metaphors of the simultaneity of comfort and grief are (when incorporated into paintings) central motifs in the pictures where van Gogh went furthest in locating paradox in spatial principles.

A fine example of this is *Wheat Field with Rising Sun* (pp. 600–1). At first glance it looks like another variation on van Gogh's theme of the enclosed area behind the asylum. But now the flatland has thematic competition. The canvas is full of bold strokes that link the foreground field to the hills and sky beyond; and if we look at the cornfield as van Gogh instructed us, we see that the field and the horizon have become a

single unity. But in that unity there is a paradox. There are two vanishing points drawing our gaze to the rear, one of them drawing lines to the shrubs and cottage at left, the other drawing concentric circles to the sun. Two spatial principles are seen clashing here. One is the conventional central perspective that had been in use since the Renaissance and depended on a vanishing point located on the horizon. The other is a more suggestive funnel effect, drawing space down into unknown depths. The perspectival conflict is located in the bushes and the sun – the everyday, familiar face of the green world, and the glittering and mysterious aureole of the heavens. These focal points do not serve as ends in themselves. They are being used as iconographic, indeed traditional markers of the conclusions of a line of thought; van Gogh has been reviewing the symbolic functions of visual space. And he has decided to take both options. The decision as to the horizon beyond has been left open. Radiant infinity and everyday familiarity are seen here setting mutual limits.

In itself, a dual vanishing point was no innovation in van Gogh's œuvre. Back in The Hague he had done drawings in which lanes and roads on the heaths had gone in different perspectival directions (seen

The Man is at Sea (after Demont-Breton)
Saint-Rémy, October 1889
Oil on canvas, 66 x 51 cm
F 644, JH 1805
Private collection
(Sotheby's Auction, New York,
18. – 21. 10. 1989)

Peasant Woman with a Rake (after Millet)
Saint-Rémy, September 1889
Oil on canvas, 39 x 24 cm
F 698, JH 1789
Whereabouts unknown

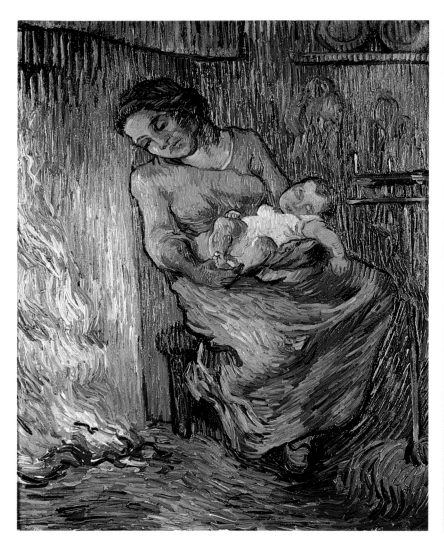

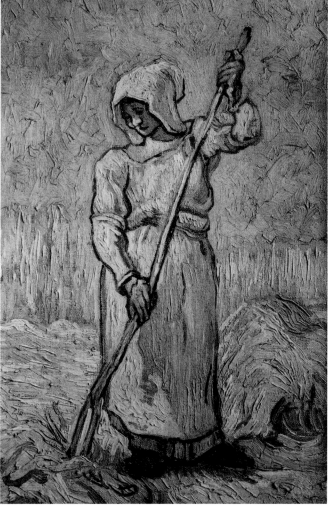

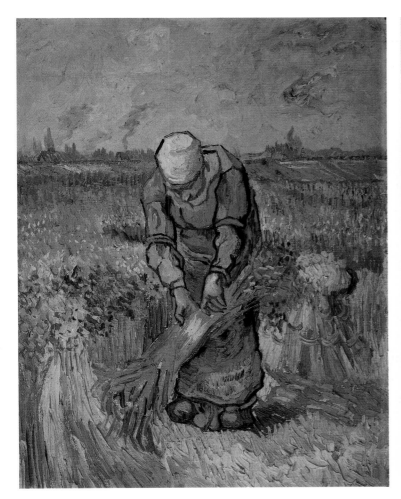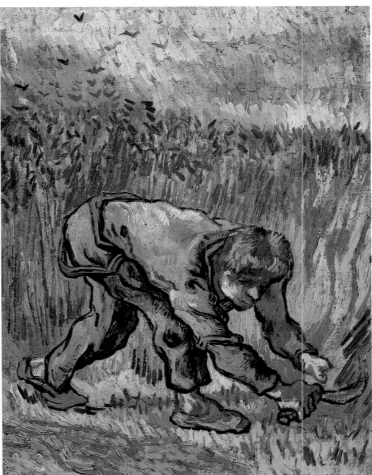

Peasant Woman Binding Sheaves
(after Millet)
Saint-Rémy, September 1889
Oil on canvas on cardboard, 43 x 33 cm
F 700, JH 1781
Amsterdam, Rijksmuseum Vincent van
Gogh, Vincent van Gogh Foundation

Reaper with Sickle (after Millet)
Saint-Rémy, September 1889
Oil on canvas, 44 x 33 cm
F 687, JH 1782
Amsterdam, Rijksmuseum Vincent van
Gogh, Vincent van Gogh Foundation

from the artist's point of view). And in Arles, for a short time, he had even adopted this approach as a method, in *The Trinquetaille Bridge* (p. 448) or *The Railway Bridge over Avenue Montmajour, Arles* (p. 448), for instance. The constructions themselves meet the eye diagonally, leaving our gaze only one option: to follow the bridges to the end, hoping for wide open space. In The Hague and in Arles, van Gogh had experimented with his perspective frame, placing it before his eye so that its diagonals and those established by his own vision were counterpoised; and so those pictures were composed according to the laws of central perspective.

In Saint-Rémy, though, the painter had abandoned his gadget. Presumably that was why he was now able to include mountains in his paintings, instead of forever following a sequence of horizontals, verticals and diagonals. Minus his perspective frame, van Gogh discovered the paradoxical power that the old system of spatial construction had over its motifs. Things could be grasped, subjected to the beholder's viewpoint, and assigned a firm and immutable place. And now van Gogh countered this with the evocative power of the sun, with longing for infinite distance. Central perspective attaches things to the foreground, as it were; whereas the whirlpool of concentric circles draws and drags them down to remote spatial depths. Thus, in *Wheat Field*

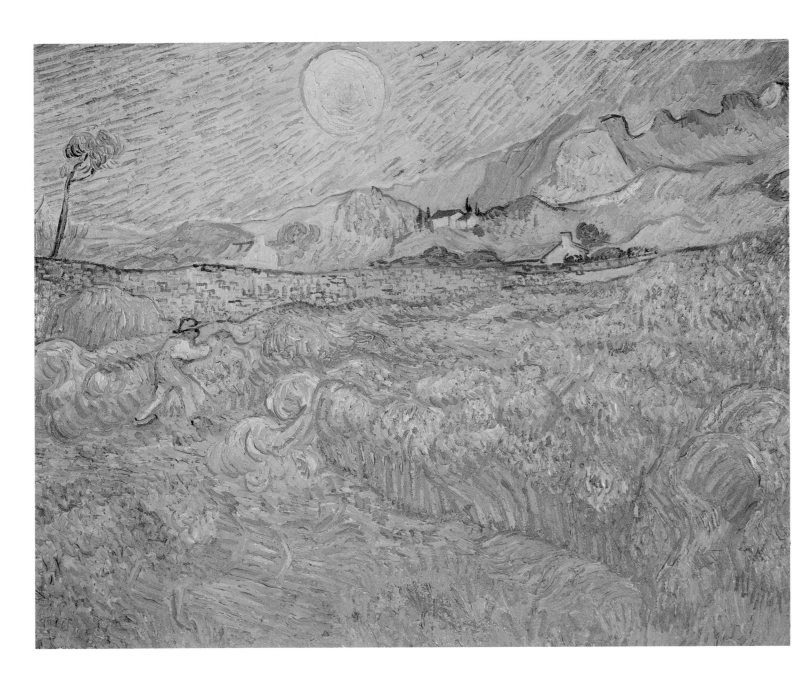

**Wheat Field behind Saint-Paul Hospital
with a Reaper**
Saint-Rémy, September 1889
Oil on canvas, 59.5 x 72.5 cm
F 619, JH 1792
Essen, Museum Folkwang

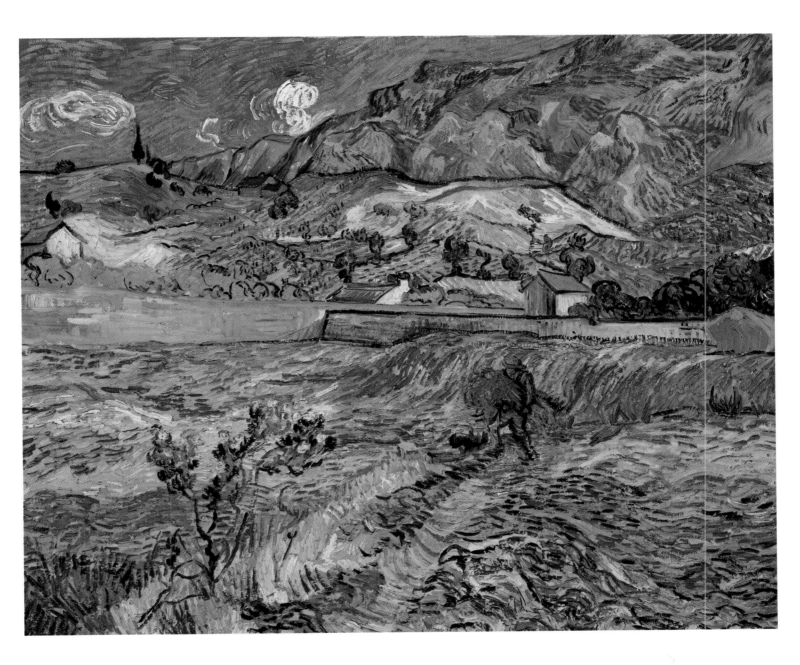

Enclosed Wheat Field with Peasant
Saint-Rémy, early October 1889
Oil on canvas, 73.5 x 92 cm
F 641, JH 1795
Indianapolis, Indianapolis Museum of Art

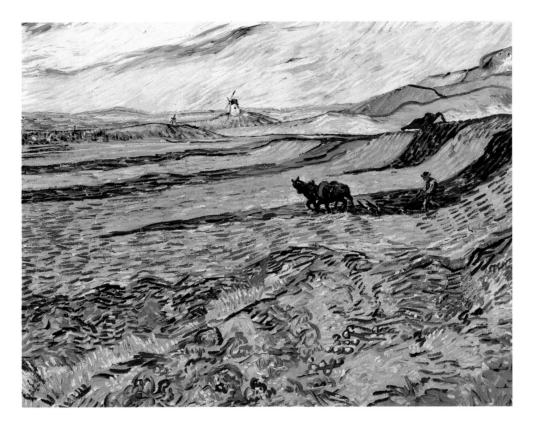

Field with Ploughman and Mill
Saint-Rémy, October 1889
Oil on canvas, 54 x 67 cm
F 706, JH 1794
Boston, Museum of Fine Arts,
loaned by W.A. Coolidge

with Rising Sun the protective and consoling aspect of the field is lost in unknown depths; it is in the intangible conflict of this balance that we see the nature of van Gogh's new reality, in which things recede from him at the very moment when he supposes he can grasp them. It is a terrible dichotomy. And even the act of rendering it on canvas can only be conceived in terms of deadly paradox.

The same is true of the use of colour. But van Gogh's strategy had no

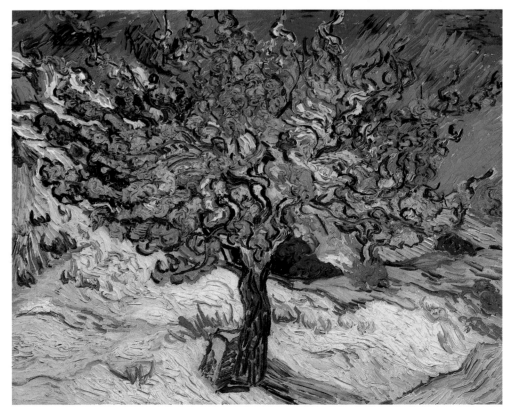

The Mulberry Tree
Saint-Rémy, October 1889
Oil on canvas, 54 x 65 cm
F 637, JH 1796
Pasadena (Cal.), Norton Simon
Museum of Art

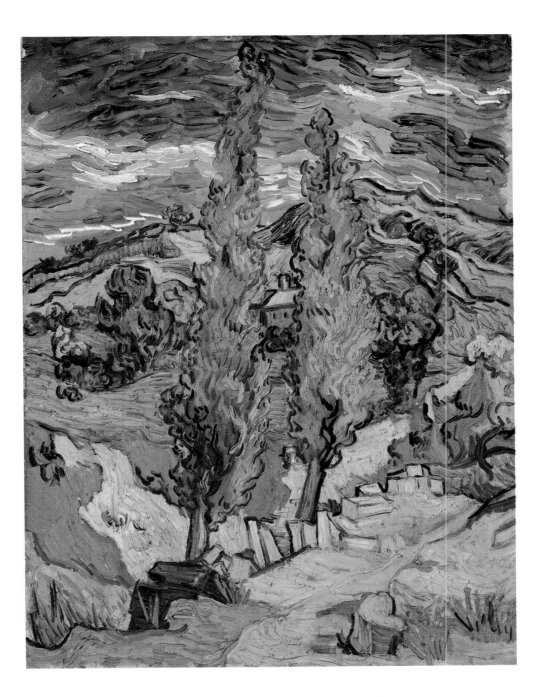

Two Poplars on a Road through the Hills
Saint-Rémy, October 1889
Oil on canvas, 61 x 45.5 cm
F 638, JH 1797
Cleveland, The Cleveland Museum of Art

need to be as radical here: his trademark, the use of contrast, was quite expressive enough. Even so, it is difficult not to conclude that the painter was only now becoming fully aware of the symbolic power hidden in the contrastive use of red and green, blue and orange, and violet and yellow. Again a vehicle was needed, one which combined everyday familiarity with oblique charm and grace; and this time van Gogh used his standard motif of the couple.

Ever since the days of Sien in The Hague (at the latest), van Gogh had had ambivalent feelings about women. "With my temperament, easy living and work are two things that are altogether irreconcilable", van Gogh had written from Arles (in Letter 480), "and in present circumstances one shall have to be content with painting pictures." But of course van Gogh was a man of flesh and blood, well aware of the dangers and temptations of the flesh; and he was also a man aware of the ideas of

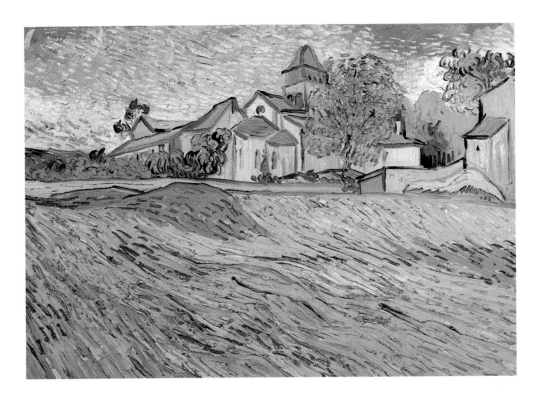

View of the Church of
Saint-Paul-de-Mausole
Saint-Rémy, October 1889
Oil on canvas, 44.5 x 60 cm
F 803, JH 2124
United States of America, Collection
Elizabeth Taylor

his age, interested in the symbolical image of the *femme fatale*, the Sphinx, or the Medusa. These considerations surely play a part in the presence of couples in van Gogh's visual world, as a metaphor of that happy family life that was denied him in reality. Thus, in *Olive Grove with Picking Figures* (p. 592) we see a couple busy picking olives. And in his bedroom (cf. pp. 548–49) he had apparently hung pictures of himself and a wife over the bed. In the better world he imaged forth in his pictures, happiness and good fortune were uncomplicated – even if van Gogh well knew that they were imaginary.

At the end of his Saint-Rémy period, van Gogh evolved what was in a sense the definitive solution of the problem in *Landscape with Couple Walking and Crescent Moon* (p. 629). The couple are seen walking amidst cypresses and olives in a moonlit idyll, the hills behind them. In this landscape – surely the very epitome of Provence – van Gogh's vision appears in all its wistful harmony. The man and woman belong together. They are going the same way, talking, gesturing. And they belong together because the colour scheme links them, too. In the man we see the contrast of orange (his hair) and blue (his clothing), while the woman offers the contrast of yellow and violet. In addition, the two figures contrast with each other. It is no coincidence that the man resembles the figure of van Gogh in self-portraits, wearing blue overalls, his hair and beard ginger. The man in the painting is van Gogh's *alter ego*. And his relation to the woman is perhaps not so much a fiction as a paradox: it contains both attraction and repulsion, just as the colour contrast already enacts polarities.

"The study of colour", wrote van Gogh in Letter 531, "I always feel I have to discover something. To express the love of two lovers through

Trees in the Garden of Saint-Paul Hospital
Saint-Rémy, October 1889
Oil on canvas, 42 x 32 cm
F 731, JH 1801
Switzerland, Private collection

The Garden of Saint-Paul Hospital
Saint-Rémy, October 1889
Oil on canvas, 64.5 x 49 cm
F 640, JH 1800
Geneva, Private collection

the marriage of two contrasting colours, through mixing and juxtaposing them, through the mysterious vibrancy of shades that are close to each other." Contrasting colours may be both mixed and juxtaposed at the same time, in a perpetual struggle for a happy mean that can never be established or preserved. The contrast itself, in other words, expresses the paradoxical: it is a symbol of the irreconcilable ambivalences that are dominant in the real world. Van Gogh focusses this insight in his couples. But of course, once we have grasped this, we will need to view his entire œuvre in terms of paradox, of simultaneous direct simplicity and complexity of expression. From a vantage point informed by van Gogh's late work, we can look back with hindsight and understand the full symbolic power of his use of colour contrasts throughout.

As if the voices of his religious education were all making themselves heard in those monastic walls, van Gogh now went about recapitulating

Trees in the Garden of Saint-Paul Hospital
Saint-Rémy, October 1889
Oil on canvas, 90.2 x 73.3 cm
F 643, JH 1799
Los Angeles, The Armand Hammer
Museum of Art

his repertoire of artistic icons. He tested to see if he had transgressed against the ban on images; he had not done justice to figures, and he tried to offer recompense. People had often been images of a worldview, a view of a paradoxical nature, but now the total picture (with its compositional structure and use of colour) acquired that function. Again we see how thoroughly thought-out van Gogh's art of the Saint-Rémy year was; he was trying to throw off the ballast of inconsistency and top-heavy significance, and if that involved him in additional distortion, that was all to the good.

Trees in the Garden of Saint-Paul Hospital
Saint-Rémy, October 1889
Oil on canvas, 73 x 60 cm
F 642, JH 1798
United States of America,
Private collection

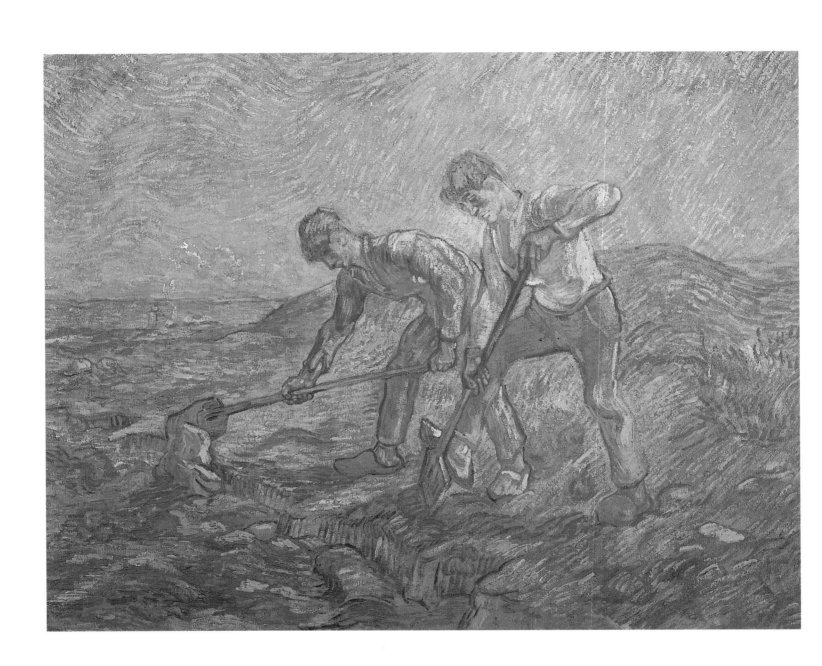

Exhibitions and Criticism
Van Gogh's First Successes

Two Peasants Digging (after Millet)
Saint-Rémy, October 1889
Oil on canvas, 72 x 92 cm
F 648, JH 1833
Amsterdam, Stedelijk Museum

For years the products of van Gogh's brush had been stockpiling. He had been sending regular consignments of his work to Paris, where Theo had been obliged to rent storage space. But the art treasures accumulating in Père Tanguy's back room could not go undiscovered for ever, and more and more interest was being shown. For his part, Theo (whom Vincent had often enough accused of doing nothing to help him) now went to work – and while the artist spent his time in an isolation of his own choosing in Provence, public interest was mounting back in the capital. The latest inside tip was Vincent van Gogh. As 1889 gave way to 1890, the signs of growing recognition became unmistakable; and van Gogh wrote (in Letter 605): "I can already see the day coming when I shall enjoy a measure of success and long for the solitude and the sad life I lead here, gazing through the iron bars of the cell at the reaper in the field. Misfortune does have its uses. To have success and lasting prosperity, one must be of a different disposition than I am; I shall never accomplish what I ought to have wanted, ought to have striven for!" Van Gogh had made himself at home in his secluded niche. He identified with his present condition, and the recognition of a world he had come to abhor sat uneasily with that state. The problem was, of course, that there was no going back.

Apart from sneak previews at Père Tanguy's store and at the Restaurant Du Châlet, Paris had not yet had an opportunity to see Vincent's art. This state of affairs changed abruptly with the opening of the fifth *Salon des Indépendants* on 3 September, 1889. This alternative salon, initiated in response to the official art normally approved by salon juries, had by now become an institution in its own right. It had been founded in 1884 by the Impressionists to offer exhibition space to those who were rejected by the Establishment. It took five years of encouragement from his brother before Vincent van Gogh submitted work. He exhibited two paintings: *Starry Night over the Rhône* (p. 431) and *Irises* (p. 505). The latter was painted in the first few days of his stay at Saint-Rémy, and in our own time has redoubled its fame by fetching a higher price at auction than any work of art ever before. Naturally the whole of Paris could hardly be said to have registered these works; but artistic

Portrait of a Patient in Saint-Paul Hospital
Saint-Rémy, October 1889
Oil on canvas, 32.5 x 23.5 cm
F 703, JH 1832
Amsterdam, Rijksmuseum Vincent van
Gogh, Vincent van Gogh Foundation

and open-minded people were impressed. "Poor as the *Indépendants* show was, many people saw your *Irises* and repeatedly mentioned it to me", wrote Theo afterwards (Letter T20). Van Gogh had started to make an impression on the art world.

"Who will interpret for us, in form and colour, this great and mighty Life that is achieving more and more self-confidence in our century? I know of one man, a man who has gone his own way, a pioneer, struggling on in the darkest night, and posterity will do well to remember his name – Vincent." Thus J. J. Isaacson in the August 1889 issue of a Dutch periodical, *De Portefeuille*. Isaacson, one of the colony of Dutch critics and painters in Paris, added a footnote reading: "I hope to be able to say more about this remarkable hero, who is a Dutchman, at a later date."

The critic, though he was forever pestering Theo van Gogh for further information and was extremely enthusiastic about Vincent's work, could say no more, for the painter had vetoed comment on his work. "I need hardly tell you that I find his note on me highly exaggerated in tone", wrote van Gogh (Letter 611), "which is one more reason why I feel it would be preferable if he said nothing about me at all." Van Gogh detested overblown rhetoric. He hated the gush that his paintings apparently prompted, and if he ventured into the public arena himself it was to engage in debate, and never to hear his own praises sung. And his homeland was going to have to wait a little longer to be familiarized with his art.

Van Gogh was given an interesting and surprising reception in Brussels. In January 1890, he had six pictures in the seventh exhibition of Les Vingt, the Belgian equivalent of the *Indépendants*. Any artist would have been glad to see opinion so divided. One Henry de Groux, a painter of conventional religious pictures, derided the riff-raff at the show, reserving special contempt for "the revolting pot of sunflowers by Monsieur Vincent," and withdrew his own work. He put in an appearance at the opening banquet nonetheless, indulged in new tirades, and provoked ripostes from Toulouse-Lautrec – who even challenged him to a duel. De Groux was debarred from membership in Les Vingt, and the painter, somewhat distraught, finally managed to bring himself to

The Entrance Hall of Saint-Paul Hospital
Saint-Rémy, October 1889 (or May)
Black chalk and gouache, 61 x 47.5 cm
F 1530, JH 1806
Amsterdam, Rijksmuseum Vincent van Gogh, Vincent van Gogh Foundation

Corridor in Saint-Paul Hospital
Saint-Rémy, October 1889 (or May)
Black chalk and gouache, 61.5 x 47 cm
F 1529, JH 1808
New York, The Museum of Modern Art

apologize. People were talking about van Gogh. They were even prepared to kill each other, if need be. Those were days when avant-garde aesthetics were still in their idealistic infancy, and artists were willing to fight – with pistols, if necessary. No report of this incident reached Saint-Rémy; but van Gogh did receive good news. He had sold his first painting in Brussels. *The Red Vineyard* (p. 450), done in Arles, went to Anna Boch (sister of his acquaintance Eugène) for 400 francs. It was to be his only sale during his lifetime. But still, the fact should not be overemphasized; after all, Vincent was so willing to give his paintings as presents that many would-be purchasers never needed to part with a penny.

Then, in January 1890, Albert Aurier's ambitious article on van Gogh appeared in the *Mercure de France*, the most important of the Symbolist publications. Bernard had drawn the Parisian critic's attention to his friend's work, and had shown him the paintings stored at Père Tanguy's shop. Theo was unaware of what was afoot – and the surprise of the article was all the greater. "Beneath skies carved from glittering sapphires and turquoises, or moulded out of some infernal sulphur, hot, deadly and dazzling; beneath skies like molten metal and melting crystals, where scorching suns shine, beneath a constant and terrible patter of all kinds of conceivable lights" – Aurier's language was elaborate as he gushed about van Gogh's paintings, pouring out metaphoric torrents that said less about the painter's art than about the Symbolists'

The Sower (after Millet)
Saint-Rémy, October-November 1889
Oil on canvas, 64 x 55 cm
F 689, JH 1836
Otterlo, Rijksmuseum Kröller-Müller

The Sower (after Millet)
Saint-Rémy, late October 1889
Oil on canvas, 80.8 x 66 cm
F 690, JH 1837
Collection Stavros S. Niarchos

liking for orgiastic language. He described the artist himself as "a sort of intoxicated giant, better equipped to move mountains than to toy with bric-à-brac, a seething brain irresistibly pouring forth its lava into all the gorges of Art, a terrible and half-mad genius, frequently sublime, sometimes grotesque, at all times very nearly sick." In a sense, Aurier was reproducing a vision of the kind of existence van Gogh himself supposed to be the only kind he was suited for – forever fighting his own madness. The idea of madness was the 19th century's only way of coping with the extraordinary qualities of genius. And Aurier, not one to hide his own light under a bushel, concluded: "Vincent van Gogh is at once too simple and too subtle for the bourgeois spirit of our contemporaries. He will only ever be fully understood by his brothers, by those who are true artists [...] and by those happy few among the lower and lowest of people who have chanced to escape the dogmas of the Latin School!"

Aurier's portrait is notable in several respects. He was the first to examine van Gogh, and thus to introduce those major themes that were to preoccupy van Gogh critics in the years to come. In the talk of genius

Evening: The Watch (after Millet)
Saint-Rémy, late October 1889
Oil on canvas, 74.5 x 93.5 cm
F 647, JH 1834
Amsterdam, Rijksmuseum Vincent van Gogh, Vincent van Gogh Foundation

The Garden of Saint-Paul Hospital
Saint-Rémy, October 1889
Oil on canvas, 50 x 63 cm
F 730, JH 1841
Private collection

and madness, of being misunderstood, of fighting for a better world, of solidarity with the common folk, and in the presence of an enlightened author alert to lofty insights, we see that curious fustian and hear that pompous tone of priestly mystification which ultimately derives its vindication from a belief that images painted in language can equal visual images. Yet the difference is of course striking. Many things can remain open in the universal language of the eye that must be nailed down and defined in the language of tongue and pen. The mysteries in van Gogh's paintings are not there because the artist was out to mystify; they arise when critics, intent on their own cleverness, fail to observe the distinction between the visual idiom and the idiom of language. We need only compare van Gogh's skies with Aurier's verbiage in his description of those skies to see this distinction at work. Aurier is nebulous, titanic, and utterly irrational.

At the sixth *Salon des Indépendants* in March 1890, van Gogh exhibited ten pictures. "Your paintings in the show are very successful", reported Theo (in Letter T32); "Monet said your pictures were the best in the whole exhibition. Many other artists have spoken to me about them." In just six months of busy public activity, Vincent van Gogh was now no longer a stranger to the art world, and his reputation was growing far beyond Paris coteries. He was seen as one of the promising new talents – and one who enjoyed the good fortune of having solid support on the gallery front. Theo had consolidated the reputation his business had as one of the leading modern art dealers. All the artists (as Monet, of all people, would know full well) had hungered not only for fame, but even at times for their daily bread in youthful years, fired by

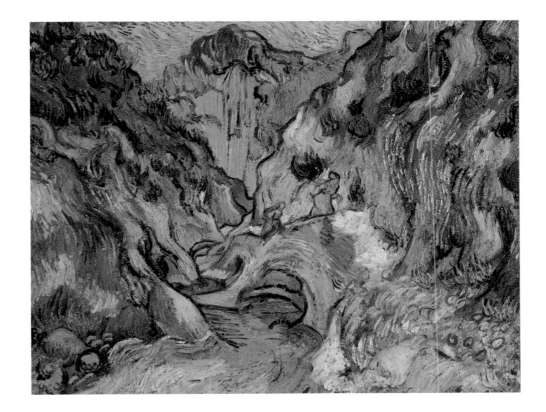

Les Peiroulets Ravine
Saint-Rémy, October 1889
Oil on canvas, 73 x 92 cm
F 662, JH 1804
Boston, Museum of Fine Arts

the conviction that their dedicated labours would ultimately be worthwhile. The Impressionists were now reaping manifold dividends. Van Gogh, too, had a debit and credit sheet in his mind – though the way he saw it was different.

"When I heard that my work was something of a success, and read the article in question, I was instantly afraid that I would have to pay; in a painter's life it is generally the case that success is the worst thing of

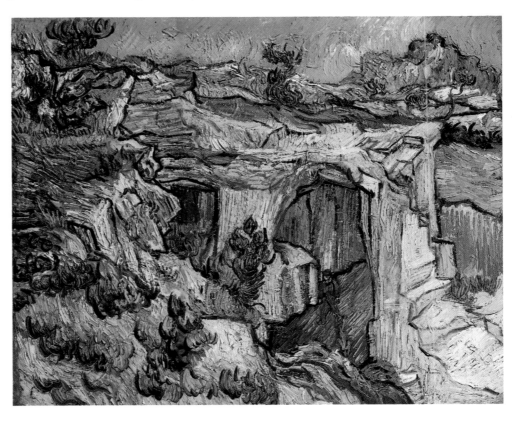

Entrance to a Quarry near Saint-Rémy
Saint-Rémy, October 1889
Oil on canvas, 52 x 64 cm
F 635, JH 1767
Private collection

Les Peiroulets Ravine
Saint-Rémy, October 1889
Oil on canvas, 32 x 41 cm
F 645, JH 1803
Amsterdam, Rijksmuseum Vincent van
Gogh, Vincent van Gogh Foundation

Wheat Field in Rain
Saint-Rémy, early November 1889
Oil on canvas, 73.5 x 92.5 cm
F 650, JH 1839
Philadelphia, The Philadelphia Museum
of Art

all." Thus Vincent to his mother, in Letter 629a. He felt he had leant too far out of the window and was in danger of falling any moment. To his fearful mind, this was mortal danger. He had accepted solitude, sickness and the contemptuous neglect of the world as the price he inevitably had to pay for his art, indeed for his very life. If he was now to enjoy success, doubtless he would soon be called upon to pay more dearly than ever. He had suffered a great deal; who could tell how much more he

Evening: The End of the Day
(afer Millet)
Saint-Rémy, November 1889
Oil on canvas, 72 x 94 cm
F 649, JH 1835
Komaki (Japan), Menard Art Museum

could take? So van Gogh was wary of even the smallest token of recognition, and his letter of thanks to Aurier was consistent in playing down his own claims and qualities: "You may possibly realise that your article would have been juster and to my way of thinking more persuasive if in your discussion of the future of painting and of colour you had dealt with Gauguin and Monticelli before referring to myself. For I assure you that the share I have or may have will remain negligible in future, too." (Letter 626a) The future came to see things differently, though, and van Gogh's share has been rated very highly by posterity. As for the artist himself, his suicide – now only months away – can in part be explained by the momentum his mounting success gathered. His solid conviction that he would have to pay for success, sooner or later, was to drive van Gogh to suicide.

Pine Trees with Figure in the Garden of Saint-Paul Hospital
Saint-Rémy, November 1889
Oil on canvas, 58 x 45 cm
F 653, JH 1840
Paris, Musée d'Orsay

The Walk: Falling Leaves
Saint-Rémy, October 1889
Oil on canvas, 73.5 x 60.5 cm
F 651, JH 1844
Amsterdam, Rijksmuseum Vincent van Gogh, Vincent van Gogh Foundation

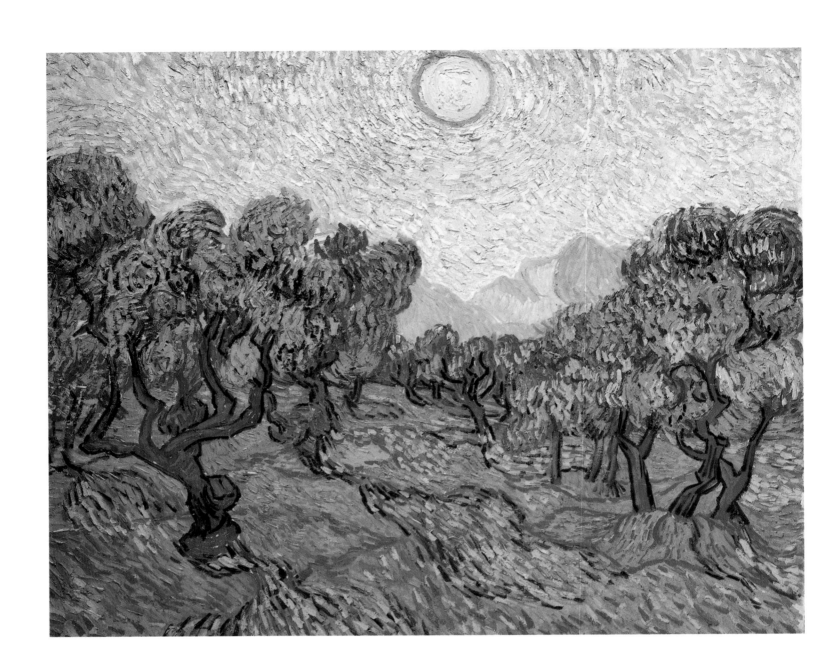

Selfhood and Otherness
Homage to the Masters

Olive Trees with Yellow Sky and Sun
Saint-Rémy, November 1889
Oil on canvas, 73.7 x 92.7 cm
F 710, JH 1856
Minneapolis, The Minneapolis
Institute of Arts

"Nowadays there are so many, many people who feel that they are not destined for public life and yet preserve and reinforce what others make. People who translate books, for example. Or engravers, lithographers." The greater the interest the public began to show in his work, the more van Gogh felt prompted to make statements such as this (from Letter 623). There are many who work to maintain cultural progress, even if they are not spearheading an avant-garde movement; they interpret and reproduce work, making the grand creations available to a wider audience. Van Gogh was only too ready to adopt a secondary (albeit creative) role, since a modest outsider's existence came naturally to him. The same letter concluded: "What I mean is that I have no reservations about painting copies." Once again he was going to hide his light under someone else's bushel; imitating the masters was lofty ambition enough.

The masters van Gogh followed at Saint-Rémy ranged from Delacroix via Rembrandt, the inevitable Millet, Daumier, and Gustave Doré, to Gauguin – and, modesty aside (for once), also included van Gogh himself. Generally he used prints from the collection he and his brother had made; Theo kept the collection in Paris, but Vincent had been involved in its creation throughout the years. Repeatedly he had prints sent in order to copy them. If we are to do justice to van Gogh's approach to this work, though, the word "copy" will surely seem inadequate. Rather, these works were paintings in their own right, and, even if the compositional and thematic choices were not originally van Gogh's, other choices were wholly his own. The prints provided a matrix for van Gogh's distinctive brushwork and use of colour. And in paraphrasing a number of works that had accompanied him throughout his career, providing points for him to take his bearings from, he was also paying homage – and in doing so, he revealed a great deal about the way he judged himself and his own ability.

At both the outset and the conclusion of this series of adaptations came very great artists indeed: Rembrandt and Delacroix. Other works in the series were of a lighter, genre nature; but Rembrandt and Delacroix gave weight and historical gravity. Apparently van Gogh only

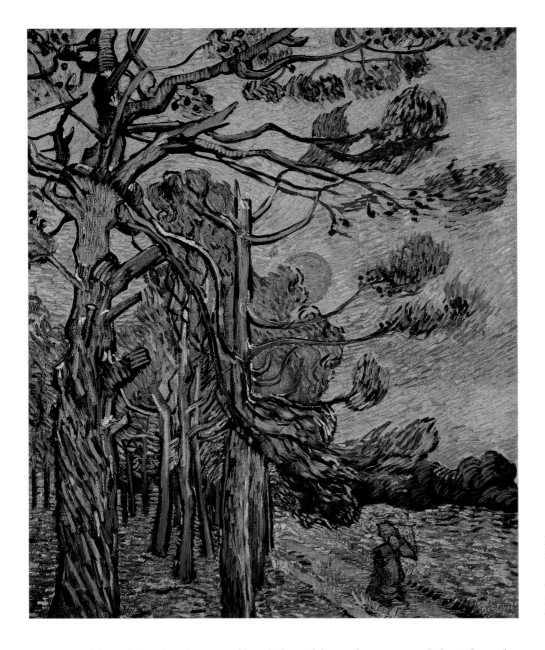

**Pine Trees against a Red Sky with
Setting Sun**
Saint-Rémy, November 1889
Oil on canvas, 92 x 73 cm
F 652, JH 1843
Otterlo, Rijksmuseum Kröller-Müller

dared tackle Biblical subjects if he did it obliquely, via models. Thus, he
painted his own versions of the *Pietà* (p. 542) and *The Good Samaritan*
(p. 627) by Delacroix, and of *The Raising of Lazarus* (p. 626) and a
monumental angel (p. 543) by Rembrandt. These are highly unusual
subjects for van Gogh. And it was only because he was using the
compositions in available lithographs that he continued in his principle
of closeness to the motif rather than slipping away into the depths of
unadulterated imagination.

Van Gogh was extremely skilful in using his models for his own
purposes. The two Rembrandt adaptations highlight this nicely. In
neither case did he do a complete copy. In *The Raising of Lazarus* he
substituted the sun for Christ. Van Gogh felt that the only plausible
subjects were those that could be grasped by everyday perception: ordi-
nary people and landscapes. Since the central character is conspicuous
by His absence, our entire attention is focussed on the dead man slowly
returning to life – Lazarus, whose features are van Gogh's own. The

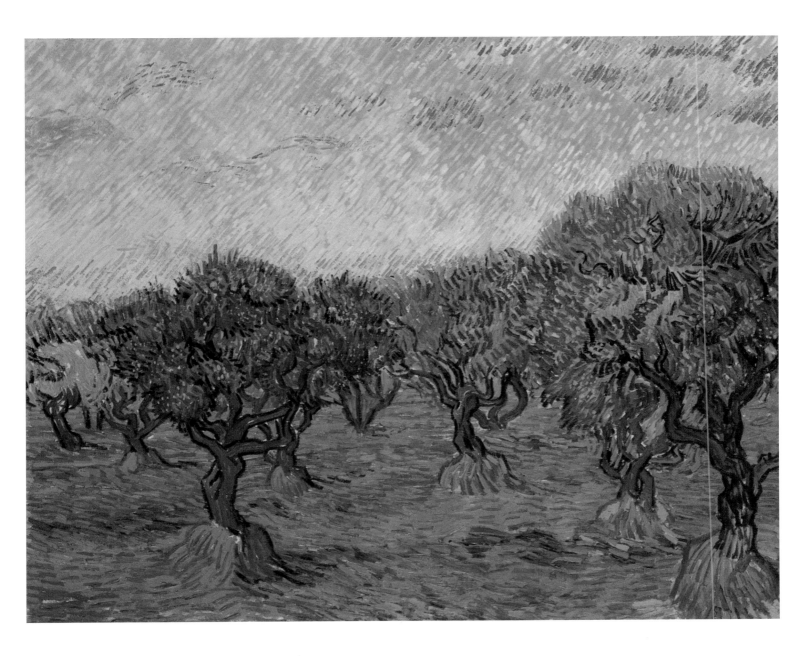

Olive Grove: Orange Sky
Saint-Rémy, November 1889
Oil on canvas, 74 x 93 cm
F 586, JH 1854
Göteborg, Göteborgs Konstmuseum

picture juxtaposes the artist's *alter ego* and the full radiance of the sun, and in the process van Gogh establishes the link with his paintings of cornfields and mountains near Saint-Rémy. Once subjected to radical revision, Rembrandt proves to have been a genuine forerunner of van Gogh.

If Lazarus lacks his divine counterpart, the angel lacks an earthly dimension. In Letter B12, van Gogh had expounded to Bernard his interpretation of a self-portrait in which Rembrandt showed himself in the company of an angel: "Rembrandt painted angels, too. He portrays himself, old, toothless, a man shrivelled up and wearing a cotton cap on his head [...] And just as Socrates and Mohammed had their guardians to watch over them, so Rembrandt has painted (behind this old man who looks like himself) a supernatural angel wearing a Leonardo smile." The old man stood for Rembrandt and subsequently for van Gogh himself: he eliminated the figure from the painting. The angel's gestures lack any object or focus, and the chosen recipient of the divine Word has van-

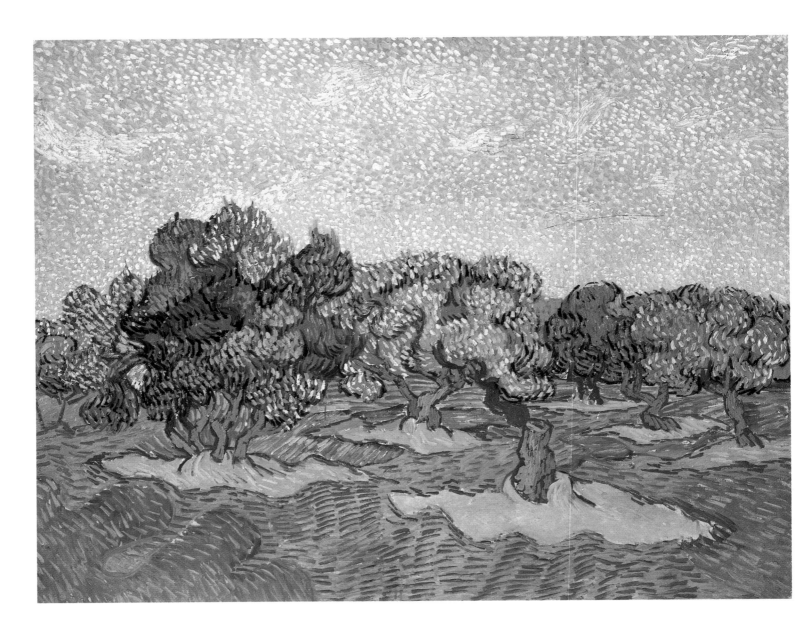

ished from sight, has quit the counterworld of Art and returned to the hard reality of an artist's life. All that remains is an icon. Divine inspiration has fled, and the angel is a mere quotation, lacking the presence of the genuinely experienced. Even so, the ideal representation still reflects van Gogh's own condition. Van Gogh had always had the ability to identify with religious art, and the works by Rembrandt and Delacroix could serve as a mirror of his own soul just as well as the people and landscape of Provence. This constitutes a major purpose of his copies: though they enabled van Gogh to pursue subsidiary aims of delicacy in presentation, above all they provided him with metaphors of exposure and isolation – and also with a very slight hope of security in a new realm beyond the grave.

Van Gogh also did some two dozen versions of Millets, though these exercises in social romanticism are less arresting and less ambitious. He gave his attention to individual figures. They were peasants binding sheaves, reaping, threshing or shearing sheep (pp. 547 and 550–53). These subjects had always been favourites with van Gogh, and now

Olive Grove: Pale Blue Sky
Saint-Rémy, November 1889
Oil on canvas, 72.7 x 92.1 cm
F 708, JH 1855
Rancho Mirage (Cal.), Collection
Mr. and Mrs. Walter H. Annenberg

Landscape with Trees and Figures
Saint-Rémy, November 1889
Oil on canvas, 49.9 x 65.4 cm
F 818, JH 1848
Baltimore, The Baltimore Museum of Art,
The Cone Collection

served as reminiscences of his own artistic origins. They reproduced the mood of his early days, when Millet had stood guardian over van Gogh the artist and van Gogh the man alike; and they helped van Gogh come to terms with the past and grasp his present and future more firmly in doing so. At Saint-Rémy, he was confronting the otherness of his early days with the selfhood of the present.

During those months, van Gogh was casting a cold eye on himself; and he summarized this process in a letter to his brother (607). "Let me try to explain what I am looking for and why it seems to me worthwhile to be copying these things", he wrote. "People always say that we artists should compose our own works, and be composers only. Very well; but in music it is not like that – if someone plays Beethoven, he adds his own personal interpretation – in music, particularly in singing, the way a composer is interpreted is an art in itself, and it is by no means necessary that only the composer play his own compositions. Very well; but at present, being ill, I want something that will afford me a little pleasure and consolation. I take the black and white of Delacroix or

Olive Grove
Saint-Rémy, November-December 1889
Oil on canvas, 73 x 92 cm
F 707, JH 1857
Amsterdam, Rijksmuseum Vincent van
Gogh, Vincent van Gogh Foundation

**The Stone Bench in the Garden
of Saint-Paul Hospital**
Saint-Rémy, November 1889
Oil on canvas, 39 x 46 cm
F 732, JH 1842
São Paulo, Museu de Arte de São Paulo

Millet, or a black-and-white copy, as my motif. And then I improvise in colour. But do not misunderstand me – this is not altogether my own, I am trying to preserve memories of their pictures – but the remembering, and the approximate harmony of emotionally registered colours (even if they are not quite the right ones), are my own interpretation."

The comfort he could derive from a symphony by Hector Berlioz or an opera by Wagner was now available to van Gogh through an activity like that of a musician. The pictures that served as his models were the equivalent of his scores. He then interpreted them, drawing both on the experience he had acquired and on his current state of mind. In his copies we see a principle at work that van Gogh obeyed in one way or another throughout his work – the principle of variation on a theme. The theme remained recognisable; but it could be treated in an infinite number of ways. Mountainous landscape, cypress trees and the en-

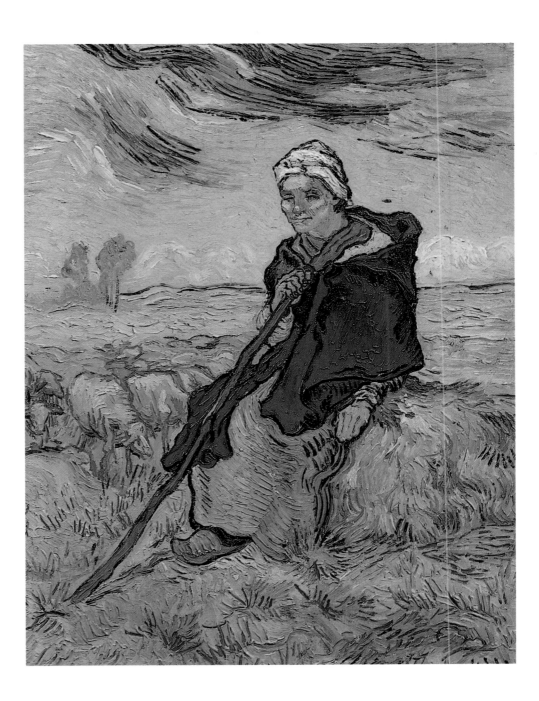

The Shepherdess (after Millet)
Saint-Rémy, November 1889
Oil on canvas, 52.7 x 40.7 cm
F 699, JH 1838
Tel Aviv, Tel Aviv Museum,
loaned by Moshe Mayer, Geneva

closed field provided van Gogh with a repertoire of themes to improvise on; and every painting was a new performance (or concert, as it were). Series work, so characteristic of van Gogh's approach, might be compared with a concert tour in which the same melodies are played but with variations according to mood, time of day, and so forth. Van Gogh's copies provide a striking reminder of the aptness of musical metaphors to his art – metaphors which do not draw their strength so much from the Symbolist cult of synaesthesia as from the opportunity to vary the forms and force of personal expression.

Indeed, in emphasizing personal expression we are touching upon an aesthetic category which might even be said to enter art history for the first time – in any meaningful sense – with van Gogh. His expressiveness consisted in freedom of interpretation, in improvisation and variation, in the rapid recording of an on-the-spot mood in order to set down a

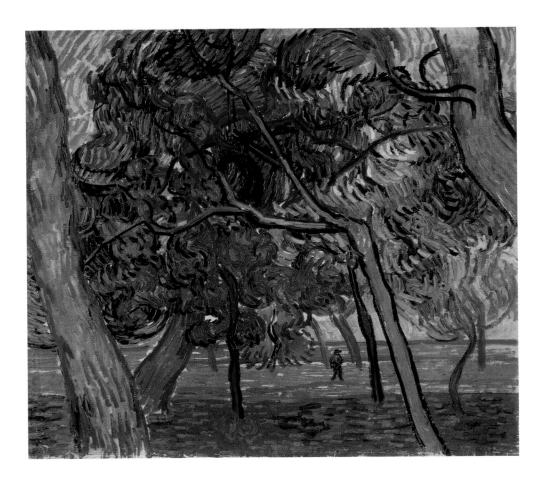

Study of Pine Trees
Saint-Rémy, November 1889
Oil on canvas, 46 x 51 cm
F 742, JH 1846
Otterlo, Rijksmuseum Kröller-Müller

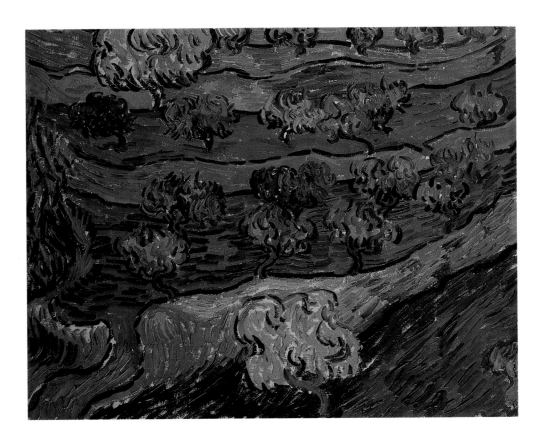

Olive Trees against a Slope of a Hill
Saint-Rémy, November-December 1889
Oil on canvas, 33.5 x 40 cm
F 716, JH 1878
Amsterdam, Rijksmuseum Vincent van
Gogh, Vincent van Gogh Foundation

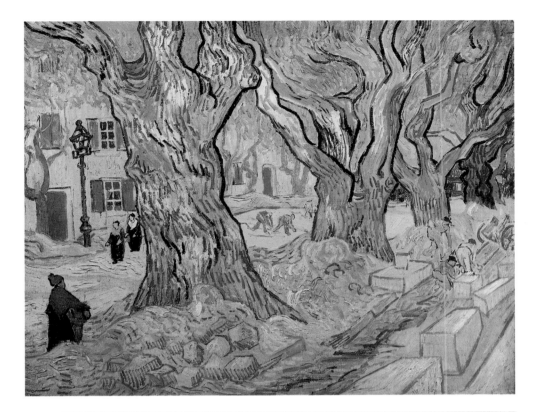

The Road Menders
Saint-Rémy, November 1889
Oil on canvas, 71 x 93 cm
F 658, JH 1861
Washington, The Phillips Collection

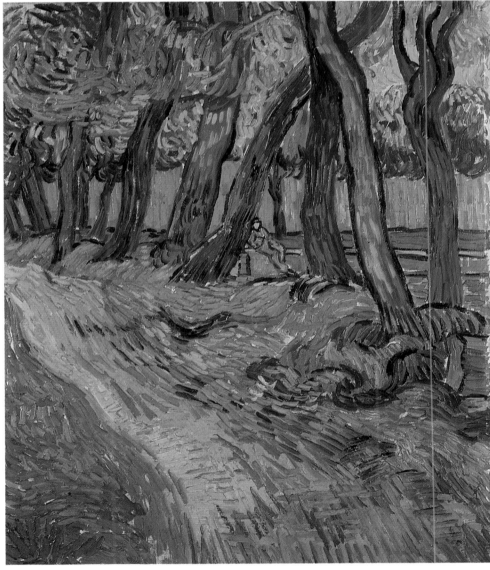

**The Garden of Saint-Paul Hospital
with Figure**
Saint-Rémy, November 1889
Oil on canvas, 61 x 50 cm
F 733, JH 1845
Otterlo, Rijksmuseum Kröller-Müller

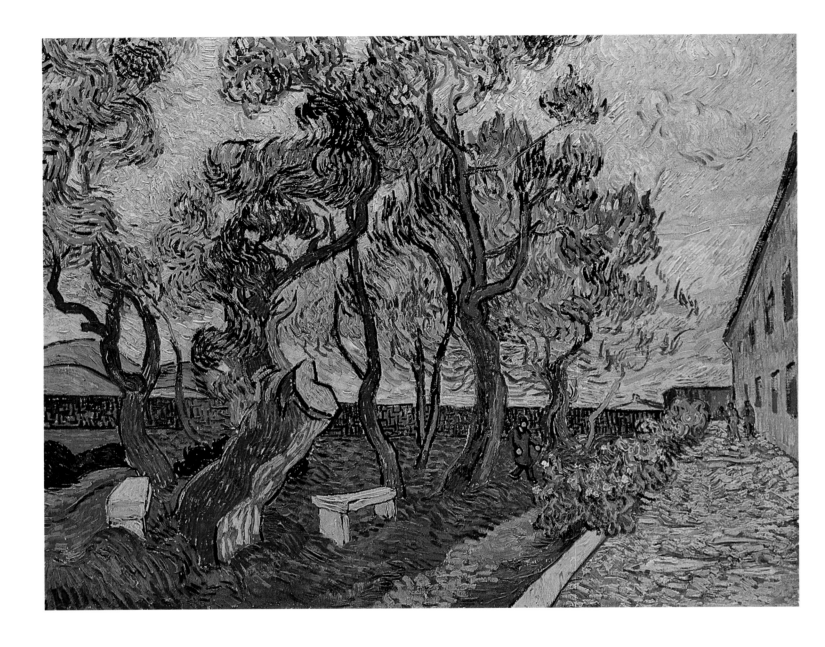

part of himself on the canvas. His jagged lines, orchestrated shapes and crude combinations of colours were not so much ends in themselves as means of attesting the immediacy of the work. The brush and canvas were his instruments, and his virtuosity produced an overall harmony that drew upon years of experience and at the same time on the mood of the moment. This was why the time he took to produce a painting was of such importance. If he had taken years over a single work (as Cézanne did at times), van Gogh would have forfeited this "musical" aspect of his work.

So van Gogh's chosen motif was the alien element, which could be used to convey meaning (feelings of loneliness, of homelessness, and so on); his work on the motif (in sketch form or in the paint) was the personal element, expressing his own personality. Essentially van Gogh did not make any subjects his own. He merely borrowed them, as it were familiarizing himself with them for as long as they were his artistic subjects. That is why the copies fit in so well with his œuvre as a whole.

The Garden of Saint-Paul Hospital
Saint-Rémy, November 1889
Oil on canvas, 73.1 x 92.6 cm
F 660, JH 1849
Essen, Museum Folkwang

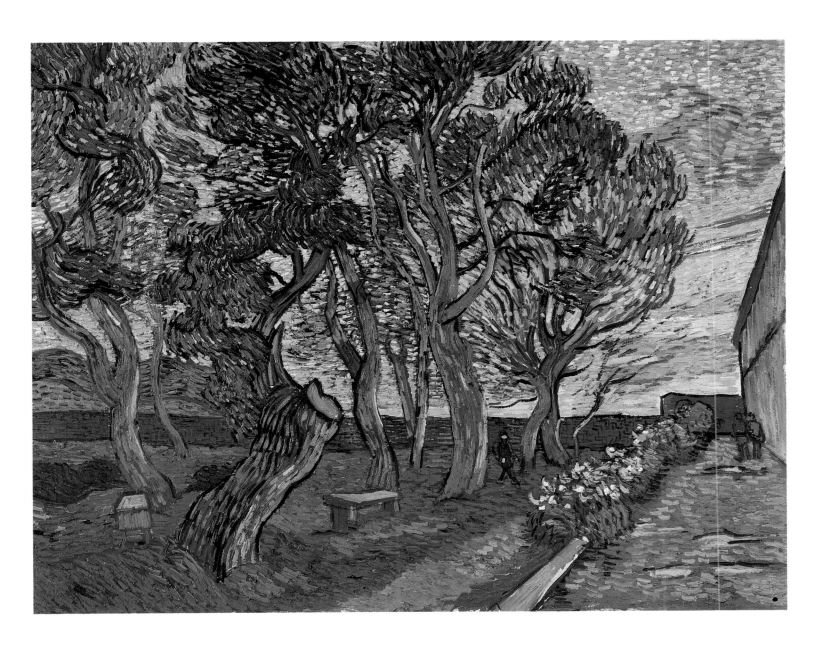

The Garden of Saint-Paul Hospital
Saint-Rémy, December 1889
Oil on canvas, 71.5 x 90.5 cm
F 659, JH 1850
Amsterdam, Rijksmuseum Vincent van
Gogh, Vincent van Gogh Foundation

Like anything else in the world, these motifs had figurative value for van Gogh, and could therefore serve for a process of identification. This was the only way van Gogh's revered masters could still contribute to his art. Daumier's *The Drinkers* simply reminded him of his own excesses in Paris and Arles; but once he painted a copy, the picture re-established its intrinsic power and meaning (cf. p. 613). Doré's *Prisoners Exercising* doubtless underlined his own sense of confinement; but it was only when he added the brooding blue to the picture that he truly expressed his own situation (p. 612). The drawing of Madame Ginoux that served Gauguin as a preliminary study (cf. p. 442) for his version of the *Night Café* was a reminder of the war the two friends had fought in the yellow house; but only when he had painted his own versions of that study (pp. 616–17) did van Gogh properly put that rivalry behind him. Van Gogh also linked up with his own younger days, reworking a piece he had done in The Hague and given a rather portentous title to (*On the Threshold of Eternity*), remaking it as a simple, albeit monumental

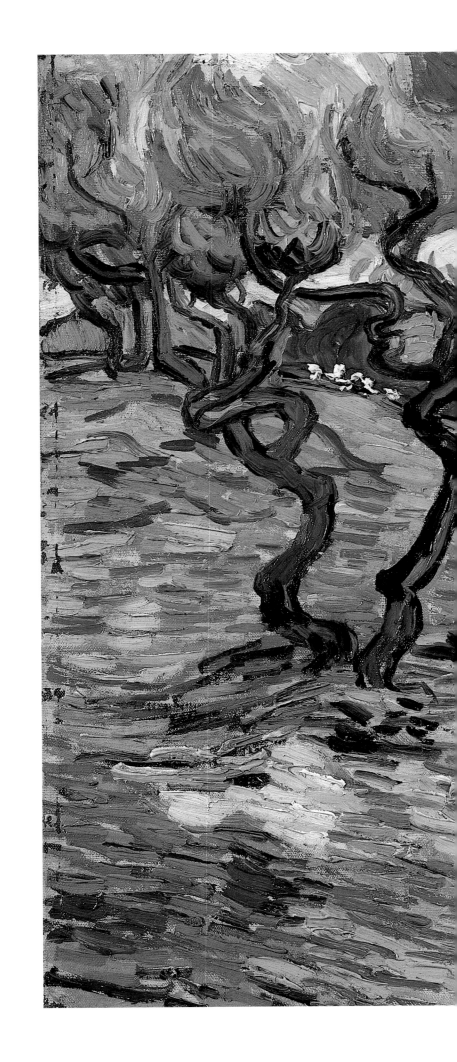

Olive Trees: Bright Blue Sky
Saint-Rémy, November 1889
Oil on canvas, 49 x 63 cm
F 714, JH 1858
Edinburgh, National Gallery of Scotland

record of the passing moment (p. 630). In painting these pictures, van Gogh recorded part of himself and at the same time located a partner for the dialogue and communication he needed: all of them provided him with figures, and he carried on the conversation in his own imagination. The words were never set down. But the people van Gogh searched out in his quest for communication are alive on the canvas, and we can hear what they are saying if we will.

The Road Menders
Saint-Rémy, November 1889
Oil on canvas, 73.7 x 92 cm
F 657, JH 1860
Cleveland, The Cleveland Museum of Art

Ways of Escape
The Final Months in Saint-Rémy

The *Trees in the Garden of Saint-Paul Hospital* (p. 560) have an assured air. The atmosphere they establish is one of snug comfort beneath their inviting shade, an atmosphere that perhaps does not quite fit the place. People are out walking in ones and twos, enjoying the idyllic mood. The setting has something of a park about it, charming and carefree, and the gloomy monastic buildings of the asylum look as graceful as an orangerie or stately home. What possessed van Gogh to transform the asylum by breathing the magic of the poet's garden at Arles upon it? Why are the male figures (who look more like chance passers-by than like careworn inmates of a lunatic asylum) accompanied by ladies (cf. the lady with the umbrella, and the couple in yellow), as if van Gogh were gazing at public gardens? And why is the painter himself (the man in the centre, in blue overalls and straw hat) in the picture? Had van Gogh's view of the asylum changed to one of cheerful optimism? Or was he merely indulging in wishful thinking, dreaming a new world free of doubt and suspicion?

Van Gogh was trying to cast a spell. He had spent several weeks isolated in his room; now he was venturing into the open. With the memory of his first attack in Saint-Rémy still very strong in him, van Gogh was hesitantly reaching out again to the world and all it had to offer. In Letter 604 he set himself the latest of his goals: "I propose to go on working hard, and if I should have another attack towards Christmas time, we shall see; if I get over it, I see no reason why I should not send the administration here to the devil and return north, in the long term or the short. To leave now, considering that I think another attack in winter probable, that is to say, in three months' time, would perhaps be incautious. For six weeks I have not set foot outside the house and have not even been in the garden; [...] but next week I plan to try it." The painting of the trees and courtyard was that attempt.

Van Gogh's balance between good cheer and *weltschmerz* had always been precarious, and now it became more unstable than ever. With all the self-discipline in the world, van Gogh could not be sure of averting an escalation of his condition. That autumn of 1889, van Gogh confronted two facts. One was that his attacks would recur. The other was

The White Cottage among the Olive Trees
Saint-Rémy, December 1889
Oil on canvas, 70 x 60 cm
F 664, JH 1865
Whereabouts unknown

Valley with Ploughman Seen from Above
Saint-Rémy, December 1889
Oil on canvas, 33 x 41 cm
F 727, JH 1877
Whereabouts unknown

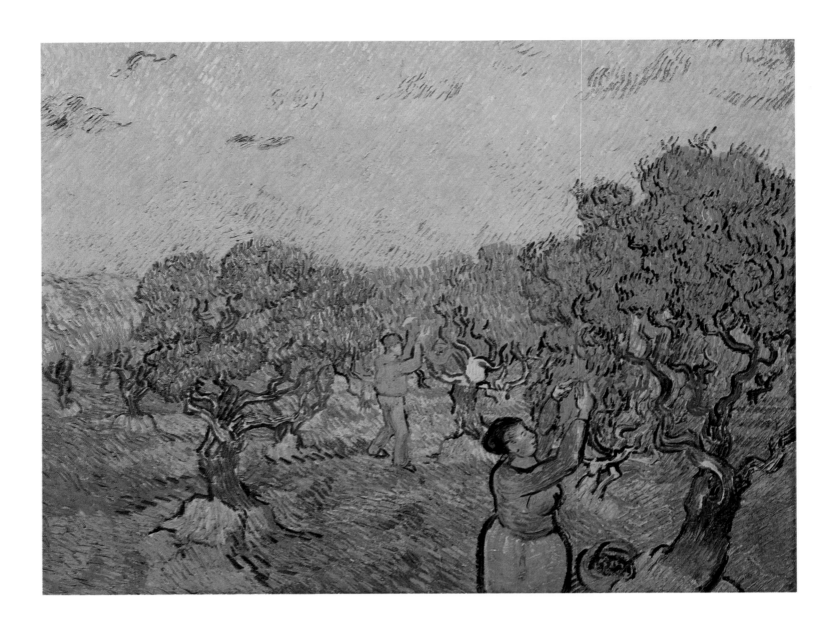

that, this being so, he might as well follow the promptings of his heart and go back north, closer to his childhood home and the affection of his brother. This twin recognition explains why his existential *angst* became all the more critical, while simultaneously his longing for the security and comfort of a familiar environment grew more and more acute. Van Gogh was to remain in the asylum for a further six months, in a stalemate of his own spirit's creation.

"It is now just a year since the attack back then", he wrote immediately before Christmas 1889 in a letter (W18) to his sister. He had scarcely written the words before the thing he had been fearing for weeks did indeed happen: again van Gogh succumbed to an attack. As in the year before, he plunged into a deep depression that lasted eight days. Again he tried to swallow his paint, and became incapable of contact with the outside world. That special affinity van Gogh had with Christmas, and his fixation on anniversaries, had joined forces against him. And when van Gogh came to mark the anniversary he had been awaiting, there was nothing joyful about the event.

Olive Grove with Picking Figures
Saint-Rémy, December 1889
Oil on canvas, 73 x 92 cm
F 587, JH 1853
Otterlo, Rijksmuseum Kröller-Müller

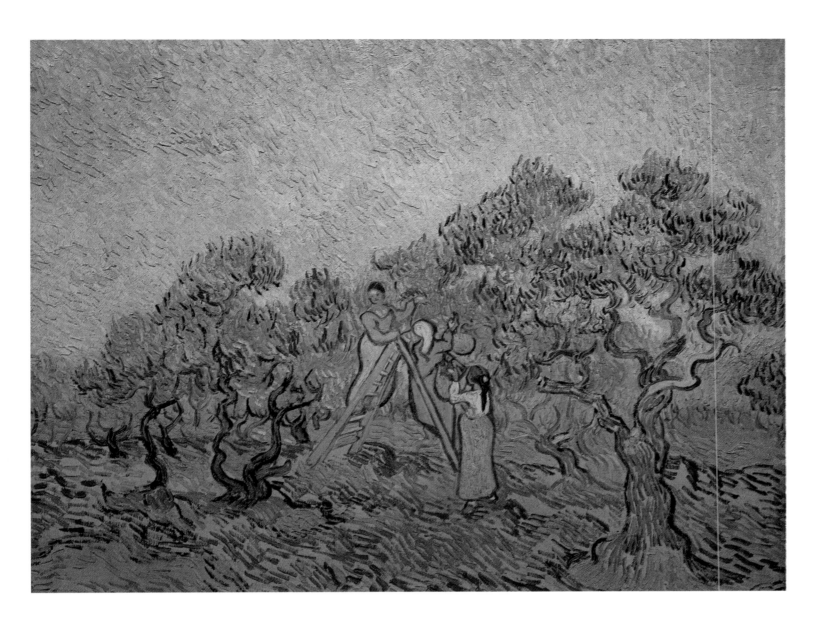

Olive Picking
Saint-Rémy, December 1889
Oil on canvas, 73 x 92 cm
F 656, JH 1870
Washington, National Gallery of Art

It was a self-fulfilling prophecy; and the same thing was to happen on two further occasions. Twice van Gogh would go to Arles, to visit friends and collect pictures and furniture; and twice he would return in a helpless, deranged condition to the asylum. It was as if he was determined that any excursion into the world of freedom would have to be paid for dearly with days of insanity. He was convinced that he was incapable of leading a normal life, and he saw to it that he got into situations that carried a high psychological charge whenever he had contact with the outside world. That was why he put up such resistance to the recognition his art was beginning to earn. And that was why, writing to Bernard in Letter B20, he allowed himself the indulgence of a little linguistic charade, slipping in and out of the familiar and formal forms of second person address within a single sentence; he did this only with his fellow artist – in the case of all his other correspondents, van Gogh was perfectly in control of his language. This suggests that there was a demonstrative, almost exhibitionist side to his attacks, as if he himself were consciously craving madness as a kind of proof of his

Olive Picking
Saint-Rémy, December 1889
Oil on canvas, 72.4 x 89.9 cm
F 655, JH 1869
Rancho Mirage (Cal.), Collection
Mr. and Mrs. Walter H. Annenberg

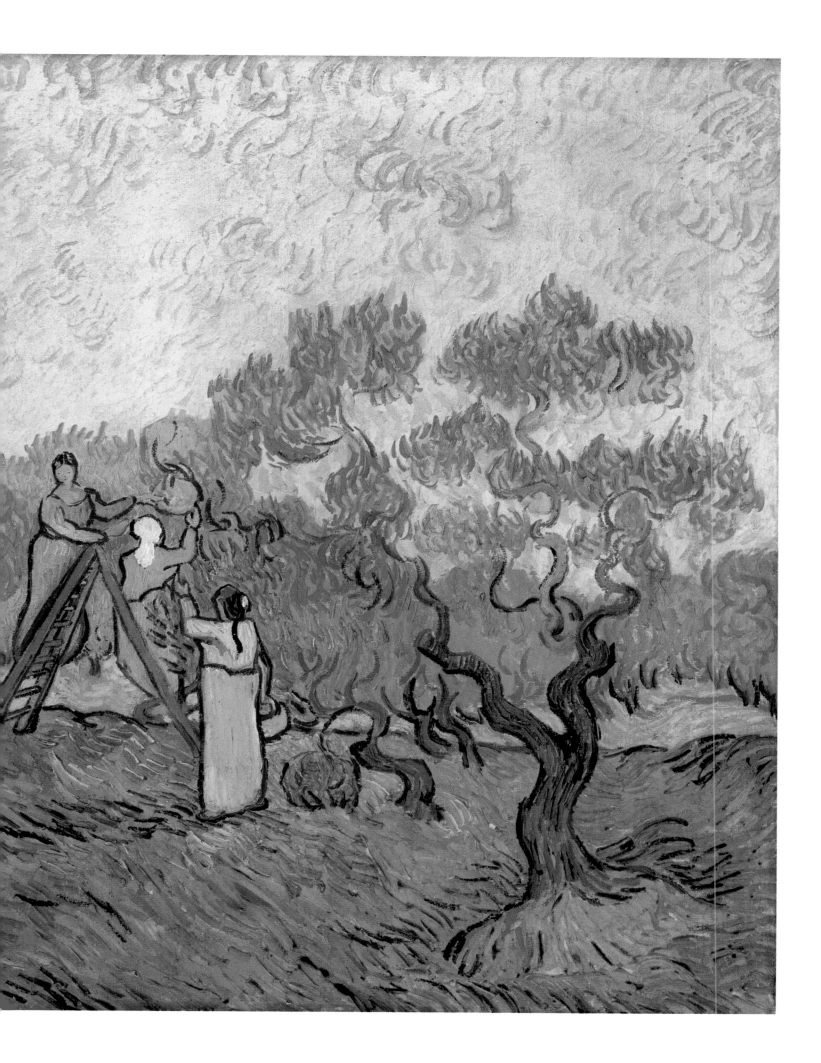

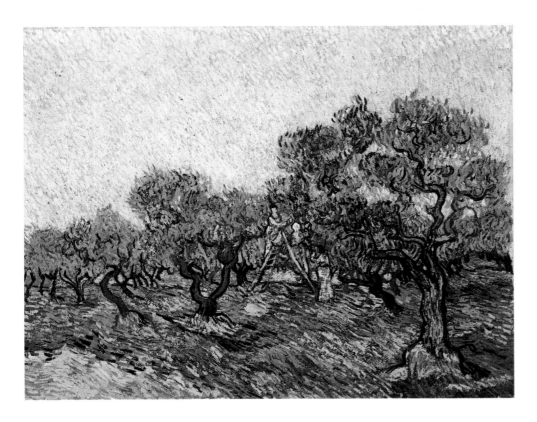

Olive Picking
Saint-Rémy, December 1889
Oil on canvas, 73 x 92 cm
F 654, JH 1868
New York, The Metropolitan Museum
of Art

artistic status. Van Gogh had quite taken to the role of the mad genius. Of course he lacked control over the situations he found himself in; but still we cannot help feeling that he was concentrating on his illness, indeed deliberately invoking bouts of insanity as a way of escaping the demands of everyday life.

Alongside flight from orderly everyday existence into the world of Art, there was a second kind of escape: the escape van Gogh longed to make back to the north, to his roots. The legacy of Arles was not madness alone. Van Gogh painted a final reminiscence of his utopian, optimistic days – a Japanese picture, *Blossoming Almond Tree* (p. 615). In painting it, he was not out to revive his own optimism, but to make an offering to his ever-caring brother. In spring 1889, Theo had married Jo Bonger, and in February 1890 she gave birth to their son, whom they named Vincent after the boy's godfather. The *Blossoming Almond Tree* was van Gogh's present to the infant that would perpetuate his name. Never before had he viewed the bright buds in such close-up; never before had he lavished such colour on the glorious blossoms. The hope expressed in the painting is bound up with human life and thoughts of the future. It is not exactly utopian in character; rather, the keynote of the painting is longing. And it is not really a reminiscence of Arles at all – in a sense, the painting is a celebration of family life, which Vincent the godfather now felt part of again. In the picture he tried to call forth for his godson what was denied to him: a carefree, happy future. "My dear brother, later one occasionally finds it necessary to remember", he wrote rather inscrutably (in Letter 597) when Theo married. Now, painting this picture, van Gogh's own remembering looked back to his

Landscape with Olive Tree and Mountains in the Background
Saint-Rémy, December 1889
Oil on canvas, 45 x 55 cm
F 663, JH 1866
Whereabouts unknown

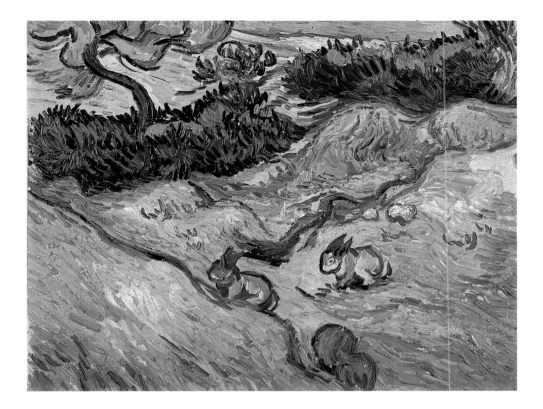

Field with Two Rabbits
Saint-Rémy, December 1889
Oil on canvas, 32.5 x 40.5 cm
F 739, JH 1876
Amsterdam, Rijksmuseum Vincent van
Gogh, Vincent van Gogh Foundation

**Landscape in the Neighbourhood
of Saint-Rémy**
Saint-Rémy, December 1889
Oil on canvas, 33 x 41 cm
F 726, JH 1874
Whereabouts unknown

origins; and the family again became the epitome of security on earth, with the birth of a boy who bore his name.

This work done towards the end of his Saint-Rémy time, then, is a work of memory. And in Letter 601 he set himself a new goal: "to start all over again, with a palette, as I did in the north." The melancholy peasant scenes he had done in Drente and Nuenen underwent a revival. And his life in the asylum helped in the process: "I am leading a simple life here because I have the opportunity to do so", he had written in Letter 599; "in the old days I used to drink because I could think of nothing else [...] Well-judged moderation [...] induces a condition in which one's thoughts (always assuming one has any) come more easily. The difference could be compared with painting in grey or in colour. And indeed I shall be painting more grey." In a less vehement mood he wrote: "I think I shall hardly paint any more pastose things; it is a result of the calm asylum life I am leading, and I feel better this way. Basically I am more self-disciplined than I was, or at any rate in this peace and quiet I feel more myself." (Letter 617) And van Gogh took to longing for the tranquil simplicity of his Dutch origins.

To his sister, he put it this way (Letter W20): "When I have such thoughts [...] I want to become a new, different person and be forgiven for painting pictures that are almost a cry of fear, even when the rural sunflower symbolizes gratitude. As you see, I can still put my thoughts together coherently – though it would be better if I knew how to work out what a pound of bread and a quarter pound of coffee cost, as the peasants do. Which brings us back to the old point. It was Millet who set the example: he lived in a cottage, amongst people unacquainted with

our foolish arrogance and stupid high-flown notions. Rather a little wisdom, then, than a great deal of energy and élan." Recent years, and involvement in the shifting fortunes of the isms, had cost him too much strength and kept him from his real task. He wanted to return to the unforced dignity of a simple way of life, close to the land, in harmony with the seasons and the elements. Van Gogh had seen that the artificial tastes he had acquired in Paris and Arles led him nowhere: "I do not believe that Impressionism, say, will ever achieve more than the Romantics." (Letter 593)

Did his colours really become more earthy and less loud and glaring? Did his brushwork really become more moderate, less inchoate? If we take a look at the pictures van Gogh was painting at this time we perhaps suspect there was a little wishful thinking in his pronouncements. His longing for northern simplicity was in the first place a matter of motifs. He was recalling the simplicity of the cottages and people up north. We see this in *Cottages and Cypresses: Reminiscence of the North* (p. 614) or in *Two Peasant Women Digging in Field with*

Enclosed Field behind Saint-Paul Hospital: Rising Sun
Saint-Rémy, November-December 1889
Black chalk, reed pen and ink,
47 x 62 cm
F 1552, JH 1863
Munich, Staatliche Graphische Sammlung

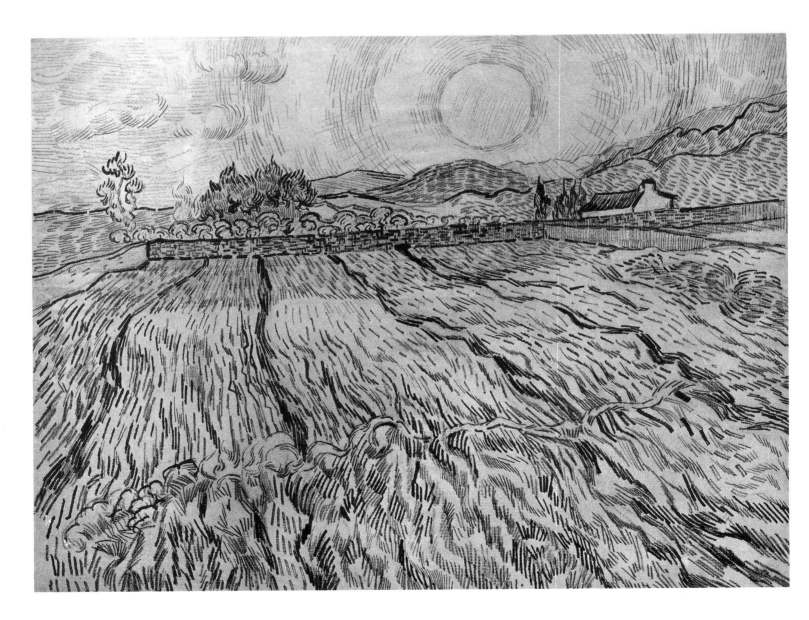

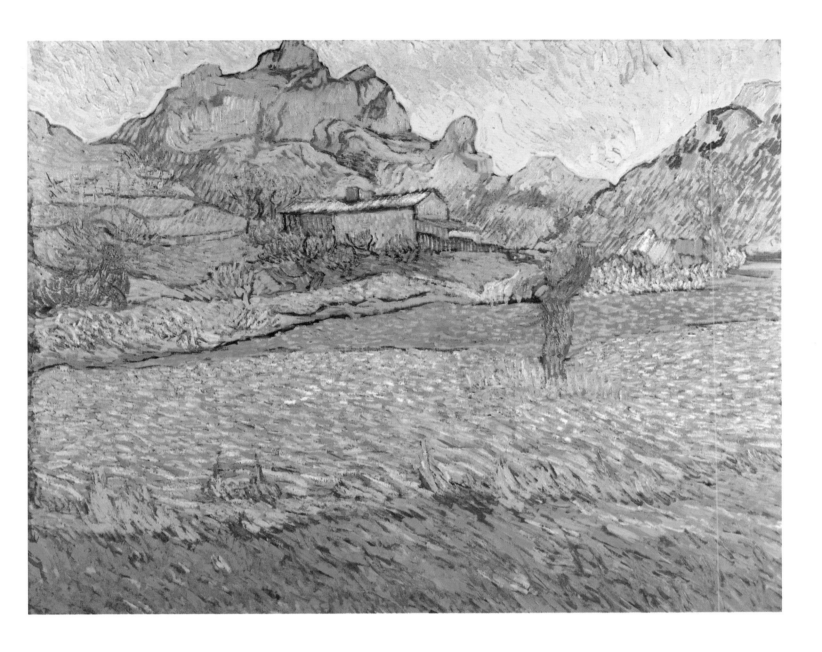

A Meadow in the Mountains: Le Mas de Saint-Paul
Saint-Rémy, December 1889
Oil on canvas, 73 x 91.5 cm
F 721, JH 1864
Otterlo, Rijksmuseum Kröller-Müller

Snow (p. 620), where the two women are seen planting potatoes in the vast plain. They were paintings done from memory; imagination no longer repelled him, as it had done in his days at the yellow house, but afforded a melancholy prospect of home and security.

The supposition that the choice and application of colours would now match his changed situation, and would be purified and smoothed out by a new inwardness, is exactly the notion we would expect of a realist like van Gogh. And sometimes he tried his hand at a dominant colour scheme, consisting of variations of a single colour – aiming at a tonal use of colour that would integrate the achievements of Impressionism (qualities of light, and less local colour) into a time-honoured use of nuanced shades in an overall dominant scheme. Examples of this are *Pine Trees and Dandelions in the Garden of Saint-Paul Hospital* (p. 621) and *Cottages and Cypresses: Reminiscence of the North* (p. 614). However, the brushwork has certainly not become more relaxed. There are still fat streaks all over the canvas, whirling and compacting as if van

Enclosed Field with Rising Sun
Saint-Rémy, December 1889
Oil on canvas, 71 x 90.5 cm
F 737, JH 1862
Private collection

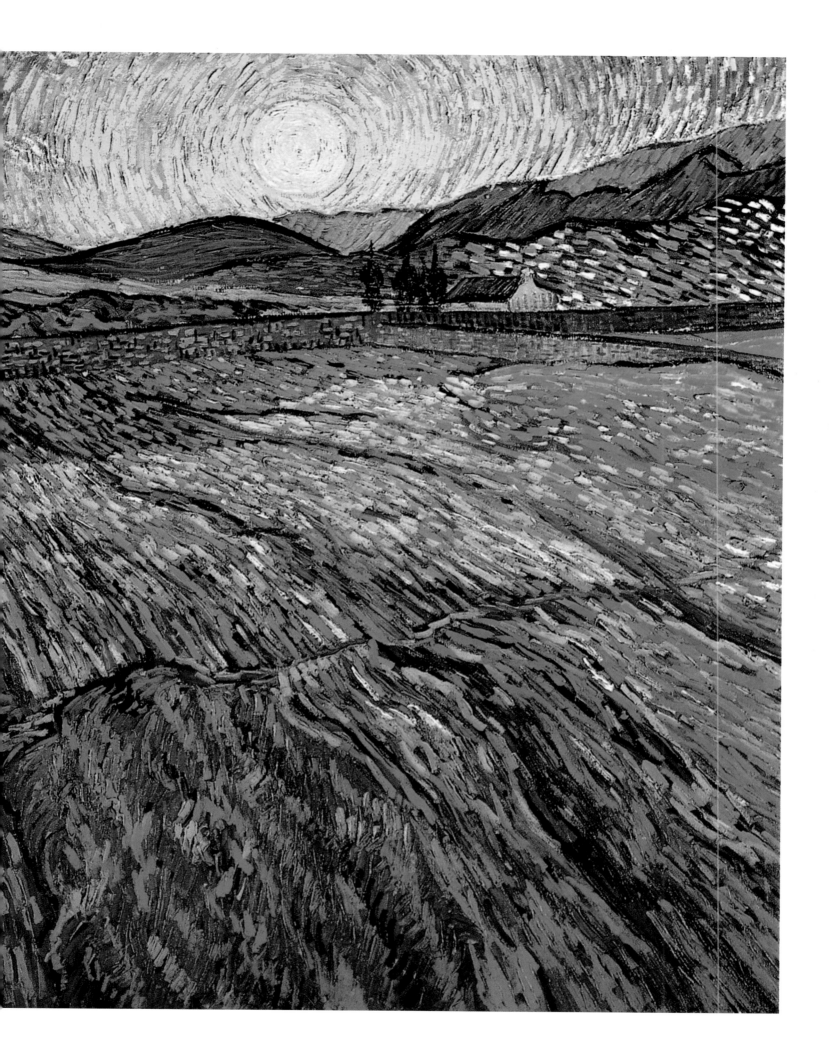

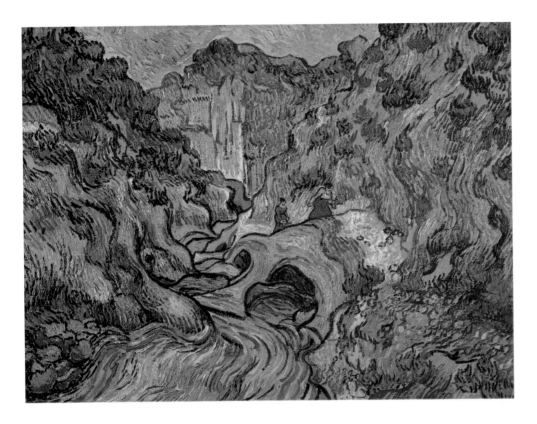

Les Peiroulets Ravine
Saint-Rémy, December 1889
Oil on canvas, 72 x 92 cm
F 661, JH 1871
Otterlo, Rijksmuseum Kröller-Müller

Gogh were out to create a relief. Of course his use of varnish was still perfect, serving to highlight the luminous power of the colours, as in *Still Life: Vase with Irises against a Yellow Background* (p. 623). Here, van Gogh has devoted his attention to the contours of the shapes that bear his colour contrast. The flower still life has a certain classical equilibrium, and could just as well have been painted in Arles – it takes obvious pleasure in colour and makes no attempt to distort or remake shapes. That said, though, we should add that the flowers are not so

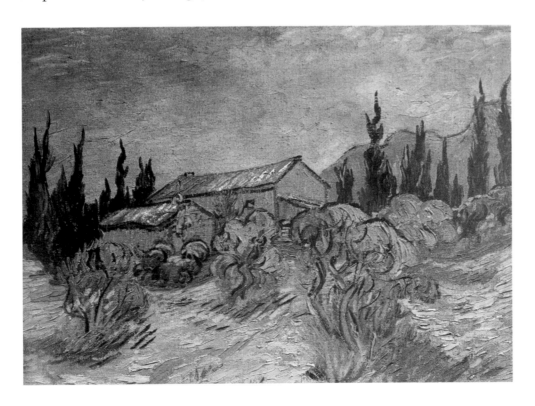

Wooden Sheds
Saint-Rémy, December 1889
Oil on canvas, 45.5 x 60 cm
F 623, JH 1873
Brussels, Private collection

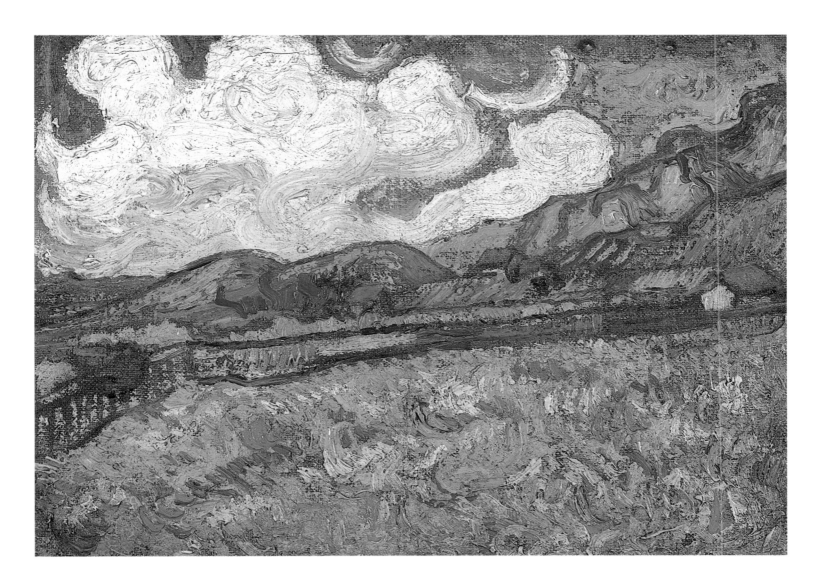

much a utopian motif as a symbol of longing, recollecting those early days in Paris when van Gogh had devoted almost all his time to still-life painting.

Van Gogh's style had a schizophrenic quality at this time: the pastose and the earthy, the smooth and the glaring were all juxtaposed. And the influences upon his art at this period became more complex and more urgent. First, van Gogh felt that his new way of life would be reflected in his work, and the contemplative mood of the asylum shows in a new moderation. Second, his wish for a home created by those who loved him, a home that would therefore be in the north, was growing: "I believe it will be good if I paint one or two pictures for Holland, for my mother and sister", he wrote in Letter 604. He wanted them to remember him, and to welcome his work home as if it were he himself – he even painted a picture for the woman who had attempted suicide in Nuenen on his account. Van Gogh hoped to revive that world of authenticity and simple needs that he had found through his Dutch work. And then, finally, we must never forget the sheer artistry of van Gogh's individual style, a style forged over the years, the principal hallmarks of which were vigour and the ability to identify. It was a style that had been

Wheat Field behind Saint-Paul Hospital
Saint-Rémy, November-December 1889
Oil on canvas, 24 x 33.7 cm
F 722, JH 1872
Richmond (Va.), Virginia Museum of
Fine Arts, Collection of Mr. and Mrs. Paul
Mellon

profoundly touched by his experience of mental instability – experience which could not simply be wished out of existence as if it had never happened. These three major ways of taking hold of his life and getting a grip on the present were not altogether compatible.

"The patient, who was calm on the whole, suffered a number of violent attacks during his stay at the asylum, lasting from a week to a month. During these attacks he was overcome by terrible fears and anxieties, and repeatedly tried to poison himself, either by swallowing paint or by drinking kerosene stolen from the assistants when they were refilling the lamps. His last attack began on a trip to Arles and lasted for two months. Between attacks, the patient was absolutely quiet, and devoted himself entirely to his painting. Today he asked to be discharged, intending to live in the north of France in future, where he is convinced the climate will do him good." Thus Doctor Peyron, director of the asylum, in his final report on van Gogh's condition. In the space of a year, van Gogh had suffered four attacks in all; and all he had to show for that year was his paintings. Since he had entered the asylum of his own free will, there was nothing to prevent his request from being granted. And, as if he had never flinched from public life or from contact with the outside world, van Gogh set off alone on the long trip to Paris on 16 May, 1890.

Escaping the orderly security of Saint-Rémy was the only way van Gogh could solve his problem. It was pointless going on in his pitiful way, pathetically hoping for recovery in the company of those he loved. Van Gogh's ways of escape – seeking oblivion through the act of remembering, a new start by staying put in the asylum – increasingly had a quality of panic. His art reflected this drifting state faithfully, with all

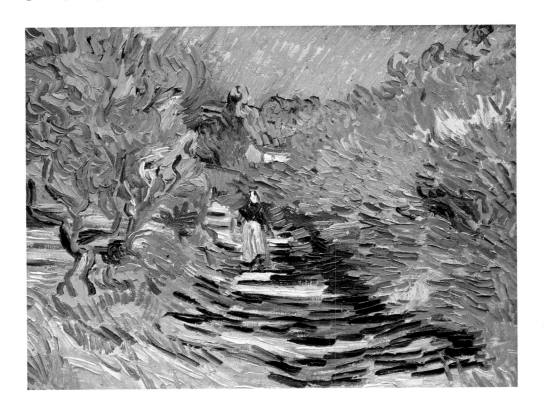

A Road at Saint-Rémy with Female Figure
Saint-Rémy, December 1889
Oil on canvas, 32.5 x 40.5
F 728, JH 1875
Lausanne, Private collection

his customary expressiveness and force. If van Gogh was changing to a new location again, it was not to expose his creative work to helpful influences, as it had been when he moved away from Nuenen or Paris. His departure was an existential act, intended to prevent the recurrence of his attacks. And van Gogh apparently succeeded; at least, he suffered no further attacks in the few months he had left to live. But then, that span of time was perhaps too short for us to be able to say his strategy had succeeded.

Morning: Peasant Couple Going to Work
(after Millet)
Saint-Rémy, January 1890
Oil on canvas, 73 x 92 cm
F 684, JH 1880
Whereabouts unknown
(presumed destroyed in the Second World War)

Reverence and Awe
Van Gogh and Nature

Van Gogh considered himself a figural painter; but his paintings of natural scenes have proved more interesting and more progressive in spirit than his paintings of people. In his pursuit of Nature he was less interested in signs of orderly human cultivation than in what remained of the wild and original character of landscapes, what still remained untouched by Man. Nature in van Gogh is seen not so much as its own neutral self as in terms of metamorphosis and power and constant flux. In trying to render this vision of Nature, van Gogh was at one with contemporary theories and thoughts opposed to industrialization and to the normative effects of the new world of commerce (though this opposition tended to be all they had in common). Van Gogh shared the 19th century's inability to interpret the obvious power in the natural world; and that is why the pictures which art history conveniently labels "landscapes" so often stagger us with their innovative energy. Van Gogh had a knack of adopting ignorance, as it were, and then following his mood, an innocent discovering the world – and as a result he had not just one concept of Nature but many.

William Blake's insistence that all living things are sacred became characteristic of the 19th century. Existence was felt to be full of the cosmic spirit and the presence of God, full of vitality, of mysterious forces. This was pantheism: the belief that all was one and one was all. If it remained unclear where the presiding first cause was to be found, what mattered most was the spirit of enthusiasm and hymn-like praise in which Creation was lauded. Naturally, pantheism was one of the major hallmarks of the great Romantics (we think of Wordsworth); and somewhat later in the 19th century John Ruskin had insisted that all great art was celebration and that, whatever the object of praise, the fire and intensity of artistic creation derived from love and joy.

Van Gogh echoed this love of natural creation countless times. When his brother Theo married, for instance, he wrote (in Letter 604): "And you know, now that I have started to hope at all once again, I am hoping that a family will be for you what Nature is to me, the clods of earth, the grass, the yellow wheat, the farmer – that is to say, that your love of human kind will not only bring you toil but also afford you comfort and

Two Diggers among Trees
Saint-Rémy, March-April 1890
Oil on canvas, 62 x 44 cm
F 701, JH 1847
Detroit, The Detroit Institute of Arts

Thatched Cottages in the Sunshine: Reminiscence of the North
Saint-Rémy, February 1890
Oil on canvas, 50 x 39 cm
F 674, JH 1920
Merion Station (Pa.), The Barnes Foundation
(Colour reproduction not permitted)

necessary recovery." How often van Gogh's view of a natural object (such as the cypress trees on page 518) is inspired by reverence and awe! How often he delights in the burgeoning vitality of Nature! This joy is especially characteristic of those works in which he seems most indebted to Impressionism; programmatic and levelheaded as they may be, they are nonetheless joyfully enthusiastic at the sight of a bright, sunshot atmosphere in which all things (in this the Romantics and the city sophisticates are not unlike) are one, at least visually. And how often, indeed, van Gogh seems to express the comfort and alleviation of infinity – a sensation he received (according to his own testimony) when he gazed into the eyes of children or out at the waves of the sea. Van Gogh's affinity to pantheism is self-evident; but there is more to it than meets the eye. Van Gogh, after all, urged his brother to draw comfort and recovery from Nature – and not only see it as a source of toil, which had apparently been his first thought. The hymn to Creation was striking a too cheerful note, perhaps: if his first thought, confronted with the all-powerful flux of Creation, was of toil, there must surely have been a profound disquiet inside him, a disquiet that would find no home in the given world. "Pantheist" (like "Romantic") is too simplistic a label for van Gogh.

Leaving the question of a first cause, of a providential presiding spirit, open and unresolved was paradoxical in an age that was getting by nicely without any god. Materialism was the creed of an era that supposed all was ideally designed in the universe. One scientist, Rudolf Virchow, declared that every being was "a sum of vital entities every one of which contains within it the total character of life"; every being was "a kind of social organization, an organism of a social kind, where a

The Plough and the Harrow (after Millet)
Saint-Rémy, January 1890
Oil on canvas, 72 x 92 cm
F 632, JH 1882
Amsterdam, Rijksmuseum Vincent van Gogh, Vincent van Gogh Foundation

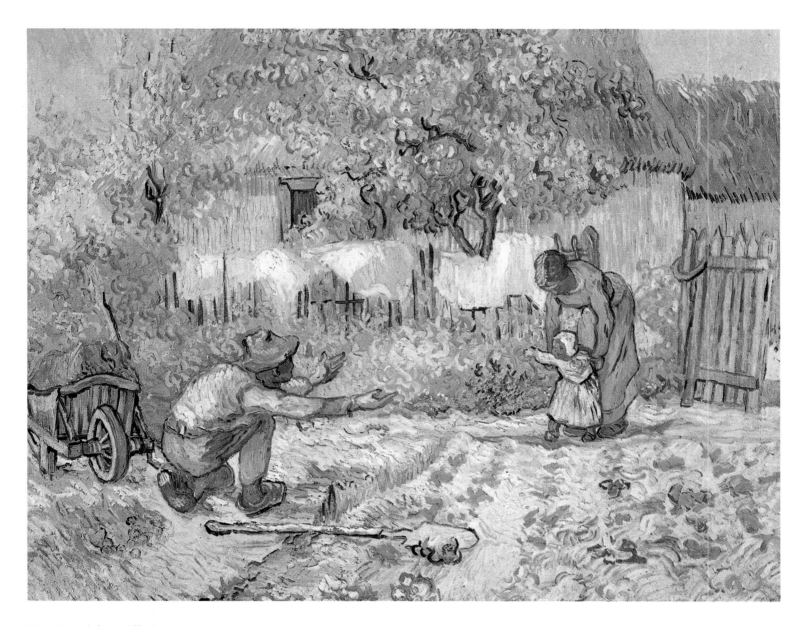

First Steps (after Millet)
Saint-Rémy, January 1890
Oil on canvas, 72.4 x 91.2 cm
F 668, JH 1883
New York, The Metropolitan
Museum of Art

Noon: Rest from Work (after Millet)
Saint-Rémy, January 1890
Oil on canvas, 73 x 91 cm
F 686, JH 1881
Paris, Musée d'Orsay

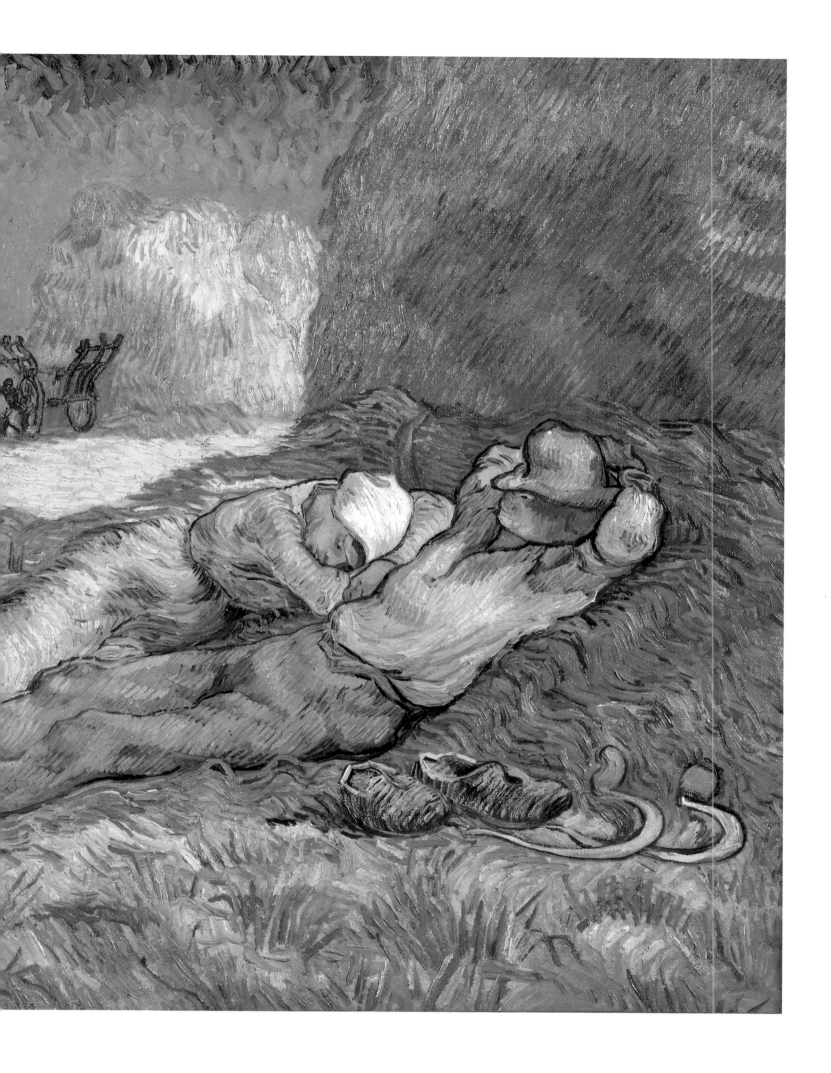

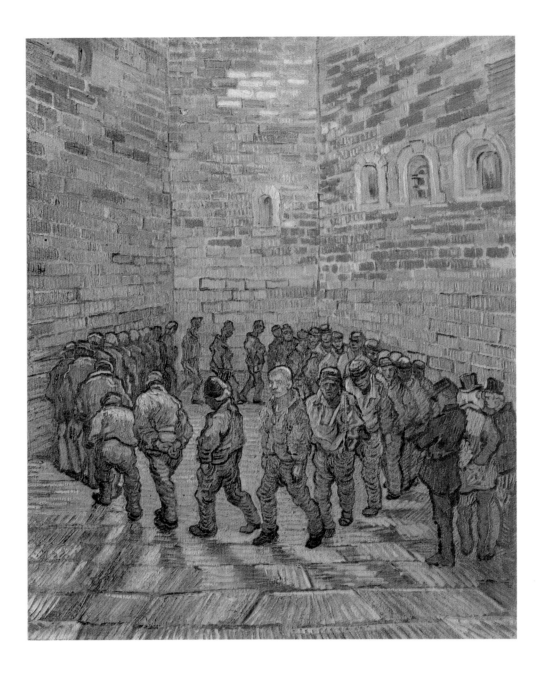

mass of individual lives are all dependent on each other". We might say that in the 19th century the monarchy of pantheism was replaced by the democracy of bodies in equilibrium: that is to say, atoms and cells were found to be the basic building blocks of life, the foundation of all manner of conceptual constructs great and small, simple and complex. The microcosm and macrocosm were of the same stuff. The world was homogeneous, not because a Creator had designed it that way, but because everything had evolved in that manner. Darwin's theory of evolution expressed the new belief of the age.

"It has been said that Man is a microcosm", Delacroix noted in his diary; and he began to wonder how the latest scientific insights could be applied to his own concerns. "Not only does he constitute a complete whole, in his unity, with a sum of laws resembling those of the Whole, but even part of a thing is a kind of complete entity in itself." And then he took the decisive step: "Thus a branch that has broken off a tree has

Prisoners Exercising (after Doré)
Saint-Rémy, February 1890
Oil on canvas, 80 x 64 cm
F 669, JH 1885
Moscow, Pushkin Museum

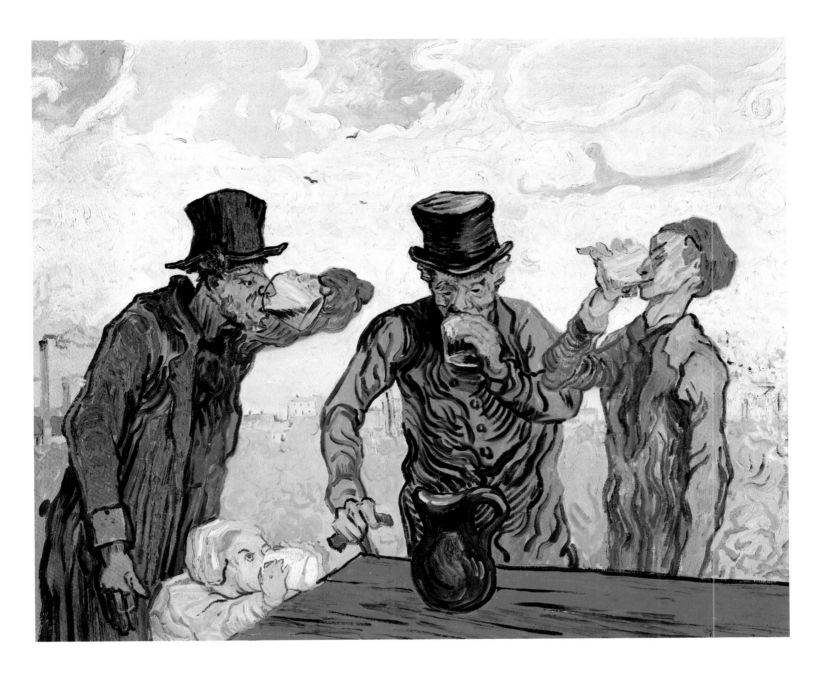

all the features of the whole tree. When drawing trees I have often noticed that a severed branch is itself a small tree: to see it as such, all that would be necessary would be for the leaves to be of the right scale." Delacroix was convinced that things were not merely constituted of the same basic material, but intimately resembled each other, too. The artist was reapplying a fundamental scientific principle to the particular science that concerned him most – optics: the leaf and branch had the whole tree within them, and anyone with eyes in his head could see as much.

As if to prove Delacroix's point, van Gogh positioned the huge blue fir in his third poet's garden canvas (*Public Garden with Couple and Blue Fir Tree*, p. 433) in the centre of the picture. The needles of a single twig have an almost monumental quality once seen as a whole tree: just as needles spread, so the tree's branches spread; just as a twig may wave in the breeze, so does the whole tree. The fir tree is no exception, either.

The Drinkers (after Daumier)
Saint-Rémy, February 1890
Oil on canvas, 59.4 x 73.4 cm
F 667, JH 1884
Chicago, The Art Institute of Chicago

**Cottages and Cypresses: Reminiscence
of the North**
Saint-Rémy, March-April 1890
Oil on canvas on panel, 29 x 36.5 cm
F 675, JH 1921
Amsterdam, Rijksmuseum Vincent van
Gogh, Vincent van Gogh Foundation

Blossoming Almond Tree
Saint-Rémy, February 1890
Oil on canvas, 73.5 x 92 cm
F 671, JH 1891
Amsterdam, Rijksmuseum Vincent van
Gogh, Vincent van Gogh Foundation

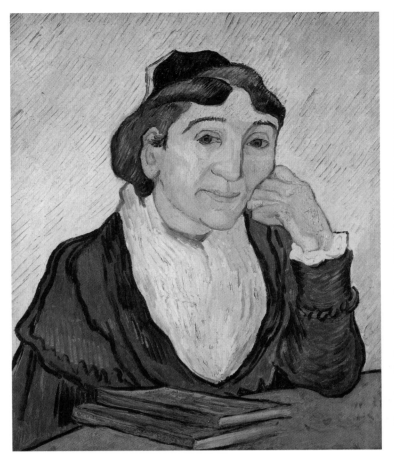

L'Arlésienne (Madame Ginoux)
Saint-Rémy, February 1890
Oil on canvas, 60 x 50 cm
F 540, JH 1892
Rome, Galleria Nazionale d'Arte Moderna

L'Arlésienne (Madame Ginoux)
Saint-Rémy, February 1890
Oil on canvas, 65 x 54 cm
F 542, JH 1894
São Paulo, Museu de Arte de São Paulo

L'Arlésienne (Madame Ginoux)
Saint-Rémy, February 1890
Oil on canvas, 65 x 49 cm
F 541, JH 1893
Otterlo, Rijksmuseum Kröller-Müller

The pines in the Saint-Paul hospital garden (cf. p. 560) or the olive trees on page 522 are seen on a basis of equivalence, clusters of foliage or of fruit matching the stateliness of the whole; and in the painting of cypresses on page 516 the knotty, relief-like surface of the painted canvas is distinctly like the gnarled textures of the bark and roots of the trees. This was not a direct, mimetic imitation of Life; but Art, for van Gogh, had to find a way of equating the real and the painted motifs.

We might pursue this line of thought. For instance, the wavy evenness that links the earth, treetops and mountaintops in *Olive Trees with the Alpilles in the Background* (p. 511) need not be seen only in terms of a wish for perfect formal analogy. In fact, van Gogh (drawing upon the kind of knowledge available in his day) was trying to establish a symbol of the interrelations of organic, material phenomena.

Let us call van Gogh as a witness at this point. "If one studies Japanese art", he wrote in Letter 542, "one sees what it is that an incontestably wise and philosophical and sensible man spends his time doing... Studying the distance of the moon from the earth? No. Studying the policies of Bismarck? No. He studies a single blade of grass. But that blade of grass leads him on to paint every plant, then every season, rolling landscapes, then at last animals and the human form. That is how he spends his life; and life is too short for him to do it all." Van Gogh had considerable admiration for *Leaves of Grass* by the American poet Walt Whitman, in which Whitman declared that a blade of grass

L'Arlésienne (Madame Ginoux)
Saint-Rémy, February 1890
Oil on canvas, 66 x 54 cm
F 543, JH 1895
Whereabouts unknown

Cottages: Reminiscence of the North
Saint-Rémy, March-April 1890
Oil on canvas, 45.5 x 43 cm
F 673, JH 1919
Switzerland, Private collection

Peasants Lifting Potatoes
Saint-Rémy, March-April 1890
Oil on canvas, 32 x 40.5 cm
F 694, JH 1922
New York, The Solomon R. Guggenheim
Museum, Justin K. Thannhauser
Collection

was no less than the motions of the stars. Van Gogh and Whitman were agreed that wisdom lay in closeness to everyday things. It was only in studying what was small that a man's eyes could be opened to what was infinitely great in Creation. An artist could do worse than to consider leaves of grass. And that was the principle behind van Gogh's close-up views – of grass in the asylum gardens, for instance (p. 621). Once the universal formula of Life was perceived, this grass – modest as it might appear – was cousin to the lush and verdant jungle, and initiated into the mysteries of Life.

Henri Bergson, assigning to individual perception the true apprisal of vitality in Creation, wrote: "Intuition is a method of feeling one's way intellectually into the inner heart of a thing, in order to locate what is unique and inexpressible in it. If there is a way of grasping a reality in absolute rather than relative terms, of entering into it rather than taking up positions on it, of seizing hold of it without any translation or symbolism, then that way is metaphysics itself." Bergson denied that a reality consisting of atoms could be sublime. The awe mankind can feel before reality has nothing to do with any objective aspects of it; rather, it is a product of Man's disposition, of a visionary gift, as it were. In stating this, Bergson had provided the 19th century with one more method of nailing down the mysteries of Nature.

In a sense, van Gogh borrowed the various approaches in the same sequence as his age appropriated them. At first, in the early days in Holland, he was enthusiastic, with a religious naivety and Romantic sentimentality about him, and with a touch of pantheism. Then in Arles he perceived the ties that bound everything in Creation, each to each, and sought ways of giving expression to the connections between great and small in his art. Finally, in Saint-Rémy, the awe van Gogh felt before

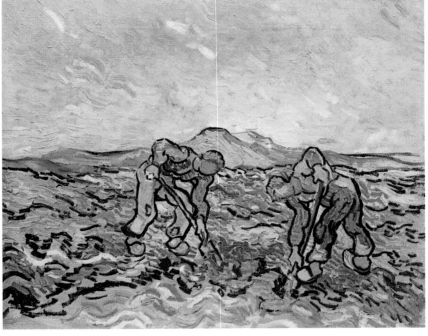

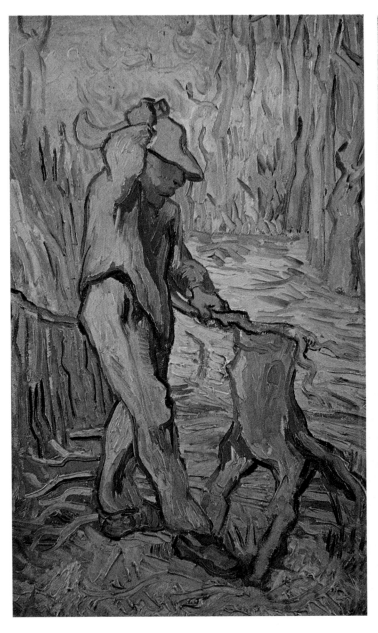

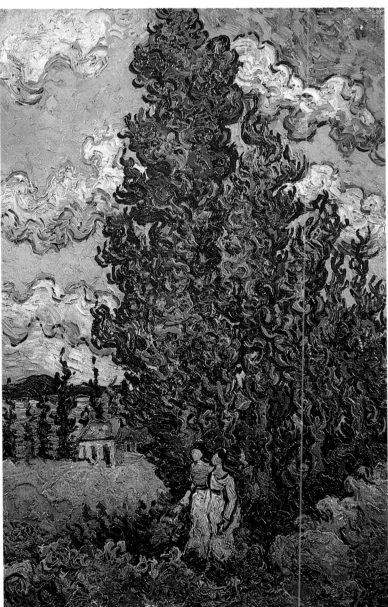

The Woodcutter (after Millet)
Saint-Rémy, February 1890
Oil on canvas, 43.5 x 25 cm
F 670, JH 1886
Amsterdam, Rijksmuseum Vincent van
Gogh, Vincent van Gogh Foundation

Cypresses and Two Women
Saint-Rémy, February 1890
Oil on canvas, 43.5 x 27 cm
F 621, JH 1888
Amsterdam, Rijksmuseum Vincent van
Gogh, Vincent van Gogh Foundation

Nature increasingly became a function of his own need for devotion, for something to revere; van Gogh felt overwhelmed.

"Ah, while I was ill, damp, melting snow fell, and I got up at night and looked at the landscape. Never ever had Nature seemed so touching or so tender to me", he wrote in Letter 620. Or, in Letter 626a: "The cypress is immensely characteristic of the landscape of Provence [...] Until now I have been unable to paint it as I feel it; the excitement that comes over me when I am confronted with Nature becomes so intense that I can do nothing, and this is followed by fourteen days during which I am incapable of working." Now, sensation and excitement governed van Gogh's approach to the world; or, to put it better, his illness had made him sensitive to an intense inner world of feeling that was arguably in command of his spirit all along. His insistence on remaking and distorting can be explained by the very fact that his work is not so much a portrait of reality as an image of it as filtered through his own spirit. Pictures such as *Entrance to a Quarry* (p. 529) express that intense, empathetic feeling. The dizzying, dragging sensations prompted by the painting are not objective phenomena; they are the nightmarish perceptions of a visionary. Bergson's "intuition", in a sense, supplied the key term in a prophetic view of the artist. Van Gogh had been loath to accept labels of mad genius and so forth, and must have been equally averse to the role of an artist overwhelmed.

Van Gogh's syncretist tendencies were not likely to pause at the seeming immediacy of Nature. The 19th century had evolved a great number of theories, which van Gogh was carried along by; and they all met, in paradoxical harmony, in his pictures. A quirky German scientist, philosopher and writer, Gustav Theodor Fechner, surely one of the

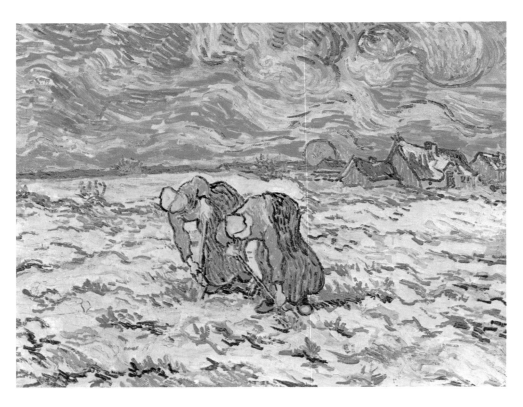

Two Peasant Women Digging in Field with Snow
Saint-Rémy, March-April 1890
Oil on canvas, 50 x 64 cm
F 695, JH 1923
Zurich, Foundation Collection E. G. Bührle

**Meadow in the Garden of
Saint-Paul Hospital**
Saint-Rémy, May 1890
Oil on canvas, 64.5 x 81 cm
F 672, JH 1975
London, National Gallery

**Pine Trees and Dandelions in the Garden of
Saint-Paul Hospital**
Saint-Rémy, April-May 1890
Oil on canvas, 72 x 90 cm
F 676, JH 1970
Otterlo, Rijksmuseum Kröller-Müller

Poppies and Butterflies
Saint-Rémy, April-May 1890
Oil on canvas, 34.5 x 25.5 cm
F 748, JH 2013
Amsterdam, Rijksmuseum Vincent van
Gogh, Vincent van Gogh Foundation

Roses and Beetle
Saint-Rémy, April-May 1890
Oil on canvas, 33.5 x 24.5 cm
F 749, JH 2012
Amsterdam, Rijksmuseum Vincent van
Gogh, Vincent van Gogh Foundation

**Still Life: Vase with Irises against a Yellow
Background**
Saint-Rémy, May 1890
Oil on canvas, 92 x 73.5 cm
F 678, JH 1977
Amsterdam, Rijksmuseum Vincent van
Gogh, Vincent van Gogh Foundation

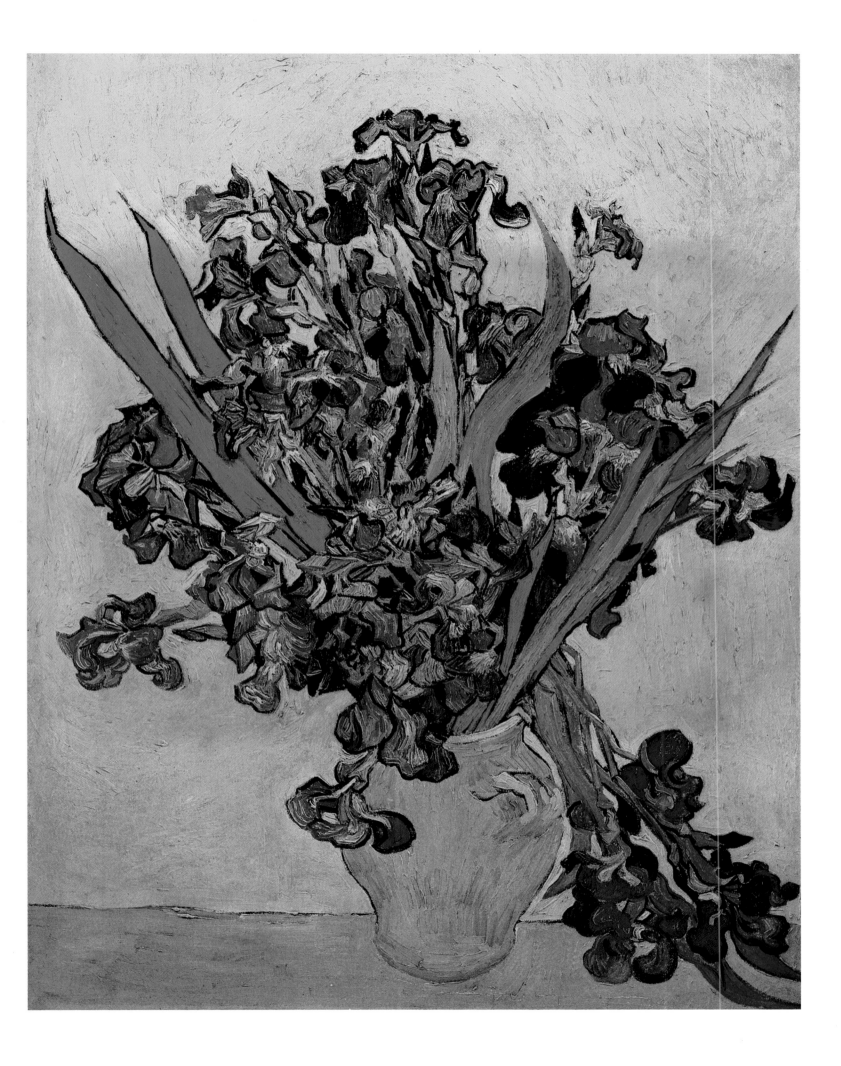

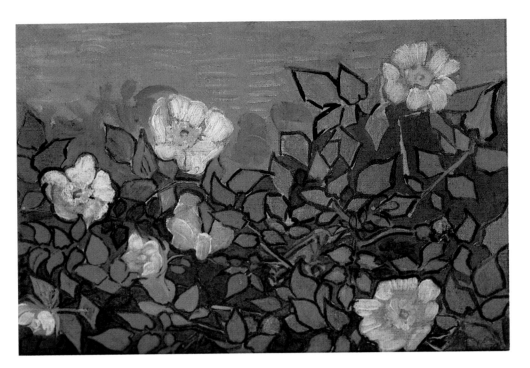

Wild Roses
Saint-Rémy, April-May 1890
Oil on canvas, 24.5 x 33 cm
F 597, JH 2011
Amsterdam, Rijksmuseum Vincent van
Gogh, Vincent van Gogh Foundation

Still Life: Vase with Irises
Saint-Rémy, May 1890
Oil on canvas, 73.7 x 92.1 cm
F 680, JH 1978
New York, The Metropolitan Museum of Art

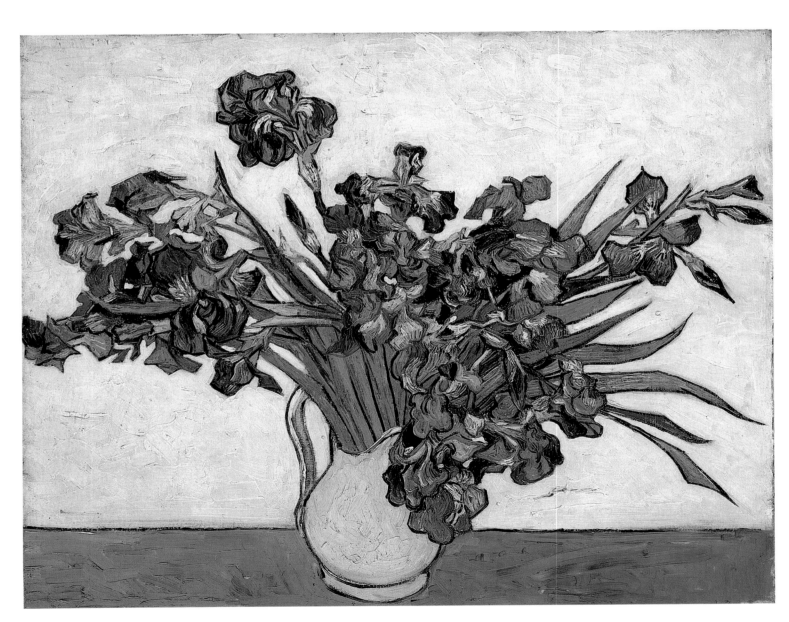

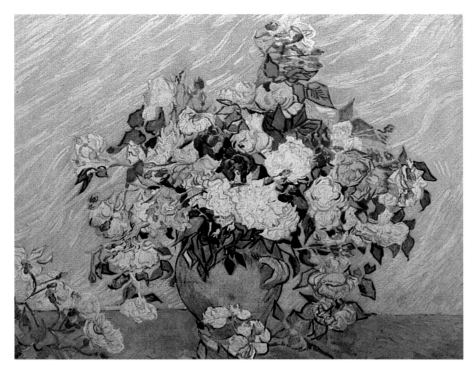
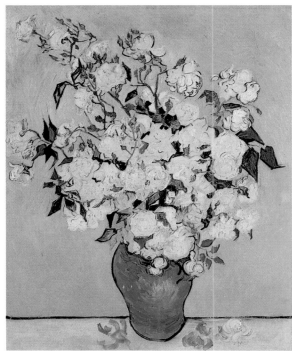

Still Life: Vase with Roses
Saint-Rémy, May 1890
Oil on canvas, 71 x 90 cm
F 681, JH 1976
New York, Collection Pamela C. Averell

Still Life: Pink Roses in a Vase
Saint-Rémy, May 1890
Oil on canvas, 92.6 x 73.7 cm
F 682, JH 1979
Rancho Mirage (Cal.), Collection
Mr. and Mrs. Walter H. Annenberg

most eccentric of characters of the age, might usefully be compared with van Gogh at this point. Like van Gogh he was profoundly Romantic in his nature – though, like van Gogh, his enthusiasm and occasional gush never kept him from seeking objective insights. There are astonishing similarities between the two men. They both tended to choose the same metaphors and analogies to explain their ideas on the forces of Nature. Both tended to juxtapose incompatibles in a typically headstrong way and then to mask their own disquiet at this forced yoking by presenting it in a veritably dithyrambic manner. One or two examples will serve to illustrate the point.

Both van Gogh and Fechner used the image of a caterpillar that ultimately and miraculously becomes a butterfly to express their hopes for recognition by posterity. Fechner wrote: "If the plant had not first suffered pains to feed the caterpillar, the butterfly would not one day be able to bring it joy. So we may conclude that what we sacrifice to others in the pain of this present life will be restored to us in terms of joy, by angels, in a life to come." Van Gogh (in Letter B8) put it this way: "So we are left with the thought that possibly we shall one day paint in better, changed circumstances – in an existence perhaps produced by changes no worse or more surprising than the metamorphosis of a caterpillar into a butterfly [...] That new life as a painter-butterfly would be led on one of the innumerable heavenly bodies." The tininess of an insect and the immensity of the heavens represent the opposite poles in a world of sensation. Fechner has as little idea what nurtures sensation as van Gogh. He writes: "It is we who first project sensation and sensibility into it; as if Nature did not have greater and richer and profounder powers of creative endowment than we, as if we could give Nature

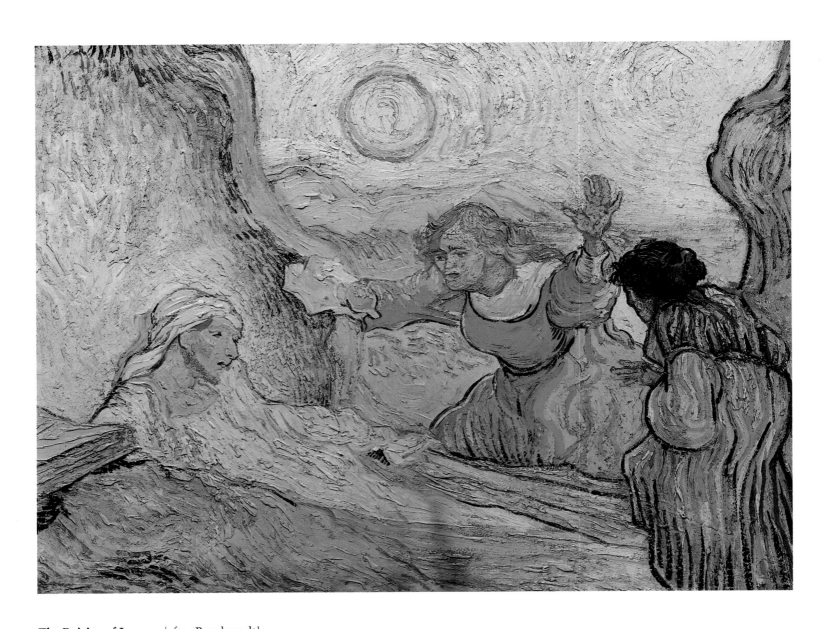

The Raising of Lazarus (after Rembrandt)
Saint-Rémy, May 1890
Oil on paper, 50 x 65 cm
F 677, JH 1972
Amsterdam, Rijksmuseum Vincent van
Gogh, Vincent van Gogh Foundation

The Good Samaritan (after Delacroix)
Saint-Rémy, May 1890
Oil on canvas, 73 x 60 cm
F 633, JH 1974
Otterlo, Rijksmuseum Kröller-Müller

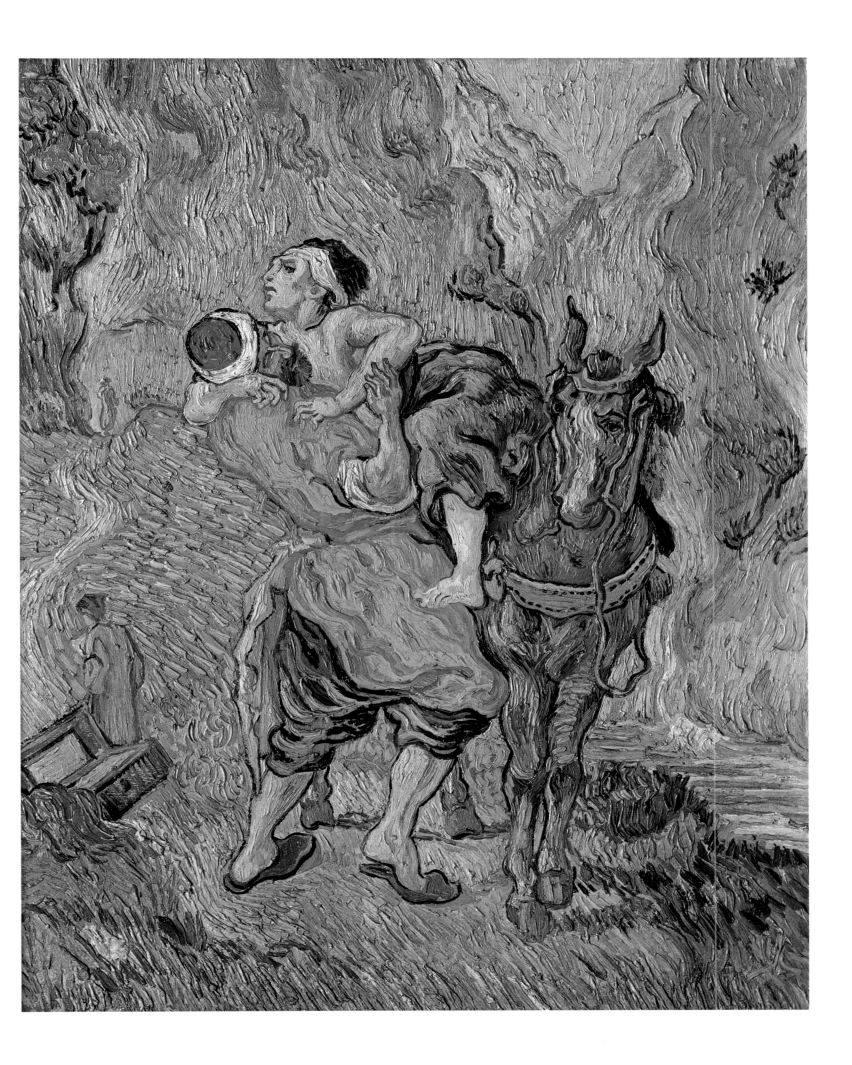

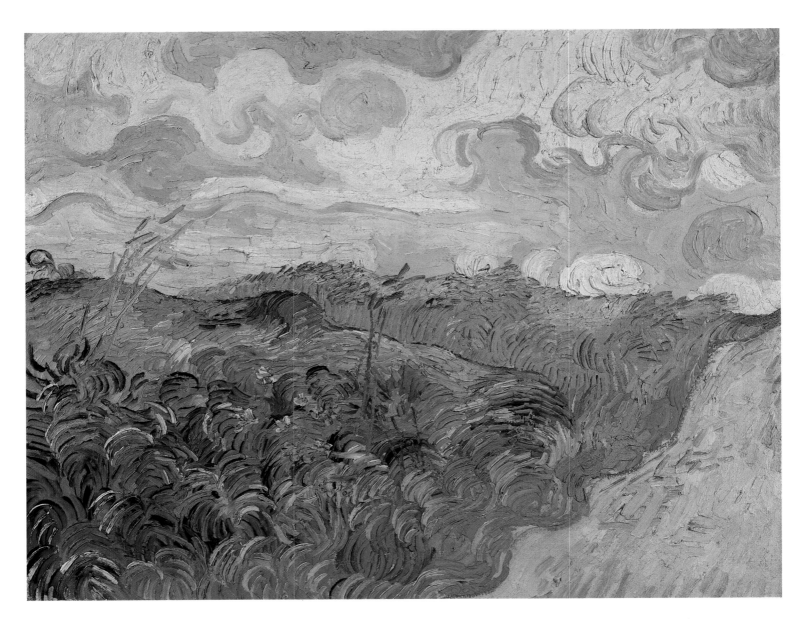

Green Wheat Fields
Saint-Rémy, May 1890
Oil on canvas, 73 x 93 cm
F 807, JH 1980
Upperville (Va.), Collection
Mr. and Mrs. Paul Mellon

anything she did not already possess within her in far greater intensity, as if all our poesy were not a feeble echo of natural sensibility (which of course we are a part of, though not the only part of)." Causes are all uncertain. All Man can know is himself, a great, yet small mote in universal Creation.

With Fechner in mind, we can see a painting such as *Starry Night* (pp. 520–21) with new eyes. Van Gogh's motifs have a striking affinity with images the writer chose to express his sense of the spirit of Nature: "Is it not greater, more beautiful and more glorious to conceive of the living trees of the forest burning heavenwards like torches of the soul than merely to think of them providing light in the death of our ovens? Can that be the purpose of their lofty growth? The sun itself cannot make the world bright without souls to feel its light." The cypresses were van Gogh's "torches of the soul", and in them the painter was expressing what he had called the "essence of the landscape" in Letter 595 (referring to the painting). That essence had nothing in common with the mere appearance of a Mediterranean landscape. Rather, it had

to do with the common bond amongst all living things: a sense of interdependence was the very foundation of Life. Again we find Fechner using the same metaphor as van Gogh: "I think that Man, animal and plant are in the same case as Sun, Earth and Moon. He who stands on the moon will see the earth and sun revolving around the moon. But he who stands on the sun will say: you are mistaken; you, and the earth too, are revolving around me. Essentially, each is revolving around the other, just depending on where one chooses to stand; but once an absolute standpoint is chosen, neither the one nor the other is revolving around anything else, but rather they are all revolving around a common centre that represents the totality of the whole system. A centre is nothing without the gravity that draws all the parts together." The swirling forces in van Gogh's firmament require each other for balance. Only because everything is in motion can order be preserved – another of the artist's characteristic paradoxes.

Thoughts of this kind are securely founded in religion. Everything in the world possesses symbolic power, and refers us to an ultimate principle, a final cause, for which faith has adopted the term God. But the century of van Gogh and Fechner was a time of emancipation. God was

Landscape with Couple Walking and Crescent Moon
Saint-Rémy, May 1890
Oil on canvas, 49.5 x 45.5 cm
F 704, JH 1981
São Paulo, Museu de Arte de São Paulo

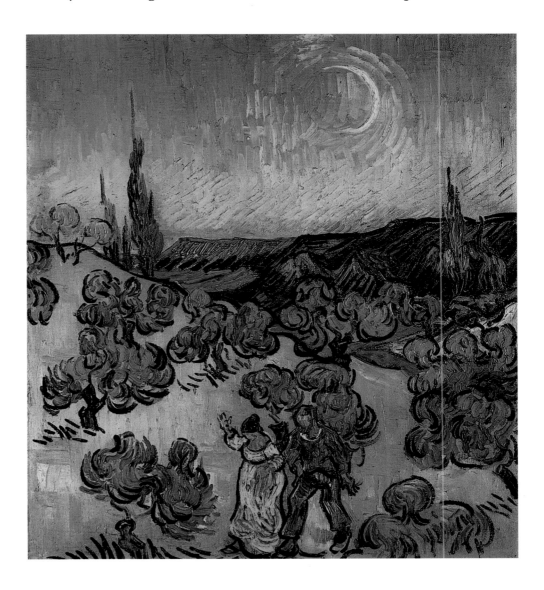

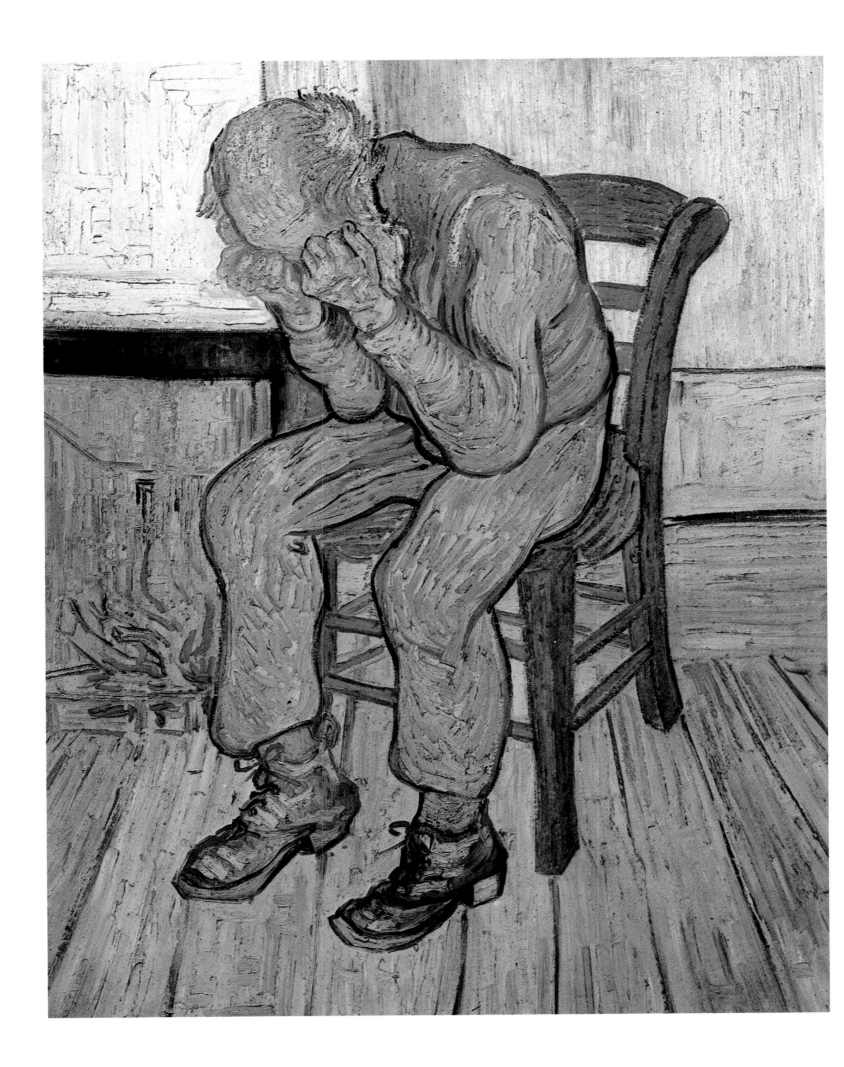

replaced by physics. In the new system, forces of attraction and repulsion could themselves make Life. Both the German writer and the Dutch painter were singing hymns of praise to the new insights of the natural sciences; this is what makes the resemblance so striking (even if they did not know each other). Their language is one of symbol and allegory, almost a religious language. But it was a religion that no longer existed. They were reciting a prayer that was calling upon the natural forces of the world, but nothing more.

Melancholy was inevitable, because in spite of the support Nature offered, the artist was ultimately on his own. He was no longer able to perceive the connections, to make out the plan and meaning which included him in the world. He had become merely a cog in an impersonal machine. And because of his ultimate solitude he had to go through all the possible concepts that linked him to Nature – a process that left him with partial answers or none at all, and feeling more desolate than ever. At least van Gogh was at one with his age and contemporaries in this. And now, vehemently, with a hope that seems forced, with an intensity beyond that of his fellow artists, he set out to break down the distinctions between the I and the not-I, at least for one brief moment of happiness – in his work.

Old Man in Sorrow (On the Threshold of Eternity)
Saint-Rémy, April-May 1890
Oil on canvas, 81 x 65 cm
F 702, JH 1967
Otterlo, Rijksmuseum Kröller-Müller

PAGE 632:
Road with Cypress and Star
Auvers-sur-Oise, May 1890
Oil on canvas, 92 x 73 cm
F 683, JH 1982
Otterlo, Rijksmuseum Kröller-Müller

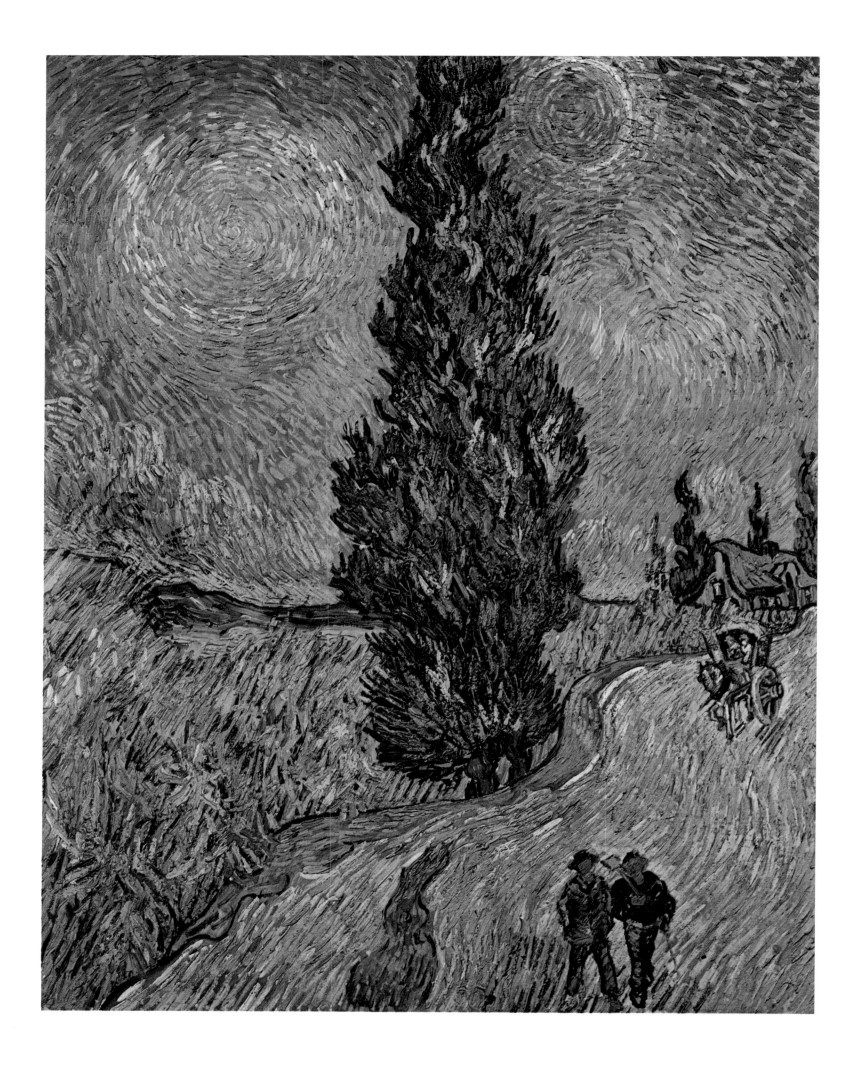

The End
Auvers-sur-Oise, May to July 1890

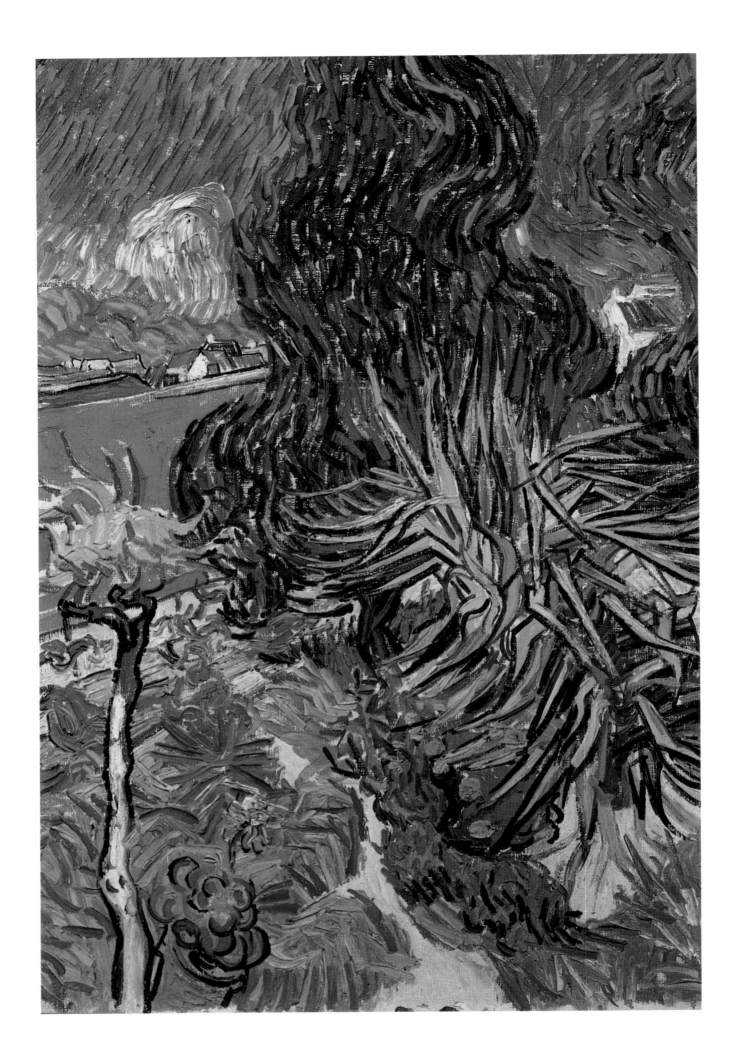

On Doctor Gachet's Territory

Van Gogh arrived in Paris looking fit and healthy. He seemed in excellent condition, and certainly much better preserved than his bowed and feeble brother. There followed three days in which he eagerly caught up on the metropolitan art scene, for all the world as if he was resuming his old role as man-about-town in the art capital of Europe. His friends came to call at Theo's home, and so did a growing number of admirers. What doubtless benefitted him most of all, though, was being able to see a large proportion of his œuvre together for the first time; he could compare his earlier work with his later, and had before him what had so far only existed in the nebulous realm of memory. For years van Gogh had been working every day, interrupted only by his bouts of madness, and now he paused for a while, inactive, his brush and pen untouched. But inactivity was not for Vincent van Gogh. He could not remain idle for long, and on 20 May, 1890 he crept off to Auvers-sur-Oise, which had been the focus of his longing for the north for some weeks. The small town on the river Oise, though scarcely beyond the outskirts of Paris, yet had that rural character he had left behind in the south: and it had the advantage of being close to the capital and his brother. For the time being, Auvers was the ideal refuge – as quiet a country place as he could wish, but with as much access to the city as he needed.

The things he had toiled to retrieve from memory in his southern days were before his very eyes in Auvers. Van Gogh promptly set about painting cottages, and developed a manic obsession with the motif, discovering an apparently endless number of interesting angles to his humble subject. Often his perspective was almost identical to that in imagined scenes he had painted in the asylum. It is interesting, for example, to compare *Cottages: Memory of the North* (p. 618), painted at Saint-Rémy, with *Thatched Cottages* (p. 636), done on the spot at Auvers. In both pictures the cottages are crowded up close, as if in need of protection. The painter is keeping his distance, as if he did not wish to intrude too much upon the idyll, and he merely records the essentials. That said, though, we must note the great difference in van Gogh's technique in Auvers: the agitation in his style has gone, the violence has vanished, and the rhetoric of the treatment is as subdued and tranquil as

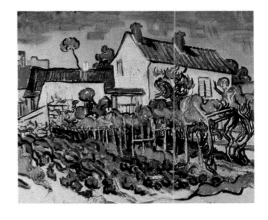

The House of Père Eloi
Auvers-sur-Oise, May 1890
Oil on canvas, 51 x 58 cm
F 794, JH 2002
Switzerland, Private collection

Doctor Gachet's Garden in Auvers
Auvers-sur-Oise, May 1890
Oil on canvas, 73 x 51.5 cm
F 755, JH 1999
Paris, Musée d'Orsay

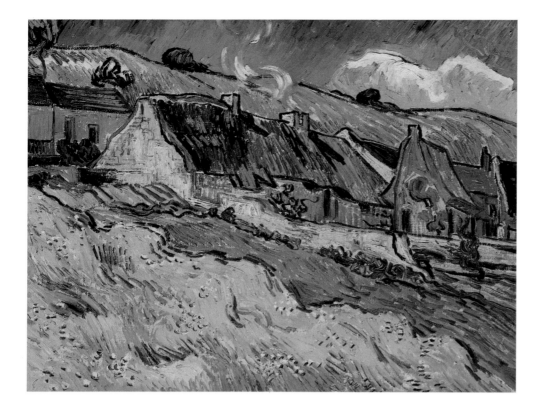

Thatched Cottages
Auvers-sur-Oise, May 1890
Oil on canvas, 60 x 73 cm
F 750, JH 1984
Leningrad, Hermitage

the scene itself – in contrast to earlier work, in which the exuberance of van Gogh the draughtsman and colourist could sometimes get rather out of hand. Van Gogh had anticipated that a return to the north would produce a more subtle and objective style. In the very first works he painted there, he was out to prove his expectations right. His longing had been gratified: his mood was calmer.

The Church at Auvers (p. 652) has a monumental quality, as if van Gogh were painting one of the famed cathedrals of the Ile de France. If we did not have the figure of the woman in traditional costume and cap to provide a sense of scale, we might well imagine these windows (which van Gogh has painted with notable attention to detail) to be those of the Gothic choir of a great diocesan church. This parish church has the lofty majesty of a fortress, and seems to be affording protection to the town: it is a symbol of faith and of security, a sanctuary and a castle in one. This architectural portrait, reminiscent of the old tower at Nuenen, shows van Gogh evading the issue of his present situation and preferring to echo older times in his homeland. The church, like the cottages, constitutes an appeal to the familiarity of the past. Neither of the motifs quite succeeded in laying to rest the doubts that had beset van Gogh even before he arrived in Auvers, though. "To be sure, it is a life of great grief and shame, if one lives a restless and homeless existence in this world and yet must needs address it, make demands of it, despise it and yet be unable to do without the object of one's contempt – this is the true dilemma of the artist of the future." Exile and homelessness, and the pain caused by exile, were the true hallmarks of the artist, according to Nietzsche. And van Gogh was very soon to be re-ac-

Houses in Auvers
Auvers-sur-Oise, May 1890
Oil on canvas, 72 x 60.5 cm
F 805, JH 1989
Boston, Museum of Fine Arts

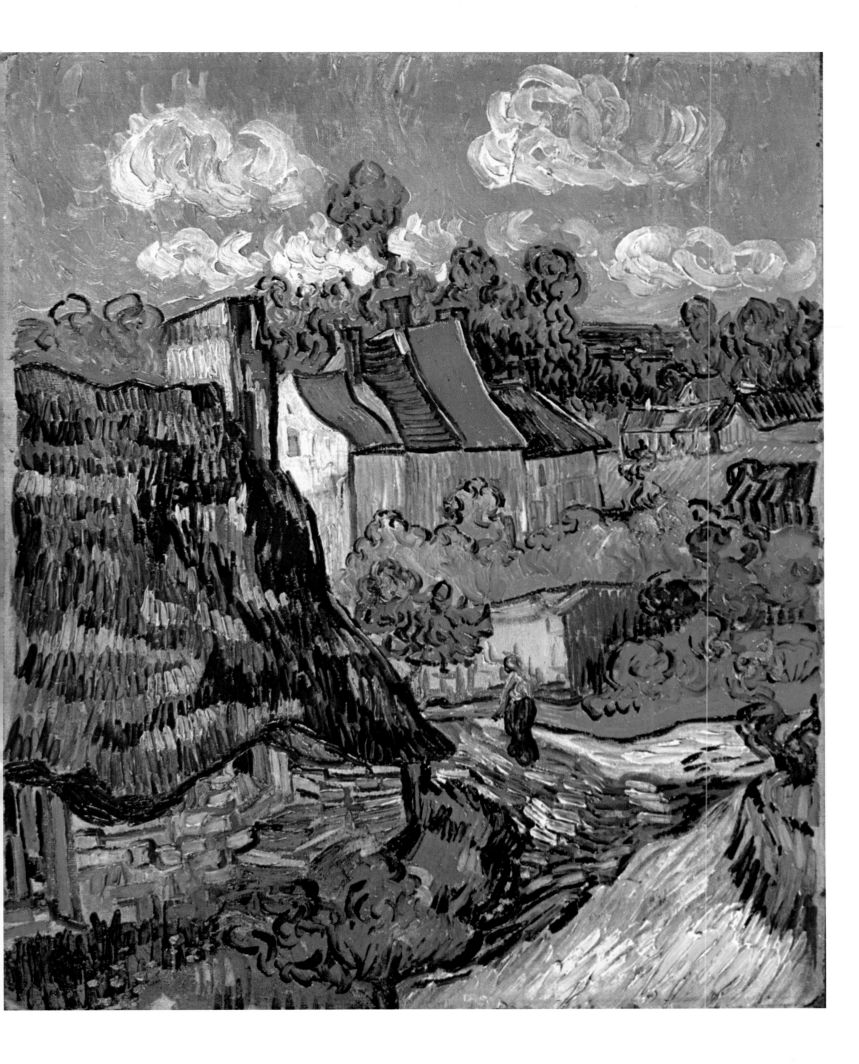

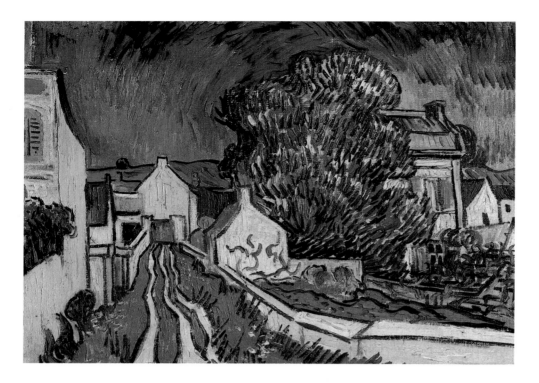

The House of Père Pilon
Auvers-sur-Oise, May 1890
Oil on canvas, 49 x 70 cm
F 791, JH 1995
Collection Stavros S. Niarchos

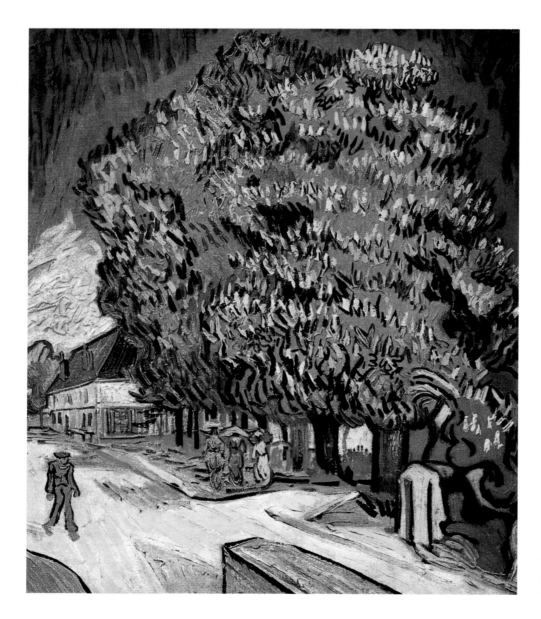

Chestnut Trees in Blossom
Auvers-sur-Oise, May 1890
Oil on canvas, 70 x 58 cm
F 751, JH 1992
South America, Private collection

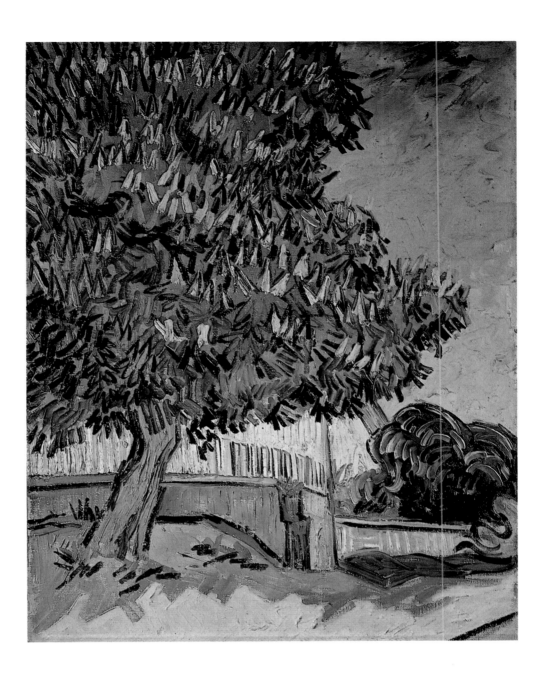

Chestnut Tree in Blossom
Auvers-sur-Oise, May 1890
Oil on canvas, 63 x 50.5 cm
F 752, JH 1991
Otterlo, Rijksmuseum Kröller-Müller

quainted with isolation and a sense of alienation; even Auvers was only a stage along a journey whose destination he did not know.

"There is nothing to keep us here, absolutely nothing, except Gachet", wrote van Gogh in Letter 638, a mere fortnight after his arrival, "but he will remain our friend, of that I am convinced. Whenever I go to see him I make quite a good impression, and he will go on inviting me to dinner every Sunday or Monday." People like van Gogh are unable to settle. All he could do was draw inspiration from a kindred spirit. His newfound friend, Paul Gachet, was the real reason why van Gogh moved to Auvers.

Mid-century, when Courbet and his circle met, a young medical student had often joined them, acquiring an evergrowing enthusiasm for art that was at last entering the modern age. Once he had completed his studies he moved to the country in 1872, in order to pursue his interest. In a sense, Dr. Gachet was an intellectual version of Pére

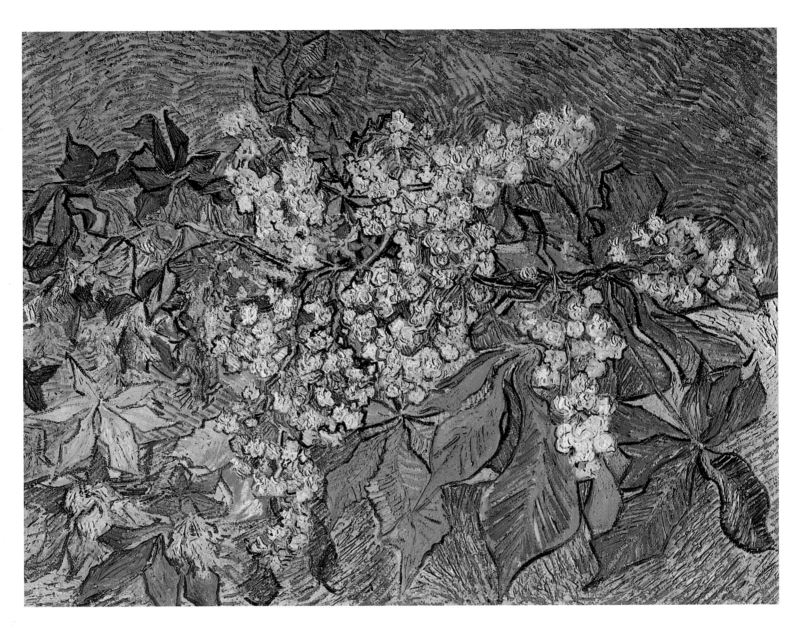

Blossoming Chestnut Branches
Auvers-sur-Oise, May 1890
Oil on canvas, 72 x 91 cm
F 820, JH 2010
Zurich, Foundation Collection E. G. Bührle

Tanguy. He was an ardent republican and socialist, and devoted to his artist friends, whose scorned and derided works he collected diligently. Soon he was inspired to paint too, and, using the pseudonym van Ryssel, he made something of a name for himself, mainly as a graphic artist. In 1873 Cézanne moved to Auvers on Gachet's account. Camille Pissarro, the grand old man of Impressionism, was living not far away, at Fontoise. And it was Pissarro who told Theo van Gogh about the doctor, saying that his knowledge of the physiology of Man was accompanied by insight into the soul. Vincent could hardly have found a better therapist. The physical and mental no-man's-land he was living in was familiar territory to Dr. Gachet. It was because of him that van Gogh went to Auvers in the first place, and why he stayed there.

"I have found a true friend in Gachet", wrote a cheerful van Gogh to his sister (Letter W22), "rather like a brother, so great is the physical and even mental resemblance between us. He himself is a nervous, eccentric man. He has given numerous proofs of friendship to the artists of the new school, and has been of service to them whenever it was in his

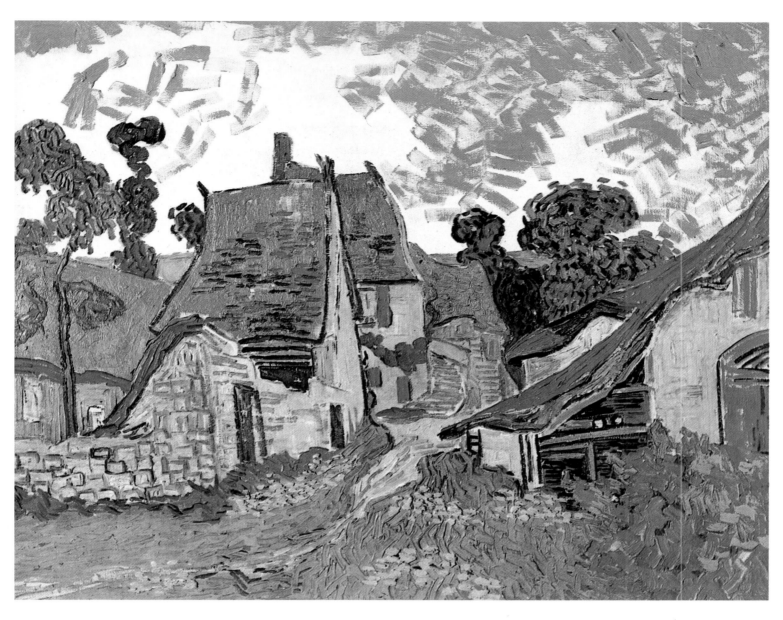

Village Street in Auvers
Auvers-sur-Oise, May 1890
Oil on canvas, 73 x 92 cm
F 802, JH 2001
Helsinki, Atheneumin Taidemuseo

power." The kindred spirit had something of that broken quality which the life of his artist friends was based on, and shared in their dedication and obsession. "He strikes me as being just as sick and nervous as you and I", we read in Letter 638, "and he is older, and lost his wife some years ago, but he is a doctor to his very fingertips, and his profession and faith keep him going." Gachet was not as prompt to pronounce a diagnosis as those who later saw van Gogh as schizophrenic or epileptic; he was merely convinced that van Gogh's attacks would not recur, and in this he was to be proved correct – though at a price.

As a token of friendship, van Gogh painted two portraits of the doctor (pp. 656 and 657). He also did an etching (p. 653); Gachet himself was a specialist in the technique and encouraged van Gogh to try his hand, though it remained van Gogh's only venture in this direction. And so we have three versions of Gachet in the pose van Gogh considered typical of the man, in a contemplative and slightly melancholy mood. Gachet had written a doctoral thesis on melancholy. In terms of his temperament, melancholy was his middle name. It was no coincidence that his pose so

closely resembled that of Madame Ginoux in *L'Arlésienne* (p. 617); van Gogh's earlier sitter, back in Arles, had had her own mental problems. Of course the head resting heavily on the hand, the arm propped on the elbow, the drooping eyelids and glum mouth, had for centuries been the stereotype image of the melancholic and, by extension, of the suffering artist. Van Gogh was painting an *alter ego*. The portrait recorded a

process of identification. The two books (cf. p. 657) are sufficient in themselves to prove that the painter was trying to conflate his own self with that of his subject: they are both by the Goncourt brothers – *Germinie Lacerteux* and *Manette Salomon*. These attributes not only suggest a well-read man. They are also symbols of the modern spirit shared by the two men, emblematic of the optimistic yet despairing vision of the future they had embraced.

No one knew better than van Gogh that in the portraits of Dr. Gachet he was borrowing an ages-old traditional mould and filling it with his own individual details of the here and now. In Letter W22 he wrote: "I should like to paint portraits that will strike people a hundred years from now like visionary apparitions. But I am not trying to achieve this by means of photographic similitude; rather, by means of passionate expression, using our modern knowledge of colour and our contemporary sense of colour as a means of expression and a way of heightening character." If the doctor's pose went back to ancient times, the treatment was extremely advanced; and it seems likely that Gachet himself was the catalyst of van Gogh's views at this point. Van Gogh was painting as he had always done, and the use of colour, and application of

Village Street and Steps in Auvers with Figures
Auvers-sur-Oise, late May 1890
Oil on canvas, 49.8 x 70.1 cm
F 795, JH 2111
St. Louis, The Saint Louis Art Museum

**Village Street and Steps in Auvers with
Two Figures**
Auvers-sur-Oise, May-June 1890
Oil on canvas, 20.5 x 26 cm
F 796, JH 2110
Hiroshima, Hiroshima Museum of Art

paint, were as vigorous and even violent as ever. But discussions with his new mentor may well have brought home to him for the first time the radically innovative quality of his own paintings. In his rural seclusion, van Gogh was thinking and working, indeed living, in a spirit of modernity almost in spite of himself. Now, after years of isolation, he fully perceived the nature of his own programme; Gachet reawakened the interest in staking out manifesto claims that van Gogh had lost in Saint-Rémy.

And van Gogh also had a new hero: Puvis de Chavannes. The rather dry and remote religious and mythic scenes of Puvis supplied a newly fashionable aesthetic demand for virginal grace and purity. "For us, he embodies a reaction to excesses in a diametrically opposed spirit, which we have tired of", he wrote to Teodor de Wyzema, a Symbolist writer. "We were thirsting for dreams, sensations, and poesy. Dazzled by a light that was all too bright, we longed for the mist. At that time, we turned enthusiastically to the poetic, veiled art of Puvis de Chavannes. We loved even its gravest flaws, the shortcomings of the draughtsmanship,

Farmhouse with Two Figures
Auvers-sur-Oise, May-June 1890
Oil on canvas, 38 x 45 cm
F 806, JH 2017
Amsterdam, Rijksmuseum Vincent van
Gogh, Vincent van Gogh Foundation

View of Auvers
Auvers-sur-Oise, May-June 1890
Oil on canvas, 50 x 52 cm
F 799, JH 2004
Amsterdam, Rijksmuseum Vincent van
Gogh, Vincent van Gogh Foundation

the lack of colour. The art of Puvis became a kind of cure; we clung to it as patients cling to a new healing process." No one could have been more reckless in his espousal of Puvis (complete with his shortcomings) than van Gogh. And, in a sense, his portraits of Dr. Gachet were recollections and even paraphrases of a work by Puvis. "For myself, the very ideal of figure painting has always been a portrait of a man by Puvis, showing an old man reading a yellow novel, with a rose beside him and a watercolour brush in a glass of water." (Letter 617) This portrait (which shows one Eugène Benon and is currently in a private collection at Neuilly) reappears in more contemporary style, the treatment more radical and the colour scheme more assured, in the portrait of Gachet on page 657. And it was not only in the painting that the influence of Puvis was of central importance: "It is a comfort", wrote van Gogh in Letter 617, referring to the picture by Puvis, "to see modern life as something serenely pleasant in spite of the inevitable sadness it brings."

The van Gogh who lived his last two months in Auvers was a more cheerful and confident artist, more cosmopolitan in temper. He painted some eighty works in that time – an average of more than one a day. Critics have commented that van Gogh's demon now had him totally in its grip, and have compared his creative fever with that similar bout of Nietzsche's that ended in insanity. One more time, the artist demanded of himself all that could possibly be demanded of a human being, determined to create an enduring memorial before he vanished for all time from the face of the earth. That, at any rate, is what the van Gogh legend claims. His correspondence unfortunately provides no substantiation whatsoever for this kind of interpretation. Rather, he was taking

Thatched Cottages in Jorgus
Auvers-sur-Oise, June 1890
Oil on canvas, 33 x 40.5 cm
F 758, JH 2016
Pleasantville (N.Y.), Reader's
Digest Collection

great pleasure in breathing the air of freedom after his spell of voluntary isolation. "It really is remarkable", he noted confidently in Letter 640, "that my nightmares have largely ceased here; I always did tell M. Feyron that I would be rid of them once I returned north." And in Letter 640a, to his friend Ginoux in Arles, he wrote: "And incidentally, now that I am no longer drinking I am doing work that is definitely better than before... a certain progress, when all's said and done."

Van Gogh painted thirteen portraits in a very few weeks, a rate of production that he had scarcely achieved even in Nuenen. He was more interested than ever in youngsters and children, seeing them as symbols of carefree, optimistic life. There is no trace of despondency, depression, or premonitions of death in a painting such as *Young Man with Cornflower* (p. 676) – indeed, none of van Gogh's other portraits can match the cheerful tone of this one. Was he perhaps asserting a confidence and

Houses in Auvers
Auvers-sur-Oise, June 1890
Oil on canvas, 60.6 x 73 cm
F 759, JH 1988
Toledo (Oh.), The Toledo Museum of Art,
Gift of Edward Drummond Libbey

Still Life: Pink Roses
Auvers-sur-Oise, June 1890
Oil on canvas, 32 x 40.5 cm
F 595, JH 2009
Copenhagen, Ny Carlsberg Glyptotek

optimism he did not truly feel? The fact is that all van Gogh's paintings sought to respond to the world by expressing an optimism he could not necessarily find within himself. It is all too easy to project our hindsight knowledge of his suicide onto these late works, just as it is easy to construe the Saint-Rémy works as expressions of mental instability. However, neither van Gogh's pictures nor the letters he wrote at the time demand interpretation as documents of a descent into the abyss – quite the contrary: van Gogh was taking considerable delight in his work. The importance of Dr. Gachet's positive influence can hardly be exaggerated. It was Gachet who brought home to van Gogh the significance and value of his art, Gachet who used his natural authority to persuade van Gogh to do a new series of portraits, and a number of townspeople to sit for him.

The town of Auvers itself had the perfect atmosphere. Decades previously, Daubigny had bought a plot of land there and tempted Daumier and Corot to follow him. Three artists van Gogh valued highly had given the area their attention, recording it in paintings, transforming its moods in their use of colour and conferring the natural nobility of Art on the townspeople. Van Gogh had always had a tendency to follow in someone or other's footsteps, and in Auvers it was an easy and natural thing to do. He painted three views of *Daubigny's Garden* (pp. 673 and 683–85) on the spot, views relaxed and unstrained in mood. He had Paris on his doorstep, a tradition of venerable predecessors to draw upon in Auvers, and a fine collection of modern art to look at in Dr. Gachet's house; there was no reason for van Gogh to feel at odds with the world. And when Theo brought his family out to the country one warm Sunday

in June, the day was one of the happiest in Vincent's life. He was already thinking of settling in Auvers: at any rate, he proposed giving up the room he had rented in Arthur Ravoux's inn and taking a more permanent apartment. Nothing in this plan suggested that the establishment of a new "yellow house" had been ruled out.

Undoubtedly van Gogh's life at Auvers was far more pleasant than it had been at Saint-Rémy. Nor was there anything to make an artist who felt homeless in the existential sense feel any more out-of-place or isolated than he had done in Arles. The year in the asylum had been more or less wasted; now van Gogh was seizing hold of the happiness Art and the pursuit of Art could afford him. It would be quite wrong to say that the suicide which so abruptly and unexpectedly ended van Gogh's two months near the capital was inevitable. If van Gogh's sense of being at odds with the world was perhaps undiminished within, he yet encountered nothing in Auvers to make his condition worse. The reasons for his suicide must be sought elsewhere.

Marguerite Gachet in the Garden
Auvers-sur-Oise, June 1890
Oil on canvas, 46 x 55 cm
F 756, JH 2005
Paris, Musée d'Orsay

Thatched Cottages in Cordeville
Auvers-sur-Oise, June 1890
Oil on canvas, 72 x 91 cm
F 792, JH 1987
Paris, Musée d'Orsay

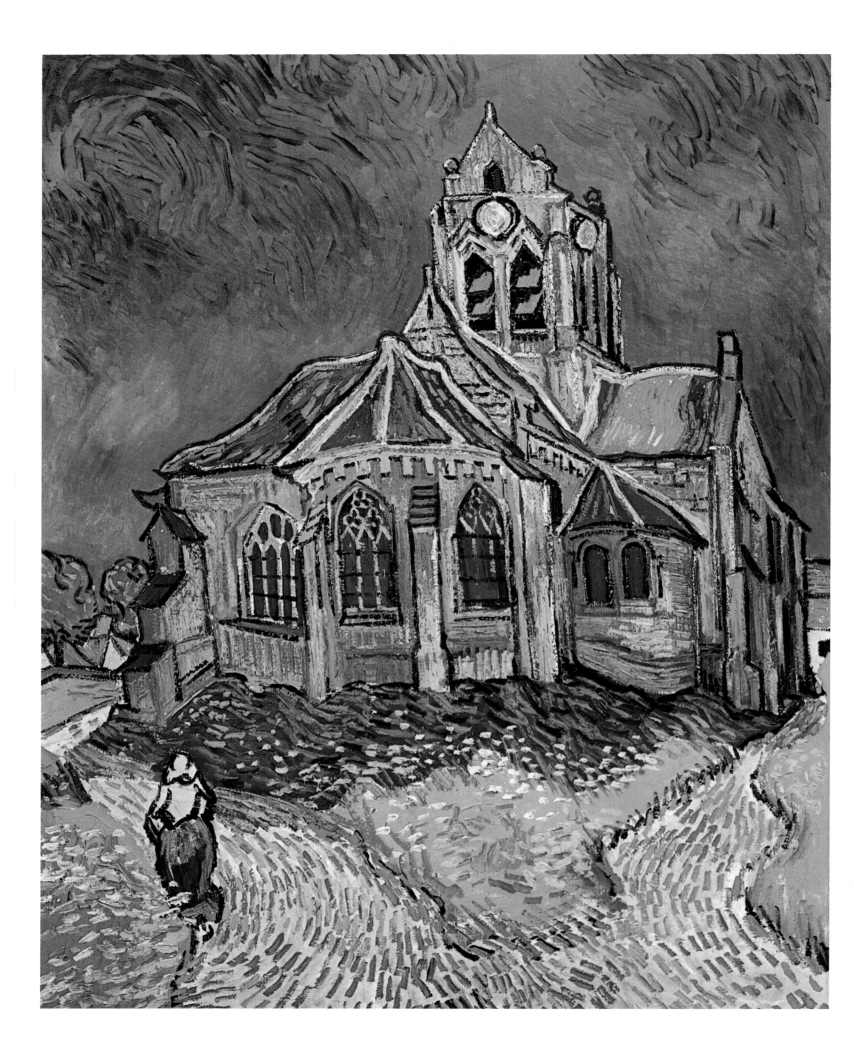

Frieze Art
Van Gogh's 'Art nouveau'

In van Gogh's end was his beginning. He rendered his new surroundings in a relaxed and calm style. In *Wheat Field at Auvers with White House* (p. 654), for instance, the house itself is positioned at a distance, allowing van Gogh a detached approach that dwells on an everyday scene caught at a given moment. The wheat is gradually ripening, and beyond the field we see a panoramic background where the motifs are packed tight and the outlines begin to dissolve. Van Gogh has put his individual style at the service of the scene, and has returned to a task he had been neglecting for years, the task of simply showing things as they are. His brushwork introduces order into the sea of wheat, recording every single ear of corn with a bold stroke. His use of colour is modest, restricted to variations on green, now with a delicate yellow touch, now with a blue; the palette's sole contribution is white, non-colour white, inexpressive white, which has the sole function of signifying the whitewashed walls of the house. Harmony prevails. Van Gogh has carefully removed all trace of his own presence and has simply, selflessly recorded the look of the country. It is an idyll. But it is a sterile idyll.

Naturally he was not always as stern towards himself as he was in this painting. This becalmed, almost anodyne art was never without its more virulent counterpart, a demonstrative art dependent on gesture and distortion. Nonetheless, we can say that in Auvers van Gogh succeeded in combining two apparently irreconcilable methods, uniting the wild and the levelheaded, the violent and the controlled, the chaotic and the orderly. Generally speaking, his pictures became more decorative in character, approaching an ideal he had already toyed with in Arles. Van Gogh was aiming at a more malleable, pliable art the basis of which was the pure beauty of interdependent forms, and in this his efforts were not so far removed from *Art nouveau*. In Saint-Rémy in particular, hampered by the limits of a difficult situation, he had tried to remake his subjects in a spirit of abstraction, till they seemed fit metaphors of his own mental condition. Now, his penchant for the chaotic was countered by his deep-seated perfectionism.

Van Gogh adopted a new close-up view of Nature, giving his attention to the natural and thus beautiful appearance of things. The paintings of wild roses on pages 622 and 624 (probably done while he was still at

Portrait of Doctor Gachet:
L'Homme à la Pipe
Auvers-sur-Oise, May 1890
Etching, 18 x 15 cm
F 1664, JH 2028

The Church at Auvers
Auvers-sur-Oise, June 1890
Oil on canvas, 94 x 74 cm
F 789, JH 2006
Paris, Musée d'Orsay

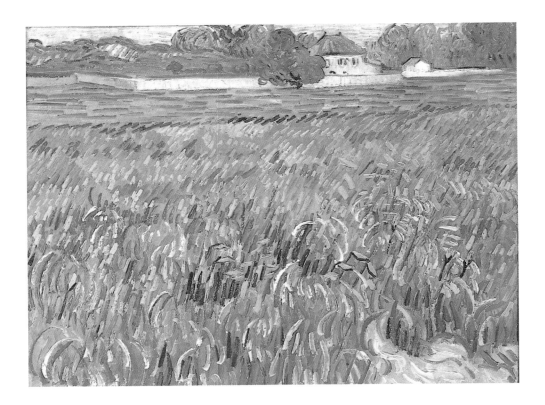

Wheat Field at Auvers with White House
Auvers-sur-Oise, June 1890
Oil on canvas, 48.6 x 63.2 cm
F 804, JH 2018
Washington, The Phillips Collection

Saint-Rémy) are a good example. Once again, van Gogh well-nigh had his nose in the flowers. A quality of wild freedom in the flowers compelled his attention, and it is this quality that removes the two pictures from the realm of the still life. In addition, the close-up treatment preserves a certain haphazard energy in the natural object without abandoning it to mere luxuriance and jungle chaos. The plant world seems more natural and less abstract than in van Gogh's earlier hymns

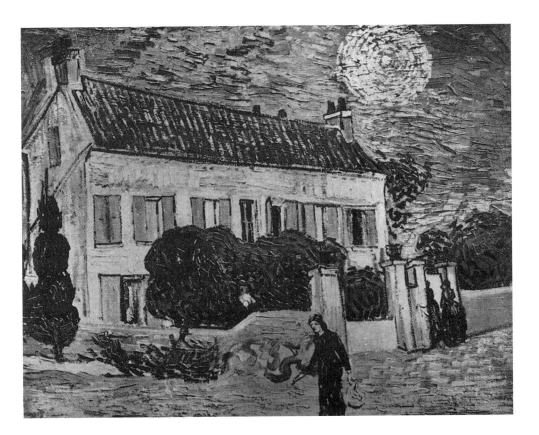

The White House at Night
Auvers-sur-Oise, June 1890
Oil on canvas, 59.5 x 73 cm
F 766, JH 2031
Whereabouts unknown

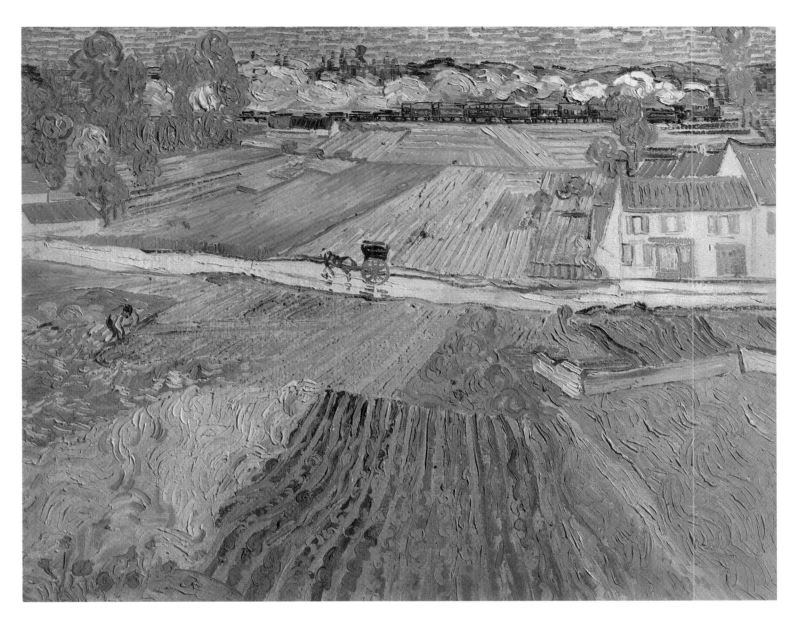

to Creation. Chaos and Order are in equilibrium here because van Gogh does not hesitate to give a detailed account of the appearance of the vegetation. His control of technique is stern; the beetle on one of the flowers (on page 622) gives the impression of being the subject of a portrait.

"We have by no means reached the point where people might understand the remarkable relations that can exist between one piece of Nature and another, mutually explanatory and setting each other off." The "remarkable relations" van Gogh wrote of in Letter 645 had now become a quality in their own right. The artist who wanted to express them was best advised to plunge into the heart of Nature, rather than stylizing them in his art. It was a plural world, with quite enough phenomena in it to make a picture perfect in form. "One piece of advice: do not copy Nature too slavishly. Art is abstraction; take your abstraction from Nature by dreaming about it, but think more of what remains to be made than about the result." Gauguin's pontification to his friend Schuffenecker said precisely the opposite of what van Gogh now be-

Landscape with Carriage and Train in the Background
Auvers-sur-Oise, June 1890
Oil on canvas, 72 x 90 cm
F 760, JH 2019
Moscow, Pushkin Museum

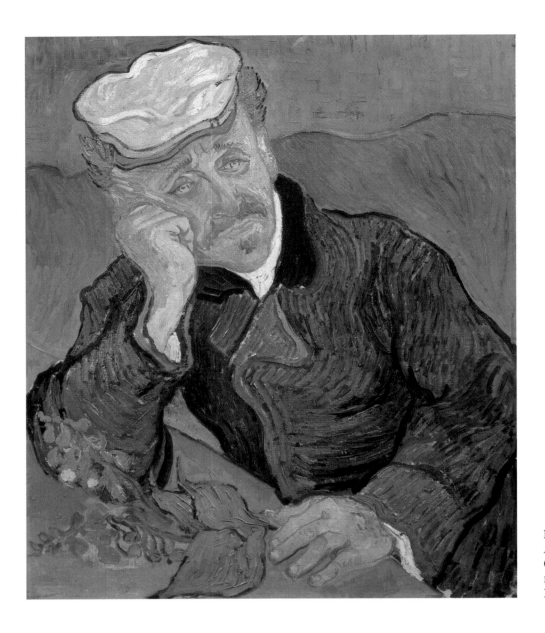

Portrait of Doctor Gachet
Auvers-sur-Oise, June 1890
Oil on canvas, 68 x 57 cm
F 754, JH 2014
Paris, Musée d'Orsay

lieved to be the case. Gauguin was only in a position to achieve a decorative lustre and consistency of mood, and all the characteristics of good art, if he turned away from his subject during the painting process. Van Gogh valued the same qualities, but, for him, recording them in Art meant capturing their presence in Nature.

The two pictures of young peasant women in wheatfields (pp. 668 and 675) are good examples of this. The model is seen posing in surroundings that constitute her livelihood and *raison d'être*, in a field of ripening wheat. This setting functions both as attribute and as a traditional item in portrait iconography. On the other hand, though, the wheatfield itself (Nature under cultivation) hardly makes much of an impression. The stalks and flowers look like a wall because the painter's close-up is so extreme as to eliminate all trace of spatial depth, and because the local colours are so intense as to dispel atmosphere. The aesthetic unity of a subtly rendered human being and a delicately decorative background has a natural inevitability to it, whereas in portraits done towards the end of the Arles period, such as *La Berceuse*, the combination had still

Portrait of Doctor Gachet
Auvers-sur-Oise, June 1890
Oil on canvas, 67 x 56 cm
F 753, JH 2007
Private collection
(Christie's Auction, New York, 15. 5. 1990)

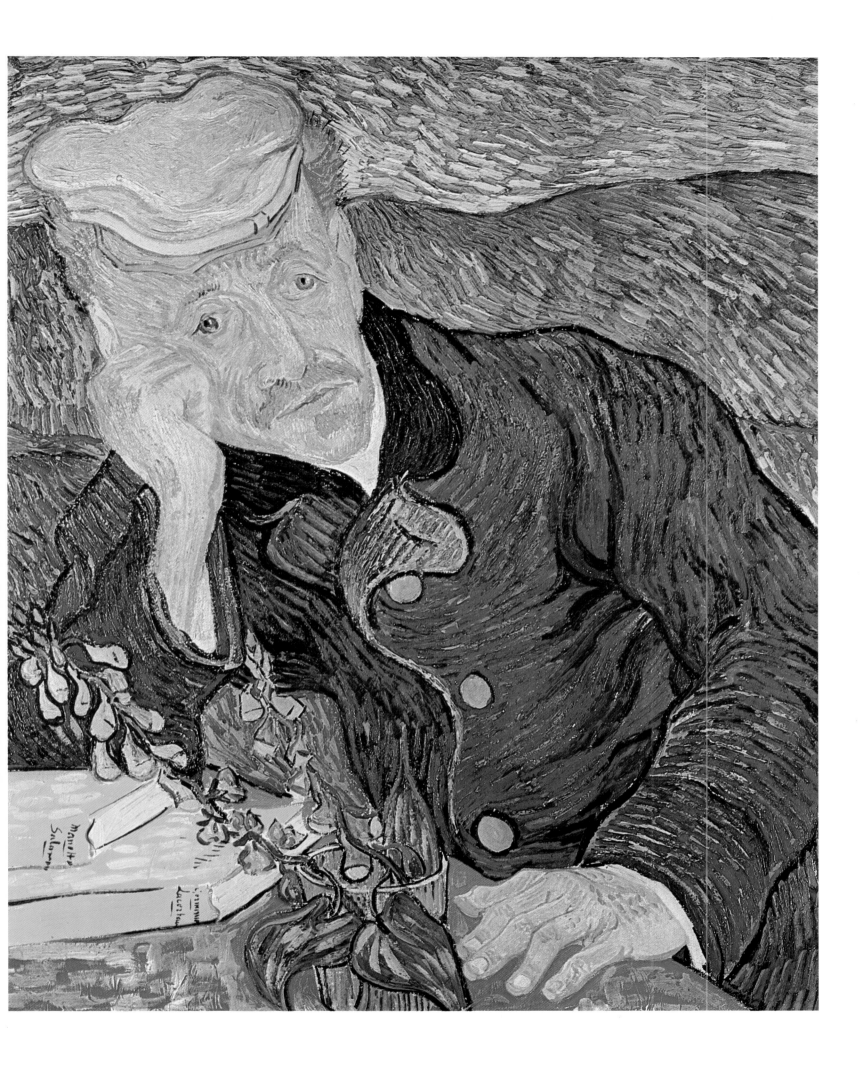

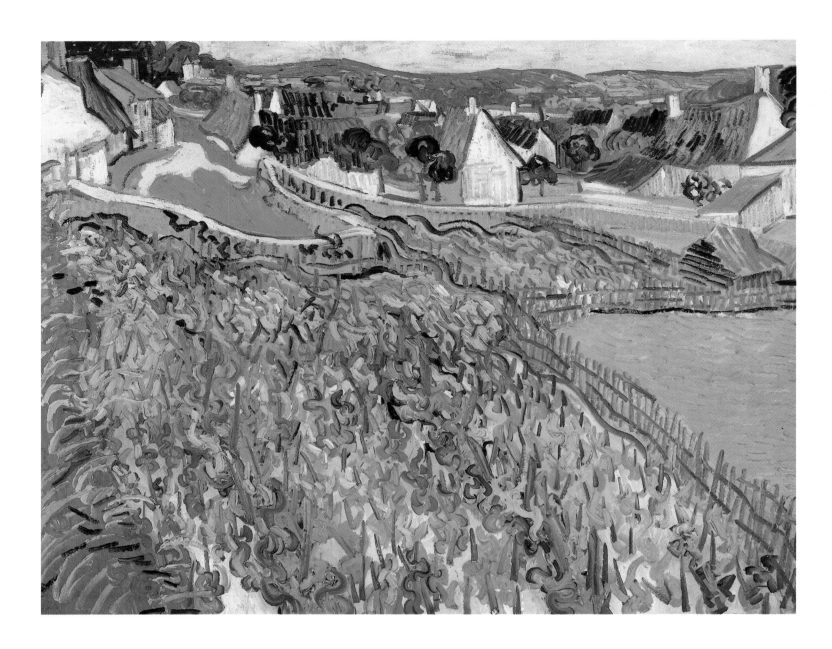

Vineyards with a View of Auvers
Auvers-sur-Oise, June 1890
Oil on canvas, 64.2 x 79.5 cm
F 762, JH 2020
St. Louis, The Saint Louis Art Museum

had something brusquely forced about it. The pattern of convoluted arabesques has been replaced with flowers; abstraction has been replaced by Nature herself. The wheat and flowers of the background serve as backdrop and natural environment, emblematic tapestry and literal field, in one.

Nature was literal, immediate and real: it was also decorative, and played a significant part in making existence a more beautiful affair. Again van Gogh's instincts anticipated ideas that were only to become commonplace years later. *Art nouveau* advocated a return to Nature, nudism and healthy living, and the wonders of Nature were appropriated by the everyday world of the home and by the crafts revival. Life would be better and more beautiful if lived in harmony with Nature. What was implicit in van Gogh became a slogan. Of course, in van Gogh this was all in an inchoate state, and proceeded from an aversion to pure aestheticism. Still, his final works do exhibit an affinity to tapestry art. The *Ears of Wheat* (p. 669) seem to have a life of their own that prevents

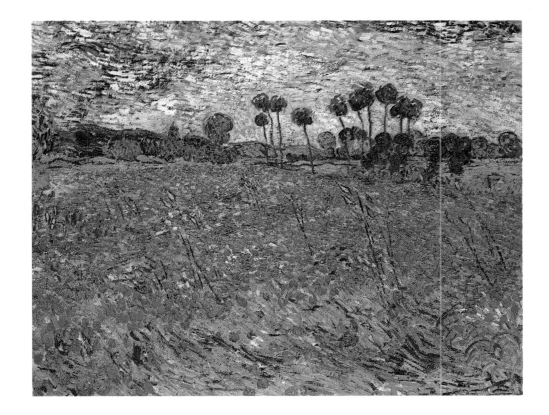

Field with Poppies
Auvers-sur-Oise, June 1890
Oil on canvas, 73 x 91.5 cm
F 636, JH 2027
The Hague, Haags Gemeentemuseum
(on loan)

them from being a mere geometrical pattern, while at the same time they bow to an overall order that governs what might threaten to become a jungle. It is a maximum of order and of chaos, at one and the same time. The natural plant kingdom and the world of decorative aesthetics meet on paradoxical ground.

"There is a wonderful picture by Puvis de Chavannes in the exhibition", van Gogh wrote to his sister (Letter W22) when he visited the Salon du Champ du Mars. It was one of numerous forums for contem-

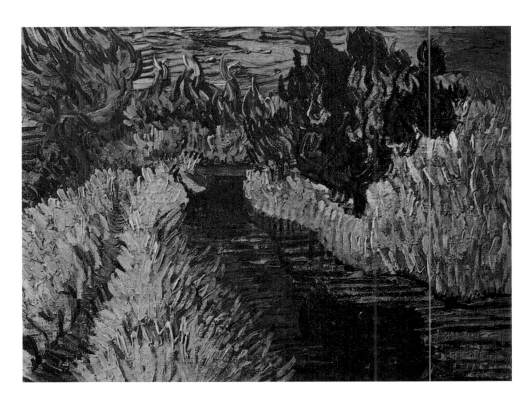

The Little Stream
Auvers-sur-Oise, June 1890
Oil on canvas, 25.5 x 40 cm
F 740, JH 2022
Private collection

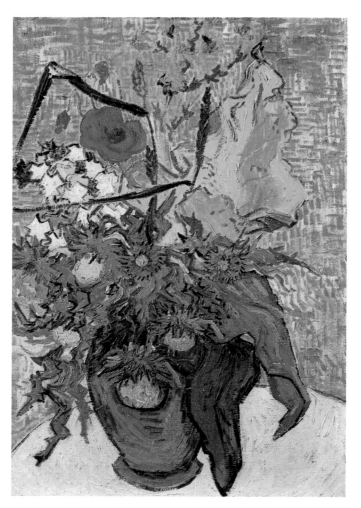
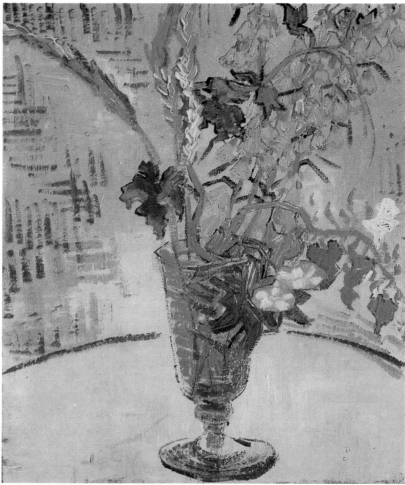

porary art, and the work by Puvis was his monumental *Inter artes et naturam*. Van Gogh's description of the painting went as follows: "The people are dressed in light garments, and one cannot tell whether it is modern dress or the garb of antiquity. Two women, both of them in long, simple dresses, are chatting at one side, and at the other are men, painters, and in the middle a woman, with her child in her arm, plucking a blossom from an apple tree in bloom [...] Blue distance, with a white city and a river. The whole of mankind, the whole of Nature, simplified yet as they might be if they are not like that now." The work offers a powerful synthesis of past and present, of arcadia and the industrial world. The figures and Nature have been "simplified" in order to remove them from reality into a timeless realm. Puvis's masterpiece was intended for the stairwell of the Musée des Beaux-Arts in Rouen: it would be decorative while conveying humanitarian ideals, thus combining beauty and instruction. In its way, it served the same ends as van Gogh – or rather, the goals he might have considered he served after looking at this superb example of that typical 19th century genre, the panorama of mankind. It was characteristic of van Gogh that what he now felt called upon to integrate into his own work was not the human statement but the decorative element; and he turned to the possibilities of broad formats.

Wild Flowers and Thistles in a Vase
Auvers-sur-Oise, June 1890
Oil on canvas, 67 x 47 cm
F 763, JH 2030
Japan, Private collection
(Christie's Auction, New York,
12. 11. 1985)

Still Life: Glass with Wild Flowers
Auvers-sur-Oise, June 1890
Oil on canvas, 41 x 34 cm
F 589, JH 2033
Pleasantville (N.Y.), Reader's
Digest Collection

Still Life: Vase with Rose-Mallows
Auvers-sur-Oise, June 1890
Oil on canvas, 42 x 29 cm
F 764a, JH 2046
Amsterdam, Rijksmuseum Vincent van
Gogh, Vincent van Gogh Foundation

Still Life: Red Poppies and Daisies
Auvers-sur-Oise, June 1890
Oil on canvas, 65 x 50 cm
F 280, JH 2032
Buffalo (N.Y.), Albright-Knox Art Gallery

Fourteen of the Auvers paintings are broad-format, and thirteen of them are almost exactly the same 50 x 100 cm format. Doubtless it was under Puvis's influence that van Gogh decided to measure out his canvas to a new norm, a norm which visually related his work to the frieze, a standard decorative medium in architecture. The first of van Gogh's broad-format paintings was even smaller. "I even feel that Nature often has all the grace of a picture by Puvis, a quality midway between Art and Nature", he wrote in Letter 645, describing the origins of the painting. "Yesterday, for instance, I saw two people: the mother in a dark carmine dress, the daughter in pale pink, wearing an unembellished hat, both of them healthy country figures, tanned by all the fresh air and sun." The painting was *Two Women Crossing the Fields* (p. 697). Van Gogh's translation of what he saw into what he painted has a distinctly Puvis character. The colours have a pastel brightness: they are light and airy. The scene is set "between Art and Nature" – *Inter artes et naturam*. It is not a typical van Gogh. Indeed, it has a touch of plagiarism to it: the brushwork is economical, the colouring patchy. Van Gogh is aiming at a quality of "grace" that is normally alien to his approach. The painting is totally in the service of the decorative principle.

Puvis's serene account of an earthly paradise was really too big. To fit

Still Life: Japanese Vase with Roses and Anemones
Auvers-sur-Oise, June 1890
Oil on canvas, 51 x 51 cm
F 764, JH 2045
Paris, Musée d'Orsay

in with the architecture it was to adorn, the centre panel alone measured 170 x 65 cm. Van Gogh had no need to think in terms of wall space, and adopted his own proportion of precisely two to one. There is a banal explanation for his faith in maths. The series of thirteen paintings uniform in format was preceded by an unremarkable work done when van Gogh lacked canvas. The first version of *Daubigny's Garden* (p. 673) was painted on a napkin, a square piece of material the sides of which measured half a metre. Soon he was planning to paint a "more important picture" (Letter 642) of the subject, which he had grown fond of; and he did the two subsequent views of the garden by simply doubling the canvas area and thus establishing the frieze format (pp. 683–85). It was the start of a new series.

It was to include the most decorative work of van Gogh's entire career. Let us take *Sheaves of Wheat* (p. 699) as an example. It uses the time-honoured contrast of yellow and violet. The sheaves are trim and neat. Van Gogh has sure-handedly opted for an additive principle for his composition: back in Nuenen he had taken a single sheaf as the solitary, monumental subject of his picture, but now he did a whole row of sheaves and in the process revealed a decorative principle at work in agriculture itself. Even farmers obey the dictates of an orderly idyll, it seems. Together with the geometry of the subject, a compositional

Child with Orange
Auvers-sur-Oise, June 1890
Oil on canvas, 50 x 51 cm
F 785, JH 2057
Winterthur, Collection L. Jäggli-Hahnloser

Two Children
Auvers-sur-Oise, June 1890
Oil on canvas, 51.2 x 51 cm
F 783, JH 2051
Paris, Musée d'Orsay

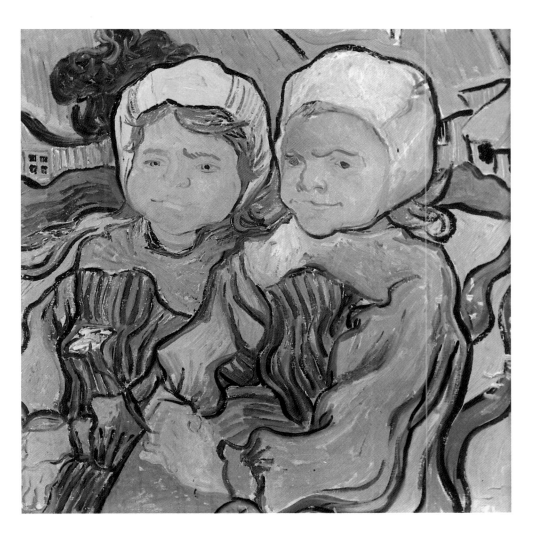

Two Children
Auvers-sur-Oise, June 1890
Oil on canvas, 51.5 x 46.5 cm
F 784, JH 2052
Lausanne, Collection Basil P. and
Elise Goulandris

rhythm is at work in the picture: the verticals of the tower-like sheaves rise against a layered sequence of horizontals which themselves constitute a vertical scale. These horizontals vanish into a vague, distant depth which has more of the tapestry and wall about it than of fields and a plain. The effect is to establish a grid built on rectilinear principles – though the painting is unarguably at odds with its own abstract leanings. The sheaves are swaying, the lines have a tendency to run in circles: the painting has achieved an equilibrium of the natural and the ornamental (projected into the natural by a sensibility attuned to see it). In his realm between Art and Nature, van Gogh countered chaos with decorative order.

There were times, though, when his harmony failed, and the result could be far less delicate and ornate, though far fuller of energy and vitality. A perfect example is *Tree Roots and Trunks* (p. 692). Again using his frieze format, van Gogh compacts the full vigour of growth in an arresting close-up view. In this undergrowth there can be no more talk of an overall principle of order: instead, the knotted and gnarled roots and trunks produce vigorous exercises in pure painting – van Gogh is not out to portray this little green world, he is establishing radical equivalence between the organic and aesthetic realms, "between Art and Nature". That said, we must add that in the convoluted roots and

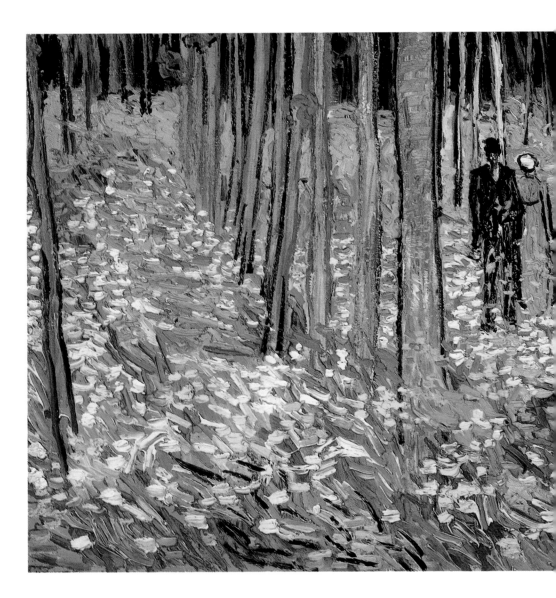

Still Life: Vase with Flower and Thistles
Auvers-sur-Oise, June 1890
Oil on canvas, 41 x 34 cm
F 599, JH 2044
Oakville (Canada), Collection J. Blair
MacAulay

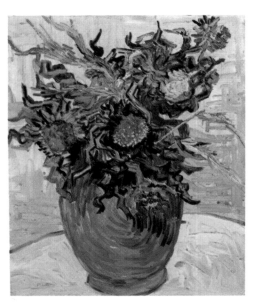

trunks there is an obviously ornamental quality. It is as if the picture could not cope with the vitality of natural Creation and were withdrawing into two-dimensional remoteness from the real. The greater the abstraction, the greater the spatial flatness: but this old maxim of decorative art, though it applies to this painting, is by no means a damnation. Quite the contrary – the *art nouveau* imagination was to derive its inspiration from these very amorphous, protean, unrepeatable shapes.

It can be argued that van Gogh had re-entered the conceptual world he inhabited at the time he decorated the "yellow house". Decorative considerations were again the cornerstone of his art. It was no coincidence that he was once more thinking of renting a house. But this time it was not to be the home of an artists' colony, but rather a place where he could spend weekends with Theo and his family. His purposes were now of a private nature – though the single-minded energy with which he pursued them remained unchanged. This is a major reason why he was influenced by Puvis de Chavannes. Every artist interested in the current revival of mural painting borrowed tips and inspiration from

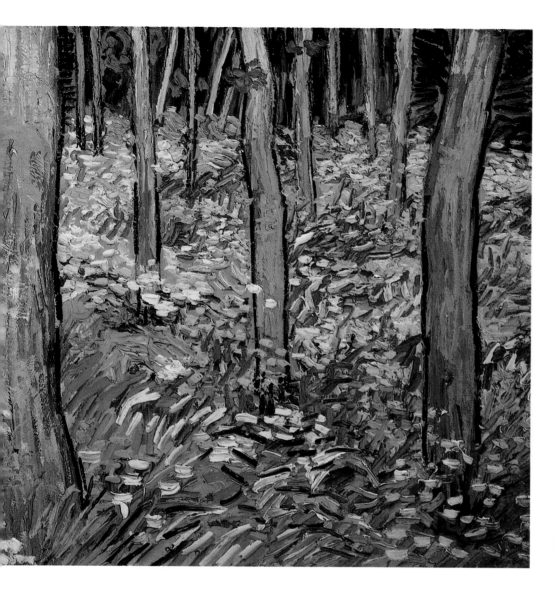

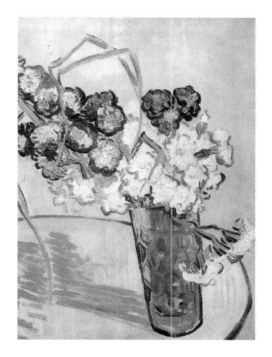

Undergrowth with Two Figures
Auvers-sur-Oise, June 1890
Oil on canvas, 50 x 100.5 cm
F 773, JH 2041
Cincinnati, The Cincinnati Art Museum

Still Life: Glass with Carnations
Auvers-sur-Oise, June 1890
Oil on canvas, 41 x 32 cm
F 598, JH 2043
Paris, Collection Fausto Capella,
and New York, William Gelender

Puvis, and van Gogh, in his modest way, did so, too. Above all, he now discovered the decorative value of the frieze. True, he had no architectural space to adorn, nothing to add his art to in physical terms, but van Gogh had always been able to compromise. Just as he had tried to translate Wagner's *Gesamkunstwerk* into his own visual idiom back in Arles, he now constructed a personal kind of memorial to Puvis. There is one further respect in which we may feel reminded of his time in Provence: van Gogh was again using the dots which are such a characteristic hallmark of Japanese art. In his portrait of *Marguerite Gachet at the Piano* (p. 677), a frieze-format painting on the vertical axis, the background is dotted with tiny dabs obviously of oriental origin.

A wiser man, purged by what he had been through, van Gogh was looking back to his personal golden age, the days of the "yellow house". Now he was free of the utopian thrill, of the ambition to change the face of Art. Rather, his decorative practice was a function of his new love of a private idyll, his need for a home, his longing for security. The new paintings, so like tapestries or friezes, were intended to create a cosy and beautiful home for himself and the family, as if by magic – or at least to

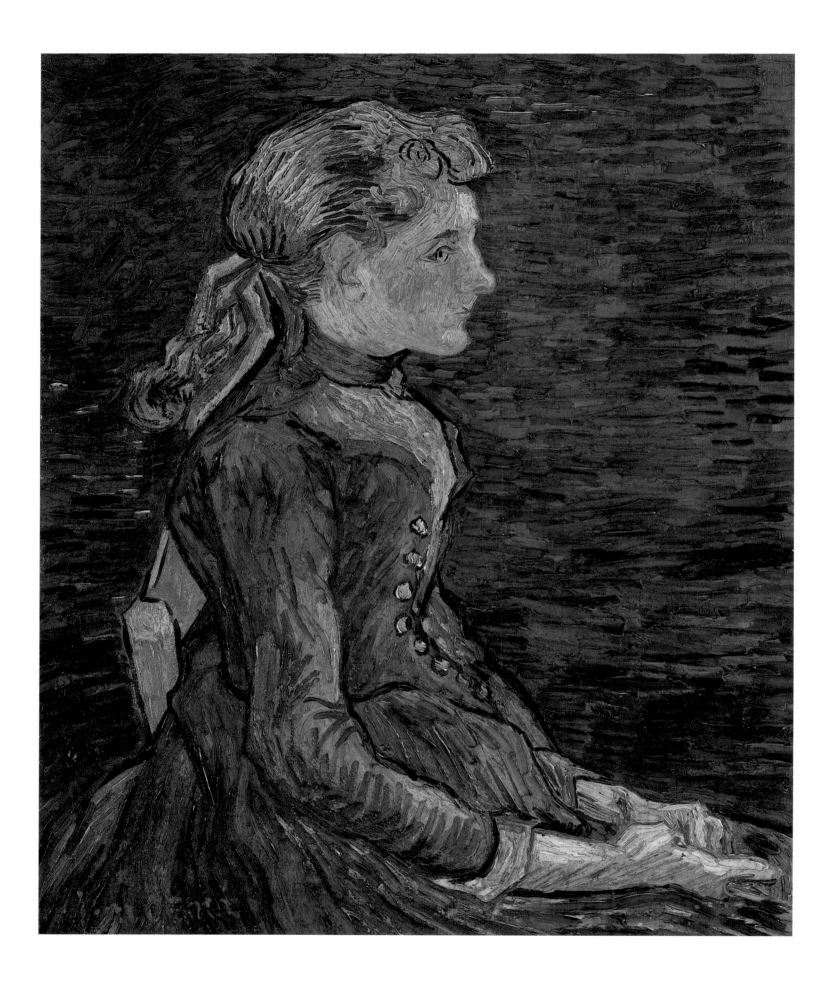

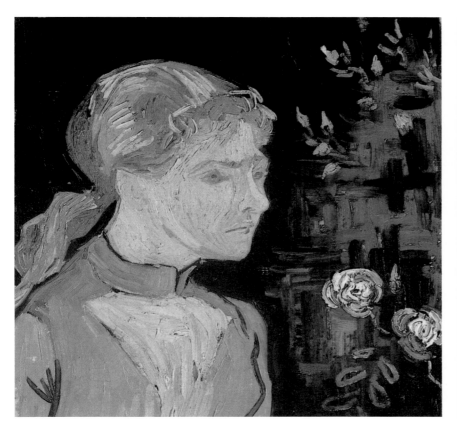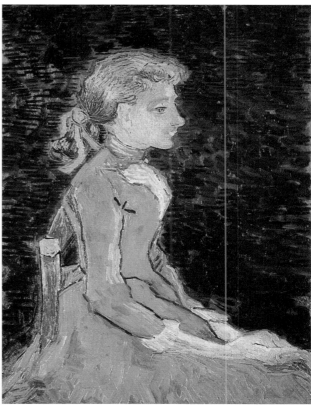

Portrait of Adeline Ravoux
Auvers-sur-Oise, June 1890
Oil on canvas, 52 x 52 cm
F 786, JH 2036
Cleveland, The Cleveland Museum of Art

Portrait of Adeline Ravoux
Auvers-sur-Oise, June 1890
Oil on canvas, 73.7 x 54.7 cm
F 769, JH 2037
Private collection
(Christie's Auction, New York, 11. 5. 1988)

fix their gaze on a world which could accommodate aesthetic achievement in a spirit independent of bourgeois conventions. We might see this as a final appeal to the sense of order before chaos finally descended upon van Gogh: but he himself (and thus his art) now had a new responsibility in the form of his heartfelt concern for his nephew and godchild. It was for him that van Gogh wanted to beautify the world, for him that (in his asylum days) he had already painted *Blossoming Almond Tree* (p. 615), a recollection of Arles. It was for him that van Gogh painted as he neared his end, for him that he craved the possibility of a life worth living. And it is in this context that we must see van Gogh's suicide.

Portrait of Adeline Ravoux
Auvers-sur-Oise, June 1890
Oil on canvas, 67 x 55 cm
F 768, JH 2035
Switzerland, Private collection

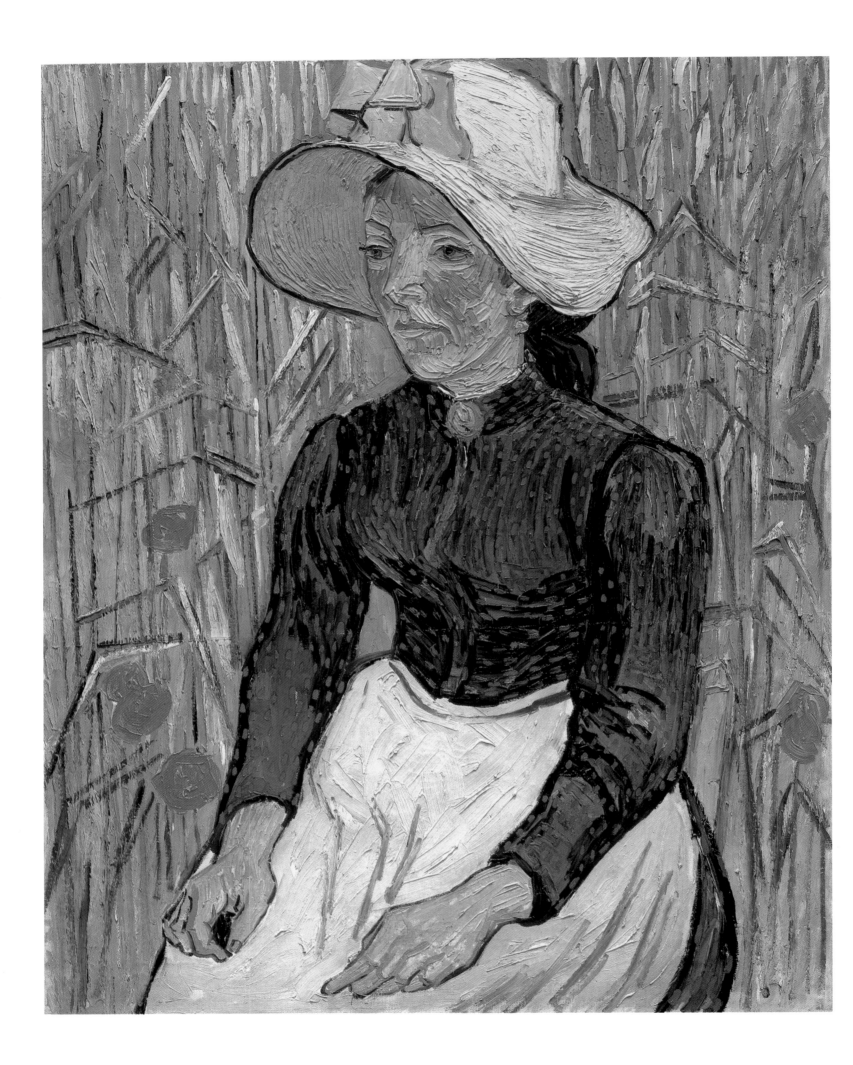

"I wish it were all over now"
Suicide

No one can say for sure where he got the revolver, nor where it was that he shot himself. But one thing is certain: on the evening of 27 July, 1890, seriously injured, he plodded heavily up the stairs at Ravoux's café to his room in the attic. Some think van Gogh shot himself in the field which had engaged his attention as an artist of late, others think he did it at a barn near the inn. At any rate, the bullet entered his chest at the very place he had had a premonition of years before, in 1875, in his obscure story 'A Stranger on Earth'. The story was about a Frenchman working in London as a teacher. "When he had been married for six or seven years", wrote van Gogh, "his chest ailment grew more serious. One of his friends asked if there was anything he wished; and he replied that he would like to see his home once more before he died. His friend paid for the journey." Shortly after, the man died: "Everyone wept on hearing of this pure and upright life." There were in fact two "strangers on earth", and, as Life imitated fiction, the real man joined the imaginary man in death.

A doctor was notified. The doctor was Gachet, who had just been praising the improvement in his friend's condition. It was not advisable to extract the bullet, so all he could do was hope for the best. Gachet wanted to notify Theo, but Vincent refused to involve the family and would not divulge Theo's private address. So Gachet contacted him at the gallery. When Theo arrived on the morning of 28 July he found van Gogh reclining peacefully in bed, puffing his pipe and with the air of a man content with a decision well taken. His last words are said to have been: "I wish it were all over now." Words of farewell, of course, invariably have a heroic flavour. Theo, writing to their mother, observed sadly: "He has found the peace he never found on earth", and he added: "He was such a brother to me." These simple words are all that need be said.

In Vincent's jacket pocket there was a letter he had meant to keep from his brother, perhaps because Theo had problems of his own at the time. Instead he wrote a second, that was more neutral and superficial in tone and the earlier unsent letter (652) remained as a kind of testament. It ended with the following passage, which for all its pessimism draws

Ears of Wheat
Auvers-sur-Oise, June 1890
Oil on canvas, 64.5 x 48.5 cm
F 767, JH 2034
Amsterdam, Rijksmuseum Vincent van Gogh, Vincent van Gogh Foundation

Young Peasant Woman with Straw Hat Sitting in the Wheat
Auvers-sur-Oise, late June 1890
Oil on canvas, 92 x 73 cm
F 774, JH 2053
Berne, Collection H. R. Hahnloser

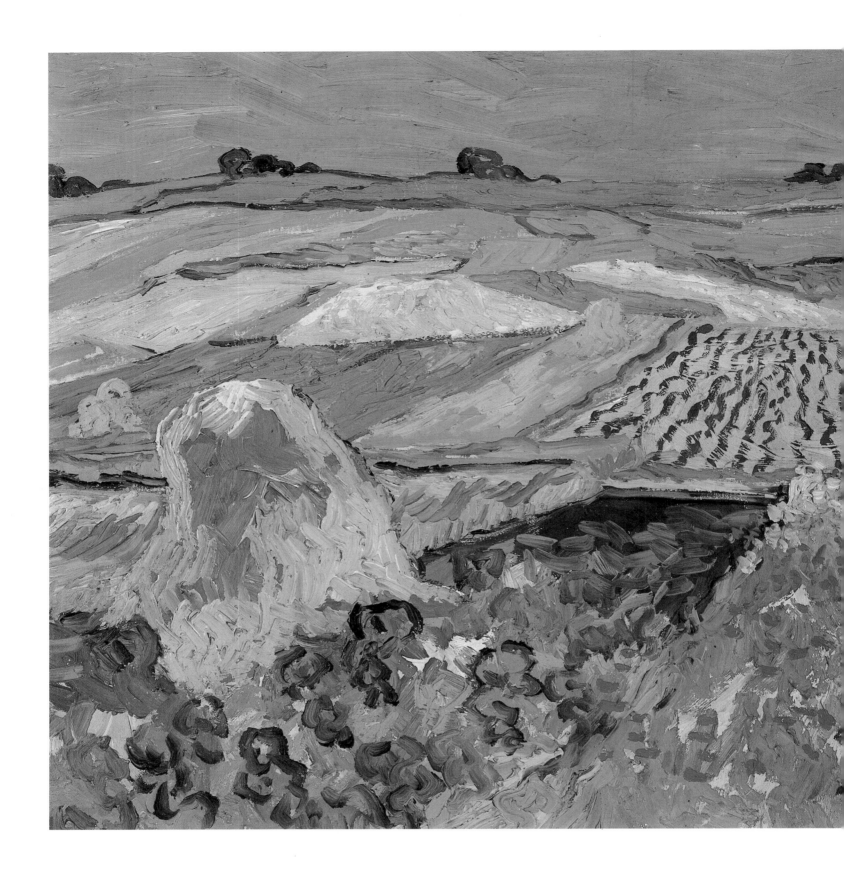

Wheat Fields near Auvers
Auvers-sur-Oise, June 1890
Oil on canvas, 50 x 101 cm
F 775, JH 2038
Vienna, Österreichische Galerie
in der Stallburg

upon considerable feeling between the brothers: "But yet, my dear brother, there is this that I have always told you, and I repeat it once more with all the earnestness that can be expressed by the effort of a mind diligently fixed on trying to do as well as possible – I tell you again that I shall always consider you to be something more than a simple dealer in Corots, that through my mediation you have your part in the actual production of some canvases, which will retain their calm even in the catastrophe. For this is what we have come to, and this is all or at least the main thing that I can tell you at a moment of comparative crisis. At a moment when things are very strained between dealers in pictures by dead artists, and living artists. Well, my own work, I am risking my life for it and my reason has half foundered because of it – that's all right – but you are not among the dealers in men as far as I know, and you can still choose your side, I think, acting with humanity – but *que veux-tu?*" This letter bespeaks a deep affinity with the true *alter ego* in Vincent's life, his brother Theo. The "stranger on earth" had a twin brother. But it also reveals a quite concrete motive on van Gogh's part, so apparent that it has tended to be overlooked.

Van Gogh's suicide has provided a host of hagiographers with their very own cottage industry. His life has provided the stuff that legends are made of and this is an appropriate moment to deal with two of them. One claims that van Gogh's suicide was a final feverish expression of insanity. The other sees it as the climax of his own personal Passion, an Imitation of Christ unto death. Both views possess a certain validity, since they both borrow terms that van Gogh himself used frequently and indeed compulsively. The unity of Life and Art was at its most perfect in the aesthetics of Death, in the kind of tragedy that theatre,

Landscape with the Château of Auvers at Sunset
Auvers-sur-Oise, June 1890
Oil on canvas, 50 x 101 cm
F 770, JH 2040
Amsterdam, Rijksmuseum Vincent van Gogh, Vincent van Gogh Foundation

requiems and history paintings illustrated. Madman and man of suffering alike had their parts to play in van Gogh's final decision though they may also obscure a full understanding of it.

Writers and critics from Stefan Zweig to A. Alvarez have been fascinated by insanity and suicide in great writers and artists. Zweig compared van Gogh with Nietzsche, and wrote: "In the garden at Arles and in the asylum, van Gogh painted at the same speed, with the same ecstatic obsession with light, and with the same manic creative plenitude. Scarcely had he completed one of his white-hot canvases but his unerring brush was at work on the next, without pause or hesitation,

Daubigny's Garden
Auvers-sur-Oise, mid-June 1890
Oil on canvas, 50.7 x 50.7 cm
F 765, JH 2029
Amsterdam, Rijksmuseum Vincent van
Gogh, Vincent van Gogh Foundation

Blossoming Acacia Branches
Auvers-sur-Oise, June 1890
Oil on canvas, 32.5 x 24 cm
F 821, JH 2015
Stockholm, Nationalmuseum

without planning or deliberation. Creation had become his overriding principle, and demonic clarity and speed of vision, and uninterrupted continuity." Zweig saw van Gogh as being in the grip of a demon that would not relax its grip, a demon that was driving him to destruction. But comparison with Nietzsche is unsatisfactory in two respects. First, van Gogh was wary of writing about himself in the smug manner Nietzsche affected: "That has been my experience of inspiration, and I have no doubt that it would be necessary to go back thousands of years to find someone who could say: it has also been mine." Zweig saw this as the euphoric tone of the doomed megalomaniac, and it is a tone wholly foreign to van Gogh. Far from burning immense beacons of self-

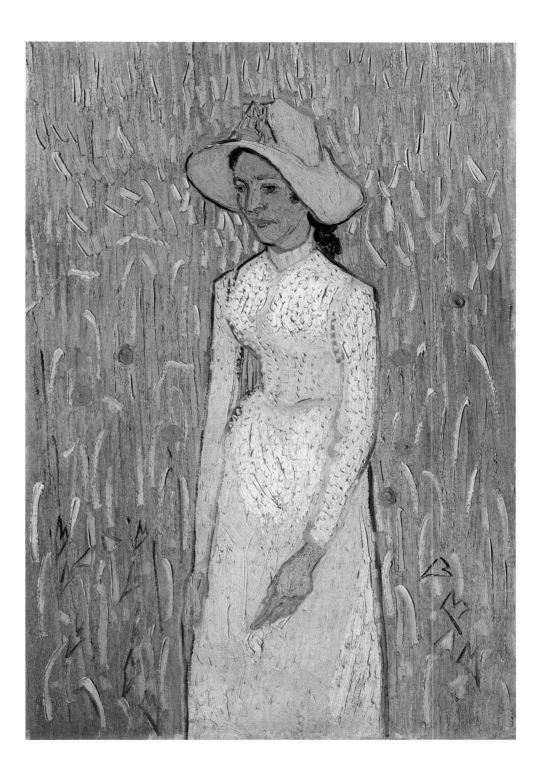

Young Girl Standing against a Background of Wheat
Auvers-sur-Oise, late June 1890
Oil on canvas, 66 x 45 cm
F 788, JH 2055
Washington, National Gallery of Art

praise, van Gogh ever tended to hide his light under a bushel. Second (and this makes the difference very clear indeed), van Gogh was not in the throes of a seizure when he killed himself. His suicide was a carefully considered act, and not undertaken at the promptings of some demon. True, he was afraid of a renewed bout of insanity; but that fear had now been with him for a year and a half.

Van Gogh's *weltschmerz* had been with him for decades. Kierkegaard wrote: "Ever since my youth the thought had been with me that in any given generation there are two or three people who are sacrificed for the others, discovering in great pain what benefits the rest; and with sadness I found that the key to my own existence was the fact that I was one

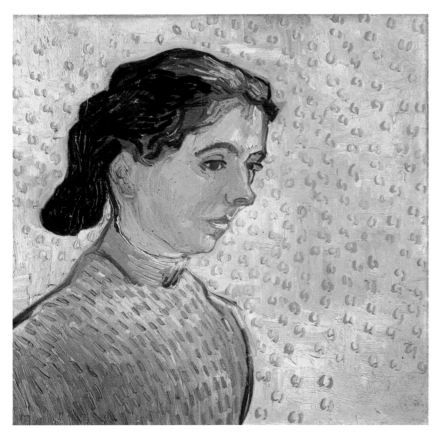

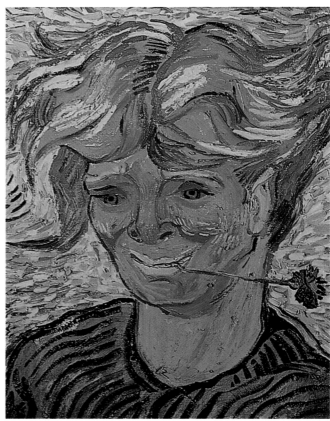

The Little Arlésienne
Auvers-sur-Oise, June 1890
Oil on canvas, 51 x 49 cm
F 518, JH 2056
Otterlo, Rijksmuseum Kröller-Müller

Young Man with Cornflower
Auvers-sur-Oise, June 1890
Oil on canvas, 39 x 30.5 cm
F 787, JH 2050
Whereabouts unknown

of these chosen ones." Kierkegaard was appointing himself to the role of proxy sufferer, and felt he was a particularly authentic example of the species. Like hundreds of others in his age (Gauguin among them) he saw himself following in the footsteps of Jesus Christ, taking the guilt of the entire world upon himself. Van Gogh, too, was one of those artists who acted out a Passion of their own. "They say it is all for the good that he is at rest", Theo wrote to his sister on 5 August, 1890, "but I hesitate to second it. Rather, I feel it is one of the greatest cruelties in life; he was one of the martyrs who die with a smile on their lips." The Paris Symbolists (a circle to which Theo was no stranger) were particularly inclined towards the Imitation of Christ; it seems it was van Gogh's own brother (who knew and understood the artist better than anyone else) who started the martyrdom myth. It was eagerly adopted and parrotted. In a letter to Aurier, Bernard pursued the idea further, envisioning a Way of the Cross: the wounded Vincent (he said) fell three times on his way home, three times he struggled to his feet again, to fulfil his mission and die at the inn – three times, like Christ carrying the Cross, falling and struggling to His feet as the blows of His tormentors rained down on Him. Even the meticulous and serious-minded John Rewald could not resist the attraction of this legend, and he, too, had van Gogh falling, like Christ.

Like so much else in the 19th century, the idea of the suffering artist had its strongest roots in Romanticism, the era van Gogh drew most freely upon in constructing his own worldview. The German writer

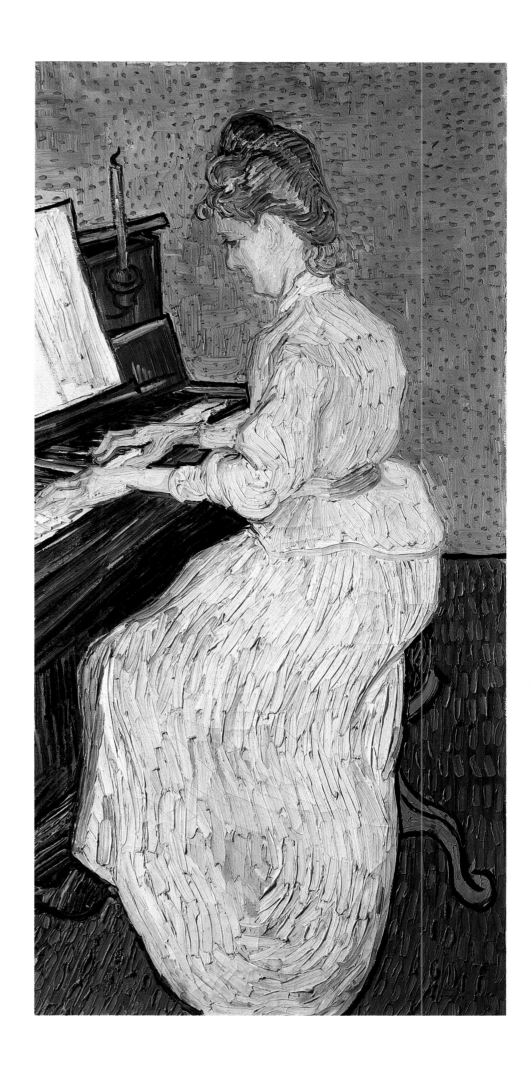

Marguerite Gachet at the Piano
Auvers-sur-Oise, June 1890
Oil on canvas, 102.6 x 50 cm
F 772, JH 2048
Basle, Öffentliche Kunstsammlung,
Kunstmuseum Basel

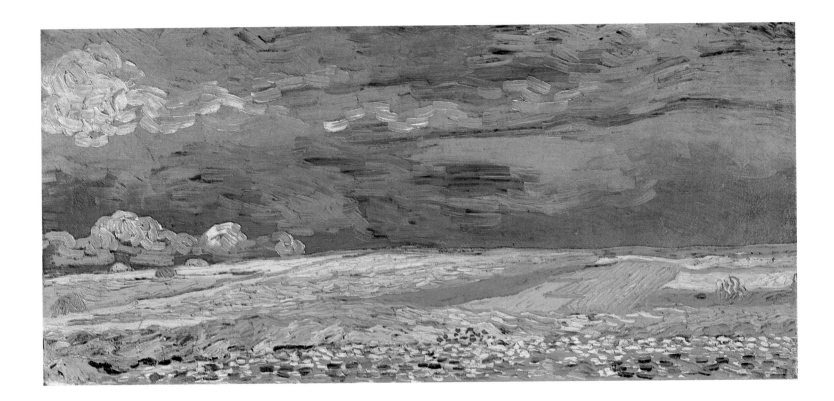

Wheat Field under Clouded Sky
Auvers-sur-Oise, July 1890
Oil on canvas, 50 x 100.5 cm
F 778, JH 2097
Amsterdam, Rijksmuseum Vincent van
Gogh, Vincent van Gogh Foundation

Heinrich von Kleist, a suicide and a flawed genius, had expressed thoughts that we might just as well encounter in van Gogh's correspondence with Theo. On exile he wrote: "There seems to me something indescribably desolate in the fact that I am forever seeking in a new place what my own unusual nature has always prevented me from finding anywhere." And on inferiority: "Heaven has denied me fame, the greatest good we can attain on earth; like a refractory child, I am throwing everything else back in Heaven's face. I cannot prove myself worthy of your friendship, nor can I live without it. I am leaping to my death." And, famously: "The truth of it is that there was nothing to be done for me on this earth." The melancholic, shrugging off his apathy and taking action, even if only to put an end to his own life, was not a common figure, though. Despite the cliché of the artist doomed to despondency, there were very few that went the way of Kleist and van Gogh, and statistics show that in the 19th century suicide among artists ran at a very low ebb. Only one social group was *less* prone to self-slaughter, in fact: priests.

The extreme avant-garde has tended to see van Gogh's suicide as an act of rebellion. The French dramatist Antonin Artaud, for instance, who has himself been in an asylum, sees the imitation principle in this way: "For it is not for this world, never for this earth, that we have all been working all along, struggling, crying out with horror, hunger, need, hatred, calumny and disgust that we were all poisoned, even if the world held us in its spell, and finally committing suicide, because we are all, like poor van Gogh, suicides by society!" Artaud's intentions were more profane, but there was as much emotional pathos as ever in his hymn to

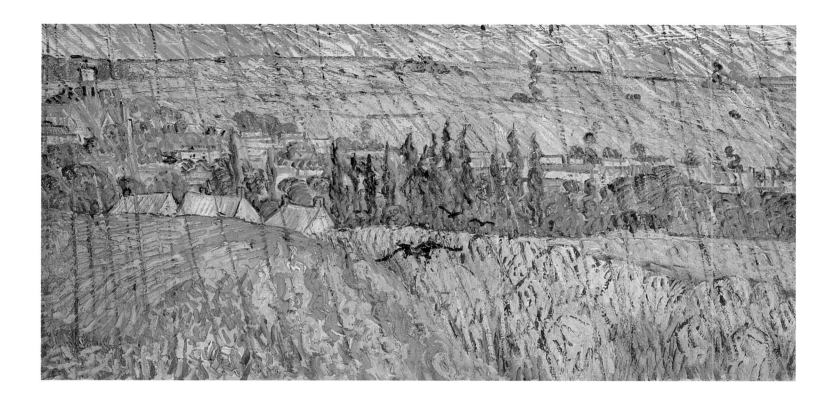

Landscape at Auvers in the Rain
Auvers-sur-Oise, July 1890
Oil on canvas, 50 x 100 cm
F 811, JH 2096
Cardiff, National Museum of Wales

the better world that the truly great sense within themselves, whether their name is Jesus Christ or Vincent van Gogh. The artist was the prophet of the new. If his contemporaries chose to ignore him, their reactionary obtuseness could be a cause of grief to him in this world, true, but his ideas would endure. The 20th century, Artaud's century, has been far more inclined to accept this notion than the 19th; and it is difficult to exaggerate van Gogh's importance for this altogether aesthetic hope for a secular Messiah.

These, then, are the usual approaches to van Gogh's suicide. But are we at all in a position to reconstruct the pressures upon the artist in the final weeks of his life? What was he thinking as he neared the end? And why did he inflict the mortal injury on himself at a time when the worst of his tribulations were already over months ago? The only answers to these questions are the answers provided by his paintings and letters. And the paintings and letters are revealing.

In Auvers, van Gogh had been able to satisfy the longing for the north which he had been feeling all year. He had a deep need to return to the milieu of his youth, to come full circle to the origins of his art in Holland. And so he took to painting updated versions of farmers' crofts, of the church, or of peasant women. *Cows* (p. 687) harked back to work done in The Hague. In a sense it was a group portrait combining individual portraits done in his early days (cf. p. 24). Van Gogh makes a wary impression in the picture, as if he were avoiding strong colour, as if he had learnt nothing at all in the years that had passed. It would be wrong to see this as the product of an inferiority complex: rather, he was reflecting upon a phase in his own life as an artist when he was not yet so

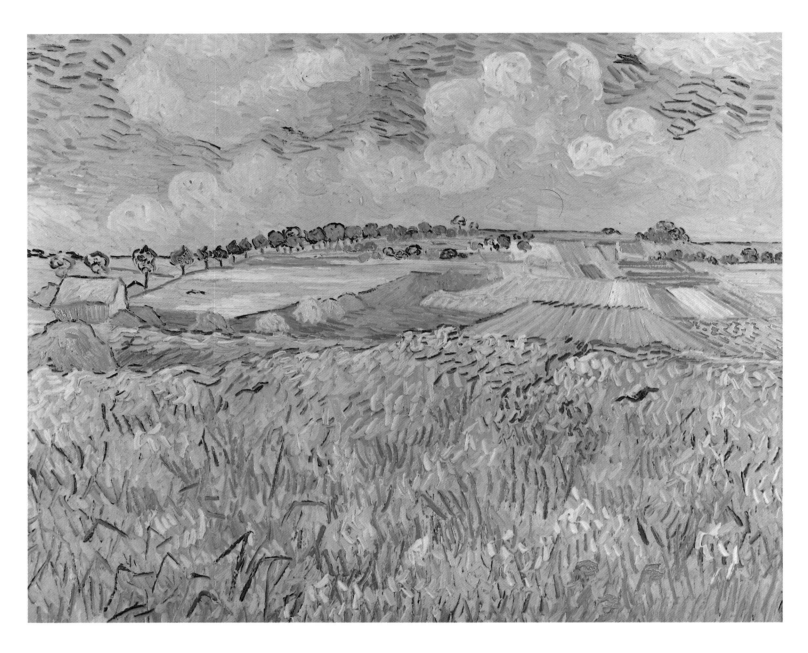

fully in command of the choices and decisions open to him – whether to go for detail or for the large, sketchy brushstrokes, and so forth. We certainly sense that van Gogh realised he had reached the end of some kind of evolutionary process. He wanted to go back, to return to the familiar environment he came from.

Wheat Field with Crows (pp. 690–91) documents this need for return in a single motif. Here, van Gogh expressed his darkest premonitions – thus, at any rate, pronounces the conventional view. Critics tend fairly unanimously to detect a sense of menace in the dark birds flying from the horizon towards the foreground. They see the three paths as symbolic of van Gogh's feeling that he had nowhere to go, no way of escape. The whole mood of darkness, they claim, is reinforced by the stormy sky, which supplies so powerful a contrast to the yellow wheat. One critic, becoming absurd in her quest for associations with evil, has even taken van Gogh's not untypically violent brushwork as representative of an angel blowing a trumpet, and thus of the Last Judgement. But what

Plain near Auvers
Auvers-sur-Oise, July 1890
Oil on canvas, 73.3 x 92 cm
F 782, JH 2099
Munich, Bayerische Staatsgemälde-
sammlungen, Neue Pinakothek

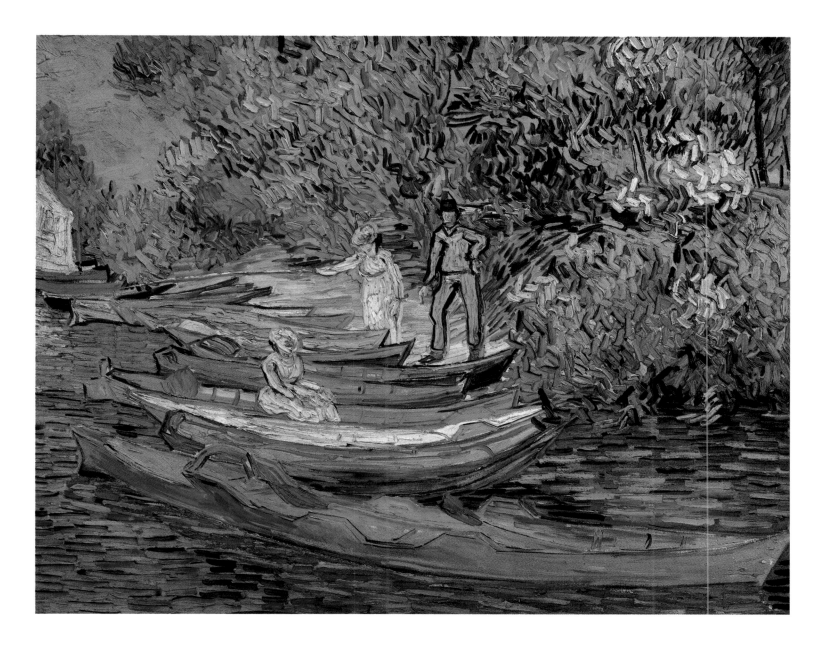

Bank of the Oise at Auvers
Auvers-sur-Oise, July 1890
Oil on canvas, 73.5 x 93.7 cm
F 798, JH 2021
Detroit, The Detroit Institute of Arts

of the artist himself? Van Gogh saw the picture as a paradoxical blend of sadness and consolation: "They are infinitely vast wheat fields beneath a dismal sky", he wrote in Letter 649, referring to this work and to *Wheat Field under Clouded Sky* (p. 678), "and I have not shied away from the attempt to express sadness and extreme loneliness . . . I almost believe that these pictures will communicate to you what I am unable to put into words: the health and vigour I see in country life." There is nothing in van Gogh's words to support a simplistic interpretation along the lines of artistic *angst* and despair – nor is there any evidence for the widely-held belief that it was this painting that van Gogh had on his easel at the time he killed himself.

Wheat Field with Crows is one of van Gogh's re-created memories of the north. In Letter 133, an important letter that broke several months of silence, he had compared himself to a bird in a cage, and commented: "But then the time comes when migratory birds fly away. A fit of melancholy – he's got everything he needs, say the children who look

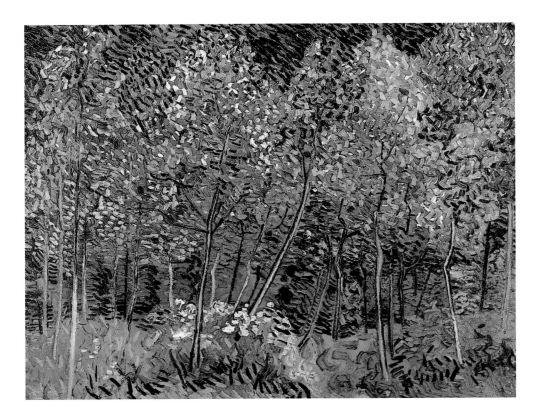

The Grove
Auvers-sur-Oise, July 1890
Oil on canvas, 73 x 92 cm
F 817, JH 1319
New York, Collection Joseph H. Hazen

after him – but the sky is brooding and stormy, and deep within he is rebelling against his misfortune. 'I am in a cage, I am in a cage, and I've got everything I need, fools! I've got everything I could possibly want! Ah, dear God, freedom – to be a bird like the other birds!' A human idler of this variety is just like a bird that idles in the same way." The metaphor stayed with van Gogh even after he had given up his secure captivity and was living the hard life of the artist. One neighbour who had watched him in Etten recalled: "He was always drawing ravens struggling in a gale." The crows in the painting, in other words, were an altogether personal symbol closely associated with van Gogh's own life. What the painting articulates is a sense of the possible danger that freedom will turn to exposure and independence to isolation. It is the continuation of the thought in Letter 133: the bird that once longed to be released into the stormy skies is now having to struggle against the elements.

The road that took van Gogh to suicide began in his longing for the simplicity of his origins, and his awareness that it was impossible – he couldn't go back. Memories of the old days even prompted him to revive Pauline thoughts. In Letter 641a (to his mother), drawing upon an undiminished store of Biblical knowledge, van Gogh reflected upon St. Paul's First Epistle to the Corinthians, in which charity is identified as the greatest of the virtues: "Through a glass, darkly – it has remained thus: Life, and the wherefore of departure and death, and the permanence of disquiet, that is all one understands of it all. For myself, Life presumably must remain lonely. I have never seen those I had the most affection for other than through a glass, darkly." Now, adult and experi-

enced, van Gogh's perceptions were reduced to paradox. The only ones who could enjoy ready understanding were children. In St. Paul (I Corinthians 13: 11–12) the thought is expressed in this way: "When I was a child, I spake as a child, I understood as a child, I thought as a child: but when I became a man, I put away childish things. For now we see through a glass, darkly; but then face to face: now I know in part; but then shall I know even as also I am known." Paul is confident of a happier existence in which knowledge is possible. But van Gogh can only see the confusions of the present.

Still, he had his art. "Painting is something in its own right", he continued in the same letter; "last year I read somewhere or other that writing a book or painting a picture is the same as having a child. I dare not assert that that is true in my own case – I have always felt that the last is the best and most natural thing... That is why I often make the utmost effort, even if that work is the least understood, and for me it is the sole link between the past and the present." Van Gogh was painfully aware of an existential lack: He had no children – and Art, however much the creative process might be identified with having children, was at best a poor substitute. As long ago as Letter W4 (written from Arles) he had lamented: "You see what I have found, my work; and you also see what I have not found: everything else that is a part of Life. What of the future? I must either become entirely indifferent to everything that is not work, or ... I dare not dwell upon that 'or'." His oppressive sense of having missed the true family meaning of Life, and his resultant governing passion for Art, are the consequences of van Gogh's soul-searching

Daubigny's Garden
Auvers-sur-Oise, July 1890
Oil on canvas, 50 x 101.5 cm
F 777, JH 2105
Basle, Kunstmuseum Basel, on loan from the Rudolf Staechelin'sche Familienstiftung

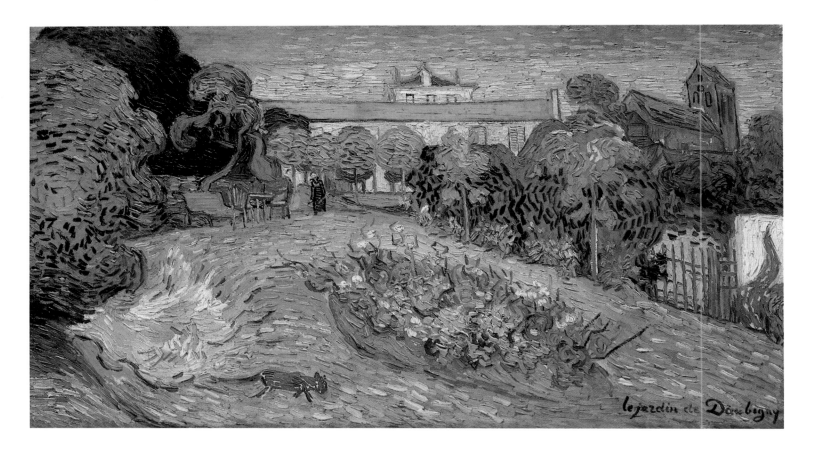

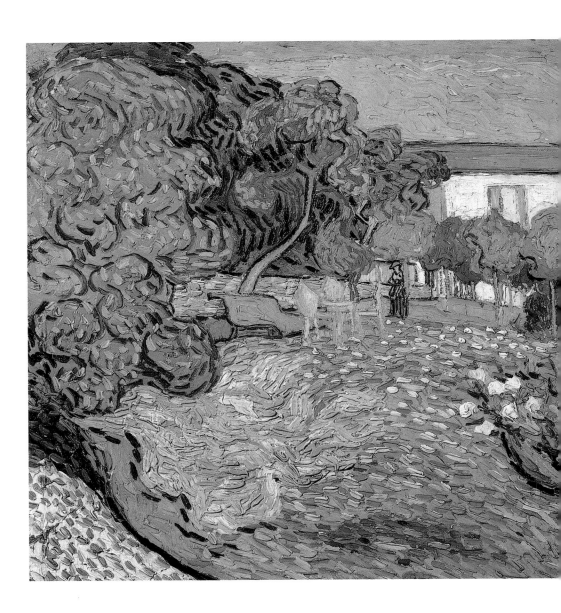

review of himself. And these were the considerations that prompted his suicide.

Let us consider the absolute claims of Art first. "At times I know exactly what I want", he wrote from Arles, in better times, in Letter 531. "In life [...] I can manage very nicely without the Lord above, but I myself, as a suffering human being, cannot get by without something greater than myself, something that *is* my life – the power to create." Art was the preeminent principle of his life, taking full and all-powerful possession of him. The individual was a servant of Art and had to bow to the force of things that were loftier than an individual life (in this view). Schiller had written that Life was not the greatest good; and since Rousseau's *Nouvelle Héloïse* and Goethe's *Sorrows of Young Werther*, suicide had repeatedly been in fashion, particularly among young people. The rationale behind it remained pretty constant: individual existence was valueless, and what mattered was to be exalted into the lofty heights of the Idea, leaving one's physical self behind, as it were.

Van Gogh considered his own efforts unworthy: Art was great, his own creations paltry. In contemplating suicide, his fatal attraction was

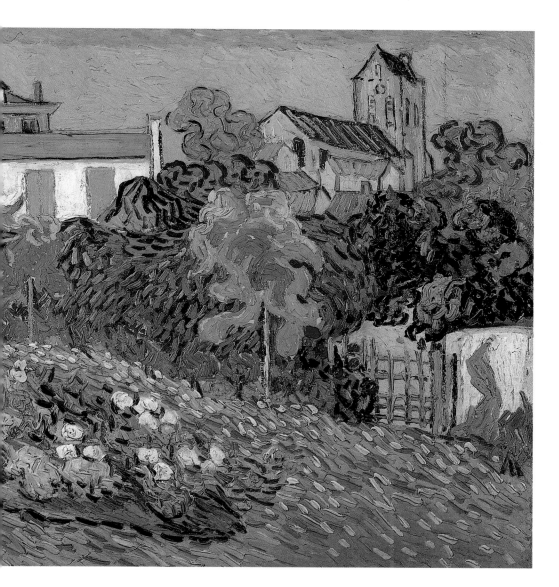

Daubigny's Garden
Auvers-sur-Oise, July 1890
Oil on canvas, 53 x 103 cm
F 776, JH 2104
Hiroshima, Hiroshima Museum of Art

the keener because of his sense of the discrepancy between ideal greatness and his own tiny achievement. This, of course, was a typically Romantic tension; and van Gogh, in this respect a child of his materialist times, took to thinking in terms of payment. These terms were associated with a nagging self-reproach for having founded no family and fathered no children. The upshot was, in a word, that van Gogh decided to kill himself in order to bequeath to Theo, and above all his godson, a treasure trove of paintings that could only increase in value after his death. If he himself was no longer alive, thought Vincent, he would at least live in his art. This may well be the solution to the puzzle of the suffering artist's desperate gunshot. And perhaps its very banality accounts for its exclusion from criticism of van Gogh.

During those few months, with his brother close to hand, taking an active interest in the affairs of the family, Theo van Gogh was in fact deep in a crisis of his own. The directors of Boussod & Valadon were good businessmen, but had little feel for the art their Dutch employee was accumulating. They preferred Salon art, and considered Theo a failure. Theo toyed with the idea of quitting and even emigrating to

House with Sunflowers
Auvers-sur-Oise, July 1890
Oil on panel, 31.5 x 41 cm
F 810, JH 2109
Whereabouts unknown

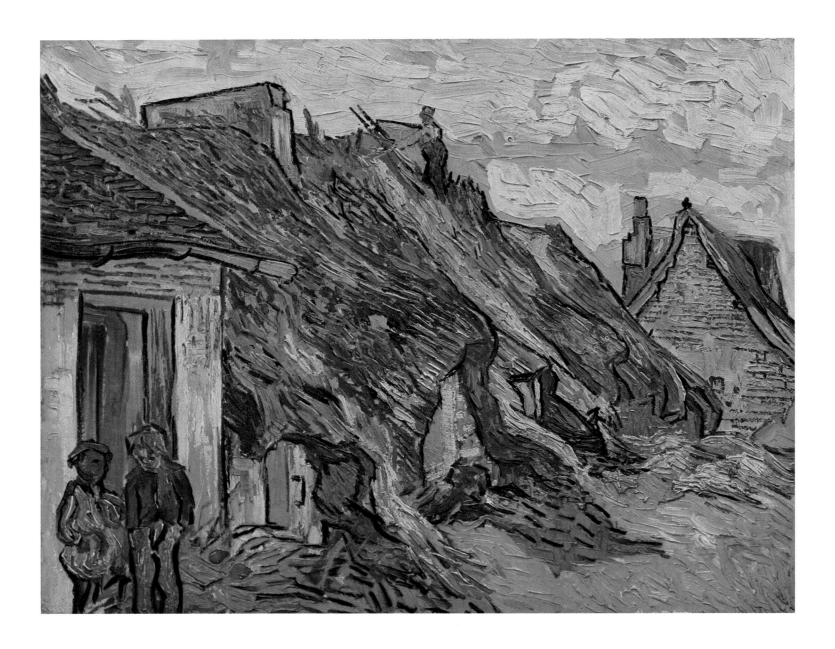

America. Vincent inevitably knew of these thoughts. And, knowing his brother as well as he did, he realised that if worse came to worse his own artistic career would still keep Theo from doing what was in his mind. He felt that his own share in the blame for Theo's sorrows and doubts was a big one. Their letters at that time had only a single theme: "I have been afraid that I am causing you all anxiety because I am a burden on you", wrote Vincent in Letter 649, "but Jo's letter plainly proves that you are aware that I, too, am distraught and as worried as yourselves." Theo's thoughts were stuck in the same groove: "Am I to live without a thought of tomorrow?" he demanded, expressing worries that he had been trying to keep from his brother. "I work the whole day long and still cannot even keep my dear Jo free of financial worries, because Boussod & Valadon are so mean and pay me so little and treat me as if I had just joined the firm." Confronted with this, Vincent took the only action he really believed might help.

Exactly one year before, in July 1889, Millet's *Angelus* had been sold

Thatched Sandstone Cottages in Chaponval
Auvers-sur-Oise, July 1890
Oil on canvas, 65 x 81 cm
F 780, JH 2115
Zurich, Kunsthaus Zürich

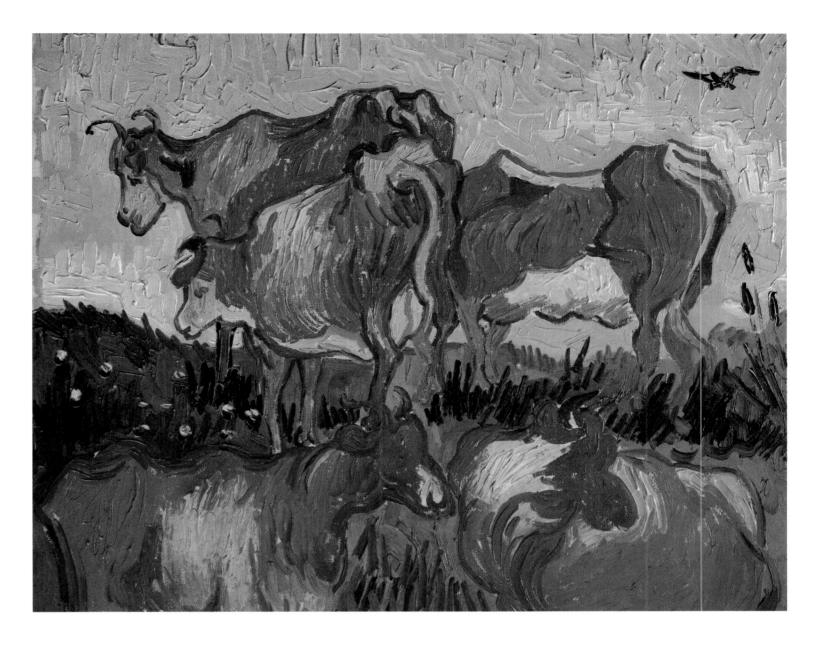

Cows (after Jordaens)
Auvers-sur-Oise, July 1890
Oil on canvas, 55 x 65 cm
F 822, JH 2095
Lille, Musée de Beaux-Arts

at auction – for over half a million francs. Millet was dead, of course. The art market's old habit of inflating prices once an artist is dead survives unchanged in our own times. Van Gogh thought this state of affairs quite wretched: "And the high prices one hears of, that are paid for works of painters who are dead and who never received such payment in their lifetimes – it is like selling tulips, and is a disadvantage to living painters, not an advantage. And, like this business of selling tulips, it will pass." (Letter 612) Needless to say, tulips are still being grown and sold: and van Gogh is one of the great darlings of the art market. In his own lifetime, at all events, van Gogh believed that he, too, would one day be fetching good prices, modest as he was about his own achievement. "And yet", he wrote in Letter 638, "and yet there are certain pictures I have painted that will be liked one day. But all the brouhaha about high prices paid recently for Millets etc. serves to make the situation worse, in my opinion." With such passages in mind, we may well find the close of his farewell letter less enigmatic. Those

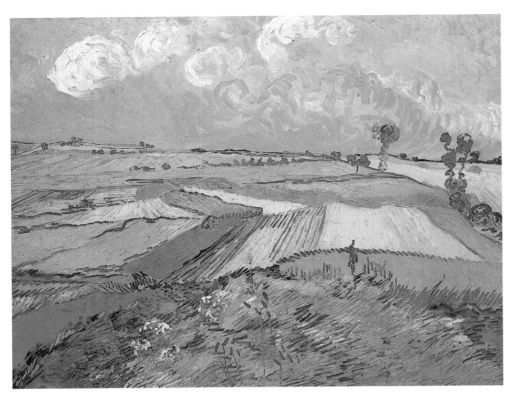

Wheat Fields at Auvers under Clouded Sky
Auvers-sur-Oise, July 1890
Oil on canvas, 73 x 92 cm
F 781, JH 2102
Pittsburgh, Museum of Art,
Carnegie Institute

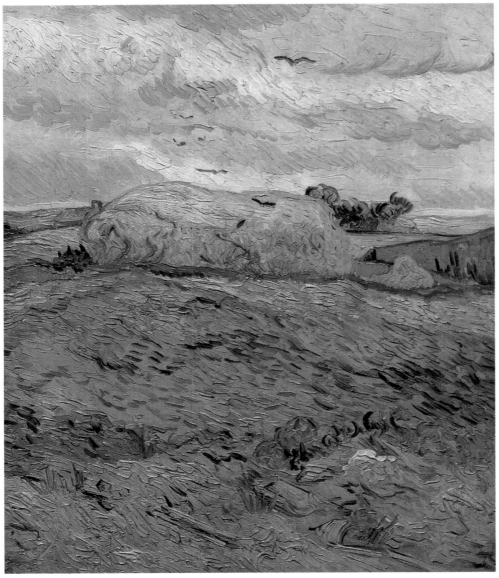

Haystacks under a Rainy Sky
Auvers-sur-Oise, July 1890
Oil on canvas, 64 x 52.5 cm
F 563, JH 2121
Otterlo, Rijksmuseum Kröller-Müller

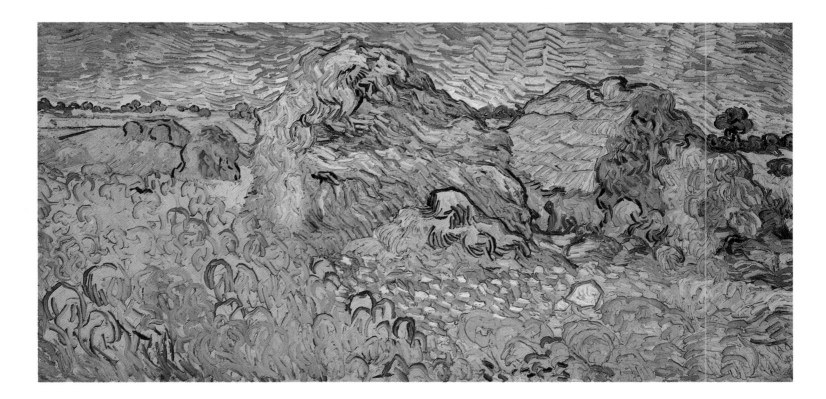

Field with Wheat Stacks
Auvers-sur-Oise, July 1890
Oil on canvas, 50 x 100 cm
F 809, JH 2098
Berne, Collection H. R. Hahnloser

words were written "at a moment when things are very strained be-tween dealers in pictures by dead artists and those who deal in living artists." Vincent's suicide would promote his brother Theo to the former category.

At this point the line of thought comes full circle: Art was perfected through the death of the artist. Of course van Gogh was wary of the machinery of the art market – that was why he was against the writing of further accounts of himself and his art. But he knew that nothing could stop the process of recognition. And he knew he would have to pay. His suicide proved it: the price of fame was death. But it was only physical death, the death of that part of the van Gogh persona called Vincent. And Theo, too, had his part in the production of some canvases (as Vincent had put it in Letter 652). In a sense, Vincent's suicide was one more way of expressing his longing to work together with his brother. His *alter ego,* who was capable of making a go of Art and family life at one and the same time, was to reap the profits of arduous years of sowing. No doubt this is a rather circuitous way of thinking; but at least it points up the dry inadequacy of supposing van Gogh had simply decided not to be a financial burden on his brother any more. It *is* true, of course, that his decision could only have been taken at a critical finan-cial moment, and only in close proximity to Theo and his family – which is why the decision was taken at Auvers, in July 1890. Some days before Vincent pulled the trigger, Theo had reached an agreement with his employers. Possibly Vincent learnt of this on his deathbed.

Vincent van Gogh died on 29 July and was buried the next day. Bernard was present at the funeral. "On Wednesday, 30 July, I arrived in Auvers around ten o'clock", he wrote to Aurier. "His brother was there

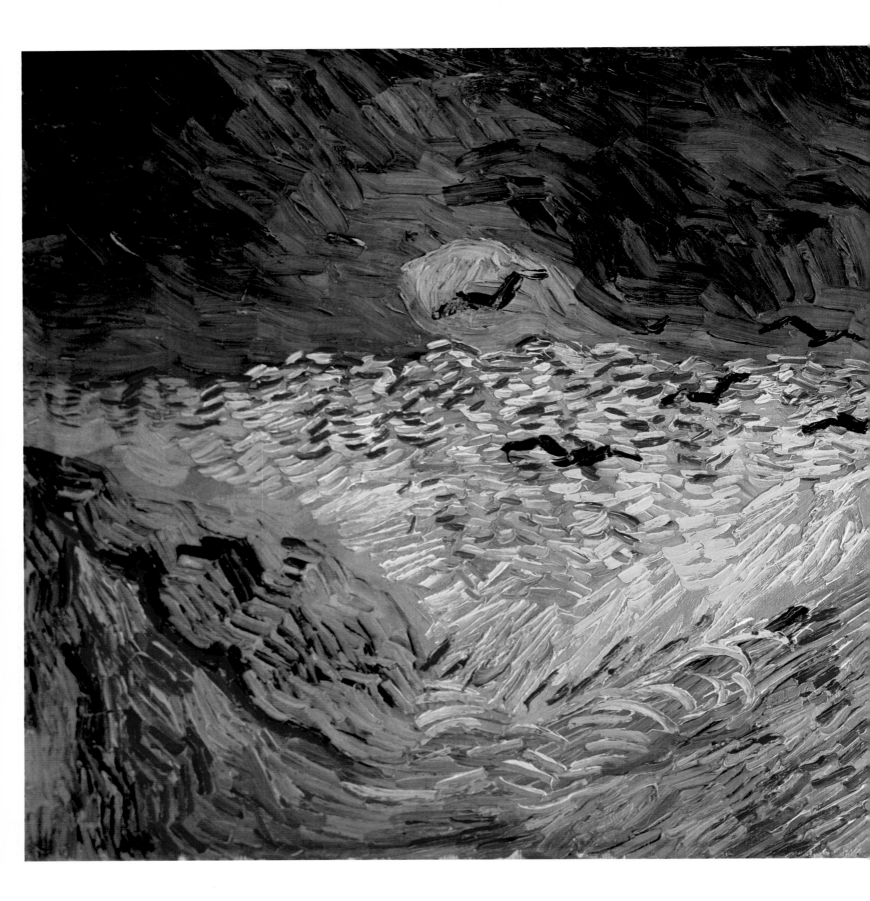

Wheat Field with Crows
Auvers-sur-Oise, July 1890
Oil on canvas, 50.5 x 103 cm
F 779, JH 2117
Amsterdam, Rijksmuseum Vincent van
Gogh, Vincent van Gogh Foundation

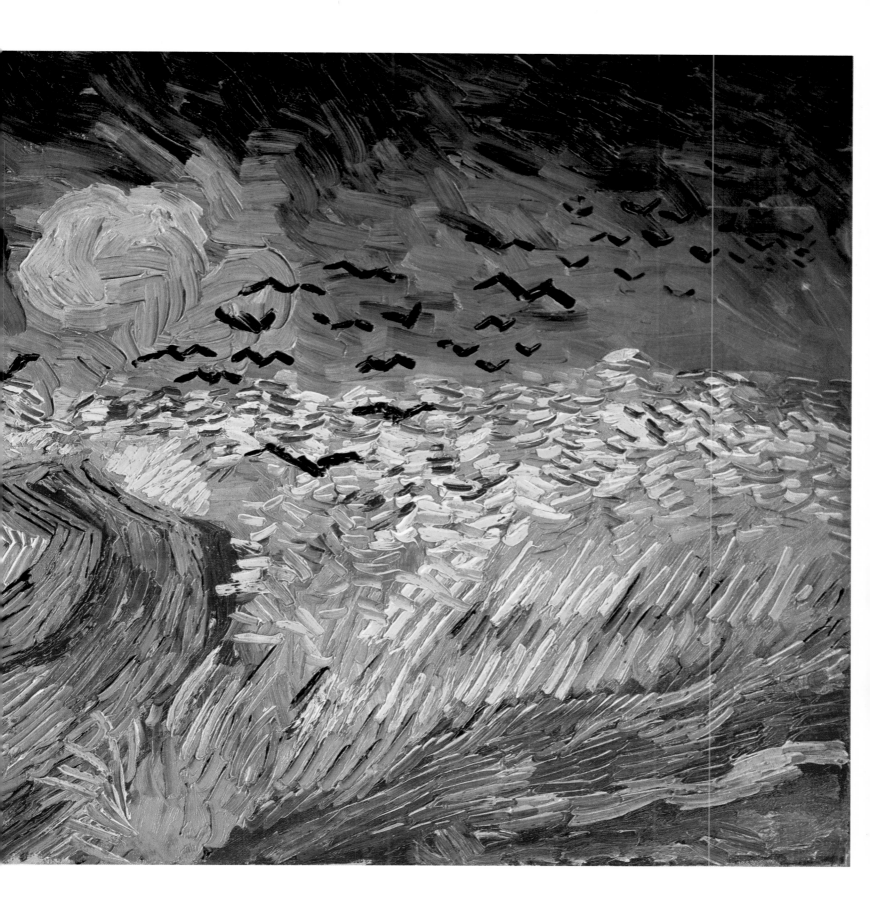

Tree Roots and Trunks
Auvers-sur-Oise, July 1890
Oil on canvas, 50 x 100 cm
F 816, JH 2113
Amsterdam, Rijksmuseum Vincent van
Gogh, Vincent van Gogh Foundation

with Dr. Gachet, and [Père] Tanguy, too. The coffin had already been closed. I was too late to set eyes once more on the man who took his leave of me so full of hope three years ago. All of his last paintings had been hung on the walls of the room where the coffin lay; they formed a kind of halo about him, and by virtue of the radiant genius they emanated, they made his death even more unbearable for us artists. A plain white cloth was draped on the coffin and there were a great many flowers – sunflowers, which he was so fond of. A great many people came, most of them artists. There were also neighbours who had seen him a time or two, briefly, but who loved him for his goodness and humanity. At three o'clock the coffin was borne to the hearse by his friends. Some of the people who were present wept. Theo van Gogh, who worshipped his brother and always supported him in his struggle for Art and the independence of Art, sobbed the whole time. Then he was lowered into the grave. He would not have wept at that moment. The day was too much his for us not to think how happy he might yet have been. Dr. Gachet tried to say a few words about Vincent's life, but he was weeping so hard that he could only stammer an indistinct farewell. He recalled Vincent's achievements, spoke of his lofty goals and of the great affection he had had for him although he had known him but a short time. 'He was an honest man and a great artist', he said, 'and there were only two things for him: humanity and art. Art mattered more to him than anything else, and he will live on in it.' Then we returned home." Bernard also left a visual record of the occasion, painting *The Funeral of Vincent van Gogh at Auvers* in 1893 (present whereabouts unknown). Of the artists he had known, Bernard was the one van Gogh was closest to.

Wheat Field with Cornflowers
Auvers-sur-Oise, July 1890
Oil on canvas, 60 x 81 cm
F 808, JH 2118
Private collection

The Fields
Auvers-sur-Oise, July 1890
Oil on canvas, 50 x 65 cm
F 761, JH 2120
Zurich, Private collection

Thatched Cottages by a Hill
Auvers-sur-Oise, July 1890
Oil on canvas, 50 x 100 cm
F 793, JH 2114
London, Tate Gallery

In the course of time, Vincent's plan to increase the value of his paintings by killing himself was to prove a success. However, his intended beneficiary was never to enjoy the fruits of this success. The two brothers were to prove inseparable even beyond this life, and a mere two months after Vincent's death Theo began to suffer delirium, and was never to recover. "This pain will remain with me for a long time, and I shall bear it with me my whole life long", he had written to his mother. In fact Theo was to die a bare six months after Vincent, on 25 January, 1891. The van Gogh persona was truly dead: and only Theo's widow Jo remained behind to see that van Gogh's art was seen by the public. Her success, of course, is history now.

A Revolution in Art: Modernism

Auvers Town Hall on 14 July, 1890 (p. 696) shows the town's main square tricked out with countless tricolours. It was Bastille Day, the day that commemorated the birth of a revolution that gave France true nationhood and a front rank in the modern era then dawning. In 1890, a hundred and one years had passed since the storming of the Bastille. And van Gogh – Dutchman, artist, social outsider – insisted on recording the festivities. It was a celebration that touched him deeply: the French Revolution had demonstrated that the world can be remade, and that fact was analogous, after all, to the artist's immemorial task of conceiving alternative counterworlds. In a sense, the utopianism of the modern age can all be traced back to the force of that tremendous upheaval, which had produced a new social order, but above all new ways of thinking. The Revolution had not only changed the state; it had changed people's minds. Van Gogh's art remains to this day the most radical testimony to the revolutionary spirit, not in his choice of subjects, but in the very look of his pictures, their coarseness and deliberately unfinished quality, the vigour with which they were painted.

"The great revolution: Art for the artists, my God, maybe it is utopian, and if so – all the worse", wrote an emphatic van Gogh from Arles (Letter 498). He had gone to Provence in quest of that better world he was so sure existed, or might exist. And there he came to see revolution as both event and historical condition – an ongoing process that would complete what the 18th century had begun. In the necessary struggle for the new era, Art was in the vanguard: it would indeed shortly take to using the term *avant-garde*. "When an Impressionist exhibition is on in Paris, I think a lot of people go home terribly disappointed or even indignant", he wrote at the same time (Letter W4), "just like in days when upright Dutch citizens would leave church and next moment hear a speech [...] by some socialist. And yet – as you know – in a period of ten or fifteen years the entire edifice of national religion has collapsed, whereas there are still socialists and will be for a long time to come, even if neither you nor I are particularly attached to either side. Art – official art – along with the training, administration and organization that go with it, are as feeble and rotten at present as religion, the decay of

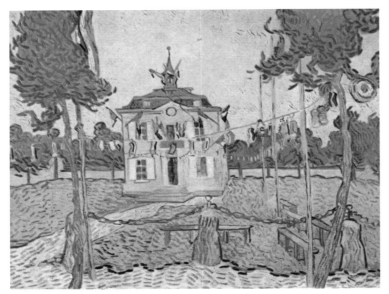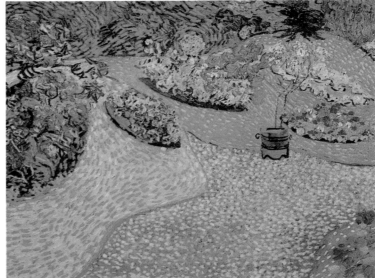

which we are witnessing." He felt that the vain custodians of Salon propriety, the painters of footling and conformist historical canvases distinguished only by their pomp and ceremony, would go the way of the parsons. His aesthetic and political convictions were of a piece.

It was only in Arles that van Gogh wrote with such commitment of working for change. Nonetheless, like millions of others in his time he was profoundly convinced that things could not go on as they were and that the world would have to change. Bernard saw this conviction as the source of Père Tanguy's friendship for van Gogh: "In my opinion, Julien Tanguy was not so much seduced by Vincent's paintings as by his socialism, though he valued the paintings as a kind of perceptible manifestation of the hopes they shared for the future." Bernard's sensitive phrasing glances at one of the functions of Art, its ability to articulate a first sensuous expression of fleeting thoughts and convey – even if it is crudely, on canvas – what the envisaged utopia might be like. Van Gogh's peculiar contribution (arguably the most important in terms of its consequences) was to free that "perceptible manifestation" from concrete representation. Of course he painted peasants, weavers, and a wide variety of everyday scenes – but what is more important is the staggering simplicity of his paintings. Of course he painted his subjects in a manner critical of society, showing them to be ugly and careworn – but what is more important is the artist's decision to side with lack of talent. Revolution was not a subject for van Gogh, it was a metaphor: the paintings themselves, rather than the subjects they depicted, articulated a concept of permanent change. His art was to be seen as a prototypical early stage in a process of evolution towards the better and nobler. Its unfinished and imperfect qualities, obvious in themselves, were apt to the age he lived in. Other, more civilized times to come might develop and complete what he could only adumbrate, if they chose. Delacroix's approach had been the same: "One cannot break out

Auvers Town Hall on 14 July 1890
Auvers-sur-Oise, July 1890
Oil on canvas, 72 x 93 cm
F 790, JH 2108
Spain, Private collection

Garden in Auvers
Auvers-sur-Oise, July 1890
Oil on canvas, 64 x 80 cm
F 814, JH 2107
Private collection

of the old routine without returning to the infancy of society, and a condition of barbarity, at the end of an unbroken chain of reforms, is the necessary consequence of change." We might see van Gogh as taking his cue from that "condition of barbarity". True perfection could only be attained by passing through that interim state – and the road that had to be travelled before it was even reached was an endless one.

Viewed from the vantage point of Tradition, of what already exists, the whole of Modernist art is an articulation of barbarity. The scandals that attended Courbet's work, the contempt that was heaped upon the Impressionists, the scorn critics affected for Symbolism, were all prompted by what we might call Art's heretical standpoint towards the complacent pieties of the Establishment. If innovators remained unmolested by the Inquisition, it was only as long as they seemed to be busy down aesthetic back-alleys where no one would even register their existence. Of course, it was precisely this peripheral, ghetto character of the new art that gave it its dynamism. In a sense, Modernism was one long series of fresh starts and prototypes. Modernism was always waiting for a new era that would adopt its inchoate ideas and fashion a classical achievement out of them, a new era that would transform its intuitive notions into reality. This meant that Modernism, rather too smugly infatuated with the idea of history as a cyclical pattern, remained too aesthetic in character – producing one manifesto after another announcing the impending downfall of the old order. The countless isms which we think of collectively as Modernism were forever hailing the imminent triumph of a new style – a triumph that never quite happened. From time to time this took on a political slant,

Two Women Crossing the Fields
Auvers-sur-Oise, July 1890
Oil on paper on canvas,
30.3 x 59.7 cm
F 819, JH 2112
San Antonio (Tex.), Marion
Koogler MacNay Art Museum

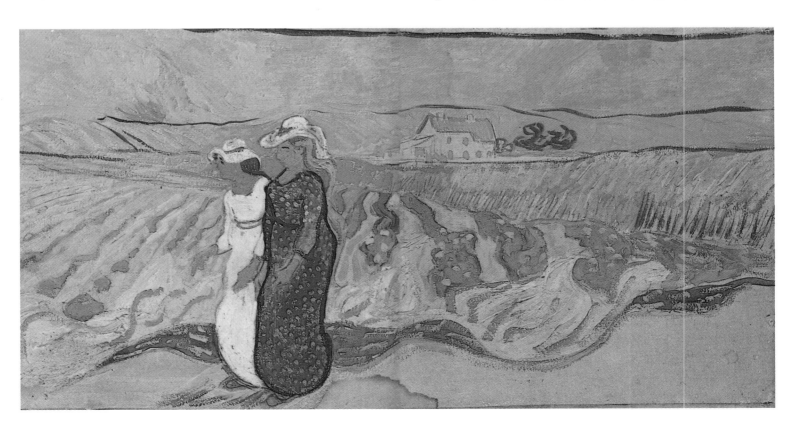

but there was never much of a social movement in early Modernism – the individual artists were so wrapped up in their own subjective views that they could barely communicate with the next table in a bar.

It was a dilemma that took intense form in van Gogh. He took compassion with the underprivileged for granted; from this there followed a religiously-motivated hope for a better age to come, when the battles would all have been fought and won. In addition, the uncompromising vehemence in van Gogh's own nature led him to identify more completely with other people's problems than was good for him. And, finally, he took pride in acquiring a virtuosity in his art that would enable him to determine the meaning of coarseness and bizarrerie, violence and the grotesque. Innocently enough, van Gogh was the very personification of qualities many of his contemporaries strained to develop. And that was the basis of his aesthetic programme. In his article, Aurier had already written of van Gogh's *idée fixe*: "a man must come, a Messiah, a sower of Truth, to rejuvenate our geriatric art, indeed perhaps the whole of our geriatric, feeble-minded, industrial society." Van Gogh had more than his fair share of critical detachment when it came to assessing himself, and he knew well enough that he was not the man Aurier meant. But he wanted to pave the way for his coming – or rather, for that societal power which he was convinced lay with the common people.

It is this that makes van Gogh the forerunner *par excellence* of Modernism, or at any rate of the Modernist *avant-garde*. Three painters in the final quarter of the 19th century – Cézanne, Gauguin and van

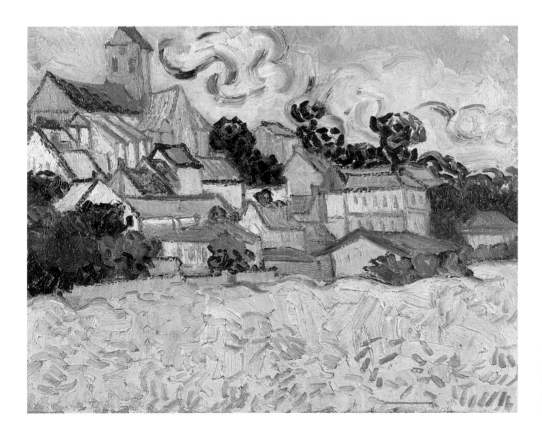

View of Auvers with Church
Auvers-sur-Oise, July 1890
Oil on canvas, 34 x 42 cm,
F 800, JH 2122
Providence (R.I.), Museum of Art

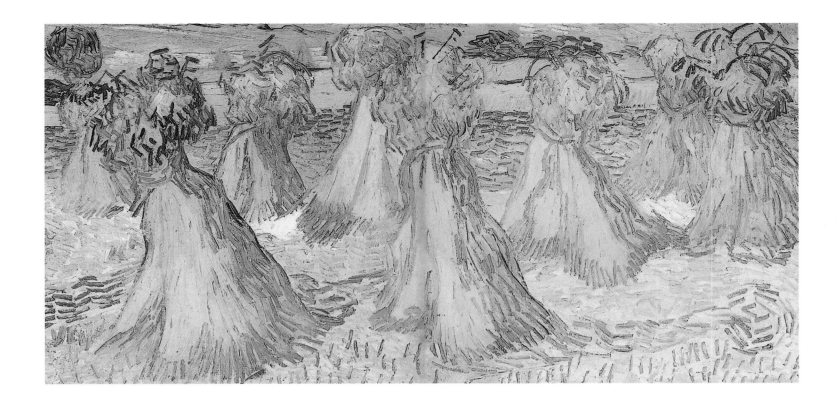

Gogh – tend to be singled out as the great precursors of 20th century art. Of the three, only van Gogh possessed that quality of utopian excitement and upheaval which can truly point the way forward in Art. Without questioning Gauguin's achievement, it seems fair to say that he withdrew too much into his own person. He, too, dreamt of a better life. But he wanted it in the here and now; he wanted the intoxicating magic of exotic simplicity. It was this that took him to the South Seas, this that prompted him to choose the present at the expense of the future. Gauguin represents the escapist pole in Modernist art rather than its utopian struggle for a better world. Writing in retrospect of the months in Arles, he claimed to have given van Gogh a feel for "overall harmony" – but the very phrase proves how radically different their concepts of Art were. Van Gogh undoubtedly took a number of hints from Gauguin – but "harmony" was not one of them. As for Cézanne, he represents the balanced and structured pole in Modernist art, a kind of classicism that is well expressed in statements such as this: "What is one to make of idiots who claim that the artist always comes second to Nature?" Consistently enough, he wrote to Bernard: "You possess the necessary insight into what has to be done, and will soon be in a position to put Gauguin and van Gogh behind you." What van Gogh and Gauguin (and others, too) thought of as Art must have struck Cézanne – who was quite capable of devoting years to a single subject, a single canvas – as the assembly-line products of charlatans. Though Cézanne returned to Catholicism late in life, he had his fair share of utopianism: but his road to utopia led via beauty, thought, and education, which would open people's eyes to the new. Cézanne was an aristocrat in every fibre of his

Sheaves of Wheat
Auvers-sur-Oise, July 1890
Oil on canvas, 50.5 x 101 cm
F 771, JH 2125
Dallas, Dallas Museum of Fine Arts

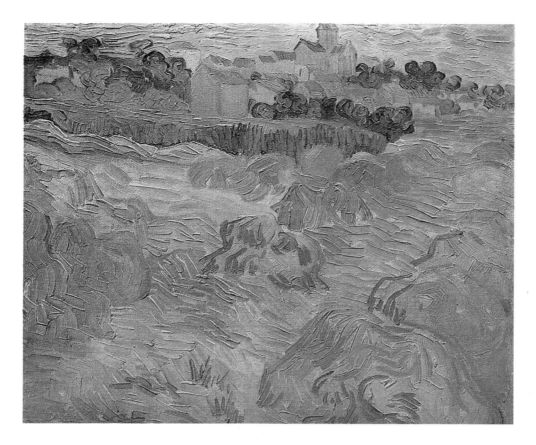

Wheat Fields with Auvers in the Background
Auvers-sur-Oise, July 1890
Oil on canvas, 43 x 50 cm
F 801, JH 2123
Switzerland, Private collection
(Sotheby's Auction, London, 1. 7. 1964)

being. To him, it would have been sacrilege if the refined harmony of crystalline form were to be replaced by vehement, exclamatory urgency.

Gauguin's brusque individualism and Cézanne's aloof cult of timelessness were wholly unlike anything in van Gogh, and irreconcilable with the character of a sometime lay preacher, an unselfish ascetic, and an unfailing friend of the poor. Both Gauguin and Cézanne exemplified the fundamental failing of Modernism, a failing van Gogh was free of. With its sharp intelligence and introspection, Modernism aimed at shaping a better world and produced countless manifestoes full of instructions. But all too often it neglected the human beings for whose sake it was supposedly staging the whole show. Contact with the public tended to be restricted to sticking out a provocative tongue; Modernists preferred to pander to the tastes of a small circle of the initiated. In a word: Modernism often dispensed with that core of human(e) concern which keeps Art in touch with humanity, and this detachment was echoed in the abstractions of its formal idiom.

Wheat Fields
Auvers-sur-Oise, July 1890
Oil on canvas, 50 x 40 cm
F 812, JH 2101
Whereabouts unknown

Appendices

Vincent van Gogh 1853–1890
A Chronology

1853 Following the birth of a stillborn son of the same name on the same day the previous year, Vincent Willem van Gogh is born on March 30. He is the first of six children born to Theodorus van Gogh (1822–1885) and his wife Anna Cornelia née Carbentus (1819–1907). Theodorus, pastor in a Dutch Reformed community, and Cornelia, daughter of a court bookbinder in The Hague, married in 1851. Vincent is born at the vicarage in Groot-Zundert, some fifty miles from Breda in Northern Brabant (Holland).

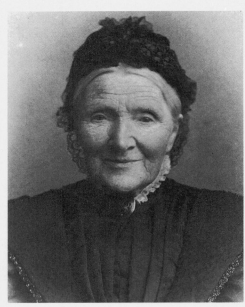

Theodorus van Gogh (1822–1885), Vincent's father. Wash drawing by Vincent van Gogh, Etten, July 1881. Pen and ink, 33 x 25 cm. The Hague, private collection. Theodorus had eleven brothers and sisters. He was appointed to the Zundert living on April 1, 1849

Anna Cornelia van Gogh, née Carbentus (1819–1907), Vincent's mother

1857 On May 1 Vincent's brother Theodorus (Theo) is born. The two brothers are to be extremely close throughout their lives, weathering crises and seeing periods of tension through with real brotherly love.

1861–1864 Vincent goes to Zundert village school, from January 1861 to September 1864.

1864 On October 1 Vincent arrives at Jan Provily's private boarding school at Zevenbergen, where he continues till August 31, 1866. He learns French, English and German, and does his first drawings.

1866–1868 From September 1866 to March 1868 Vincent attends the state-run King Wilhelm II boarding school at Tilburg.

The presbytery (centre) in Zundert where Vincent and Theo van Gogh were born. Vincent first saw the light of day in the room from which the flag has been run out

1868 Vincent's schooling ends in March 1868 and he returns to the family home in Groot-Zundert, where he remains till July 1869. It is uncertain whether this was for financial reasons or whether Vincent's performance as a scholar had left something to be desired.

1869 On August 1 Vincent is apprenticed to a branch of the Paris art dealers Goupil & Cie which his Uncle Vincent has established in The Hague. Thanks to his uncle, Vincent (and subsequently his brother Theo, at the Brussels branch) gets to know various works of art and individual artists. Under the supervision of H. G. Tersteeg, Vincent assists in the sale of paintings, photographes, copper engravings, lithographs, etchings and reproductions, mainly of works by the French Barbizon School and the Dutch Hague School. Vincent reads a great deal and visits the museums of The Hague.

1871 His father is transferred to a parish at Helvoirt in Brabant, where he moves with his family at the end of January.

1872 Vincent spends his holiday with his parents at Helvoirt. He sees a good deal of Theo, visiting him in The Hague in August too. Their lifelong correspondence begins, a correspondence that is rarely to be interrupted and which now constitutes our major source for Vincent's aesthetic and other feelings and beliefs.

1873 JANUARY: Uncle Vincent gets Theo into the Brussels branch of Goupil & Cie, where Theo learns the art trade.

MAY: Vincent is transferred to Goupil & Cie's London branch. First he visits his parents and then spends a few days in Paris, where the Louvre and other museums and galleries make a deep impression.

JUNE: Vincent starts work in London, where he remains till October 1874. He puts up in a boarding house run by Mrs. Ursula Loyer and falls in love with her daughter Eugenie, who is already secretly engaged. When his advances are met with equally impassioned rejection, Vincent is extremely depressed

NOVEMBER: Theo is transferred to the branch of Goupil & Cie at The Hague.

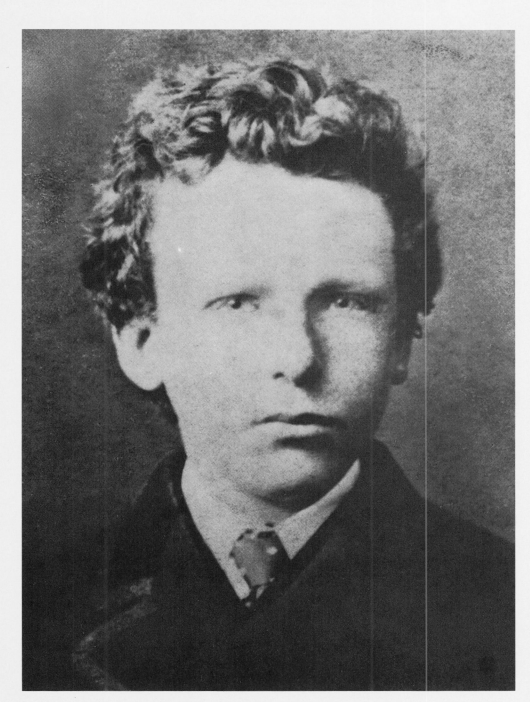

Vincent in 1866, aged 13. The photograph was probably taken after his time at boarding school in Zevenbergen, before he went to high school at Tilburg

Zundert church

Zundert town hall

703 A CHRONOLOGY

Vincent's sister Anna Cornelia van Gogh (1855–1930)

Vincent's brother Theodorus (Theo) Vincent (1857–1891), photographed about 1888–1890

Vincent's sister Wilhelmina (Wil) Jacoba (1862–1941)

1874 SUMMER: Vincent holidays for a few weeks with his parents at Helvoirt. Though he has not told Theo, he tells them of his disappointment with Eugenie, in order to account for his low spirits. In mid-July he returns to London with his sister Anna, though he takes new rooms. He leads a solitary life and shows little interest in his work, reading a great deal instead, mainly religious writings. In secret he works at translating the Bible from Dutch into other languages.

OCTOBER–DECEMBER: His uncle has Vincent transferred to the Paris headquarters of Goupil & Cie to take his mind off his sad London memories, hoping that a change of scene will do his nephew good. Since this plan meets with no success, Vincent returns to London at the end of the year.

1875 MAY: Vincent is permanently transferred to Goupil & Cie's Paris house. He neglects his work, though, and is unpopular with colleagues and customers alike. His Bible study becomes an obsession. He visits museums and galleries and is particularly enthusiastic about the works of Camille Corot (1796–1875) and of the 17th century Dutch painters.

OCTOBER: Vincent's father is transferred to the parish at Etten near Breda.

DECEMBER: Vincent spends Christmas with his parents at Etten without permission from his Paris employers Goupil & Cie.

1876 APRIL: Goupil & Cie have been taken over by Boussod & Valadon, and Vincent hands in his notice on April 1 because he does not get on with Boussod and expects to be sacked for his lack of interest in the company – indeed, for conducting himself in a manner liable to damage the firm's interests. He travels to Ramsgate in England, where he takes a post in a small private school run by the Reverend William Port Stokes. Vincent is an assistant teacher of French, German and arithmetic; his pay comes in the form of board and lodging only.

JULY–DECEMBER: Following Rev. Stokes's transferral of the school closer to London, Vincent continues his work at Isleworth, a working-class suburb of the city. He visits his sister Anna, who is working in a girls' boarding school at Welwyn in Hertfordshire. Vincent takes a new job as teacher and curate with the Reverend T. Slade Jones, a Methodist minister, who pays him very poorly too. Vincent is excited at delivering his first sermon in November, and proposes to devote his life to evangelical work with the poor. Vincent is also interested in art, and goes to see the Holbeins, Rembrandts and Italian Renaissance and Dutch 17th century art in Hampton Court Palace several times. He spends Christmas at Etten with his parents, who are dismayed by his physical and mental state and persuade their son not to return to London.

1877 JANUARY–APRIL: Recommended once again by his namesake uncle, Vincent is apprenticed at Blussé & van Braam, a bookshop in Dordrecht. He takes lodgings with a grain merchant's family, the Rijkens, together with a young teacher named P. C. Görlitz, his only friend. Vincent leads a lonely life, and goes to church every day, sometimes to other denominations. He continues his Bible translations, visits museums and galleries, and draws.

MAY: With the help of his friend Görlitz, Vincent persuades his father that he has a religious vocation, and goes to Amsterdam to prepare for the theology faculty entrance examination. He lives with his Uncle Johannes or Jan (1817–1855), a widower and the superintendent of the naval dock yards. Pastor J. P. Stricker, an uncle by marriage to his mother's sister Catrina Gerardina Carbentus, arranges for Dr. Mendes da Costa to teach him Latin and Greek, and the doctor's nephew teaches him maths. Vincent reads a great deal and goes to museums, above all the Trippenhuis, which later became the Rijksmuseum. He also draws a lot. But he finds his studies difficult. He enjoys teaching at a Sunday school for a while but gives it up again on the grounds that it is not essential to his evangelical calling.

1878 JULY: Vincent returns to Etten. With his father and Rev. Jones from Isleworth, who is visiting, he goes to

Brussels to begin a three-month course for lay preachers.

AUGUST–OCTOBER: Vincent takes the probationary course at the evangelical college at Laeken (near Brussels), and resumes drawing during the same period. When he takes the final exam, however, he is found unsuited to the job of lay preacher, and returns to Etten.

DECEMBER: In quest of another way of satisfying his sense of a religious calling, Vincent goes to the Borinage, a coal-mining district in Belgium, between Mons and the French border. He takes a room at Pâturages near Mons. Working and housing conditions in this industrial region are very bad. Vincent lives in poverty himself, visits the sick, and reads the Bible to miners.

1879 JANUARY–JULY: The evangelical college in Brussels assigns Vincent to work as a lay preacher at Wasmes in the Borinage for six months. He lives in a hovel, sleeping on straw, believing he has to share in the frightful conditions of the miners. He works hard on their behalf, and tends the sick and wounded following an explosion in a pit and during a strike. Fanatical and over-zealous in his social commitment, he irritates his superiors, and they allow his commission to lapse on the grounds that he has no rhetorical talent.

AUGUST: Vincent makes the journey to Brussels on foot, to ask the advice of Pastor Pietersen at the evangelical college. He shows his sketches of miners to Pietersen, who is an amateur artist himself. Vincent decides to return to Cuesmes in the mining district, and continues doing the same work unpaid, till July 1880. Though he is living in poverty himself, he does all he can to help the needy. He also reads (Charles Dickens, Victor Hugo, Shakespeare) and draws miners. His interest in painting is growing. It is a critical period for Vincent, one that is to leave its mark on his subsequent life. For a while he even breaks off his correspondence with Theo because his brother disapproves of his choice of career.

1880 At the beginning of the year, without money or food, Vincent walks 70 kilometres to Courrières in France, where Jules Breton (1827–1906) lives, a painter he admires. He looks at the house but does not dare go in. He also sees poverty-stricken weaving communities.

Vincent in 1871 when he was attached to the Goupil & Cie branch in The Hague

The sales rooms of the Goupil & Cie branch in The Hague

The Protestant church in Etten

The house where Rev. T. Slade Jones lived. Vincent lodged here when he was in Isleworth from July to December 1876

The building in Ramsgate where Rev. William Port Stokes ran a private school. In 1876 Vincent taught French, German and arithmetic in return for board and lodging

JULY: Vincent writes to Theo, who is now working at the Paris head office of Goupil & Cie. Theo starts sending Vincent a share of his monthly salary, and this provides Vincent's living till the end of his life. Vincent describes his own agonizing uncertainty about his future.

AUGUST–SEPTEMBER: Vincent decides to become an artist and devotes his time to drawing scenes of life in a mining community. Theo encourages him, and sends reproductions of paintings by the French artist Jean-François Millet (1814–1875), which Vincent copies.

OCTOBER: Vincent goes to Brussels and studies anatomical and perspective drawing at the Academy, since this will be vital to him in his new career. He admires the work of Millet and Honoré Daumier (1808–1879). In November he meets the Dutch painter G. A. Ridder van Rappard (1858–1892). They become friends, and for a while Vincent works in Rappard's studio. Vincent stays in Brussels until April 1881.

1881 APRIL: Vincent goes to Etten to see Theo, and they discuss his future as an artist. He stays in Etten, drawing landscapes in the main but also figures. Rappard spends two weeks with him and they take long rambles, discussing art.

SUMMER: Vincent's recently widowed cousin Cornelia Adriana Vos-Stricker (known as Kee), daughter of Rev. Stricker of Amsterdam, is staying at the vicarage in Etten with her son Jan. She and Jan accompany Vincent when he goes out drawing. Vincent falls in love with her, but she has not yet come to terms with the death of her husband, rejects his advances, and returns to Amsterdam earlier than planned. Vincent goes to The Hague to discuss his artistic career with Tersteeg, who has given help to many a young artist and rates as the true founder of the Hague School. Vincent calls on Anton Mauve (1838–1888), a painter he admires greatly, who gives him a box of watercolours to encourage him to use colour.

AUTUMN: Vincent goes to Amsterdam to see Kee and propose to her. But she does not even allow him to call. Vincent holds a hand in a candleflame to prove to her parents how serious he is – his left hand, fortunately. His right, which he will be needing for painting, is unhurt.

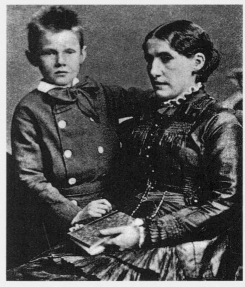

Vincent's widowed cousin Cornelia Adriana Vos-Stricker (Kee) with her son Johannes Paulus about 1880. Vincent fell in love with Kee but she rebuffed his advances

NOVEMBER–DECEMBER: Vincent spends a month working at Mauve's in The Hague, painting. Relations with his parents are strained because he is still obsessed with Kee and his religious views are extreme. He cannot imagine life without love and a wife. At Christmas he has a violent quarrel with his conservative, mulish father, who is orthodox in his religious convictions. Quarrels of this kind have already been the occasion of depression and thoughts of suicide on Vincent's part. This time he even rejects his father's gift of money and leaves the parental home at the end of the year in a black mood.

1882 JANUARY: Vincent moves to The Hague, living near to Mauve, who gives him painting tuition and lends him money. Theo continues to send the monthly allowance, and Tersteeg disapproves. Vincent's relations with Mauve cool off, partly because he refuses to work from plaster models. He meets Clasina Maria Hoornik (known as Sien), an alcoholic prostitute, who is pregnant. For a while they live together and Sien occasionally sits for him, while he looks after her five-year-old daughter.

MARCH: Though his admiration is undiminished, Vincent severs his links with Mauve. His relations with other painters are strained at this time as well. The only one who really values his work, and says as much to third

parties, is Jan Hendrik Weissenbruch (1824–1903). Vincent does a good deal of drawing from Nature, sometimes with Georg Hendrik Breitner (1857–1923). Apart from Sien, most of his models come from poor districts. Uncle Cornelis, an art dealer, orders twenty ink drawings of the city – Vincent's only commission for a long time to come.

JUNE: Vincent spends three weeks in hospital in The Hague to be cured of gonorrhoea. His father and Tersteeg visit him. He wants to marry Sien, though his family and friends advise against it. He takes her to Leiden to give birth, and looks for a flat for a family of four.

SUMMER: Vincent resumes contact with Mauve. Having done drawings and watercolours for two years, he now discovers the attraction of oils and begins to examine the problems of colour. Generally he does preliminary studies which he considers the "seed" from which the "harvest" of the finished picture results. Theo not only provides a subsistence allowance but also pays for his painting materials. At first Vincent mainly paints landscapes.

Pit 7 at Wasmes in the Borinage. Vincent spent a lengthy period from late 1878 in the coal mining region on the French-Belgian border, partly as a lay preacher

He develops under the avowed influence of Mauve, of Eugène Delacroix (1798–1863) and Millet, and also of Jozef Israels (1824–1911), Adolphe Monticelli (1824–1886) and Pierre Puvis de Chavanne (1824–1898). Vincent's father accepts a living at Nuenen and moves there with his family.

AUTUMN: For the rest of the year (and through to summer 1883) Vincent stays in The Hague, drawing and painting landscapes from Nature. During the winter he does sketches and portraits of ordinary people. His models are people in an old people's home, and Sien and the newborn child. He also develops an interest in lithography. He meets the painter H. J. van der Weele (1852–1930) and they become friends. Both of them go painting in the dunes at Scheveningen in the spring. Vincent continues to be a voracious reader, and his reading includes periodicals such as *Harper's Weekly* and *The Graphic*.

"Sien's Daughter Wearing a Shawl". The Hague, January 1883. Black chalk and pencil, 43.5 x 25 cm. F 1007, JH 299. Otterlo, Rijksmuseum Kröller-Müller

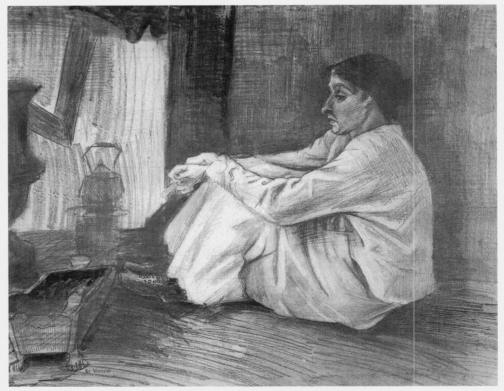

"Sien with a Cigar. Sitting on the Floor by the Hearth". The Hague, April 1882. Pencil, black chalk, ink and brush, 45.5 x 47 cm. F 898, JH 141. Otterlo, Rijksmuseum Kröller-Müller. For a time, Vincent lived with a prostitute called Sien (i.e. Clasina Maria Hoornik) in The Hague, and looked after her five-year-old daughter. Theo and the family had the greatest difficulty persuading Vincent not to marry Sien

1883 SEPTEMBER–NOVEMBER: Conversations and his correspondence with Theo lead Vincent to conclude that family life is irreconcilable with further development as an artist. He takes the painful decision to leave Sien, with whom he has been together for over a year. Lonely once more, he goes to Drente in northern Holland, and settles initially in the marshlands of Hoogeveen. He takes a barge to Nieuw Amsterdam and goes on long walks. The dark peaty landscape makes a strong impression on him, as it had done on Max Liebermann (1847–1935) and on his friends Mauve, Rappard and Weele. Vincent draws and paints the local peasants hard at work. He visits the village of Zweeloo, where Liebermann had been spending most summers since the early 1870s, and draws the old church there. He also tries his hand at lithographs.

DECEMBER: Vincent cannot stand loneliness for very long, and moves to Nuenen, a preponderantly Catholic town, where his parents are now living. He stays till November 1885. During these two years he does almost two hundred paintings as well as numerous watercolours and drawings. His work is expressive and uses dark, earthy colours. Vincent reads Zola, and aesthetic writings by Delacroix and another French painter, Eugène Fromentin

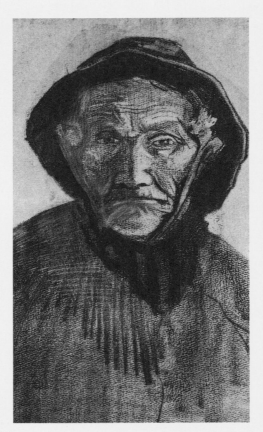

"Head of an Old Fisherman in a Sou'wester". The Hague. January 1883. Black chalk and ink, 43 x 25 cm. F 1011, JH 309. Otterlo, Rijksmuseum Kröller-Müller

(1820–1876). He is convinced that colour and music are closely related, especially the music of Richard Wagner, and takes piano and singing lessons. His parents try to help by overlooking his negligent dress style and unusual behaviour. He sets up a studio in a vicarage outbuilding where he can work undisturbed. For a while he also considers trying to find a job as an illustrator, perhaps in England.

1884 JANUARY: Vincent's mother breaks a leg when alighting from a train and is confined to bed for a lengthy period. Vincent gives her loving care and attention, and does a drawing of the little Protestant church surrounded by trees for her.

MAY: Vincent rents two rooms in the Catholic sexton's house and sets up a studio there. His friend Rappard pays a ten-day visit.

AUGUST: Margot Begemann, a neighbour's daughter, joins Vincent when he goes out to paint. Constantly in his company, she declares her love, and Vincent returns it, albeit with some hesitation. In spite of the difference of nearly ten years in their ages, they decide to marry, but both sets of

parents are strongly opposed to the idea. Vincent's parents demand how he proposes to support a family, while Margot Begemann's mother is afraid that her four other daughters might be left on the shelf. Margot tries to poison herself, which distresses Vincent.

AUGUST–SEPTEMBER: Vincent designs six decorative pictures for the dining room of Charles Hermans, an Eindhoven goldsmith.

OCTOBER: Rappard returns to Nuenen for a further ten-day visit.

OCTOBER–NOVEMBER: Vincent gives tuition to amateur painters from Eindhoven. Among them is a tanner, Anton C. Kerssemakers (1846–1926), who becomes a close friend. They take long walks and go to museums together.

DECEMBER: Hitherto, landscapes and pictures of peasants and weavers at work have predominated in Vincent's work. Now he tries his hand at portraits from models, and plans to do fifty bust studies during the winter months.

1885 Vincent's father Theodorus dies of a stroke on March 26. In spite of their disagreements in recent years, Vincent is deeply affected. Following a quarrel with his sister Anna he moves into his studio in Schafrath the sexton's house. For the first time, some of his work excites interest in Paris

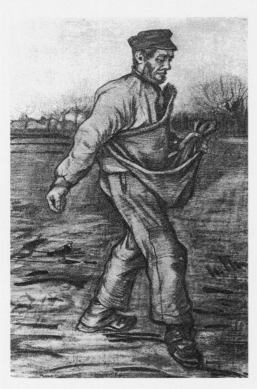

"The Sower". The Hague, 1882. Pencil, brush and ink, 61 x 40 cm. F 852, JH 275. Amsterdam, P. and N. de Boer Foundation

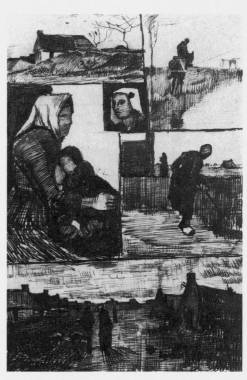

"Sketch". Drente, October 1883. Ink drawing in Letter 330. Not listed in F. JH 405. Amsterdam. Rijksmuseum Vincent van Gogh, Vincent van Gogh Foundation

Nuenen church (cf. p. 53)

Nuenen vicarage, where Vincent and his parents lived from December 1883 to November 1885 (cf. p. 129)

The wash-house of the vicarage at Nuenen, which served Vincent as a studio during the winter of 1883/84

APRIL–MAY: Having done numerous studies of peasants and interiors, in cramped and poorly-lit conditions, Vincent paints *The Potato Eaters* (pp. 96 ff.). It is the major work of his Dutch period. He makes a lithograph copy of an early version and sends it to Rappard, whose reservations about the work annoy Vincent so intensely that their friendship founders. Their correspondence, which has been going on for over five years, also comes to a gradual end.

AUGUST: Leurs, a paint dealer in The Hague, exhibits some of Vincent's work in two of his windows – the first time.

SEPTEMBER: The Catholic priest in Nuenen forbids the villagers to go on sitting for Vincent. An attempt is made to blame him for the pregnancy of a young peasant girl he had recently drawn. Vincent takes to drawing mostly still lifes, showing potatoes, a copper kettle and birds' nests among other things.

OCTOBER: Together with his friend Kerssemakers, Vincent goes to Amsterdam and devotes three days to the Rijksmuseum, filled with admiration for his fellow-countrymen Rembrandt and Frans Hals in particular.

NOVEMBER: Vincent studies colour theory, and the writings of Edmond (1822–1896) and Jules de Goncourt (1830–1870). At the end of the month he moves to Antwerp and rents a room above a paint shop, till February 1886. He tries to make contact with other artists and sell his pictures. In the museums he is especially impressed by the work of Peter Paul Rubens, and tries to use stronger, more luminous colours as a result. He no longer avoids carmine and cobalt, and begins to value emerald green. He draws Antwerp cathedral and marketplace, and paints a portrait of a woman with a red ribbon in her hair (p. 141). Roaming the docklands he finds some Japanese woodcuts which he hangs in his room and which later provide him with subjects for his own art.

1886 JANUARY: Vincent matriculates at the Ecole des Beaux-Arts and takes painting and drawing classes. How-

Left: the house belonging to Schafrath, the Catholic sexton in Nuenen, where Vincent had a studio after moving out of his parental home. "The Potato Eaters" (p. 97) was painted here

Vincent's pupil, a tanner from Eindhoven named Anton C. Kerssemakers (1846–1926), in his studio

A water mill at Opwetten (cf. p. 55)

The Academie Royale des Beaux-Arts in Antwerp, where Vincent studied in January–February 1886

ever, he rejects the academic principles on which tuition is based and there are disagreements in consequence. Nevertheless he takes the admission exam for higher levels. In St. Andrews, an old church in Antwerp, he is impressed by a particularly beautiful stained-glass window.

FEBRUARY: Overworked, poorly nourished and smoking too much, Vincent is ill for most of the month. At the end of February he decides to move to Paris to take classes with Cormon (1845–1924).

MARCH: At the beginning of the month he arrives in Paris, without having notified Theo, and arranges to meet his brother in the Louvre. Theo is working for Boussod & Valadon, managing a small gallery in the Boulevard Montmartre. He gives Vincent a room in his own home, though his brother's difficult character and the financial strain are a source of further problems. Meanwhile the Antwerp Academy rejects Vincent's work and puts him in the beginners' class – a snub that leaves him cold now.

APRIL–MAY: Vincent studies at Cormon's atelier and meets fellow artists John Russell (1858–1931), Henri de Toulouse-Lautrec (1864–1901) and Emile Bernard (1868–1941). He and Bernard subsequently exchange pictures as souvenirs of their first meeting. Theo introduces Vincent to the Impressionists and their work: Claude Monet, Pierre-Auguste Renoir, Alfred Sisley, Camille Pissarro, Edgar Degas, Paul Signac and Georges Seurat. Under their influence, Vincent uses brighter, livelier colours in his still lifes and pictures of flowers. He makes friends with Pissarro (1831–1903) and his son Lucien (1863–1944).

MAY: His mother and his sister Wil move from Nuenen to Breda. Some

Vincent lived in this house in Beeldekenstraat (Rue des Images) when he was in Antwerp in the winter of 1885/86

54 Rue Lepic, where Vincent lived with Theo in Paris (cf. pp. 222 ff.)

seventy paintings left behind by Vincent are bought by a junk dealer. Some are sold off for a song, others burnt.

JUNE: Vincent and Theo move to 54 Rue Lepic in Montmartre, and Vincent sets up a studio there. He paints Paris scenes in a pointillist style, some of them (pp. 222 ff.) looking out of the window. He frequents Julien 'Père' Tanguy's paint store, and Tanguy (1825–1894) introduces him to other artists.

WINTER: Vincent and Paul Gauguin (1848–1903) become friends. Gauguin has arrived in Paris from Pont-Aven in Brittany. Vincent's complicated nature leads to tension between him and Theo, who has a nervous ailment, and Theo writes to their sister Wil that life together is "almost unbearable". Later, relations between the two brothers improve.

1887 SPRING: Tanguy commissions two portraits. Vincent works in the open on the banks of the Seine at Asnières with Bernard. In heated discussions with Bernard and Gauguin, Vincent refuses to see Impressionism as the culmination of the evolution of painting. He paints the famous self-portrait at the easel (p. 2), buys some Japanese coloured woodcuts at the Galerie Bing, and paints three Japonaiseries himself (pp. 284 ff.). He is a regular at the Café du Tambourin in the Boulevard de Clichy, and has a brief affair with the proprietress, Agostina Segatori, who has sat for Corot and Degas and whose portrait Vincent now paints (p. 206). He and Bernard, Gauguin and Toulouse-Lautrec exhibit at the Café, and Vincent decorates the walls with Japanese woodcuts. They call themselves the Peintres du Petit

Rue Lepic in Montmartre, Paris. Theo van Gogh moved into no. 54 in June 1886 and took Vincent with him, allowing him to set up a studio

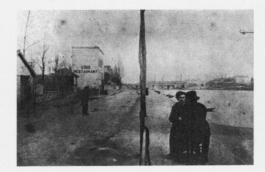

Vincent (with his back to the camera) with friend and fellow-painter Emile Bernard on the bank of the Seine at Asnières, 1886

Students at Fernand Cormon's Paris atelier, which van Gogh attended for four months in 1886. Toulouse-Lautrec can be seen on the far left

Boulevard, to distinguish the group from the Peintres du Grand Boulevard (Monet, Sisley, Pissarro, Degas, Seurat), who exhibit at Theo's gallery.

SUMMER: Vincent paints a number of pictures in the pointillist style, including the restaurant interior on page 238.

NOVEMBER–DECEMBER: Vincent meets Seurat, the found of the Pointillist school. At the invitation of André Antoine (1858–1943) he joins Seurat and Signac in exhibiting in the rehearsal room of the newly-established Théâtre Libre.

1888 FEBRUARY: Together with Theo, Vincent calls on Seurat at his studio. Then he leaves Paris, where he has painted over two hundred pictures in two years, and moves to Arles, quite possibly at Toulouse-Lautrec's prompting. At first he takes a room at the

Hotel Carrel. He finds the bright southern light and the warmth of the colours wonderful. But initially the weather is harsh and there is snow in Arles, so that Vincent cannot paint in the open (cf. pp. 309–11).

MARCH: Vincent's dream is of an artists' colony that would put an end to financial worry. For two months the Danish painter Christian Mourier-Petersen (1858–1945), who is later to live with Theo in Paris for some time, is his only companion. Vincent paints numerous pictures of flowers and trees in blossom, which remind him of Japanese landscapes. For preliminary study work he often uses the kind of perspective frame that Italian, Flemish and German masters had used at one time. On hearing that Mauve has died, he inscribes the words *Souvenir de Mauve* on his *Pink Peach Tree in Blos-*

"Portrait of Vincent van Gogh". John Russell, a fellow student at Cormon's atelier, painted this study in 1886. Oil on canvas, 60 x 45 cm. Amsterdam, Rijksmuseum Vincent van Gogh, Vincent van Gogh Foundation

som (p. 318). Three of Vincent's paintings are exhibited at the Salon des Artistes Indépendants in Paris.

APRIL: Vincent sees the bullfighting season begin at the Arles arena and finds the colours of the crowd dazzling. To preserve his link with Holland he dedicates some views of Montmartre to the "Modern Museum" in The Hague. As long as the trees are in blossom he works untiringly in the orchards of apricot, plum and cherry trees. In order to conserve his costly paint he draws in ink at intervals. The American painter Dodge MacKnight (1860–1950), a friend of Russell's, comes to call from the nearby village of Fontvieille. Vincent has to take a week's break because his stomach is playing up and he has toothache.

MAY: Vincent rents the right-hand side of the "yellow house" in the Place Lamartine. It has four rooms and he is paying 15 francs a month. There he hopes to realise his dream of an artists' colony, perhaps with Gauguin or MacKnight... He tries to hire a bed or pay the furniture store in instalments, but in vain. Entangled in disagreements with Carrel concerning his room price, Vincent moves to the station café run by Joseph and Marie Ginoux. They become friends, and he stays there until the "yellow house" is ready for him to move in. Following a

Fernand Cormon's salon. Vincent worked at Cormon's atelier together with Toulouse-Lautrec, Bernard and others

*"Portrait of Vincent van Gogh in a Café" by Henri de Toulouse-Lautrec, 1887. Pastel,
54 x 45 cm. Amsterdam, Rijksmuseum Vincent van Gogh, Vincent van Gogh Foundation*

Goupil & Cie in The Hague, London
and Paris between 1869 and 1876, dies
at Prinsenhage near Breda. Latterly
they had been estranged, and Uncle
Cent had been more interested in
Theo, to whom he left a small legacy.

AUGUST: Vincent makes the ac-
quaintance of Joseph Roulin, a post-
man "with a big, bearded face, very like
Socrates". He paints several portraits
of Roulin (pp. 392 ff., 468, 488 ff.) and of
a peasant called Patience Escalier
(pp. 402 ff.) from the Camargue, and
then does large-scale drawings. By way
of Milliet the Zouave he sends 36 pic-
tures to Theo in Paris. He now paints a
sunflower series to decorate his studio,
and compares the glowing yellow of
the flowers with the effect of stained-
glass in a Gothic church. He watches
sand being unloaded from boats on the
banks of the Rhône and does drawings
and paintings of the scene (pp. 412 ff.).

SEPTEMBER: Vincent frequently
paints out in the open by night, report-
edly fixing candles on the easel and on
the brim of his hat, and sleeping by
day. *The Night Café in the Place
Lamartine in Arles* (pp. 428–29) is one
of these paintings. The unusual colour
scheme is intended to express "terrible
human passions". Boch visits again,
and Vincent records his affection and
admiration for him in a portrait. Lack-
ing models, he paints another self-por-
trait, which he dedicates to Gauguin
(p. 396). When his paints run out, he
draws. He moves into the "yellow
house" (cf. p. 423), which he has fur-

break of over two weeks he continues
work on his landscapes, among them
the famous second version of *The
Langlois Bridge at Arles* (p. 343). On
several occasions he sends crates of
paintings and ink drawings of the
nearby Montmajour monastery ruins
back to Theo in Paris by rail.

JUNE: Vincent takes a trip to Saintes-
Maries-de-la-Mer, his first visit to the
Mediterranean. During his stay and
subsequently he paints pictures of
boats on the beach (pp. 352 ff.). Vincent
meets Paul-Eugène Milliet, a Zouave
second lieutenant. Milliet takes draw-
ing lessons, accompanies Vincent on
walks, and sits for him (p. 426).
MacKnight introduces Vincent to the
Belgian writer and painter Eugène Boch
(1855–1941, see p. 420). Vincent writes
to Theo of his "series of pictures" –

orchards in white and pink, wheat
fields in yellow *(Harvest in Provence,
The Sower)*, seascapes in blue, and
vineyards and autumn scenes, together
covering the entire colour spectrum.
Rain and cold interrupt his hard work
in the sun out in the fields. Vincent is
delighted that Gauguin has finally agr-
eed to join him in Arles.

JULY: Vincent does numerous land-
scapes and ink drawings on his trips to
the Montmajour ruins. He and Boch
(who lives at nearby Fontvieille for in-
termittent periods) call on each other.
Reading *Madame Chrysanthème*, a
novel by Pierre Loti (1850–1923), and
studying Japanese art and culture,
prompt Vincent to paint *La Mousmé,
Sitting* (p. 389). On July 28, his
namesake uncle, the art dealer who
had got Vincent his employment with

*Armand Roulin in 1920, thirty-two years
after van Gogh painted him (cf. pp. 459 and
461)*

nished with two beds, a table, some chairs, and a few household essentials.

OCTOBER: Vincent informs Boch in a letter that he has hung his portrait and that of Milliet the Zouave in his bedroom. In addition the rooms are decorated with *The Green Vineyard* (p. 415) and various autumnal garden scenes. Following a lengthy correspondence and hesitations prompted partly by illness, Gauguin responds to Vincent's repeated requests and leaves Pont-Aven in Brittany, reaching Arles on October 23. Vincent has long been wishing he could live with Gauguin, so that they could provide mutual artistic stimulus and inspiration. Gauguin receives 500 francs from Theo, the proceeds of the sale of his *Four Breton Women*, and is able to pay off his debts. Vincent is surprised to learn that Gauguin had once been a seaman, a fact that prompts him to respect and trust Gauguin even more.

NOVEMBER: Vincent and Gauguin cook, eat and paint together. Often (particularly when the weather is bad) they paint from memory. After one evening stroll Vincent paints *The Red Vineyard* (p. 450) and Gauguin *Women in the Vineyard*. Madame Ginoux sits for *L'Arlésienne* (pp. 454 ff.). At Boussod & Valadon in Paris, Theo succeeds in selling further Gauguins for good prices. Vincent shares Gauguin's pleasure in this encouragment. Degas praises Gauguin's pictures from Brittany which Theo puts on show in Paris.

DECEMBER: With Gauguin, Vincent visits the Musée Fabre in Montpellier. They see numerous works by Delacroix and Gustave Courbet (1819–1877), among them Courbet's *Bonjour, Monsieur Courbet!*, which inspires a later painting by Gauguin. The subsequent discussions are described

Paul Gauguin, who joined van Gogh at the "yellow house" from October to December 1888. Van Gogh had hoped that they would found an artists' colony in Arles. Instead, their life together came to a traumatic end. The photograph was taken in Paris in 1891

The Belgian writer and painter Eugène Boch (1855–1941), whose portrait Vincent painted in 1888 (p. 420). Boch's sister Anna, herself a painter, bought "The Red Vineyard" (p. 450) in late 1889 at the exhibition of Les XX in Brussels – probably the only picture van Gogh ever sold

by Vincent as "excessive tension": they can talk about everything under the sun except Art, their conflicting views on which invariably lead to quarrels. In the space of just two months these disagreements lead to a serious deterioration in their relations. According to Gauguin, on December 23 Vincent comes at him with a razor. Gauguin leaves the house in a hurry and spends the night in a hotel. During the night, Vincent cuts off his left earlobe in a temporary fit of insanity. He wraps it in newspaper and offers it as a gift to Rachel, a prostitute at a nearby brothel. Next morning the police find him in bed in his injured state and take him to hospital, where Dr. Félix Rey

(1867–1932) cares for him. Gauguin leaves Arles and informs Theo of his brother's condition. Theo immediately travels to Arles and asks Rev. Salles of the Reformed Church community to look after Vincent. Madame Ginoux also visits Vincent in hospital. Epilepsy, alcoholism and schizophrenia have all been proposed as the reason for Vincent's fit. He is in a critical condition for a few days, then begins to recover.

1889 JANUARY: Writing from hospital, Vincent tells Theo he is better and sends warm greetings to Gauguin. On January 7 he returns to the "yellow house" and writes reassuring letters to

The 'Alcazar' in Arles, immortalized by Vincent as the "Night Café" (pp. 428–29)

The Langlois bridge in Arles (cf. pp. 323–25 and 343)

The "yellow house" in Arles. Vincent rented the right half in May 1888 and lived there till April 1889 (cf. p. 423). The building was destroyed in the Second World War

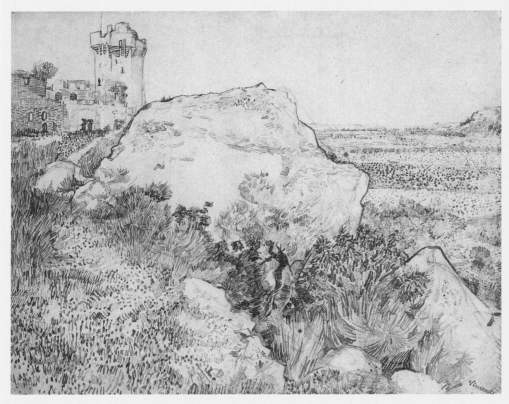

"Hillside and the Ruin of Montmajour". Arles, July 1888. Pen and ink, 47.5 x 59 cm. F 1446, JH 1504. Amsterdam, Rijksmuseum Vincent van Gogh. Vincent van Gogh Foundation. Cf. another drawing with a similar subject, p. 385

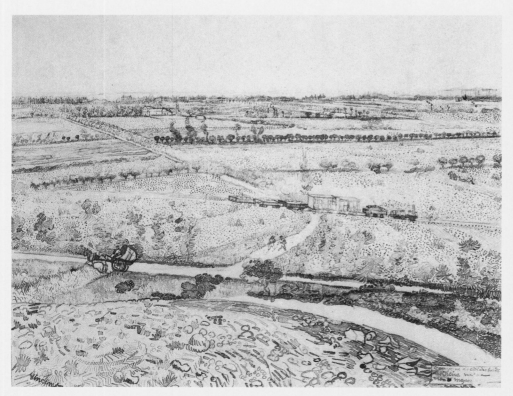

"The Plain of 'La Crau' near Arles and a Train". Arles, July 1888. Pen and black chalk, 49 x 61 cm. F 1424, JH 1502. London, British Museum. Cf. the painting on p. 347 and the drawing on p. 369

his mother and his sister Wil, though he is still suffering from insomnia. Theo becomes engaged to Jo – Johanna Gesina Bonger (1862–1925), the sister of his friend Andries Bonger. Vincent paints two self-portraits showing him with a bandaged ear (pp. 478 and 484) and a portrait of Dr. Rey by way of thanks for his care in hospital (p. 480). Roulin, who visited Vincent frequently in hospital, is unfortunately transferred to Marseille. Vincent paints several versions of *La Berceuse* (pp. 481–3).

FEBRUARY: Vincent is taken to hospital again, suffering from insomnia and hallucinations and from the delusion that someone is trying to poison him. He works intermittently, in the "yellow house".

MARCH: Thirty townspeople of Arles, calling themselves the *anthropophages* (cannibals) of Arles, petition the mayor to have Vincent hospitalized again. He is nicknamed the *fou roux* – the redheaded madman. The police close down his house with all the paintings. Signac visits him in hospital before moving to Cassis. Vincent is allowed to go home in Signac's company and paint again, and Signac writes to Theo that Vincent seemed completely sound in body and mind.

APRIL: Vincent moves out of his rooms in the "yellow house" after all. Floods have damaged both the premises and the paintings and studies he had left there. He moves into two small rooms belonging to Dr. Rey, and the Ginoux family store his furniture at their station café. In Amsterdam, Theo marries Johanna Bonger. Vincent is suffering repeated bouts of weakness and feels it would be advisable to enter an asylum for a while.

MAY: Vincent sends Theo two crates of paintings by rail, though he feels that some are failures or have been ruined and Theo would do best to destroy them. He goes back to ink drawing, as in Montmajour. Though he feels better, on May 8 Vincent – accompanied by Rev. Salles, who has been looking after him for some time – enters Saint Paul-de-Mausole mental asylum at Saint-Rémy-de-Provence, less than 20 miles from Arles. He has two rooms there, paid for by Theo. His living room is small, with grey-green wallpaper, sea-green curtains and a battered armchair. From the barred window, Vincent can watch the sun rise above a wheat field. The second room, with a view of the garden, serves as a studio. With the permission of Dr.

The "Forum Républicain" of December 30, 1888, containing a report of the incident of the ear

The courtyard of the hospital in Arles (cf. pp. 494 ff.) where Vincent recovered from his attack

Vincent's bedroom in the hospital at Arles

Théophile Peyron (1827–1895), who diagnoses Vincent's ailment as epilepsy, he is able to paint outdoors, under the supervision of an orderly, Georges Poulet. Vincent paints a number of views of the rather neglected grounds of the asylum. He talks to other patients, and his fears begin to wane. He is sleeping and eating better.

JUNE: Theo is struck by the vitality of the colours in Vincent's Arles paintings, but fears that he is taking too many pains to emulate the Symbolists'

use of form. Vincent, though, insists that no pains are involved at all, but that his work is a welcome occupation and does him good. He now has permission to go painting beyond the asylum precincts and is doing landscapes, olive groves, wheat fields in bright yellows, and cypresses. Frequently he draws his subjects as well as painting them. When he goes into the village on one occasion, though, the bombardment of new impressions leaves him weak and ill.

JULY: After a lengthy pause, Vincent writes to his mother once more. He describes the beauty of the landscape, the fields and olive trees and their silvery-grey leaves, the hillsides where thyme and other fragrant plants grow, but he misses the mossy barns back home, the undergrowth and knotgrass and beech hedges, the heather and birches of Nuenen. He reads a good deal of Shakespeare, in an edition Theo sent him at his own request. Accompanied by the head orderly, Charles-Elzéard Trabuc (p. 539), he goes into Arles to fetch some paintings that had been left behind, but to his disappointment cannot see either Rev. Salles or Dr. Rey. Shortly afterwards he has another attack while painting out of doors, and is confined to the asylum for six weeks.

AUGUST: Vincent is very interested in the catalogue of the exhibition of work by Monet and Auguste Rodin (1840–1917) at the Galerie Georges Petit in Paris. For some time he himself is forbidden to paint or enter his studio because he had tried to swallow toxic paints in the course of his attack. But Vincent urgently needs to work: it is his way of recovering, and enforced idleness is a torment. It is not until late August that he is allowed to paint again. His youngest brother, Cornelius (known as Cor), travels via Southampton to the Transvaal (South Africa).

SEPTEMBER: Vincent exhibits *Starry Night over the Rhône* (p. 431) and *Irises* (p. 505) at the Salon des Indépendants, at which no artist may show more than two works. Other artists exhibited are Toulouse-Lautrec, Seurat and Signac. Vincent wants to return to the north, to Paris or Brittany, to visit old friends and the parts he came from, but be knows he is not yet in a fit state to do so. For a while he works like one possessed, because it is only at the easel that he feels at ease – though he is still afraid of working outdoors. He paints various duplicates or new versions of

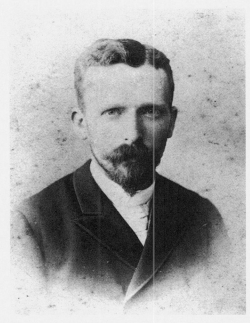

Theo van Gogh, about 1889

Theo's wife Johanna Gesina (Jo), née Bonger, who married Theo in April 1889

older works, and copies of pictures by Millet and Delacroix.

OCTOBER: In conversation with Theo, Pissarro suggests that Vincent move to Auvers-sur-Oise. Paul Gachet (1828–1909), a doctor and amateur painter, might be able to look after him. Meanwhile Vincent is again painting in the open, preponderantly landscapes, the asylum garden, the Alpilles mountains and time after time the olive trees and cypresses which he considers particularly difficult. He also

View of Saint-Paul-de-Mausole hospital in Saint-Rémy, where Vincent stayed voluntarily from May 1889 to May 1890. The Alpilles mountains, which appear in several of van Gogh's paintings, are in the background

The entrance hall of Saint-Paul hospital (cf. p. 565)

does a portrait of a patient (p. 564). The Dutch artist and critic Joseph Jacob Isaacson writes in *De Portefeuille*: "Who is there that conveys, in form and colour, the magnificent, dynamic energy the 19th century is again becoming aware of? I know of one man, a lone pioneer, struggling on his own in the depths of darkest night. His name, Vincent, will go down to posterity. There will be more to be said about this heroic Dutchman in future." Vincent considers this excessive and feels he would prefer it if nothing were written about him.

NOVEMBER: Once again Vincent takes his inspiration from reproductions of work by Millet, thinking of his own versions as "translations" rather than simple copies: *Evening* (pp. 567

and 572), *The Shepherdess* (p. 583) and *The Sower* (p. 566). He is looking for a powerful, spontaneous style of draughtsmanship, even if it means a similarity to Bernard or Gauguin. Again he spends a few days in Arles, visiting Rev. Salles and the Ginoux. Octave Maus (1856–1919), secretary of the Belgian artist group Les XX, invites Vincent to exhibit in Brussels along with Paul Cézanne, Renoir, Signac, Sisley, Toulouse-Lautrec and others. Vincent chooses six paintings, among them *The Reaper* (p. 547) and a self-portrait. He sees photographic reproductions of Biblical scenes by Gauguin and Bernard and is harsh in his condemnation. He believes one ought to think, not dream; one ought to seek what is possible, logical and true; one ought to

work from Nature and models, and not produce abstractions. He urges his friends to rethink.

DECEMBER: Vincent sends Theo three packages of pictures, some of them intended for his mother and Wil, who are moving to Leiden. In spite of the cold he paints in the open, thinking it will be good both for him and for his work. This work again shows olive-trees and windblown pines. Père Tanguy puts several of Vincent's paintings on show in his Paris store. At the end of the month, while he is quietly at work, he has another attack and again tries to poison himself by swallowing paint. It is a serious attack, lasting a full week. Dr. Peyron removes his oil paints and for the time being he is only allowed to draw.

Saint-Paul-de-Mausole hospital, Saint-Rémy

Van Gogh's cell at Saint-Paul asylum, Saint-Rémy, furnished with an iron bedstead and a chair

The "bathhouse" in the asylum at Saint-Rémy. Van Gogh was mainly "treated" by means of hydrotherapy

1890 JANUARY: Sister Wil goes to Paris to be with Theo's wife Jo during the last month of her pregnancy. Vincent wants to paint more pictures of cypresses and mountains in order to convey a vivid impression of Provence to others. A. M. Lauzet (1865–1898), an artist who was born in Provence, confirms that Vincent has already succeeded in doing this: "This is what Provence is really like!" For the moment, Vincent is at work in his studio on pictures after Millet, Daumier and Gustave Doré (1832–1883). On January 18 the exhibition of Les XX in Brussels, containing six works by Vincent, opens its doors. Toulouse-Lautrec challenges a painter who speaks dismissively of Vincent's work to a duel. For the first time an article on his work, by the art critic Albert Aurier, appears outside Holland, in the *Mercure de France*. In Arles, Vincent visits Madame Ginoux, who has been ill for a long time, and two days later has another attack, which lasts for a week. On January 31 Theo's wife Jo gives birth to a son, who is christened Vincent Willem after his uncle and godfather and is destined to live to the ripe age of 88.

FEBRUARY: Vincent dedicates *Blossoming Almond Tree* (p. 615) to his nephew. Theo informs him that Anne Boch, sister of Eugène Boch, has bought *The Red Vineyard* (p. 450) in Brussels, for 400 francs. This is probably the only painting Vincent ever sold. On February 22 Vincent goes to Arles to visit Madame Ginoux again and present her with a new version of *L'Arlésienne* (pp. 616 ff.), but he suffers a further attack which lasts two months. Two orderlies are obliged to drive him back to Saint-Rémy in a wagon next day.

MARCH: Vincent shows ten pictures in the Salon des Indépendants in Paris. At the opening, Theo and Jo accept the congratulations of numerous people on his behalf, Pissarro among them. Gauguin sends good wishes in writing and asks if they can exchange pictures. Theo meets Dr. Gachet for the first time. On hearing Theo's description of Vincent's sickness, Dr. Gachet feels the prospects of recovery would be good if Vincent came to Auvers.

APRIL: During his illness, Vincent dwells on memories of his Brabant homeland. He does a few paintings and a number of small drawings of the landscape back home from memory: mossy thatched cottages, beech hedgerows on autumn evenings under

"Ivy-clad Trees and Bench in Saint-Paul Hospital Garden". Saint-Rémy, May 1889. Pencil, pen and ink, 62 x 47 cm. F 1522, JH 1695. Amsterdam, Rijksmuseum Vincent van Gogh, Vincent van Gogh Foundation

stormy skies, women lifting turnips in snowy fields. Monet too feels that Vincent's paintings are remarkable: "The best in the exhibition."

MAY: In preparation for Vincent's move, Theo writes to Dr. Peyron in Saint-Rémy and Dr. Gachet in Auvers. Vincent makes the journey to Paris on his own, to see Theo and his family. His sister-in-law meets a broad-shouldered, well-built man with a healthy complexion, a smiling and resolute man who seems stronger than Theo, who has been suffering from a chronic cough for some time. Some of Vincent's best works are on the walls of

Theo's flat: *The Potato Eaters* (p. 96), *Starry Night over the Rhône* (p. 431) and *Blossoming Almond Tree* (p. 615). The two brothers call on Tanguy, who has many of Vincent's paintings in storage, and visit Ernest Meissonier's (1815–1891) secessionist salon. But Paris is too noisy and restless for Vincent, and three days later he travels on to Auvers-sur-Oise, some 20 miles away. At first he lodges at the Saint-Aubin hotel, then in a small café opposite the town hall run by a couple called Ravoux. Vincent found the town very attractive, with its curious thatched roofs and its rural, pictur-

"Marguerite Gachet at the Piano". Auvers-sur-Oise, June 1890. Sketch in Letter 645, 30 x 19 cm. Not listed in F. JH2049. Amsterdam, Rijksmuseum Vincent van Gogh, Vincent van Gogh Foundation. Cf. Vincent's portrait of Dr. Gachet's daughter (p. 677)

Dr. Paul-Ferdinand Gachet's house in Auvers

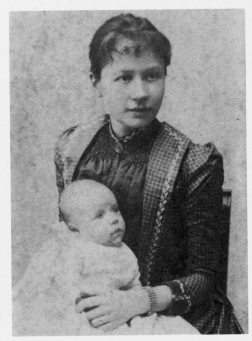

Johanna van Gogh, Theo's wife, with the infant Vincent Willem, Vincent's nephew, 1890

esque character. Dr. Gachet – whose presence is the reason why Theo has chosen Auvers for Vincent – attends his practice in Paris three days a week, paints himself, and is friends with some of the Impressionists. Soon a friendship develops between Vincent and the doctor (who admires Vincent's art) and the doctor's daughter Marguerite (aged 20) and son Paul (16). Vincent is soon busy painting and drawing landscapes, village scenes, vineyards, Dr. Gachet's house and garden, and portraits. In the two months that now remain to him he produces over eighty paintings.

JUNE: Dr. Gachet visits Theo at the Paris gallery. He feels Vincent has recovered completely and that there need be no fears of a further attack. He invites Theo and his family over to Auvers the following Sunday. Vincent meets them at the station in Chaponval himself, carries his baby nephew, and shows him the animals around the yard: cats and dogs, rabbits, and chickens. They lunch together in Gachet's garden and then go for a walk. It is an extremely enjoyable day. Vincent is now tireless in his output: gardens and landscapes, wheat and poppy fields, Auvers church, portraits of Dr. Gachet, his daughter Marguerite, the daughter of the Ravoux, peasant girls. The

Dutch painter Anton Matthias Hirschig (1867–1939) comes to Auvers and moves in to the room next to Vincent's. In letters, Gauguin recalls their conversations in Arles, when they thought of setting up a studio together in the tropics. Gauguin is now living and working with fellow artists Paul Sérusier (1864–1927) and Jacob Meyer de Haan (1852–1895) in Le Pouldu, a pretty fishing village in Brittany, but he says he hopes to go to Madagascar and start a simple, natural life there. (In fact Gauguin made his first trip to Tahiti in 1891.) Vincent successfully tries his hand at etching, and has free use of Dr. Gachet's press – which he uses for the portrait of Dr. Gachet (p. 653). He plans a series of landscape etchings titled *Recollections of Provence.*

JULY: On the morning of July 6, Vincent goes to Paris to see Theo. But his brother is extremely worried about his work, his financial situation, and the question of a place to live. His baby boy is ill into the bargain. It is a troubled household. Vincent manages to see Toulouse-Lautrec and Aurier, the art critic, but he is so tired and agitated that he returns to Auvers in a hurry. He writes to Theo that he is only a burden to him and that he is sad to see him in difficulty himself. Nonetheless he continues painting large-format pictures, wheat fields beneath a stormy sky (p. 678) or Daubigny's garden (pp. 673

and 683 ff.). In his last letter to his mother and sister Wil he writes that he feels far calmer than the previous year. On 14 July (Bastille Day) he paints Auvers town hall festooned with bunting (p. 696). On July 23 he writes his last letter to Theo, enclosing sketches for four paintings and ordering paints for Hirschig and himself. On July 27 he goes out for a walk as evening falls, returns late, and retires to his room. M. and Mme. Ravoux realize that he is in pain and send for the village doctor, Mazery, and for Dr. Gachet. Vincent admits having fired a bullet into his chest. The doctors bandage him but cannot remove the bullet. Next morning, Hirschig goes to Paris with a letter from Dr. Gachet to Theo. Theo comes to Auvers immediately. Vincent sits propped up in bed all day, smoking his pipe. Early next morning, July 29, he dies. Theo, at his bedside, records his last words as: "I wish it were all over now." Dr. Gachet makes a drawing of him on his deathbed. Next day Vincent's coffin, already closed, is placed in his room at the Ravoux' inn, with his easel, stool and painting utensils beside it. The coffin is covered with flowers, among them dahlias and sunflowers, which Vincent so loved. His final paintings are on the walls. The Catholic priest in Auvers having refused to allow the community's hearse to be used for a suicide, Vincent is taken away on a hearse borrowed

from the next town. He is buried in Auvers cemetery by the cornfields beneath a vast blue sky. As well as Theo and Dr. Gachet, friends from Paris pay their last respects, among them Bernard, A. M. Lauzet, Charles Laval (1862–1904) and Lucien Pissarro. Père Tanguy and Andries Bonger are also there. The church service that was proposed having been cancelled, Dr. Gachet, choking back the tears, speaks at the graveside of Vincent's achievement, of his noble aims, and of his own great affection for him: "He was an honest man and a great artist, and there were only two things for him: humanity and art. Art mattered to him more than anything else, and he will live on in it."

AUGUST: With Bernard's assistance, Theo mounts a retrospective of Vincent's work at his Paris home in Montmartre.

Dr. Paul-Ferdinand Gachet (1818–1909) was a good friend to van Gogh in Auvers. In 1890 he was 62 years old (cf. the portraits, pp. 656 ff.)

Vincent's mother in old age

1891 After Vincent's death, Theo is a broken man. He loved his brother dearly and had great hopes of what they could achieve together. His health deteriorates, and he is taken to Holland for treatment. On January 25 he dies at Utrecht.

1914 Theo's body is exhumed and reinterred beside Vincent in the cemetery at Auvers.

1961 A memorial to Vincent van Gogh, by the sculptor Ossip Zadkine

(1890–1967), is put up at Auvers-sur-Oise.

1962 The Vincent van Gogh Foundation is established in Amsterdam, with the aim of acquiring all the paintings, studies, drawings, and letters and documents relating to himself, his family and his friends, that are still accessible. The van Gogh family sell the collection still in their keeping to the Dutch state for a considerable sum, on condition that a special van Gogh museum is created.

1964 A memorial to Vincent and Theo van Gogh is put up in Groot-Zundert in northern Brabant, where the brothers were born. It too is the work of the Franco-Russian sculptor Ossip Zadkine.

1973 The Rijksmuseum Vincent van Gogh, built by the Dutch state to designs made by the architects Gerrit Thomas Rietveld, van Dillen and van Tricht, is officially opened in Amsterdam. It is situated between the old Rijksmuseum and the Amsterdam

The café where van Gogh lodged at Auvers-sur-Oise

Ravoux's café in Auvers, where Vincent stayed in Auvers and where he died. The proprietor, Arthur Gustave Ravoux, is seated at the far left. His daughter Adeline, whose portrait Vincent painted three times (pp. 666 ff.), is standing in the doorway. 1890

The room where van Gogh died at Ravoux's café in Auvers

— AUVERS-SUR-OISE. — Dimanche 27 juillet, un nommé Van Gogh, âgé de 37 ans, sujet hollandais, artiste peintre, de passage à Auvers, s'est tiré un coup de revolver dans les champs 'et, n'étant que blessé, il est rentré à sa chambre où il est mort le surlendemain.

"L'Echo Pontoisien" of August 7, 1890, containing the report of van Gogh's suicide

Municipal Museum. In addition to 207 of van Gogh's paintings and almost 600 drawings, it houses a vast archive of documentary material relating to van Gogh, his family, and his contemporaries.

1990 On the occasion of the centenary of Vincent van Gogh's death, the Rijksmuseum Vincent van Gogh in Amsterdam mounts a mammoth retrospective containing some 120 paintings. The Rijksmuseum Kröller-Müller in Otterlo exhibits some 250 drawings. Both exhibitions run from March 30 (the date of van Gogh's birth) to July 29 (the date on which he died).

The headstones on Vincent and Theo van Gogh's graves in Auvers cemetery

Bibliography

1. CATALOGUES

FAILLE, JACOB-BAART DE LA: L'Oeuvre de Vincent van Gogh. Catalogue Raisonné. 4 vols. Paris-Brussels, 1928

FAILLE, JACOB-BAART DE LA: Les faux van Gogh. Paris-Brussels, 1930

SCHERJON, WILLEM and W.J. DE GRUYTER: Vincent van Gogh's Great Period: Arles, Saint-Rémy and Auvers-sur-Oise (Complete catalogue). Amsterdam, 1937

VANBESELAERE, WALTHER: De Hollandsche Periode (1880-1885) in het werk van Vincent van Gogh. Antwerp-Amsterdam, 1937 (French edition: ibid. 1937)

FAILLE, JACOB-BAART DE LA: Vincent van Gogh. Paris, 1939. English edition: Paris-London-New York, 1939 (Compilation of the 1928 edition in one volume with revised numeration)

FAILLE, JACOB-BAART DE LA: The Works of Vincent van Gogh. His Paintings and Drawings. Amsterdam-New York, 1970 (revised version of the 1928 French edition which, however, contains only minor variations; the catalogue numbers of the index of works from de la Faille are cited in the present edition with an F)

LECALDANO, PAOLO: Tutta la pittura di Van Gogh. 2 vols. Milan, 1971

HULSKER, JAN: Van Gogh en zijn weg. Al zijn tekeningen en schilderijen in hun samenhangen en ontwikkeling. Amsterdam, 1978, 6th ed. Amsterdam, 1989. English edition: The Complete van Gogh: Paintings, Drawings, Sketches. Oxford-New York, 1980; Japanese edition: The Complete Works of Vincent van Gogh. 3 vols. Tokyo, 1978 (Revised edition of the index of works from de la Faille with a revised chronology; the catalogue numbers of the index of works from Jan Hulsker are cited in the present edition with JH)

HAMMACHER, ABRAHAM MARIE (ed.): A Detailed Catalogue of the Paintings and Drawings by Vincent van Gogh in the Collection of the Kröller-Müller Museum. 5th ed., Otterlo, 1983 (List of works in the Museum collection)

UITERT, EVERT VAN and MICHAEL HOYLE (eds.): The Rijksmuseum Vincent van Gogh. Amsterdam, 1987 (List of works in the Museum collection)

2. VAN GOGH'S OWN WRITINGS

GOGH, VINCENT VAN: Brieven aan zijn broeder. Edited by Johanna van Gogh-Bogner. 3 vols. Amsterdam, 1914. Expanded new edition: Verzamelde brieven van Vincent van Gogh. 4 vols. Amsterdam, 1952-1954

GOGH, VINCENT VAN: The Complete Letters of Vincent van Gogh. Introduction by Vincent Wilhelm van Gogh. Preface and Memoir by Johanna van Gogh-Bonger. 3 vols. London-New York, 1958

GOGH, VINCENT VAN: Correspondance complète de Vincent van Gogh. 3 vols. Paris, 1960

GOGH, VINCENT VAN: Sämtliche Briefe. Translated by Eva Schumann, edited by Fritz Erpel. 6 vols. East Berlin, 1965-1968

LETTERS OF VINCENT VAN GOGH. 1886-1890. A Facsimile Edition. Preface by Jean Leymarie. Introduction by Vincent Wilhelm van Gogh. London, 1977

KARAGHEUSIAN, A.: Vincent van Gogh's Letters Written in French: Differences between the Printed Versions and the Manuscripts. New York, 1984

3. DOCUMENTS, MEMOIRS

AURIER, ALBERT: Les Isolés: Vincent van Gogh. "Mercure de France" no. 1 (Jan. 1890), pp. 24-29. Reprinted in "Oeuvres posthumes", Paris, 1893, pp. 257-265

BERNARD, EMILE: Vincent van Gogh. "Les hommes d'aujourd'hui", Paris, 1891

QUESNE-VAN-GOGH, ELISABETH-HUBERTA DU: Persoonlijke herinneringen aan Vincent van Gogh. Baarn, 1910 (English edition: London-Boston, 1913)

KERSSEMAKERS, ANTON: Herinneringen aan Van Gogh. "De Amsterdamer", Amsterdam, 14 and 21 April 1912

GAUGUIN, PAUL: Avant et après. Paris, 1923 (Condensed English edition: The Intimate Journals of Paul Gauguin. New York, 1921)

BERNARD, EMILE: Souvenirs sur Van Gogh. "L'Amour de l'Art" 5 (1924), pp. 393-400

STOCKVIS, BENNO J.: Nasporingen omtrent Vincent van Gogh in Brabant. Amsterdam, 1926

BREDIUS, A.: Herinneringen aan Vincent van Gogh. "Oud Holland" 51 (1934)

LORD, D. (ed.): Vincent van Gogh: Letters to Emile Bernard. London-New York, 1938

HARTRICK, ARCHIBALD STANDISH: A Painter's Pilgrimage through Fifty Years. Cambridge, 1939

GAUGUIN, PAUL: Lettres de Paul Gauguin. Paris, 1946

COURTHION, PIERRE (ed.): Van Gogh raconté par lui-même et par ses amis, ses contemporains, sa postérité. Geneva, 1947

BERNARD, EMILE: L'Enterrement de Van Gogh. "Arts-documents" 29 (Feb. 1953), pp. 1f.

GACHET, PAUL: Souvenirs de Cézanne et de van Gogh à Auvers (1873-1890). Paris, 1953

GAUTHIER, MAXIMILIEN: La Femme en bleu nous parle de l'homme à l'oreille coupé. "Nouvelles littéraires, artistique et scientifique" no. 1337, 16 April 1953

CARRIÉ, ADELINE: Les Souvenirs d'Adeline Ravoux sur le séjour de Vincent van Gogh à Auvers-sur-Oise. "Les Cahiers de Van Gogh" 1 (1956), pp. 7-17

4. BIOGRAPHIES AND STUDIES

MEIER-GRÄFE, JULIUS: Vincent van Gogh. Der Roman eines Gottsuchers. Munich, 1910

BREMMER, HENRICUS PETRUS: Vincent van Gogh. Inleidende beschouwingen. Amsterdam, 1911

HAUSENSTEIN, WILHELM: Van Gogh und Gauguin. Berlin, 1914

HARTLAUB, GUSTAV FRIEDRICH: Vincent van Gogh. Leipzig, 1922

MEIER-GRÄFE, JULIUS: Vincent. A Biographical Study. London-New York, 1922

COQUIOT, GUSTAVE: Vincent van Gogh, sa vie, son oeuvre. Paris, 1923

PIERARD, LOUIS: La Vie tragique de Vincent Van Gogh. Paris, 1924

FELS, FLORENT: Vincent van Gogh. Paris, 1928

MEIER-GRÄFE, JULIUS: Vincent van Gogh, der Zeichner. Berlin, 1928

KNAPP, FRITZ: Vincent van Gogh. Leipzig, 1930

TERRASSE, CHARLES: Van Gogh, peintre. Paris, 1935

PACH, WALTER: Vincent van Gogh, 1853- 1890. A Study of the Artist and His Work in Relation to His Time. New York, 1936

VITALI, LAMBERTO: Vincent van Gogh. Milan, 1936

FLORISOONE, MICHEL: Van Gogh. Paris, 1937

UHDE, WILHELM: Vincent van Gogh. Vienna, 1937

NORDENFALK, CARL: Vincent van Gogh. En livsväg. Stockholm, 1943 (English edition: London, 1953)

JOSEPHSON, R.: Vincent van Gogh naturalisten. Stockholm, 1944

HAUTECOEUR, LOUIS EGÈNE GEORGES: Van Gogh. Monaco, 1946

SCHMIDT, GEORG: Vincent van Gogh. Berne, 1947

BUCHMANN, MARK: Die Farbe bei Vincent van Gogh. Zurich, 1948

MÜNSTERBERGER, W.: Vincent van Gogh. Dessins, pastels et études. Paris, 1948

WEISBACH, WERNER: Vincent van Gogh. Kunst und Schicksal. 2 vols. Basel, 1949-1951

SCHAPIRO, MEYER: Vincent van Gogh. New York, 1950

LEYMAIRE, JEAN: Van Gogh. New York, 1951

VALSECCHI, MARCO: Van Gogh. Milan, 1952

BEUCKEN, JEAN DE: Un Portrait de Vincent van Gogh. Paris, 1953

COGNIAT, RAYMOND: Van Gogh. Paris, 1953

ESTIENNE, CHARLES: Vincent van Gogh. London, 1953

COOPER, DOUGLAS (ed.): Vincent van Gogh. Drawings and Watercolours. New York, 1955

PERRUCHOT, HENRI: La Vie de Van Gogh, Paris, 1955

REWALD, JOHN: Post-Impressionism. From Van Gogh to Gauguin. New York, 1956 (3rd revised edition: New York-London, 1978)

ELGAR, FRANK: Vincent van Gogh. Life and Work. New York, 1958

FEDDERSEN, HANS: Vincent van Gogh. Stuttgart, 1958

HULSKER, JAN: Wie was Vincent van Gogh? Who was Vincent van Gogh? Qui était Vincent van Gogh? Wer war Vincent van Gogh? The Hague, 1958

TRALBAUT, MARC EDO: Van Gogh. Eine Bildbiographie. Munich, 1958

STELLINGWERF, JOHANNES: Werkelijkheid en grondmotief bij Vincent Willem van Gogh. Amsterdam, 1959

TRALBAUT, MARC EDO: Van Gogh. Paris, 1960

BADT, KURT: Die Farbenlehre van Goghs. Cologne, 1961

CABANNE, PIERRE: Van Gogh, l'homme et son oeuvre. Paris, 1961

BRAUNFELS, WOLFGANG (ed.): Vincent van Gogh. Ein Leben in Einsamkeit und Leidenschaft. Berlin, 1962

LONGSTREET, S.: The Drawings of Van Gogh. Los Angeles, 1963

MINKOWSKA, FRANÇOISE: Van Gogh. Sa vie, sa maladie et son oeuvre. Paris, 1963

ERPEL, FRITZ: The Self-Portraits by Vincent van Gogh. Oxford, 1964

HUYGHE, RENÉ: Van Gogh. Munich, 1967

NAGERA, HUMBERT: Vincent van Gogh. A Psychological Study. London-New York, 1967

LEYMARIE, JEAN: Who was van Gogh? London, 1968

HAMMACHER, ABRAHAM MARIE: Genius and Disaster: The Ten Creative Years of Vincent van Gogh. New York, 1969 (New edition: New York, 1985)

KELLER, HORST: Vincent van Gogh. The Final Years. New York, 1969

TRALBAUT, MARC EDO: Van Gogh, le mal aimé. Lausanne, 1969 (English edition: Vincent van Gogh. London, 1974)

WADLEY, N.: The Drawings of Van Gogh. London-New York, 1969

HULSKER, JAN: »Dagboek« van van Gogh. Amsterdam, 1970 (English edition: Van Gogh's "Diary": The Artist's Life in His Own Words and Art. New York, 1971)

ROSKILL, MARK: Gauguin and French Painting of the 80s: A Catalogue Raisonné of the Key Works. Ann Arbor, 1970

WALLACE, ROBERT: The World of Van Gogh. New York, 1970

HUYGHE, RENÉ: Van Gogh ou la poursuite de l'absolu. Paris, 1972

LASSAIGNE, JACQUES: Vincent van Gogh. Milan, 1972 (English edition: London, 1973)

LEPROPHON, PIERRE: Vincent van Gogh. Cannes, 1972

LUBIN, A.J.: Stranger on the Earth: A Psychological Biography of Vincent van Gogh. New York, 1972

CABANNE, PIERRE: Van Gogh. Paris, 1973

HULSKER, JAN: Van Gogh door van Gogh. De brieven als commentaar op zijn werk. Amsterdam, 1973

BOURNIQUEL, C., PIERRE CABANNE and Georges Charensol: Van Gogh. Heideland, 1974

WELSH-OVCHAROV, BOGOMILA: Van Gogh in Perspective. Eaglewood Cliffs (N.J.), 1974

DESCARGUES, PIERRE: Van Gogh. New York, 1975

DOBRIN, A.: I Am a Stranger on the Earth. The Story of Vincent van Gogh. New York, 1975

FRANK, HERBERT: Van Gogh in Selbstzeugnissen und Bilddokumenten. Reinbek near Hamburg, 1976

UITERT, EVERT VAN: Vincent van Gogh. Leben und Werk. Cologne, 1976

LEYMARIE, JEAN: Van Gogh. Geneva, 1977

UITERT, EVERT VAN (ed.): Vincent van Gogh. Zeichnungen. Cologne, 1977

POLLOCK, GRISELDA and FRED ORTON: Vincent van Gogh: Artist of His Time. Oxford-New York, 1978

HAMMACHER, ABRAHAM MARIE and Renilde: Van Gogh. A Documentary Biography. London, 1982

FORRESTER, V.: Van Gogh ou l'enterrement dans les blés. Paris, 1983

BARRIELLE, JEAN-FRANÇOIS: La Vie et l'oeuvre de van Gogh. Paris, 1984

HULSKER, JAN: Lotgenoten. Het leven van Vincent en Theo van Gogh. Weesp, 1985

ZURCHER, BERNHARD: Van Gogh, vie et oeuvre. Fribourg, 1985

STEIN, SUSAN ALYSON (ed.): Van Gogh. A Retrospective. New York, 1986

WALTHER, INGO F.: Vincent van Gogh 1853-1890. Vision and Reality. Cologne, 1986

WOLK, JOHANNES VAN DER (ed.): De Schetsboeken van Vincent van Gogh. Amsterdam, 1986 (English edition: The Seven Sketchbooks of Vincent van Gogh. New York, 1987)

BERNARD, BRUCE (ed.): Vincent van Gogh. London, 1988

ERPEL, FRITZ (ed.): Vincent van Gogh. Lebensbilder, Lebenszeichen. East Berlin and Munich, 1989

5. THE DUTCH PERIOD 1881-1885

CLEERDIN, VINCENT: Vincent van Gogh

en Brabant. Hertogenbosch, 1929

HULSKER, JAN: Van Gogh's opstandige jaren in Nuenen. "Maastaf" 7 (1939), pp. 77-98

GELDER, J.G. VAN DER: De genesis van de aardappeleters (1885) van Vincent van Gogh. "Beeldende Kunst" 28 (1942), pp. 1-8

DERKERT, CARLO: Theory and Practice in Van Gogh's Dutch Painting. "Konsthistorisk Tidskrift" 15 (Dec. 1946), pp. 97-119

GELDER, J.G. VAN (ed.): The Potato Eaters. London, 1947

ZERVOS, CHRISTIAN: Vincent van Gogh. Special issue of "Cahiers d'Art" 22 (1947)

TRALBAUT, MARC EDO and STAN LEURS: De verdwenen kerk van Nuenen. "Brabantia" 1/2 (1957), pp. 29-68

TRALBAUT, MARC EDO: Vincent van Gogh in Drenthe. Assen, 1959

NIZON, PAUL: Die Anfänge von Goghs: der Zeichnungsstil der holländischen Zeit. Diss. Bonn, 1960

BOIME, ALBERT: A Source for van Gogh's Potatoeaters. "Gazette des Beaux-Arts" 67 (1966), pp. 249-253

SYZMANSKA, ANNA: Unbekannte Jugendzeichnungen Vincent van Goghs und das Schaffen des Künstlers in den Jahren 1870-1880. Berlin, 1967

TELLEGEN, ANNET H.: De Populierenlaan bij Nuenen van Vincent van Gogh. "Bulletin Museum Boymansvan Beuningen" 18 (1967), pp. 1-15

HULSKER, JAN: Van Gogh's Dramatic Years in The Hague. "Vincent" 1 (1971), no. 2, pp. 6-21

HULSKER, JAN: Van Gogh's Years of Rebellion in Nuenen. "Vincent" 1 (1971), no. 3, pp. 15-28 Eerenbeemt, Hendricus F. van den: De onbekende Vincent van Gogh; leren en tekenen in Tilburg 1866-1868. Tilburg, 1972 (English translation: "Vincent" 2 (1972), no. 1, pp. 2-12)

POLLOCK, GRISELDA: Vincent van Gogh and the Hague Scool. Diss. London, 1972

VISSER, W.J.A.: Vincent van Gogh and The Hague. "Jaarboek van geschiedenes van de Maatschappij van Den Haag" 1973, pp. 1-125

NOCHLIN, LINDA: Van Gogh, Renouard and the Weaver's Crisis in Lyon: The Status of a Social Issue in the Art of the Late Nineteenth Century. "Art the Ape of Nature: Studies in Honour of H.W. Janson", New York, 1981

POLLOCK, GRISELDA: Vincent van Gogh

in zijn Hollandse jaren. Kijk op stand en land door van Gogh en zijn tijdgenoten 1870-1890. Rijksmuseum Vincent van Gogh, Amsterdam, 1981 (Exhibition catalogue)

POLLOCK, GRISELDA: Stark Encounters: Modern Life and Urban Works in Van Gogh's Drawings from The Hague. "Art History" 6 (1983), no. 3, pp. 330-358

BROUWER, TON DE: Van Gogh en Nuenen. Venlo, 1984

GOETZ, CHRISTINE: Studien zum Thema »Arbeit« im Werk von Constantin Meunier und Vincent van Gogh. Diss. Munich, 1984

UITERT, EVERST VAN (ed.): Van Gogh in Brabant. Noord-Brabants Museum, Zwolle- Hertogenbosch, 1987 (Exhibition catalogue)

6. THE ANTWERP AND PARIS PERIOD 1885-1888

TRALBAUT, MARC EDO: Vincent van Gogh in zijn Antwerpsche periode. Amsterdam, 1948

GANS, LOUIS: Vincent van Gogh en de Schilders van de Petit Boulevard. "Museumsjournaal" 4 (1958), pp. 85-93

TRALBAUT, MARC EDO: Van Gogh te Antwerpen. Antwerp, 1958

ROSKILL, MARK: Van Gogh, Gauguin and the Impressionist Circle. New York, 1970

ORTON, FRED: Vincent's Interest in Japanese Prints: Vincent van Gogh in Paris, 1886-1888. "Vincent" 1 (1973), no. 3, pp. 2-12

GOGH, VINCENT WILHELM: Vincent in Paris. Amsterdam, 1974

WELSH-OVCHAROV, BOGOMILA: Vincent van Gogh. His Paris Period, 1886-1888. Utrecht-The Hague, 1976

KODERA, T.: Japan as Primitivistic Utopia. "Simiolus" 1984, pp. 189-208

CACHIN, FRANÇOISE and Bogomila Welsh-Ovcharov (eds.): Van Gogh à Paris. Musée d'Orsay, Paris, 1988 (Exhibition catalogue)

7. THE ARLES PERIOD 1888-1889

LEROY, EDGAR: Vincent van Gogh et le drame de l'oreille coupée. "Aesculape" July 1936, pp. 169-192

REWALD, JOHN: Van Gogh en Provence. "L'Amour de l'Art" 17 (Oct. 1936),

pp. 289-298

LEROY, EDGAR and VICTOR DOITEAU: Van Gogh et le portrait du Dr. Rey. "Aesculape" Feb. 1939, pp. 42-47, and March 1939, pp. 50-55

LEROY, EDGAR: Van Gogh à l'asile. Nice, 1945

ELGAR, FRANK: Van Gogh. Le Pont de l'Anglois. Paris, 1948

COOPER, DOUGLAS: The Yellow House and its Significance. "Medelingen" (Gemeentemuseum, The Hague) 7 (1953), no. 5/6, pp. 94-106

LEROY, EDGAR: Vincent van Gogh au pays d'Arles. "La Revue d'Arles" 14 (Oct./Nov. 1954), pp. 261-264

PRIOU, J.-N.: Van Gogh et la famille Roulin. "Revue des P.T.T. de France", 10 (1953), no.3, pp. 26-33

BLUM, H.P.: Les Chaises de van Gogh. "Revue française de Psychoanalyse" 21 (1958), no. 1, pp. 82-93

MAURON, CHARLES: Van Gogh au seuil de la Provence: Arles, de février à octobre 1888. Saint-Rémy de Provence, 1959

HULSKER, JAN: Van Gogh's extatische maanden in Arles. "Maatstaf" 8 (1960), pp. 315-335

HOFFMANN, KONRAD: Zu Vincent van Goghs Sonnenblumenbildern. "Zeitschrift f. Kunstg." 31 (1968), pp. 27-58

HULSKER, JAN: Critical Days in the Hospital at Arles: Unpublished Letters from the Postman Joseph Roulin and the Reverend Mr. Salles to Theo van Gogh. "Vincent" 1 (1970), no. 1, pp. 20-31

TELLEGEN, ANNET H.: Van Gogh en Montmajour. "Bulletin Museum Boymans-van Beuningen" 18 (1970), no. 1, pp. 16-33

HULSKER, JAN: Van Gogh's Ecstatic Years in Arles. "Vincent" 1 (1972), no. 4, pp. 2-17

HULSKER, JAN: The Poet's Garden. "Vincent" 3 (1974), no. 1, pp. 22-32

HULSKER, JAN: The Intriguing Drawings of Arles. "Vincent" 3 (1974), no. 4, pp. 24-32

JULLIAN, RENÉ: Van Gogh et le »Pont de l'Anglois«. "Bulletin de la Societé de l'histoire de l'art français" 1977, pp. 313-321

ARIKAWA, H.: La Berceuse: An Interpretation of Vincent van Gogh's Portraits. "Annual Bulletin of the National Museum of Western Art" (Tokyo) 15 (1981), pp. 31-75

PICKVANCE, RONALD: Van Gogh in Arles. The Metropolitan Museum of Art, New York, 1984 (Exhibition catalogue)

DORN, ROLAND: Décoration. Vincent

van Gogh's Werkreihe für das gelbe Haus in Arles. Mannheim, 1985

8. THE SAINT-REMY AND AUVERS PERIOD 1889-1890

LEROY, EDGAR: Le Séjour de Vincent van Gogh à l'asile de Saint Rémy de Provence. "Aesculape" May 1926, pp. 137-143

SCHERJON, WILLEM:: Catalogue des tableaux par Vincent van Gogh décrits dans ses lettres. Périodes Saint-Rémy et Auvers-sur-Oise. Utrecht, 1932

HENTZEN, ALFRED: Der Garten Daubignys von Vincent van Gogh. "Zeitschrift für Kunstgeschichte" 4 (1935), pp. 325-333

PFANNSTIEL, ARTHUR and M.J. SCHRETLEN: Van Gogh's »Jardin de Daubigny«. Stilkritische und röntgenologische Beiträge zur Unterscheidung echter und angeblicher Werke van Goghs. "Maanblad voor beeldende Kunsten" 13 (1935), pp. 140-145

HENTZEN, ALFRED: Nochmals: Der Garten Daubignys von Vincent van Gogh. "Zeitschrift für Kunstgeschichte" 5 (1936), pp. 252-259

ÜBERWASSER, WALTER: »Le Jardin de Daubigny«. Das letzte Hauptwerk van Goghs. Basel, 1936

LEROY, EDGAR: A Saint Paul de Mausole, quelques hôtes célèbres au cours du XIXème siècle. "La Revue d'Arles" June 1941, pp. 125-130

CATESSON, JEAN: Considerations sur la folie de van Gogh. Diss. Paris, 1943

FLORISOONE, MICHEL and GERMAIN BAZIN: Van Gogh et les peintres d'Auvers chez le docteur Gachet. Special issue of "L'Amour de l'Art", Paris, 1952

GACHET, PAUL: Van Gogh à Auvers, histoire d'un tableau. Paris, 1953

GACHET, PAUL: Vincent à Auvers, "Les vaches" de J. Jordaens. Paris, 1954

LEROY, EDGAR: Quelques Paysages de Saint Rémy de Provence dans l'oeuvre de Vincent van Gogh. "Aesculape" July 1957, pp. 3-21

OUTHWAITE, DAVID: The Auvers Period of Vincent van Gogh. Master's thesis, London University, 1969

CABANNE, PIERRE: A-t-on tué van Gogh? "Jardin des arts" 194 (1971), pp. 42-53

HULSKER, JAN: Van Gogh's Threatened Life in St. Rémy and Auvers. "Vincent" 2 (1972), no. 2, pp. 21-39

CHÂTELET, ALBERT: Le dernier tableaux de Van Gogh. "Société de l'histoire de l'art français: Archives" 25 (1978), pp. 439-442

PEGLAU, CHARLES MICHAEL: Image and Structure in Van Gogh's Later Paintings. Diss. Pittsburgh, 1979

KORSHAK, Y.: Realism and Transcedent Imagery. Van Gogh's »Crows over the Wheatfield«. "Pantheon" 48 (1985), pp. 115-123

PICKVANCE, RONALD: Van Gogh in Saint-Rémy and Auvers. The Metropolitan Museum of Art, New York, 1986 (Exhibition catalogue)

MOTHE, ALAIN: Vincent van Gogh à Auvers-sur-Oise. Paris, 1987

9. EXHIBITIONS AND EXHIBITION CATALOGUES (SELECT LIST)

L'Epoque française de Van Gogh. Compiled by Jacob-Baart de la Faille. Bernheim Jeune, Paris, 1927

Vincent van Gogh. Edited by Alfred H. Barr, Jr. The Museum of Modern Art, New York, 1935

Vincent van Gogh. Sa vie et son oeuvre. Edited by Michel Florisoone and John Rewald. Exhibition of the occasion of the World Exposition in Paris. Special issue of "L'Amour de l'Art". Paris, 1937

Vincent van Gogh. Musée des Beaux-Arts, Luttich, 1946

Vincent van Gogh. Kunsthalle Basel, Basel 1947

Van Gogh. An Illustrated Supplement to the Exhibition Catalogue. Preface by Philip James and Contributions by Roger Fry and Abraham Marie Hammacher. Arts Council of Great Britain, London, 1947

Vincent van Gogh. The Metropolitan Museum of Art, New York, 1949

Vincent van Gogh. City Art Museum, Saint Louis, 1953

Van Gogh et les peintres d'Auvers-sur-Oise. With Contribtutions by Germain Bazin, Paul Gachet, Albert Châtelet and Michel Florisoone. Orangerie des Tuileries, Paris, 1954

Vincent van Gogh. Kunsthaus Zürich, Zurich, 1954

Vincent van Gogh. Collection Vincent Wilhelm van Gogh. Stedelijk Museum, Amsterdam, 1955

Vincent van Gogh 1853-1890. Compiled by Louis Gans. Haus der Kunst, Munich, 1956

Vincent van Gogh, 1853-1890, Leben und Schaffen. Dokumentation, Gemälde, Zeichnungen. Compiled by Marc Edo Tralbaut. Villa Hügel, Essen, 1957

Vicent van Gogh (1853-1890), Leven en Scheppen in Beeld. Stedelijk Museum, Amsterdam, 1958

Vincent van Gogh. With Contributions by J. G. Domergue, Louis Hautecoeur and Marc Edo Trabault. Musée Jacquemart-André, Paris, 1960

Vincent van Gogh. Paintings-Drawings. The Montreal Museum of Fine Arts, Montreal, 1960

Vincent van Gogh. Paintings, Watercolors and Drawings. The Baltimore Museum of Art, Baltimore, 1961

Vincent van Gogh. Paintings, Watercolors and Drawings. The Washington Gallery of Modern Art, Washington, 1964

Pont-Aven. Gauguin und sein Kreis in der Bretagne. Kunsthaus Zürich, Zurich, 1966

Vincent van Gogh dessinateur. Institut Néerlandais, Paris, 1966

Vincent van Gogh. Paintings and Drawings. Hayward Gallery, London, 1968

Vincent van Gogh. Orangerie des Tuileries, Paris, 1972

Les sources de l'inspiration de van Gogh. With Contributions by Sadi de Gorter and Vincent Wilhelm van Gogh. Institut Néerlandais, Paris, 1972

English Influence on Vincent van Gogh. Compiled by Ronald Pickvance. University Art Gallery, Nottingham, 1974

Japanese Prints Collected by Vincent van Gogh. Introduction by Willem van Gulik. Essay by Fred Orton. Rijksmuseum Vincent van Gogh, Amsterdam, 1978

Van Gogh en Belgique. With an introduction by Abraham Marie Hammacher. Musée des Beaux-Arts, Mons, 1980

Vincent van Gogh and the Birth of Cloisionism. Compiled by Bogomila Welsh-Ovcharov. Art Gallery of Ontario, Toronto, 1981

Vincent van Gogh Exhibition. The National Museum of Western Art, Tokyo, 1985

Vincent van Gogh from Dutch Collections. Religion - Humanity - Nature. The National Museum of Art, Osaka, 1986

Vincent van Gogh. Galleria Nazionale d'Arte Contemporanea, Rome, 1988

Van Gogh & Millet. Edited by Louis van Tilborgh. Rijksmuseum Vincent van Gogh, Amsterdam, 1989

10. Essays and Special Studies

Westerman Holstijn, A.J.: Die psychologische Entwicklung Vincent van Goghs. "Imago" 10 (April 1924), no. 4, pp. 389-417

Leroy, Edgar: L'Art et la folie de Vincent van Gogh. "Journal des Practiciens" 29 (1928), pp. 1558-1563

Leroy, Edgar: La Folie de Vincent Van Gogh. "Cahiers de Pratique Medico-Chirurgicale" 9 (15 Nov. 1928), pp. 3-11

Doiteau, Victor and Edgar Leroy:La Folie de Vincent van Gogh. Preface by Paul Gachet. Paris, 1928

Shikiba, Ryuzaburo: Van Gogh, His Life and Psychosis. Tokyo, 1932

Beer, François-Joachim: Essai sur les rapports de l'art et de la maladie de Vincent van Gogh. Diss. Strasbourg, 1936

Arndt, Joachim: Die Krankheit Vincent van Goghs nach seinem Briefen an seinen Bruder Theo. Diss. Leipzig, 1945

Beer, J.P. and Edgar Leroy: Du Démon de Van Gogh. Nice, 1945

Leroy, Edgar: Van Gogh à l'asile. With »Du Démon de Van Gogh« by François-Joachim Beer. Preface by Louis Piérard. Nice, 1945

Meyerson, A.: Van Gogh and the School of Pont-Aven. "Konsthistoriske Tidskrift" 15 (Dec. 1946), pp. 135-149

Artaud, Antonin: Van Gogh - Le suicidé de la societé. Paris, 1947

Nordenfalk, Carl: Van Gogh and Literature. "Journal of the Warburg and Courtauld Institute" 10 (1947), pp. 132-147

Jaspers, Karl: Strindberg und van Gogh. Versuch einer pathographischen Analyse unter vergleichender Heranziehung von Swedenborg und Hölderlin. Munich, 1949

Rewald, John: Van Gogh: The Artist and the Land. "ARTnews Annual" 19 (1950), pp. 64-73

Seznec, Jean: Literary Inspiration in van Gogh. "Magazine of Art" 43 (1950), pp. 282-307

Gachet, Paul: Vincent van Gogh aux »Indépendants«. Paris, 1953

Kraus, Gerard: De verhouding van Theo en Vincent van Gogh. Amsterdam, 1954

Tralbaut, Marc Edo: Van Gogh's Japanisme. "Mededelingen" (Gemeentemuseum, The Hague) 9 (1954), no. 1/2, pp. 6-40

Gachet, Paul: Les Médicins de Théodore et Vincent van Gogh. "Aesculape" March 1957, pp. 4-37

Tralbaut, Marc Edo: Vincent van Gogh chez Aesculape - quelques rapports nouveaux à la connaissance de la santé, la maladie et la mort du grand peintre. "Revue des lettres et des arts dans leur rapports avec les sciences et la médicine" 1957 (Dec.)

Novotny, Fritz: Die Bilder van Goghs nach fremden Vorbildern. "Festschrift Kurt Badt", pp. 213-230. Berlin, 1961

Graetz, Heinz P.: The Symbolic Language of Vincent van Gogh. New York, 1963

Roskill, Mark: Van Gogh's Blue Cart and His Creative Process. "Oud Holland" 81 (1966), no. 1, pp. 3-19

Sheon, A.: Montecelli and van Gogh. "Apollo" 85 (June 1967), pp. 444-448

Boness, Alan: Vincent in England. "Van Gogh", Hayward Gallery, London, 1968 (Exhibition catalogue)

Wylie, A.: An Investigation of the Vocabulary of Line in Vincent van Gogh's Expression of Space. "Oud Holland" 85 (1970), no. 4, pp. 210-235

Hulsker, Jan: Vincent's Stay in the Hospital at Arles and St.-Rémy. Unpublished Letters from Reverend Mr. Salles and Doctor Peyron to Theo van Gogh. "Vincent" 1 (1971), no. 2, pp. 24-44

Roskill, Mark: Van Gogh's Exchanges of Work with Emile Bernard in 1888. "Oud Holland" 86 (1971), pp.142-179

Welsh-Ovcharov, Bogomila: The Early Works of Charles Angrand and His Contact with Vincent van Gogh. Utrecht-The Hague, 1971

Heelan, Patrick A.: Toward a New Analysis of the Pictorial Space of Vincent van Gogh. "Art Bulletin" 54 (1972), pp. 478-492

Werness, Hope Benedict: Essays on Van Gogh's Symbolism (unpublished Diss.). University of California, Santa Barbara, 1972

Wichmann, Siegfried: Ostasiatischer Strich- und Pinselduktus im Werk van Goghs. "Weltkulturen und moderne Kunst", Munich, 1972 (Exhibition catalogue)

Nagera, Humberto: Vincent van Gogh. Psychoanalytische Deutung seines Lebens anhand seiner Briefe. With a Preface by Anna Freud. Munich, 1973

Rewald, John: Theo van Gogh, Goupil and the Impressionists. "Gazette des Beaux-Arts" 81 (Jan./Feb. 1973), pp. 1-108

Hulsker, Jan: What Theo Really Thought of Vincent. "Vincent" 3 (1974), no. 2, pp. 2-28

Chetman, Charles: The Role of Vincent van Gogh's Copies in Development of Art. New York-London, 1976

Heimann, Marcel: Psychoanalytical Observations on the Last Paintings and Suicide of Vincent van Gogh. With critical notes by Arthur F. Valenstein and Anne Styles Wylie. "International Journal of Psychoanalysis" 57 (1976), pp. 71-79

Mauron, Charles: Van Gogh. Etudes psychocritiques. Paris, 1976

Ward, J.-L.: A Reexamination of Van Gogh's Pictorial Space. "Art Bulletin" 58 (1976), pp. 593-604

Zemel, C.M.: The Formation of a Legend - Van Gogh Criticsm, 1890-1920. Diss. Columbia University, Washington, 1978

Destaign, Fernand: Le Soleil et l'orage ou la maladie de van Gogh. In: Fernand Destaign, "La Souffrance et le génie", Paris, 1980

Pollock, Griselda: Artists' Mythologies and Media Genius: Madness and Art History. "Screen" 21 (1980), no. 3, pp. 57-96

Pollock, Griselda: Van Gogh and Dutch Art. A Study of the Development of Van Gogh's Concepts of Modern Art. Diss. London, 1980

Wolk, Johannes van der: Vincent van Gogh in Japan. "Japonism in Art", Tokyo, 1980 (Exhibition catalogue)

Clébert, Jean-Paul and Pierre Richard: La Provence de van Gogh. Aix-en-Provence, 1981

Walker, J.A.: Van Gogh Studies. Five Critical Essays. London, 1981

Krauss, André: Vincent van Gogh. Studies in the Social Aspects of His Work. Gothenburg, 1983

Uitert, Evert van: Van Gogh in Creative Competition. Four Essays from "Simiolus". Zutphen, 1983

Boime, Albert: Van Gogh's "Starry Night". A History of Matter and a Matter of History. "Arts Magazine" 59 (Dec. 1984), pp. 86-103

Kôdera, Tsukasa: Japan as Primitivistic Utopia: Van Gogh's Japanisme Portraits. "Simiolus" 14 (1984), pp. 189-208

Soth, L.: Van Gogh's Agony. "Art Bulletin" 68 (1986), pp. 301-313

Feilchenfeldt, Walter: Vincent van Gogh & Paul Cassirer, Berlin. The Reception of van Gogh in Germany from 1901 to 1914. Zwolle, 1988

Comparative Table of Catalogue Numbers

This table makes it a simple task to locate van Gogh's paintings listed in de la Faille's or Hulsker's catalogues in the present "Complete Paintings". Numbers in de la Faille's catalogue appear in the left column under F, those in Jan Hulsker's are in the centre column under JH, and the right-hand column gives page references to the present edition (W). The table observes Hulsker's chronological order: that is, his catalogue numbers appear in sequence.

F	JH	W	F	JH	W	F	JH	W
1	81	16	35	478	37	76	542	64
1a	82	16	30	479	39	177	543	56
2	173	17	32	480	38	143	546	83
2a	176	17	185	484	41	136a	548	74
7	178	17	48a	488	40	75	550	69
13	179	18	33	489	38	146	551	69
8a	180	20	88	490	41	164	558	68
1665	181	19	190	492	44	144	561	68
8	182	18	175	497	47	160a	563	68
192	184	19	24	500	43	146a	565	67
12	185	12	37	501	42	159	–	67
3	186	20	27	503	43	156	569	68
4	187	21	38	504	45	132	574	68
5	188	22	39	505	46	169a	583	69
6	189	22	40	507	45	133	584	69
204	190	22	41	513	47	135	585	66
186	361	25	172	514	48f.	153a	586	69
1666	383	26	43	516	46	153	587	66
10	384	24	42	517	46	137	593	75
9	385	27	123	518	50	87	600	72
189	386	30	120	519	52	67a	602	72
15	387	28	25	521	53	194	603	77
1b	388	24	122	522	51	67	604	73
1c	389	24	46	524	55	154	608	71
16	391	26	125	525	54	65	627	71
11	392	25	47	526	54	1667	629	70
15a	393	27	48	527	55	168	632	76
–	394	24	178r	528	56	169	633	76
17	395	27	50	529	58	138	644	83
18	397	29	56	530	57	74	648	74
19	409	31	58	531	62	151	649	70
188	413	32	55	532	61	150	650	78
21	415	30	61r	533	59	127	651	78
20	417	32	49	534	57	145	653	80
22	421	33	52	535	59	365r	654	83
26	450	35	54	536	63	126a	655	79
162	457	36	64	537	60	152	656	79
184	458	34	53	538	60	171a	657	81
34	459	34	57	539	62	171	658	80
29	471	36	60	540	65	80	681	86
31	477	40	200	541	64	80a	682	86

F	JH	W		F	JH	W		F	JH	W
136	683	85		91	809	110		196	957	128
134	684	93		92	810	108		45	959	136
131	685	92		90	823	111		195	961	134
77r	686	82		–	–	111		44	962	132f.
163	687	89		170	824	113		260	970	142
165	688	89		1669	825	108		205	971	139
167	689	81		95	827	114		206	972	139
149	690	85		166	850	114		211	973	137
1668	691	88		97	876	117		174	978	143
130	692	87		96	878	112		207	979	140
85	693	87		147	891	117		212	999	138
85a	694	94		94	893	115		215	1045	144
81	695	94		95a	899	115		216a	1054	145
128	697	88		98	901	117		216g	1055	145
36	698	81		139	905	116		216h	1058	146
144a	704	84		148	908	112		216j	1059	147
157	712	92		193	914	116		216b	1060	146
70	715	82		63	920	119		216d	1071	148
70a	716	82		59	921	120		216i	1072	148
73	717	82		62	922	121		216f	1076	149
72	718	92		104	923	126		216e	1078	149
71	719	84		104a	924	125		216c	1082	151
160	722	93		51	925	123		208a	1089	153
69	724	90		105	926	123		181	1090	150
269r	725	90		101	927	125		199	1091	154
129a	727	101		103	928	124		214	1092	152
78	734	97		212a	929	118		244	1093	156
202	738	95		99	930	124		666	1094	156
66	743	107		100	931	120		231	1099	152
140	745	95		118	932	121		265	1100	150
185a	761	91		107	933	122		261	1101	182
191	762	100		116	934	122		262	1102	182
79	763	102		115	935	118		278	1103	158
82	764	96		106	936	123		279	1104	178
84	772	102		102	937	122		249	1105	185
83	777	103		112	938	127		243a	1106	180
388r	782	99		111	939	127		666a	1107	180
141	783	107		108	940	126		222	1108	166
86	785	103		110	941	126		221	1109	157
179r	786	99		109r	942	118		225	1110	159
155	787	98		113	944	128		223	1111	157
161	788	98		114	945	129		224	1112	157
158	792	113		117	946	104		232	1113	155
176	799	106		210	947	130		1672	1114	193
126	800	106		182	948	129		274	1115	165
89	803	112		119	949	131		273	1116	164
93	805	108		191a	950	130		219	1117	163
92a	806	109		183	952	128		285	1118	160
142	807	109		124	955	134		1670	1119	162
187	808	110		121	956	135		283	1120	161

F	JH	W	F	JH	W	F	JH	W
253	1121	154	177a	1192	199	345	1249	221
1671	1122	160	14	1193	198	343	1250	228
203	1123	161	180	1194	187	313	1251	239
255	1124	183	208	1195	186	312	1253	244
198	1125	164	178v	1198	187	299	1254	236
327	1126	169	263a	1199	205	351	1255	252
286	1127	176	288	1200	202	342	1256	238
286a	1128	176	209	1201	204	298	1257	236
243	1129	174	263	1202	204	314	1258	242f.
236	1130	174	289	1203	205	276	1259	240
237	1131	181	207a	1204	140	361	1260	248
259	1132	174	215b	1205	208	367	1261	228
246	1133	162	369	1206	218	368	1262	247
241	1134	172	270	1207	203	583	1263	251
596	1135	171	370	1208	206	362	1264	250
235	1136	181	294	1209	213	305	1265	246
324a	1137	172	296	1210	213	355	1266	240
220	1138	174	295	1211	211	239	1267	249
201	1139	173	328	1212	203	240	1268	245
252	1140	173	330	1214	202	293	1269	245
258	1141	170	329	1215	203	354	1270	237
251	1142	175	357	1216	209	353	1271	246
281	1143	168	292	1219	224	270a	1272	250
218	1144	168	348a	1221	225	310a	1273	247
245	1145	167	266a	1223	219	310	1274	251
248	1146	167	267	1224	212	300	1275	233
242	1147	176	380	1225	212	275	1278	246
248a	1148	179	335	1226	216	317	1287	253
247	1149	170	336	1227	216	318	1288	248
248b	1150	179	334	1228	230	322	1292	261
217	1164	168	337	1229	227	324	1293	260
282	1165	177	283b	1230	217	286b	1294	255
250	1166	184	287	1231	231	323	1295	254
197	1167	169	253a	1232	231	371	1296	284
234	1168	177	332a	1233	210	372	1297	284
256	1169	184	332	1234	201	373	1298	285
227	1170	189	331	1235	210	268	1299	262
228	1171	188	333	1236	210	179v	1300	264
226	1172	188	338	1237	230	269v	1301	266
266	1175	194	339	1238	227	61v	1302	268
229	1176	196	340	1239	226	109v	1303	267
230	1177	197	—	1240	225	77v	1304	265
238	1178	190f.	347	1241	214f.	264a	1306	257
264	1179	200	341	1242	222	388v	1307	257
233	1180	196	341a	1243	223	526	1309	269
348	1182	195	346	1244	224	469	1310	271
272	1183	192	350	1245	234f.	321	1311	270
349	1184	195	316	1246	241	309a	1312	277
271	1186	193	213	1247	229	308	1313	259
28	1191	199	356	1248	220	291	1314	248

F	JH	W	F	JH	W	F	JH	W
309	1315	258	396	1367	320	558	1481	364f.
277	1316	256	397	1368	323	560	1482	370f.
306	1317	274	544	1369	315	562	1483	374f.
307	1318	276	400	1371	324	423	1486	362
817	1319	682	403	1378	334f.	424	1488	367
315	1320	258	394	1379	318	466	1489	377
352	1321	256	555	1380	320	427	1490	378
302	1322	273	552	1381	321	448	1491	386
303	1323	241	556	1383	327	428	1499	384
311	1325	275	511	1386	337	430	1510	380
304	1326	273	553	1387	330	429	1513	383
301	1327	272	554	1388	329	431	1519	389
377	1328	278	513	1389	328	432	1522	392
375	1329	281	404	1391	332	433	1524	393
452	1330	281	571	1392	325	578	1538	399
376	1331	279	405	1394	332	443	1548	402
359	1332	270	551	1396	328	447	1550	381
319	1333	290	557	1397	333	447a	1551	408
320	1334	291	399	1398	326	446	1553	390
588	1335	280	406	1399	333	445	1554	407
603	1336	289	407	1402	326	449	1558	413
382	1337	289	409	1416	342	453	1559	410
374	1338	283	408	1417	339	459	1560	411
383	1339	279	567	1419	316	456	1561	409
378	1340	286	570	1421	343	454	1562	411
379	1341	287	575	1422	338	444	1563	403
254	1342	288	576	1423	338	524	1565	398
602	1343	288	600	1424	340	593	1566	405
1672a	1344	297	384	1425	340	594	1567	410
366	1345	297	410	1426	341	592	1568	388
297	1346	294	591	1429	336	461	1569	404
297a	1347	294	412	1440	347	437	1570	412
216	1348	292	425	1442	351	438	1571	412
360	1349	295	565	1443	368	549	1572	406
363	1351	282	416	1447	349	549a	1573	406
364	1352	296	415	1452	352	462	1574	420
344	1353	299	417	1453	353	463	1575	428f.
365v	1354	299	413	1460	355	550	1577	419
381	1355	293	420	1462	361	468	1578	416
522	1356	298	419	1465	358	467	1580	425
390	1357	308	535	1467	345	476	1581	396
391	1358	309	426	1468	379	470	1582	414
389	1359	309	422	1470	350	566	1585	417
290	1360	310f.	465	1473	373	574	1586	418
392	1361	313	564	1475	373	473	1588	426
393	1362	312	411	1476	376	464	1589	423
395	1363	312	545	1477	344	474	1592	431
607	1364	314	–	1478	385	475	1595	415
386	1365	314	559	1479	372	575a	1596	430
398	1366	306	561	1480	366	572	1597	437

F	JH	W	F	JH	W	F	JH	W
472	1598	435	510	1661	474	709	1760	514
478	1599	439	606	1662	475	735	1761	527
477	1600	438	605	1663	475	746	1762	528
479	1601	433	502	1664	474	747	1763	531
480	1603	448	525	1665	541	745	1764	530
481	1604	448	457	1666	476	622	1766	529
478a	1605	443	458	1667	477	635	1767	569
482	1608	442	455	1668	476	625	1768	532
358	1612	436	505	1669	482	626	1770	534
471	1613	432	506	1670	481	484	1771	549
485	1615	432	508	1671	483	627	1772	537
494	1617	434	507	1672	483	618	1773	533
573	1618	446	439	1673	488	629	1774	539
486	1620	444	435	1674	489	630	1775	542
487	1621	445	436	1675	488	757	1776	542
568	1622	449	460	1676	498	631	1777	538
569	1623	447	402	1677	489	624	1778	543
488	1624	455	582	1678	492	531	1779	540
489	1625	454	580	1679	498	528	1780	536
495	1626	450	584	1680	493	700	1781	553
450	1627	452	514	1681	496f.	687	1782	553
451	1629	453	515	1683	490f.	688	1783	547
496	1630	451	516	1685	487	692	1784	550
497	1632	454	646	1686	486	693	1785	550
501	1634	456	519	1687	495	696	1786	547
498	1635	464	517	1689	498	634	1787	551
499	1636	467	520	1690	499	697	1788	551
490	1637	457	608	1691	505	698	1789	552
491	1638	457	579	1692	504	743	1790	546
440	1639	462	609	1693	507	711	1791	532
441a	1640	463	734	1698	502	619	1792	554
441	1641	462	601	1699	500	483	1793	548
492	1642	461	610	1702	503	706	1794	556
493	1643	459	723	1722	515	641	1795	555
537	1644	460	611	1723	510	637	1796	556
538	1645	460	719	1725	512	638	1797	557
503	1646	463	718	1727	510	642	1798	561
434	1647	468	720	1728	509	643	1799	560
536	1648	469	612	1731	520f.	640	1800	559
533	1649	468	712	1740	511	731	1801	558
532	1650	469	725	1744	508	744	1802	529
534	1651	466	724	1745	508	645	1803	570f.
547	1652	470f.	613	1746	516	662	1804	569
548	1653	472	620	1748	519	644	1805	552
504	1655	482	581	1751	513	703	1832	564
604	1656	473	617	1753	514	648	1833	562
527	1657	484	615	1755	544	647	1834	567
529	1658	478	717	1756	523	649	1835	572
500	1659	480	585	1758	526	689	1836	566
283a	1660	475	715	1759	522	690	1837	566

F	JH	W	F	JH	W	F	JH	W
699	1838	583	673	1919	618	766	2031	654
650	1839	572	674	1920	608	280	2032	661
653	1840	573	675	1921	614	589	2033	660
730	1841	568	694	1922	618	767	2034	669
732	1842	582	695	1923	620	768	2035	666
652	1843	576	702	1967	630	786	2036	667
651	1844	573	676	1970	621	769	2037	667
733	1845	585	677	1972	626	775	2038	670f.
742	1846	584	633	1974	627	770	2040	672
701	1847	606	672	1975	621	773	2041	664f.
818	1848	579	681	1976	625	598	2043	665
660	1849	586	678	1977	623	599	2044	664
659	1850	587	680	1978	624	764	2045	662
587	1853	592	682	1979	625	764a	2046	661
586	1854	577	807	1980	628	772	2048	677
708	1855	578	704	1981	629	787	2050	676
710	1856	574	683	1982	632	783	2051	663
707	1857	580f.	750	1984	636	784	2052	663
714	1858	588f.	792	1987	650f.	774	2053	668
657	1860	590	759	1988	647	788	2055	675
658	1861	585	805	1989	637	518	2056	676
737	1862	600f.	752	1991	639	785	2057	662
721	1864	599	751	1992	638	822	2095	687
664	1865	591	791	1995	638	811	2096	679
663	1866	596	755	1999	634	778	2097	678
654	1868	596	815	2000	642	809	2098	689
655	1869	594f.	802	2001	641	782	2099	680
656	1870	593	794	2002	635	812	2101	700
661	1871	602	797	2003	642	781	2102	688
722	1872	603	799	2004	645	776	2104	684f.
623	1873	602	756	2005	649	777	2105	683
726	1874	597	789	2006	652	814	2107	696
728	1875	604	753	2007	657	790	2108	696
739	1876	597	595	2009	648	810	2109	685
727	1877	591	820	2010	640	796	2110	644
716	1878	584	597	2011	624	795	2111	643
665	1879	458	749	2012	622	819	2112	697
684	1880	605	748	2013	622	816	2113	692
686	1881	610f.	754	2014	656	793	2114	694
632	1882	608	821	2015	674	780	2115	686
668	1883	609	758	2016	646	779	2117	690f.
667	1884	613	806	2017	645	808	2118	693
669	1885	612	804	2018	654	761	2120	693
670	1886	619	760	2019	655	563	2121	688
621	1888	619	762	2020	658	800	2122	698
671	1891	615	798	2021	681	801	2123	700
540	1892	617	740	2022	659	803	2124	558
541	1893	616	636	2027	659	771	2125	699
542	1894	617	765	2029	673	—	—	44
543	1895	618	763	2030	660	—	add. 2	159

Index of Paintings

The index of painting contains the titles of all 871 paintings by Vincent van Gogh which appear in this book, but does not include the titles of watercolours, drawings and etchings. The titles of the paintings are listed in alphabetical order, disregarding definite and indefinite articles at the beginning. In other words, a title such as *The Red Vineyard* is indexed under Red. To simplify use of the index for the reader, however, numerous titles have been listed more than once; for example, *Portrait of Joseph Roulin* can be found under *Portrait* as well as under the name *Roulin, Joseph*.

Acknowledgements

The authors and publishers wish to thank the museums, public and private collections, archives, photographers and other people who helped make this "Complete Paintings" of van Gogh possible. We are particularly grateful to the two museums that house the largest van Gogh collections, the Rijksmuseum Vincent van Gogh, Vincent van Gogh Foundation, Amsterdam (picture archive: A. M. Daalder-Vos, Stedelijk Museum, Amsterdam) and the Rijksmuseum Kröller-Müller, Otterlo (Margaret Nab-van Wakeren). We are also grateful to Sotheby's of London (Marjorie Delpech, Lucy Dew) and New York, and Christie's of London (Claudia Brigg, Deborrah Keaveney, Angela Hucke) and New York (Betsy Fleming). Of the numerous archives that helped, we owe a particular debt to Ursula and André Held, Ecublens. Translations from the letters of van Gogh and his family and friends are original to this edition. We have made every attempt to trace the holders of copyright in photographs reproduced in the book, but if by some oversight we have omitted any copyright holders the publishers would be very glad to hear from them. We wish to express special thanks to the following institutions and individuals for their assistance in obtaining material: Aberdeenshire: Mike Davidson, Positive Image. Alling: Bildarchiv Walther & Walther Verlag; Marianne Walther. Allschwil: Colorphoto Hans Hinz SWB. Arlesheim: Anna Maria Staechelin, Rudolf Staechelinsche Familienstiftung. Baden: Professor Florens Deuchler, Stiftung Langmatt Sidney und Jenny Brown. Baltimore: Nancy Boyle Press and Maria Zwart Breshears, The Baltimore Museum of Art. Basle: Klaus Hess, Kunstmuseum Basel. Belgrade: Jevta Jevtovic, Narodni Muzej. Berne: Heidi Frautschi, Kunstmuseum Bern. Chicago: Paula Pergament, The Art Institute of Chicago. Cincinnati: Beth Dewall, Cincinnati Art Museum. Copenhagen: Flemming Friborg, Ny Carlsberg Glyptotek. Diessen: Odo Walther (biography). Edinburgh: Michael Clarke, National Gallery of Scotland. Germering: Herbert K. Mayer (data base). 's-Gravenhage: Peter Couvée, Dienst voor Schone Kunsten. Hamilton: Kim G. Ness, The Art Gallery of McMaster University. Hartford: Raymond Petke, Wadsworth Atheneum. Hedel: Jac Peeters, Wim van Kerkhof. Jerusalem: Irene Lewitt, Israel Museum. Kensington: Joel Breger. Kiel: Dr. Thorsten Rodiek, Stiftung Pommern; Horst Rothaug. Landsberg: Anneliese Brand. Laren: E. J. C. Raasen-Kruimel, Singer Museum. London: The Bridgeman Art Library Ltd.; David Ellis-Jones, Widenstein & Co.; Robert Lewin. Merion Station: Esther Van Sant, The Barnes Foundation. Munich: Archiv Alexander Koch; Bayerische Staatsbibliothek; Johanna Goltz. New York: Julie Roth, Solomon R. Guggenheim Museum; Deanna Cross, The Metropolitan Museum of Art; Thomas D. Grischkowsky; The Museum of Modern Art; Vredy Lytsman-Zivkovich. Ouderkerk: Tom Hartsen. Paris: Marie-Lorraine Meurer-Revillon, Musée Rodin; Service Photographique de la Réunion des Musées Nationaux; Photographie Giraudon. Philadelphia: Conna Clark and Beth A. Rhoads, Philadelphia Museum of Art. Obbach: Thea Kühnlein, Sammlung Georg Schäfer. Ottawa: Susan Campbell, National Gallery of Canada. Planegg: Artothek. Providence: Melody Ennis, Museum of Art, Rhode Island School of Design. Rancho Mirage: Mr. and Mrs. Walter H. Annenberg. Richmond: Pinkey Near, Virginia Museum of Arts. St. Louis: Patricia Woods, The St. Louis Art Museum. Stockholm: Märta Ankarswärd, Nationalmuseum. Tokyo: Naoko Kichijoji, Bridgestone Museum of Art. Toledo: Lee Mooney, The Toledo Museum of Art. Toronto: David McTavish, Art Gallery of Ontario. Upperville: Mrs. and Mr. Paul Mellon. Washington: Beverly Carter, Paul Mellon Collection; David Lloyd Kreeger. Winterthur: Dr. Rudolf Koelle and Erica Rüegger, Kunstmuseum Winterthur. Wuppertal: Holger Zibrowius, Von der Heydt-Museum. Utrecht: Charlie Koens, Centraal Museum der Gemeente Utrecht. Zurich: Dr. H. Bänniger, Oberlikon-Bührle Holding A. G.; Annamarie Andersen, Gallerie Koller; Cécile Brunner, Kunsthaus Zürich; Hortense Anda-Bührle and B. Steinegger, Stiftung Sammlung E. G. Bührle; Walter Feilchenfeldt, Galerie Feilchenfeldt. To all of these, and many more too numerous to name, our sincerest thanks.

I.F.W.

Index of Names